Master Drawings

from the Cleveland Museum of Art

Master Drawings

from the Cleveland Museum of Art

DIANE DE GRAZIA AND CARTER E. FOSTER, EDITORS

The Cleveland Museum of Art in association with
Rizzoli International Publications

Published on the occasion of the
exhibition *Master Drawings from the
Cleveland Museum of Art* organized
by the Cleveland Museum of Art.

The Cleveland Museum of Art,
27 August–15 October 2000

The Pierpont Morgan Library, New York,
24 May–19 August 2001

Published by
The Cleveland Museum of Art
11150 East Blvd.
Cleveland, Ohio 44106

in association with
Rizzoli International Publications, Inc.
300 Park Avenue South
New York, New York 10010

Copyright © 2000 by The Cleveland
Museum of Art

Library of Congress card number:
00-104123.

ISBN: 0-940717-63-8 (CMA cloth)
ISBN: 0-940717-64-6 (CMA paper)
ISBN: 0-8478-2296-6 (Rizzoli cloth)

Editing: Barbara J. Bradley and
Kathleen Mills
Design: Thomas H. Barnard III
Production: Charles Szabla
Photography: Howard T. Agriesti; addi-
tional photography: Gary Kirchenbauer
Printing: Amilcari Pizzi, Milan
Composed in Monotype Walbaum
Cover: Giovanni Battista Piazzetta, *A
Young Woman Buying a Pink from a
Young Man* (detail), c. 1740 (no. 21).
Purchase from the J. H. Wade Fund
1938.387.

National City is the sponsor of
*Master Drawings from the Cleveland
Museum of Art.*

Table of Contents

While the Cleveland Museum of Art is widely known for the quality of its holdings, often the individual objects visitors remember are those that are on more permanent view in the galleries. Works on paper are necessarily exhibited infrequently because of the damaging effects of ultraviolet rays. Although a number of sheets have been on view in the galleries, loaned to exhibitions elsewhere, and published in articles and books, the drawing collection as a whole, with its unique and noteworthy works, is known primarily to connoisseurs and art historians. Thus it is a pleasure to present this exhibition, which brings to light the distinction of the museum's collection of drawings. This accompanying catalogue documents and celebrates some of the masterpieces in a collection of more than 2,700 sheets, allowing the breadth and quality of these holdings to be admired by a wider audience for the first time.

One of Diane De Grazia's first proposals when she came to the museum in 1995 was to catalogue the collection of drawings and present the best works in a traveling exhibition, in order to show the public that every collection in the museum is characterized by discriminating quality and importance. She and her associate Carter Foster have chosen the objects for this exhibition, which is the first manifestation of the cataloguing and research that have been undertaken on the collection.

Master Drawings from the Cleveland Museum of Art has been generously supported by National City, to whom we extend our profound gratitude. With the assistance of the Getty Grant Program, the museum continues to gather data for a catalogue of European drawings before 1900. In addition, the Samuel H. Kress Foundation has provided support for a Kress curatorial fellow to aid in the cataloguing of the drawings collection. All these efforts will contribute both to our understanding of the museum's holdings in the area of drawings and to the general advancement of scholarship in the field. Both are admirable expressions of essential aspects of the museum's central mission, in which research and scholarship are fundamental.

Katharine Lee Reid
Director

Acknowledgments

It is a pleasure to extend our thanks to friends and colleagues who have helped us in the completion of this catalogue. The research involved is only one component of the effort to catalogue the Cleveland Museum of Art's entire collection of European drawings, work that has been funded over the past two years by the Getty Grant Program, and more recently by the Samuel H. Kress Foundation. As part of this larger project, we consulted several experts in specialty areas of old master drawings and gratefully acknowledge their input: for Dutch and Flemish: Egbert Haverkamp-Begemann; for Italian: William M. Griswold; for French: Margaret Morgan Grasselli and Colta Ives; for German: Martha Wolff.

We are particularly indebted to the contributors to the catalogue, all of whom are current or former museum staff members: Henry Adams, Sylvain Bellenger, Patrick Shaw Cable, Jane Glaubinger, Sabine M. Kretzschmar, Shelley R. Langdale, Jeannine O'Grody, William H. Robinson, and Stanton Thomas. For their help with individual entries we would like to acknowledge Bernard Aikema, Roberta Bernstein, Ken Bohač, John Christian, Sarah R. Cohen, Roger Diederen, James Ellis, Betty Elzea, Stephen Fliegel, Adelaide Gealt, Jo Hedley, Jane Kallir, Ellsworth Kelly, George Knox, Gode Krämer, Evelyn Lafave, Mary Lublin, Edgar Munhall, Hal Opperman, Jenifer Neils, Suzanne Folds McCullagh, Kathleen McKeever, Kerin Mertagh, Michael Pantazzi, Roy Perkinson, A. W. C. Phelps, Sue Welsh Reed, Marcel Roethlisberger, Rachel Rosenzweig, Kristel Smentek, Sally Smith, Gary Tinterow, Lilian Tone, Paul Vercier, David Weinglass, Thomas Williams, Juliet Wilson-Bareau, and Linda Wolk-Simon.

A number of museum staff members deserve special mention. Todd Herman, a research assistant during most of the project, made many contributions to individual entries, to provenance research, and to the introduction; he also oversaw much of the compilation and editing of the bibliography. Patrick Shaw Cable compiled exhibition histories for the French and Italian drawings and assisted with translation, editing, and writing. Dena Woodall also worked on the exhibition histories and on the bibliography. Joseph Giuffre and Jeannine O'Grody helped with entries and basic cataloguing of many of the works. The staff at the museum's Ingalls Library provided much-needed time and expertise, and we are very grateful to Christine Edmonson for tracking endless citations and interlibrary loans and to Louis Adrean, particularly for his help with botany questions. Joan Brickley assisted with numerous photography requests and a variety of administrative duties, as did Jill Jiminez. Moyna Stanton, associate conservator for paper, lent her expertise throughout the duration of this project, and she beautifully conserved a number of the works in the exhibition. Preparator Charles Eiben also helped with conservation and with preparation of the pieces for the exhibition. Archivist Ann Marie Pryzbyla and registrar Carol Thum helped us track down many obscure records. Jane Glaubinger, curator of prints, and her pre-

decessor Louise Richards shared their knowledge on the history of the collection. Kate Sellers, deputy director, and Jill Barry, Rob Krulak, and Judith Paska of the development department helped secure financial support for the project. The photography studio, headed by Howard Agriesti, completed new photography for every work in the catalogue, and Bruce Shewitz ably coordinated much of that work as well as provided scans of the drawings for our study on the computer. The publications department, headed by Laurence Channing, worked patiently with all the authors under a tight deadline: editor Barbara J. Bradley oversaw the project from start to finish, Tom Barnard beautifully designed the catalogue, and Chuck Szabla coordinated its production.

For coordination of the exhibition and its tour we acknowledge Katherine Solender and Heather Ulrich of the exhibitions department, as well as Mary Suzor, chief registrar, and her associate Beth Gresham. We thank the design and installation staff under the direction of Jeffrey Strean for their handsome presentation of the exhibition in Cleveland. William H. Griswold, Charles W. Engelhard curator of drawings and prints at the Pierpont Morgan Library, supported the show's venue in New York.

Carter Foster extends special thanks to Julien Chapuis, Jay Clarke, Martin Kline, Steve Mazoh, Kristel Smentek, Craig Starr, Mark Turner, and David Zaza for their support. He also thanks Richard Allen Berman, Corin Bennett, Antoine Cahen, Alvin L. Clark Jr., Cathy Curry, Starr Figura, Wayne Furman, Rita Gallagher, Dario Gamboni, Michel Gierzod, Margaret Glover, John W. Ittmann, Lowell Libson, Jean-François Méjanès, Hannelore Osborne, Alan Salz, Gabriel Terrades, and Roberta Waddell.

This project began with support from the museum's late director Robert P. Bergman, who had a strong commitment to promoting research on the permanent collection, and we fondly remember his encouragement and enthusiasm for this exhibition and catalogue. Following his death, Kate Sellers and his successor, Katharine Lee Reid, continued to support our project to present the museum's collection to the public.

Diane De Grazia
Carter Foster

ABBREVIATIONS

Bartsch
Adam Bartsch. *Le peintre-graveur.* 21 vols. Vienna, 1803–21. Reissued as *The Illustrated Bartsch,* 50 vols. New York, 1978–87.

Briquet
C. M. Briquet. *Les Filigranes: Dictionnaire historique des marques du papier.* 4 vols. Amsterdam, 1968.

CMA
Cleveland Museum of Art.

CMA Bulletin
The Bulletin of the Cleveland Museum of Art.

Gernsheim
Gernsheim Corpus Photographicum of Drawings. 1956–. Photographs of mostly old master drawings from American, European, and Australian museums and private collections.

Heawood
Edward Heawood. *Watermarks, Mainly of the Seventeenth and Eighteenth Centuries.* Hilversum, 1950.

Hollstein
F. W. H. Hollstein. *Dutch and Flemish Etchings, Engravings, and Woodcuts, 1450–1700.* Amsterdam, 1949–.

Lugt
Frits Lugt. *Les Marques de Collections de Dessins & d'Estampes.* Amsterdam, 1921; Supplement, The Hague, 1956.

Publications abbreviated in the notes in each entry and in the Documentation section are cited fully in the Bibliography.

PAPER
Paper color is described as it currently appears, with discoloration indicated if there are areas on the sheet that show (or suggest) the original color. The Print Council of America Paper Sample Book (1996) was used as a guideline in describing paper color; all drawings were compared to the color samples in this book, and its terminology was adapted when possible. Paper is described as either laid or wove; laid paper is assumed to be antique laid paper unless indicated as modern laid paper.

MEASUREMENTS
Height precedes width.

WATERMARKS
If present, the orientation and location of a watermark is described in relation to the orientation of the recto of the sheet.

INSCRIPTIONS

Recto is assumed; any change of surface is noted ("verso," "secondary support," etc.); the inscriptions following a change of surface notation are on that surface until another change of surface is indicated. Orientation of the verso was determined by flipping the recto like a book page from left to right. If there is an image on the verso, it is catalogued separately, the orientation determined by the image. Descriptions of the orientation and location of inscriptions thus correspond to these rules.

Inscriptions have been transcribed exactly as they appear, without correcting spelling or other errors. Inscriptions added since the work was acquired by the museum (generally the accession number) have not been included. Brackets are used to indicate illegible or partially illegible inscriptions and for further descriptive information regarding the inscription.

Inscriptions are related in the following order: 1. Signature (including elements clearly written along with the signature); 2. Date/Title (if separate from signature); 3. Other inscriptions known to be by artist; 4. Inscriptions by other hands, given in chronological order from earliest to latest if that was able to be determined. Those inscriptions for which no precedence could be determined are related from top to bottom, left to right. Authorship of inscriptions is assumed to be unknown unless noted otherwise.

PROVENANCE

Previous collectors (or records of whereabouts) are given in chronological order, with the source of that information following in parentheses if known. If the work bears a collector's mark, its Lugt number is given when possible. Sales at auction and by dealers or agents, as well as other commercial transactions, are listed within brackets. If the work passed directly from one party to another, the entries are separated by a semicolon; if there is a break in the provenance or if it is unknown whether the work passed directly between two parties, they are separated by a period.

EXHIBITIONS

Exhibitions, including CMA exhibitions with a catalogue or other publication, are abbreviated by the city name(s) and the year(s) of the exhibition, with full citations listed in the Bibliography. Authors are indicated where known. CMA exhibitions without a catalogue or publication are abbreviated in the exhibition section with a "CMA" followed by the year; a list of them is found at the end of the Bibliography.

CONTRIBUTORS TO THE CATALOGUE

HA	Henry Adams
SB	Sylvain Bellenger
PSC	Patrick Shaw Cable
DDG	Diane De Grazia
CEF	Carter E. Foster
JG	Jane Glaubinger
SMK	Sabine M. Kretzschmar
SRL	Shelley R. Langdale
JO	Jeannine O'Grody
WHR	William H. Robinson
ST	Stanton Thomas

Sylvain Bellenger's entries were translated from the French by Patrick Shaw Cable.

Drawings in Cleveland
The Evolution of a Collection

Diane De Grazia

The collection of drawings at the Cleveland Museum of Art began with its first gift in 1915, a year before the museum opened its doors to the public. Today the collection consists of about 2,700 sheets, divided almost evenly between European and American schools, with about 600 sheets by artists working in Cleveland. No artist is represented comprehensively, but there are several groups of drawings by a few regional figures.[1] The collection is small by international standards but has earned its reputation over the years for the outstanding quality and historical importance of individual drawings. Although the emphasis in graphic arts at the museum has been primarily on prints, with experts in this area guiding the collection's formation, over the years Cleveland has by gift and purchase become one of the significant drawing collections in the country. Its strength lies in its holdings of key works by artists of the sixteenth century in Italy, the eighteenth and nineteenth century in France, and the early twentieth century in Europe and America.

When the Cleveland Museum of Art was founded in 1913, one of its aims was "to here display examples of the highest art as it has existed in all ages and in all countries."[2] In spite of this lofty goal and a separate gallery designated for print exhibitions when the building opened in 1916, the administration of the museum did not organize a graphic arts department. That process began in 1919 when Ralph T. King (1855–1926) led a group of print collectors to organize the Print Club of Cleveland (now the oldest print club connected to a museum) to help the museum "acquire a print collection of high excellence."[3] King, a museum trustee and collector, volunteered as the first acting curator of prints and served the museum in that capacity between 1920 and 1922.[4] Nothing was mentioned at the time about a collection of drawings, but a few drawings had already entered the museum by donation. The earliest gift, in 1915, consisted of eight views of Cleveland by a local painter, Otto Bacher (1856–1909), donated by his wife Mrs. Mary H. Bacher. Some minor drawings by contemporary German and American artists were given, as were twelve recent drawings by Kenyon Cox.[5] Major pastels by Edgar Degas (fig. 1) and Mary Cassatt (fig. 2) entered the collection in 1916 and 1920, but at that time pastels were considered paintings and were exhibited as such.[6]

By 1920 the collection held 555 prints and 41 drawings, largely because of the efforts of Ralph King, who instilled enthusiasm for the graphic arts in Cleveland and for building up the museum's print collection in just a few years. By his death in 1926 he had given the museum more than 900 prints as well as 17 drawings, among which are sheets by Degas, Henri Fantin-Latour, Jean-Louis Forain, Edward Burne-Jones, Dante Gabriel Rossetti, Augustus John, William Orpen, James McNeill Whistler, and John Singer Sargent. King was considered a creative collector for forming a collection that "does not end with the Barbizon school, as does that of so many collectors and public institutions but comes down bravely to our own day."[7] King's interest in modern French art formed the basis for later strength

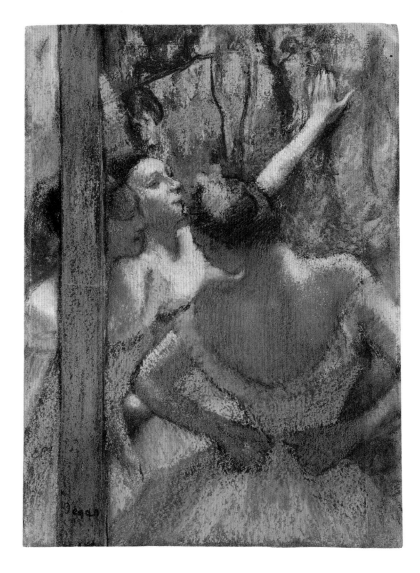

in this area of the collection. Twenty years after his death, his wife and four children gave additional works in his memory, including Sargent's watercolor *The Patio* and drawings by John LaFarge, Edward Burne-Jones, and Augustus John.[8] The first president of the Print Club, Charles T. Brooks (1867–1935), a member of the museum's Advisory Council (now the Museum Council), also donated prints and two drawings by Cassatt, a favorite artist of American collectors of the 1920s.[9]

Theodore Sizer (fig. 3), a pupil of Paul Sachs at Harvard, took over the print department in 1922 and remained as curator of prints and oriental art until 1927. The professionalization of the department required the establishment of a print study room and the rotation of works in the print gallery. Sizer noted the scarcity of means to purchase drawings and responded by acquiring facsimiles. There was no indication that there would ever be a collection of great old master drawings. In 1924 Sizer exhibited some forty drawings owned by the museum, supplemented by works lent by dealers. In *CMA Bulletin* articles of 1923 and 1924, Sizer reported the slow growth of the drawing collection and pleaded for donations of contemporary art, justifying the request with the statement that the "public is always, and quite justly, interested in the work of living artists."[10] He purchased recent works by Preston Dickinson, Maurice Prendergast, Rockwell Kent, and others. Sizer's view that modern and old drawings and reproductions were both instructive to

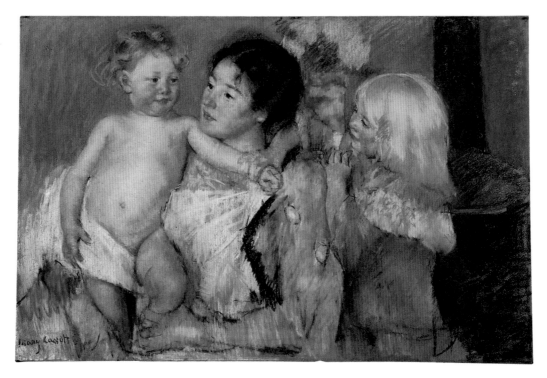

art students and of interest to the public shaped the collection in its early years.[11] The founders of the museum had emphasized the goal of educating the public by buying and exhibiting the best of crafts of different kinds. Indeed, the donation of the Severance collection of arms and armor was specifically aimed at raising the standards of craftsmanship in a city built on steel.[12] The annual exhibition of Cleveland artists and craftsmen (later titled the "May Show"), begun in 1919, reiterated that intention as did the purchase of works for the museum directly from the exhibition.[13] As Sizer stated, drawing is "elementary and the basis of the visual arts."[14] His purchase of four sixteenth-century drawings for goldsmith work attributed to Perino del Vaga and a Swiss design for stained glass indicate his aim of educating artists in earlier forms of craftsmanship.[15] At the same time, he was responsible for the first purchases of Italian drawings, another strength of the collection. Besides the studies for goldsmith work, drawings by Ottavio Leoni, Giulio Campi, Parmigianino, Guercino (no. 14), and Palma Giovane made their appearance in Cleveland. He did not neglect modern and old master French drawings, purchasing sheets by Jean-Honoré Fragonard, Puvis de Chavannes, Jean-Auguste-Dominque Ingres (no. 50), Odilon Redon, Constantin Guys, Aristide Maillol, André Derain, Honoré Daumier (no. 54), and Camille Pissarro. With the help of Leonard Hanna, who is discussed below, Sizer bought major drawings by François Boucher (no. 38), Hubert Robert (no. 45), Redon, Henri Matisse, and Degas. He purchased contemporary American drawings by Charles Sheeler and Arthur B. Davies. Sizer was able to acquire such important sheets because, as he said, "the collection of drawings is apparently the last stage reached by the discriminating and discerning connoisseur."[16]

During the thirty-seven-year tenure of Sizer's successor, Henry Sayles Francis (fig. 4), the "discriminating and discerning connoisseur" would have to find increased means to acquire the most important drawings available because they com-

Fig. 3. Theodore Sizer, curator of prints and oriental art, 1922–27.

Fig. 4. Henry Sayles Francis, curator of paintings, drawings, and prints, 1931–67.

manded higher prices on the art market and more drawing collectors appeared ready to compete for the best works. First as curator of prints (1927–29), then as curator of prints and drawings (1929), and finally as curator of paintings, drawings, and prints (1931–67), Henry Francis, with Leona Prasse (see below), guided the formation of a notable collection of old master drawings.[17] Francis was also responsible for many of the great painting purchases in the museum's history, including masterpieces by Pablo Picasso (*La Vie*) and Francisco Zurbarán (*Christ and the Virgin in the House at Nazareth*). In November 1927, another exhibition of old master and modern drawings was supplemented with loans from the collections of Paul J. Sachs and the Pierpont Morgan Library.[18] In 1928 Francis purchased a sheet by Jean-Antoine Watteau, and an important landscape by Claude Lorrain (no. 34) was given to the museum. Interest in French art at the Cleveland Museum of Art throughout its first years was heightened by the frequent European trips taken by local collectors and their aspirations to equal the growing collections in New York in the 1920s. An exhibition of French landscapes, *Poussin to Corot*, held in Paris in 1925 may also have influenced Cleveland collectors.[19]

In 1929 Henry Francis was sent to Europe with $5,000 to purchase prints but wrote that it was definitely "a drawing year." He took advantage of the opportunity and returned with works attributed to Giovanni Benedetto Castiglione, Pieter Brueghel, Jan van Goyen, Wenceslaus Hollar, and others.[20] As Francis related in the museum's 1929 annual report, in which thirty-five drawings were listed for that year's acquisitions, "the effort in recent years has been to include yearly, if possible, at least one outstanding drawing."[21] For the next four decades, he was almost always able to ensnare at least one significant object each year and often did much better. Throughout the depression years of the 1930s, however, the pace slowed remarkably, although contemporary American drawings by Edward Hopper (no. 106), John Marin, and others entered the collection. During this period, Francis was still able to acquire major eighteenth-century Venetian drawings such as Canaletto's *Capriccio: A Palace with a Courtyard by the Lagoon* (no. 23) and a group of portrait drawings and the *Flying Angel* (no. 20) by Giambattista Piazzetta and seven drawings by Giovanni Domenico Tiepolo from his "Pulchinello" (no. 27) and "Scenes of Contemporary Life" series. Acquisitions during the Second World War also reflected the limited means and the caution of the museum, but Francis did purchase Winslow Homer's *Girls with Lobsters* and *Clam Bake*, Fragonard's *Invocation to Love* (no. 47), and works by Thomas Eakins and others. It was in the period just after the war, with the breakup of many European collections and renewed prosperity in America, that the museum stepped up its purchasing activity.

During the years of America's acute financial difficulty, however, gifts from generous donors continued to enhance the quality of the drawing collection. Today, each of the museum's collections is known as a "curatorial collection" because most of the primary works were purchased rather than given and no single privately donated collection dominates. In the drawing collection, however, and especially in the area of nineteenth-

and early twentieth-century French art, some of the finest objects were donated by supporters of the museum. A total of sixty-one percent of the drawings in the museum's collection are gifts. With Ralph King's leadership, other friends of the new museum joined in creating its drawing collection. The Print Club, whose mission was (and is) to "promote the development of art in the community by the acquiring and owning of prints and other art objects and things, and presenting prints and other art objects and things to the Cleveland Museum of Art," gave the museum Degas's *Jockey* in 1927 and later added his *Angel Blowing a Trumpet* (in 1976 [no. 51]).[22] Other drawings given by the Print Club over the years included William Blake's *The Thought of Death Alone, the Fear Destroys*, Cassatt's *The Visitor*, Käthe Kollwitz's *Pregnant Woman Committing Suicide*, Charles Burchfield's *Sunflowers*, and Eugène Isabey's *Cliffs by the Sea at Lezembre, Brittany*. The club commissioned prints annually for its members, and preparatory drawings for those works included sheets by Lionel Feininger and Thomas Hart Benton, among the many others who took on the challenge of creating a new print.[23]

Jeptha Homer Wade (1857–1926), one of the founders of the museum and donor of the land upon which the building stands, presented almost 3,000 objects to the museum.[24] He began giving works of art in 1914 with 532 items; in 1916 he gave 34 nineteenth-century paintings by Eugéne Delacroix, Fantin-Latour, Puvis de Chavannes, Claude Monet, and Degas. The earliest gifts of pastels by Degas and Cassatt (mentioned above), which he had purchased with prescience in 1900 and 1901, entered the museum from his collection.

Among the important private collectors who gave groups of graphic works to the museum was James Parmelee (1855–1931), whose bequest in 1940 of 524 items included (besides paintings by the Italian "primitives") a number of drawings by such artists as Abraham Bloemaert, Thomas Rowlandson, and Maxfield Parrish (no. 92).[25] For the next thirty-five years, Mr. and Mrs. Lewis B. Williams donated from their collection notable French drawings by Delacroix, Degas, Pierre Auguste Renoir, Paul Gauguin (no. 57), Amadeo Modigliani, Matisse, Pissarro, Picasso, and many others. Williams (1880–1966) was a financier who was president of the Print Club (1927) and became a distinguished member of the museum's Advisory Council (1925), Accessions Committee (1936), and Board of Trustees (1935).[26] Mrs. Henry (Josephine Pettengill) Everett (1866–1937) established a memorial collection for her daughter (The Dorothy Burnham Everett Memorial Collection) that consisted primarily of American art, Mrs. Everett's interest.[27] From her the museum received James McNeill Whistler's pastel *Japanese Woman Painting a Fan*, John La Farge's *Choir Boy*, watercolors by Thomas Moran, and drawings by John Constable, Muirhead Bone, Thomas Dewing, Childe Hassam, Arthur B. Davies, and Andreas Zorn. Mrs. Malcolm L. (Lucia McCurdy) McBride was also a strong supporter of contemporary American and Mexican art in the 1930s and 1940s. A president of the Print Club (1931–33) and a member of the Advisory Council (from 1937), her donations of Mexican prints and drawings form the core of that collection at the museum. Her gifts include drawings by

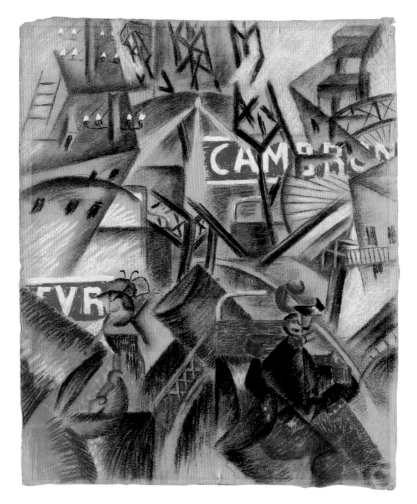

Thomas Hart Benton, Carlos Merida, Miguel Covarrubias, Wanda Gág, Guy Pène du Bois, James McBey, Yasuo Kuniyoshi, Walt Kuhn, Jose Clemente Orozco, Joseph Stella, Alexander Archipenko, Rufino Tamayo, and an extremely important pastel by Gino Severini [fig. 5]).[28]

Robert Hays Gries donated almost sixty old master "study" drawings (a collection formed by his uncle Daniel Adolph Huebsch [1871–1936]), among which are important sheets by Taddeo Zuccaro and Paolo Veronese (no. 12), and a recently identified preparatory study by Guercino.[29] In 1942, a key work in the drawing collection, Michelangelo's two-sided study for the Sistine Chapel ceiling (no. 6), came as a gift from George S. Kendrick and Harry D. Kendrick in honor of their uncle Henry G. Dalton. Although there are other gifts from this family in both the painting and drawing collections,[30] Dalton and the Kendricks will always be known for the gift of this single Renaissance drawing, a highlight of the museum's holdings. In 1934 Henry Francis had been alerted by Felix Wildenstein of the drawing's availability, and Francis arranged for Dalton to purchase it, with the understanding that it would be a gift to the museum.[31]

Other loyal friends of the museum added significantly to the collection. Edward B. Greene (1878–1957), banker and industrialist and son-in-law of Jeptha Homer Wade, donated the noteworthy *View of the Acqua Acetosa* by Claude Lorrain in 1928 (no. 34). In 1947 he and his wife contributed an extremely important group of eighteenth-century pastel portraits by Jean-Etienne Liotard, Sir Francis Cotes, and the school of Quentin de La Tour. Later gifts included Giambattista Tiepolo's *Commun-*

ion of St. Jerome as well as the large group of portrait miniatures in the collection. Other drawings seem to have passed to their daughter, Mrs. A. Dean Perry, but eventually came to the museum.[32] Severance A. (1895–1985) and Greta Millikin (1903–1989), well-known donors to the museum, presented drawings by Pierre-Paul Prud'hon and Egon Schiele (no. 99).[33] Emery May Holden (Mrs. R. Henry) Norweb (1895–1984), a president of the Board of Trustees (1962–71), gave the museum its important coin collection, but also contributed about sixty study drawings, among them sheets by Filippo Napoletano, Edwin Henry Landseer, Richard Parks Bonington, and Jules Dupré.[34] Helen Wade Greene (Mrs. A. Dean) Perry (1911–1996) is known for her unique collection of Chinese paintings gathered with the advice of the museum's third director, Sherman Lee, and bequeathed to the museum, but she also donated drawings over the years: works by Giandomenico Tiepolo, John Downman, John Smart, Jean-Baptiste Isabey, Johan Barthold Jongkind, and Maurice Prendergast (works inherited from her mother).[35]

The most significant donor of funds and art to the drawing collection was certainly Leonard C. Hanna Jr. (1889–1957).[36] After graduating from Yale University Hanna gained experience in the iron and steel industry and later joined the family business, M. A. Hanna & Co., which handled ore, coal, and pig iron. Although he is known in the art world primarily for his bequest of over $33,000,000, which came to the Cleveland Museum of Art in 1958, Leonard Hanna, also a noted collector, began his philanthropy to the museum much earlier. His first gift dates to 1920, and he continued to give paintings, sculpture, drawings, and prints to the museum until his death thirty-seven years later. He purchased a drawing by François Boucher (no. 38) for the museum in 1925 and one by Hubert Robert (no. 45) the following year. As a founding member of the Print Club, its president (1922–23), and a member of the Board of Trustees and the Accessions Committee, Hanna knew the collecting wishes of the curatorial staff, often stepping in when help was needed. In a letter of 1924, curator Theodore Sizer wrote enthusiastically of Hanna's generosity. Sizer had found important prints he wanted to purchase, but could not spend his entire appropriation for them. Hanna came to the rescue by giving "all the expensive ones." As Sizer put it, "you really cannot ask anything better than that."[37] Other drawings purchased for or bequeathed to the museum by Hanna include works by Cassatt, Berthe Morisot, Henri de Toulouse-Lautrec (fig. 6), Paul Gauguin, Vincent van Gogh, Paul Cézanne, Redon, Georges Rouault, and Picasso (no. 95).[38] His collection of impressionist and post-impressionist paintings, which entered the museum at his death, provides the core of the museum's late nineteenth- and early twentieth-century collection of French paintings.

Following the end of World War II and throughout the 1950s, Henry Francis, who also donated prints and drawings to the collection,[39] pursued old master and modern drawings, buying when the opportunities presented themselves after the breakup of many European collections flooded the market with great works of art. Between 1945 and 1950 he added sheets by Fra Filippo Lippi (no. 2), Albrecht Altdorfer (no. 61), Alessandro Magnasco, Giandomenico Tiepolo, William Blake (no. 77), John

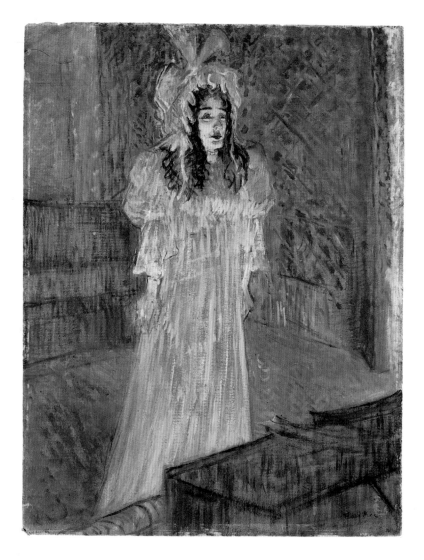

Singleton Copley (no. 83), Reginald Marsh, and John Marin (no. 98). During the 1950s he continued with major works by Bernardo Strozzi (no. 18), François Boucher (no. 36), Francesco Guardi (no. 25), Joseph Mallord William Turner (no. 79), Degas (no. 52), Winslow Homer (no. 86), and Charles Demuth. In 1952, he proudly announced the acquisition of two Albrecht Dürer drawings from the famed Lubomirski collection that had recently been returned to the family after confiscation by the Nazis.[40] During the later 1950s he purchased drawings by Fra Bartolommeo (no. 4), Domenico Beccafumi (no. 8), Georges Seurat (no. 55), Federico Barocci, and Rembrandt. After the windfall of Hanna's bequest, which designated half the funds donated were to be used for acquisitions, significant drawings by Parri Spinelli (no. 1), Lorenzo di Credi, Albrecht Dürer (no. 59), Domenichino (no. 17), Giambattista Tiepolo, Pierre-Paul Prud'hon, Théodore Géricault, Ernst Ludwig Kirchner, Picasso, Joan Miró, and Robert Motherwell increased the already growing importance of the collection.

Working alongside Henry Francis in the development of a notable collection of prints and drawings was Leona E. Prasse (1897–1985) (fig. 7), who joined the department in 1925 and, like Francis, retired in 1967. Educated at Mather College of Western Reserve University and the Cleveland Institute of Art, Prasse had an eye for contemporary artists, worked well with them, and promoted their art. Throughout her career she reso-

lutely strove to build a balanced collection of the finest material in both old master and modern art. Francis said of her, "Leona was always filling in the gaps; she kept getting things that we couldn't find or couldn't afford. Her own collection was formed with great discrimination and intelligence and always with the thought of how it would fit into the museum's collection."[41] Prasse gave the museum, in honor of her parents, more than 500 objects, mostly prints (making her the most significant donor to the department), but also important drawings.[42] Among them are Murillo's *Madonna Nursing the Christ Child* (no. 30), and drawings by Gaetano Gandolfi, Lovis Corinth, Jean Baptiste Pillement, Richard Parkes Bonington, Maurice Prendergast,

Fig. 8. Charles Burchfield. *Chestnut Trees*, 1920, pen and black ink and wash and pencil. Mr. and Mrs. Charles G. Prasse Collection 1981.209.

Piet Mondrian, Lyonel Feininger, and eleven sheets by Charles Burchfield. Her scholarship dovetailed with her collecting interests. In 1972 she published the still-definitive catalogue of Feininger's prints. Earlier, in 1953 she organized the first exhibition of drawings by Burchfield. From that show she bought ten drawings that she later gave to the museum (fig. 8, for example); because of her determination Cleveland now owns forty-three drawings by this artist.

After the retirements of Francis and Prasse, Louise Richards (fig. 9), who had been in the department since 1952, was named curator of prints and drawings. Like Prasse, Richards was a scholar who raised the standards of research on the drawings in the collection. Her many articles about new acquisitions in the *CMA Bulletin* and her contribution on the prints of Federico Barocci and the section on drawings for the Johann Liss catalogue have provided essential background for later writers.[43] During her tenure, which lasted until 1986, she continued to enlarge the collection with key examples by leading old masters such as Annibale Carracci, Raphael (no. 5), Peter Paul Rubens, Rembrandt (no. 68), and Anne-Louis Girodet de Roussy-Trioson (no. 48), and modern masters such as Paul Klee, Barnett Newman (no. 117), and David Smith (no. 118). Also during this period, there was an attempt to build up the underrepresented but historically important holdings of nineteenth-century German drawings. Sheets by Johann Wolfgang Baumgartner (no.

Fig. 9. Louise Richards, curator of prints and drawings, 1967–86.

63), Friedrich Preller (no. 65), Ludwig Ferdinand Schnorr von Carolsfeld, Carl Wilhelm Tischbein, and Adolf von Menzel were acquired. Like her predecessors, Richards generously donated prints, and one drawing (Félicien Rops), to the collection.

In the 1980s, two young scholars at the museum concentrated on research of the drawing collection. From 1980 to 1985, Hilliard Goldfarb, as a curatorial fellow, purchased drawings by Nicolas Poussin, François Boucher (no. 37), and Philipp Hackert (no. 64) and published many of the French drawings in his catalogue *From Fontainebleau to the Louvre: French Drawing from the Seventeenth Century*.[44] Michael Miller, as an assistant curator in the department from 1986 to 1993, purchased Pietro da Cortona's *Idolatry of Solomon* (no. 15) and Giorgio Vasari's *Resurrection* (no. 11) and organized exhibitions of the collection's Italian drawings.

In the 1970s and 1980s the formation of an important collection of French eighteenth- and nineteenth-century paintings and drawings was taking place in Cleveland. Noah Butkin (1918–1980), who from 1975 was a trustee of the museum, had an interest first in seventeenth-century Dutch painting, which evolved into a passion for nineteenth-century French realist painting.[45] He bought astutely in an area underappreciated at the time and consequently amassed a collection, now at the museum, of noteworthy pictures by François Marius Granet, Jean-Victoire Bertin, Léon Bonvin, and Albert Besnard. Concurrently, his wife, Muriel, indulged her passion for eighteenth- and nineteenth-century French drawings, which she found on their travels to New York, London, and Paris. Some of these drawings have been given to the museum, including sheets by Bonvin, Constant Troyon, and Lhermitte. Her collection, which now numbers more than 400 sheets, with important works by

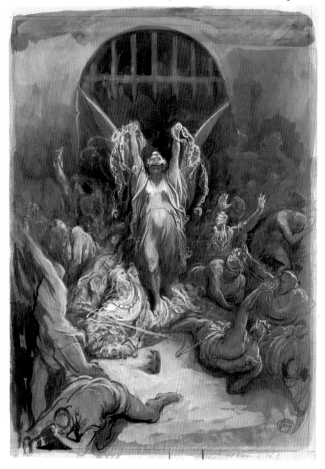

Fig. 10. Gustave Doré. *Liberty*, brush and brown wash over graphite, heightened with white gouache. Mrs. Noah L. Butkin, Cleveland.

Gustave Doré (fig. 10), Théodore Géricault, François Boucher, Jean-François Millet, and others, will be exhibited here in 2001 as a promised gift to the museum. The combination of the museum and the Butkin drawing collections makes Cleveland an important resource for serious study of French realist art.[46]

Lockwood Thompson (1902–1992), a prominent Cleveland lawyer and a founding member in 1961 of one of the museum's support groups, the Cleveland Society for Contemporary Art, possessed a collection of modern and contemporary paintings and drawings that was bequeathed to the museum at his death. From him came drawings by Ben Nicholson, Graham Sutherland, Paul Klee (no. 110), Wassily Kandinsky, Salvador Dalí, Yves Tanguy (no. 111), and René Magritte (no. 113). The Society has also been active in encouraging contemporary art collectors, many of whom are gathering paintings, sculpture, and drawings that have been designated for the museum's collection.[47]

Jane Glaubinger, who joined the department in 1974, took over in 1987 after the retirement of Louise Richards. Primarily a print specialist, Glaubinger nevertheless augmented the drawing collection with meaningful purchases of both old master and modern drawings: Edward Burne-Jones (no. 81), Adolf von Menzel (no. 66), Hendrick Goltzius (no. 69), and Francisco de Goya (no. 31) for old masters and Joseph Stella (no. 103), Jacob Lawrence (no. 114), and Ludwig Meidner in the modern area. Her unflagging energy in working with the Print Club and the annual Print Fair in Cleveland continues to encourage collecting and brings the museum important gifts from loyal members.

In 1995 Diane De Grazia joined the staff as chief curator and curator of paintings and drawings. The development and increasing importance of the collection of drawings warranted the addition of a second drawing expert: Carter Foster, associate curator of drawings, who was hired in early 1996. With expertise in Italian and French art, respectively, they gave impetus to a plan to publish a catalogue of the collection of European drawings before 1900, currently in the research stage. Continuing in the tradition of the museum's earliest mission to "collect superior examples" of drawings, they have attempted to add works to the collection that can stand up to those contributed by earlier curators. In the increasingly tight market for drawings they have purchased major old master sheets by Baccio Bandinelli (no. 7), Annibale Carracci (no. 13), Pietro da Cortona (no. 16), Jusepe Ribera (no. 29), Giandomenico Tiepolo (no. 26), Jean-Baptiste Oudry (no. 41), Charles-Nicolas Cochin (no. 40), Jean-Baptiste Greuze (no. 43), John Robert Cozens (no. 76), and John Martin (no. 78), and modern works by Charles Sheeler (no. 107), Thomas Hart Benton (no. 109), Louise Bourgeois (no. 115), and Ed Ruscha (no. 120). With the founding in 1999 of another support group for the museum, the Painting and Drawing Society, new collectors of drawings are emerging to aid the future development of the collection.

If there is a pattern to the collecting of drawings at the Cleveland Museum of Art, it can be seen in the repetition of certain artists' names throughout its development. The taste for French art has been constant, especially for that of the late nineteenth and early twentieth century. Degas, Picasso, and Redon (fig. 11)

are favorites and were collected early in Cleveland, making the museum a regional leader in collecting contemporary art.[48] Most of these drawings, however, came to the museum by gift. In purchasing drawings, curators attempted to find the unique object that private collectors might miss or disdain. Almost all the fifteenth-century drawings in the collection, for example, were purchased. Most of the Italian drawings also were curatorial finds (collectors in Cleveland have not been interested in Italian draftsmanship). American artists were esteemed for their paintings but their drawings were not always appreciated. Thus sheets by John Singleton Copley, Jasper F. Cropsey, and William Sidney Mount were purchased. In the 1920s and 1930s curators bought sheets by contemporary American artists (the Charles Demuth *Amaryllis* [no. 102] came straight from an exhibition of his works in 1923), but, by and large, curators sought the drawings of established artists. Perhaps they hoped, as had Theodore Sizer, that artists would generously donate their drawings, and that collectors of contemporary art would look first to the museum. The museum was fortunate, however, to have curators who were well versed in both old master and modern art, as proved by the acquisitions of Leona Prasse and Louise Richards in particular.

Throughout its history, the directors of the museum have been supportive of the collecting of drawings and, at times, have found important sheets to add. William Milliken (director 1930–58) encouraged Henry Francis in his purchases, was very interested in contemporary Cleveland artists, and donated works by them to the museum; Sherman Lee (director 1958–83) acquired sheets by Federico Barocci, Jean-Etienne Liotard (fig. 12), and Albrecht Dürer (no. 59); and Evan Turner (director 1983–93) found drawings by Jean-Baptiste Greuze (no. 44), Agnes Martin, and Stanley Spencer.[49]

The museum now owns a varied collection of works in different media, of different sizes, and representing varied purposes (and reproductions are no longer necessary). There are compo-

Fig. 12. Jean Etienne Liotard, *Portrait of François Trochin*, 1757, pastel. John L. Severance Fund 1978.54.

sitional drawings, preparatory sheets and cartoons, finished presentation drawings, sketchbooks, sheets from modelbooks, landscapes, single figure drawings, and so on. Although strong in only a few areas, the collection of drawings at the Cleveland Museum of Art includes a significant number of recognized masterpieces in all areas, and thus can claim to have fulfilled its founders' aim to represent superior examples of the wide range of human aesthetic production.

NOTES

The following current and former staff members aided in the research for this article: Mary Suzor, chief registrar, for compiling endless lists of drawings in various orders and finding information on donors; Ann Marie Przybyla, the museum's archivist, for finding letters, memos, and articles on donors; Roger Diederen and Todd Herman, for archival research; Jane Glaubinger, for her earlier histories of the department, exhibition labels from her 1991 show *Generous Donors: A Tribute to the Print Club of Cleveland*, and for discussing the contributions of donors and former curators; and both Jane Glaubinger and Louise Richards, for sharing invaluable information about the department

and reading drafts of this article, adding important information and correcting errors; and Henry Hawley, Carter Foster, and Katherine Solender, for reading the essay and correcting errors.

1. Most notably Henry Keller (137, including a sketchbook with 45 drawings), William Sommer (385 drawings), and Charles Burchfield (43 drawings).

2. Judge William B. Sanders, president of the museum, in *CMA Bulletin* 3 (1916), 3.

3. *The Print Club of Cleveland 1919–1969* (Cleveland, 1969), 10–11.

4. On the origins of the museum, see Carl Wittke, *The First Fifty Years. The Cleveland Museum of Art 1916–1966* (Cleveland, 1966); Turner 1991, 1–17 (with bibliography). On Ralph King, see *CMA Bulletin* 13 (1926), 95–98 and 207–11, and 34 (1947), 23. On the collecting of drawings and paintings in Cleveland, see also Coe 1955 (on King, see 1:XLIV–XLV and 2:107–17); and on the drawing collection at the museum, see Michael Miller, "Drawings in the Cleveland Museum of Art," *Drawing* 8 (March–April 1987), 125–27.

5. 1916.1070–79.

6. Large pastels in the collection were transferred from the painting department to the department of prints and drawings only in 1995.

7. Theodore Sizer in 1915, *CMA Bulletin* 13 (1926), 96. Mr. and Mrs. King's other gifts to the museum included an important collection of lace. His collection of prints included an overview of Whistler (88 etchings, 58 lithographs, and 2 drawings) and nineteenth-century French prints (Toulouse-Lautrec, Matisse, Daumier, Redon) not yet collected by many in the United States at that time.

8. Other works given by the Kings included prints by Rembrandt as well as miniatures. On the gift in memory of King, see *CMA Bulletin* 24 (1947), 23–31.

9. On Brooks, see *CMA Bulletin* 22 (1935), 31.

10. *CMA Bulletin* 10 (1923), 47.

11. Ibid.

12. In his wish to democratize the museum, Dudley P. Allen (1852–1915), one of the original board members of the museum and an influence on its collection development, called for a "department which should collect artistic implements and articles of common use as models for the handicraftsmen of Cleveland" (Turner 1991, 6). He left an unrestricted purchase fund to the museum that has often been used in the acquisition of drawings. On Allen, see also *CMA Bulletin* 1 (1915), 2–7.

13. From 1919 through 1954 the exhibition had that title, with the number of the year. From 1955 through 1957 it was titled the *Annual Exhibition*, although it was often referred to in print as the "May Show." In 1958 it was officially given the title the *May Show*. The exhibition was discontinued in 1993.

14. *CMA Bulletin* 11 (1924), 141.

15. Workshop of Perino del Vaga: 1924.586–89. Design for stained glass attributed to Tobias Stimmer: 1923.74.

16. *CMA Bulletin* 13 (1926), 6.

17. On Henry Francis, see his obituary, *Plain Dealer* (8 January 1994), 6–c.

18. *CMA Bulletin* 14 (1927), 147.

19. *Exposition du paysage Français de Poussin a Corot*, exh. cat., Petit Palais (Paris, 1925). A Fragonard landscape drawing in the exhibition (p. 63, no. 440) was purchased that year by the museum (1925.1006); see *CMA Bulletin* 13 (1926), 7.

20. Not all the attributions have stood the test of time.

21. *CMA Annual Report* (1929), 38.

22. *CMA Bulletin* 7 (1920), 20.

23. On the history of the Print Club of Cleveland and the prints it commissioned, see *Print Club of Cleveland 1919–1969*, 10–17, 35–98, and Print Club of Cleveland 1994, 30–68.

24. On Wade, one of the earliest collectors of impressionist art in Cleveland, see *CMA Bulletin* 13 (1926), 63–70; *Plain Dealer* (8 April 1949), 14; Coe 1955, 1:XXII–XXIV and 2:245–55; and Turner 1991, 18–20.

25. On Parmelee, see *CMA Bulletin* 28 (1941), 15–18. Some of the English drawings in the bequest turned out to have inflated attributions.

26. Of the 390 items presented to the museum, Williams also gave a definitive collection of Alphonse Legros drawings and prints, a group of Dutch and Flemish prints, a distinguished collection of French paintings, and an outstanding survey of American and European lithographs from the beginning of lithography in the nineteenth century through the twentieth century. On Williams, see *CMA Bulletin* 31 (1944), 170; Coe 1955, 1:XLV–XLVI and 2:256–65; and *CMA Bulletin* 53 (1966), 136.

27. On Mrs. Everett, see *CMA Bulletin* 25 (1938), 123–30.

28. 1942.249. On Lucia McCurdy McBride, see *CMA Bulletin* 57 (1970), 76; and Coe 1955, 1:L–LI, and 2:133–39.

29. Museum archival records show that Mr. Gries acquired the collection from his uncle, who was married to Nettie Hays Huebsch (thus, the connection). Huebsch, a psychoanalyst and author of several books, used the drawings in classes he taught at the Cleveland Institute of Art (according to Henry Hawley). Mr. and Mrs. Robert Hays Gries were donors of many other works to the collection, including Chinese export porcelain and English silver. On Huebsch, see Coe 1955, 1:XXXV-XXXVI, 2:92–97, and his obituary, *Plain Dealer* (3 September 1936), 3.

30. Dalton was a member of the museum's first Advisory Council (1914) and elected a trustee in 1926. Both he and his nephews were benefactors to the museum. His gifts included prints by Charles Huard. Harry D. Kendrick donated paintings by Pater, Robert, and Giandomenico Tiepolo and prints. George S. Kendrick gave the museum paintings by Fiorenzo di Lorenzo, David, and Henri Fantin-Latour. A polychromed marble by Giovanni di Agostino was also given by the Kendrick nephews in honor of Henry G. Dalton. On Dalton, see *CMA Bulletin* 27 (1940), 31, and Coe 1955, 1:XLIX and 2:43–47.

31. Letters of 20 and 31 December 1934 and 3 January 1935 between Francis and Wildenstein, CMA archives.

32. On Greene, see *CMA Bulletin* 34 (1947), 213–15; 38 (1951) 128–29, and Coe 1955, 1:XLVIII–XLIX and 2:63–67.

33. The Millikins gave fifteen drawings, which reflected Mrs. Millikin's tastes. Their other gifts were mainly Indian and Asian paintings, sculpture, and objects. On Severance Millikin, see his obituary, *Plain Dealer* (8 April 1985), 3B, and *CMA Bulletin* 72 (1985), 298–99.

34. Mrs. Norweb's collection was formed by her grandfather, Liberty E. Holden. Her drawing collection may also have been inherited from her grandmother, Mrs. Liberty E. Holden (1838–1932). Mrs. Norweb's tastes ran to pre-Columbian objects and the decorative arts, whereas Mrs. Holden's tastes would have included drawings. On Mrs. Holden, see Coe 1955, 1:XII–XVI and 2:78–91; and Turner 1991, 16–17. On Mrs. Norweb, see *CMA Bulletin* 71 (1984), 130–31; *Plain Dealer* (31 January 1962), 1, 6; and her obituary, *Plain Dealer* (28 March 1984), 6D. On her husband, see his obituary, *Plain Dealer* (2 October 1983), 31A.

35. These drawings were inherited upon the death of her mother, Helen Wade Greene, who probably inherited them from her husband, Edward Greene, who died in 1957. On Mrs. Perry, see CMA archives with a written appreciation by Sherman Lee and her obituary, *Plain Dealer* (3 December 1996), 70–B.

36. On Hanna, see *CMA Bulletin* 44 (1957), 195; Coe 1955, 1:LI–LII and 2:70–77; and Turner 1991, 83, 152–53; obituaries, *Plain Dealer* (5 October 1957), 1, 10, and *New York Times* (6 October 1957), 84; and CMA archives.

37. Letter of 10 May 1924 from Theodore Sizer to FitzRoy Carrington (copy in CMA archives).

38. Hanna also donated 174 lithographs by George Bellows, giving the museum an almost complete set by this artist.

39. He donated drawings by Burchfield and Whistler among the 26 prints and drawings given to the museum.

40. The museum owns three drawings from the Lubomirski collection: *Ascension* (1952.530) and *Dead Christ* (1952.531), purchased from Richard Zinser in 1952, and the *Head of a Man in a Cap* (no longer attributed to Dürer, 1963.88), purchased from Zinser in 1963. On the history of the confiscation of the Lubomirski Dürers, see *CMA Bulletin* 42 (1955), 3–5; Martin Bailey, "Hitler, the Prince, and the Dürers," *Art Newspaper* 47 (April 1995), 1, 6; Martin Bailey, "The Lubomirski Dürers: Where Are They Now?" *Art Newspaper* 48 (May 1995), 5; and Martin Bailey, "Growing Unease over Lubomirski Dürers," *Art Newspaper* 93 (June 1999), 3.

41. *Plain Dealer* (6 January 1985), 12–P.

42. Mr. and Mrs. Charles G. Prasse Collection. On Leona Prasse, see obituary cited above and CMA press release 31 December 1984, CMA archives.

43. Edmund Pillsbury and Louise Richards, *Federico Barocci*, exh. cat., Yale University Art Gallery/Cleveland Museum of Art (1978); *Johann Liss*, exh. cat., Augsburger Rathaus/Cleveland Museum of Art (1975–76).

44. Exh. cat., National Gallery of Canada/Fogg Art Museum/Cleveland Museum of Art (1989–90).

45. On Noah Butkin, see *CMA Bulletin* 67 (1980), 30.

46. Most of the paintings from the Butkin collection are published in Cleveland Museum of Art, *European Paintings of the Nineteenth Century* (Cleveland, 1999).

47. Jeannette Dempsey was the guiding force behind the organization of the Cleveland Society for Contemporary Art. On Lockwood Thompson see CMA press release 22 February 1993, CMA archives; and Coe 1955, 1:LXIII–LXIV, 2:241–44, and his obituary, *Plain Dealer* (28 March 1992), 5B.

48. Most of the Degas and Picasso drawings were gifts and spanned a wide range of time from 1916 to 1919. On some of the Degas drawings, see *CMA Bulletin* 44 (1957), 212–17. Of the eleven Degas drawings, seven were gifts. Five of the six Picasso drawings were gifts.

49. Much of this information comes from archival records of the museum.

Italian Drawings

Parri Spinelli

Arezzo 1387–1453

Once thought to be a study by Giotto for his *Navicella* mosaic in the portico of Old St. Peter's, Rome (after 1300), this drawing was attributed to Parri Spinelli by A. E. Popham and is now accepted as autograph by most scholars.[1] The most important painter from Arezzo in the early fourteenth century, he was praised by Giorgio Vasari in his *Lives*.[2] Spinelli is studied in depth today because of the serendipitous existence of about thirty of his drawings, more than for any other artist of his period.[3] *Navicella* is an interpretation of the story related in Matthew 14:25–33. At right, Christ, having walked on the water and now standing on shore, pulls the doubting Peter from the water. Behind, the other eleven apostles react emotionally to the storm and Christ's miraculous presence. As some of the apostles fight with the resisting sail, four wind gods at left blow to agitate the sea. Giotto's ruined mosaic, known best in Nicolas Beatrizet's engraving of 1559,[4] is quite different from this drawing, which is based on intermediary versions Spinelli would have seen in Florence in the second decade of the fifteenth century, when he may have studied and worked with Lorenzo Ghiberti.[5] Spinelli probably knew Andrea Bonaiuti's *Navicella* fresco in the Cappella degli Spagnoli, Santa Maria Novella (c. 1355–68), which differs in similar aspects from the mosaic.[6] Spinelli may also have participated in Ghiberti's bronze version of the theme on the north doors of the Baptistery of 1414–16.[7]

Spinelli's *Navicella* formed part of a model or pattern book that was broken up, probably by the sixteenth century.[8] Two other drawings with the same subject—in the Metropolitan Museum of Art (fig. 1), and the Musée Bonnat (fig. 2)—relate to this sheet and belonged to the same model book, perhaps forming subsequent folios.[9] The Cleveland and Metropolitan drawings are on single sheets of paper similar in size and folded at center with traces of stitch marks; the Musée Bonnat sheet is on a half sheet of paper. All have nearly identical tears in the same place.[10] The Cleveland *Navicella* deviates from the earlier drawing in New York, which is closer to Giotto's original, in its elimination of the castle and fisherman at left, the less static relationship between Christ and St. Peter, the addition of more wind gods, and a decoratively pierced deck at the boat's stern. It is freer in execution and movement of forms. The subsequent drawing in Bayonne, in a vertical format and freer still, represents a different story: the miraculous draft of fishes (John 21:1–8).[11] The three sheets contrast with most of Spinelli's drawings, which date from the 1430s and 1440s, by their less agitated rendering of drapery and hair. As the only known early sheets by the artist, they give a sense of his youthful style in the 1410s.

The verso of the Cleveland *Navicella* has received little attention. Like the verso of the New York sheet, it contains two separate drawings that were part of a larger composition that was divided when the album was broken up. The scene at left represents a naval battle with archers in small boats attacking a ship. The artist rendered the men and crossbows with a minimum of lines, yet the action and movement of the battle is apparent. At right is a depiction of a ship drawn with more care to describe the various forms of the rigging and crow's nest. At upper left is a separate sketch of sails. The eagle and cross on the ship have not been identified, but could suggest a crusader's ship belonging to the Holy Roman Empire.[12] Because all three drawings have representations of ships on their versos, Bernhard Degenhart suggested that these sheets formed part of a pattern book of ships, which often contained a depiction of the Navicella.[13]

The conjecture that the drawings formed part of Vasari's *Libro dei Disegni* is based on the eighteenth-century claim by John Richardson;[14] the remnants of Vasari-like cartouches on the New York (at right) and Cleveland (at lower left) drawings make such a claim plausible. DDG

Fig. 1. Parri Spinelli. *Free Copy of Giotto's "Navicella,"* c. 1410s, pen and brown ink. The Metropolitan Museum of Art, New York, Hewitt Fund 19.76.2.

Fig. 2. Parri Spinelli. *The Miraculous Draft of Fishes*, c. 1410s, pen and brown ink. Musée Bonnat, Bayonne, inv. no. 661.

1. *Navicella*

1410s

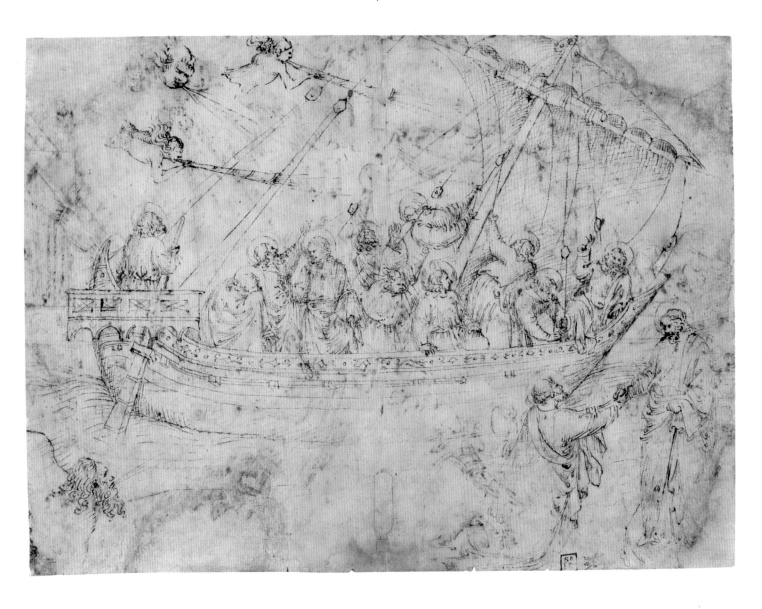

Pen and brown ink (iron gall)
(recto and verso), on beige laid
paper, tipped onto cream-yellow
wove paper

272 x 372 mm (10¹¹⁄₁₆ x 14⅝ in.)

Purchase from the J. H. Wade
Fund 1961.38.a,b

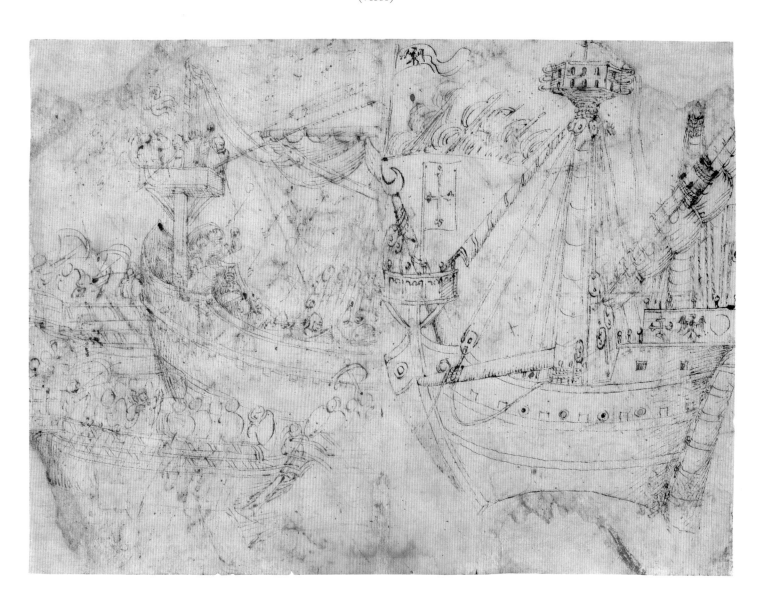

1. Popham 1931, 1.

2. Vasari/Milanesi 1906, 2:275–85. On Spinelli's life and importance, see Zucker 1973.

3. For a discussion of Spinelli's drawings, see Zucker 1981 and Mark Zucker, "Drawings by Parri Spinelli, the Gothic El Greco," *Drawing* 17 (May–June 1995), 7–12.

4. Köhren-Jansen 1993, pl. 79. See this book also for a study of Giotto's *Navicella* and copies after it.

5. According to Vasari, Vasari/ Milanesi 1906, 2:275–76, Spinelli studied with Ghiberti. Although there is no documentation for this assertion, Vasari did know Ghiberti's nephew and could have received accurate information on Ghiberti's workshop from him. Subsequent scholars have placed Spinelli in the workshop in the 1410s. See Zucker 1973, 56–83, on his Florentine years.

6. As well as other interpretations enumerated by Venturi 1922 and Zucker 1981, 431–38.

7. Zucker 1981, 431–32.

8. If, indeed, the drawing belonged to Vasari.

9. Richards 1962a, 168–69, first noted that they were part of a model book. See, most recently, Elen 1995, 183, who believed the drawings were part of a model book of sixteen or twenty leaves. He also has a good discussion on the makeup of the album.

10. Zucker 1981, 436.

11. For a detailed account of the differences and similarities of the drawings and their Florentine models as well as the developmental progression among the three drawings, see ibid., 431–38.

12. Implied also by Richards 1962a, 174 n. 10.

13. Degenhart in Degenhart/ Schmitt 1968, 1:part 2, 278–80.

14. First suggested by Virch 1961, 191.

Fra Filippo Lippi

Florence c. 1406–Spoleto 1469

In spite of the differences of opinion as to the attribution of this drawing, scholars have agreed that it is "one of the most important quattrocento composition studies to have come down to us."[1] Few sheets of this period exist, other than figure and drapery studies from model books, so the *Funeral of St. Stephen* helps us understand the preparatory methods of fifteenth-century painters. Most writers believe the composition is a study for Fra Filippo Lippi's fresco the *Celebration of the Relics of St. Stephen* (fig. 1), one of the stories in the cycle of the lives of Sts. Stephen and John the Baptist in the choir vault of the cathedral at Prato, documented between 1452 and 1465. Those who disagree with the attribution to Lippi date the drawing in the 1480s and place it in the workshop (or by the hand of) Domenico Ghirlandaio, relating the composition to his *Funeral of St. Francis* in the Sassetti chapel, Santa Trinitá, Florence.[2]

The drawing's composition is vaguely reminiscent of numerous funeral scenes in quattrocento Florence; yet, the argument for relating the sheet to Lippi's Prato painting is compelling, notwithstanding the differences between drawing and fresco. In the drawing a priest and attendants in the left foreground pray by a corpse on a bier at right. Behind, three figures suggest that a funeral mass in the church is in progress, perhaps indicating that two succeeding phases of the same narrative are represented. The scene looks much like the left-hand portion of the Prato fresco except for a variance of figures. The architecture has changed from an early Florentine Renaissance vaulted church to an early Christian basilica, chronologically appropriate to the story.[3] Although the artist retained the Brunelleschian pilaster with applied columns and impost blocks in the painting,[4] the architecture of the drawing contains such oddities as double rectangular windows over double arched windows not seen in any existing Tuscan church. Lippi is known to have continued to change his compositions even after having begun painting; consequently, the differences between painting and preparatory drawing are not surprising. Moreover, the figure of the deacon with a censer was used in the *Ordination of St. Stephen*, the fresco immediately above the *Celebration of the Relics of St. Stephen*.[5]

The artist first drew the figures in the foreground, added the architecture around them, and finished with the figures at rear, which are drawn over the lines of the architecture and show more pentimenti, an indication that the foreground figures were drawn from another sheet. Drawings that followed this study would have refined the composition further. At some point the decision was made to change the subject from the funeral of St. Stephen to the celebration of the transfer of his relics, a legendary event that took place after his secret burial outside Jerusalem. Eve Borsook proposed that the feast day of this event and the installation in 1460 of Carlo de'Medici as provost of the cathedral of Prato were the same, 3 August, suggesting that the signature and date of 1460 on the fresco commemorate that event.[6] Without an inscription noting the installation and because he is not a prominent person in the fresco, it seems more likely that the signature and date record the completion of the fresco.[7]

Stylistically the drawing is difficult to place within the oeuvre of an artist to whom only a handful of autograph sheets exist.[8] However, the staccato strokes and energetic hatching are not inconsistent with Lippi's only documented drawing, found on a letter of 1457,[9] and are different from Ghirlandaio's regular, closely spaced hatching and fussy, stylized drapery.[10] The broad, flat faces accord with those in the Prato frescoes and the artist's panel paintings. The dynamic movement of the drapery and the deep spatial perspective do not reflect a late quattrocento style[11] but are consistent with the experimentation and innovation characteristic of Lippi's work.

DDG

Fig. 1. Fra Filippo Lippi. *Celebration of the Relics of St. Stephen*, 1452–65, fresco. Choir, Prato Cathedral.

1. Pouncey 1964, 287. Cadogan 1980, 25, no. 13, called the drawing "One of the most important quattrocento drawings to survive." For a good review of the opinions and characteristics of this drawing, see Bambach in New York 1997, 94, no. 3.

2. See especially Ruda 1993, 153, and Olszewski in Dunbar/Olszewski 1996, 22. The drawing came to the collection as an anonymous Florentine artist. It was first attributed to Fra Filippo Lippi by William Suida (Francis 1948b, 16).

3. Lippi's architecture in the drawing is vaguely reminiscent of the Prato cathedral itself; see Giuseppe Marchini, *Il Duomo di Prato* (Milan, 1957), pls. VI–VII. Ruda 1993, 343, noted that the architecture in the drawing is similar to Starnina's lost fresco of the funeral of St. Jerome, once in Santa Maria del Carmine, Florence.

4. Noted by Pouncey 1964, 287.

5. Ibid.

6. Borsook 1975, 23, suggested that the date indicates not the execution of the fresco but refers to the investiture of Carlo de'Medici as provost of cathedral of Prato. For dating of the series and references to the documents, see ibid., 102–5; Roettgen 1996, 1:302–5; and Ruda 1993, 258–92.

7. Proposed by Roettgen 1996, 1:309.

8. On Lippi as a draftsman, see Ruda 1993, 326–47.

9. Florence, Archivio di Stato, inv. no. Doc.7.II (Ruda 1993, pls. 15, 387). Another accepted drawing close in style to this one is in the British Museum, inv. no. 1936-10-10-9 (Ruda 1993, pls. 185, 386).

10. On Ghirlandaio's drawings, see Jean K. Cadogan, "Reconsidering Some Aspects of Ghirlandaio's Drawings," *Art Bulletin* 65 (June 1983), 274–90.

11. Suggested by Olszewski in Dunbar/Olszewski 1996, 23.

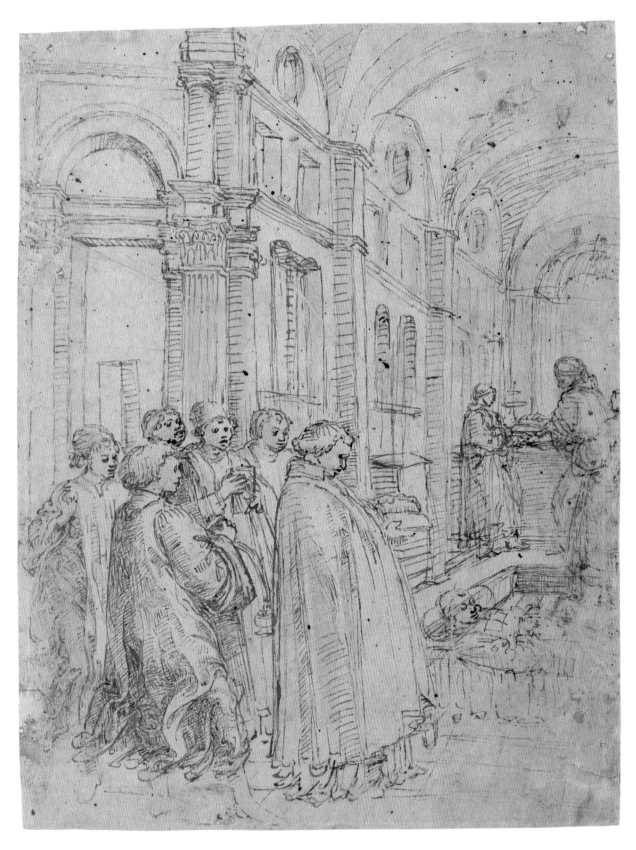

Pen and brown ink with brush
and brown wash and traces of
stylus over traces of black chalk,
on beige laid paper lined with
cream laid paper

249 x 193 mm (9¾ x 7⁹⁄₁₆ in.)

WATERMARK: none visible
through mount

INSCRIPTIONS: verso of secondary
support, center, in brown ink:
Pordonone Fece

John L. Severance Fund 1947.70

Pietro di Cristoforo Vannucci, called Perugino

Città di Pieve c. 1450/55–Fontignano 1523

The elegant and lithe St. Sebastian in this drawing is typical of Perugino's figures, which were praised for their beauty and adherence to classical forms. This canon influenced his pupil Raphael, whose early drawings are dependent on those of his teacher.[1] Perugino based his St. Sebastian on classical models he would have seen in collections in Florence and Rome, possibly of the elongated Antinous type,[2] but he also drew from the live model to combine the natural form with the ideal. The figure's left heel seems to be placed on a block for balance, suggesting a posed nude model.[3] The static frontal stance gives him an air of quiet solemnity. The closely spaced, regular hatching is typical of the refinement and care needed to execute work in metalpoint, Perugino's preferred medium. Although there are only sixty to seventy drawings by him known, making sheets difficult to date, St. Sebastian is closest in style to the artist's "classical" period of the early 1490s.

One of the most sought-after painters at the turn of the sixteenth century, Perugino operated studios with assistants in both Perugia and Florence to keep up with his numerous commissions. Because of the demand for his work, he often repeated figures and compositions from painting to painting. In spite of Vasari's criticism of Perugino for what he perceived as a lack of originality,[4] a drawing such as this one should be judged within the context of late quattrocento studio practice, in which popular models were reused. Certain devotional images followed an accepted formula, and patrons expected artists to create works adhering to their expectations. St. Sebastian provides an insight into this practice. The worn condition of the sheet attests to its having been copied more than once by both the master and probably studio assistants. Despite this treatment, its inherent beauty and grace are evident.[5]

This figure of Sebastian—body gracefully swaying, hands bound behind his back, head tilted upward—appears in at least two autograph paintings by Perugino. A number of pictures by followers and copyists also include this St. Sebastian. In Perugino's signed and dated 1493 altarpiece of the Madonna and Child with Sts. John the Baptist and Sebastian for San Domenico, Fiesole (Uffizi, Florence),[6] the same figure pierced with an arrow wears a striped loincloth. Shadows at his feet from light coming from the right are visible in the painting but less so in the drawing. A second painting of St. Sebastian (fig. 1), datable to the period of the Fiesole altarpiece, depicts the same figure tied to a column and pierced with two arrows but bathed in light coming from the left as the shadows at the right of his feet indicate. Variations of the figure are found in Perugino's fresco of the martyrdom of St. Sebastian in Panicale (c. 1505–7), in a half-length St. Sebastian in the Hermitage, St. Petersburg, considered autograph, and in full-length copies in the Museo di San Paolo and the Villa Borghese, Rome.[7] At least eleven paintings of St. Sebastian, the popular patron saint of the plague, come from Perugino's hand or from his studio, and many are dependent on the Cleveland drawing.[8] DDG

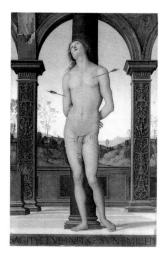

Fig. 1. Pietro Perugino. *St. Sebastian*, 1490–93, oil. Musée du Louvre, Paris, inv. no. R.F. 957.

1. Francis Ames-Lewis, *The Draftsman Raphael* (London, 1986), 14–16.

2. A Roman marble statue of Antinous, with similar proportions and pelvic tilt, was in the Farnese Collection in Rome by c. 1520. One in bronze was known to be in the collection of Cosimo I at the Palazzo Vecchio in the sixteenth century. Their earlier history is not known. See Bober/Rubinstein 1986, 163, no. 128. Other statues, such as the Apollo Belvedere, also come close in pose to the torso of St. Sebastian (ibid., 71, no. 28).

3. The condition of the sheet makes it difficult to tell whether it is a block or a pentimento adjusting the heel.

4. Vasari/Milanesi 1906, 3:585–87.

5. The drawing is often reproduced. Moskowitz 1962, 1:no. 241, for example, noted that the sheet is "somewhat rubbed but still eloquent."

6. Inv. no. 1453; Scarpellini 1984, 86, no. 51, figs. 83–84, 86.

7. For the Panicale fresco, see ibid., 110–11, no. 143, figs. 226–28; for the Hermitage picture (inv. no. 281), see ibid., 87, no. 54, fig. 88. The painting in San Paolo (inv. no. 13) was considered to be partially autograph by Scarpellini 1984 (p. 87 under no. 53). The picture in the Villa Borghese (inv. no. N.386) is an old copy.

8. For other pictures of St. Sebastian, see those reproduced in Camesasca 1969.

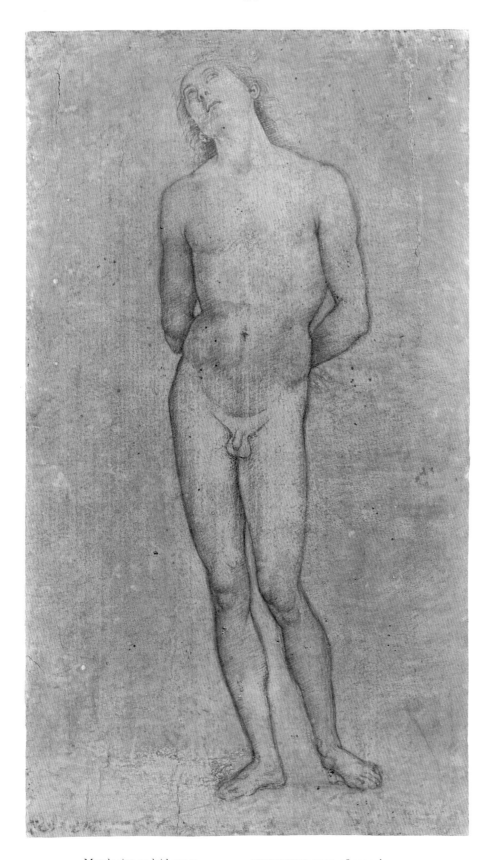

Metalpoint on laid paper
prepared with gray ground,
lined with beige laid paper

256 x 146 mm (10¹⁄₁₆ x 5¾ in.)

INSCRIPTIONS: verso of secondary
support, center left, stamped in
red ink: *11/68* [circled, sideways]

Dudley P. Allen Fund 1958.411

Baccio della Porta, called Fra Bartolommeo

Florence 1472–1517

Fra Bartolommeo is acknowledged as one of the most influential Italian artists of the High Renaissance, lending ideas to Raphael, Titian, Correggio, Beccafumi, and others. Like most Florentine painters he was a prolific draftsman: today more than 1,000 sheets from his hand are extant.[1] Modern scholarship has concentrated on the drawings, especially since the forty-one sheets with sixty landscapes (including this sheet) that appeared on the market in 1957 changed the perception of his drawing oeuvre, which until then had been made up almost entirely of compositional and figure drawings.[2] The landscapes are among the very first in Western art wholly in this genre and as such present an idea of how early sixteenth-century artists perceived the world around them.[3] Their immediacy suggests that Fra Bartolommeo may have drawn them outside directly from nature, an idea accepted by most scholars. However, the purpose of these sheets is unknown. Either the artist drew them for his own pleasure, for the love of nature and man's place in it, or to get ideas for his paintings. In fact, *Farmhouse on the Slope of a Hill* is his only landscape drawing that can be connected with one of his paintings.[4] The buildings show up, albeit from a slightly different perspective and adjusted a little, in the background of *God the Father with Sts. Mary Magdalene and Catherine* (fig. 1).[5] They are seen in two other paintings from his workshop (Rijksmuseum, Amsterdam, and private collection [by Mariotto Albertinelli]), but in this case the similarity of the motif with the altarpiece in Lucca suggests that the artists copied the Lucca altarpiece.[6] Even Raphael looked to Fra Bartolommeo's landscape motif: several of the buildings show up in the background of the *Disputà* in the Sala della Segnatura in the Vatican (1509).[7]

The Cleveland drawing necessarily predates both the Lucca altarpiece and Raphael's interpretation in the *Disputà*. The suggestion that it was drawn during Fra Bartolommeo's trip to Venice in 1508[8] cannot be proved, as the farmhouse and the landscape could as easily have been part of a Tuscan landscape. The rapidity of the strokes for the foliage of both the spiky firs and the blooming deciduous trees, and the shorthand strokes for the figures caught in action suggest that the artist drew this scene outside. The careful hatching on the retaining wall and the embankment, however, indicate that he probably completed it, perhaps from a previous drawing,[9] in the studio. Fra Bartolommeo's landscape drawings are remarkable for their clarity of atmosphere, attention to detail, and evocation of life in the countryside. Unlike his sacred works, redolent with religious conviction, these drawings offer a more personal and immediate vision of contemporary life.

A copy of part of this drawing by Domenico Beccafumi is in the Uffizi;[10] another by Robert Surtees in 1768 was sold in 1980.[11] Surtees filled in the lower foreground, blank in the drawing here, with another hillock and a man with a bundle and a staff. DDG

Fig. 1. Fra Bartolommeo. *God the Father with Sts. Mary Magdalene and Catherine* (detail), 1508, oil. Pinacoteca, Lucca.

1. An inventory of the drawings at his death was compiled by Lorenzo di Credi. Most of his drawings are in Rotterdam (600 in the Museum Boymans van Beuningen), Florence (250 in the Uffizi), Paris (60 in the Louvre), and elsewhere; see Monbieg-Goguel 1991, 453.

2. On the discovery of these landscape drawings and their provenance in Fra Bartolommeo's studio, see Carmen Gronau in Sotheby's, London, 20 November 1957, ii–vi; on his landscape drawings in general with an analysis of the provenance see Fischer 1989 and Fischer in Rotterdam et al. 1990–92, 375–77. For a different view see Ellis 1990.

3. Because landscapes were of minor importance, many by Fra Bartolommeo and other artists were destroyed. According to an anecdote by Gabburri, who owned 500 drawings by Fra Bartolommeo, including the album sold in 1957, the nuns of the convent of St. Catherine had used the drawings to wrap parcels and light fires (Gronau in Sotheby's 1957, iv.).

4. See Fischer 1989, 319.

5. First noted by Glazer in New York 1959a, 17. Fischer 1989, 327, fig. 34.

6. Everett Fahy (in a letter of 8 March 1967 to Henry Francis, CMA files) noted the connection with the painting in the Rijksmuseum (Fischer 1989, 328, fig. 35) while von Holst 1971, 18, added the picture in a private collection (Fischer 1989, 328, fig. 36).

7. Fischer 1989, 329, fig. 37.

8. Kennedy 1959, 8.

9. There are several instances in which Fra Bartolommeo worked up a rapidly executed earlier rendition of an outdoor site. See, for example, Fischer in Rotterdam et al. 1990–92, 378–82, nos. 105–6.

10. Ellis 1990, 3, fig. 1, as Beccafumi. Fischer in Rotterdam et al. 1990–92, 394 under no. 111, fig. 261, returned the drawing to Beccafumi.

11. Christie's, London, *Important English Drawings and Watercolours*, 18 March 1980, 8 (repr.), lot 6.

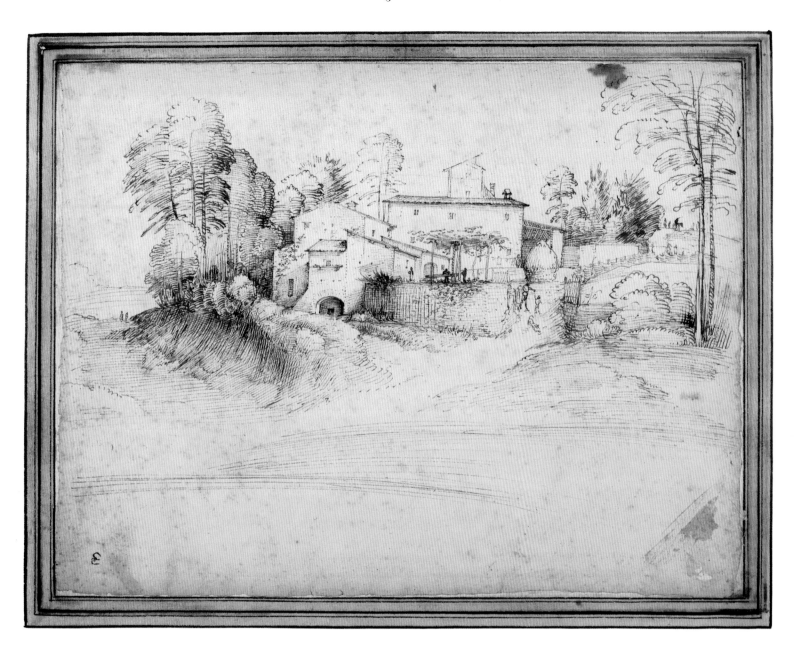

Pen and brown ink, on cream
laid paper, perimeter mounted
to cream laid paper (F.M.N.
Gabburri mount)

223 x 294 mm (8¾ x 11⁹⁄₁₆ in.)

WATERMARK: center: chariot
(similar to later mark, Briquet
3541 [1529])

INSCRIPTION: a bird in ink lower
left recto

Gift of the Hanna Fund, pur-
chase, Dudley P. Allen Fund,
Delia E. Holden Fund, and L. E.
Holden Fund 1957.498

Raffaello Santi, called Raphael

Urbino 1483–Rome 1520

This colorful sheet by Raphael represents a transitional phase in the artist's style between his Florentine (1504–15) and Roman (1508–20) periods. Drawn in silverpoint on pink prepared paper, it continues a technique popular in the fifteenth century, but its freedom of handling, pentimenti, and repeated contour lines look forward to his later preferred technique of pen or chalk to express movement. The seated female nude and the child's head at upper right are delineated with careful contour lines and closely spaced hatching, typical of metalpoint drawings, but the repetition of the female's position at left in simple contour lines and the freely executed forms of the reclining child at bottom extend the possibilities of the medium. In this respect Raphael was influenced by Leonardo, whose works he would have studied in Florence. The head of the child comes from Leonardo's Christ child in the *Benois Madonna* (1470s, St. Petersburg, Hermitage), which was in a Florentine collection when Raphael was there.[1] Raphael interpreted Leonardo's painting in his own *Madonna of the Pinks* (Alnwick Castle, The Duke of Northumberland Collection) dated at the end of the Florentine or beginning of the Roman period.[2] In fact, the head of the Christ child in the underdrawing of the Alnwick picture is closer to Leonardo's rounder child than it is to that in the completed picture.[3] Raphael's study in the Cleveland drawing may have followed his copy of Leonardo's painting, which he then used as a further study for the child's head for the *Madonna of the Pinks*.[4] The seated female model at left has been associated with the much later *Madonna*

della Sedia (1514–16, Palazzo Pitti, Florence), but the connection appears coincidental.[5]

The three sketches of the child at bottom have been associated with a lost picture by Raphael, the *Madonna of the Veil*, known in a contemporary copy (fig. 1). The child, drawn from life in various squirming positions, lies on a bed resting on a pillow. There are four known drawings with similar babies for this painting: two in Lille, one in the British Museum, and the Cleveland sheet.[6] Obviously, because of the many drawings of the child on each sheet, Raphael played with various positions before deciding on the final pose, which appears on one of the Lille sheets.[7]

The Cleveland drawing is one of a group that Oskar Fischel stated came from a single sketchbook, which he called the Pink Sketchbook based on the similarity of prepared grounds. The drawings are also comparable in size and contain mostly sketches for the subject of the Madonna and child. They have been associated with various paintings of this subject from the late Florentine and early Roman periods.[8] One of the drawings has a study for the *School of Athens* (Sala della Segnatura, the Vatican), helping to date part of the series between 1508 and 1511. Because of its small format the artist could have carried the notebook with him, and most likely he used it both in Florence and after he arrived in Rome. Because this sheet relates to the picture by Leonardo that Raphael would have known in Florence, its date must be early in the series of Madonna studies in the sketchbook. DDG

Fig. 1. Copy after Raphael. *Madonna of the Veil*, c. 1509, oil. Musée Condé, Chantilly, inv. no. 40.

1. As noted by Fischel 1941, 366–67, no. 354. For Leonardo's painting, see Edinburgh 1994, 52, fig. 42.

2. Once thought to be an old copy, the Alnwick picture is now considered Raphael's original. See Nicholas Penney, "Raphael's 'Madonna dei garofani' Rediscovered," *Burlington Magazine* 134 (February 1992), 67–81, who first recognized the Alnwick picture to be the original.

3. Edinburgh 1994, 52.

4. Fischel 1941, 366, no. 354, and others noted the Leonardesque quality of this head.

5. First connected by Fischel 1941, 366, no. 354, who suggested that Raphael looked back to this drawing when painting the *Madonna della Sedia* some years later.

6. Lille inv. no. 437–438. British Museum inv. no. Pp.1–72. Joannides 1983, 201, nos. 271–74 (repr.).

7. Inv. no. 437.

8. Such as the *Bridgewater Madonna*, the *Aldobrandini Madonna*, the *Alba Madonna*, and others.

5. *Studies of a Seated Female, Child's Head, and Three Studies of a Baby*

c. 1507–8

Silverpoint on cream laid paper
prepared with a pink ground

120 x 153 mm (4¹¹⁄₁₆ x 6 in.)

INSCRIPTIONS: lower right, in
brown ink: *74*

Purchase from the J. H. Wade
Fund 1978.37

Michelangelo Buonarroti

Caprese 1475–Rome 1564

Apart from the occasional reservations that have surfaced regarding the attribution of this drawing for the Sistine Ceiling, it is today recognized as autograph Michelangelo and considered one of the finest examples of his red chalk technique. The Cleveland drawing has often been connected in style, medium, and technique with a drawing for the *ignudo* (one of the youthful male nudes on the ceiling) to the right above the Persian Sibyl (Teylers Museum),[1] and another for the ignudo to the left above the same Sibyl (Albertina).[2] Michelangelo worked horizontally across the surface of the ceiling, proceeding toward the altar end of the chapel. He prepared the drawings as he progressed, with each section worked out only shortly before the *intonaco* (the section of wet plaster on which he painted) was laid.[3] Judging from the extant drawings executed for the early bays versus those for the later ones, Michelangelo apparently became increasingly interested in the characteristic effects afforded by the use of red chalk. Of the small number of existing highly detailed red chalk figure studies for the Sistine Ceiling, the above-mentioned drawings in Haarlem and Vienna and this one in Cleveland represent three of the four ignudi flanking the scene of the *Separation of Land from Water*. Therefore, because this increased use of red chalk is found in the preparatory drawings for the figures painted soon after the August 1510–June 1511 interruption of work, the Cleveland drawing probably dates to some point during that hiatus.[4]

On the verso of the sheet are four studies for the left foot of the ignudo from the recto, a portion of a heel, and two youthful figures, both incomplete. The largest of the foot studies reveals that Michelangelo was having difficulty with the angle of the foot, particularly the big toe, which is twice depicted at a more frontal angle than in the final fresco.[5] While neither of the two figure studies have a direct correlation to a frescoed figure, they were surely sketched for the ceiling but later rejected by the artist.[6]

A close examination of the drawing for the ignudo compared to the fresco (fig. 1) reveals information about Michelangelo's working practice. It is clear from the fresco that Michelangelo must have used a cartoon for the final figure, as pouncing is apparent in the hands, the curls of hair, and in certain areas of the face.[7] Both the Haarlem and Vienna drawings are extremely close to their fresco figures, and therefore probably just one step from the cartoons.[8] Yet the Cleveland drawing, though just as highly detailed, has marked differences with the frescoed ignudo. In the fresco the figure is hunched further forward and inclines more toward his proper right. Again in the fresco, the right forearm is pushed forward toward the picture plane and therefore increasingly foreshortened, rather than faithfully following the drawing, which places the forearm at an angle closer to ninety degrees from the elbow.

Michelangelo sketched the Cleveland figure from a live model, just as he did the Haarlem and Vienna drawings.[9] It would seem, however, that between the Cleveland drawing and the fresco, Michelangelo turned (or returned) to a sculptural model, the *Torso Belvedere*, to modify the figure. The fresco figure, as noted above, is hunched over more and thus closer to the *Torso Belvedere* than to the drawing. Compelling evidence for Michelangelo's use of wax and clay models as part of the preparatory process for his paintings can be found in several mid sixteenth-century treatises.[10] Michelangelo probably found it more convenient to make a small-scale copy of the *Torso* that would allow him to manipulate the figure easily and study it from any angle. Although his standard practice was generally to use the models earlier in his creative process, it seems apparent from the above-mentioned discrepancies between the Cleveland drawing and the fresco that Michelangelo diverged from that practice here and instead referred again to the three-dimensional model.[11] The purpose this drawing served was to render the ignudo from a more foreshortened viewpoint, one more strikingly complex once placed on the curved vault. It also reveals Michelangelo's affinity for three-dimensional models regardless of the stage in the creative process. JO

Fig. 1. Michelangelo Buonarroti. Ignudo above the Prophet Daniel (detail), 1508–12, fresco. Sistine Chapel ceiling, the Vatican.

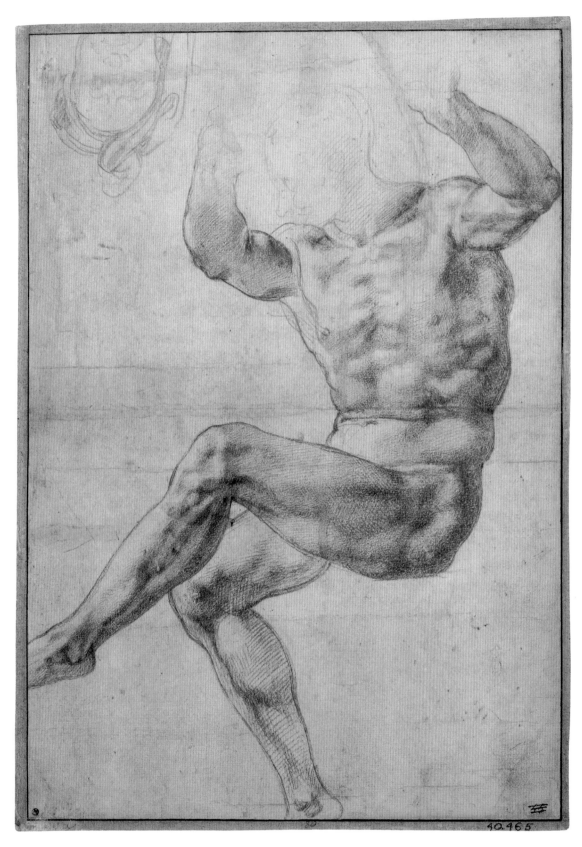

Red chalk and black chalk[12] on beige laid paper, perimeter mounted to gray laid paper; verso, red chalk heightened with traces of white

343 x 243 mm (13³⁄₁₆ x 9³⁄₁₆ in.)

INSCRIPTIONS: lower right, in black ink: *55* [crossed out]; verso, upper center, in brown ink: [Jr?]; upper right, in brown ink: *V./*.

Gift in memory of Henry G. Dalton by his nephews George S. Kendrick and Harry D. Kendrick 1940.465.a,b

1. Teylers Museum, Haarlem, inv. A 27; recto, red chalk.

2. Albertina Graphische Sammlung, Vienna, inv. 120; red chalk heightened with white over traces of stylus.

3. Michael Hirst, *Michelangelo and His Drawings* (New Haven/London, 1988), 25.

4. Miller 1990a, 165, suggested Michelangelo may have located a quantity of high-quality red chalk during that break, perhaps in Florence or Bologna.

5. The middle study is the one closest to the fresco; Hartt 1972, 82. This practice of drawing the overall figure, then studying details of extremities in greater depth is in keeping with other examples of Michelangelo's working process.

6. Miller 1990a, 171 n. 2.

7. Pouncing is the technique whereby the final, full-scale drawn design (the cartoon) is transferred to the wet plaster. It involves pricking the outline of the cartoon with holes and rubbing ground charcoal into them, so that the general outline is visible on the wet plaster painting surface.

8. Hirst, *Michelangelo and His Drawings*, 25.

9. Indeed, it would seem that Michelangelo probably used the same model, merely repositioning him for each pose. The distinctive nose hinted at on the Cleveland and Haarlem drawings would corroborate such a supposition. De Tolnay 1945, 211, noted this similarity, but rather than concluding that the two were drawn from the same model, he erroneously attributed it to the hand of a copyist.

10. See Jeannine O'Grody, "'Un Semplice Modello': Michelangelo and His Three-Dimensional Preparatory Works," Ph.D. diss. (Case Western Reserve University, 1999).

11. De Tolnay 1975, 112, noted the similarities to the *Torso Belvedere* and suggested a somewhat comparable progression of development. For a different reading of the place of the three-dimensional model in the creative process, see Miller 1990a, 154–55.

12. An infrared reflectogram of the drawing made in 1990 clearly revealed a continuous black chalk outline of the figure (see Miller 1990b, Miller 1990a). Given that the nature of the outline is unusual for Michelangelo and that it is impossible to determine conclusively if it was drawn under or over the red chalk, an intriguing solution has recently been posited. Carter Foster, associate curator of drawings at the CMA, has suggested that the outline might be the result of a copy having been made of the drawing with the aid of a pantograph (personal communication with the author). Interestingly, the drawings connoisseur Pierre Jean Mariette (former owner of this drawing) had several of the Michelangelo drawings in his possession copied (see Simonetta Prosperi Valenti Rodino, "Le Lettere del Mariette a Giovanni Gaetano Bottari nella Biblioteca Corsiniana," *Paragone* 339 [May 1978], 44–45), although admittedly we do not know what technique was used to do so.

Baccio Bandinelli

Florence 1493–1560

Considered among the most important sculptors of the sixteenth century, Bandinelli suffered in reputation in his own period because of his difficult personality, violent temper, unashamed ambition and megalomania, harsh competitiveness, and unpopular support of the Medici family against republican causes. His sculptures reflect an adherence to ancient prototypes as well as a dependence on *disegno*. In the sixteenth-century controversy between the superiority of painting or sculpture, Bandinelli surprisingly inclined toward the former with his reliance on the authority of disegno as the basis of all art. Vasari praised Bandinelli's drawings, stating that "without a doubt it would be impossible to improve upon them."[1] Although Vasari criticized many of Bandinelli's sculptures, he included his drawings in his famous *Libro dei disegni*.[2] Bandinelli's drawings were prized by others, too, and imitated during and after his lifetime by his many students and admirers. He had also opened one of the first drawing academies in Renaissance Italy.

Probably in his academy, which is recorded in a contemporary print,[3] Bandinelli normally drew from sculptural rather than live models, although this sheet seems to reflect a live nude model.[4] Numerous sheets exist with these so-called academies in red chalk showing the model posed in various difficult positions. Bandinelli's chalk style did not change dramatically throughout his life, making these drawings difficult to date. Because they do not relate to the artist's sculptures, it is likely that they were made as finished works of art. The forms are precisely outlined and then filled in with painstaking hatching that renders them in careful relief. Bandinelli prized these sheets and admonished his heirs to save his drawings for posterity.[5]

Some of these male nudes, including the present sheet, were executed in the late 1510s, during one of Bandinelli's stays in Rome, and are based on the *ignudi* (nudes) from Michelangelo's Sistine Chapel ceiling, finished a few years before.[6] The drawings do not reproduce the ignudi exactly but rather interpret and build on them. Neither is the drawing style that of Michelangelo. The emphasis on sculptural musculature is absent in Bandinelli's nude, which has echoes of Leonardo in the atmospheric rendering, of Raphael in the graceful physical beauty, and of Andrea del Sarto in the thickly applied red chalk. (Bandinelli's later drawings tended toward an abstraction and faceting of form with more emphasis on linearity.) In the *Seated Male Nude* Bandinelli instilled a sense of drama to the figure by emphasizing the movement of his body in one direction as he looks backward over his shoulder, as if surprised by something behind him. Similar red chalk male nudes inspired by the ignudi from this period are found in London (British Museum), Melbourne (National Gallery of Victoria), and Paris (Louvre).[7] The drawing in the Louvre may even represent the same posed model as that in the Cleveland sheet.
DDG

1. Vasari/Milanesi 1906, 6:190: "e nel nostro Libro ne sono di penna e di matita alcuni, che no si può certamente far meglio."
2. Ragghianti Collobi, *Il Libro de' Disegni del Vasari* (Florence, 1974), 134–35, figs. 412–16.
3. Dated 1531. Walter Strauss, ed. *The Illustrated Bartsch* (New York, 1978), 14:167, no. 418.
4. According to Ward 1982a, 98, few of Bandinelli's drawings are from the live model but are taken from the prototypes of earlier artists.

5. "All my concentration was fixed on drawing: in the Judgment of Michelangelo, of our Princes [the Medici] and other notables, it is above all in that activity that I have prevailed." A. Colasanti, "Il *Memoriale* di Baccio Bandinelli," *Repertorium für Kunstwissenschaft* 28 (1905), 433.
6. For dating of Bandinelli's drawings, see Ward 1982a and Ward 1982b.
7. London inv. no. Pp. 1-61; Ward 1982a, fig. 11. Melbourne inv. nos. 563/4 and 564/4; Ward 1982b, figs. 1–2. Paris inv. no. 93; Ward 1982a, fig. 12.

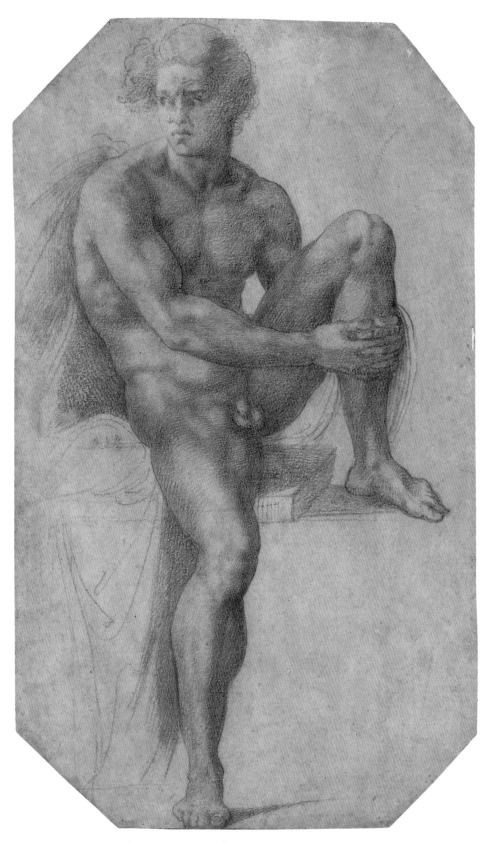

Red chalk over faint traces of
black chalk, on beige laid paper,
lined with Japanese paper

400 x 237 mm (15¾ x 9¼ in.)

John L. Severance Fund 1998.6

Domenico Beccafumi

Cortine, in Valdiviana Montaperti, 1484–Siena 1551

Domenico Beccafumi experimented with different drawing and printmaking techniques, especially a combination of engraving and woodcut.[1] *Three Male Nudes* is a mature study for one of those endeavors. The sheet is a jumble of black chalk lines that delineate the general contours of the forms and helped the artist place shadows in the print. The white areas indicate highlights to be printed from the woodblock. The appendages and background are not yet thought out. Beccafumi normally elaborated his forms on the plate from such vague indications. Here the large reclining nude's hand is only rounded lines and he seems to hold a book. In the background at right is a tree, seen in the print, while another tree at center has been eliminated in favor of a second mountain. From the drawing, made on a colored ground to simulate the middle tone of one of the woodblocks, the artist transferred the incised contours probably directly to a copper plate, which he engraved (fig. 1). The unfinished look of some of Beccafumi's engravings indicates that they are first states. In the final prints, the use of the white and toned blocks would give the image color and drama (fig. 2).[2]

The drawing has been connected with figures in various scenes in Beccafumi's Old Testament narratives on the pavement of the cathedral in Siena. There is a similar figure, in reverse, in *Moses Striking the Rock* of 1524–25 and in the *Sacrifice of Isaac* of 1547, but Beccafumi used reclining nudes, both male and female,[3] throughout his career, and more often than not they twist and rest on one elbow. Dating of the drawing depends instead on its similarity with other preparatory drawings and chiaroscuro prints. The density of the nervous black lines and delicacy of the white chalk highlights is similar to other

sheets of the 1540s.[4] In late works he increased the contrast between lights and darks. The Cleveland drawing probably grows out of a slightly earlier print, *Two Nude Men*, in which one figure reclines in the same position.[5] Beccafumi used the pose again (in reverse of the Cleveland sheet) in chiaroscuro drawings in the Albertina and the Louvre.[6] As with the Cleveland drawing, he copied the pose from his print.

The reclining figures are reminiscent of ancient Roman river gods, the Belvedere Torso, and Michelangelo's sculptures and paintings.[7] That they are manipulated into poses from these sources but differ in various details suggests that the artist employed wax models that he could maneuver at will. In his *Vite* Giorgio Vasari listed works in the round by Beccafumi and related that he was an acknowledged master sculptor.[8] He may also have been interested in the wax and clay models of others, particularly those of Michelangelo. Michelangelo's wax model of a male torso (also based on the Belvedere Torso) of c. 1516–18 was probably known to Beccafumi either in the original or in a copy.[9]

The subject of *Three Male Nudes* has not been explained satisfactorily. It certainly does not represent three river gods, as the old title indicates, or Moses with the tablet and one of the Israelites drinking from the miraculous spring, as also proposed.[10] Although it is tempting to identify the subject of the print as Diogenes holding his cup and listening to his teacher, the figure in the drawing holds a book, not a cup. It is likely that he, the turbaned nude with a book (possibly a tablet), and the crouching nude in the background are three Greek philosophers carrying on an intense and thoughtful debate.
DDG

1. On Beccafumi and woodblock prints, see Hartley 1991; for his various drawing techniques, see Siena 1990, 428–509, nos. 85–177.

2. For an analysis of the print and its date, see Hartley 1991, 422–24. Only two impressions of the engraving with the woodcut are known: Pinacoteca Nazionale, Siena, and Library of Congress, Washington (fig. 2). A pen and ink copy of the engraving is in the Pinacoteca Nazionale, Siena (inv. no. 46); see Cesare Drandi, "Disegni inediti di Domenico Beccafumi," *Bollettino d'Arte* 27 (1934), 362, fig. 12.

3. See, for example, *Venus* (Barber Institute of Fine Arts, Birmingham; Torriti 1998, 94, P29 [repr.]), Jonah in *The Descent of Christ into Limbo* (Pinacoteca Nazionale, Siena, inv. no. 427; ibid., 143–45, P66 [repr.]), and the Christ in the

Nativity (Chiesa di San Martino, Siena; ibid., 116–17, P40 [repr.]). For *Moses Striking the Rock* and the *Sacrifice of Isaac*, see ibid., 200–215.

4. For example, *Two Nude Men* (Chatsworth, Duke of Devonshire Collection, inv. no. 6), a red chalk drawing similar in technique and dated c. 1537 (Torriti 1998, 305–6, no. D113), and *St. Bartholomew* of c. 1540 (Bologna, Pinacoteca Nazionale, inv. no. B.53 [414]; Siena 1991, 483, no. 152).

5. For dating of this print c. 1537, see Siena 1990, 479, no. 146. Hartley 1991 dates both *Two Nudes* and *Three Male Nudes* to c. 1547. A drawing in the Uffizi (inv. no. 1510 E), by some considered preparatory for the Cleveland drawing, is likely an early thought for the *Sacrifice of Isaac* in the Siena cathedral, as noted by Torriti 1998, 320, no. D140.

6. Albertina Graphische Sammlung, Vienna, inv. no. 276 (SC.R.205) and Musée du Louvre, Paris, inv. no. 257 (Torriti 1998, 321–22, nos. D143–44).

7. See, for example, Richards 1959, 24–25, for river gods and Michelangelo's Adam on the Sistine ceiling; Gordley 1988, 283, for Michelangelo's Adam and Noah on Sistine ceiling and *Day* in Medici Chapel; and Siena 1990, 481, for Michelangelo's *Dawn* and *Dusk* in Medici Chapel.

8. Giorgio Vasari, annotated by Gaetano Milanesi, *Le vite d' piu eccellenti pittori, scultori, ed architettori* (Florence, 1906), 5:644: "Nella quale opera mostrò Domenico non intendersi meno della scultura, che si facesse della pittura." English translation: Vasari, translated by Gaston du C. De Vere, *Le vite* (London, 1912–14), 6:244.

9. Todd Herman suggested Michelangelo's model as a source. For information on the model (Casa Buonarotti inv. no. 542), see Jeannine O'Grody, "'Un Semplice Modello': Michelangelo and His Three-Dimensional Preparatory Works" (Ph.D. diss., Case Western Reserve University, 1999), 234–38, no. 4.

10. By Olszewski in Cleveland 1979a, 30, no. 5. There is no precedent for Moses reclining with the Israelites drinking.

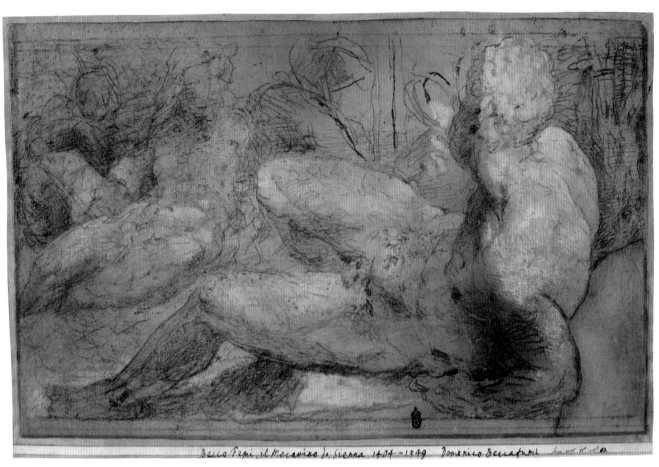

Black chalk or charcoal (stumped in places), with traces of brush and black chalk wash, heightened with white, incised, framing lines in black chalk or charcoal (top and bottom), on light brown laid paper (discolored), laid down on a secondary support (not visible), laid on a tertiary support of laid paper

232 x 417 mm (9⅛ x 16⅜ in.)

WATERMARK: none visible through mount

INSCRIPTIONS: tertiary support, along bottom, in brown ink: *Becco Fumi, il Mecarino da Sienna. 1404–1549 Domenico Beccafumi*; lower right, in brown ink: *from vol 1.st P.* [1?]*2.*

Delia E. Holden Fund 1958.313

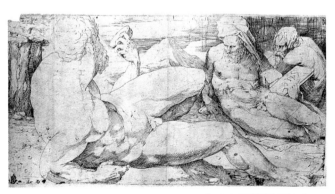

Fig. 1. Domenico Beccafumi. *River Gods*, c. 1540–47, engraving. The Cleveland Museum of Art, Delia E. Holden Fund 1958.314.

Fig. 2. Domenico Beccafumi. *River Gods*, c. 1540–47, engraving and one woodblock. The Library of Congress, Washington.

Federico Barocci

Urbino c. 1535–1612

This large and colorful drawing has been associated with the figure of the Christ child in Barocci's early painting *The Martyrdom of St. Sebastian* (1557–58) in the cathedral at Urbino,[1] as well as two decorative winged putti (1561–65) in the Casino of Pius IV in the Vatican.[2] The pose of the Cleveland figure does not accord exactly with those in either of the painted compositions, and poses of babies often tend to be similar. Although the drawing is squared for transfer, no corresponding painting of the subject exists. However, it appears to have been preparatory for a picture representing Venus seated in the heavens with Cupid on her knee as he draws his bow to aim at an unsuspecting mortal below.[3] Such a mythological subject would have been rare in Barocci's oeuvre, which consists mostly of devotional pictures and a few portraits.[4]

Recently, several scholars have either questioned this drawing's authenticity or rejected it from Barocci's oeuvre based on the artist's handling of the colored chalks, the lack of a corresponding painted composition, and the difficulty of dating the sheet.[5] Other scholars have accepted the *Cupid* as fully autograph.[6] Edmund Pillsbury suggested that a studio assistant or follower, such as Ventura Mazzi, could have produced such a sheet. Filippo Baldinucci stated that Mazzi made large colored-chalk drawings based on Barocci's putti of the 1560s;[7] however, no works by the unknown Mazzi have come to light and the style of this sheet makes it difficult to date. Neither does the application of color to the form appear antithetical to Barocci's methods. The artist did use an extensive amount of black chalk shading and red highlights on Cupid's body as well as an ocher tint for his hair. Further, similar sharp, repetitious black chalk contour lines and a comparable use of heightening are seen in several head studies in the Nationalmuseum, Stockholm,

which were rejected by Harald Olsen.[8] Yet, an accepted drawing in the Metropolitan Museum of Art, New York, is similar in the application of yellow ocher.[9] The searching quality of the lines of the right hand and left leg preclude the drawing's being a copy of a lost sheet, and no known artist works in a fashion so close to Barocci's style. *Cupid* exhibits Barocci's usual homage to Correggio in the sweetness of the child's expression, the plumpness of his body, and the characteristic Correggesque sfumato, achieved here by the stumping or rubbing of the chalk.

Barocci's biographer, Gian Pietro Bellori, described the artist's painstaking working method, which began with studies from nature, included sculpted models in wax, and concluded with small cartoons in oil and full-scale cartoons in colors.[10] A drawing such as *Cupid Drawing His Bow* would have followed numerous compositional and life studies (more than two thousand drawings by the artist are known). Barocci began employing colored chalks, called "pastelli," in the 1560s, the decade that their use spread from Venice along the Adriatic coast to Urbino. According to Bellori, the artist learned the technique from a Parmese artist who visited Urbino carrying such drawings ("teste a pastelli") by Correggio.[11] No pastels by Correggio have come to light, and, in any case, Barocci probably learned the technique from the Venetians. First training in Urbino under the Venetian Battista Franco and then copying Titian's paintings in Pesaro, Barocci would have taken up the effects that Venetian artists achieved in black and white. He and the Venetian Jacopo Bassano began using pastels at the same time, but it was certainly Barocci who first understood the potential of the medium and secured its later popularity.[12] DDG

1. Emiliani 1985, 6–9.

2. Barocci is documented as working in the Casino of Pius IV between 1561 and 1563. He has been considered the designer but not the author of those two putti (see Olsen 1962, 143).

3. Olszewski 1981, 61, noted that Cupid sits on the knees of Venus.

4. For Barocci's paintings see Olsen 1962 and Emiliani 1985.

5. Pillsbury in Cleveland/New Haven 1978, 39–40, no. 11 questioned the drawing whereas McCullagh 1991, 62–65, rejected it from the artist's oeuvre.

6. Including James Byam Shaw, Rodolfo Pallucchini (letter of Nathan Chaïkin to Sherman Lee, 18 August 1981, CMA files), Graham Smith (letter of 31 March 1973, CMA files), Per Bjürstrom, and William Griswold (oral communication 1998, 1999).

7. Pillsbury in Cleveland/New Haven 1978, 40. See Filippo Baldinucci, *Vite de pittori italiani del Seicento* (1681), 6:78, who said that these putti were in folio sizes.

8. Inv. nos. NM H 403/1863 and NM H 405/1863; see Olsen 1962, 290–91.

9. Inv. no. 64.136.3. Jacob Bean and Lawrence Turčić, *Fifteenth–Sixteenth Century Italian Drawings in the Metropolitan Museum of Art* (New York, 1982), 31, no. 19.

10. Gian Pietro Bellori, *Le Vite de'pittori, scultori, et architetti moderni* (Rome, 1672), 194–96; English translation in Cleveland/New Haven 1978, 23–24.

11. Bellori, *Le Vite*, 173; English translation in Cleveland/New Haven 1978, 15.

12. For a discussion of Barocci, his relation to Correggio, and the use of pastel, see Diane De Grazia, *Correggio and His Legacy: Sixteenth-Century Emilian Drawings*, exh. cat., National Gallery of Art (Washington, 1984), 37 and 284–86.

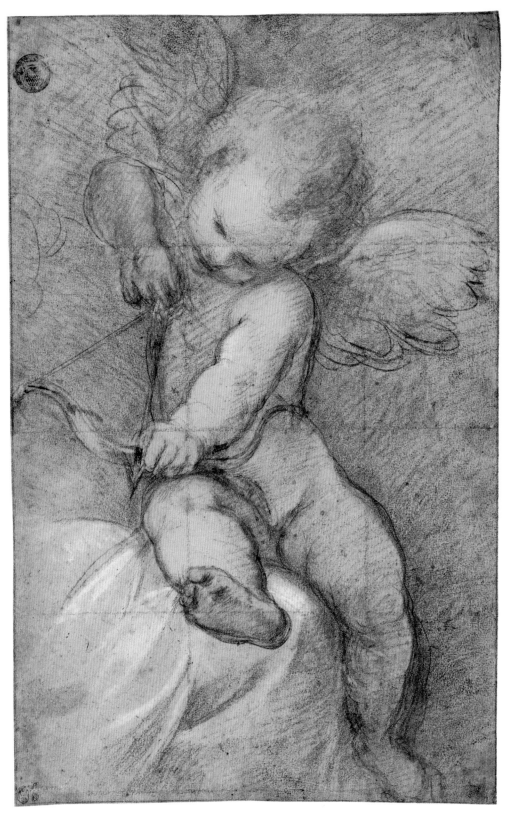

Black chalk with pastel
(stumped in places), heightened
with white chalk, squared with
black chalk, framing lines in
graphite, on gray-green laid
paper, laid down on cream wove
paper

424 x 272 mm (16¹¹⁄₁₆ x 10¹¹⁄₁₆
in.)

WATERMARK: none visible
through mount

INSCRIPTIONS: lower left, in
brown ink: [illegible]; verso,
upper left, in graphite: *4*
[circled]; upper center left, in-
cised: *ADAMID*[I?] *BL / HOTEL F*[o?]
/ Chateau Front[as?]

Dudley P. Allen and Delia E.
Holden Funds 1969.70

Federico Barocci

Urbino c. 1535–1612

The now-lost painting *The Flight of Aeneas from Troy*, painted by Barocci for the Holy Roman Emperor Rudolf II in 1586 and delivered in 1589, elicited praise and copies as soon as it was completed.[1] Even Barocci painted a second version for Giuliano della Rovere (fig. 1), which appears to have been an exact replica of the first picture.[2] The painting depicts Virgil's narrative of the dramatic destruction of Troy as Aeneas escapes the fire, carrying his elderly father, Anchises, and accompanied by his wife, Creusa, and son, Ascanius.[3] This picture is the only example of a mythological or literary subject in Barocci's oeuvre. Rudolf II asked specifically for a nondevotional picture suitable for an emperor, and certainly the escape of Aeneas, the founder of Rome, was an apt subject. Aeneas flees with his family (and the household gods carried by his father) before an architectural background of elements influenced by both ancient Roman and Renaissance buildings, suggesting that the new city he would found will be based on the old one he abandoned. In the background are copies of the column of Trajan and Donato Bramante's Tempietto, Rome, as well as Jacopo Sansovino's Biblioteca Marciana, Venice (or the Theater of Marcellus, Rome). Barocci rooted his depictions not in the original buildings, which he would not have seen for some time, but on engravings from Sebastiano Serlio's *Antichità di Roma*, published in 1540.[4] The affecting motif of Aeneas carrying his aged father with Ascanius alongside is also based on engravings, by Jacopo Caraglio and Giorgio Ghisi, which in turn reflect Raphael's figures in the *Fire in the Borgo* (1514–17, Stanza dell'Incendio, the Vatican). Barocci's meticulous preparatory methods of studying each element individually in numerous drawings resulted in the additive quality of the painted version.

More than a dozen drawings and one partial cartoon are known for Barocci's *Flight of Aeneas from Troy*.[5] This elaborately worked-up sheet is the most complete extant compositional study and came very late in the preparatory process, following the cartoon. Barocci corrected his compositions continually, even after preparing his cartoons.[6] An early compositional sketch, in the Uffizi,[7] depicts a different background: a staircase at left recedes backward into space, and buildings at right form a receding backdrop reminiscent of sixteenth-century stage scenery. Barocci carried this idea through to the full-scale cartoon, in the Louvre,[8] before rethinking it in the compositional drawing in Cleveland, the background of which indicates the final solution. The artist began the sheet with a chalk underdrawing, which was already different from the cartoon, but he changed that too when he added pen and wash. This solution of the background and the pathetic fleeing figures returns to Raphael's *Fire in the Borgo*. Still a working drawing, the sheet differs from the painting in several respects. The domestic touch of the dog running down the stairs and the niche with a bust or statue behind Aeneas were eliminated in the painting, possibly because they distract from the pathos of the central event.[9] At the right of the sheet, Barocci continued to consider the position of Anchises in Aeneas' arms, and other minor adjustments occur in the painting.

The Cleveland drawing is important not just for its completeness of conception and technical and stylistic virtuosity, but for the information it conveys about the artist's painstaking concern that all elements of a composition be studied continuously until the painting was finished. DDG

Fig. 1. Federico Barocci. *The Flight of Aeneas from Troy*, 1598 (second version), oil. Galleria Borghese, Rome.

1. The painting was commissioned in 1586, executed between the spring of 1587 and summer of 1588, and delivered in 1589. Praise of the picture is exemplified by the laudatory poem "Incendio di Troia del Barocci" by Bernardino Baldi (*Versi e Prose*, Venice, 1590), a friend of Barocci's who (Olsen 1962, 100) may have given advice on the subject. Agostino Carracci copied the painting (or, rather, an unknown oil sketch for the painting) in an oil sketch and an engraving (De Grazia Bohlin 1979, 326–28, no. 203). The figures of Aeneas, Anchises, and Ascanius were copied possibly from Agostino's print rather than from Barocci's 1598 replica in a drawing of c. 1608 by Peter Paul Rubens, now in the Albertina, Vienna (Larsen 1994, 80, fig. 4). The copy in oil attributed to Rubens by Larsen appears instead by an inferior hand (repr. ibid., 81).

2. For a history of the paintings, see Emiliani 1985, 231–37.

3. Virgil *Aeneid*, book 2, lines 671–804. The picture depicts the moment when the family leaves the gates of Troy, just before Creusa is lost. Aeneas returned to find her but her vision told him to leave.

4. On this point, see Olsen 1962, 78, no. 153; Günther 1970; Günther 1977; and Ronald Malmstrom, "A Note on the Architectural Setting of Federico Barocci's *Flight of Aeneas from Troy*," *Marsyas* 14 (1969), 43–47.

5. Mostly in the Uffizi, Florence, and the Kupferstich-kabinett, Berlin, but others are in Urbania, Windsor Castle, and elsewhere. See Olsen 1962, 180; and Emiliani 1985, 231–37.

6. Barocci's working methods are described in detail by Gian Pietro Bellori in *Le Vite de'pittori, scultori, et architetti moderni* (Rome, 1672), 194–96; English translation in Cleveland/New Haven 1978, 11–24.

7. Inv. no. 11296 verso; Emiliani 1985, 231, fig. 476.

8. Inv. no. 35774; ibid., 231, fig. 477. Roseline Bacou, who discovered the cartoon, first noted that the Cleveland drawing was late in the preparatory process, after the cartoon (Paris 1974c, 19).

9. Also, in the drawing Barocci experimented with uncovering Creusa's left arm but reverted to the solution of the Louvre cartoon in the painting.

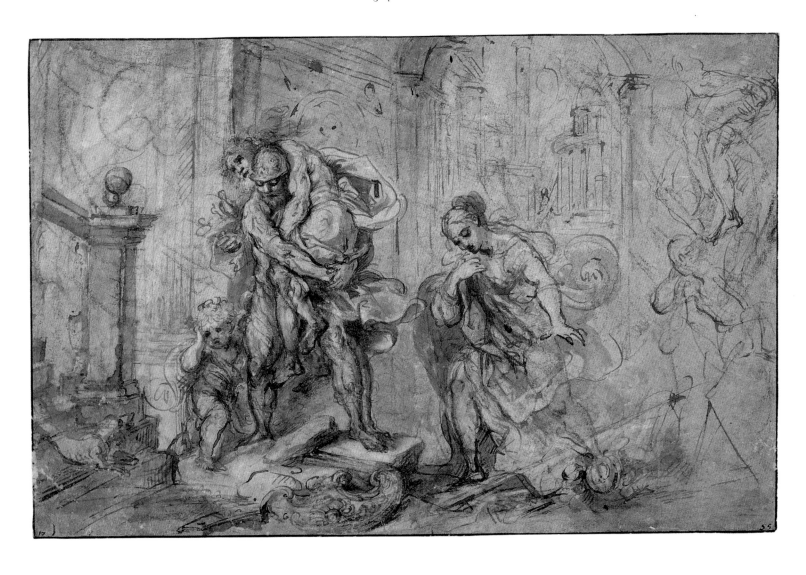

Pen and brown ink, brush and brown wash and yellow gouache heightened with traces of white, over black chalk, with stylus (banister), framing lines in brown ink, on gray-green laid paper, laid down on cream laid paper

277 x 426 mm (10⅞ x 16¾ in.)

WATERMARK: none visible through mount

INSCRIPTIONS: lower left, in brown ink: *17*; lower right in brown ink: [illegible]; lower right, in brown ink: *55*; verso of secondary support, center, in brown ink: *Intagliato da Agostino Caracci. Il quadro è in Casa Borghese.* [sideways]; upper right, in graphite: *2767* [circled]

L. E. Holden Fund 1960.26

The Risen Christ Adored by Saints and Angels relates to one of Giorgio Vasari's best documented commissions: his altarpieces for Santa Maria Novella, Florence.[1] In 1565 Duke Cosimo de'Medici had given Vasari the task of renovating the Florentine churches of Santa Croce and Santa Maria Novella to conform to the counter-reformatory requirements to make church liturgy more accessible to the congregation. Vasari noted the renovations in his *Vite* and specifically mentioned his painting of the Resurrection of Christ for Andrea Pasquali, the duke's physician.[2] Pasquali, a friend of Duke Cosimo, had subsidized Vasari's renovation of the Pasquali family chapel in Santa Maria Novella.[3] Designs for the Resurrection were made before 28 January 1567, when Vincenzo Borghini wrote to Vasari to counsel him on the iconography of a drawing for the altarpiece.[4] Borghini said that the drawing (now lost) pleased both him and Pasquali but that it did not accord with the scriptures because it failed to include the angel that appeared from heaven during an earthquake, opened the door to the tomb, and sat on the monument. He told Vasari that it was true soldiers had to be in the middle of the composition, but they distract from where our eyes focus when the Eucharist is raised and should be covered up a bit with the angel. Also, he advised Vasari to make a very finished drawing of the composition as the patron wished. The two extant drawings and the altarpiece show the requested change. The drawing in Lille (fig. 1) places the angel in the center as the nude figures fall and run from the miraculous sight. The style of this drawing suggests that the upper part with the Resurrection of Christ and angels was executed by Giovanni Battista Naldini, one of Vasari's assistants.[5]

Vasari took Borghini's advice and created a finished drawing (*modello*) to show his patron. That drawing, in Cleveland, is one of very few highly worked-up sheets that the artist created.[6] The drama of the white heightening against the colored paper would have given Pasquali an idea of the chiaroscuro effects Vasari wanted to achieve in the finished painting. The final Cleveland sheet and the earlier drawing are slightly different. The meaningless columns connecting the upper and lower portions of the composition have been eliminated, the soldiers in the center and babies are seen in different attitudes, and the figure of Christ[7] and his attendant angels have been finalized. Only minor adjustments occur between the modello and the altarpiece (fig. 2). In both, the Resurrection is witnessed by Sts. Cosmos and Damian at left and John the Baptist and Andrew at right.[8]

The altarpiece was finished by the end of 1568 when Vasari noted the receipt of payment.[9] In spite of Borghini's earlier letter noting his pleasure at what Vasari had drawn, in his book *Il Riposo* (1584) he criticized the picture for the inclusion of saints not present at the Resurrection.[10] Borghini was also correct to note the discrepancy in the sizes of the kneeling and standing saints. The entire composition of figures piled upon one another is indeed confusing, but at the same time the movement and twisting forms create a dynamic narrative. DDG

Fig. 1. Giorgio Vasari and Giovanni Battista Naldini. *Sketch for "Risen Christ Adored by Saints and Angels,"* pen and wash. Musée des Beaux-Arts, Lille, Collection Wicar, inv. no. 901.

Fig. 2. Giorgio Vasari. *Risen Christ Adored by Saints and Angels,* 1568, oil. Pasquali Chapel, Santa Maria Novella, Florence.

1. For a history and description of these commissions, see Hall 1979.

2. Vasari/Milanesi 1906, 7:709–13: "For the same church I painted a Resurrection of Christ in a similar framework as God inspired me. I did this for Messer Andrea Pasquali, the Duke's physician, and it pleased my dear friend very much." (p. 710, translation in Hall 1979, 5).

3. On the history of the chapel and Vasari's involvement, see Hall 1979, 111–14.

4. Quoted in ibid., 111–12.

5. On the attribution of this drawing, see ibid., 113, and Monbeig-Goguel/Vitzthum 1968, 93, under no. 14. The lower half probably came from a drawing by Vasari and was traced to this sheet by Naldini, who then added the upper zone. See also Alessandro Nova, "Salviati, Vasari, and the Reuse of Drawings in their Working Practice," *Master Drawings* 30 (1992), 83–108. Another drawing for the painting was recently identified (Sotheby's, London, 5 July 2000, lot 13).

6. Two similar modelli are known: in the Galleria Nazionale, Bologna (Hall 1979, pl. 37) and the Louvre, Paris (Monbeig-Goguel/Vitzthum 1968, 93, no. 15).

7. The figure of Christ is influenced by Bronzino's *Resurrection* in SS. Annunziata, Florence of 1549–52 (Hall 1979, pl. 100) as well as Michelangelo's Christ in the Sistine Chapel *Last Judgment* (ibid., 113), and possibly Michelangelo's sculpture of Bacchus (according to Patrick Cable, unpublished article in CMA files).

8. Sts. Cosmos and Damian were patron saints of medicine and the Medici, John the Baptist the patron saint of Florence, and Andrew, the name saint of the patron and physician Andrea Pasquali. The putti below hold a plaque with the inscription "Victime Paschal," referring to Christ as the paschal lamb and to the patron Pasquali. It has been said that the kneeling saint at left represents Pasquali (according to Biliotti, see Hall 1979, 113).

9. See ibid., 112.

10. Vincenzo Borghini, *Il Riposo* (Florence, 1584), 93–94.

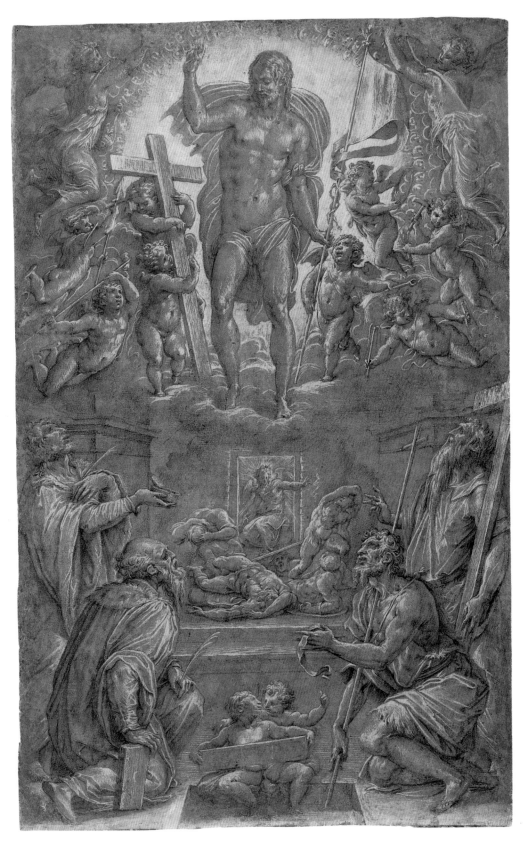

Point of brush and brown ink and black chalk with traces of stylus, heightened Cwith white, on yellow-brown laid paper

419 x 265 mm (16½ x 10⁷⁄₁₆ in.)

WATERMARK: none visible through mount

INSCRIPTIONS: by artist, lower center, in black chalk: [VICTIME] PAS[CHALI]; verso of secondary support, upper right, in brown ink: [illegible] *274*; center left, in brown ink: [5?] [illegible]

John L. Severance Fund 1991.43

Paolo Caliari, called Veronese

Verona 1528–Venice 1588

The multifaceted draftsmanship of Paolo Veronese has been clarified only in the past thirty years.[1] This study sheet, for example, was attributed to other Venetian artists, most notably Palma Giovane, until 1971 when David Rosand published the work as that of Veronese.[2] Dating of the sheet remains uncertain, however, ranging in opinion from 1555 to 1580.[3] Most recently, Roger Rearick used the architectural sketches showing through from the verso to date the sheet precisely to 1569.[4]

The sketches of the Virgin and child begin in the middle of the sheet with three iconographical variations. At left is the Madonna and child with St. John the Baptist; at right the two sketches depict the Flight into Egypt. The three sketches at left in the lower register are further ideas for a Madonna and child and relate to those above. Two standing Madonnas and child at lower right vary the subject further. The sketch at the top center is an elaboration of the donkey below, while at right is a half-kneeling female(?) supplicant.[5] Surprisingly, the three sketches in the middle register are not ideas for one picture but were developed in different paintings by Veronese and his shop and in three separate chiaroscuro drawings by the master. The Madonna with the child leaning toward St. John the Baptist (at left) is fully worked out in a chiaroscuro in Berlin;[6] a variation of the Rest on the Flight (at center) appears in a sheet in the British Museum;[7] and the family resting (at right) is found in a drawing in the Fogg Art Museum.[8] Paintings related to two of the compositions are found in Ottawa (National Gallery of Canada, considered autograph and datable to c. 1570)[9] and Atlanta (High Museum of Art, considered a studio production).[10] Rearick connected the architectural elements showing through from the verso with the 1569 painting of *Alexander and the Family of Darius* in the National Gallery, London.[11] The elements are close but by no means exact.

If the chiaroscuro drawings come from early in Veronese's career, as Richard Cocke suggested, then the Cleveland drawing, from which they derive, would necessarily also be early.[12] If, as Rosand and others suggested convincingly, the chiaroscuro drawings are later works by Veronese and the shop, one has to date the present sheet by other means. The *Various Sketches of the Madonna and Child* was rapidly drawn by the artist without a particular composition in mind, but rather to work out different attitudes and situations of the Madonna and child. Veronese could have looked back at the sheet at different times for poses when he wanted to work up a composition fully. The use of pen and ink and wash aided the artist's rapid exploration of forms. In this and in the mis-en-page of variations on a theme, the sheet is reminiscent of the practice of Parmigianino, whose drawings the young Veronese could have studied in the Muselli collection in Verona.[13] The style, however, does not accord with the carefully constructed early drawings that depend on hatching as well as wash for lighting[14] but is closer to the freely drawn wash and ink studies of Veronese's late maturity.[15] DDG

1. For a history of connoisseurship of Veronese's drawings, see Cocke 1984, 26–29.

2. Opinions of various scholars over the years in CMA files. Van Regteren Altena appears to have been the first to put forward Veronese's name. Because the drawing is the source for Veronese's chiaroscuro drawings, the attribution to Palma and others must be discarded.

3. Rosand 1971, c. 1580; Rearick in Washington 1988–89, 1569; Olszewski in Cleveland 1979a, 134–36; Pignatti 1976, 1580s; Cocke 1984, 1550s; Bettagno 1988, 1569.

4. In Washington 1988–89, 94, no. 46.

5. Related by Rearick (Washington 1988–89, 94, no. 46) to the painting, the *Mystic Marriage of St Catherine* (Musée des Beaux-Arts, Brussels; Rearick in Washington 1988–89, 90, fig. 32). The pose is not exact.

6. Inv. no. KDZ 1549 (Cocke 1984, 111, no. 38). The three chiaroscuro drawings and the paintings were connected with the Cleveland sheet first by Rosand 1971.

7. Inv. no. 1854-6-28-4 (Cocke 1984, 95, no. 28). The donkey is at left in the British Museum chiaroscuro.

8. Inv. no. 1928.681 (ibid., 96, no. 29).

9. Inv. no. 4268 (Rearick in Washington 1988–89, 98, fig. 34).

10. Inv. no. K.2151. Shapley 1973, 3: 43–44.

11. Inv. no. 294, Pignatti 1976, 132 no. 163, figs. 428–30.

12. The purpose of the chiaroscuro sheets is disputed. Cocke 1977, 259–56, suggested they were made as private experiments to be collected in a book. Rosand 1971, 206–7, saw them convincingly as part of a model/pattern book to show potential clients. Howard Coates (review of Cocke 1984 in *Master Drawings* 23–24 [Autumn 1985–86], 401) believed the sheets were *modelli* for paintings, each to gain patrons' approval. Luciana Larcher Crosato (review of Cocke 1984 in *Arte Veneta* 40 [1986], 252) also dated the chiaroscuro drawings early. Luisa Vertova (review of Cocke 1984 in *Apollo* 122 [July 1985], 75–77) dated the chiaroscuri late (and as related to edicts of the Council of Trent) and stated that comments on the back of the sheets are neither by Veronese nor the studio but by an early collector.

13. For works by Veronese in the Muselli collection, see Carlo Ridolfi, *Le maraviglie dell'arte*, ed. Deltev von Hadeln (Berlin, 1914), 1:320–21. For an inventory of 1662 of works in the collection, including numerous items by Parmigianino, see Giuseppe Campori, *Raccolta di cataloghi ed inventorii inediti* (1870), 175–92.

14. Compare, for example, the drawing for *Christ among the Doctors* of 1548 (Rosand 1971, 203, fig. 1).

15. See, for example, the drawing in Berlin (inv. no. KDZ 26 359) datable to c. 1584 (Cocke 1984, 272–73, no. 116) and one in Oxford of c. 1586 (inv. no. 0341; ibid., 274–75, no. 117) with similar use of dark, bold wash and a repeated use of rounded contour lines.

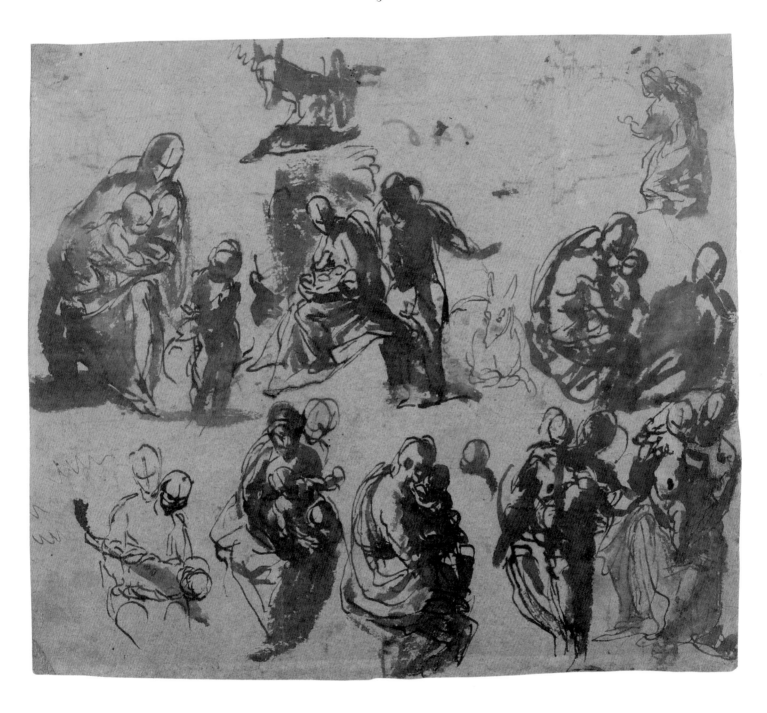

Architectural Studies (verso)
[partially visible on recto]

Pen and brown ink (iron gall)
and brush and brown wash, on
blue laid paper (discolored to
blue-green), laid down on blue
laid paper; verso, pen and brown
ink

205 x 234 mm (8¹/₁₆ x 9³/₁₆ in.)

WATERMARK: none visible
through mount

Gift of Robert Hays Gries
1939.670.a,b

Bologna 1560–Rome 1609

Hercules Resting is a study for the fresco of the same subject on the ceiling of the Camerino Farnese, Palazzo Farnese, Rome, painted between 1595–97 (fig. 1). The ceiling represents the virtue of Hercules, seen here resting after his twelve labors.[1] At the lower right is the head of the Erymanthian boar he captured; at his feet are the three golden apples he took from the garden of the Hesperides. Lightly sketched at right is a figure of the Sphinx from Thebes, birthplace of Hercules. In the fresco further evidence of Hercules' labors surround him: the dagger he holds, his club and bow and arrows, the hide of the Nemean lion, the three golden apples of the Hesperides, the head of the Arcadian stag, the three-headed dog Cerberus, and the snout of the Erymanthian boar. Hercules contemplates the sphinx, whose inscription translates "Toil is the bringer of sweet rest." Squaring at right on the drawing suggests that the composition was transferred to the badly damaged cartoon, now in the Uffizi.[2] The cartoon may not have been used, as the fresco represents the composition in reverse of the drawing and also reflects a rethinking of the subject, which there shows Hercules in a position with his upper body twisted, contemplating a sphinx who faces him.

This sheet, the final compositional drawing known for the fresco (other than the cartoon), is one of the most important studies connected with the ceiling.[3] The initial pose of Hercules (in the Cleveland drawing and the Uffizi cartoon) depends on that of Adam on the Sistine Chapel ceiling,[4] which in turn recalls the Belvedere Torso.[5] However, the pose is very close to two river gods in the Farnese collection whose raised legs and twisting torsos Hercules' figure imitates, suggesting that these were also primary sources for the artist. Annibale was impressed, too, by a gem of Hercules Resting owned by Fulvio Orsini.[6]

The artist further developed his idea for the Hercules by continuing to look at ancient sculpture in the Farnese household and in other Roman collections. The exaggerated musculature of the hero in the drawing and the curly beard and hair in the fresco rely on Roman sculptures of Hercules, such as the *Farnese Hercules* and the *Hercules Resting* in the Villa Borghese.[7] Another, recently discovered drawing of Hercules, which precedes the penultimate solution in Cleveland, indicates that the artist studied the statue of the river god Tiber, which was then located in the Belvedere courtyard.[8] What could be seen as a kind of mannerist overindulgence in the musculature of the figures in the drawings for the Camerino is instead a result of Annibale's intense study of his Roman sources. Annibale made a conscious and consistent effort to compare his artful, painted figures to known sculpture, mostly in the Farnese collection.

The drawing in Cleveland has been laid down, but a photograph taken of the verso before this intervention reveals a black chalk study of a footed vessel with a handle, which has not yet been connected with a painting but appears to be a thought for the decorative grisaille decoration of the Camerino. Whereas the recto of the drawing emphasizes the antique sculpture Annibale saw around him, the verso recalls the basis of his drawing technique in the softened contours of his early idol, Correggio, whose influence can be seen in other drawings for the Camerino. DDG

Fig. 1. Annibale Carracci. *Hercules Resting*, 1595–97, fresco. Palazzo Farnese, Rome.

1. As John Rupert Martin pointed out in *The Farnese Gallery* (Princeton, 1965, 27–30), Hercules resting after his labors represents the active life, whereas Hercules bearing the globe reflects the contemplative life of a man seeking wisdom, symbolized by the globe.

2. Inv. no. 96777. Donald Posner, *Annibale Carracci. A Study in the Reform of Italian Painting around 1600* (London, 1971), 2:pl. 92e.

3. Martin, *Farnese Gallery*, no. 19 and fig. 121, considered a drawing in the Louvre (inv. no. 7404) to be a study for Hercules' left leg as seen in the fresco. It is, however, in reverse of the Cleveland drawing but its position is closer to that of the drawing than to the reversed finished fresco, where the leg is more upright. This suggests that it is not, in fact, connected with this work. It is drawn from the model and probably would not have been done at this late date in the compositional thinking. An early study for the sphinx, in the Fitzwilliam Museum, Cambridge, was published by Michael Jaffe: "A Drawing by Annibale in the Fitzwilliam," *Burlington Magazine* 127 (November 1985), 776.

4. According to Martin, *Farnese Gallery*, 184.

5. Bober/Rubinstein 1986, no. 13.

6. Martin, *Farnese Gallery*, 184, pl. 278. In the gem and in Annibale's drawing, Hercules, with hand to head, contemplates the sphinx, whose back is to him. The head of the Erymanthian boar, the golden apples of the Hesperides, and Hercules' club diagonally placed behind the sphinx are the same in each, except that the gem is in reverse of the drawing.

7. For *Hercules Resting*, see Bober/Rubenstein 1986, no. 130. In 1556 this sculpture was in the *vigna* of Cardinal Ridolfo Pio da Carpi. For the Farnese Hercules, see Bertrand Jestaz, François Fossier, and François-Charles Uginet, *Le Palais Farnese* (Rome, 1981), 2:pl. 132.

8. Thomas Williams, Ltd., London; Sotheby's, New York, 28 January 1998, lot. 18 (repr.); black chalk, heightened with white on blue paper; 258 x 396 mm. See also Washington 1999–2000, 136, fig. 2. For the sculpture, see Bober/Rubenstein 1986, no. 66. Annibale manipulated the left leg and right arm slightly, replaced the rudder with Hercules' club, and supplanted the long, unruly beard with the short neat beard common to Hercules.

Footed Vessel with Handle
(verso) [known in photographs]

Black chalk heightened with
white, squared in black chalk on
right, incised (edges of figure),
on blue paper (faded to brown-
green), laid down on beige laid
paper; verso, black chalk

355 x 524 mm (13¹⁵⁄₁₆ x 20⅝ in.)

WATERMARK: center: letter M in
shield

Leonard C. Hanna Jr. Fund
1997.52.a,b

Giovanni Francesco Barbieri, called Guercino

Cento 1591–Bologna 1666

From the time of its discovery, *Venus and Cupid* has been considered one of Guercino's most important early drawings. The rapidity and sureness of the pen lines, the variegation of the washes, the sharp contrasts of bright light and dark shadows, and the beauty of the nude forms seen from below mark it as a paradigm of the artist's exuberant high baroque style. Once thought to be a study for his masterpiece *Aurora* (1621) in the Casino Ludovisi, Rome, Sir Denis Mahon connected it with the artist's early frescoes (1615–17) in the Casa Pannini, Cento.[1] The frescoes, now detached and mostly in the Pinacoteca Civica, Cento, consisted of various friezes and pictures of landscapes, allegories, and mythological and genre scenes.[2]

There were two frescoed scenes on the stairway of the Casa Pannini to which the Cleveland drawing relates— *Apollo* and *Diana*—but Ann Tzeutschler Lurie showed that it is closest to the fresco of *Diana* (fig. 1).[3] Lurie noted two small pen sketches in the clouds at the lower edge of the sheet, one of which is a half-length female nude that corresponds exactly with Diana's pose in the fresco.[4] Unlike the large form of Venus with her arm pulled back, the smaller figure leans her arm on the chariot while turning her head to look behind. In addition, the depiction of the wheel and the chariot base are similar in both drawing and fresco. Guercino habitually drew his compositions in various formats, often in reverse, and changed the inclusion of various protagonists and characters frequently. Evidently, Guercino first considered the figure of Venus on a chariot facing right (as in the fresco of *Apollo* executed by Lorenzo Gennari), but with the sketches at bottom he rethought the pose to face the other direction. That Diana, not Venus, appears in the final picture is probably due, as Mahon pointed out, to a revision of the placement of the mythological figures in the program.[5] Venus appears, nursing Cupid, in a scene on the fireplace of the Camera della Venere (one drawing connected with the figures shows them also in reverse of the final picture).[6] Above the reclining Venus is Mars in a chariot, much like those for Apollo and Diana. In light of Guercino's preparatory methods that were nonlinear in direction, the artist was probably working simultaneously on different ideas and compositional formats for the picture and subject placements in the program.

The similarity of *Venus and Cupid* to *Aurora* is often remarked. The connection is one of format rather than style. In fact, Guercino returned again to a figure in a chariot seen from below in his ceiling fresco with Rinaldo and Armida in the Palazzo Costaguti (1621–23). Guercino abandoned the high-spirited virtuosity of the Cleveland drawing in his studies for *Aurora*, mostly in chalk, and in other drawings of the 1620s, which became more restrained in movement. While painting *Aurora*, however, he may have had this drawing in his working portfolio and referred to it as he conceived the energetic motion of the goddess of dawn racing across the skies.

A copy of this drawing attributed to Francesco Bartolozzi sold at Christie's in 1998.[7] DDG

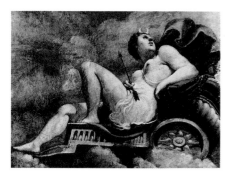

Fig. 1. Guercino. *Diana*, 1615–17, fresco. Formerly Casa Pannini, Cento.

1. Letter to Henry Francis (17 September 1951), CMA files.

2. For reproductions of the frescoes, see Roli 1968, 57–97, and Bagni 1984.

3. Lurie 1963.

4. Ibid., 221, also noted the doves at the lower right, which were considered for the task of leading Venus's chariot.

5. Bologna 1969, 48.

6. Bagni 1984, 147, no. 117.

7. Christie's, South Kensington, 21 April 1998, lot 115.

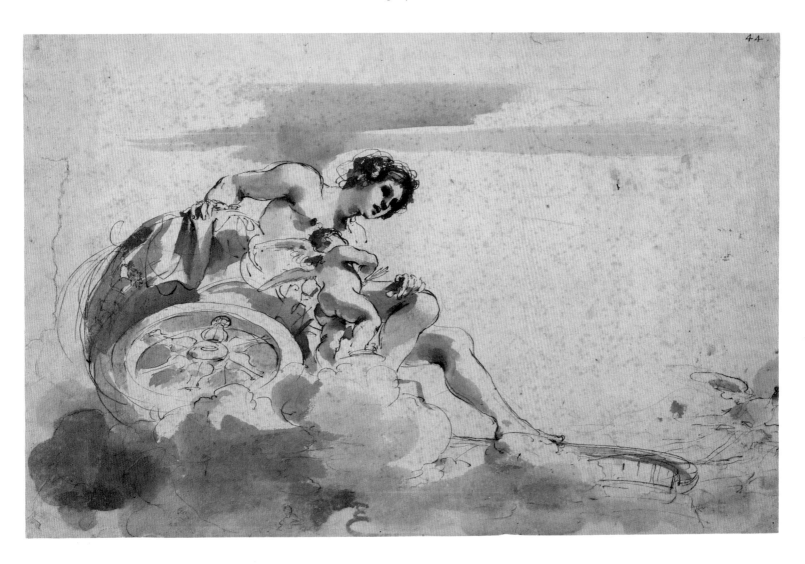

Pen and brown ink and brush
and brown wash over red chalk,
on cream laid paper

255 x 394 mm (10 x 15½ in.)

WATERMARK: upper center:
mountains (similar to Briquet
11938 [Lucques 1582], a variant
in Rome 1591–92)

INSCRIPTIONS: Upper right, in
brown ink: *44*

Dudley P. Allen Fund 1925.1188

Pietro Berrettini, called Pietro da Cortona

Cortona 1596–Rome 1669

One of Cortona's earliest commissions in Rome, the frescoes with the story of Solomon in the gallery of the Palazzo Mattei di Giove[1] were executed when he was already twenty-seven years old. The *Meeting of Solomon and the Queen of Sheba* and the *Idolatry of Solomon* take up the two main *quadri riportati* on the ceiling, while four hexagonal pictures represent *Solomon's Anointment as King, Solomon's Marriage to Pharaoh's Daughter, The Death of Joab*, and *Solomon Thanks God for the Gift of Wisdom*.[2] Eight lunettes represent Mattei castles and other properties. The decorative surrounding elements were executed by Pietro Paolo Bonzi (c. 1576–1636), who introduced his countryman Cortona to the patron Asdrubale Mattei (1556–1638). Asdrubale hired Cortona to paint the bronze medallions but admired his work enough to give him the commission for the primary paintings on the vault. The frescoes, although painted between June 1622 and December 1623, may make reference to Asdrubale's marriage of thirty years before to his second wife, Costanza Gonzaga (1594), or to that of his sister-in-law Eleonora Gonzaga to the Holy Roman Emperor Ferdinand II (1622).[3] The Gallery, adapted to show works of art, contained numerous easel paintings with religious subjects—two painted by Cortona—that accorded with the biblical subjects of the ceiling, which were specified by Asdrubale. The ceiling paintings represent the Old Testament figure of Solomon as both the wisest (his affinity with God) and most foolish (his profligacy and idolatry) of men.

Asdrubale Mattei, like many other Roman aristocrats, was a collector of Roman antiquities. Pietro da Cortona, like many other artists in Rome, was an ardent student of the antique. Cassiano dal Pozzo, the erudite antiquarian and collector, a friend of the artist who commissioned drawings after the antique from Cortona and others for his Museo Cartaceo (paper museum of drawings after antique artifacts), encouraged Cortona's antiquarian interest. These mutual interests found a happy confluence in the Solomon frescoes for Mattei. Here Cortona combined a strict classical relief-like composition with numerous specific references to Roman objects and architectural elements he would have been studying and drawing. The *Idolatry of Solomon* represents Solomon's worship of idols caused by his love of many strange women who turned "away his heart to follow their gods" (Kings 3:11). In the drawing for the fresco, the artist carefully indicated the correct perspective of the marble floor and the proportions of columns and pilasters at rear. The urns carried by the women may also have been known to Cortona in Roman examples. At the same time he referred to sixteenth- and seventeenth-century examples of the subjects he was painting: Polidoro da Caravaggio's painted facades, Raphael's Vatican Loggia frescoes, Cristofano Roncalli's and Domenichino's drawings of the same Solomon subjects, as well as an engraving by Philip Galle.[4]

The Cleveland drawing, with its highly worked-up and colorful media is typical of Pietro's finished preparatory sheets and differs little from the final composition (fig. 1) in which much of the landscape is eliminated in favor of a dramatic receding temple, boughs of leaves definitively close off the top of the scene, and the entire composition is more tightly compacted and brought forward.[5] This is the only extant sheet for the *Idolatry of Solomon*. Three drawings are known for the *Meeting of Solomon and the Queen of Sheba*—a study for Solomon in Düsseldorf and two finished compositional drawings, in the Teylers Museum, Haarlem, and the Pierpont Morgan Library, New York.[6] DDG

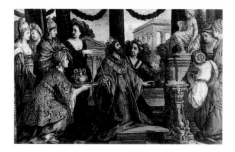

Fig. 1. Pietro da Cortona. *The Idolatry of Solomon*, 1622–23, fresco. Palazzo Mattei, Rome.

1. For a history of the Palazzo Mattei and Cortona's commission, see Francesca Cappelletti and Laura Testa, *Il trattenimento di Virtuosi. Le collezioni secentesche di quadri nei Palazzi Mattei di Roma* (Rome, 1994), 53–72, and Merz 1991, 51–75.

2. Of the four hexagonal pictures, only two, *The Death of Joab* and *Solomon Thanks God for the Gift of Wisdom*, are by Cortona.

3. Cappelletti/Testa, *Il trattenimento di Virtuosi*, 58. Michael Miller in an unpublished, undated lecture (copy in CMA files) suggested that the marriage of Eleonora Gonzaga and Ferdinand II rationalized the subject matter of the Gallery.

4. Merz 1991, 72 noted the influence of Polidoro's Palazzo Milesi reliefs. In his unpublished lecture Miller first noted the influences of Raphael, Domenichino, Roncalli, and Galle.

5. The figure of an older bearded god in the drawing has been changed to a youthful Apollo with a lyre in the fresco. The columns are simplified and their bases hidden, one wife is eliminated at left, and the tall urn has been replaced with a tripod brazier.

6. Düsseldorf inv. no. F.P. 524. Haarlem inv. no. E.53. New York inv. no. 1975.33. Merz 1991, figs. 100, 103–4.

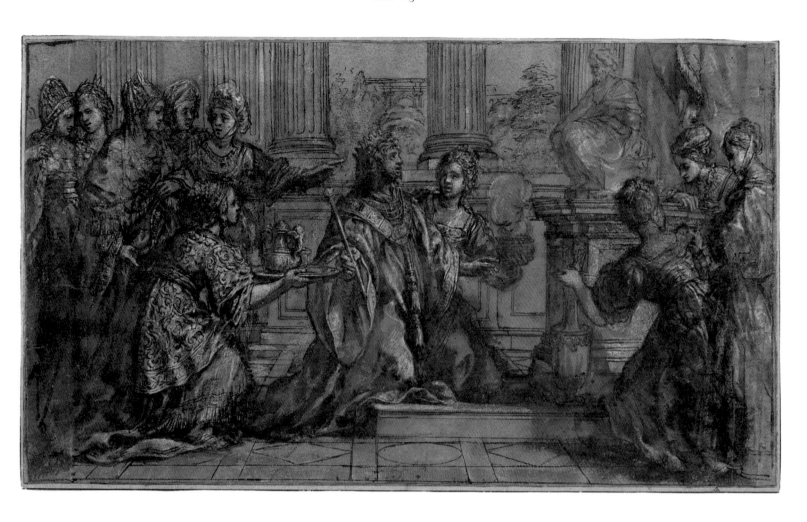

Pen and brown ink, point of brush and black ink, brush and brown wash, and white and blue gouache, framing lines in brown ink, on brown laid paper, laid down on cream laid paper

248 x 434 mm (9¾ x 17 in.)

WATERMARK: none visible through mount

INSCRIPTIONS: verso of secondary support, upper center, in graphite: *44*; center, in blue ballpoint: *Maria* [Shisa?] [Alia ?] [??udy] *di Bernasconi* [underlined] / *1977* [all upside down]; center, in graphite: *Paolo Farinato*; center,

in graphite: [illegible]; lower left, in graphite: [illegible, partially masked]

John L. Severance Fund 1987.142

Pietro Berrettini, called Pietro da Cortona

Cortona 1596–Rome 1669

Pietro da Cortona's frescoes in the Chiesa Nuova (Santa Maria in Vallicella), Rome, constitute one of the few baroque painted cycles conceived and completed by a single artist. In 1625 Padre Giuliano Giustiniani, the head of the Oratory of San Filippo Neri, proposed the decoration of the church, which was begun in 1621. The sacristy, where Cortona began work, was constructed between 1629 and 1632.[1] Although the artist was not the Oratorians' first choice to decorate their church,[2] their evident satisfaction with the ceiling fresco in the sacristy, *St. Michael and Angels with the Instruments of the Passion* (fig. 1), for which Cortona was paid 250 scudi, secured him all further commissions for the church. By his death Cortona had completed not only the sacristy vault but the chapel of the stanze di San Filippo (*St. Philip Neri in Ecstasy*, after April 1636), the frescoes in the dome and apse (*Trinity in Glory*, 1647–52; *Assumption of the Virgin*, 1655–60), the pendentives of the dome (with the four Old Testament prophets, 1659–60), and the nave vault (*Vision of St. Philip Neri*, 1664–65).

The composition of *St. Michael and Angels with the Instruments of the Passion* takes advantage of its position in the sacristy. St. Michael presents the cross of the Crucifixion while surrounding angels carry the other instruments of the Passion: the nails, reed, hammer, robe, crown of thorns, lance and sponge, scourge, column, and the veil of Veronica. The archangel looks down and flies toward the altar where a statue of St. Philip Neri by Alessandro Algardi was placed in 1635.[3] The theme of the angel with the instruments of the Passion had already been popularized in the church of the Gesù by Gaspare Celio in 1596, which may have influenced Cortona, as had Guercino's fresco *Fame* (1623) in the Casino Ludovisi.[4]

This drawing of St. Michael's head must have been a final study, for the saint's tender expression and the position of his head are the same in drawing and fresco. Executed in Cortona's typical black chalk medium, the sheet is the only known preparatory drawing for the fresco. It was formerly attributed to the Florentine Giovanni Francesco Romanelli before Francis Russell identified it as a study for the Chiesa Nuova sacristy. Considered Raphaelesque and Florentine in style,[5] based on the emphasis on contour and fine detail typical of Raphael's graphic works, the Cleveland sheet also exhibits the softened chalk style (sfumato) and sweet expression characteristic of Correggio's drawings. If Cortona did not know Correggio's frescoes in Parma directly, he would have known the artist's painting and drawing style through his Emilian followers, such as Annibale Carracci and Giovanni Lanfranco, who were active in Rome in the late sixteenth and early seventeenth centuries. In fact, the head of St. Michael is comparable in technique and style to Annibale's drawings for the Camerino Farnese in the Palazzo Farnese in Rome.[6] DDG

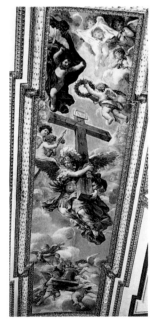

Fig. 1. Pietro da Cortona. *St. Michael and Angels with the Instruments of the Passion*, 1633, fresco. Sacristy, Chiesa Nuova, Rome.

1. For a history of the artist's connection with the Oratorians and the Chiesa Nuova, see Merz 1991, 233–34, and Merz 1994, 37–76. For the building of the Oratory of the Chiesa Nuova, see Joseph Connors, *Borromini and the Roman Oratory* (Cambridge, Mass./London, 1980).

2. Possibly Cortona's patron Cardinal Francesco Barberini secured him the commission (Merz 1994, 38).

3. Jennifer Montagu, *Alessandro Algardi* (New Haven, 1985), 2:380–81, no. 75, figs. 47–49.

4. As noted by Merz 1991, 234.

5. Merz 1994, 38.

6. For Annibale Carracci's drawings, see Washington 1999–2000, nos. 27, 35–36.

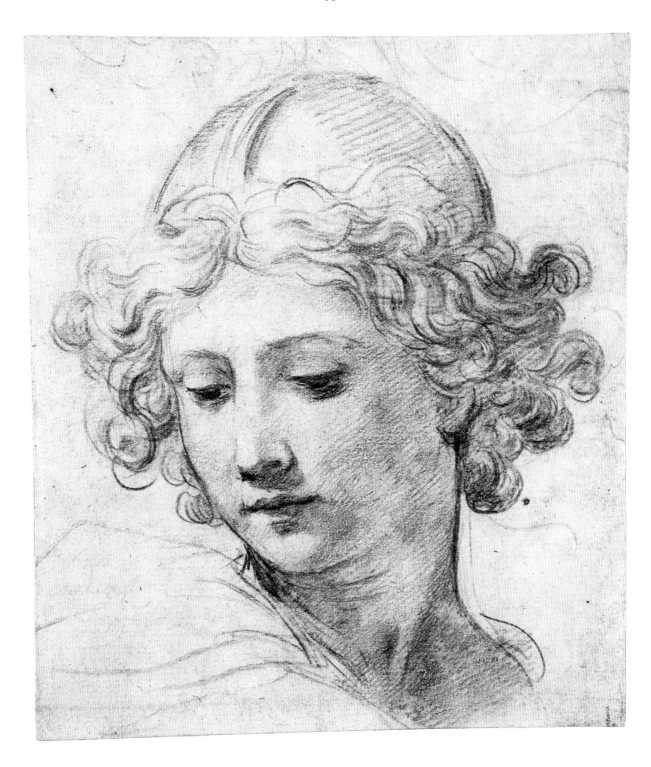

Black chalk on beige laid paper,
perimeter mounted to cream
laid paper

190 x 168 mm (7⁷⁄₁₆ x 6⁹⁄₁₆ in.)

Leonard C. Hanna Jr. Fund
1996.257

Domenico Zampieri, called Domenichino

Bologna 1581–Naples 1641

The Roman biographer Gian Pietro Bellori described the figures and iconography of the cupola pendentives that Domenichino painted in San Carlo ai Catinari, Rome, between 1628 and 1630.[1] In this church, dedicated to St. Charles Borromeo, Domenichino depicted the four cardinal virtues: Justice, Prudence, Temperance, and Fortitude. The figure of Temperance (fig. 1) is represented by a woman seated on a cloud, painted in profile, holding a palm branch in her left hand and presenting a bridle to a flying putto. At her feet is a kneeling camel, and behind her two putti pour water from one vase into another half-filled with wine. Below, Virginity, a companion of Temperance, holds a unicorn. Temperance with the bridle signifies the will to restrain ourselves; the palm is the sign of victory over appetites; the putti pouring water into wine suggest the virtue of restraint within temperance; the camel, who can survive for long periods without drinking, is a sign of the temperate soul. The camel, bridle, and unicorn were the emblems of St. Charles Borromeo. Domenichino did not conceive his iconography independently but based the attributes of Temperance on Cesare Ripa's various descriptions of this virtue.[2]

The commission for the pendentives was originally to have gone to the little-known Giacomo Semenza, but when Cardinal Giovanni Battista Lenzi, the church's benefactor, died in 1627, his executor Cardinal Scipione Borghese took over and handed the commission to Domenichino. The artist prepared the pendentives carefully with many drawings: several are as large and squared as this one;[3] others are individual figure studies.[4]

These large drawings would then have been transferred to cartoons, now lost. There are nine drawings for the pendentive of Temperance, more than for any other virtue. In spite of his care in preparing this, his last, pendentive, Domenichino did not finish it. He left for Naples in 1630 and the painting was completed, probably after his death, by a pupil, Francesco Cozza.

The drawing is made up of three large pieces of paper, indicating that Domenichino continued to change his mind and the figures as he was working. There are two camels and no bridle in the preparatory drawing, and the putti at right are not fully conceived. Of the nine single figure studies at Windsor Castle, five are of the Virgin, whom Domenichino at first envisioned as seated on a cloud. He elongated her pose in several of the drawings and in the Cleveland sheet. The figure of Temperance, studied in three of the Windsor drawings, is also more relaxed in the present sheet. All the drawings are executed with black chalk and white heightening on paper that was once blue but has faded to gray. The sheets were made to study not only the poses and their movement but the fall of light on the figures. One for the figure of Temperance is squared and seems to have been the drawing transferred to the Cleveland sheet. Although this drawing and its preceding studies exemplify Domenichino's careful preparation in analyzing all elements of a composition in detail, the strange disconnectedness of the figures of Temperance and Virginity reflect his additive working method of studying various parts of a composition separately before joining them together.

DDG

Fig. 1. Domenichino. *Temperance*, 1628–30, fresco. Chiesa di San Carlo ai Catinari, Rome.

1. Gian Pietro Bellori, *Le vite de' pittori, scultori, et architetti moderni* (Rome, 1672), 329–33.

2. Cesare Ripa, *Iconologia* (Siena, 1622), 295–97.

3. Two in the Ashmolean (for Justice and Fortitude) are of the size and type as the Cleveland drawing but less well preserved. See Macandrew 1980, 105–6, 842B, and 842C.

4. They are in Windsor Castle, inv. nos. 431, 443, 456, 499, 501, 502, 503, 504, 505. See Sir John Pope-Hennessy, *The Drawings of Domenichino in the Collection of His Majesty the King at Windsor* (London, 1948), 80, nos. 869–77.

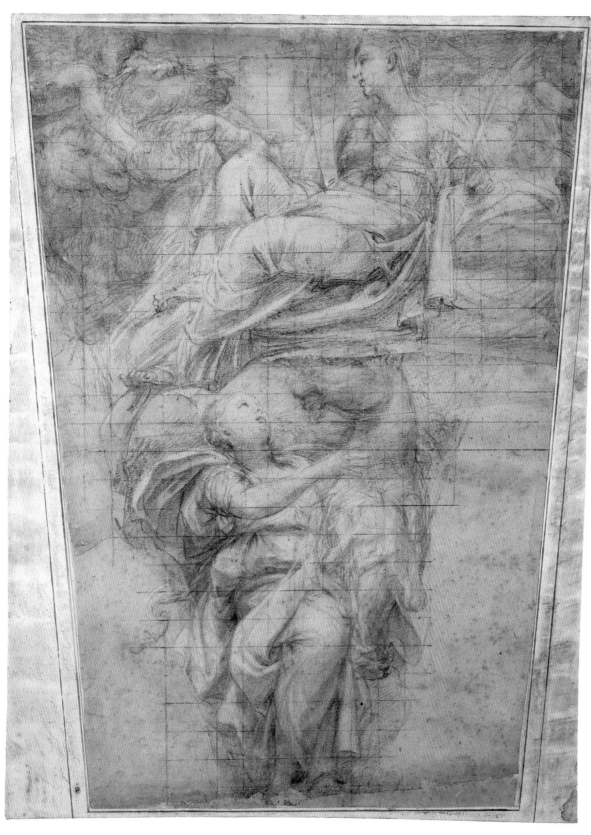

Black chalk heightened with white chalk, squared with black chalk, on four sheets (joined) of light gray laid paper, laid down on cream laid paper, perimeter mounted to a tertiary support of laid paper

592 x 437 mm (23⁵/₁₆ x 17³/₁₆ in.)

INSCRIPTIONS: verso of secondary support, lower left, in graphite: *I. 1081* [circled]; lower center, in graphite: ? [Pelio?] [Candio?]; lower center, in graphite: *204.*; lower center, in graphite: *From the coll of Lord Barrymore*; verso of secondary and tertiary supports, lower right, in graphite: *Carlone (Carlo) Scaria 1686–1776 / Design for a Sculpture / Black Crayon*; verso of tertiary support, lower right, in graphite: [illegible]

Dudley P. Allen Fund 1964.445

Bernardo Strozzi

Genoa 1581?–Venice 1644

Of the few drawings by Strozzi that exist, most are studies of heads, legs, arms, hands, feet, and drapery. Fully worked-up preparatory studies in chalk such as *Allegorical Figure* are especially infrequent in his oeuvre.[1] Thus, this drawing has been published numerous times and praised as one of the artist's most beautiful graphic works. The sheet is dated by comparison with the painting, also in the Cleveland Museum of Art (fig. 1), for which it is a study. Typical of Strozzi's naturalism, three-dimensionality of forms, and vibrant colorism, *Allegorical Figure* is close stylistically to many works of the artist's Venetian period in the mid 1630s, such as the *St. Sebastian* (San Benedetto, Venice) and *David with the Head of Goliath* (Cincinnati Museum of Fine Arts), datable to the 1630s.[2] The single-figure female subject is comparable to the *Allegory of Painting* (private collection, Genoa) also of the mid 1630s.[3] In the drawing the figure is fully completed, while there are indications in the background for the broken arch, armor, shield, and plumage of the helmet. The use of red and black chalk, also typical of Strozzi in his Venetian period, gives the figure the voluptuousness and physicality seen in the painting. Typical, too, are the pudgy hands with pointed fingers, the frizzy hair, and the bulbous, flaccid flesh of arms and legs. The upward gaze appears in many of Strozzi's religious and mythological works.

The subject of the painting and drawing has not been determined satisfactorily. A seated woman, one breast bared, holds a helmet in one hand and a shield in the other. In the drawing, at left, above the helmet, are some sketches that probably indicate the colorful plumage seen in the painting. Flowers on the woman's head and at her waist appear in the painting but are absent in the drawing. The figure has been described variously as Minerva, Bellona, and Thetis. Although Minerva, the goddess of wisdom, seems to have been the preferred identification, in most representations this goddess wears armor (with the Medusa's head on the shield), and nowhere does one see her adorned with flowers. Neither would flowers be expected for Bellona, the Roman goddess of war. The recent identification as Thetis, the mother of Achilles,[4] depends on the story that during the Trojan war Thetis asked Vulcan to make a set of armor to replace that lost by her son. As a favor Vulcan fashioned an elaborate set, which included a crested helmet, a shining breastplate, and a large shield decorated with elaborate pictures.[5] The softness of the flesh, the bared breast, and the lack of an aggressive air would argue for such a reading, but the lack of a detailed descriptive shield could argue against it. Alternative identifications could include Venus, the goddess of love, wife of Vulcan, and lover of Mars, the god of war; or Peace, who, festooned with flowers, holds the armor of war as decorative rather than bellicose objects. Lack of specific attributes, however, makes any such identification tentative.

Michael Milkovich compared the drawing to a head of a woman (formerly in the Manning collection, now Jack S. Blanton Museum of Art, Austin) as executed in the same manner and contemporaneously.[6] Also similar in style is a sheet in the Louvre of the head of a woman.[7] There is a study for Minerva's foot in the Musée des Beaux-Arts, Rouen.[8] DDG

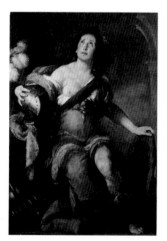

Fig. 1. Bernardo Strozzi. *Allegorical Figure*, c. 1635, oil. The Cleveland Museum of Art, Gift of the Friends of the Cleveland Museum of Art 1929.133.

1. On Strozzi's drawings, see Newcome 1993 and Mortari 1995.

2. Mortari 1995, nos. 508, 490.

3. Ibid., 200, no. 528 (repr.).

4. Chong 1993, 229.

5. Joaneath Spicer, Peter Lukehart, Martha Lucy, *Bernardo Strozzi: Master Painter of the Italian Baroque (1581/2–1644)*, exh. cat., Walters Art Gallery (Baltimore, 1995), no. 25.

6. Inv. no. 532-1999; Mortari 1995, 235, no. 53 (repr.).

7. Inv. no. R.F. 818; Mortari 1995, 239, no. 61 (repr.).

8. Inv. no. 975-4-5380, red chalk, 170 x 152 mm; Genoa 1995, 304 (repr.).

Black chalk with red chalk, on
beige laid paper

373 x 262 mm (14¹¹/₁₆ x 10⁵/₁₆ in.)

INSCRIPTIONS: lower left, in
brown ink: *Prete Genovese*;
verso, lower center, in brown
ink: *P.G. r: 35.*

John L. Severance Fund
1953.626

Giovanna Garzoni

Ascoli Piceno 1600–Rome 1670

The artistic personality of Giovanna Garzoni has come to light only recently, mainly from the research of Mina Gregori, who attributed works to her that were languishing under the label "anonymous Florentine," and of Gerardo Casale, who traced her origins and influences.[1] Trained in Venice, Garzoni became known as a portraitist in miniature. After working in Rome, Naples (1630–31), Turin (1632–37), and probably France and England (1638–41?), she was documented at the Medici court in Florence (1647–49) before she settled again in Rome (by 1654). By the time of her death, her fame rested on her naturalistic portrayals of still lifes.[2] Those pictures on vellum of fruit, flowers, and small animals and birds combine a penchant for detail, which relies on northern artists like Jan Brueghel the Elder and Ambrosius Bosschaert, and an interest in scientific inquiry, based on that of Jacopo Ligozzi. Garzoni would have seen works by Brueghel and other northerners on her sojourns in Turin and beyond the Alps, and she certainly knew Ligozzi's botanical and zoological studies for the Medici.[3]

While *Still Life with Fruit and Birds* relies on the experiments of both Ligozzi and the northern still-life painters, it is characteristic of Garzoni's peculiar blend of detail and decorative placement of forms in a unifying atmosphere. Garzoni's fruit and birds are recognizable to a naturalist but are disposed across a plane to give them a semblance of life. Spread on a brown bumpy ground that simulates dirt are three small goldfinches on fruit branches and a larger bee-eater.[4] The goldfinches sit on branches with two plums (left), a peach (center), and a pear (right). In the left foreground are a yellow quince and purple fig. All are represented according to rules from natural science: the goldfinches are studied from three different viewpoints, and leaves are placed on the branches to help identify the fruit. Garzoni's watercolor is neither purely scientific in nature, although the study of the individual forms appears to depend on specimens, nor does it depict a realistic setting in nature.[5] It is characteristic of her incorrect perspective and high viewpoint in which forms are out of scale with one another and their simple setting. Yet, her employment of a stipple technique on vellum, particular to miniaturists, unifies the disparate elements and gives them the hazy atmosphere and tonal warmth unique to her still lifes.

From the 1640s until her death, Garzoni's still lifes did not change radically in style, but it is possible to distinguish the *Still Life with Fruit and Birds* as close to one she produced for Leopoldo de'Medici. In the 1692 inventory of his heirs there is an entry for a "painting on parchment 5/6 high, 2/3 wide—in miniature, four birds who are each placed on a fruit branch, that is, peaches, plums, cherries, and muscat pears by the hand of Giovanna Garzoni."[6] The watercolor may have been made during Garzoni's stay in Florence in the late 1640s or have been sent from Rome later. Her relationship with the Medici remained active until the end of her life.

A number of Garzoni's still lifes were made in pairs or in a series, but no pendant for the Cleveland picture can be identified. DDG

1. In Naples et al. 1964–65, 27–28. Gregori identified works by Garzoni from Medici inventories; see Casale 1991, 14–32, and Gerardo Casale, *Gli Incanti dell' Iride: Giovanna Garzoni pittrice nel Seicento* (Cinisello Balsamo, 1996), 13–23.

2. Lione Pascoli, *Vite de' Pittori, Scultori, ed Architetti Moderni* (1736), 2:451, noted that she was admired for her works in several cities and became rich from her work. For an analysis of her interest in still life, strengthened by her time at the court of Savoy in Turin and her undocumented trip beyond the Alps, see Casale, *Gli Incanti dell' Iride*, 18–19.

3. For recent studies of Brueghel and Bosschaert see Alan Chong and Wouter Kloek, *Still Life Paintings from the Netherlands 1550–1720*, exh. cat., Rijksmuseum, Amsterdam, and Cleveland Museum of Art (1999). For Ligozzi plant studies, see Lucia Tongiorgi Tomasi, *Intratti di piaste di Jacopo Ligozzi Ospre deletto* (Pisa, 1993). The Cleveland watercolor was attributed to Ligozzi before Mina Gregori (in Naples et al. 1964–65, 28, under nos. 14–17) recognized it as by Garzoni.

4. Todd Herman has identified the birds and fruit in this picture.

5. On Garzoni's place in history between a fantastic vision of nature and scientific inquiry, see Casale 1991, 47.

6. "Un quadro in Cartapecona alto 5/6 largo 2/3 miniatov quattro uccelli che posano ciasceo di essi sopra un ramo di frutti, cioè Pesche susine, ciliege e pere moscadille di mano della Giovanna Garzoni" as transcribed in Casale 1991, 244. As suggested by Gregori in Naples et al. 1964–65 and noted by Casale 1991, 90, no. 35.

Watercolor with graphite,
heightened with lead white, on
vellum

257 x 416 mm (10⅛ x 16⅜ in.)

Bequest of Mrs. Elma M.
Schniewind in memory of her
parents, Mr. and Mrs. Frank
Geib 1955.140

Giovanni Battista (Giambattista) Piazzetta

Venice 1682–1754

In 1723 Giovanni Battista Piazzetta received the most prestigious religious commission of his career, the ceiling painting with the Glory of St. Dominic for the eponymous chapel in the church of SS. Giovanni e Paolo in Venice (fig. 1). His competitors for the ceiling included the young Giovanni Battista Tiepolo,[1] whose early work was influenced by Piazzetta, and the little-known Mattia Bortolini. When completed in 1727, the ceiling—with its central painting in oil and surrounding grisaille ovals with the virtues of Justice, Fortitude, Forbearance, and Authority—was a successful and innovative departure from the tradition of Venetian wooden coffered ceiling and fresco decorations.[2] The painting instead depended on the bold, realistic forms and illusionistic perspective found on religious and secular ceilings in Bologna, where Piazzetta had studied from 1701 to 1705. Piazzetta would have known similar ceiling paintings in Bologna by Giovanni Antonio Burrini in S. Giovanni Battista (*The Glory of St. Pier Celestino*, 1688), Marcantonio Franceschini in Corpus Domini (*Glory of St. Catherine*, 1693), as well as the weighty forms of Giuseppe Maria Crespi at the Palazzo Pepoli Campogrande (*Olympus*, 1691).[3] The *Glory of St. Dominic* is divided into sections that lead the eye from the solid, terrestrial realm where five Dominicans look down and point upward to the intermediate realm where St. Dominic is carried aloft to the heavens. There, awaiting him, are the Virgin and the Trinity, set apart by the bright light surrounding them. Music-making angels scattered about the sky announce St. Dominic's arrival in heaven. Piazzetta contrasted these different areas of naturalistic forms by means of strong chiaroscuro accents amid a swirling and rising vortex.

Also unlike his fellow Venetians, Piazzetta prepared for this complex composition with a series of chalk studies, based on the preparatory methods he learned in Bologna. These methods harked back to the Carracci academy where artists, after making compositional drawings, elaborated the arrangement of light and shade and movement of each figure, drapery, arms, legs, and facial features in individual chalk studies. Few of Piazzetta's preparatory studies for paintings exist, but a number of figure studies are known for the *Glory of St. Dominic* in a similar chalk medium on blue paper. Two sketches (on the recto and verso of one sheet) in the Accademia, Venice, represent angels in the middle register on the right of the ceiling composition. One, at the border, prays with clasped hands, and the other, on clouds, plays the chitarrone.[4] Drawings for the head of a monk, a figure high up in the air, and St. Dominic, are in the Tiroler Landesmuseum Ferninandeum, Innsbruck.[5] Like Bolognese artists, Piazzetta must have used wax or clay models, which he would have hung in the air, to study the *di sotto in su* perspective and the strong play of light on the forms found in these studies.[6]

Cleveland's *Flying Angel* is the largest and most impressive of any of Piazzetta's preparatory studies. Here the artist considered the pose of the angel carrying St. Dominic, understanding that the final form would be covered by the shadow of the cloud it supported. There are only slight changes in the arm and leg and twist of the body between this drawing and the completed painting. In spite of the academic purpose of the sheet, it captures the immediacy of movement and the volumetric weight of a living model, with candlelight casting strong shadows. Such a sheet gives a sense of the naturalism Piazzetta garnered from his Bolognese training with the liveliness of movement and colorism of Venice.

The verso of the drawing depicts studies of different positions for the hands of the angels playing the violin and lute in the clouds above the Dominican friars on the ceiling. DDG

Fig. 1. Giovanni Battista Piazzetta. *The Apotheosis of St. Dominic*, 1723–27, oil. SS. Giovanni e Paolo, Venice.

1. Knox 1992, fig. 89.

2. For an excellent discussion of the entire chapel decoration, including documentation and iconography, see Catherine Puglisi, "I. The Cappella di San Domenico in Santi Giovanni e Paolo, Venice," *Arte Veneta* 40 (1986), 230–38, and Puglisi 1987.

3. Renato Roli, *Pittura bolognese 1650–1800 dal Cignani al Gandolfi* (Bologna, 1977), pl. 25b (Franceschini); Puglisi 1987, 213, fig. 5 (Burrini); Mira Pajes Merriman, *Giuseppe Maria Crespi* (Milan, 1980), pl. 149 (Crespi). These comparisons have been made by Jones 1981, 81 and 91, no. 13, and Puglisi 1987, 210–12. Puglisi noted Piazzetta's friendship with the Bolognese Angelo Mazza, who was responsible for the bronze reliefs with the life of St. Dominic on the walls of the chapel.

4. Inv. no. 1703; Puglisi 1987, 212, figs. 2–3.

5. Head of monk, inv. no. 250; Cambridge/New York 1996, 91, fig. 4. The present writer has seen only a photograph of this work. Figure high up in the air, inv. no. 256, and St. Dominic, inv. no. 270, are unpublished. The present writer has not seen photographs of these works.

6. The effect is reminiscent of Correggio's angels in the Duomo at Parma, which were studied after clay models. These frescoes were, of course, studied by all Bolognese artists in the seventeenth century.

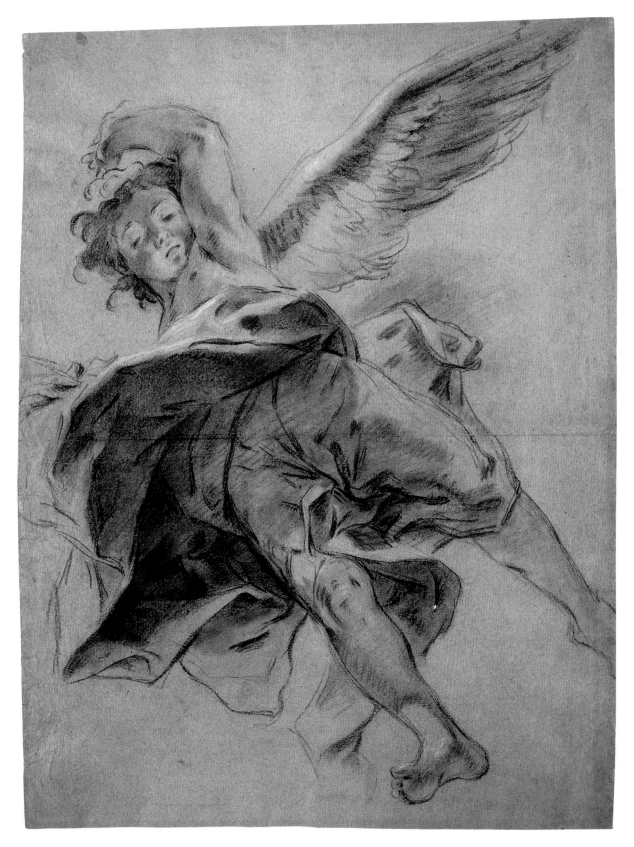

Studies of Hands Playing Instruments (verso)

Black chalk heightened with traces of white chalk, on blue laid paper; verso, black chalk

563 x 426 mm (22⅛ x 16¾ in.)

INSCRIPTIONS: verso, lower left, in red chalk: *17* [sideways]; lower right, in graphite: *Piazzetta*

Purchase from the J. H. Wade Fund 1938.388.a,b

Giovanni Battista (Giambattista) Piazzetta

Venice 1682–1754

Piazzetta was praised in his own day for the beauty of his independent drawings in black velvety chalk heightened with white on blue paper, which rivaled the pastels of the famous portraitist Rosalba Carriera. These drawings consisted of portrayals of saints, portraits, and *teste di carattere*. Because of their finished quality, they were meant to be framed and treated as paintings rather than placed in folios like other drawings collected during the period. In 1733 the critic Anton Maria Zanetti stated that these heads were the most beautiful of this genre that he had ever seen.[1] The justly celebrated Cleveland drawing falls into the category of teste di carattere. Three seemingly independent portrayals of individuals are placed together in a scene, which we take to be that of a young man perhaps giving or selling a lady a flower (a pink) while a second young woman looks on. Nothing tells the viewer more about the situation; one can interpret it as one wishes. Because the sheet is comparable to others in New York and Windsor Castle in scale and content, however, Piazzetta may have been creating a series of the five senses, as has been suggested.[2] The New York drawing, *Young People Feeding a Dog,* would represent taste and the Windsor Castle, *A Bravo, a Girl, and an Old Woman,* would depict touch.[3] In another drawing (which appears to be a copy of Piazzetta), formerly in the collection of the duc de Talleyrand, one of the three figures holds a glass of wine, again depicting the sense of taste.[4] Thus, the Cleveland drawing may symbolize the sense of smell or possibly sight.

The quickly sketched drawing of a head in profile in the Museo Civico, Castello Sforzesco, Milan, may have served as a study for the young woman at right in the Cleveland drawing.[5] Other drawings with the same figure are found in Venice (Gallerie dell'Accademia), Windsor Castle, and Turin (Biblioteca Reale).[6] The woman has been identified tentatively as Piazzetta's daughter Barbara Angiola (b. 1729). The boy at left has been considered to be Piazzetta's son Giacomo Giusto (b. 1725). He, too, appears in other drawings.[7] Dating of the drawing based on the individuals portrayed can be dangerous because Piazzetta repeated the same figures and poses in different drawings, which possibly date years apart. Dating the artist's teste di carattere is extremely difficult because of their similarity of style, subject, and medium. Only two are signed and dated, one a portrait (1735), the other a bust of Diana (1743), and neither compares closely with our drawing.[8] The present sheet has been dated variously from c. 1720 to c. 1745. Because of its similarity to drawings connected with paintings of c. 1745, consensus has placed the sheet in the same decade. If the Cleveland drawing is part of a series with that in Windsor Castle (they are almost identical in size), it would date before 1743, when the latter was engraved by Giovanni Cattini.[9]

A version of the drawing was known to be in the collection of the marquis Talleyrand Périgord in 1952.[10] DDG

1. Quoted in Milan 1971, 14: "si puo dir solo, che oltre a'molti suoi pregi è assai distinto quello del disegnare le test sopra la carta con gesso e carbone; più belle delle quali in questo genere altre non se ne sono mai vedute."

2. According to Bean and Stampfle in New York 1971, 34, under no. 40. Metropolitan Museum of Art inv. no. 1972.118.266, 384 x 511 mm. Windsor Castle inv. no. 01251, 408 x 558 mm. Anthony Blunt and Edward Croft-Murray, *Venetian Drawings of the XVII and XVIII Centuries* (London, 1957), 29, no. 32; Washington 1983–84, 130, no. 47.

3. Arguing against placing these drawings together is the fact that the drawing in New York has a pendant with a similar theme. (Washington 1983–84, 132, no. 50 [repr.]).

4. Morassi 1958, 13, no. 1, 37 x 50 cm.

5. Inv. no. Coll. 526/1 Gen. 4884, Pallucchini 1956, fig. 142. Byam Shaw 1983b, 786, fig. 44. This drawing has been erroneously considered a copy of the Cleveland sheet (Pallucchini 1956, 142; Pallucchini et al. 1983, 133), but Knox in Washington 1983–84, 37, suggested that it should be related to the painting of the *Pastorale* in Cologne. Knox identifies the figure in a drawing in a private collection (ibid., no. 45) as the same woman, but that is not certain. The head of a boy in profile looking to our left, also in the Museo Civico (inv. no. Coll. D 223/1 Gen. 4884/1; Byam Shaw 1983b, 788, fig. 45) appears to be of the same youth as that in the Cleveland drawing, seen in the opposite direction (noted also by Percerutti-Garber in Milan 1971, 23, under no. 2).

6. Venice inv. 301 (Venice 1983, no. 16 [repr.]); Windsor Castle (Pallucchini 1956, fig. 160; Venice 1983, no. 42), Turin inv. Ms. Var. 204, f. 40.

7. Such as one in Milan (Washington 1983–84, 29, fig. 12); and possibly another in the Museo Civico (Coll. E 82/10 Gen. 4884/10; Milan 1971, 27–28, no. 5). See the drawing in the Fogg, Cambridge (Harvard University Art Museums inv. no. 1932.319, Washington 1983–84, 74, no. 19) of Giacomo in c. 1745.

8. Washington 1983–84, 30, fig. 16 (self-portrait in Albertina, Vienna) and 134–35, no. 52 (*Diana*, National Gallery of Victoria, Melbourne).

9. As part of his series after Piazzetta entitled "Icones ad vivum expressae." Washington 1983–84, 130, no. 48 (repr.).

10. The drawing is reproduced in an article on the decor of the Talleyrand house, Pavillon Colombe, in *House and Garden* (April 1952), 118. A drawing above the fireplace in the library is a reflection of the Cleveland drawing, but it is not possible to see from the reproduction if the drawing is by Piazzetta, a copy, or even a facsimile.

Black crayon (wetted and
rubbed) heightened with white
chalk, on blue laid paper (faded
to green-gray)

427 x 549 mm (16¹³⁄₁₆ x 21⅝ in.)

Purchase from the J. H. Wade
Fund 1938.387

Giovanni Battista (Giambattista) Tiepolo

Venice 1696–Madrid 1770

Two canvases by Giambattista Tiepolo with the subject of the Adoration of the Magi are known: a large altarpiece, painted in Würzburg in 1753 for the Benedictine church at Schwarzach (Alte Pinakothek, Munich) and a small picture (possibly a *modello*), painted toward the end of the 1750s (Metropolitan Museum of Art, New York), the composition of which recalls the Munich picture.[1] A large print of the subject, similar to the Munich picture, is usually dated in the 1740s (fig. 1).[2] In addition, five drawings by Giambattista have been connected with the etched and painted compositions: in New York (Metropolitan Museum of Art), San Francisco (Achenbach Foundation for Graphic Arts, Fine Arts Museums of San Francisco), Berlin (Kupferstichkabinett), the sheet in Cleveland, as well as a smaller drawing in Palo Alto (Stanford University Museum of Art).[3] The drawings have been dated from the 1730s into the 1750s and usually connected with either the print or the Munich painting.[4]

Giambattista's mature prints and drawings are notoriously difficult to date for two reasons. Once developed, his graphic style was very consistent, and he had a repertoire of motifs he returned to throughout his life. Yet, there are consistencies in these drawn Adorations that set them apart from other compositions. The Madonna sits on a raised platform as the three magi approach. Two bearded magi kneel before the Christ child as the elaborately turbaned black magi stands behind them. The number of attendants and animals vary. Both the etching and the painting are elaborations of the elements found in the drawings.

The Cleveland *Adoration of the Magi* shares an element with the etching and painting—the broken wheel—that is missing in the New York, Berlin, San Francisco, and Palo Alto sheets. This motif, normally associated with St. Catherine of Alexandria as her attribute, is incongruous in an Adoration composition.[5] In all the drawings Tiepolo played with the limited repertoire of Madonna, child, magi, animals, attendants, and architecture. As he did with all his compositions, he brought originality to a time-honored, traditional subject by changing the characters and their movements. The asymmetrical composition itself harks back to Paolo Veronese's painted interpretations in London (National Gallery) and St. Petersburg (Hermitage).[6]

The three drawings are consistent with the rapidly executed graphic works of Tiepolo's early maturity (c. 1740) in which figures tend toward some elongation and blotches of dark shadow contrast with the softer middle tones and sharp white of the paper. In all his drawings, the luminosity of the paper suggests a clarity of atmosphere. As in the etching, these drawings present the magi as priestly supplicants,[7] suggesting they were thoughts that led to the etching. Some years later Tiepolo returned to the composition but transformed the wise men into crowned monarchs for his enormous and elaborate altarpiece for the Benedictines at Schwarzach.[8] DDG

Fig. 1. Giovanni Battista Tiepolo. *Adoration of the Magi*, c. 1753, etching. The Cleveland Museum of Art, Dudley P. Allen Fund 1965.18.

1. Alessandro Gemin and Filippo Pedrocco, *Giambattista Tiepolo. I dipinti. Opera completa* (Venice, 1993), 428, no. 418 and 462, no. 477, with discussions on the history and dating of the pictures.

2. For information and a discussion of previous scholarship on the print, see Succi in Gorizia 1985, 40–42, who dated the etching c. 1745. Dating of the etching also depends on the dating of Giambattista's series of etchings, the "Scherzi," to which it is similar in style. The "Scherzi" are generally dated in the 1740s but have been dated to 1735–40 by Aldo Rizzi, *The Etchings of the Tiepolos* (London, 1971), 14, and to 1753–55 by Russell 1972, 16–17.

3. Metropolitan Museum of Art inv. no. 37.165.16; Bean/Griswold 1990, 200, no. 190). Achenbach Foundation; Russell 1972, 29, fig. 21. Berlin inv. no. KdZ 1367; *Tiepolo in Würzburg*, exh. cat., Residenz Würzburg (1996), 130, no. 63. Stanford inv. no. 1950.392; Stanford 1993, 138–39, no. 274. The Stanford drawing seems closest to the print (Eitner et al. 1993, 138). Russell 1972, 28–29, best described the similarities and differences among the drawings, print, and Munich painting.

4. The drawings were dated to 1730s–40s by Pignatti in Washington 1974–75, 37–38; to 1753–55 in Russell 1972, 28–29; to c. 1743 in Knox/Dee 1976, 40; to 1735–40 in Dreyer 1979, n. 74; to late 1730s in Bean/Griswold, 1990, 200; to before 1753 by OT in London/Washington 1994–95, 498; to 1753 by Krückmann in *Tiepolo in Würzburg*, 130; and most recently to mid 1730s by Bernard Aikema (letter of 12 October 1999 in CMA files).

5. In his paintings with St. Catherine and the Madonna and child, Giambattista inserted similar broken wheels. See, for example, Massimo Gemin and Filippo Pedrocco, *Giambattista Tiepolo: i dipinti, opera completa* (Venice, 1993), 265, no. 100, and 464, no. 481. There are, however, two Adoration of the Shepherd drawings that also include the broken wheel: Civico Museo del Castello di San Giusto, Trieste, Gernsheim 25515; Museo Civico, Bassano del Grappa, Gernsheim 20442.

6. Terisio Pignatti and Filippo Pedrocco, *Veronese: catalogo completo dei dipinti* (Florence, 1991), 196, no. 115 (repr.; National Gallery, London), and 271, no. 193 (repr.; Hermitage, St. Petersburg).

7. Noted by Russell 1972, 29.

8. As discussed by Succi in Gorizia 1985, 40–42.

Pen and brown ink and brush
and brown wash, over black
chalk, on cream laid paper

387 x 285 mm (15³⁄₁₆ x 11³⁄₁₆ in.)

INSCRIPTION: verso, lower left, in
graphite: [T?]. *5533*; lower right,
in graphite: [J?]

Dudley P. Allen Fund 1944.474

Giovanni Antonio Canal, called Canaletto

Venice 1697–1768

Canaletto employed a composition similar to that of this drawing in three related paintings. In *Capriccio: with a Palace, an Obelisk, and a Church Tower* (Earl of Cadogan collection),[1] a similar arch and building appear at right but from a different perspective, and the building has been given an extra story in the drawing. The left portion of the scene has been entirely changed, although both show a bridge with a low, broad arch. Because of comparisons with St. Mary's Church, Warwick, this picture has been dated to or after Canaletto's English period of 1746–55. A second painting, *Capriccio: with a Palace, Bridge, and an Obelisk* (fig. 1), is similar to the Earl of Cadogan painting but in a vertical format.[2] A third painting, in a modified ovoid format to fit a decorative wall scheme, has elements found in the other pictures and dates to c. 1751–72 (private collection, formerly Chesterfield House, London).[3]

Because the paintings are from the English period, the Cleveland drawing must also date to that period, probably in the early 1750s, but its relation to the paintings is unclear. The right half of the drawing comes closest to the picture formerly belonging to the Earl of Lovelace: both show a stairway leading to the entry arch. Winslow Ames believed that Cleveland's drawing succeeded the Earl of Cadogan painting (placing it at the end of the English period) whereas W. G. Constable suggested that it was made earlier, possibly as a study for an engraving but used instead for the paintings.[4] As there is no engraving extant and the differences with the paintings are many, especially on the left side, the sheet could well have been an independent work of art instead of preparatory to a work in another medium.

The off-center composition, typical of Venetian art, is comparable to other *capricci* by Canaletto that seem to relate to this drawing.[5] Canaletto often referred to actual buildings in his capricci, manipulating forms and adding to or subtracting from reality to give an imaginary view. In the Cleveland drawing he appropriated the neo-Palladian portal to the Palazzo Tasca in Venice,[6] with its Corinthian columns on high socles below and a balustrade above, but giving the structure grandeur by placing it above a stairway and leading to a courtyard beyond. The courtyard and well inside refer vaguely to that at the Palazzo Ducale, Venice,[7] and the interior stairway could also depend on the same palace. Canaletto's palace looks like a mixture of different sixteenth-century Venetian buildings. The lagoon behind is certainly not that of Venice: the building in the distance is reminiscent of the Pantheon. The artist enlivened the scene by the addition of chimneys on the roof, vases and a statue of a seated bishop on the balustrade, various peasant figures, and a column with a crouching statue. The glimpse of the rooftop of a house and the mast of a ship lends mystery to the composition, as does the movement of the clouds, accomplished with various tones of wash. Canaletto took his usual care in preparation by first ruling in the lines of the buildings in black chalk before adding ink and wash.

A copy of the Cleveland drawing is in the British Museum.[8] The motif of the woman at the well, larger and in the foreground, appears in a painting in Springfield (Museum of Fine Arts).[9] Canaletto reused the arch in another painting in the collection of the Duke of Norfolk.[10] The palace in the paintings appears in a drawing at Windsor Castle. DDG

Fig. 1. Canaletto. *Capriccio: with a Palace, Bridge, and an Obelisk,* c. 1754, oil. Private collection; formerly Earl of Lovelace collection.

1. Constable/Links 1989, 2:462–63, no. 502.

2. Private collection; with Harari & Johns, Ltd., London, in 1985. Constable/Links 1989, 2:463–64, no. 504. For the dating of the Lovelace Canalettos see ibid., 2:378, under no. 367.

3. For the discovery that this painting belonged at Chesterfield House and its dating, see Francis Russell, "Canaletto and Joli at Chesterfield House," *Burlington Magazine* 130 (August 1988), 627, fig. 62, 628–30.

4. Ames 1938, 53; Constable/Links 1989, 607.

5. Constable/Links 1989, 2:figs. 820–21.

6. Noted by Corboz 1985, 119 and fig. 127.

7. Ibid., 286.

8. Inv. no. 1878-12-28-10, pen and brown ink and gray wash, over black chalk, 277 mm x 434 mm, Gernsheim 4821; *CMA Bulletin* 20 (1933), 23–26.

9. Noted by Constable in Toronto et al. 1964–65, 92, no. 73, 133. See also Constable/Links 1989, 468–69, no. 513.

10. Constable/Links 1989, 426–27, no. 505.

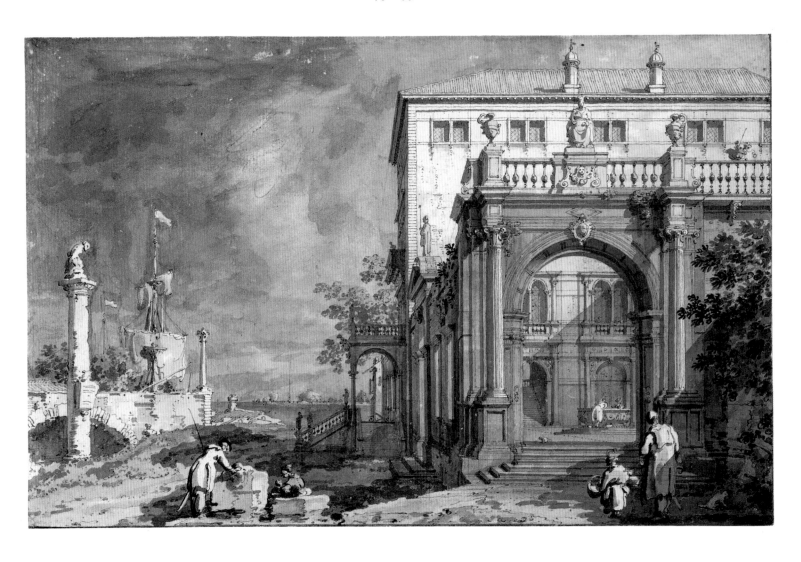

Pen and brown ink and brush and gray wash with brush and black ink, over traces of graphite(?), framing lines in brown and black ink, on cream laid paper

269 x 421 mm (10⁹⁄₁₆ x 16⁹⁄₁₆ in.)

WATERMARK: none visible through media

Purchase from the J. H. Wade Fund 1930.23

Francesco Guardi

Venice 1712–1793

For centuries, the Piazza San Marco has been a favorite destination of tourists, who took home painted and drawn souvenirs of the scene. Francesco Guardi provided numerous examples of this popular view throughout his life: we know of at least twenty autograph canvases that reproduce the piazza with the façades of the basilica of San Marco and the Doge's Palace, the campanile, and the arcaded buildings of the Procuratie Vecchie at left and the Procuratie Nuove at right. The Cleveland drawing is one of a number that depict the same view, and several canvases are close in viewpoint: in Richmond (fig. 1), London (National Gallery), Bergamo (Accademia Carrara), New York, and Paris.[1] In each of these pictures, Guardi chose a late afternoon scene with the western sun bathing the right half of the square in sunlight and people taking leisurely strolls. In the drawing and those paintings groups of figures and dogs are similarly placed, the vantage points are alike, and the strong light comes from the left.

Another drawing with similar characters, light, and viewpoint exists in Rotterdam (Museum Boymans-van Beuningen) that probably postdates the Cleveland sheet, which has been noted as superior in quality.[2] Another sheet in the Fondazione Querini Stampalia, Venice, appears to be a copy of the same scene by Francesco's son Giacomo Guardi.[3] The *Piazza San Marco, Venice* was likely carefully drawn in the studio from a model made on the spot using a camera obscura to capture the wide-angle viewpoint of the square. Over black chalk (traces of which are left) Guardi indicated the arrangement of the perspective of the Procuratie buildings at right and left. Over them he placed the buildings in staccato strokes of the pen, a technique he employed late in his career. The figures would have come from one of his numerous sketchbooks. Once chosen, he repeated his stock of figures in other drawings and paintings, sometimes changing their positions within the composition. In spite of the repetition of these San Marco scenes, Guardi managed to give each drawing and painting a freshness and immediacy that creates the impression of a moment in time quickly rendered. The short, zigzag strokes and wash that exceeds the contours of the forms lend a movement and liveliness to the composition, and the bright white of the paper captures the sparkling sunlight typical of Venice. Although none of these pictures or drawings is dated, comparison of the stylistic characteristics of this sheet with securely dated works (for example, the *Procession in the Piazza San Marco*, no. 25) suggests that *Piazza San Marco, Venice* dates to the 1780s.[4] DDG

Fig. 1. Francesco Guardi. *Piazza San Marco with Basilica and Campanile*, 1775–85, oil. The Virginia Museum of Fine Arts, Richmond.

1. London inv. 2525; Antonio Morassi, *Guardi: Antonio e Francesco Guardi* (Venice [1973]), 2:pl. 352. Bergamo, inv. no. 236; ibid., 2:pl. 353. Formerly in New York (coll. C. V. Hickox) and Paris (coll. Fodor); ibid., 2:pls. 354–55.

2. Byam Shaw 1954, 160; Venice 1993, 90, no. 24.

3. Venice 1962, 57 n. 69. See also Venice 1993, 90, under no. 24.

4. For Guardi's late style, see Byam Shaw 1951, 37–38.

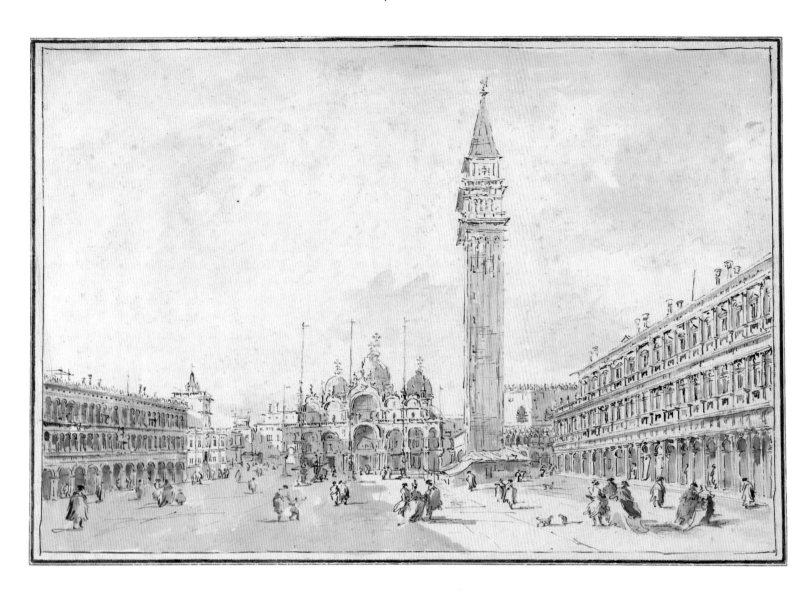

Pen and brown ink, brush and
brown wash, with brush and
gray wash (possibly chalk) and
traces of black chalk, framing
lines in brown and black ink, on
cream laid paper

313 x 465 mm (12⁵⁄₁₆ x 18⁵⁄₁₆ in.)

WATERMARK: center: GFA (similar
to Heawood 877)

John L. Severance Fund 1951.83

Francesco Guardi

Venice 1712–1793

Francesco Guardi not only painted views of Venice but also recorded important events that took place in the city, such as the visits of famous dignitaries and the pope.[1] These events were celebrated with the erection of temporary structures and elaborate festivities that Guardi chronicled for posterity. He was likely commissioned by the Venetian state to document the visit of Grand Duke Paul (Pavel) Petrovitch and his wife, Maria Feodorovna of Russia, which took place 18–25 January 1782.[2] The grand duke's mother, Catherine II (Catherine the Great), initiated the extended journey to the capitals of Europe by the famous pair,[3] who were fêted everywhere and traveled incognito as the count and countess of the north (*i conti del nord*). In Venice, the complicated visit was painstakingly planned and the heir apparent to the throne and his German wife were treated to concerts, plays, banquets, a bullfight, and a regatta. Six documented paintings and a number of drawings attributable to Francesco Guardi record the week's various festivities.[4]

The drawing in Cleveland depicts the festival that took place in the Piazza San Marco on the penultimate day of the ducal visit: a *gran finale* in which the visitors and public viewed a procession of decorated allegorical carriages driven by oxen, which was later followed by a bullfight. For the occasion, the piazza was equipped with an oval arena, a triumphal arch, and decorative stands in front of the Procuratie Vecchie (visible in the drawing) and the Procuratie Nuove (from which Francesco's view is taken). Five carriages alluding to the triumph of Peace were festooned with allegories of Abundance, Agriculture, the Pastoral Life, the Mechanical Arts, and Commerce meant to celebrate the enlightened government of Catherine II and the stability of the ancient republic of Venice.[5] The design for the apparati of the event belonged to the architects Giorgio and Domenico Fossati, with the aid of Antonio Codognato.[6] In the present sheet, in order to include as much of the piazza as possible, Guardi manipulated the perspective of the clock tower, the façade of San Marco, and the side of the campanile at right. The drawing is cut at left, possibly because the artist had incorrectly added a sixth, undocumented, carriage.[7] A succeeding drawn representation of the event (fig. 1) is more carefully rendered and includes only five carriages and the west side of the piazza with the church of San Gemignano, in front of which the royal visitors viewed the activities. It suggests how the original composition may have looked before it was cut. The Cleveland drawing is much livelier than the later work and evokes the immediacy of the event itself, perhaps having been drawn on the spot.[8] The Berlin drawing shows a subsequent stage in the working process by its tighter handling, and may well have been used as the final preparatory drawing for the painted composition. Two canvases with the composition survive (Guardi often made multiple versions of saleable motifs), in Venice (fig. 2) and in a private collection, Milan.[9] Unlike the festive event, shown in full sunlight in the drawings, the painted procession takes on a somber note in the cloudy late afternoon panorama.[10]

On the verso of the drawing Guardi lightly sketched arches with decorative festoons, which relate to paintings in the Gulbenkian Foundation, Lisbon, of the *Festival of the Ascension in Piazza San Marco*, the design for which dates to before 1776. As he did often, Guardi may have been looking back on a composition he had used previously.[11] DDG

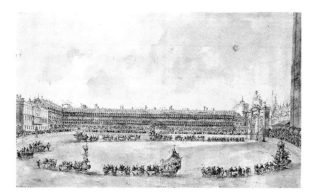

Fig. 1. Francesco Guardi, *Festival in Piazza San Marco*, 1782. Kupferstichkabinett, Staatliche Museen Preußischer Kulturbesitz, Berlin, inv. no. KdZ 17885.

Fig. 2. Francesco Guardi, *Procession of Triumphal Cars in Piazza San Marco*, 1782, oil. Private collection, Venice.

25. A Procession of Triumphal Cars in the Piazza San Marco, Venice, Celebrating the Visit of the Conti del Nord

1782

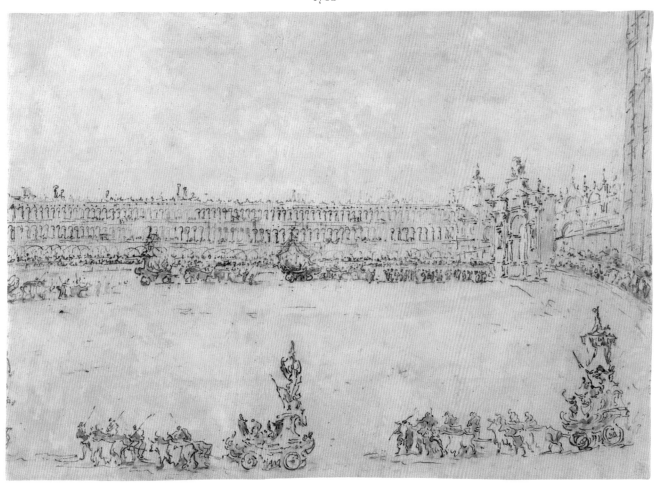

Three Sketches of Arches (verso)

Pen and brown ink with brush and brown wash, on cream laid paper; verso, pen and brown ink

259 x 368 mm (10³⁄₁₆ x 14⁷⁄₁₆ in.)

WATERMARK: center: triple crescent (cropped)

INSCRIPTIONS: verso, center right, in graphite: *Francesco Guardi / 208* [circled]; lower right, in graphite: *208*

John L. Severance Fund
1955.164.a,b

1. Such as the visit of Pope Pius VI in 1782, recorded in several paintings, including two in the Cleveland Museum of Art: Count Zambeccari's flight in a balloon in 1784 and the wedding of the Count Polignac in 1790. See Antonio Morassi, *Guardi: Antonio e Francesco Guardi* (Venice [1973]), 2:pls. 291–304, and Morassi 1975, pls. 312, 315–18.

2. Guardi was commissioned by Pietro Edwards, the inspector general of the public collections of the Venetian state, to record Pius VI's visit in May 1782. It has been suggested that this earlier visit was also commis-

sioned by the state to promote the appearance of stability and good government of Venice during its final years; see Pask 1992, 51–52, no. 28.

3. Portraits of the pair are in the Hillwood Museum, Washington; see ibid., 48, figs. 4–5.

4. For the paintings with depictions of the *Concert of Orphan Girls in Honor of the "Conti del Nord,"* the *Dinner and Ball in the Theatre of S. Benedetto,* the *Banquet in the Sala dei Filarmonici,* the *Regatta on the Grand Canal,* the *Bullfight in the Piazza S. Marco,* as well as the *Procession of Allegorical Carriages in the*

Piazza San Marco, see Morassi, *Guardi,* 2:pls. 255–61. For the drawings see Morassi 1975, 2:pls. 267–72, and, most recently, Pask 1992. The visit was amply recorded in letters and prints of the period; see especially Pask 1992, Biadene 1992, and Venice 1993 with information and bibliography.

5. See Venice 1993, 169, no. 69, and Biadene 1992, 100.

6. Prints reproduce the allegorical carriage by Fossati. See Biadene 1992, 251.

7. According to Byam Shaw 1951, 69.

8. Suggested by Francis 1958, 12. However, the unwieldy size of the sheet may indicate otherwise.

9. Morassi, *Guardi,* 2:pls. 287–88.

10. The funereal note was mentioned by Biadene 1992, 102.

11. Morassi, *Guardi,* 2:pls. 305–7. Dating is based on the change of the design of the shops in 1776; see *Francesco Guardi. Vedute, Capricci, Feste,* exh. cat., Fondazione Giorgio Cini (Venice, 1993), 182.

Giovanni Domenico (Giandomenico) Tiepolo

Venice 1727–1804

By the eighteenth century artists commonly produced drawings as finished works of art, but Giandomenico Tiepolo was unusual in creating numerous finished drawings on particular themes.[1] Most of those series date to the period after his return to Venice from Spain in 1771, following the death of his father, Giambattista. Giandomenico's penchant for storytelling led to the completion in the 1780s and 1790s of several series of drawings, including a group of 104 sheets of carnival scenes with the Italian *commedia dell'arte* figure of Pulchinello as the leading character ("I Divertimenti per li Regazzi" series, see no. 27), genre scenes of everyday life, and stories related to the Bible.

The most impressive of Giandomenico's religious drawings is the "Large Biblical Series," in which he related the stories of the Old and New Testaments, the Apocrypha, and the Acts of the Apostles in more than 260 impressive drawings. Unlike the horizontal carnival and genre scenes, these large independent drawings were executed in a vertical format and remained in albums in Giandomenico's possession his entire life. Today they form two groups. The first, known as the Recueil Fayet, consists of an album of 138 drawings sold to M. Fayet in a shop in Venice in 1833. That album has been in the collection of the Louvre since 1892.[2] A second group was also purchased in Italy in the early nineteenth century by M. Luzarches, mayor of Tours.[3] The Cleveland drawing derives from that source.[4]

The Disrobing of Christ depicts the story of the tenth station of the cross (John 19:23–24; Matthew 27:31) in which soldiers cast lots for the seamless robe of Christ. The drawing combines Giandomenico's ability to concentrate on the essence of a narrative while incorporating peripheral characters that add a touch of contemporary reality to a historical scene. He had painted the subject for the Oratorio del Crocifisso, S. Polo, Venice (c. 1747–50), and for the convent of S. Filippo Neri, Madrid (c. 1772, now Madrid, Prado), and drawn it in a sheet in the Recueil Fayet (fig. 1).[5] The paintings bring the action close to the picture plane, unlike the drawings, which enliven the scene with a distant landscape. In the Cleveland drawing, Giandomenico added a dramatic diagonal sweep of the ladder that leads to the central protagonists and set the executioner apart by means of a colorful brown wash. In all the paintings and drawings, he placed the figure of one of the executioners on his knees in front of Christ, providing an ironical and potent moment to the event.[6] In this subtle manner Giandomenico implied the impact of Christ's presence and the religious significance of his death. The agitation of the contour lines and the varying contrasts of different colors of ink against the white of the paper add to the movement and emotional impact of the scene.

The dating of Giandomenico's drawings is difficult because of his rather uniform style, but scholars believe that the "Large Biblical Series" dates after 1785 and that Giandomenico may have worked on it for five to ten years. Giandomenico likely made the works for his own edification rather than for sale because he kept them during his lifetime and no prints were made. DDG

Fig. 1. Giandomenico Tiepolo. *The Disrobing of Christ*, c. 1772, pen and ink and wash. Musée du Louvre, Paris, inv. no. R.F. 1713bis.

1. Giambattista Tiepolo did a series of religious drawings, and Pietro Monaco engraved a group of 112 religious prints after Venetian artists (1739–45) (Udine/Bloomington 1996–97, 52). Francesco Fontebasso also did a series of biblical and historical drawings (Byam Shaw 1962, 37 n. 1).

2. Byam Shaw 1962, 36, noted that it was bequeathed in 1889.

3. For the history of the small and large biblical series, see Byam Shaw 1962, 36–37, and Knox in Udine/Bloomington 1996–97, 76–86.

4. It was not, however, in the sale of 30 April 1921 in which 82 drawings were sold from the collection of Rogier Cormier, Tours. Camille Rogier inherited the drawings from a kinsman who had inherited them from Luzarches (Knox in Udine/Bloomington 1996–97, 91). The drawings were certainly in the possession of the Louvre by 1892.

5. S. Polo painting, Mariuz 1971, pl. 12; Madrid painting, Mariuz 1971, pl. 236; drawing, Recueil Fayet 30, Udine/Bloomington 1996–97, 84 (repr.).

6. Knox in Udine/Bloomington 1996–97, 82.

26. The Disrobing of Christ

c. 1785–90

Pen and brown and black ink,
brush and black, brown, and
red-brown wash, over black
chalk, framing lines in brown
ink, on cream laid paper

479 x 382 mm (18¹³⁄₁₆ x 15 in.)

WATERMARK: center: crescent
with face

INSCRIPTIONS: signed, lower left,
in brown ink: *Dom' Tiepolo f*

Purchase from the J. H. Wade
Fund 1999.5

Giovanni Domenico (Giandomenico) Tiepolo

Venice 1727–1804

A Spring Shower is one of the most evocative and discussed of Giandomenico's late series of drawings, "I Divertimenti per li Regazzi," which consisted of 104 sheets (of which 102 were still extant when they were sold in 1920) and a title page.[1] The drawings depict the story of the exceptional events and everyday life of Pulchinello, while recalling the social mores of late eighteenth-century Venice. Giandomenico's Pulchinello is not the stupid and malicious character of the street theater *commedia dell'arte,* but a reflection of any human being, a kind of Everyman.[2] In the series he, and Pulchinellos like him, go through life working, loving, enjoying themselves, being festive, as well as facing ordinary and extraordinary difficulties. Some of the scenes are joyful, others tragic, and others enigmatic, as is *Spring Shower.* Here seven people, including two Pulchinellos, wander aimlessly and in different directions in a simple landscape amid a shower, protecting themselves with umbrellas, hats, and a cape. A small dog accompanies one of the Pulchinellos. Although it rains, the sun shines from the right, adding to the enigma of the scene. While there are amusing passages in the drawing, such as a Pulchinello covered with a cape and the skinny woman at left, other disconcerting elements contribute to its ambiguity. We see the figures from the back: we do not know who they are, where they are going, or how they relate to one another. They are isolated in their arrested movement and walk into a blank space behind. Some of this isolation may be due to the origin of the composition: several figures are copied from two earlier sheets by Giandomenico. The thin woman with earrings appeared in a somewhat earlier drawing of two women, without umbrellas, seen from behind (Metropolitan Museum of Art, New York).[3] Another drawing (private collection, Rome) represents the five figures at right.[4]

In spite of the apparent melancholic atmosphere of *Spring Shower,* the element of amusement exists in the contrast of the shapes of the figures and our inability to see their faces: a playful motif that might suggest a scene from the Venetian *carnevale.*[5] Tiepolo had employed the device in numerous pictures earlier in his career, including the paintings of the *Cavadenti* (Musée du Louvre, Paris, and private collection) and the *Ciarlatono* and in the scene of the figures walking along a road in the Foresteria of the Villa Valmarana (1757).[6] They also appear in his frescoes in his country villa at Zianigo (Venice, Ca'Rezzonico).[7] The motif suggests a casual, quotidian scene, not a formal, studied composition.

The unresolved intention of the series has caused scholars to seek a deeper meaning and literary sources in them other than the title of amusement for children would suggest.[8] In 1797 Giandomenico signed the room of the Pulchinello at Zianigo, the year that the Republic of Venice fell and Napoleon handed the city over to Austria, and commedia dell'arte troupes were seen as a local form of protest against foreign domination. It is likely, however, that Giandomenico made this incredible series of drawings not as a protest—both he and his father had been representing the character of Pulchinello since the 1730s—but as an ironic comment on his life and that in Venice and, as he said, as a *divertimento.*[9] DDG

1. *A Spring Shower* is one of nine drawings from the series in the collection of the Cleveland Museum of Art. The others are 1937.569, 1937.570, 1937.571, 1937.572, 1937.574, 1947.12, 1947.13, 1981.36. On the series see Vetrocq 1979, Bloomington/Palo Alto 1979, Gealt 1986, and Knox in Udine/Bloomington 1996–97, 95–101. Attempts to seek an order to the series (which is numbered internally) have been unsuccessful.

2. As suggested by Knox 1983, 131.

3. Inv. no. 1975.I.508; Wolk-Simon 1996–97, 26, fig. 39.

4. According to Vetrocq in Bloomington/Palo Alto 1979, 82, under no. 23.

5. As has been suggested, many of the Pulchinello scenes refer to the Veronese tradition of Venerdí Gnoccolare; see Knox in Udine/Bloomington 1996–97, 57.

6. Mariuz 1971, pls. 85, 195, 197.

7. Ibid., pls. 369, 383 (with umbrella).

8. Such as the plays of Carlo Gozzi and Carlo Goldoni. For a balanced view of the Pulchinello imagery, see Knox 1983 and Wolk-Simon 1996–97, 59–66.

9. Knox 1983, 124–25.

Pen and brown ink and brush and brown wash over black chalk, framing lines in brown ink over graphite, on cream laid paper

355 x 471 mm (13¹⁵⁄₁₆ x 18½ in.)

WATERMARK: lower center: triple crescent

INSCRIPTIONS: signed, bottom right, in brown ink: *Dom. Tiepolo f*; upper left, in purple crayon: *74*; verso, top right, in black chalk: *1*; top right, in blue crayon: *7* [written over the "1"]; bottom right, in graphite: [Painting?] small of 4 figures only [upside down]

Purchase from the J. H. Wade Fund 1937.573

Giuseppe Cades

Rome 1750–1799

Portrait of a Lady with an Elaborate Cartouche reflects Giuseppe Cades's interest in French art and antique forms.[1] It was drawn at a period when the Roman painter came under the influence of foreign artists active in the city who looked to ancient Greek and Roman literature for inspiration and translated forms in a literal fashion. The flying male nudes, who symbolize Victory and Fame,[2] not only depend on idealized antique forms but are drawn with a linear emphasis. This precision of rendering contour lines indicates the kind of historicism characteristic of the period. In contrast to the fastidious, finished contours of the decoration is the "painterly" rendering of the profile portrait within the cartouche. The head is freely drawn in another medium (red chalk), meant to suggest a different artist and era from that of its surround. The sitter's upswept curls and frilly bodice reflect the current French style, while the profile depiction harks back to the ancient and Renaissance prototypes for portraiture on medals and coins. The contrast in technique between cartouche and portrait is significant, purposefully emphasized to indicate that the portrait is an older "icon" of reverence. Whereas the chalk portrait appears French, the cartouche is purely Italian in style and form. The masks, boughs of fruit, grotesques, and winged figures holding a crown—traditional forms that usually surround coats of arms—are known in many engravings dating back to the sixteenth century. Cades would have been aware of Agostino Carracci's engravings, especially, either from knowledge of them in Rome or from his study trip to northern Italy c. 1785.[3] The griffins, masks, ribbons, fruit, and nudes are similar to those in several of Agostino's engravings of coats of arms.[4]

Cades was famous for his fresco schemes; those of the 1780s reflect an interest in decorative forms similar to the cartouche of this drawing.[5] The colorful aspect, with the red chalk portrait and the yellow, gray, and red washes of the surround, is comparable also to the pastel palette he used in his virtuoso painted decorations of the period. The sheet seems not to be a study for another work but a finished presentation drawing for the sitter,[6] and Cades was praised for his independent drawings. Who that sitter is has not been determined but is hinted at by the incomplete and faint inscription within the oval: "CAT.A V.essa de" and "AETS. 3 [2?] AD. 1785." The coronet with ermine, jewels, silver bells, and crimson velvet held aloft is that of an English viscountess.[7] The incredible elaboration of the cartouche surrounding the formal profile portrait gives the sitter an importance worthy of her rank. The drawing certainly would have been made for the English visitor during her stay in Rome on the Grand Tour as a souvenir from one of the most sought-after artists in the city.[8] DDG

1. Cades's father was French. His sketchbooks have studies after antique forms, including vases, statues, friezes, and gems. For drawings after the antique see Caracciolo 1990, 212–38.

2. For drawings by Cades similar to those figures see Caracciolo 1990, 251–55.

3. He is known to have been an admirer of Bolognese artists. His sketchbooks are filled with drawings after those artists. On the study tour, see Caracciolo 1990, 91–97.

4. See, for example, the *Coat of Arms of Cardinal Fachinetti* of c. 1590–95 (De Grazia Bohlin 1979, 316–17, no. 196). Also influential on Cades's drawing style here are the paintings and drawings of the Bolognese artist Pellegrino Tibaldi, whose works Cades would have seen in Rome and Bologna.

5. Compare, for example, his work in the Capitoline, Rome, of 1779, for decorations similar to that of this drawing (Caracciolo 1990, 239–41, no. 47).

6. A drawing similar in style to the red chalk portrait in the cartouche is that of the Princess Anna Maria Salviati Borghese and her sons (Caracciolo 1990, 239, no. 46, and 99, fig. 29). A drawing in black chalk (Phila-delphia Museum of Art, inv. no. 1978-70-207) of a woman in profile facing left is similar to the Cleveland drawing in both style and subject and dates close to this sheet (dated 1788; Caracciolo 1990, 306–7, no. 100 [repr.]).

7. Anthony Phelps kindly identified the coronet as that of an English (or British Isles) viscountess. See C. W. Scott-Giles and J. P. Brooke-Little, *Boutell's Heraldry*, rev. ed., (London/New York), 186, and pl. XVI, no. 2. No Viscountess Catherine is found in John Ingamells, *A Dictionary of British Travellers in Italy 1701–1800*, compiled from the Brinsley Ford Archive (New Haven/London), 1997.

8. Cades was a favorite of tourists on the Grand Tour and may have sold more drawings to visitors than any other artist of the period; see Anthony Morris Clark, "An Introduction to the Drawings of Giuseppe Cades," *Studies in Roman Eighteenth-Century Painting*, ed. Edgar Peters Bowron (Washington, 1981), 151.

Red chalk over graphite (portrait), pen and black ink and watercolor over graphite (surround), circular framing line in graphite, on cream laid paper laid down on cream laid paper (with blue modern laid paper and strip gold leaf added as decorative mount to primary or secondary support)

360 x 359 mm (14⅛ x 14⅛ in.) (visible area of primary support)

WATERMARK: center (possibly in secondary support): M [L?]OHANNOT / & FILS / DANNONAY

INSCRIPTIONS: by artist, center, around portrait, in red chalk: *CAT⁴ cssa de* [illegible] *AETS. 3*[2?] *AD. 1785.*

John L. Severance Fund 1999.172

Spanish Drawings

Jusepe de Ribera

Játiva, Valencia, 1591–Naples 1652

Jusepe de Ribera's activities as both painter and printmaker are widely known and well documented, but his drawn oeuvre is the result of recent scholarship. Thanks to the work of Walter Vitzhum and Jonathan Brown, Ribera's drawing style is now well understood.[1] Yet only about a hundred sheets by him are known, a small number considering he was active for nearly four decades. His drawings are rare partly because they were, as recently as the 1970s, frequently confused with his contemporaries Salvator Rosa and Luca Giordano. Furthermore, the survival rate of seventeenth-century Neapolitan drawings is for some reason unusually low (possibly because of burnings in the wake of the 1656 plague outbreak).[2]

Despite their relative scarcity today, Ribera's drawings were a fundamental part of his art, and we know he drew throughout his lifetime. This sheet depicting St. Sebastian tied to a tree falls in the first part of his mature career, when Ribera was already established as the most important painter in Naples. It belongs to a group of red chalk figure studies that spans the decade of the 1620s. Brown established a relative chronology for these works based on a signed and dated sheet from 1626 depicting St. Albert, now in the British Museum.[3] In that work, Ribera displayed the solid, careful modeling of the human form that shows the influence of both Italian Renaissance art and academic teaching methods, which stressed the study of the nude figure from life. Although the same issues bear on the work here, it also reflects a change in style and may have been done slightly later, when Ribera's draftsmanship became more expressive, sketchy, and linear.[4] The artist's mastery of anatomy is clear, but he economized on the internal modeling of the musculature in order to stress the figure's lean, elongated outline. A closely related work in Princeton (fig. 1) shows the same figure of St. Sebastian in an even looser manner.[5] The difference between the two works prompted Brown to suggest that the Princeton sheet may have been preparatory for a painting, while the Cleveland drawing was likely conceived as an independent study.[6]

Whatever its purpose, the work is an important example of the artist's interest in the subject of St. Sebastian and of martyred saints in general. Ribera was also fascinated by the compositional problem of presenting a tied and bound figure and treated it over and over in prints, drawings, and paintings. Thus, although he surely intended this work to represent St. Sebastian, he was equally interested in the expressive possibilities inherent in the bound human form. In this sheet we see, atypically, the saint without arrows in his body. Instead, Ribera seems to depict the moment just before the soldiers shoot St. Sebastian, and he turns hopefully toward heaven as if succored by divine light. Although some scholars have read an obsession with cruelty and even torture in Ribera's art, his many depictions of martyrs are often empathetic and tender. Even in this small-scale work, one can read an emotional depth typical of Ribera's Counter-Reformation sensibility. CEF

Fig. 1. Jusepe de Ribera. *St. Sebastian Being Bound to a Tree*, c. 1626–30, red chalk. The Art Museum, Princeton University, Gift of Frank Jewett Mather Jr. 52–176.

1. See Florence 1967; Princeton/Cambridge 1973–74.
2. The suggestion of Renato Ruottolo Galasso, cited in New York 1992c, 194.
3. Princeton/Cambridge 1973–74, 120.
4. Ibid., 124, 165.
5. Brown 1972, passim.
6. Princeton/Cambridge 1973–74, 124.

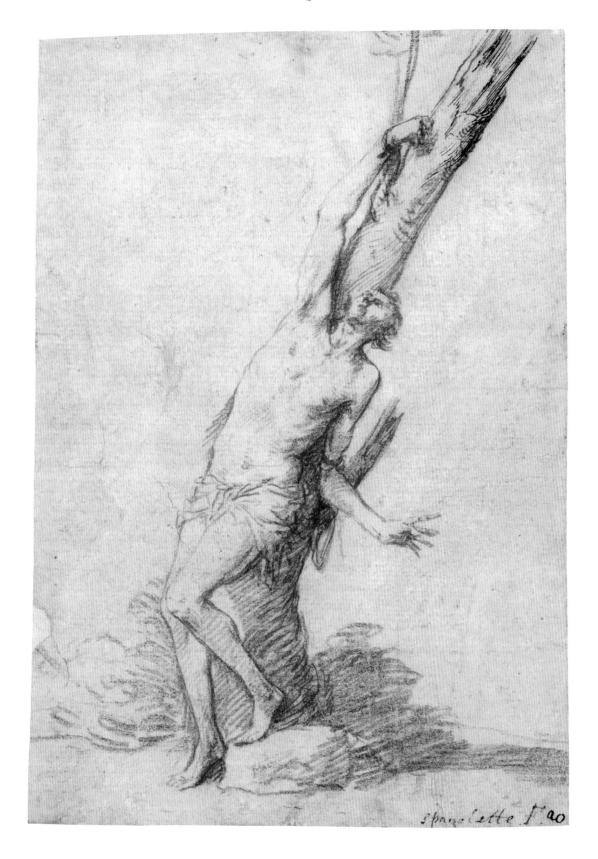

Red chalk with pen and brown
ink, on cream laid paper

173 x 124 mm (6¹³⁄₁₆ x 4⅞ in.)

INSCRIPTIONS: lower right, in
brown ink: *spanolette.F*; lower
right, in black ink: [20?]

Delia E. Holden Fund 1997.53

Bartolomé Esteban Murillo

Seville 1617–1682

This sheet is one of the finest of the rare drawings by Bartolomé Murillo, whose meticulous preparatory methods indicate that many once existed.[1] Here he followed the traditional iconography of the tender young mother and playful infant on her lap that Raphael popularized in the early sixteenth century.[2] In fact, Murillo looked directly to Italian art for his inspiration, possibly as he and many Spaniards did, via an engraving.[3] The poses of the Madonna and child are reminiscent of those (in reverse) in a painting by Titian once in the Escorial.[4] Murillo could have seen the painting on his one documented trip to Madrid in 1658.

The Cleveland drawing is a rapidly executed study for the *Virgin and Child* (Virgin of Santiago) now in the Metropolitan Museum of Art but commissioned for the family chapel of the Marques de Santiago in Madrid (fig. 1).[5] The Madonna's pose is identical, but that of the Christ child is different. He no longer pauses while nursing (the Madonna's breast is covered in the painting) but looks toward the viewer in a more formal manner, consistent with his role as savior of the world.[6] The tender contact between mother and child in the drawing was eliminated in the painting; their eyes do not meet as the Madonna gazes down as the newborn ruler confronts the world. The movement and immediacy inherent in the graphic medium has changed to the timeless monumentality of an iconic image. The drawing is an image based on nature and real models, but the painting has entered the realm of the sacred. Neither painting nor drawing is dated, but all scholars place them in the last decade of Murillo's life.[7]

Murillo's preparatory drawings, consistent in their method, conform to traditional seventeenth-century Italian academic practice.[8] He rapidly sketched the outlines of the forms in black chalk before setting them down permanently in ink. In the Cleveland drawing, after the initial black chalk sketch, he probably tried another pose at upper left, also in black chalk, before the addition of pen. In most extant preparatory drawings, Murillo stopped here, but in this sheet he sought the light effects for the painting by the addition of wash. The light comes from upper left in both drawing and painting, and a luminescent halo is already suggested in the drawing by the blank background above the heads of the figures. In his late drawings Murillo increased the energy of line with crinkled contours and tumbling zigzag hatching. Closest in style and frenetic energy to the *Madonna Nursing the Christ Child* is a study of the Immaculate Conception, formerly in the collection of Lord Kenneth Clark, also dated c. 1670.[9] In both drawings the figures appear active because of the movement of the contours, which animate rather than contain form. Shading is accomplished by means of irregular, electrically charged hatching that increases the feeling of incessant motion. The purpose of these sheets was not to suggest beauty—that was strictly the realm of painting—but to record the positions of the figures. Murillo's drawings today are appreciated for their dynamism, but, in spite of his having signed many of them, they were made not as finished works of art to be collected but exclusively as workshop tools for constant use.[10] DDG

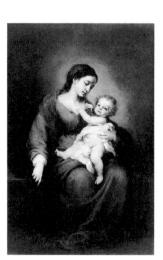

Fig. 1. Bartolomé Esteban Murillo. *Virgin and Child*, c. 1670–75, oil. The Metropolitan Museum of Art, New York, Rogers Fund, 43.13.

1. According to Manuela Mena in Madrid/London 1982–83, 54, about 70 extant autograph drawings by Murillo exist. Mena in Turner 1996, 22:347, raised the number to about 100. Brown in Princeton 1976–77 listed 95 drawings, but later scholars reject some of them. See Mena in Madrid/London 1982–83, 53.

2. Richards 1968, 235, believed that Murillo was influenced by Raphael in this depiction.

3. Murillo is known to have copied engravings for his compositions. See, for example, Mena in Turner 1996, 22:343.

4. Iniguez 1981, 2:60, no. 164, noted that Mayer suggested the inspiration of the painting by Titian, now in the Alte Pinakothek, Munich, inv. no. 667; see Harold E. Wethey, *The Paintings of Titian* (London, 1969), 1:100–101, pl. 50. Wethey did not record any engraved copies.

5. Richards 1968, 235, first connected the Cleveland sheet to the New York painting. Brown 1998, 231, noted that it is the last of about 20 versions of the subject.

6. The best analysis of the relationship of drawing to painting is still Richards 1968, 235–38.

7. Brown, c. 1675–80, in Princeton 1976–77, 165, under no. 79; Nuño, c. 1670, in Nuño 1978, 105, no. 217; Iniguez, 1670–80, in Iniguez 1981, 2:159, no. 164; Mena, c. 1670, in Madrid/London 1982–83, 216, no. D19; Brown, 1675–80, in Brown 1998, 231.

8. On Murillo's methods based on Italian models see Brown in Princeton 1976–77, 31–32, and Mena in Madrid/London 1982–83, 53–62. Murillo helped initiate the first academy in Spain, in Seville, in 1660.

9. Richards 1968, 238, fig. 5, 239, first connected the Cleveland sheet with the Clark drawing, which sold at Sotheby's, London, 5 July 1984, lot 177.

10. For the vicissitudes of survival of Spanish drawings, see, for example, Feinblatt in Los Angeles 1976a, 205, and Mena in Madrid/London 1982–83, 53–54.

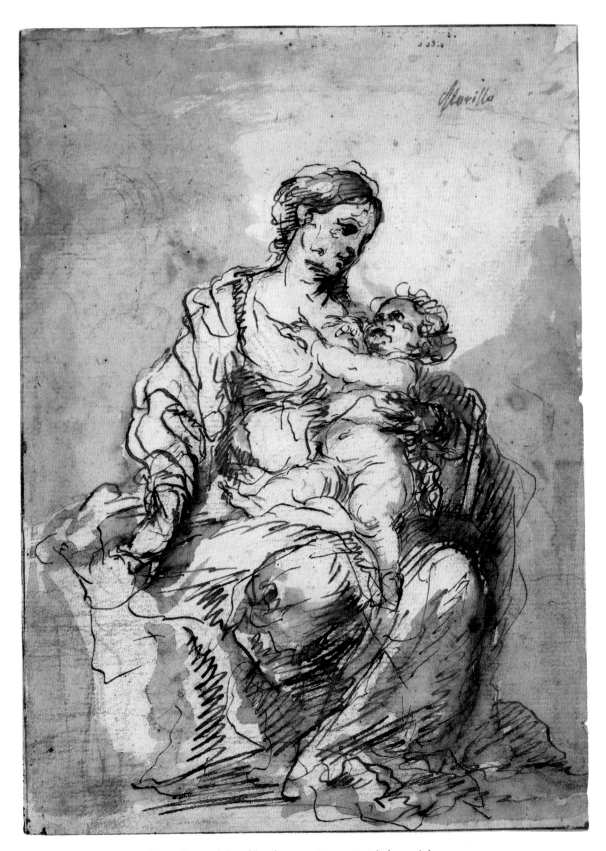

Pen and brown ink and brush
and brown wash over red and
black chalk, with traces of
white, framing lines in brown
ink, on cream laid paper

214 x 154 mm (8⅜ x 6¹/₁₆ in.)

INSCRIPTIONS: in brown ink,
upper right: *Murillo*

Mr. and Mrs. Charles G. Prasse
Collection 1968.66

Francisco (José) de Goya (y Lucientes)

Fuendetodos, Spain, 1746–Bordeaux 1828

Among the great figures of the pictorial arts in the West, Goya is one of the very few whose body of work as a graphic artist is arguably more important than his paintings. Goya's print series, beginning with "Los Caprichos" in 1799, ushered in a new aesthetic and revolutionized the range of subject matter and expressive possibility not just in printmaking but in European art. Bridging the gap between the Rococo and Romanticism, his imagery foreshadowed much of what would come later, even in the art of the twentieth century. Given the importance of graphic art in Goya's oeuvre, it is surprising that he only began to make drawings in earnest relatively late in his career, when he was about fifty years old. For Goya, the function and purpose of drawings was different than for most artists. Among the more than nine hundred sheets now known by him, almost none are preparatory studies for paintings: most were made as part of sketchbooks or relate to prints. Indeed, one of the most innovative characteristics of Goya's output as a draftsman is his interest in working serially.

Scholars have identified eight groups of album drawings by the artist,[1] works he worked on sequentially that form coherent groups related by media, paper size and type, and similarity of subject matter. These album drawings span his later career, and he began the earliest in 1796 during a visit to the duchess of Alba at her estate in Sanlúcar de Barrameda.[2] As one writer put it, the primary theme of this Sanlúcar album is "Woman,"[3] and in it Goya recorded his observations (fantasies?) of the duchess and her circle. The album to which the Cleveland drawing belongs (known both as the Madrid Album and Album B) relates to this group both thematically and stylistically, especially the first half of the album. Goya began working on it not long after the first, probably in Cádiz, near Sanlúcar. He then took the album with him to Madrid where he completed it.

Goya drew this series of ninety-four works[4] on both sides of the pages of a bound sketchbook. Taken as a whole, the series shows a significant transition in his art. Because he numbered each of the drawings in the Madrid Album himself, we know that he conceived them in a fixed sequence.[5] The earlier drawings have much the same sensibility as the Sanlúcar album, with many scenes of elaborately dressed women. Representations of love and sexuality become, however, more overt. The detached page now in Cleveland fell roughly midway through the album; Goya numbered the recto and verso "49" and "50," respectively. The former shows a young woman, no doubt a prostitute, propositioning an older man. There is a coarseness to the encounter and especially in the rendering of the man that is new in Goya's work. As Pierre Gassier described it, "Caricature and the grotesque—major elements of Goya's art—appear for the very first time in this drawing."[6] It thus marks an important transition within the sequence of the album. It comes before a drawing[7] in which the artist turns satire into something more brutal, otherworldly, and sinister.[8] In the images that follow, Goya intensified his social satire and explored the darker themes of the occult and witchcraft that are such an important part of his art in general. As one of the earliest examples in Goya's work of the satire of human nature and folly, it relates to his first print series, "Los Caprichos," on which he seems to have set to work almost simultaneously. The vertical format and use of brush and gray wash are very similar in his drawings for the "Caprichos," some of which are derived directly from images in the Madrid Album.[9]

The verso of the Cleveland sketchbook page is an unusual subject: a young woman laments the death of a young man to whose dead body she has apparently been led by the little dog that tugs at her skirt. Recently, Juliet Wilson-Bareau has suggested that Goya is here following the traditional iconography for representations of Saint Margaret of Cortona, a nobleman's mistress who repented and entered a convent after his dog led her to her murdered lover's corpse.[10] The drawing is related to a number of ironic scenes of Love and Death, as in Madrid Album pages 35 and 77.[11] Wilson-Bareau has also pointed out the similarity of her pose to an earlier work from the Sanlúcar album.[12] CEF

Brush and black and gray wash (recto and verso), on cream laid paper

235 x 145 mm (9¼ x 5¹¹⁄₁₆ in.)

WATERMARK: lower left: fleur-de-lys (partially cut off)

INSCRIPTIONS: by artist, upper right, in gray wash: *49*; verso, by artist, upper left, in gray wash: *50*

John L. Severance Fund 1995.15.a,b

1. For a discussion of the history of these notebooks and their reconstruction, see Gassier 1973, 9–16, where he summarizes past scholarship on this group of works. See also Eleanor A. Sayre, "Introduction to the Prints and Drawings Series," in *Goya and the Spirit of the Enlightenment* (Boston, 1989).

2. The album is catalogued and discussed in Gassier 1973, 17–44.

3. Gassier 1973, 46.

4. Several of which are missing; the highest number inscribed on the known surviving pages is 94.

5. A knowledge of the sketchbook as a whole has only been possible in modern times. Goya's drawing albums were private works that the artist kept to himself until his death. They were later broken up and are now dispersed all over the world, and their reconstruction has been the result of relatively recent scholarship.

6. Gassier 1973, 130, under no. b 49.

7. The Cleveland drawing came before two pages (51/52 and 53/54, as the artist numbered them) that are unknown and missing; we do not know whether they represented the last of the earlier sequence of untitled drawings in the sketchbook or belong to the later sequence, when the subject matter changed and the artist began inscribing the sheets with titles.

8. Gassier 1973, nos. b 55–56.

9. See Eleanor A. Sayre, *The Changing Image: Prints by Francisco Goya* (Boston, 1974), 59–60, 70–73, 80–81.

10. Juliet Wilson-Bareau, recorded in CMA files and electronic communication with author, 15 February 2000. My thanks for her help in the preparation of this entry.

11. Wilson-Bareau, electronic communication with author, 15 February 2000.

12. Wilson-Bareau, letter to Jane Glaubinger, 27 March 1997, CMA files, referring to the drawing in Gassier 1973, no. A.m [13].

French Drawings

Since its acquisition, this lovely but enigmatic drawing has been the subject of many scholarly attempts to assign it a secure date or attribution. As William Wixom pointed out, the clothing of all the figures seems to reflect French court fashions during the reign of Charles VIII.[1] Other authors have made similar observations, generally dating the work to the first decades of the sixteenth century and attributing it to a French master.[2] The style of the drawing itself, in passages such as the beautifully crumpled drapery of the lady's skirt or the reserved, aristocratic facial types, supports these general assumptions.[3]

The problems with dating and attributing this drawing are paralleled by the question of the work's exact meaning. J. L. Schrader suggested that the wicker enclosure surrounding the young lady may recall the theme of the Unicorn in Captivity, and its symbolic association with chastity.[4] Likewise, another scholar noted that the young woman's pose—seated directly upon the ground—recalls the iconography of the Madonna of Humility.[5] Despite these virtuous or sacred associations, however, it seems clear that the drawing is associated with the pur-suit of amorous pleasures. The text above the image reinforces this interpretation: "He who will conquer my love / This [barrier] must overcome / Neither destroying it nor loosening it / Going neither below it nor above."[6] The origin of this verse lies within the tradition of late medieval collections of love riddles. Among the most famous of them is the illuminated manuscript *Les Adevineaux Amoureux* (Musée Condé, Chantilly).[7] Compiled by an anonymous author in 1478, these guessing games, like the inscription on the Cleveland drawing, involve verbal sparring matches between courtly ladies and gentlemen.

Because of the rather featureless landscape behind the figures, several scholars have associated this drawing with models for tapestries or other decorative textiles, although whether it served as a pattern or was copied after a completed work is unclear.[8] It has also been suggested that the work may have been a preparatory drawing for a print.[9] Regardless of how it is related to the artistic process, it almost certainly belonged, as Wixom noted, to a series of similar images paired with inscriptions. ST

1. Wixom 1967, 314.

2. Schrader, in Lawrence 1969, 43–44.

3. See Joan Evans, *Dress in Mediaeval France* (Oxford, 1952), 62–63.

4. Schrader in Lawrence 1969, no. 38.

5. Ann Arbor 1975, 97, no. 58.

6. My thanks to Christine Edmonson of the museum's Ingalls Library for her help translating this passage.

7. Ms. 654 (1572); James Woodrow Hassell, *Amorous Games: A Critical Edition of Les Adevineaux amoureux*, 1974.

8. Muylle 1983, 131. The present author compared the Cleveland drawing to the *Bourbon-Emblem Book* (Bibliothèque Nationale, Paris, ms. fr. 24461), which contains a series of gouaches intended as patterns for tapestries and other decorative projects.

9. Ann Arbor 1975, 97.

Celuy mamour conquestera.
qui deca ce las passera.
Sans lempirer ne desnouer
sans dessus ne dessoubz passez

Pen and brown ink, brush and
brown wash, with traces of
black chalk, on cream laid paper

230 x 193 mm (9 x 7⁹/₁₆ in.)

WATERMARK: center: wheel (simi-
lar to Briquet, 1923, no. 13389)

INSCRIPTIONS: upper center, in
brown ink: *Celuy mamour
conquestera / qui deca ce laß
passera / Sanß lempirer ne
desnouer / sanß dessuß ne
dessoubz passez*

John L. Severance Fund 1956.40

Claude Gellée, called Claude Lorrain

Champagne 1604/5–Rome 1682

The pastoral group in this drawing probably originated as a study of figures for a painting. The figures relate to at least three pictures by Claude dating to the 1640s, but not to any one exactly.[1] In the *Pastoral Landscape* of 1641[2] similar figures of a seated shepherd and two standing women appear at left. The *Landscape with the Judgment of Paris* of 1645 in the National Gallery of Art (Washington) shows Paris seated at left with the standing figures of Venus and Hera in attitudes like those in the drawing here.[3] A third painting, lost but known from a drawing in Claude's *Liber Veritatis*, is dated 1647 and again repeats the three figures at left.[4] Typically Claude drew figures in poses that he would employ in paintings and then completed the drawing as a finished work of art. First he would draw the figures and later add an appropriate setting and enclose the composition with a drawn frame, as here.[5] As his landscapes always evoked a human theme, figural drawings were central to his work and he viewed his drawings as autonomous products.

In the 1640s Claude became more interested in classical subjects and art and looked mainly to Raphael for inspiration for themes and figural compositions. The *Pastoral Scene with Classical Figures*, like many of Claude's figural groups, depended on narratives in Raphael's Vatican *loggie*, namely, the scene of Jacob and Rachel.[6] The grouping is natural for a Judgment of Paris composition, and Claude also looked at Marcantonio Raimondi's print after Raphael of that subject.[7] A print of the Judgment of Paris by Giorgio Ghisi after Giovanni Battista Bettano[8] may actually be another source for the grouping. There Paris sits under a tree with his right leg extended while Mercury stands next to him; Venus and Minerva stand near in poses close to those of the standing women in the Cleveland sheet. Claude repeated similar groupings in other drawings of the same period in London (British Museum) and New York (Wildenstein & Co.);[9] other paintings also have a figure seated on a rock with two standing figures at right.[10] The number of these drawings indicates the care with which the artist composed his paintings, his interest in Renaissance sources for classical themes, and his ability to give infinite variation to a simple figural composition.

Pastoral Landscape with Classical Figures is one of a group of eighty-one drawings that were gathered into an album, probably by Claude's heirs, possibly to present to a prospective collector who could have been the connoisseur Queen Christina of Sweden.[11] The drawings include the entire range of the artist's oeuvre and are admitted to be among the finest of his graphic works. The Cleveland drawing is the earliest of his great classical figure studies in the album and one of the earliest examples of a figure study transformed into a finished work of art. It works as an autonomous picture not just by the addition of the landscape elements and the surrounding frame but by the concern for gestural effects and the addition of deep washes to evoke a silent drama in which these unknown bucolic characters take part. DDG

1. First noted by Roethlisberger 1962b, 21–22, no. 27.

2. Collection of George Howard, Esq., Castle Howard; see Roethlisberger [1961], 2:fig. 124. Drawing 56 from Claude's *Liber Veritatis* (British Museum, London) that is related to *Pastoral Landscape* has further figures and is also close to the Cleveland drawing; see Roethlisberger [1961], 2:fig. 125.

3. For the drawing in the *Liber Veritatis* related to this landscape, see ibid., 2:fig. 175; for the painting, see Russell in Washington 1982–83, 34.

4. Roethlisberger [1961], 2:fig. 200.

5. Note here how the figures were obviously drawn first and the landscape added behind and between them. For a discussion of Claude's figure drawings with a history of the bibliography, see Michael Kitson, "Claude Lorrain as a Figure Draughtsman," in *Drawings: Masters and Methods. Raphael to Redon*, ed. Diana Dethloff, Papers presented to the Ian Woodner Master Drawings Symposium at the Royal Academy of Arts (London, 1992), 64–88.

6. Roethlisberger 1968, 197, no. 461, and fig. 1181. Scholars also acknowledge Claude's debt to Annibale Carracci's figure style.

7. Roethlisberger 1970, 53, fig. 22. Roethlisberger noted how often Claude employed this theme. Goldfarb 1983, 169, suggested that the figures were closer to an engraving by Marcantonio Raimondi after Francesco Francia but later (Goldfarb in Cleveland et al. 1989–90, 71, no. 30) agreed with Roethlisberger's suggested source of the Vatican *loggie* composition.

8. Roethlisberger 1970, 54, fig. 23 (Roethlisberger 1968, 1:no. 371).

9. Roethlisberger 1970, 51–52, figs. 20–21 (Roethlisberger 1968, 1:no. 597).

10. See, for example, the *Landscape with Rural Dance* of 1640–41 (Collection Duke of Bedford; see Roethlisberger 1968, 2:fig. 122).

11. On the provenance of the drawings, see Roethlisberger 1962b, 9–10.

Pen and brown ink and brush
and brown and gray wash over
graphite, on cream laid paper

192 x 258 mm (7⁹⁄₁₆ x 10⅛ in.)

Leonard C. Hanna Jr. Fund
1982.13

Claude Gellée, called Claude Lorrain

Champagne 1604/5–Rome 1682

Although depicting the real view of an area north of Rome where the bend in the Tiber River is called the Acqua Acetosa, this drawing evokes an arcadian era of harmony between man and nature. The classically garbed figures in the foreground look over the cows and goats coexisting on the grassy hillside, while smaller figures carrying spears in the background appear as peaceful Roman soldiers. The composition is typical of Claude's organizational method: closing the dark repoussoir foreground at the sides with trees and giving the middle ground an all-encompassing light from the central background. No tree nor mountain is proportioned according to nature, yet the overall feeling is that of a perfection of nature. The care that Claude expended to reach this ideal can be seen in his many known sketches of animals and figures and quick pen sketches drawn on the spot in the Roman countryside.[1]

According to his biographer, Joachim Sandrart, Claude often sketched his scenes on trips to the Roman campagna with his friend Nicolas Poussin.[2] In fact, Poussin depicted the same view in the background of his painting *Landscape with St. Matthew and an Angel* (Berlin, Gemaldegalerie) of 1640.[3] Possibly the two sketched this scene simultaneously and each used his sketch for reference when back in the studio: the Cleveland drawing was certainly worked up as a finished work of art. The new interest in classical references and the arcadian feeling apparent in this view may also be based on the older artist's intellectual influence on Claude. This connection may afford a date for a lost sketch from which the Cleveland sheet would derive. In addition, for humanists of the period the Roman campagna was associated with the glories of the Roman past.[4] The style of the finished composition has been placed in the early to mid 1640s based on comparisons with drawings of the period.[5] Claude returned to the view of the Acqua Acetosa in three other drawings, one possibly from the 1640s and two others from the 1660s.[6] In those drawings the squarish rock at the bend of the river has been changed to a house or a tower. Only in the present sheet is the serenity and vast expanse of the landscape emphasized.

On the verso of the sheet are black chalk sketches of two figures identified by a later hand as David and Goliath. For these figures Claude looked to several sources, including Poussin's painting the *Victory of Joshua over the Amalekites* of 1625/26 (Hermitage, St. Petersburg), Bernini's sculpture of David with a sling of 1519–23, and possibly the battles by Raphael and his circle in the Sala di Costantino of the Vatican.[7] The difference in scale between the figures is remarkable and does not depend on any of Claude's visual sources, but rather accentuates the uneven match between the small Israelite and his giant opponent. These figures are not found in any painting by the artist, who did represent other episodes from David's life.[8] DDG

34. *View of the Acqua Acetosa*

c. 1645

Pen and brown ink and brush and brown and gray wash over graphite, framing lines in brown ink, on cream laid paper; verso, black chalk

260 x 405 mm (10³⁄₁₆ x 15¹⁵⁄₁₆)

INSCRIPTIONS: verso, lower left, in brown ink: *beau peisage de claude Le Lorrain*; lower left, in graphite: *David*; lower right, in graphite: *Golia*; upper center, in graphite: *No 2599*; lower center, in graphite: *Claude Lorraine / From the Collection of / Lord Brownlow (The Belton / House Collection) / Signed Claudio Gellée.*; lower left, in red watercolor: *55*

Gift of Mr. and Mrs. Edward B. Greene 1928.15.a,b

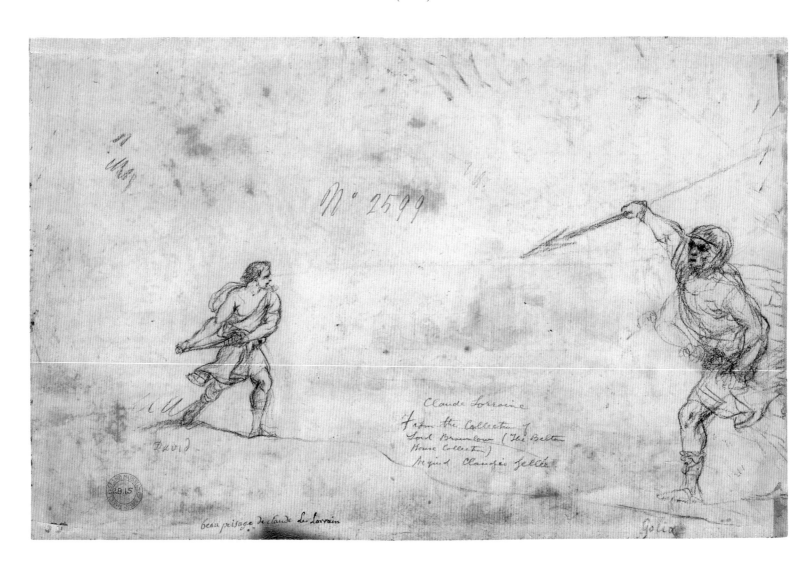

1. See, for example, Roethlisberger 1968, 2:pls. 136–38, 144, 206–67, 317.

2. Joachim Sandrart, *Teutsche Academie* (Nuremberg, 1675), 1:332, trans. Roethlisberger [1961], 1:52.

3. Noted first by Roethlisberger 1968, 1:235, no. 591. For Poussin's painting and its date, see *Nicolas Poussin. 1594–1665*, exh. cat., Galeries Nationales du Grand Palais (Paris, 1994–95), 288–89, no. 94.

4. See Langdon 1989, 17, on a poem by Maffeo Barberini (b. 1568, elected Pope Urban VIII 1623, d. 1644) celebrating the Roman campagna for its evocation of the Roman history.

5. For example, Roethlisberger 1968, 2:pl. 424–25. As Roethlisberger noted earlier, drawings do not suggest classical subjects.

6. Ibid., 2:pls. 874, dated 1662; 875, datable to 1640s, according to Marcel Roethlisberger, *The Claude Lorrain Album in the Norton Simon Inc., Museum of Art* (Los Angeles, 1971), 17, no. 12 (both ex Wildenstein album); and 876 (Albertina Graphische Sammlung, Vienna, inv. no. 11,525).

7. Roethlisberger 1962c, 157, suggested the Poussin influence from the picture in the Hermitage, St. Petersburg. He also noted the relationship with Raphael's scene of David and Goliath in the Vatican *loggie*, which is not as close. Goldfarb in Cleveland et al. 1989–90, 72, no. 31, connected the figure of David with Bernini's sculpture.

8. In a painting of 1658 he depicted *King David and the Three Heroes* (National Gallery, London), and in a lost drawing he depicted David triumphant with the head of Goliath. Both noted by Roethlisberger 1962c, 157. The painting is reproduced in Roethlisberger [1961], 2:pl. 240. The drawing in a private collection (see Roethlisberger, "Newly Discovered Drawings by Claude Lorrain," *Drawing* 15 [May–June 1993], 9) sold at Sotheby's as lot 1394 in 1866 Wellesley sale.

Charles de La Fosse

Paris 1636–1716

An important transition figure in the history of French painting, Charles de La Fosse trained with Charles Le Brun, the most influential decorative painter of large-scale works in seventeenth-century France, and then became the major practitioner of the genre for his generation, though much of his work has not survived.[1] Unlike Le Brun, however, La Fosse was heavily influenced by Venetian painting and the work of Peter Paul Rubens. In that sense, his work illustrates the colorist side of the ideological debate between color and line (between "Rubénistes" and "Poussinistes") that marked much of the intellectual discourse on art at the time, most importantly in the work of theorist Roger de Piles (an avid Rubéniste).[2] La Fosse was also an important early supporter of Jean-Antoine Watteau and did much to help the younger artist establish himself. La Fosse's style anticipated some of Watteau's developments, which is especially apparent in La Fosse's drawings.[3]

The Cleveland sheet is an important example of La Fosse's "trois crayons" (three-chalk) technique (using black, red, and white chalk together), which became Watteau's hallmark and influenced many eighteenth-century draftsmen. La Fosse drew it in preparation for his monumental fresco decorations at the church of the Invalides, including the main dome and its four pendentives,[4] painted between 1703 and 1706.[5] The pendentives show the Four Evangelists, and the Cleveland sheet relates to the design for St. John. As was normal for such an involved project, La Fosse developed his ideas in numerous preparatory studies. An oil sketch now in the Musée des Arts Décoratifs, Paris (fig. 1), shows an early version of the design: the saint wields a pen, ready to write on a scroll held by an angel as he looks upward, receiving the word of God. The Cleveland drawing relates to this stage of composition, not to the final fresco in which La Fosse changed the pose of St. John to include an emphatic, upward gesture of his proper left hand.[6] A drawing with an important connection to the Cleveland sheet is in Le Havre, a figure study of the same model in the same position, but drawn in the nude.[7] The Cleveland sheet is, by contrast, primarily a drapery study, one that allowed La Fosse to exploit the tonal range of the trois crayons technique to its fullest.[8] CEF

Fig. 1. Charles de La Fosse. *St. John, Study of the Pendentive for the Invalides,* c. 1700, oil. Musée des Arts Décoratifs, Paris, inv. no. 2019.

1. Margret Stuffmann, "Charles de La Fosse et sa Position dans la Peinture Française à la Fin du XVIIe Siècle," *Gazette des Beaux-Arts* 64 (July-August 1964), 1–121.

2. On the connections between La Fosse's work and de Piles's ideas, see Hedley 2001.

3. Hedley 2001 is a study of the artist's development as a draftsman.

4. Stuffmann 1964, 80–87, 107, no. 46; Pierre Marcel, "Les Peintures Décoratives de l'Église des Invalides et de la Chapelle de Versailles," *Gazette des Beaux-Arts* 34 (October 1905), 265–80; Louis Dimier, *L'Hotel des Invalides* (Paris, 1928), 46–52.

5. Rosenberg in Toronto et al. 1972–73, citing C. Souviron, "Les Peintures de l'église Saint-Louis des Invalides" (thesis, L'École du Louvre, Paris, 1954).

6. A recently discovered oil sketch on the Parisian art market corresponds to the final composition. See Hedley 2001.

7. See Vercier 2000, 137, fig. 7.

8. La Fosse executed another drawing of St. John the Evangelist that was possibly for another part of the Invalides commission, one that was eventually passed on to Jean Jouvenet; see Musée du Louvre, *Dessins français du XVIIIe siècle de Watteau à Lemoyne* (Paris, 1987), 8–9, no. 2.

35. *St. John the Evangelist*

c. 1700–1702

Black, red, and white chalk on beige laid paper

420 x 262 mm (16½ x 10⁵⁄₁₆ in.)

INSCRIPTIONS: verso, center, in brown ink: *191* [underlined with flourish]; upper left, in graphite: *Lot 353* [underlined] / *Hotel Drouot / Vente Chardey / 14–17*

Mai/77; lower left, in graphite: *C. Delafosse* [underlined]

Gift of Alida di Nardo in memory of her husband, Antonio di Nardo 1956.602

François Boucher

Paris 1703–1770

Boucher's playful drawing of a rococo fountain belongs to a series of seven designs that Gabriel Huquier etched and published in 1736.[1] Many consider Boucher one of the defining artists of the Rococo, but within the more narrow definition of this style, described by the French terms *l'art rocaille* (rock and shell art) or *goût pittoresque* (picturesque taste), Boucher's body of work is quite small and falls fairly early in his career. The Cleveland sheet well illustrates his understanding of the rocaille vocabulary: a rocky grotto frames a fountain of shells supported by intertwined dolphins, with two tritons blowing water from conchs. His melding of plants, animals, rocks, shells, and mythological beasts into one seamless, asymmetrical form is the very definition of the term.[2]

Although Boucher himself made a number of original prints in the 1730s, the reproductive prints after his designs were far more significant in spreading his influence.[3] With regard to the rocaille, the printmaking and publishing activity of Gabriel Huquier is hard to overstate: his efforts in diffusing the genre helped to define it, since many of the most innovative examples of rococo design exist only as abstractions in prints and ornament books.[4] This is certainly true for the work of Gilles-Marie Oppenord, who became known thanks to Huquier's publications and who influenced Boucher at the time he made the Cleveland drawing.[5] The same is true of Juste-Aurèle Meissonnier, who was godfather to Boucher's son. Huquier owned drawings by both Meissonnier and Oppenord, and Boucher was certainly familiar with their contributions to rococo design in the mid-1730s, when the *style rocaille* was at its height.

Boucher likely drew his series of fountains specifically for the print market, and we can date the Cleveland drawing because of the sale announcement for the prints.[6] In his print after *Fountain with Two Tritons Blowing Conch Shells* (fig. 1), Huquier altered Boucher's design significantly and would have made his own drawing based on Boucher's as a guide in etching the plate.[7] His changes no doubt reflect a design he considered more appropriate for reproduction in etching.[8] The main difference is the architectural niche that replaced Boucher's rocky grotto. Huquier also clarified certain details left sketchy in the drawing, and added some plant forms of his own.[9]

Shortly after the publication of this series, Huquier published a second group of fountain designs after Boucher, of a similar size and format.[10] Although the Cleveland drawing is the only one for either series that has survived, Huquier seems to have owned a number of them.[11] Other fountain drawings by Boucher include the sheet in Saint Louis[12] and one recently on the New York art market,[13] but both date to later in Boucher's career. The present drawing and the two related print series, along with an important group of screen designs from the same time, form the core of Boucher's work in the style rocaille and have become part of the corpus of work that defines the genre. CEF

Fig. 1. Gabriel Huquier, after François Boucher. *Fountain with Two Tritons Blowing Conch Shells*, 1736, etching with engraving. The Cleveland Museum of Art, Gift of Erich Lederer 1952.518.

1. On the etchings, see Roux 1933, 11:457; Paris 1971, 78–79; Jean-Richard 1978, 273–74, nos. 1090–97.

2. Several scholars point to the Widow Chéreau's advertisement in the *Mercure de France* for a suite of prints by Juste-Aurèle Meissonnier as the best definition of the style rocaille; see Laing 1979, 113–14; Roland Michel 1984; see also Bruno Pons, "The Rocaille," in *The History of Decorative Arts: Classicism and the Baroque in Europe* (New York/London/Paris, 1996), 327–29.

3. Jean-Richard 1978.

4. Roland Michel 1984, 148–50.

5. See, for example, Oppenord's fountain designs, *Livre de differents Fragments pour des Fontaines* (whose designs date to the 1690s) published by Huquier around 1742–48 as part of the "Petit Oppenord" (Roux 1933, 11:506, nos. 1294–99); reprinted in *Recueil des Oeuvres de Gille-Maris Oppenord* (Paris, 1888).

6. It appeared in the *Mercure de France*, April 1736 (cited in Paris 1971, 78–79).

7. On Huquier's methods as a draftsman and printmaker, see Martin Eidelberg, "Gabriel Huquier—Friend or Foe of Watteau," *The Print Collector's Newsletter* 15 (November–December 1984), 158–64; Martin Eidelberg, "Huquier in the Guise of Watteau," *On Paper* 1 (November–December 1996), 28–32.

8. On Huquier's methods of working, see ibid., and Roland Michel 1984, 149.

9. Such design changes were typical of Huquier, and his creative role in the prints he published is now better understood; see Eidelberg, "Gabriel Huquier"; Eidelberg, "Huquier in the Guise of Watteau."

10. Engraved by Aveline; see Jean-Richard 1978, 82–83, nos. 216–22.

11. See the provenance section in the back of this catalogue. For more details on the provenance of Boucher's fountain drawings, see Paris 1971, 78–79, no. 72.

12. See Washington/Chicago 1973–74, 39, no. 30.

13. Christie's, New York, 10 January 1996, no. 205.

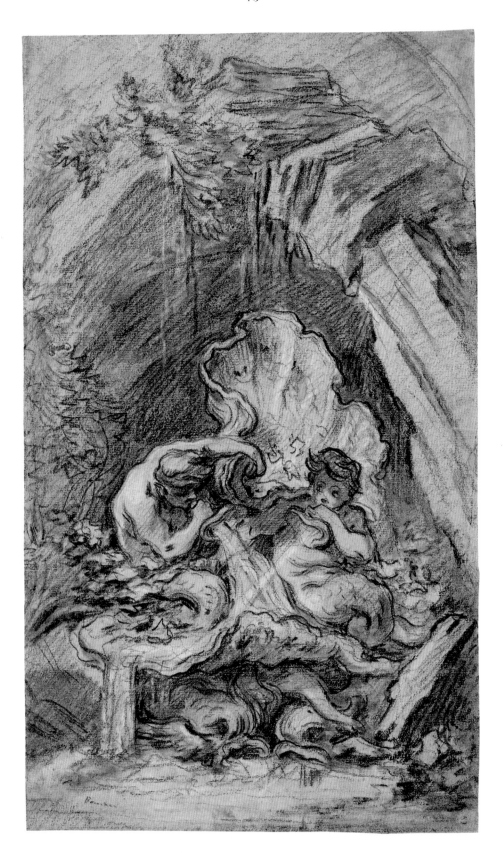

Black and red chalk and black chalk wash, heightened with white chalk, on beige laid paper, laid down on beige laid paper

377 x 222 mm (14¹³⁄₁₆ x 8¹¹⁄₁₆ in.)

WATERMARK: none visible through mount

INSCRIPTIONS: lower left, in brown ink: *Boucher*; secondary support, in graphite: [195?]; verso of secondary support, upper center, in brown ink: *M / No. 53*; center, in graphite: *B / [illegible]*

John L. Severance Fund 1952.529

François Boucher

Paris 1703–1770

Alexandre Ananoff and Daniel Wildenstein were the first to publish this drawing,[1] and they considered it a preparatory study for a lost Boucher painting of similar composition, which they dated to 1729. The painting is known only through the print after it by Elisabeth Cousinet-Lempereur (fig. 1).[2] After the CMA's purchase of the sheet, Hilliard Goldfarb argued for a later date of c. 1755, based on stylistic comparison to other drawings in Boucher's oeuvre.[3] Although the chronology of Boucher's drawings poses many problems,[4] Goldfarb was certainly justified; the sheet is clearly not an early one by the artist,[5] and the carefully layered combination of pen work, thin brushstrokes, and broadly applied washes compares well to securely datable works from this mature period in Boucher's career.

Yet, the Cleveland drawing does have much in common with the lost painting, and the identification of the work with the subject of the Departure of Jacob is logical. In the Old Testament story of Jacob and his marriage to the daughters of Laban, Jacob departs in secret for Canaan with his wives, children, and herds of livestock after having worked for Laban many years to secure his marriage to Rachel. The drawing shares the same basic composition as the lost painting, with a female figure holding a baby at her breast reclining on the ground next to a donkey. In the drawing, Boucher eliminated the figures visible in the left background of the print, where they represent Rachel's father in search of the household idols she stole. This omission makes the Cleveland work less clear in terms of the Jacob narrative, but the subject is certainly more than a simple Boucher pastoral.[6]

Goldfarb related the drawing to the biblical narratives of the seventeenth-century Genoese master Giovanni Benedetto Castiglione.[7] Castiglione depicted the Departure of Jacob more than once, and for him it became an excuse to present a profuse, raucous procession of animals and figures.[8] Although Boucher's work is more tightly composed, it does suggest the influence of Castiglione. We know that Boucher owned several of Castiglione's drawings,[9] and the use of red wash in the Cleveland work recalls his technique of red and brown oil washes on paper. Certain elements in the Cleveland drawing do suggest the idea of the pastoral, most notably the male figure's offer of a pear to his companion, a gesture that recalls some of Boucher's best-known works of country lovers, such as *Pensent-ils au raisin?* (*Are They Thinking of Grapes?*).[10] The presence of babies, however, one of which the mother suckles, leaves no doubt that this couple is far beyond the early stages of courtship typical of Boucher's pastorals. CEF

Fig. 1. Elisabeth Cousinet-Lempereur (French, b. 1726), after Boucher. *Depart de Jacob*, engraving.

1. Ananoff/Wildenstein 1976, 171–72. However, what appears from reproduction to be a copy of the present sheet appeared on the London art market in 1969; see *Apollo* 90 (September 1969), lxvi.

2. Sylvain Boyer recently published a drawing after Boucher related to this painting, which Jean-François Méjanès proposed might be by Cousinet-Lempereur; see Amiens 1997–98, 50–51.

3. Goldfarb 1984.

4. For more on this subject, see the following reviews: Eunice Williams, "François Boucher in North American Collections," *Master Drawings* 12 (Summer 1974), 172–76; Regina Slatkin, "Alexandre Ananoff: *L'Oeuvre dessiné de Boucher, Catalogue raisonné, Vol. 1* [review]," *Master Drawings* 5, no. 1 (1967), 54–66.

5. A comparison with any number of Boucher's drawings from the 1720s and early 1730s shows how distinctly different he was during this period of his career; see Beverly Schreiber Jacoby, *François Boucher's Early Development as a Draughtsman 1720–1734* (New York/London, 1986).

6. For an insightful discussion of the original characteristics of Boucher's pastorals, see Laing 1986. In addition to the Jacob story, the drawing holds some analogies with Boucher treatments of the Rest on the Flight into Egypt, most notably the 1757 painting in the Hermitage, St. Petersburg; see Alastair Laing et al., *François Boucher* exh. cat., Metropolitan Museum of Art (New York, 1986), 277–80, no. 68 (repr.).

7. Goldfarb 1984, 84–86.

8. Ann Percy reproduces a Castiglione drawing of the subject in *Giovanni Benedetto Castiglione: Master Draughtsman of the Italian Baroque* (Philadelphia, 1971), 94–95, no. 58; a painting of the subject by Castiglione is in the Museo del Prado, Madrid; see *Museo del Prado Inventario General de Pinturas I La Collección Real* (Madrid, 1990), 177, no. 619 (repr.).

9. Washington/Chicago 1973–74, 7, under no. 4.

10. For a discussion of Boucher's treatment of this subject, see Laing, *François Boucher*, 233–37, no. 53.

37. *The Departure of Jacob* (also known as *Pastoral Scene with Family at Rest*)

c. 1755

Pen and brown and black ink and brush and brown wash, with black chalk, red chalk, and red chalk wash, framing lines in black ink, on cream laid paper

348 x 231 mm (13¹¹⁄₁₆ x 9⅛ in.)

WATERMARK: center: crown with shield / VANDERLEY

Delia E. Holden and L. E. Holden Funds 1981.58

François Boucher

Paris 1703–1770

One of the masterpieces of Boucher's late drawing style,[1] this sheet has a confusing provenance because of ambiguous listings in older sale catalogues. Boucher executed at least two versions of the subject during the last decade of his life: this work, and the brown oil sketch on paper now in the Louvre (fig. 1).[2] Other versions may have existed. A sheet with the same title passed through the sale of the painter Aved in 1766 and most have assumed it to be a different drawing from the Cleveland sheet (though we cannot be certain). The CMA drawing was probably the work sold in 1770 by Blondel d'Azincourt.[3] Confusion exists as well in the provenance of the oil sketch in the Louvre. Some have taken it to be a study for another oil sketch sold out of Boucher's property after his death[4] rather than the work that appeared in the sale.[5] The ambiguity of the sale records suggests the likelihood of multiple versions, and speculation beyond that seems pointless.

If the Aved version was indeed an earlier version, then we know that Boucher was interested in the subject before 1766. The Louvre oil sketch is signed and dated 1770, and the Cleveland drawing must date to around that time, a step on the development of the final work—presumably an oil painting he never completed. In any case, this major religious composition is complicated, and Boucher necessarily worked out ideas for it in numerous preparatory sheets.[6] Scholars have assumed the Louvre work came after the Cleveland sheet because it is signed and was executed in oil. Such a supposition makes sense,

but the Cleveland drawing differs in interesting ways: the composition seems more focused on Mary and the priest because the figures around them are fewer and open up more. The effect of light is also important, with Boucher using it to highlight the main figures and organize the space more so than in the oil sketch. The shaft of divine light emanating from the holy spirit down onto the head of the priest has iconographic significance: the blind priest Simeon, who was promised the sight of the messiah before his death, was cured of his blindness upon seeing the infant Christ.

Because the Louvre *Presentation* is dated, we know it was one of the artist's very last projects, and it shows he was aware of the tradition of the subject in French painting. He would have known Simon Vouet's important altarpiece, owned and displayed by the Royal Academy since 1764—perhaps its entry into their collection even inspired him to attempt the subject.[7] But Boucher also made a trip to the Low Countries in 1766, and how Rubens treated the subject in his celebrated Antwerp altarpiece must have had an impact. Boucher's figure of Joseph is quite close to that of Rubens. More significant still was Sébastien Bourdon's large painting of the subject, which belonged to the duc d'Orleans and which Boucher thus could have seen in the Palais Royal in the 1760s.[8] Boucher reversed the composition, but the positions of the main figures are similar, especially the female figure of Charity, which Boucher seems to have taken directly from the seventeenth-century master. CEF

Fig. 1. François Boucher. *The Presentation in the Temple,* 1770, oil on paper, heightened with gouache. Musée du Louvre, Paris, inv. no. R.F.24751.

1. On Boucher's late style, see Beverly Schreiber Jacoby, "Boucher's Late Brown Chalk Composition Drawings," *Master Drawings* 30 (Autumn 1992), 255–86.

2. Guiffrey/Marcel 1907–28, 2:56, no. 1370; Paris 1971, 103–4, no. 113, pl. 24.

3. The literature on the Cleveland sheet has only confused matters related to provenance. To clarify the evidence: there were drawings of the *Presentation in the Temple* listed in the Aved sale (1766) and the Blondel d'Azincourt sale (1770). The Cleveland drawing roughly fits the measurements given in the Blondel d'Azincourt catalogue. (According to the annotated copy of this catalogue, this drawing was sold to Chariot, though the dimensions of the sheet in the subsequent Chariot sale do not match the Cleveland drawing—a discrepancy that could be explained by the old mount, now removed. Yet the reference to Baudoin as the

previous owner of the sheet in the Chariot catalogue suggests it is not the one in the Blondel d'Azincourt collection. Perhaps this reference to Baudoin is a mistake?) The Aved and Blondel d'Azincourt drawings were likely not the same. Because the former predates 1766, it probably was another variant of the subject, perhaps one quite different from the later project represented by the Cleveland and Louvre versions. A pen and ink version appeared in the Tripier-LeFranc sale of 1883; its dimensions also roughly match the Cleveland sheet, but Tripier-LeFranc could have instead owned the Aved version (as Michel [1906] suggests). In other words, if there were indeed two versions (one owned by Aved and one owned by Blondel d'Azincourt), we do not know which appeared in the 1883 Tripier-LeFranc sale—the inconsistency of previous literature about the provenance makes that point. The only

absolute certainties in the Cleveland drawing's provenance are the Graaf and Heseltine collections, since their marks appear on the work.

4. Sérullaz 1968, no. 50; Washington/Chicago 1973–74, 129.

5. The conclusion of Ananoff/Wildenstein 1976, 311, no. 686, and Michel [1906], no. 712.

6. A red chalk drawing shown in an exhibition at Férault in Paris in 1929 shows a head very similar to that of the figure of Joseph in the Cleveland sheet; see *Exposition et Vente d'un Cabinet de Dessins du XVème au XVIIIème Siècle* (Paris, 1929), 32, no. 57, pl. XVII.

7. See Jacques Thuillier, *Vouet* (Paris, 1990), 310–15, no. 51.

8. Now in the Musée du Louvre, Paris; see Gilles Chomer and Sylvain Laveissière, *Autour de Poussin* (Paris, 1994), 34–35, fig. 3.

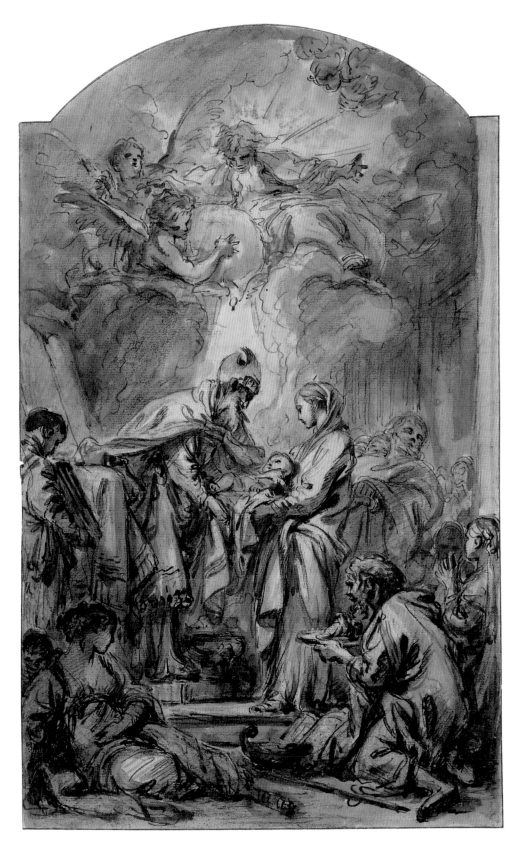

Pen and brown ink, brush and
brown wash, and black chalk,
heightened with white paint,
framing lines in brown ink, on
cream laid paper

323 x 200 mm (12⅝ x 7⅞ in.)

WATERMARK: center right: wing

INSCRIPTIONS: verso, center, in
graphite: *G*; lower left, in graph-
ite: *Lest R./–oc–*.

Gift of Leonard C. Hanna Jr.
1925.1005

Maurice Quentin de La Tour

Saint-Quentin 1704–1788

In May 1737, the Royal Academy of Painting and Sculpture accepted La Tour into its ranks as a provisionary member (*agréé*). The next month, it assigned him to execute, as reception pieces, portraits of two senior academicians, the painters François Le Moyne and Jean Restout.[1] La Tour exhibited a pastel of Restout at the Salon in 1738[2] and was accepted as a full member (*reçu*) in 1746 with another version of that work.[3] But he never submitted the portrait of Le Moyne (who had killed himself), nor the sitter assigned to him after Le Moyne's death, Jean-Baptiste Van Loo (who had left Paris).[4] Finally, in 1750, La Tour submitted of his own accord a belated second reception piece, a pastel portrait of his friend the painter Jacques Dumont Le Romain, exhibited in the Salon of 1748 (fig. 1).[5] It shows Dumont in three-quarter length, seated at a small table, holding his palette and brushes.

The Cleveland drawing, a quickly drawn study of Dumont's facial features and expression done directly from life, corresponds very closely to that portrait. La Tour had exhibited another finished pastel portrait of Dumont several years before in the 1742 Salon.[6] In this earlier work, Dumont's face and head are very close to the Louvre pastel, and he wears a similar foulard on his head. But he is playing the guitar, not about to paint (as in the Louvre version), and his pose and costume are totally different. The details of the Cleveland sheet, such as the position of the ear, the shape of the foulard, and the rendering of the proper right eyebrow, correspond to the Louvre pastel rather than the 1742 portrait. But as one author has suggested, La Tour must have used the Cleveland sheet in preparation for the earlier version, since he clearly drew it from life.[7]

La Tour's contemporaries lauded his talent for creating an uncanny likeness of his sitter.[8] He sometimes executed the face for a large portrait on a separate sheet of paper, then attached it to the larger sheet.[9] He often made several facial studies in preparation for a fully finished pastel.[10] These *masques*, as they are often called, usually display a spontaneity of execution and convey the psychological presence of the sitter more intensely than any other type of work by the artist. La Tour usually rendered such works in pastel; the Cleveland sheet, however, is more of a chalk drawing (though with some touches of color), sketchier in technique than is typical of the artist. La Tour captured his sitter in a moment of engagement with someone or something outside the frame of the image, thus activating the viewer's space. His mastery of psychological portrayal and human expression are as beautifully realized here as in any of his works. CEF

Fig. 1. Maurice Quentin de La Tour. *Portrait of Jacques Dumont, called Le Romain, Painter*, c. 1748, pastel. Musée du Louvre, Paris.

1. Montaiglon 1972, 5:205–6.
2. Now lost; see Besnard/Wildenstein 1928, 162, no. 419.
3. Musée du Louvre, Paris; see Monnier 1972, no. 63.
4. Montaiglon 1972, 5:207. Van Loo was unavailable to sit because he moved to London and then to Aix; see New York 1996, 95.
5. Montaiglon 1972, 6:234; see Monnier 1972, no. 64. La Tour seems to have conceived the portraits of Dumont Le Romain and Restout as pendants despite the years between their execution: the compositions complement each other, and the Academy kept them together over the years, since they were still a pair in the 1793 inventory; see André Fontaine, *Les collections de l'Académie Royale de Peinture et de Sculpture* (Paris, 1930) 210, nos. 652–53.
6. Recently on the New York art market; see New York 1996, 42, 94–95, pl. 9.
7. Christopher Robinson in New York 1996, 95.
8. For example, Mariette 1854–56, 3:66–78.
9. As is the case with his celebrated portrait of Madame de Pompadour in the Louvre; see Monnier 1972, no. 74.
10. A large group is in the Musée Antoine Lécuyer de Saint-Quentin; see Christine Debrie, *Maurice-Quentin de La Tour* (Saint-Quentin, 1991). That collection includes a study for the Jean Restout portrait that was the pendant to his portrait of Dumont Le Romain. A similar study of Restout is now in the Horvitz collection, see Cambridge et al. 1998–2000, 421, no. A190.

Black and white chalk with
pastel, on blue laid paper (par-
tially faded to brown-green)

308 x 208 mm (12⅛ x 8³⁄₁₆ in.)

John L. Severance Fund 1983.89

Charles-Nicolas Cochin the younger

Paris 1715–1790

This newly discovered drawing by Cochin belongs to the series of highly finished sheets he made over a period of fifteen years depicting the festivals, firework displays, parties, and funerals that marked important occasions in the life of the French royal family.[1] Cochin was commissioned to do these works by the Menus-Plaisirs, the branch of the royal household charged with organizing and presenting the royal ceremonies during the ancien régime. His prints were available for sale as well as distributed among members of the court. They were later assembled in a large festival book that became a document of these lavish spectacles under Louis XV.[2]

The prints usually marked birth, marriage, or, as in the work here, death. The Dauphin Louis, eldest son of Louis XV and heir to the throne, had married the Infanta Marie-Thérèse of Spain in the chapel of Versailles in 1745. In what are perhaps his best-known works for the Menus-Plaisirs, Cochin designed prints showing the marriage ceremony and the three events staged at Versailles to celebrate it: a costume ball, a theatrical piece by Voltaire, and a dress ball.[3] Yet just over a year later, the dauphine was dead, and funerals were given for her both in Saint-Denis and at Notre Dame in Paris. Cochin depicted both funerals in detailed drawings that served as models for etchings.[4]

In the present work, Cochin shows the interior of Notre Dame as it was transformed by the decoration of Sébastien-Antoine and Paul-Ambroise Slodtz, the sculptors and designers who worked for the Menus-Plaisirs during the first half of the eighteenth century. As detailed visual documents of the Slodtzs' work—ephemeral constructions made of trompe l'oeil painted decoration, wood, canvas, plaster, papier-mâché, and the like—

Cochin's Menus-Plaisirs prints and drawings are valuable records of some of the most innovative and important designs of the Rococo. Here, one can see how the gothic interior of Notre Dame was completely transformed into a theatrical rococo space, with a large catafalque as the focus, curtained arcades down the aisles, and a massive, columned altar at the far end.[5] Highly unusual motifs such as skull-and-batwing brackets help define this unusual funerary mode of the Rococo, one unique to ephemeral design.[6] Images of funerals form an almost independent subgenre within the tradition of festival prints, one that stretched back to the seventeenth century in the work of Sébastien Leclerc and Jean Bérain.[7] Cochin added his own innovations to this tradition, enlivening his compositions by presenting the spatial recession at an oblique angle, as in the Cleveland work, thus dramatically emphasizing the perspective through the rows of lit candles.[8] Cochin was also adept at capturing the gestures and expressions of the courtiers. We know that he attended these events because he made individual figure studies that he then incorporated into the finished design.[9] He also likely had access to the Slodtzs' designs to help rendering their complicated decoration as he worked on the drawing. His job was to create more than just a document of the event; he was to enliven it with his own artistic skills. His comments about the Slodtzs' funeral designs are telling: "funerals became something in their hands. . . . It's true that some reproached them for bringing a gallant taste and a festive atmosphere unsuitable to the gravity of the occasion, but it was necessary to please the court, who acted solemnly only with difficulty."[10] CEF

1. For an analysis of these works, see Carter E. Foster, "Charles-Nicolas Cochin *fils* and Festival Designs, 1735–51: From Drawings to Prints and Fête Books," *Master Drawings* (forthcoming, 2001); Christian Michel in Cambridge et al. 1998–2000, 254–56; and Christian Michel, *Charles-Nicolas Cochin et l'Art des Lumières* (Rome, 1993), 56–61, 393–95; on p. 57 is a list of all the events produced by the Menus-Plaisirs that Cochin depicted, as well as the drawings related to them known at the time of publication. For additional drawings, see Foster, "Charles-Nicolas Cochin *fils*."

2. *Receuil des festes, feux d'artifice, et pompes funebres, ordonnées pour le roi, Par Messieurs les Premiers Gentilhommes de sa Chambre,*

Conduites par Messieurs les Intendans & Contrôleurs Généraux de l'Argenterie, Menus Plaisirs & Affaires de la Chambre de Sa Majesté (Paris, 1756).

3. The drawings for these three events are all in the Louvre; see Guiffrey/Marcel 1907–28, 3:71–73, nos. 2280–82.

4. The drawing for the dauphine's funeral in Saint-Denis is in the Musée Carnavalet, Paris; see "Dessins Parisiens du XVIIIe Siècle," *Bulletin du Musée Carnavalet* (1971), 10, 12, no. 16 (repr.).

5. This decoration was described, as was typical for royal spectacles, in the journal of the French court, the *Mercure de France* (December 1746), 169–72.

6. For a discussion of funeral design in France, see François Souchal, *Les Slodtz sculpteurs et décorateurs du Roi (1685–1764)* (Paris, 1967), 371–422.

7. Michel, *Charles-Nicolas Cochin,* 393.

8. Ibid., 394.

9. Ibid., 60; Foster, "Charles-Nicolas Cochin *fils*." No figure studies for the Cleveland work have yet been identified.

10. Charles-Nicolas Cochin, ed. Charles Henry, *Memoires inédits sur le Comte de Caylus, Bouchardon, les Slodtz, publiés d'après le manuscrit autograph* (Paris, 1880), 129.

40. Funeral for Marie-Thérèse of Spain, Dauphine of France, in the Church of Notre Dame, Paris, on 24 November 1746

c. 1746

Pen and black ink and brush and gray wash, heightened with white gouache, incised, verso coated with red chalk, on beige laid paper

450 x 309 mm (17¹¹⁄₁₆ x 12⅛ in.)

INSCRIPTIONS: on scrap of old mount, now removed, in eighteenth-century hand, in brown ink: *C. N. Coc*[hin] [abraded] *filius delineavit. Novemb. 1746.*

John L. Severance Fund 2000.2

Jean-Baptiste Oudry

Paris 1686–Beauvais 1755

Jean-Baptiste Oudry began his career as a portraitist, studying first with Nicolas de Largillière, but he was eventually received by the French Royal Academy of Painting and Sculpture as a history painter in 1719. He gained renown, however, for his paintings of animals and hunt scenes and received numerous royal commissions. With the rise in importance of the public Salon exhibitions, his successes there further established his popularity. This recently discovered drawing relates to one of Oudry's most successful Salon paintings, a work of the same subject shown to great acclaim in 1748 (fig. 1).[1] Lenorement de Tournehem, director of the king's buildings, purchased the painting for Louis XV as soon as he saw it in the Salon and had it installed at the château of la Muette as a pendant to the artist's 1746 *Wolf Hunt*. Oudry himself enlarged the painting to accommodate its placement at la Muette.

Until its purchase by the CMA in 1997, this sheet was known only through its listing in the catalogue for the Nijman (Neyman) sale in Paris in 1776. The description and dimensions given there match it fairly closely.[2] In his preliminary catalogue raisonné, Hal Opperman suggested that the then-unknown work was likely a preparatory study for the painting, an observation that now seems borne out by the sheet itself. Toward the end of his career, Oudry regularly made finished drawings after his paintings, such as the *Water Spaniel Attacking a Swan in Its Nest* in Chicago.[3] While it is not impossible that the Cleveland sheet was made after the painting, it is sketchier in technique and less detailed compared to the Chicago sheet and other drawings by the artist of that type.[4] *Wild Sow* is fully worked out as a composition, but the rapidly drawn pen lines (especially apparent in the sow and the fallen dog at the left) and the sketchy background landscape contrast with Oudry's use of more carefully built-up washes in finished presentation sheets.[5] There are, furthermore, some minor differences between the drawing and the painting, changes one would not expect to see in a drawing made after a painting. The most obvious are the tail of the fallen dog at the left, which is shorter in the drawing, and the tuft of vegetation at the right, which is fuller in the drawing and partially hides the dog's tail. The drawing also corresponds to the format of the painting before Oudry made the additions at the sides.

Oudry placed a high value on his drawings and was a prolific draftsman, but he purposely kept them during his lifetime as an asset for his heirs, parting with very few before his death.[6] One can assume, then, that this sheet was dispersed from his estate when his drawings began to appear on the market after 1755, but that it had remained in his possession up to then.[7] CEF

Fig. 1. Jean-Baptiste Oudry. *Wild Sow and Her Young Attacked by Dogs*, 1748, oil. Musée des Beaux-Arts, Caen.

1. On the painting, see Opperman 1977, 114, 427, no. P193; Paris 1982–83, 204–7, no. 110.

2. Though not exactly: there are seven dogs in both the painting and drawing, not six as stated in the sale catalogue; that is, however, an understandable oversight since the dog attacking the sow's hindquarters is nearly hidden by the others.

3. See Paris 1983–83; Harold Joachim, *Dessins français de l'Art Institute de Chicago de Watteau à Picasso* (Paris, 1976), no. 4.

4. For example, the work in the Horvitz collection; see Cambridge et al. 1998–2000, 176–79, no. 38.

5. See Opperman's discussion of such works in Paris 1982–83, 218–20, nos. 119–20; and in Cambridge et al. 1998–2000, 176–79, no. 38.

6. Opperman 1977, 135.

7. For a discussion of the market for Oudry's drawings in the late eighteenth century, see ibid., 135–39.

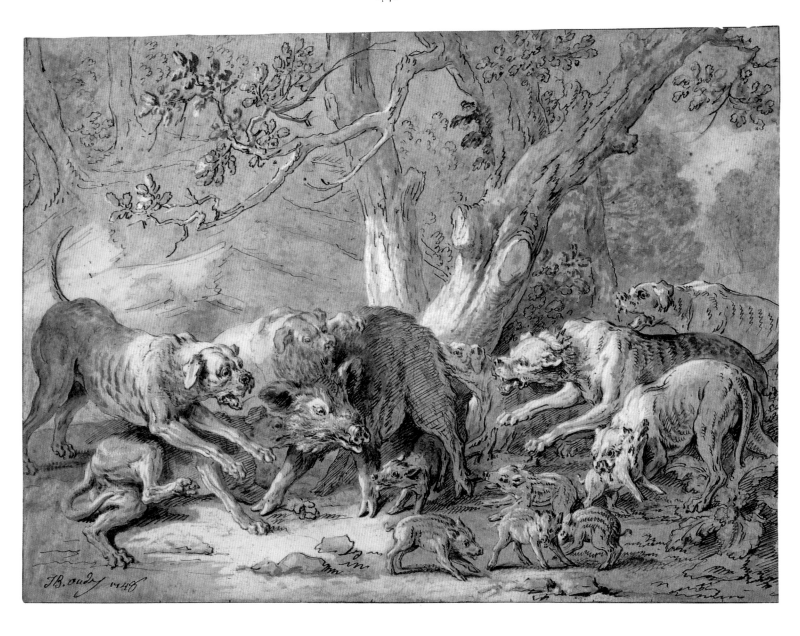

Pen and brown and gray ink,
brush and brown and gray wash,
heightened with white gouache,
framing lines in brown ink, on
light brown laid paper

377 x 517 mm (14¹³⁄₁₆ x 20⁵⁄₁₆
in.)

INSCRIPTIONS: signed, lower left,
in brown ink: *JB. Oudry 1748*

Andrew R. and Martha Holden
Jennings Fund 1997.191

Gabriel (-Jacques) de Saint-Aubin

Paris 1724–1780

Pierre Rosenberg has described this drawing as one of Saint-Aubin's "most beautiful,"[1] but it was known by neither the Goncourt brothers nor Emile Dacier, scholars and admirers of the artist whose research on his oeuvre is fundamental.[2] K. T. Parker was the first to publish it, in 1938, when it belonged to John Thacher, but its provenance before then is unknown. Parker's transcription of the inscriptions on the work has led to some confusion about its subject and date. According to him, the work bore the inscription "aux Tuileries" in the lower left. There is, however, no trace of it now, though the work was cut down at some point and such an inscription may have disappeared then. Parker also noted that the work was signed and dated; the artist's name is visible at the lower left in graphite, but it is partially cut off and may not be a signature.[3] The only inscription that seems certain to be by Saint-Aubin is the date, visible but barely distinguishable from the ink around it and only partially legible. In any case, all agree that the sheet dates to the early 1760s because of its connection to several similar works by the artist.[4]

Despite Parker's assertion, this lively dancing scene does not take place in the Tuileries but is related instead to *La Guinguette*, a lost gouache by the artist known now through an engraving by Pierre-François Basan (fig. 1).[5] Saint-Aubin drew a number of dance scenes in outdoor settings, as well as scenes of stylish men and women taking their leisure in parks and gardens and strolling the boulevards of Paris.[6] Best known among the prints are two works that depict the Tuileries, *The Chairs* and *The Watering Cart*.[7] More closely related in subject is *The Dance at Auteuil* (*Bal d'Auteuil*) of 1761, Saint-Aubin's

etching of a fashionable outdoor ball commissioned as the frontispiece to a book on dancing.[8] *Costumed Dancers Performing in a Garden Tavern* shows a similar setting, with swags of flowers strung from trees and hung with lights and spectators watching dancers while a small orchestra plays at the right.

In the Cleveland work, however, the setting is more a commercial establishment, a *guinguette*, or outdoor tavern with pleasure garden, as toward the right one can clearly see a waiter serving a bottle of wine to seated patrons. The drawing is closely related to *La Guinguette* (and could even be a variation of it), which Saint-Aubin made around 1760[9] and which depicts the ballet-pantomime of the same title by Jean-Baptiste-François De Hesse, ballet master of the Théatre-Italien in Paris.[10] Saint-Aubin used the same female dancer in the Cleveland sheet but put her in a different, more theatrical costume. Like her male partner, she performs in a jester type of dress, with jagged hemlines hung with bells. The two dance in a comic theatrical "grotesque" style, with exaggerated leg lifts and arm gestures, not the more refined social dancing.[11] Clearly, they perform for those seated around them. The mouse on the woman's head is possibly a symbol of domestic havoc and must relate to her performance.[12] Saint-Aubin conveys the scene with virtuoso use of washes, and the expressive faces conveyed with economy of means throughout the sheet are masterful. This lively record of Parisian outdoor life exemplifies especially well Saint-Aubin's sketchy style and seemingly rapid execution, but it was no doubt intended as a finished work of art. CEF

Fig. 1. Pierre-François Basan after Gabriel de Saint-Aubin. *La Guinguette, Divertissement pantomime—du Théâtre Italien, Composé par le Sr. De Hesse,* etching and engraving. Philadelphia Museum of Art, Print Club Permanent Collection 1961-60-23.

1. Toronto et al. 1972–73, 208.
2. Dacier 1929–31; Goncourt/Goncourt 1880.
3. Parker did not note the media of the inscriptions. When the work was shown the year after Parker published it, at Jacques Seligmann & Co., the catalogue to that exhibition transcribed the inscription as follows: "Signed, dated, and inscribed lower left: G. de St. Aubin, 1760 (?66)—aux Tuileries," which seems to be a repetition of Parker. The work was in the Thacher collection until at least the 1950s, when John Thacher lent it anonymously to a show in Pittsburgh (letter, CMA files). That cata-

logue makes no mention of the "aux Tuileries" inscription or the date.
4. Rosenberg 1972 and Cailleux 1960 both tried to pin the date down more specifically based on the inscription; Parker 1938 and some subsequent publications noted it was 1760 or 1766; however, a close re-examination of the work by the author revealed that only the "1" and "7" are clear; the third digit is totally illegible, the last is probably a zero. For a discussion of this sheet in the context of similar works by Saint-Aubin, see McCullagh 1981, 169–85.

5. For the print, see Dacier 1914, 149–50; Le Blanc 1854–88, 367; Roux 1933, 2:148, no. 268. On *La Guinguette* and its pendant, *Le Carneval du Parnasse*, see Dacier 1929–31, 1:40–41, 137, nos. 775–77; McCullagh 1981, 183.
6. For other examples, see Launay 1991, nos. 299, 308; Washington et al. 1981–82, no. 108.
7. Dacier 1914, 72–76, nos. 18–19; Victor Carlson and John W. Ittman, *Regency to Empire: French Printmaking 1715–1814,* exh. cat., Baltimore Museum of Art/Minneapolis Institute of Arts (1984), 158–59, no. 49; Paris 1985, 39–41, nos. 40–41;

42. *Costumed Dancers Performing in a Garden Tavern*

c. 1760

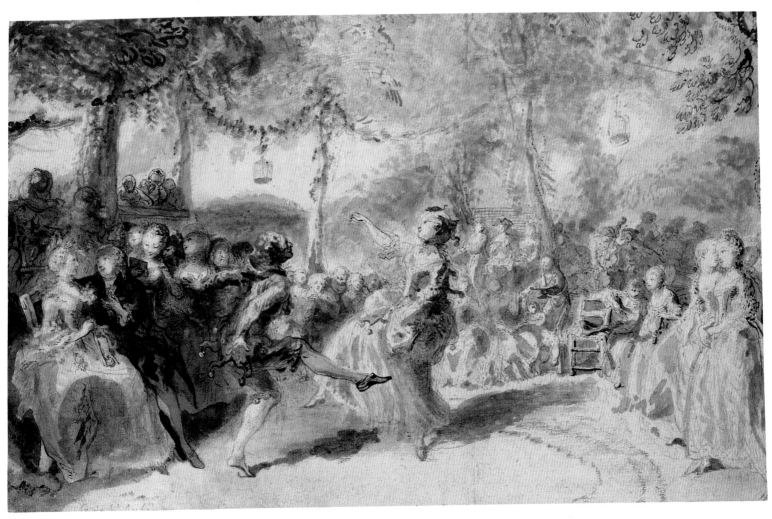

Brush and brown and gray wash, with gouache, watercolor, and traces of graphite, on cream laid paper, laid down on cream wove paper

198 x 313 mm (7¾ x 12⁵⁄₁₆ in.)

WATERMARK: center: winged animal?

INSCRIPTIONS: lower left, in brown ink: *17*[60?]; lower left, in graphite: *G de St Aubin* [partially cut off]; verso, visible through transmitted light, lower left: [aif?]; lower left: *Fragonard*; lower right: *22* / [illegible] / *22*; verso of secondary support, center, in graphite: *N*

Purchase from the J. H. Wade Fund 1966.124

these works are likely the reason for the supposed inscription on the CMA sheet that Parker mentioned.

8. De La Cuisse, *Répertoire des bals, ou Théorie practique des contredanses* (Paris, 1762); see Dacier 1914, 100–2, no. 25; also: Middletown/Baltimore 1975, 54, no. 25, 63 (repr.); Carlson/Ittman, *Regency to Empire*, 156–57, no. 48; Paris 1985, 43, no. 44.

9. The work is not dated, but Basan's print after it came out around 1762; see Dacier 1929–31, 137, no. 776; McCullagh 1981, 183, dates it to 1759–61; the Goncourts described a preparatory drawing for the head of the main female dancer (Goncourt/Goncourt 1880, 447).

10. See Artur Michel, "Two Great XVIII Century Ballet Masters: Jean-Baptiste De Hesse and Franz Hilverding: La Guinguette and Le Turc Généreaux seen by G. de St. Aubin and Canaletto," *Gazette des Beaux-Arts* 27 (May 1945), 271–86.

11. My thanks to Sarah R. Cohen for her help explaining Saint-Aubin's depiction of dance and costume in this work. She pointed out the similarity in both costume and dancing style of the figures in the present sheet with two prints after Jean Bérain drawings showing Jean Ballon and Mlle Dufort as a madman and madwoman; the prints are reproduced in Marian Hannah Winter, *The Pre-Romantic Ballet* (London, 1974), 68.

12. Richards 1967.

Jean-Baptiste Greuze

Tournus 1725–Paris 1805

Charles Le Brun's theories of expression experienced a revival at the French Academy in the eighteenth century,[1] and Greuze explored this tradition and extended its range far more than any other artist. This red chalk study of the head of Caracalla is surely one of his most powerful essays in the genre *tête d'expression* (expressive head). It is related to the painting that changed the course of his career and caused his break with the Academy, *Septimius Severus Reproaching Caracalla*.[2] In that work Greuze depicted the Roman emperor confronting his son, following the latter's attempted murder of his father. In the painting, Caracalla turns away from his father's confrontational gesture, and the close-up study of his face in this sheet seems to reflect a mixture of shame and anger, as appropriate to the subject.

To prepare for the painting, Greuze made at least two oil sketches[3] and numerous drawings, including red chalk head studies of the other figures in the painting, Castor and Papinian, and nude figure studies for Caracalla and Septimius Severus.[4] Another red chalk drawing of Caracalla in the Musée Bonnat, Bayonne,[5] is closely based on the famous Caracalla portrait bust (in the Farnese collection for much of the eighteenth century),[6] which Greuze likely knew firsthand as a student in Rome. He no doubt used a plaster cast or a copy when he drew the Bayonne sheet. His use of antique sources was an important part of the painting's conception and made it a landmark of neoclassicism.[7] One critic noted specifically the influence of the Antique on the figure of Caracalla.[8] The Cleveland drawing, however, illustrates Greuze's adaptation of classical sculpture to his own innovative ends. Although inspired by the Farnese bust, Greuze shows Caracalla younger in this sheet, with only a slight beard. He created an expression that conveys the intensity of a son's betrayal. The artist underscored this troubled face through the positioning of Caracalla's hand, tightly pressed into his chin, his index and middle fingers splayed and rendered with cubic economy. Greuze likely drew other sheets for the same painting from life,[9] but it is difficult to say for certain whether that is the case here. If we assume this drawing was done in preparation for the painting, then he would have drawn it at an intermediate stage in the composition's design. One of the oil sketches, known from a photograph, shows the hand in the same position, but the artist had changed it by the time he made a nude figure study for the Caracalla figure,[10] and he kept it that way, the hand near the throat, for the final painting. Yet it seems possible that Greuze drew this sheet to sell independently after he finished the painting.[11] A counterproof of the drawing is in Besançon (fig. 1).[12] CEF

Fig. 1. Jean-Baptiste Greuze. *Head of Caracalla*, c. 1768, red chalk counterproof. Musée des Beaux-Arts, Besançon.

1. Jennifer Montagu, *The Expression of the Passions* (New Haven, 1994), 85–100.

2. Salon of 1769; Musée du Louvre, Paris. On the history of the painting and its reception, see Seznec 1966, and Hartford et al. 1977, 146–49, no. 70.

3. One of them is illustrated in Seznec 1966, 345, fig. 2; Hartford et al. 1977, 147–48.

4. See Munhall 1965 and Hartford et al. 1977, 142–49, nos. 67–70, where these sheets are discussed and illustrated.

5. Hartford et al. 1977, 148, fig. 19.

6. Now in the Museo Nazionale, Naples; see Francis Haskell and Nicholas Penny, *Taste and the Antique* (New Haven, 1981), 172–73, no. 18.

7. Munhall 1965, 29, 59; Hartford et al. 1977, 148.

8. The anonymous critic writing for *L'Avant-Coureur*, cited in Munhall 1965, 29. For the body of Caracalla, Greuze adapted the pose of the Belvedere *Antinous*.

9. Hartford et al. 1977, 144.

10. The oil sketch that Diderot saw in Greuze's studio is more closely related to the final composition; the earlier one is illustrated in Seznec 1966, 345, fig. 2; for Diderot's description of the oil sketch he saw during a studio visit, see Seznec 1966, 342–43. The preparatory nude study for Caracalla is in the Musée Greuze, Tournus; see Munhall 1965, 27, fig. 11.

11. In that case, he could have done it after the oil sketch (a suggestion from Margaret Morgan Graselli).

12. A counterproof of the Louvre drawing of the head of Papinian is in the Louvre, inv. no. 26970.

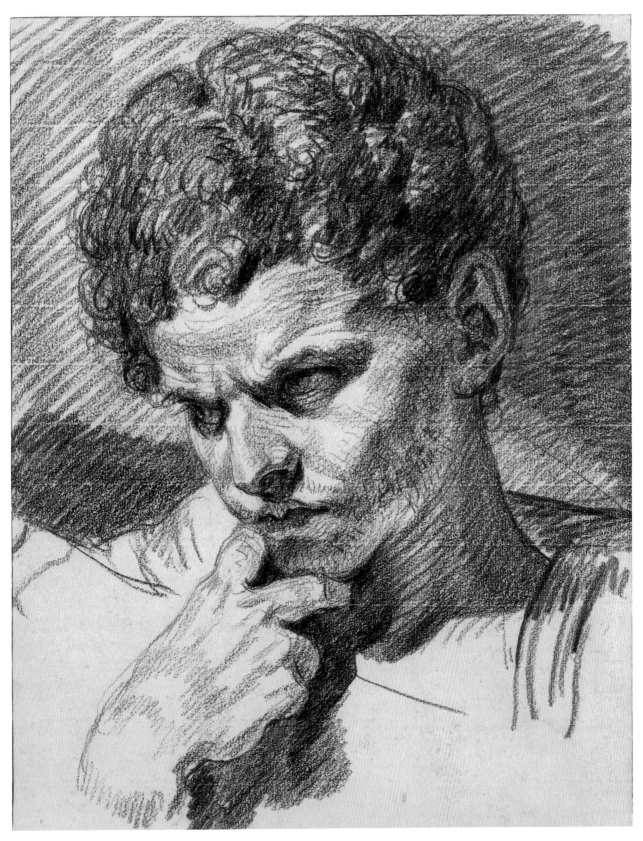

Red chalk on cream laid paper

388 x 303 mm (15¼ x 11¹⁵⁄₁₆ in.)

Purchase from the J. H. Wade
Fund 1999.48

Jean-Baptiste Greuze

Tournus 1725–Paris 1805

This drawing was a new discovery when it appeared at auction in London in 1984. Edgar Munhall dated it at that time to the early 1770s,[1] and it has a strong stylistic affinity to other sheets in the same technique, also datable to this period.[2] It fits perfectly into the category Munhall described as "highly finished drawings Greuze produced as complete works in themselves."[3] Greuze executed numerous scenes of family crises, characterized by tightly interlocking figural groups set in shallow interior spaces, as both paintings and presentation drawings. All use the artist's highly refined vocabulary of gesture and expression to convey the particulars of the narrative. His touchstone works in the genre are the pair of paintings on the theme the Father's Curse, executed in 1777–78.[4] The present work is similar in spirit, though its architecturally grand interior make it a particularly strong example of his neoclassical, Poussinian compositional style.[5]

The precise subject of the Cleveland drawing is unclear. In the center, a father is attended to by his son, who holds a lance or some other instrument with which to treat a wound or boil on his leg.[6] The traditional title used here comes from the old (nineteenth-century) backing on the frame, where it was inscribed in brown ink.[7] It clearly refers to the pregnant girl entering the room at right. She is apparently unmarried and in disgrace, hiding her face in her hands. The real confrontation, however, is between the patriarch in the center and the woman bursting into the room at right, ahead of the pregnant girl. Her gestures clearly link the girl to the seated man: with her left hand she indicates the girl's swollen stomach, and with her right she reaches aggressively toward the man, who extends his hand in response. She seems to have taken the family by surprise, perhaps defending the girl as she directs her wrath at the patriarch. The man behind her and the young man kneeling physically restrain her from confronting the older man. The scene thus suggests not a guilty daughter but a young girl ruined, perhaps even by the man in the center. Is the angry woman the girl's mother, accusing him of impregnating her daughter as his shocked family reacts?

Although we know of no preparatory studies directly connected to this sheet, there are several related drawings. Greuze's red chalk studies of expressive heads (see no. 43) often relate to more than one finished work; here, we can connect the old woman looking upward at the far left to the head study in New York.[8] A red chalk counterproof, once in the Lanckoronski collection (fig. 1), shows the upturned head of a young boy, quite similar to the boy in the center of the present work. The same man who served as the model for the father also appears as a butcher in a drawing in the Polakovits collection at the École des Beaux-Arts.[9] CEF

Fig. 1. Jean-Baptiste Greuze. *Study of a Boy's Head.* Formerly in the Lanckoronski collection, Vienna.

1. Noted in Christie's, London, *Important Old Master Drawings,* 4 July 1984, 81, no. 121.

2. For example, *The Return of the Young Hunter,* Minneapolis Institute of Arts; *The Angry Woman,* Metropolitan Museum of Art, inv. no. 61.1.1; see Hartford et al. 1977, 162, no. 72, and 192–93, no. 96.

3. Ibid., 162, no. 79.

4. Ibid., 170–73, no. 84.

5. Ibid., 170–72.

6. A drawing of c. 1777 in the National Gallery of Canada, Ottawa, recently retitled *Return of the Traveler,* inv. no. 17235, bears some similarities to the Cleveland work, especially in the position of the central figure; see *Master Drawings from the National Gallery of Canada,* exh. cat., National Gallery of Art (Washington, 1988), 175–76, no. 55.

7. Perhaps by the framer Alfred Giry of Marseilles, whose label is pasted above the inscription, or by the collector C. Magne, also of Marseilles, for whom Giry must have framed the drawing.

8. See Hartford et al. 1977, 74–75, no. 27.

9. Paris 1989, 240, no. 99.

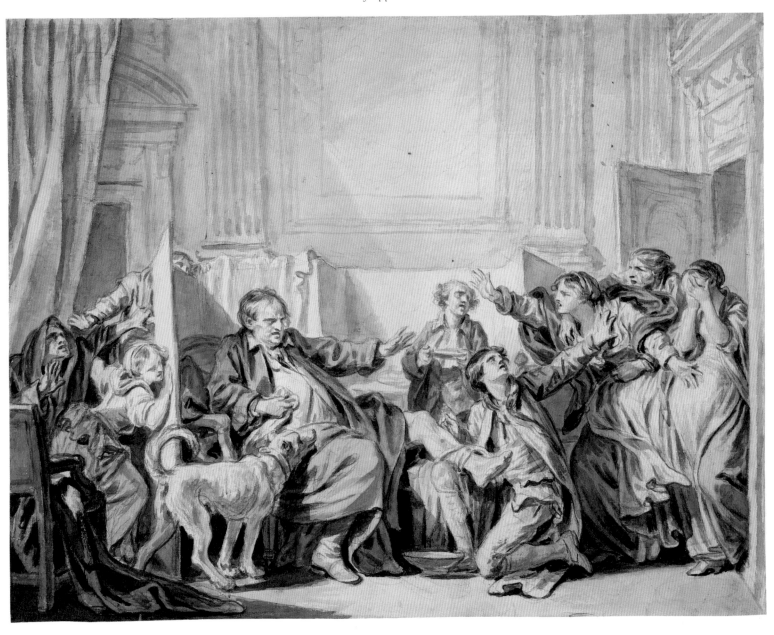

Brush and black and gray wash over black chalk, on cream laid paper, perimeter mounted to cream board

498 x 643 mm (19⁹⁄₁₆ x 25⁵⁄₁₆ in.)

WATERMARK: center: shield?

INSCRIPTIONS: secondary support, upper center, in graphite: *60½ x 78 / vue du cadre* [upside down]; on 19th-century backing of old frame, upper center, in black ink: *Cabinet de Mʳ Cˡᵘ Magne*; upper center, in brown ink: *La fille Coupable et Repentante / Déssiné par J. B. Greuze* [overlined and underlined]; center, in black ink: *M*

Leonard C. Hanna Jr. Fund 1989.46

Hubert Robert

Paris 1733–1808

Hubert Robert spent more than ten years in Rome, and much of his work is about the architecture of that city. He drew its monuments on site and, more significantly, created his own imagined variations based on the Roman architectural vocabulary. This particular drawing owes much to the printmaker and draftsman Giambattista Piranesi, as Victor Carlson has emphasized.[1] Robert's rendering of a vaulted staircase leading up to an open landing reflects the imagined buildings Piranesi created for his first print series, the "Prima Parte." Specifically, one can compare the Cleveland drawing to the second plate, *Carcere oscura* (fig. 1).[2] There, Piranesi developed a more complex space but one with an overall structure similar to Robert's *Vaulted Staircase*, which is also defined by horizontal railed landings and soaring vaults supported by heavy, rusticated piers. Even the row of bars in the arched doorway recalls the prison theme that so occupied Piranesi.[3] Like him, Robert presents a massive, imagined architectural form rather than an actual building.

Brown ink and wash was not Robert's preferred medium: he is far more renowned for his red chalk drawings, a medium he helped refine working alongside his friend Jean-Honoré Fragonard. Fragonard worked in brown wash more often (see no. 47), which may be why some attributed this sheet to him (see Literature and Provenance sections under no. 45 in the back of this catalogue); it sold as a Fragonard at the end of the nineteenth century, when Baron Vivant-Denon owned it. Robert's freely brushed wash and bold pen strokes here are striking compared to his carefully finished chalks and watercolors.[4] Again, this technique owes a debt to Piranesi, whose drawing style Robert seems to have consciously emulated. Carlson has pointed out its similarity to another sheet in Montpellier whose subject also took inspiration from the Italian printmaker.[5] Piranesi's biographer J. G. Legrand reported that Piranesi and Robert drew together during the latter's stay in Rome, and Robert himself owned a number of Piranesi's prints.[6] While in Rome, Robert executed several paintings in a Piranesian mode as well,[7] but the Cleveland sheet likely dates to the 1770s, after he had returned to Paris. The inscription on the panel over the arched doorway, while mostly illegible, seems to refer to Robert's Russian patron, Count Alexandre Sergevitch Stroganov,[8] who was in Paris between 1770 and 1779. In 1773, Stroganov commissioned a series of six monumental paintings from Robert, one of which depicts a massive stone vault with a staircase similar to the one in the Cleveland drawing. There are significant differences between the two works, but Ekaterina Deriabina has recently suggested this drawing is likely Robert's first idea for the painting.[9] If so, it could be dated more precisely to c. 1773. CEF

Fig. 1. Giambattista Piranesi. *Carcere oscura* (from *Prima Parte de Architetture, e Prospettive*), 1743, etching. Print Collection, Miriam and Ira D. Wallach Division of Art, Prints and Photographs, The New York Public Library, Astor Lenox and Tilden Foundations.

1. In Washington 1978–79.

2. Henri Focillon, *Giovanni Battista Piranesi* (Paris, 1914), no. 4; Andrew Robison, *Piranesi—The Early Architectural Fantasies* (Washington/Chicago, 1986), no. 3.

3. For its similarities to Piranesi, one wonders whether Robert intended this drawing to represent a prison, and whether it might have been the drawing listed in the inventory of Hubert Robert's widow, under no. 298: "Un dessin représentant l'intérieur d'une prison"; see C. Gabillot, *Hubert Robert et son Temps* (Paris, 1895), 254.

4. Carlson in Washington 1978–79, 112.

5. Ibid., 43; the Montpellier drawing, no. 54, is discussed on p. 134 and illustrated in color on the cover.

6. Ibid., 20–21; see also Marianne Roland Michel in *Académie de France à Rome, Piranèse et les Français, 1740–1790* (Rome, 1976), 304–26, nos. 171–84.

7. Catherine Boulot et al., *J. H. Fragonard e H. Robert a Roma* (Rome, 1990), 102–3, nos. 51–52.

8. See Louis Réau, "L'Art Français du XVIIIe siècle dans la Collection Stroganov," *Bulletin de la Société de l'Histoire de l'Art Français* (1931), 62–68.

9. Deriabina 1999, 95.

Pen and brown ink and brush and brush and brown wash over graphite, framing lines in brown ink, on beige laid paper, laid down on beige board (18th-century mount?)

529 x 387 mm (17⅜ x 11¹¹/₁₆ in.)

WATERMARK: none visible through mount

INSCIRPTIONS: by artist, center, in brown ink: [Villaporta?] / *nel S*[illegible] / [illegible] / *Stroganoff*; verso of secondary support, upper left, in red chalk:

fragonard del / *Collection de M Denon Directeur du Musée Napoleon*

Gift of Leonard C. Hanna Jr. 1926.504

Pierre-Henri de Valenciennes

Toulouse 1750–Paris 1819

"Elevating Nature above itself carries profound and delightful sensations for the soul."[1] Valenciennes thus described the ideal of landscape painting he espoused. Although he is better known today for his open-air oil sketches,[2] he was the most important theorist of the neo-classical landscape. He developed and promoted the genre he described as "paysage historique" (an idealized historical landscape), and the Cleveland drawing is one of the earliest major examples of the type in his oeuvre. He took his cue from the seventeenth-century theorist Roger de Piles, who also wrote about a "heroic style" of landscape painting.[3] Valenciennes was interested in elevating the status of landscape painting by combining classical subjects and visual references to classical art and architecture with a harmonic, carefully composed construction of nature. Nicolas Poussin was his most important model, and Valenciennes's neo-Poussinisme is especially strong in the Cleveland drawing.

As Peter Galassi has noted, the most important models for Valenciennes's paysages historiques were Poussin's landscapes of the 1640s and early 1650s.[4] Works such as the Phocion landscapes come to mind,[5] or the *Landscape with Diogenes*,[6] with which the present work shares a similar composition. The artist used flat expanses of water to lead the eye back into the picture plane, balancing the view with carefully placed rocks and trees, and his construction of a regular, self-contained space in this manner is directly from Poussin. The Cleveland work shares these traits with another drawing, now in the British Museum (fig. 1), on a similar type of blue paper (now faded to a green in both) and also drawn in Rome in 1779. These two sheets prove that his work exemplified the paysage historique well before his public debut in the Salon of 1787, when his paintings in the same vein inspired critical praise.[7] In fact, the Cleveland and London drawings have more in common with paintings from Valenciennes's mature period than they do with his typical drawings of the 1770s, which are primarily studies of individual motifs in nature, such as trees, and overall landscapes and city views of actual places, often done on site.[8] In that sense, both works suggest his ideas about landscape painting gestated before they became fully realized in his later paintings or in his writing.

Unlike its counterpart in London, the Cleveland drawing is much less specific regarding both subject and visual sources in its evocation of the classical world. The former shows Socrates and two followers in a landscape embellished with several famous buildings, including Rome's Castel Sant'Angelo. For the Cleveland drawing, however, the artist did not develop an easily identifiable subject. We see three maidens cutting their hair and offering it on an altar to a river god. Although this ritual was well known in the classical world and is mentioned in numerous textual sources,[9] it was rarely depicted in the visual arts and is difficult to associate with a specific literary or historical text. Similarly, the figures in the background (which have nothing to do with the primary narrative), especially the water nymph chased by a satyr in the right middle ground, are simply motifs meant to suggest ancient culture. The open-air temple seems likely to have been inspired by a pictorial source, such as Roman wall painting or South Italian vase painting, rather than by an actual building.[10] CEF

Fig. 1. Pierre-Henri de Valenciennes. *Classical Landscape*, 1779, graphite and wash, heightened with white. The British Museum, London, inv. no. 1993-5-8-16.

1. Pierre-Henri de Valenciennes, *Éléments de perspective pratique à l'usage des artistes suivis de réflexions et conseils à un élève sur la peinture et particulièrement sur le genre du paysage* (Paris, 1800; reprint: Geneva, 1973), 375.

2. See Philip Conisbee et al., *In the Light of Italy: Corot and Early Open-Air Painting*, exh. cat., National Gallery of Art, (Washington/New Haven, 1996), 126–33 and passim.

3. De Piles, cited in Peter Galassi, *Corot in Italy: Open-Air Painting and the Classical-Landscape Tradition* (New Haven/London, 1991), 43.

4. Ibid., 46.

5. Pierre Rosenberg, *Nicolas Poussin 1594–1665* (Paris, 1994), 387–90, nos. 168–69.

6. Ibid., 392–94, no. 171.

7. See Spoleto 1996, 142–43, no. 60; Dewey F. Mosby, "A Rediscovered Salon Painting by Pierre-Henri de Valenciennes: Landscape of Ancient Greece," *Bulletin of the Detroit Institute of Arts* 55 (1977):153–57.

8. Gallo in Spoleto 1996, 37.

9. See Walter Burkert, *Greek Religion* (Cambridge, Mass., 1985), 70.

10. My thanks to Michael Bennett, Ken Bohač, Jenifer Neils, and Rachel Rosenzweig for their suggestions about the subject and visual sources for this drawing.

Black gouache and brush and
gray wash, over black chalk and
graphite, heightened with white
gouache, on green laid paper

413 x 483 mm (16¼ x 19 in.)

INSCRIPTIONS: signed, lower left,
in brown ink: *Valencienne Fecit
/ a Rome. 1779 / 1779*

Purchase from the J. H. Wade
Fund 1980.91

Jean-Honoré Fragonard

Grasse, France, 1732–Paris 1806

Four works by Fragonard relate to the subject the Invocation to Love. Two are oil paintings on panel: one in a private collection in New York,[1] the other in the Louvre, Paris.[2] There is also a preparatory drawing, now in Princeton (fig. 1).[3] The Cleveland sheet closely matches the New York painting but seems to be an independent presentation drawing. Eunice Williams first noticed that the squaring is under, not over, the wash and concluded that it was therefore made as a reduced drawn replica of the New York painting,[4] not in preparation for it as indicated in some of the previous literature.[5] Because of their lack of finish, the Princeton and Louvre works have understandably been considered preparatory studies,[6] and the latter, executed in a hazy sfumato, has become famous for its ethereal quality, which sets it apart from the other versions.[7]

Although the Cleveland sheet derives from the finished oil, the differences between them are significant and show the artist reconsidered many of the work's subtleties as he redrew it. While the fall of light in the drawing does correspond to that in the painting almost exactly, it lacks the latter's dramatic tenebrism. The drawing's technique, with the white of the paper serving as the lightest tonal range, allows a completely different, much lighter effect.[8] As a result, certain details come out more clearly. The putto at left is more visible; the sad expression on his face is not present in the painting. The statue of Cupid has a half-smile, while the woman's open-mouthed swooning is dramatically apparent. Furthermore, she wears Greek sandals, a detail unique to the Cleveland sheet.

The subject, which has no literary source, belongs to a group of thematically inventive works that Fragonard executed around the same time, all of which address the subject of love through allegory.[9] Because one of the drawings sold in 1781, the artist's four versions of the subject can be dated to c. 1780.[10] Although the subject was not common, Carle Van Loo, Jean-Baptiste Greuze, and Louis Jean François Lagrenée painted versions of it before Fragonard.[11] Many scholars have noticed, however, a proto-Romantic tone in Fragonard's treatment, even though the planar composition and certain details, such as the sandals noted above, reflect contemporary neoclassic taste.[12] While the narrative is open to some interpretation, the woman clearly seems desperate for the aid of Cupid in some amorous affair; thus, *Invocation to Love* seems a more appropriate title than *Vow to Love*.[13] The blindfolded Cupid suggests the uncertainty of love and has a long tradition in Western art.[14] The sorrowful putto at the left portends an unhappy outcome. Fragonard's treatment, very much his own, nonetheless relates ultimately to the Garden of Love and Testament to Venus themes known especially from paintings by Titian and Rubens.[15] These subjects had a major impact on eighteenth-century French artists, notably Watteau and other *fête galante* painters.[16] Fragonard depicted love and courtship in garden settings in some of his most important works, most notably the "Progress of Love" series (Frick Collection, New York), and the Cleveland sheet attests to his fascination with the subject. CEF

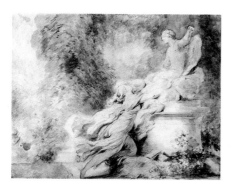

Fig. 1. Jean-Honoré Fragonard. *Invocation to Love*, c. 1781, brush and brown ink, brown wash, black chalk. The Art Museum, Princeton University, Given by Margaret Durand Mower for the Elsa Durand Mower Collection, 65-37.

1. Georges Wildenstein, *The Paintings of Fragonard* (London, 1960), no. 491; Cuzin 1988, no. 377.

2. Wildenstein, *Paintings of Fragonard*, no. 493; Cuzin 1988, no. 378.

3. Williams in Washington et al. 1978–79, 128, thought the Princeton sheet might be a copy; Ross 1983, 18, and Rosenberg in Paris/New York 1988, 546, felt it was definitely by Fragonard, its apparent weaknesses a result of fading and not evidence of a follower's hand.

4. Washington et al. 1978–79, 128–29, no. 50.

5. Francis 1945, 88; Montreal 1950, 15, no. 73; Rotterdam et al. 1958–60, 54, no. 51; Vermeule 1964, 129; Princeton 1968, 19; Providence 1975, 174.

6. Which came first, however, is unclear. The composition of the oil sketch is different from the other three works in that the cupid's arm is lowered, making its place in the chronology unclear. Is it an early idea for the composition or a variant done later?

7. Paris/New York 1988, 543–44, no. 281.

8. There is no white gouache or paint anywhere on the sheet, as incorrectly stated in Los Angeles 1961, 52, no. 46; Providence 1975, 174; Washington et al. 1978–79, 128; Ashton 1988, 218; Los Angeles et al. 1993–94, 156.

9. They include *Fountain of Love*, *The Warrior's Dream of Love*, and the *Sacrifice of the Rose*. For a discussion of these works, see Cuzin 1988, 207–15; Paris/New York 1988, 546–53.

10. Toronto et al. 1972–73, 159; Paris/New York 1988, 542; Washington et al. 1978–79, 23, 158.

11. Respectively: *Hommage à l'amour*, lost painting (known from print by Jean-Baptiste de Lorraine), see Marie-Catherine Sahut, *Carle Vanloo: Premier peintre du roi* (Nice 1977), 99, no. 247; *L'offrand à l'amour*, oil on canvas, Wallace collection, London, Salon of 1769, see John Ingamells, *French before 1815*, vol. 3 of *The Wallace Collection: Catalogue of Pictures* (London, 1989), 3:202–5, no. P441; *Invocation à l'amour*, oil on canvas, Paris art market (1982), Salon of 1777, see Marc Sandoz, *Les Lagrenée* (Paris, 1983), 245–46, no. 285, pl. 38.

12. See Vermeule 1964; Cuzin 1988, 209–12; Los Angeles et al. 1993–94, 156, no. 220.

13. The former title is supported by the description in the Sireul sale catalogue: "une jeune fille invoquant l'Amour." The title *Vow to Love* seems to have gained precedence in the nineteenth century; see Paris/New York 1988, 544.

14. Erwin Panofsky, "Blind Cupid," in *Studies in Iconology* (New York, 1962), 95–128.

15. See Elise Goodman, *Rubens: The Garden of Love as Conversatie à la Mode* (Amsterdam/Philadelphia, 1992).

16. See Eisenstadt 1930; Frankfurt 1982.

c. 1781

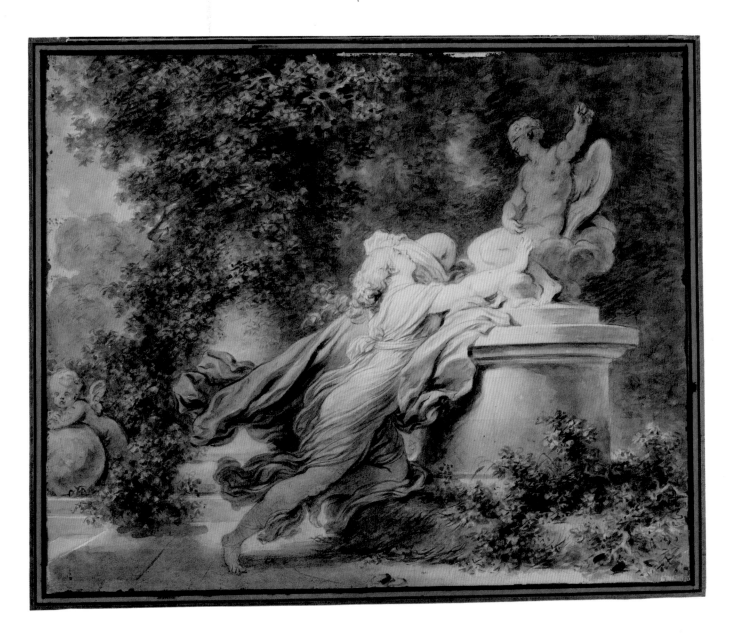

Brush and brown wash over
graphite, over squaring in
graphite, on cream laid paper,
laid down on board (François
Renaud's mount)

335 x 416 mm (13¹³⁄₁₆ x 16³⁄₈ in.)

WATERMARK: none visible
through mount

INSCRIPTIONS: secondary support,
lower right, in graphite: *62
[L?]3*; verso of secondary sup-
port, center left, in graphite:
Salon

Grace Rainey Rogers Fund
1943.657

Anne-Louis Girodet de Roussy-Trioson

Montargis 1767–Paris 1824

A devotee of literature, Girodet was especially concerned with the relationship between text and image. For that reason, he excelled in history painting, the premier genre in the neoclassical period, and he devoted himself particularly to illustrating literature. Nowhere better than in his illustrations for Racine's *Phèdre* and *Andromaque* did Girodet advance the sophistication and subtlety of literary illustration to create profound historical compositions. He explained their importance in a letter to the Marquis de Pastoret,[1] who had been assigned in 1810 to conduct a survey of the state of the arts in the Empire: "I should mention here the drawings that I composed for the *Virgil*[2] and the *Racine* in-Folio, printed by M. Didot. It is a mistake for drawings to be nothing but drawings, and they require the same conception and almost the same study as a painting when one takes pride in giving them style and character; only the process of execution is different. The artist who succeeds at such drawings can be none other than a history painter."[3]

In 1789, Pierre Didot's father, François Ambroise, retired, leaving the family printing business to his twenty-eight-year-old son. From 1789 to 1809 Pierre's associate was his brother Firmin, who received the rights to the printing type their father had developed. Firmin Didot[4] went on to produce a typeface whose regularity and sobriety corresponded in printing to the School of David in painting. Surpassing the printers and typographers John Baskerville in England and Giambattista Bodoni in Parma was essential. Logically, Pierre Didot called upon David to help produce the perfect neoclassical edition associating typography and radically modern illustrations.[5] David delegated Girodet to illustrate the principal dramas *Andromaque* and *Phèdre*.

Andromaque, shown for the first time before Louis XIV in November 1667, was such a success that Charles Perrault compared it to *Le Cid* by Corneille. Inspired by Euripides' ancient tragedy, *Andromaque* is a political and moral drama where passions of jealousy and patriotism clash among four principal characters: Andromaque, widow of Trojan hero Hector; Achilles' son Pyrrhus, king of Epirus; Agamemnon's son Orestes, who is in love with Helen's daughter Hermione; and Hermione, who is promised to Pyrrhus. Pyrrhus falls in love with his prisoner Andromaque, and she agrees to marry him to save her son Astyanax. Hermione then uses her power over Orestes to incite him to assassinate Pyrrhus.

Girodet portrayed Andromaque, a sentimental figure ill suited to a neoclassical viewpoint, in only one of his five illustrations for the five acts (act 3), interpreting Hermione as the lead character instead. She manipulates the love-blind Orestes because Pyrrhus' infidelity with a Trojan hurts her both as a Greek and as a lover. By satisfying her vengeance as outraged lover, Hermione also satisfies patriotic Greek law. Girodet's illustration for act 2, scene 2, engraved by Raphael Urbain Massard (fig. 1), represents Hermione's duality. Girodet's image follows the play and presents Hermione as lonely and withdrawn. Her confidante Cléone introduces Orestes, the unknowing instrument of revenge. Hermione embodies perfidy in both text and image: arms crossed over her chest, her unoffered body contradicts her words. She stands like a statue between the columns of the labyrinthine structure, paired with an antique table. The table's leg has the form of a siren, a dangerous mythological creature that bewitches and destroys its listeners. In the purest Davidian tradition, perhaps with more subtlety, Girodet's image is so masterful that the text is hardly necessary for comprehension. SB

Fig. 1. Raphael Urbain Massard after Girodet. *The Meeting of Orestes and Hermione*, engraving. From Pierre Didot, *Oeuvres de Jean Racine Tome Premier* (Paris: Pierre Didot l'Aîné, An IX, 1801).

1. Claude Emmanuel Joseph Pierre de Pastoret, comte d'Empire, marquis under the Restoration (1756–1840).

2. The drawings in question were made to illustrate magnificent large folios known as *éditions du Louvre*, thus named because Didot was then installed as artist at the Louvre (1797–1804). *Virgil* appeared in 1797 and *Racine* between 1801 and 1805, in three volumes. Printing was limited in each case to 250 examples, 100 of which were printed before the text was added.

3. For the French, see Coupin 1829, 2:343.

4. The Bibliothèque Nationale de France acquired many important works from Firmin Didot's collection sales. In 1824, Van Praet, curator of the Bibliothèque Royale, mentioned in his *Catalogue de livres imprimés sur vélin appartenant aux bibliothèques publiques et collections privées* (a catalogue of examples not in the Bibliothèque Royale) a unique Didot *Racine* in Firmin Didot's collection that was ornamented with original drawings. The Bibliothèque Royale acquired the book between 1828 and about 1840, when it no longer contained the drawings, which had curiously been replaced by engravings before the text was printed. Over the past ten years or so, original drawings for *Racine* have reappeared on the market, including some Girodet designs. Thus the CMA acquired the final design of *The Meeting of Orestes and Hermione* and the Art Institute of Chicago purchased Girodet's preparatory drawing to illustrate the final act. For more on the Didot family, see the excellent work of Osborne 1985.

5. In his *Prospectus: Publius Virgilius Maro* (Paris, June 1797), a prospectus published to explain and advertise his *Virgil*, Didot wrote, "Aspiring to raise a dignified monument to the glory of the prince of poets, I believed that I could not succeed without the aid and collaboration of all the arts that could cooperate. I informed David, the premier painter of France and perhaps of Europe, of my project. He accepted with enthusiasm and offered to make the drawings himself; or at least, if his activities did not permit him to devote himself to them without interruption, he proposed to relegate some to his students."

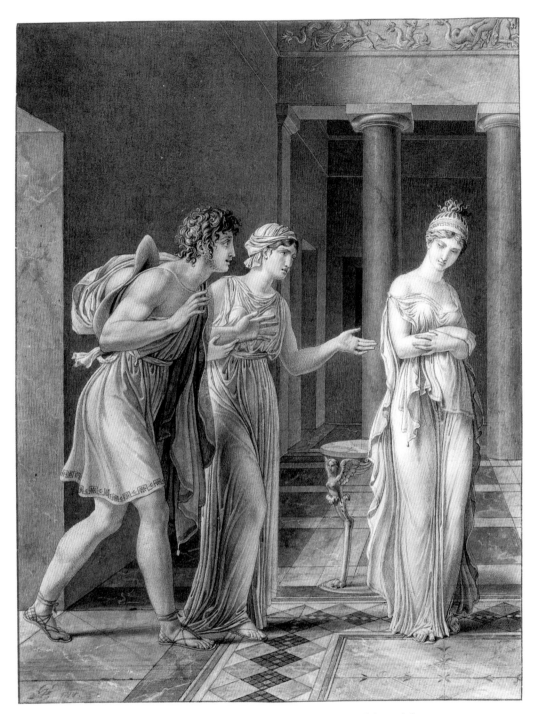

Pen and brown ink, point of
brush and brown and gray wash,
brush and brown and gray wash,
with black chalk and graphite,
heightened with white gouache,
framing lines in brown ink, on
cream wove paper

285 x 218 mm (11³⁄₁₆ x 8⁹⁄₁₆ in.)

INSCRIPTIONS: signed, lower left,
in brown ink: [artist monogram:
ALG] / *INV*. ; signed, lower left, in
black chalk: *A L GIRODET INV*.

Leonard C. Hanna Jr. Fund
1989.101

(Jean-Louis-André-) Théodore Géricault

Rouen 1791–Paris 1824

In his first Salon showing in 1812, Géricault's monumental painting *Charging Chasseur* revealed a fascination with the horse and horsemanship that continued throughout his short life. Some of his major works show horses as part of battles or races, but he was also interested in their untamed nature and sheer physical beauty. His most extraordinary depictions of the horse have a psychological intensity and an understanding of the animal matched by few painters in the history of art.

In the Cleveland watercolor, a group of horses gathered in an outdoor pen clash as a stable hand tries to control them. The theme of horses fighting appears in just a handful of Géricault's works,[1] and the Cleveland watercolor and the related lithograph of 1818, *Two Dappled Gray Horses Fighting in a Stable,*[2] are the two major examples. In the lithograph, two horses grapple and bite each other as a stable hand approaches them with a raised broom. The watercolor features a similar group of figures in the background,[3] but the focus of the composition is a white stallion and two other horses. The Cleveland sheet is datable because of its connection to the lithograph and because two related drawings form part of the sketchbook now in Chicago, which includes numerous other drawings for the early lithographs of 1818–19.[4] Folio 21 (fig. 1) contains two studies for the white stallion in the CMA sheet: observations drawn from life of a horse, head turning back and right hind leg raised. One is a thumbnail sketch in the upper right, the other is a

larger and more finished study in the center of the sheet. In the smaller sketch, Géricault studied the animal from a more foreshortened viewpoint, which corresponds most closely to the angle of the horse in the Cleveland sheet.

The Cleveland watercolor has extensive underdrawing showing that Géricault established the main elements first in graphite, probably using his sketches from life as a guide. The white stallion in the center, for example, is fully worked in pencil, with well-defined edges and areas of parallel and cross hatching. The artist then finished the composition in watercolor, but numerous graphite pentimenti are visible, especially in the heads of the horses at the left, the horses battling in the background, and the hoofs of the white stallion. The palette is limited mostly to brown, blue, and black, with touches of red, but the great tonal variety in the layered washes gives the horses convincing volume and weight. The relatively loose handling of the washes is different in style from some of Géricault's other watercolors and drawings dated to the period around 1818–19. Thus both Philippe Grunchec and Lorenz Eitner have suggested it may date later than the early lithographs; Eitner proposes around 1820.[5] Sylvain Laveissière and Régis Michel related it stylistically to a watercolor in Chicago, *Before the Charge.*[6] Another version of Cleveland's *Fighting Horses* in oil on paper is in the Emil G. Bührle Foundation Collection, Zurich, but both Eitner and Germain Bazin consider it an anonymous copy of the Cleveland watercolor.[7]

CEF

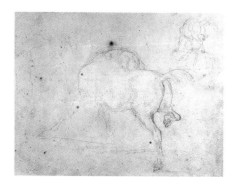

Fig. 1. Théodore Géricault. *Study of a Horse Turning Its Head and Raising Its Hind Leg,* 1818–19, graphite. The Art Institute of Chicago, Gift of Tiffany and Margaret Day Blake, 1947.35.21.

1. Bazin 1992, 69.
2. Loys Delteil, *Le Peintre-Graveur Illustré (XIXe et XX Siècles),* (Paris, 1924), 18:no. 12. See Paris/Cambridge 1997–98, 221, no. E. 9; Musée des Beaux-Arts, *Géricault: Tout l'oeuvre gravé et pièces en rapport* (Rouen, 1981), 36, no. 11.
3. A drawing in the Musée Bonnat, Bayonne (inv. no. 716, old inv. no. 2037; Bazin 1992, no. 1662), shows the same group but is clearly a preparatory drawing for the lithograph, not for the Cleveland watercolor (contrary to what is suggested in Los Angeles et al. 1971–72, under no. 65; New York et al. 1985–86, 123, under no. 59; Paris 1991–92, 393, under no. 248) since it shows the interior of a stable and essentially the same composition as the lithograph but in reverse (as it would have been in

the final preparatory study for the lithograph; see *Exposition d'oeuvres originales de Théodore Géricault (1791–1824) Peintres et dessins appartenant au Musée,* exh. cat., Musée Bonnat (Bayonne, 1964), 22, no. 110.
4. For a full discussion of this album, reproduced in its entirety, see Eitner 1960.
5. Eitner in Los Angeles et al. 1971–72, 107, no. 65, and San Francisco 1989, 64, no. 48; Grunchec 1982, 94; Grunchec in New York et al. 1985–86, 123, no. 59.
6. In Paris 1991–92, 393, no. 248.
7. Eitner 1980, 206; Bazin 1992, 214–15, no. 1658.

49. *Fighting Horses*

c. 1820

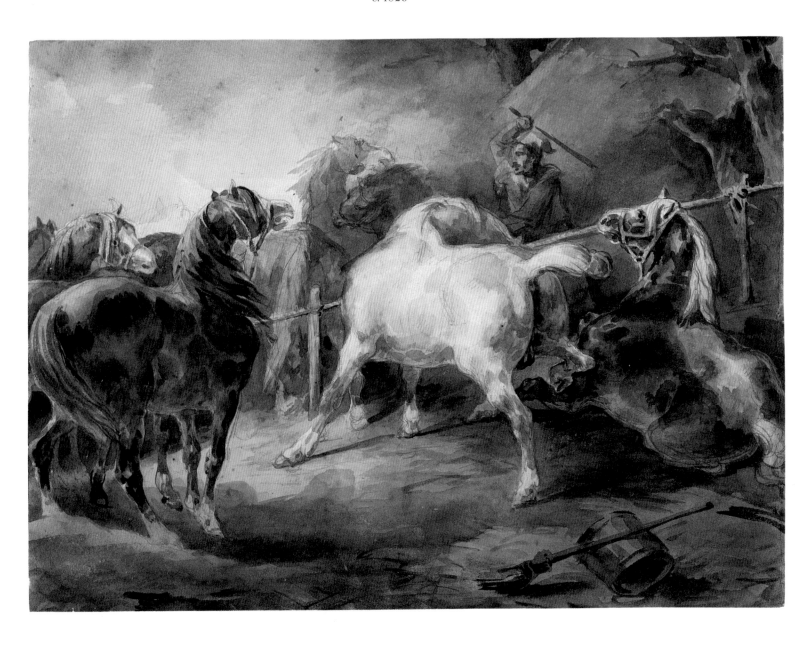

Watercolor over graphite, on cream wove(?) paper, laid down on secondary, tertiary, and quaternary supports (partially removed)

217 x 294 mm (8½ x 11⁹⁄₁₆ in.)

WATERMARK: none visible through mount

INSCRIPTIONS: on old label (now removed), in brown ink: *This drawing by Géricault was / the property of The Marquis of / Hertford & left to Sir Richard / Wallace, who in time bequethed / it to Sir John Murray Scott / Bart: / Purchased by Leggatt Bros at / the sale of Sir John Murray / Scott's Drawings etc, at 5 / Connaught Place Marble Arch. / Feb: 9th 1914.*; on old label (now removed): across top, in graphite: *41* [circled] *Dr. Bellingham Smith*; down center, in brown ink: *J. L. A. T. Géricault / Horses Fighting / Colles Marquess of Hertford /*

Sir Richard Wallace and / Sir John Murray Scott / Exhib. Burlington Fine Arts Club / 1922 . No 52. / Pictures drawings & Sculptures of French School / of the last 100 years.

Charles W. Harkness Endowment Fund 1929.13

Jean-Auguste-Dominique Ingres

Montauban, France, 1780–Paris 1867

In an often repeated anecdote about Ingres's career while he was in Rome, a tourist seeks him out and asks whether he has found the man who draws the "little portraits." The proud artist replies in the negative, informing the man that he has found the house of a painter.[1] Ingres meant that he considered himself a history painter, for like any artist of great ambition during his day, he aspired to the intellectual side in his art, one concerned with noble themes and subjects taken from sacred and classical literature. In reality, however, he was forced by economics to make portraits, and his work in the genre was much sought after during his first stay in Italy (1806–24). By far, the majority of his portraits are drawings in graphite on paper, of which he made hundreds.[2] He was accomplished as a portrait draftsman before he was twenty, but it was only after he moved to Rome and had finished his obligations at the French Academy that this aspect of his art flourished. Needing to support himself, Ingres drew and painted the many French officials in the city sent there under Napoleon's rule. Later, he drew the many tourists—especially the British—who visited the city after the fall of the Napoleonic regime.

After he returned to Paris, Ingres finally enjoyed public success at the Salon for one of his history paintings and began receiving commissions for more. Finally, he no longer needed to churn out the drawn portrait commissions, and his later portraits in graphite were generally made as gifts for friends. He drew the Cleveland sheet for the husband of the sitter, to whom the work is dedicated in the lower right. Désiré Raoul-Rochette was an impor-

tant archaeologist whom Ingres met during the winter of 1824–25. Ingres drew his portrait, a work now in Vienna, probably around the same time he made that of his wife.[3] Born Antoinette-Claude Houdon and known as Claudine, she was the youngest daughter of Jean-Antoine Houdon, one of the most important French sculptors of the eighteenth century.

Ingres's supreme mastery of the graphite medium is fully evident here. He normally produced such a work during more than one sitting but generally without making any preparatory studies. He did erase at times, and even scraped out the paper and used white paint to make changes, but no such corrections are evident on this sheet.[4] Typically, he brought the face and head to a high degree of finish and rendered the costume more sketchily. By varying the pressure and thickness of his pencil line, Ingres convincingly achieves different textures; the mass of curls in her elaborate coiffure, for example, shows broad patches of graphite combined with light, thin lines. The paper, fine-textured but not completely smooth, helped him achieve such effects and was essential to his technique. Ingres was always attentive to the dress of his sitters, and Madame Raoul-Rochette is shown here in day-wear, sporting a redingote with wide revers over a dress with long gigot sleeves, fashionably enormous at the top.[5] Her hairstyle, parted down the center with a profusion of curls at the sides and massed into a tight roll at the top (known as an Apollo's knot), was popular at the time and can be seen in many contemporary portraits.[6] CEF

1. Philip Conisbee and Gary Tinterow, *Portraits by Ingres: Image of an Epoch* (New York, 1994), 111, note there are several versions of the story.

2. Naef 1979 catalogued 456, and these works continue to be discovered.

3. Ibid., 5:160–61, no. 333; Innsbruck/Vienna 1991, 29–30, no. 1.2.

4. On Ingres's technique in his portrait drawings, see Marjorie Cohn, "The Original Format of Ingres Portrait Drawings," Colloque Ingres, *Numéro Spécial de la Revue "Bulletin du Musée Ingres"* (Montauban, 1969), 15–27. The Cleveland sheet does have extremely fine incised lines along the neck and at the outer edge of the proper left eye (visible with raking light and magnification).

5. Ribeiro 1999, 72.

6. My thanks to Sylvain Bellenger and Gary Tinterow for their help with this entry.

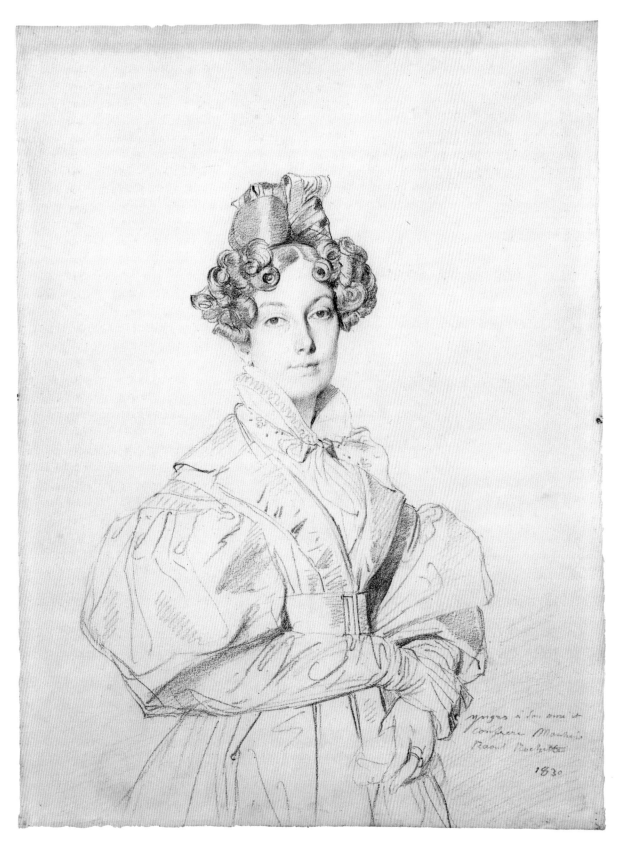

Graphite on beige wove paper

321 x 240 mm (12⅝ x 9⁷⁄₁₆ in.)

INSCRIPTIONS: signed, lower
right, in graphite: *Ingres à son
ami et / confrere Monsieur /
Raoul Rochette / 1830*

Purchase from the J. H. Wade
Fund 1927.437

(Hilaire-Germain) Edgar Degas

Paris 1834–1917

As an academic draftsman, Degas had few equals in the nineteenth century. He executed this black chalk study of a woman blowing a trumpet in preparation for an ambitious, unrealized painting, *St. John the Baptist and the Angel*, for which there are more than twenty related drawings, most of them in his sketchbooks in the Bibliothèque Nationale, Paris.[1] A brief passage by Degas from one of those sketchbooks well describes his idea of drawing at the time, beautifully realized on the Cleveland sheet: "It is courageous to confront nature with its main outlines, and cowardly to approach it through facets and details."[2] The ideal beauty of the figure and the carefully shaded linear technique reflects his academic training, and we know that during his stay in Rome, where he likely executed this sheet, he was attending life drawing class regularly at the French Academy.[3]

The subject of the intended final work seems to derive from several passages in the Book of Revelation.[4] In the preliminary version, known from a watercolor[5] and several of the sketchbook pages,[6] an angel shown frontally strides forward blowing a trumpet, arms outspread, with St. John the Baptist on the right. Although the chronology of the composition is unclear, several scholars have suggested that this version represents Degas's earliest conception, and that he then changed the composition to a horizontal format, with the angel turned toward the right and seen in profile, and St. John moving toward the right as well.[7] While we cannot be certain of his final intent, it does seem likely that Degas developed the composition around the striding figure of the angel, moving it from the left to the right side and experimenting with the pose.[8] He seems not to have changed the figure of St. John much from the initial conception. The Cleveland sheet probably shows a later, perhaps even the last, stage of the composition's development, with the angel's head in profile, left arm extended, and right arm near the trumpet's mouthpiece. A closely related drawing now in Pittsburgh reflects this same stage in the design.[9]

Carol Nathanson and Edward Olszewski have pointed out the problematic issue of how Degas used life drawing in the Cleveland sheet.[10] Two of the most finished figure studies for *St. John the Baptist and the Angel* were clearly done from life and show the same young boy posing for both figures.[11] Degas seems to have used this model in other sheets as he developed the angel's pose, as evidenced by two drawings in Oxford.[12] At some point, he made a full-length figure study of a female nude for the angel figure (fig. 1), perhaps, but not necessarily, done from life. The Cleveland sheet, although probably a life study, appears to be the torso of a male model: the breasts seem an afterthought on a lean but muscled male body.[13] The result is an abstract, idealized figure. It reflects Degas's study of nature through the live model, as well as the academic learning process that mediated this reality through the careful study of classical sculpture and Renaissance masters, works in which Degas was thoroughly steeped during his stay in Rome (see no. 52). CEF

Fig 1. Edgar Degas. *Angel Blowing a Trumpet; Drapery: Studies for St. John the Baptist and the Angel*, 1857, graphite. Private collection, New York.

1. For related drawings, see Saint Louis et al. 1967, 52–54, nos. 26–27; Rome 1984–85, 106–115, nos. 33–36; Nathanson/Olszewski 1980; Artemis Group, *Edgar Degas 1834–1917* (London, 1983), no. 4; Adriani 1985, 341–42, nos. 22–23; Paris et al. 1988–89, 67–68, no. 10; Thomson 1988, 36–40; for drawings in the notebooks, see Reff 1976, notebook 5, p. 48, notebook 7, p. 27, notebook 8, pp. 5, 7v, 8v, 24, 68v, 70v, 73v, notebook 9, pp. 9, 11, 15, 29, 42, 43, 55, notebook 10, pp. 33, 35, 40, 49, notebook 11, pp. 34–36, and notebook 12, p. 24.

2. Cited in Paris et al. 1988–89, 49.

3. Ibid., 65–66.

4. Since the Book of Revelation is associated with St. John the Evangelist, not John the Baptist, Degas either mingled their identities intentionally or confused the two; see Saint Louis et al. 1967, 52–54; Nathanson/Olszewski 1980, 243.

5. Lemoisne 1946, 8, no. 20.

6. Reff 1976, notebook 8, pp. 5, 8, notebook 9, pp. 11, 29, 42, 55.

7. See Reff's comments in the individual entries on the notebook pages cited in note 1 above; Boggs in Saint Louis et al. 1967, 52–54, under nos. 52–54; Thomson 1988, 36–37.

8. Of the drawings reflecting the later composition, one of the notebook pages shows the angel on the left with St. John on the right (notebook 7, p. 27), as does the drawing in Pittsburgh; other studies show the opposite (a sheet in the Ashmolean Museum, Oxford; notebook 10, pp. 40, 49, notebook 11, pp. 35–36); Nathanson/Olszewski 1980, 250–51, describes how Degas likely proceeded.

9. See Saint Louis et al. 1967, 27–28, no. 27.

10. Nathanson/Olszewski 1980, 245.

11. Now in the Von Der Heydt Museum, Wuppertal; see Paris et al. 1988–89; Saint Louis et al. 1967, 52–53, no. 26; a related drawing was in the fourth Degas studio sale (no. 70b) and is illustrated in Rome 1984–85, 108–9, no. 34.

12. See Rome 1984–85, 107–8, no. 33, 112–13, no. 36.

13. Nathanson/Olszewski 1980, 246; Thomson 1988, 37.

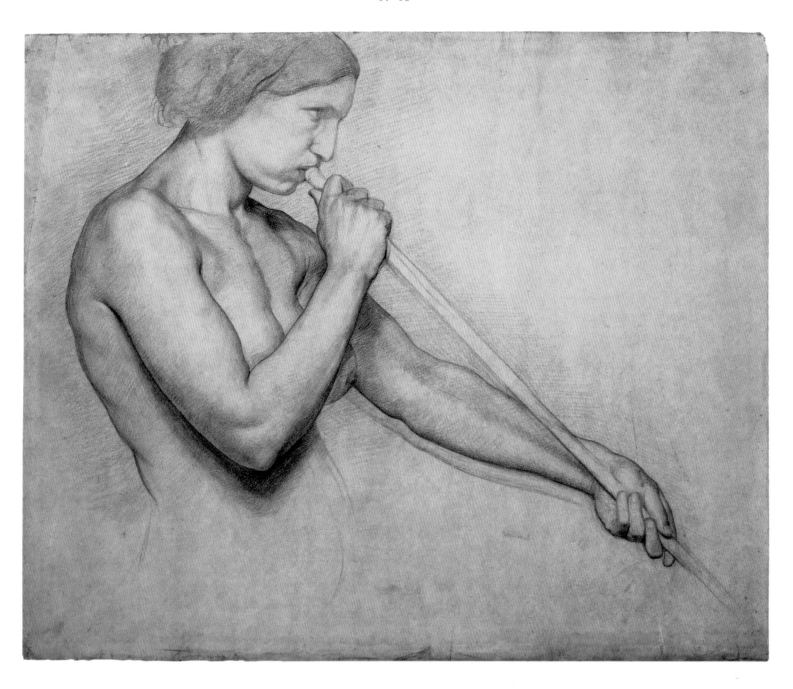

Black chalk on gray wove paper

441 x 541 mm (17¾ x 21¹⁵⁄₁₆ in.)

INSCRIPTIONS: verso, lower right, in graphite: *43 53 / 93 99* [underlined] / *65 75*; lower right, in graphite: [illegible] *ppl*[illegible] [sumi?] [natural?] *T A*

Gift of The Print Club of Cleveland 1976.130

(Hilaire-Germain) Edgar Degas

Paris 1834–1917

In July 1858, Degas traveled from Rome to Florence, where he made this sheet of studies. Although it is inscribed "Flor. 1857" in the artist's own hand, the date is incorrect; we know Degas was not in Florence until the next year and he must have inscribed the work years later. The fragmented, dissociated imagery makes it a beguiling document of artistic process and of the hold the art of the past took on the young Degas. It reflects a variety of techniques and media, from the abstract crosshatching in the upper right with which he tested his pen to the highly finished and refined head in graphite that dominates the sheet. He copied this head from a silverpoint drawing in the Uffizi gallery, a work then believed to be by Leonardo da Vinci (fig. 1).[1] Degas used graphite to mimic the subtle effects of the original's technique, and his masterful control makes a striking contrast with the sketchier treatment of the rest of the sheet. He seems to have drawn the Leonardesque head first—it is well centered on the paper—then used the perimeter to try other ideas in pen, ink, and watercolor. The idealized, early Renaissance style of the central image makes a fascinating juxtaposition with the more realistic study of the girl's head at the upper right. The latter may be a small portrait of Degas's cousin Giulia Bellelli and seems related to the Bellelli family portrait, one of the artist's early masterpieces, begun during his stay in Florence.[2]

The other sketches show Degas's free adaptations of works he saw in Florence, and one can connect several to images in a notebook (Reff no. 12)[3] he used while there. At the lower right, for example, are three rapidly drawn pen-and-ink horse studies, one on top of the other.[4] The most dominant—of a horse striding forward, proper right front leg raised—was no doubt inspired by Anthony Van Dyck's *Equestrian Portrait of Charles V* on view in the Uffizi, of which Degas made several copies in his notebook.[5] The two other sketches of a rearing horse also relate to notebook drawings.[6] Similarly, the fragmented male figure at the right margin with widely splayed legs is a motif Degas repeated at the bottom of the sheet, there completing the figure as an archer; the notebook contains a variant of this.[7] Classical sculpture also interested him on his Italian trip: the head at the upper left seems an adaptation of a Roman portrait bust or some other work from antiquity—perhaps a statue of Jupiter or Hercules. At the bottom, the female nude recalls several famous statues of Venus while copying none of them exactly, and Degas's suggestion of a garden setting indicated by the plants at her left suggests a figure of Eve. In short, we find Degas copying, adapting, and transforming the history of art in his own mind through the act of drawing. CEF

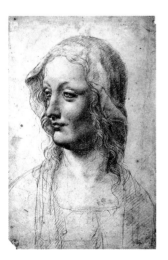

Fig. 1. School of Leonardo da Vinci. *Head of a Woman*, silverpoint heightened with white. Uffizi, Florence, no. 426e.

1. Degas's better-known copy after a Leonardesque drawing is his "completion" of a portrait drawing in the Uffizi as an oil painting (now in Ottawa); see Paris et al. 1988–89, 76, no. 18.
2. Ibid., 77–85, nos. 20–25.
3. See Reff 1976, 1:73–78; Degas used it in Florence, Siena, and Paris between August 1858 and June 1859 (ibid., 1:73).
4. On Degas's interest in the horse around this time, see Jean Sutherland Boggs, "The Horse in Art and Legend," in Boggs et al., *Degas at the Races*, exh. cat., National Gallery of Art (Washington, 1998), 16–35.
5. Reff 1976, notebook 12, pp. 11, 72.
6. Ibid., 1, 67.
7. Ibid., 90.

Graphite (central head study), pen and brown ink, brush and brown wash, and watercolor, on cream wove paper

303 x 235 mm (11¹⁵⁄₁₆ x 9¼ in.)

INSCRIPTIONS: by artist, lower left, in graphite: *Flor. 1857*; estate stamp, lower left, in red ink; verso, in top half, in blue crayon: *Ph. 2249*; in bottom half, in black chalk: [seul?] / *haut 30 cm / larg 23 cm*

John L. Severance Fund 1951.430

Jean-François Millet

Gruchy, near Cherbourg, 1814–Barbizon 1875

Jean-François Millet's *First Steps* is one of four extant finished versions of the subject. Besides the present sheet, there is the pastel reproduced by Alfred Sensier in 1881,[1] the chalk and watercolor drawing that sold in New York in 1994,[2] and the pastel in the Lauren Rogers Museum of Art (fig. 1). The last has only recently become well known.[3] A comparison of these four works with the numerous preparatory drawings clarifies where the Cleveland sheet fits into the chronology and how the artist likely developed the composition.

In a letter to Millet dated 9 January 1859, his friend, patron, and sometime dealer Sensier commissioned him to make a drawing of "a father encouraging his child to walk in a garden in the same way as in the one [owned by] Feydeau."[4] A week later, Sensier reminded the artist to work on the drawing and suggested he use pastel on it. Sensier noted he already had a client for the work, and his statements imply that his client had seen and liked the pastel owned by Feydeau.[5] We therefore know that Millet had completed one of the *First Steps* before 1859 and likely finished another in 1859, shortly after Sensier's letter. The Rogers sheet and the one Sensier reproduced in his 1881 Millet monograph are closely related, and thus they are likely the two works datable by Sensier's letters, though the order of their execution is not clear. As in the Cleveland *First Steps*, each shows a family in a small part of a fenced-in garden behind a house, the mother and child next to the open gate. The father encourages his child from across a row he has just

dug for planting, over which he has laid his shovel. The white sheets of laundry appearing on the back fence create the most obvious difference between those two works and the Cleveland version, where the laundry is absent. The angle of the row is also different in the present sheet: it runs from the bottom of the sheet toward the father, rather than toward the mother and child. In that regard, the Rogers and Sensier drawings are closer to the majority of Millet's preparatory sketches,[6] which also show the row running toward the child. This fact further suggests these two works are the earliest finished versions of *First Steps*. The watercolor version is different from the other three, not only in media but in composition: the garden is more open, the house is at the right side, and the father is very close to his child on the same side of the row.[7]

Sensier's appeal to Millet to make another pastel version of *First Steps* illustrates the critic's importance in promoting the artist's acclaim and connecting him with patrons,[8] as well as in changing the critical perception of his work. In the late 1850s and early 1860s, many critics still disparaged Millet's representations of the peasantry, often reading them as politically radical. Sensier was a key voice in deflecting such commentary by presenting the artist's peasant images not as a social critique but as sincere representations of a peasantry preordained to live modestly at one with nature, closer to family and faith.[9] Millet himself came from a peasant background in Normandy. CEF/PSC

1. Alfred Sensier, *La Vie et L'oeuvre de Jean-François Millet*, (Paris, 1881; published in English as *Jean-François Millet: Peasant and Painter* [Boston, 1881]), 345; this version must be the pastel measuring 63 x 75 cm, now in a German private collection; see, for example, Herbert in Paris/London 1975–76, 139–40 (p. 128, Eng. ed.).

2. Christie's, New York, 13 October 1994, no. 91; it had also sold in 1992 at Christie's, London, 27 November, 1992, no. 17.

3. Both Herbert in Paris/London 1975–76, 139 (p. 127, Eng. ed.), and Murphy in Boston 1984, 155, list it as lost. It was published as early as 1905 in Richard Muther, *Jean François Millet* (New York, 1905), repr. opp. p. 14. A photograph by Braun existed of it in the late nineteenth century and was copied by Van Gogh (repr. in Paris 1998–99, no. 82).

4. "Vous pouvez en outre faire un dessin, q'on vous commande, représentant un père fesant [sic] marcher son enfant dans un jardin, dans la même analogie que celui de Feydeau. Il est placé d'avance." (Cited without bibliographic info. by Herbert in Paris/London 1975–76, 140 [p. 129, Eng. ed.].)

5. "N'oubliez pas le dessin, le père, la mère et l'enfant, et mettez-y du pastel. On y tient, car on a vu celui de Feydeau" (as cited by Herbert in ibid., 140). The extensive Sensier-Millet correspondence is in the Cabinet des dessins, Musée du Louvre, where Herbert must have seen the letters he quotes.

6. The conté crayon sketch in the Museum of Fine Arts, Boston, inv. no. 1993.1465 (repr. in Boston 1984, 115) and the black chalk sketch on blue paper in the Cabinet des dessins, Musée du Louvre, inv. no. 10639 (Moreau-Nélaton 1921, 3:fig. 343).

7. This version is dated as the earliest, to probably 1853–54, in *Nineteenth Century European Paintings, Drawings, Watercolors, and Sculpture*, Christie's, New York, 13 October 1994, 70, no. 91. Conversely, one could argue that its composition seems to develop logically from the Cleveland sheet because of the positioning of the row. Some scholars have doubted the watercolor's authenticity: Murphy in Boston 1984, 115, mentions a watercolor and crayon version of *First Steps* with the same measurements, of unknown location, as appearing in reproduction not to be by Millet. Future analysis of the paper used in all four works may eventually provide the proof of their chronology. Gavet, who owned the Cleveland pastel, contacted Millet in September 1865 in order to become practically the exclusive purchaser of his pastels, even supplying him with paper for works in the medium; see Moreau-Nélaton 1921, 2:181–82. Some of them were variations on earlier compositions, which would suggest a date of c. 1866 for the Cleveland work, since Millet first handed over a large number of pastels to Gavet during the course of that year (ibid., 3:4–7, 11–14). A comparison of the Cleveland sheet with the paper provided by Gavet might provide final proof. Yet, we also know that Gavet acquired many of his pastels from Alfred Feydeau; see ibid., 3:97, leaving open the possibility that the Cleveland work is the very one that prompted Sensier's January 1859 letter. For this reason, we have chosen to date the Cleveland pastel c. 1858–66.

8. There are other instances in which Sensier expressed his belief to Millet that lighter drawings with pastel were more marketable; see Moreau-Nélaton 1921, 2:57.

9. On Sensier's central position to Millet's career, see Christopher Parsons and Neil McWilliam, "'Le Paysan de Paris': Alfred Sensier and the Myth of Rural France," *Oxford Art Journal* 6, no. 2 (1983), 38–58.

Black chalk and pastel, on beige
laid paper, perimeter mounted
to beige wove paper

295 x 459 mm (11⁹/₁₆ x 18¹/₁₆ in.)

WATERMARK: none visible
through mount

INSCRIPTIONS: signed, lower
right, in black chalk: *J. F. Millet*

Gift of Mrs. Thomas H. Jones
Sr. 1962.407

Fig. 1. Jean-François Millet.
First Steps, c. 1856–58, pastel.
The Lauren Rogers Museum of
Art, Laurel, Mississippi, 27.17.

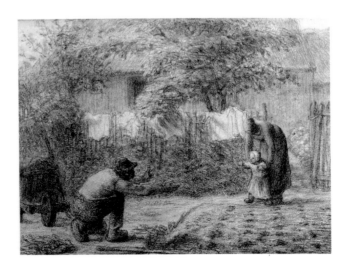

Honoré Daumier

Marseilles 1808–Valmondois 1879

Depictions of art collectors (*amateurs*)[1] and spectators form one of the most thematically significant group of works in Daumier's oeuvre. In the 1830s, 1840s, and 1850s, he made numerous mocking caricatures of visitors at the Paris Salon exhibitions as newspaper illustrations.[2] He continued to depict the Salon later in his career, but he also developed the theme of collectors and connoisseurs examining art objects in auction house sale rooms, artist's studios, commercial galleries, and private *cabinets*. Most of these works date to the 1860s.[3]

The Cleveland drawing is related to an illustration by Daumier (fig. 1) that appeared in the French newspaper *Le Monde Illustré* for an article by Champfleury, "The Auction House" (*L'Hotel des commissaires-priseurs*), which ran in installments over several issues. Daumier illustrated each one,[4] and this particular installment was subtitled "The Art Collector" (*L'Amateur*). Its illustration, a woodcut by C. Maurand after a Daumier drawing, shows a group of top-hatted men scrutinizing a framed painting, one peering at it close up with a magnifying glass. The drawing after which it was made is not now known but would have been one of the artist's important variations on this theme. From Maurand's woodcut, one can see that Daumier emphasized three different reactions to a single work of art by the three men, who nonetheless seem almost to act as one.[5] In that sense, it is quite different from the version of the subject in Cleveland. One could add, too, that the illustration follows quite specifically Champfleury's text in which he mocks the experts "armed with round magnifying glasses"[6] that he described as the habitués of the auction sale rooms.

In the Cleveland drawing, the three spectators each look at different works of art and seem to regard them with quiet respect rather than invasive scrutiny. This work was never reproduced as a print, and Daumier does not caricature his subjects the way he does in the illustration, which is typical of his work done for newspapers. It is better understood as a reworking of the illustration, perhaps done several years later. A drawing now in Chicago, datable to after 1869, shows similarly dressed men in an almost identical room.[7] CEF

Fig. 1. C. Maurand after Honoré Daumier. *The Auction House: The Connoisseur*, 1863, woodcut. The Metropolitan Museum of Art, Rogers Fund, 1920 (20.48.6).

1. The French word *amateur* had numerous connotations in the period under discussion; it basically meant "art collector" but could reflect a wide range of connoisseurship skills, from pretentiousness to true expertise. For a discussion of the term as it relates to Daumier's art, see Bruce Laughton, *Honoré Daumier* (New Haven/London, 1996), 51.

2. For examples, see Eugène Bouvy, *Daumier L'Oeuvre gravé du maître* (Paris, 1933; reprint, San Francisco, 1995), nos. 59, 294, 301–2, 826–31; Loys Delteil, *Le Peintre-Graveur Illustré Honoré Daumier* (Paris, 1926), 5:nos. 1473, 1542; 6:nos. 2292–93, 2294–95, 2298–3000, 2675.

3. See Maison 1968, 1:nos. 14, 62–64, 71, 131–33, 135–37, 146–48, 151–52, 163, 167, 176, 234–36; 2:nos. 362–93; Frankfurt/New York 1992–93, 162–73; Ottawa et al. 1999–2000, 394–410.

4. See Bouvy, *Daumier L'Oeuvre gravé du maître*, nos. 930, 939–40.

5. Sonnabend in Frankfurt/New York 1992–93, 165.

6. The full quote is: "Sont-ils assez importants ceux armés de loupes rondes qu'ils s'assujettissent dans l'oeil comme un horloger étudiant les rouages d'une montre." See Champfleury, "L'Hotel des Commissaires-Priseurs (Suite) L'Amateur," *Le Monde Illustré* 7 (18 April 1863), 253.

7. See Ottawa et al. 1999–2000, 409–10, no. 258 (repr. in color).

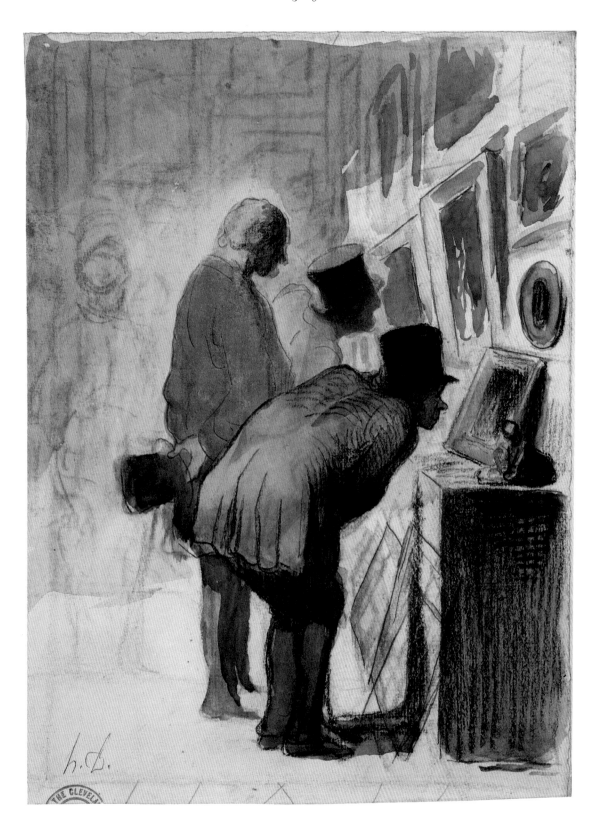

Brush and gray and black wash, charcoal, and graphite, with orange and red wash, on cream modern(?) laid paper, laid down on wove paper

261 x 193 mm (10¼ x 7⁹⁄₁₆ in.)

WATERMARK: along right margin: letters (illegible through mount)

INSCRIPTIONS: signed, lower left, in black ink: *h.D.*

Dudley P. Allen Fund 1927.208

Georges Seurat

Paris 1859–1891

Georges Seurat's extraordinarily original drawings rank him among the greatest draftsmen of the nineteenth century. He developed a tonal technique using black conté crayon that parallels the pointillist painting style he also created. Pointillism used short strokes or dots of divided hues of paint that the eye combines at a distance: a broad area of color is thus made up of many individual strokes of its component hues. Similarly, Seurat's drawings exploited paper texture as a way to separate his applications of black chalk into minutely discrete areas. Only the sheet's highest ridges catch the crayon, leaving small interstices of white visible and thus allowing startling optical effects. His late drawings, including this sheet, are virtually devoid of line and instead develop form through tonal range—the variously concentrated ridges of black created by changing the pressure of the crayon on the paper.

The Cleveland sheet belongs to a series of eight drawings devoted to the "Café-concert." These popular gathering places for the middle class in late nineteenth-century Paris featured singers and other forms of vaudeville entertainment. Many of Seurat's contemporaries, most notably Edgar Degas, also treated this subject. In fact, the compositional type Seurat explored in this series, which features an audience-eye view of the stage and performers, had been pioneered by Degas and Honoré Daumier in the 1860s and 1870s.[1] Of the drawings in the series, this work is most similar to *Au Concert Européen* (fig. 1), in which Seurat turned a row of female spectators into abstracted curving forms. In the Cleveland drawing, the point of view from which Seurat rendered the audience of men in bowler hats seems to have inspired their flat, nearly abstract shapes. But his development of a viewpoint through heads also emphasizes perspective recession in a way quite unlike the other "Café-concert" drawings.

The Cleveland drawing has been exhibited and published with various titles in the twentieth century—most recently as *Au Concert Parisien*.[2] The Concert Parisien was a popular nightclub,[3] and five of Seurat's "Café-concert" series works apparently depict known establishments (such as the Eden Concert, the Divan Japonais, and the Gaité Rochechouart), which we know because they were exhibited during the artist's lifetime with titles naming the place.[4] The present work was not,[5] however, and one author has suggested it may depict the Concert Européen.[6] Unless more evidence comes to light, it seems appropriate to use the more general title, *Café-concert.*
CEF

Fig. 1. Georges Seurat. *Au Concert Européen*, 1887–88, Conté crayon. The Museum of Modern Art, New York, Lillian P. Bliss Collection.

1. Herbert 1962, 136–44.

2. Paris/New York 1991–92, 302, no. 197.

3. Discussed by Tinterow in ibid., under no. 197.

4. The works exhibited in Seurat's lifetime are Hauke 1961, 2:nos. 685–86, 688–90; see Richard Thompson, *Seurat* (Oxford, 1985), 197; Zimmermann 1991, 366.

5. It may have been shown at the offices of *La Revue Indépendant* in 1888, but if so, Fénéon only describes it as a "café-concert"; see Provenance in Documentation section.

6. Tinterow in Paris/New York 1991–92, 300, under no. 195; Zimmermann 1991, 366–68.

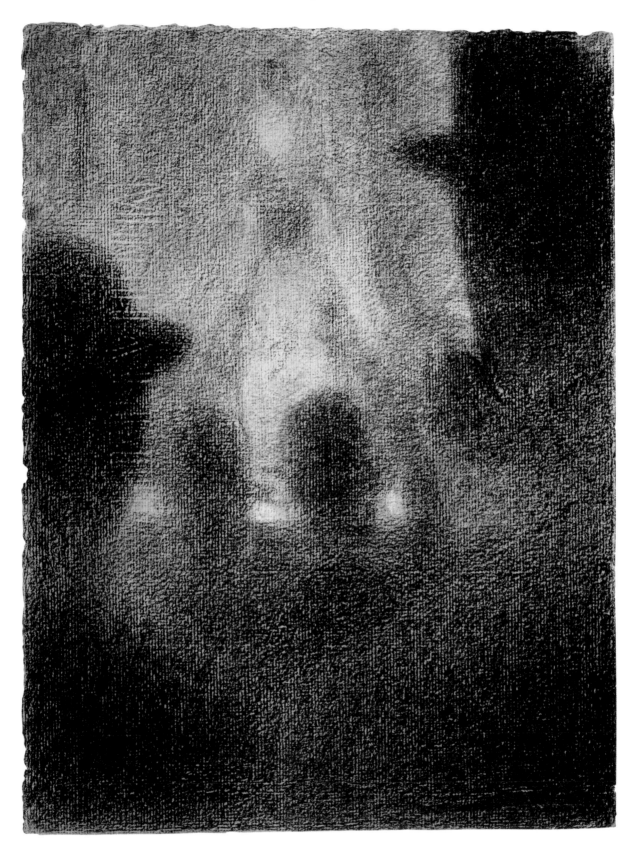

Conté crayon heightened with
white chalk, on cream modern
laid paper

314 x 236 mm (12⁵⁄₁₆ x 9¼ in.)

WATERMARK: along left margin:
Michallet

INSCRIPTIONS: verso, by
Maximilien Luce, in bottom
half, in blue crayon: *G Seurat /
[L?].* [all upside down]; center
left, in red crayon: *299* [upside
down]

Leonard C. Hanna Jr. Fund
1958.344

Henri (-Marie-Raymond) de Toulouse-Lautrec (Montfa)

Albi 1864–Château de Malromé, near Langon, France, 1901

This large brush drawing in grisaille appeared as an illustration at the head of Émile Michelet's article "L'Été à Paris" in the July 1888 edition of *Paris illustré,* a magazine popular among the bourgeoisie.[1] The article describes the "poor Parisians"[2] condemned to the city in the summer, unable to escape to the country or the seaside for vacation. Lautrec made four drawings for the article,[3] but Michelet's text addresses the subject of the laundress more fully than it does those of the other illustrations.[4] The sexual availability of working-class women for bourgeois men forms the subtext of Lautrec's image,[5] and Michelet alludes to it several times. He describes young, working-class women in general as the understood object of the male gaze on the streets of Paris in summer.[6] He also describes them as smiling and happy at the abundance of work,[7] but Lautrec's image provides an ironic contrast to the text. This weary woman with dark circles under her eyes bears her labor with a haggard look, and the artist seems to invite comparison of her situation to that of the workhorse on the street behind her. In that sense, Lautrec's illustration makes an interesting comparison to one he made the year before, *Sur le Pavé,* in which a lecherous older man confronts a young milliner.[8] That street scene is composed in much the same way as *The Laundress,* with a sharp receding perspective emphasizing the act of street-level spectatorship, by definition masculine in the context of both these images. In the Cleveland work, the man's top hat visible above the coach receding behind the woman alludes to her subservient social and sexual role.

Lautrec had depicted the subject before; one of the first and most notable is the painting in a private collection datable to c. 1886 featuring the model Carmen Gaudin.[9] The Cleveland work probably depicts Suzanne Valadon, the artist who as a young woman modeled for Lautrec, Renoir, and others.[10] Another drawing, closely related stylistically to the Cleveland sheet, also featured Valadon.[11] In contemporary photographs her resemblance to Lautrec's *Laundress* is apparent; in one she even wears her hair exactly the same way.[12]

A preparatory study for the Cleveland drawing in charcoal is now in Albi (fig. 1).[13] The present work is larger and shows an expanded view of the street with additional figures. It is also in a much different technique, done in gray washes on a board prepared with a white ground, a media better suited for photomechanical reproduction in black and white.[14] Lautrec left a fair amount of blank space at the top and bottom, but those areas were cropped for the reproduction in *Paris illustré,* changing the format into a square that filled three-quarters of the page. It thus appears quite different from the three other illustrations for the article, all vertical and in a different technique as well, in opaque black and white paint rather than transparent, loosely brushed washes.
CEF

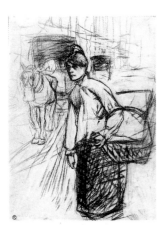

Fig. 1. Henri de Toulouse-Lautrec. *Study for The Laundress,* 1888, charcoal and stump. Musée de Toulouse-Lautrec, Albi, inv. no. D. 80.

1. For a discussion and reassessment of the artist's stylistic development around the time of these works, see Murray 1991, 123–75; see also London/Paris 1991–92, 196–201.

2. Michelet 1888, 425.

3. Actually grisaille paintings on cardboard: Dortu 1971, 2:134–35 (repr.), nos. P.298–300; Dortu lists the Cleveland work among the drawings, reflecting its different technique.

4. See Murray 1991, 166.

5. This aspect of French society at the time is well studied; see Eunice Lipton, "The Laundress in Late Nineteenth-Century French Culture: Imagery, Ideology, and Edgar Degas," *Art History* 3 (September 1980), 295–313; Hollis Clayson, *Painted Love: Prostitution in French Art of the Impressionist Era* (New Haven/London, 1991), 113–32.

6. Michelet 1888, 426: "Aussi la Parisienne demeurée fidèle à son Paris comprend qu'elle attire plus de regards l'été."

7. Ibid.: "son visage frêle est éclairé d'un sourire. Elle est joyeuse, pendant ces chaleurs, malgré sa rude tâche."

8. Dortu 1971, no. D.3.001; London/Paris 1991–92, 194–5, no. 47.

9. Dortu 1971, no. P.346; on the dating, see Murray 1991, 90.

10. Lautrec's friend François Gauzi posed for another of the "L'Été à Paris" illustrations and recounted the session later: see London/Paris 1991–92, 200; one can assume the artist held a similar session with Valadon.

11. Dortu 1971, no. D.3.092; London/Paris 1991–92, 190–91, no. 46.

12. See Palazzo Fort, *Henri de Toulouse-Lautrec* (Verona, 1994), 228, photograph illustrated at lower left.

13. Dortu 1971, no. D.3.028; London/Paris 1991–92, 198–99, no. 48.

14. Murray 1991, 166–67, describes the Cleveland drawing as pen and ink and as the only one of the "L'Été à Paris" illustrations not painted in grisaille, which is misleading as the work is executed in brush and gray and black washes on a white ground and is thus more aptly described as grisaille than the three other illustrations, which are on a beige-colored ground.

Black and gray wash with white
paint, scratched away in places,
on gray cardboard prepared
with a white ground

759 x 631 mm (29⅞ x 24¹³⁄₁₆ in.)

INSCRIPTIONS: signed, lower
right, in black crayon: *T-
Lautrec;* verso, upper center, in
graphite: *M*

Gift of the Hanna Fund
1952.113

Paul Gauguin

Paris 1848–Atuona, Marquesas Islands, 1903

Paul Gauguin was an innovative graphic artist, but given the number of major oil paintings in his oeuvre, he produced relatively few drawings. The Cleveland head study relates to the figure in the upper center of *Les Parau Parau* (fig. 1),[1] one of the first paintings he made during his first trip to Tahiti in 1891–93. However, the drawing was not necessarily made in preparation for the larger work. Gauguin more likely drew it independently and then decided to use it in the painting. In his writings, Gauguin often referred to his drawings as "documents,"[2] by which he seems to have meant records of motifs and ideas that he could use later. From a statement in a letter to his friend Daniel de Monfreid, we know that these "documents" were among the first works of art Gauguin produced in Tahiti, made before he had finished any paintings.[3] The carefully drawn, finished quality of this study in graphite suggests he made it from life and then used it to develop the seated female figure in the painting. Because the painting is dated 1891 and Gauguin had arrived in Tahiti in June of that year, he must have drawn the sheet during the first few months after his arrival.

The Cleveland drawing forms part of a stylistically coherent group of portrait heads all datable to around 1891–92.[4] Although most of them are in charcoal, rather than graphite, each reflects a similar mask-like stylization of the facial features.[5] Some relate to figures in paintings, but the artist seems to have intended them as finished works of art meant for sale. One, for example, Gauguin signed with his initials.[6] Another, which is also connected to *Les Parau Parau*, was begun in graphite but then worked up and finished in watercolor.[7] The Cleveland work is far from a quick sketch and shows an extremely refined use of both graphite and delicate graphite washes applied with a brush. Along with several other drawings and monotypes, it may have been included in the exhibition Gauguin held in his studio in the rue Vercingétorix in Paris during the first week of December 1894. Evidence for this supposition comes from the similar mounts that appear on a group of his works on paper.[8] The Cleveland drawing no longer has this mount,[9] but it is visible in a photograph taken of the piece in 1946. According to Charles Stuckey, this type of overmat is similar to the mounts visible in photographs taken of works in the artist's studio.[10] It seems possible, in fact, that Gauguin sold the drawing around December 1894. Charles Morice, who was then in the artist's circle and wrote about the exhibition, reproduced the work in one of the first monographs on the artist, published in 1919, ten years before César M. de Hauke sold it to the Williamses of Cleveland. At that time, it was presumably in the collection of someone Morice knew, or perhaps he even owned it himself. CEF

Fig. 1. Paul Gauguin. *Les Parau Parau*, 1891, oil. The Hermitage Museum, St. Petersburg, Russia.

1. See Kantor-Gukovskaya et al. 1988, 64–67.

2. Stuckey in Washington et al. 1988–89, 218.

3. Mme Joly-Segalen, *Lettres de Gauguin à Daniel de Monfreid* (Paris, 1950), 52, in a letter dated 7 November 1891, Gauguin writes: "Jusqu'à présent je n'ai rien fait de saillant; je me contente de fouiller mon moi-même et non la nature, d'apprendre un peu à dessiner, le dessin il n'y a que cela, et puis je cumule des documents pour peindre à Paris."

4. See Washington et al. 1988–89, 224–25, 229–32, 270, 288, nos. 118–19. 122–25, 148, 158.

5. Ibid., 231, under no. 125.

6. Ibid., no. 124.

7. Ibid., 225, no. 119.

8. See Richard S. Field, *Paul Gauguin: Monotypes* (Philadelphia, 1973), 16, 58–59.

9. The mount was likely removed after the drawing entered the CMA, but no records for such were found.

10. Washington et al. 1988–89, 224, under no. 118.

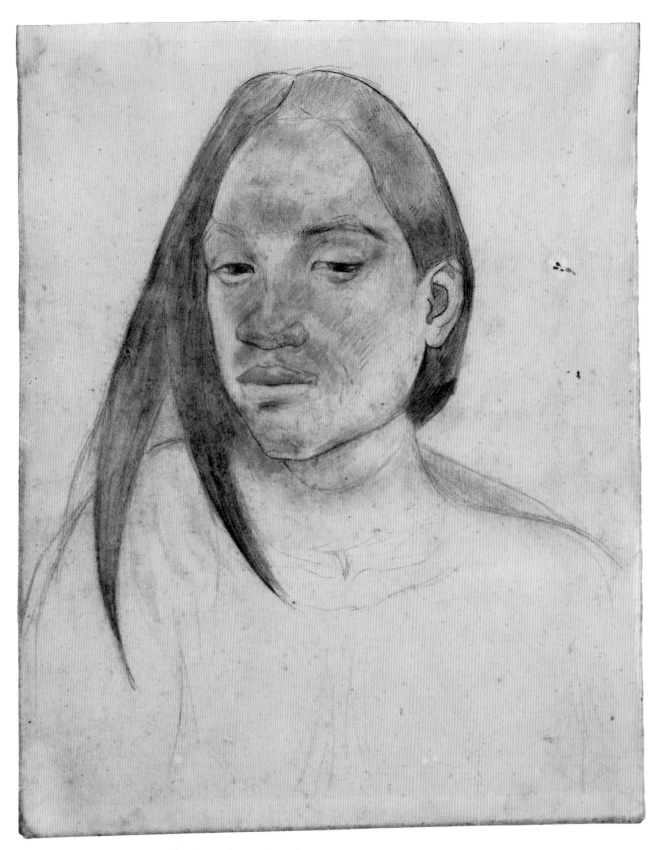

Graphite with stumping and
graphite wash, on imitation
vellum

305 x 244 mm (12 x 9⁹⁄₁₆ in.)

Mr. and Mrs. Lewis B. Williams
Collection 1949.439

Charles Angrand

Criquetot-sur-Ouville, Normandy, 1854–Rouen 1926

Originally from Normandy, Charles Angrand received his early training at the Rouen Academy and moved to Paris in 1882. He developed a friendship with Georges Seurat and experimented with the latter's ideas about using divided hues and short strokes of paint, the technique that became known as divisionism. By the late 1880s, Angrand was an important practitioner of the new movement, and he exhibited with Seurat in the *Salon des Independants*. In 1891—the year of Seurat's death—Angrand almost totally abandoned painting in favor of drawing in black crayon. The technique of his drawings owes much to Seurat (see no. 55). Both artists explored on paper some of the same visual ideas of divisionist painting, though the results they achieved in the monochrome media of black crayon have their own esthetic.

End of the Harvest exemplifies Angrand's interest in images of rural labor and farming. He was one of the few artists associated with divisionism who favored the subjects made popular by the Barbizon school painters, especially François Millet (see no. 53).[1] The Cleveland drawing is datable to the 1890s because the artist was working in a similar pointillist technique throughout that decade and one can compare it stylistically to numerous dated sheets.[2] Angrand also executed paintings

with similar themes, including a work from 1892 now in Houston.[3] A nearly identical version of the Cleveland drawing is known, though it is also undated.[4] A third sheet of the same subject and title may also be related,[5] and yet another drawing repeats the Cleveland composition but reflects Angrand's later drawing style.[6] The Cleveland version of *End of the Harvest* well exemplifies Angrand's use of black crayon to construct form through tonal gradation rather than line. His technique makes light appear to envelope and dissolve the forms and sets an ethereal tone. The disc of the sun is the focal point of the composition; its light reflects off the piles of harvested hay, which seem to emanate from the sun itself, sweeping into the foreground in a gentle arabesque. His use of the white of the paper is essential in the creation of these luminous effects, and one can well understand Paul Signac's description of Angrand's drawings as "poems of light."[7] A later work of the same subject (fig. 1) includes many of the same compositional elements, but its conventional technique only emphasizes the innovative, abstract quality of the artist's 1890s drawings. Angrand was able to push a drawing style that originated with Seurat into new directions, expanding the range of subject matter and increasing the size into a format closer to easel painting. CEF

Fig. 1. Charles Angrand. *Fin de moisson*, 1905, Conté crayon. Petit Palais-Musée d'Art Moderne-Genève, inv. no. 10095.

1. Millet treated the same theme, albeit in a much different way, in a drawing from the early 1850s, sold Christie's, New York, 25 February 1988, lot 153.

2. For example, *La ménagère*, dated 1892 and executed on exactly the same type of paper; see *L'École de Rouen de l'impressionnisme à Marcel Duchamp 1878–1914* (Rouen, 1996), 170; other drawings by Angrand from the 1890s are catalogued there as well on pp. 171–76.

3. See Richard Thomson, *Monet to Matisse: Landscape Painting in France 1874–1914* (Edinburgh, 1994), 156, fig. 243.

4. See Jean Sutter, *The Neo Impressionists* (Greenwich, 1970), 84, where it is reproduced. This drawing appeared on the art market at least twice in the 1970s (Sotheby's, London, 29 November 1972, no. 35; Christie's, London, 3 April 1979, no. 116).

5. See Chateau-Musée de Dieppe, *Charles Angrand 1854–1926* (Dieppe, 1976), 41, no. 23: "Fin de Moisson, vers 1895–1900. Dessin à la mine noire. H = 500 mm; L = 650 mm." The work is not reproduced, so determining how it might relate to the Cleveland sheet was not possible.

6. *Charles Angrand: Correspondances 1883–1926* (Paris, 1988), 374 (repr.).

7. "Ce sont les plus dessins de peintre qui soient, des poèmes de lumière, bien combinés, bein exécutés, tout à fait réussis." See John Rewald, "Extraits du Journal Inédit de Paul Signac III 1898–1899," *Gazette des Beaux Arts* 42 (July–August 1953), 45; the entry is dated 15 March 1899.

Conté crayon on cream modern
laid paper

488 x 635 mm (19³⁄₁₆ x 25 in.)

WATERMARK: upper right:
Lalanne; lower left: L. BEREVILLE

Purchase from the J. H. Wade
Fund 1999.49

German Drawings

Albrecht Dürer

Nuremberg 1471–1528

The *Arm of Eve* is the only known study for Albrecht Dürer's pair of life-size panels in the Prado of Adam and Eve, dated, like the drawing, to 1507 (fig. 1).[1] Dürer returned from his second trip to Italy in February of that year, having left there in either December 1506 or the following month. The Cleveland sheet was probably executed in Nuremberg, as he would have spent little if any time in Italy in 1507. *Arm of Eve* is Dürer's only surviving work on blue Venetian paper (*carta azzurra*) dated after 1506.[2] He began to use blue paper for his chiaroscuro studies while in Venice, influenced by the drawing techniques of contemporary Venetian artists. After 1507, Dürer continued this practice, but he used papers prepared with a colored ground painted on the surface of the sheet instead of blue Venetian paper, which is inherently blue, made from dyed fibers.

This drawing is typical of Dürer's Venetian drawings, most of which are large-scale studies of single figures, heads, hands, or draperies made in preparation for paintings such as *The Feast of the Rose Garlands* (1506, Národni Galeri, Prague) and *Christ among the Doctors* (1506, Thyssen-Bornemisza Collection, Madrid).[3] It is a meticulous study of light and shadow, which masterfully captures the surface contour of an arm. As such, with the monogram and date, the drawing has the appearance of a finished work. However, there are a few visible changes that underscore the prepatory function of this sheet.

Dürer broadened the upper arm, adding a few outlines with brush and wash along the right side. He also changed the position of elbow, which he adjusted even further in the final work.

A comparison between the Cleveland study and the finished panel reveals several interesting aspects of Dürer's working procedure. Although the arm is a bit more rounded in the painting, its position closely follows the drawing. In addition, the treatment of light is nearly identical in both works. Typical of Dürer's painting style, the highlights on the *Eve* panel are linear, created with brush strokes that approximate the white heightening found in the drawing. Also, the triangular-shaped shadow on the upper left portion of the arm appears both in the drawing and the painting, indicating that Dürer had the overall lighting scheme of the painting worked out in advance of the Cleveland sheet.

Throughout his life, Dürer was interested in the study of human proportion, resulting in the production of scores of prints, drawings, paintings, and treatises on the subject. The *Adam and Eve* panels mark a shift in his conception of ideal human beauty, from the classically inspired proportions of his 1504 engraving *Adam and Eve*,[4] to a slimmer, graceful, more elongated aesthetic, described by Erwin Panofsky as both "Gothic" and "Proto-Mannerist."[5] SMK

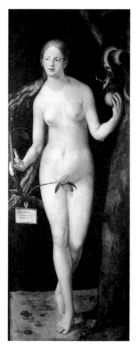

Fig. 1. Albrecht Dürer. *Eve*, 1507, oil on panel. Museo del Prado, Madrid, inv. no. 2178.

1. These two panels were sent as a gift to Philip IV by Queen Christina of Sweden.
2. For a discussion of blue papers, see Brückle 1993, 74.
3. Prague inv. no. O.P. 2148, Madrid inv. no. 90.
4. Bartsch 1.
5. Panofsky 1943, 119–20.

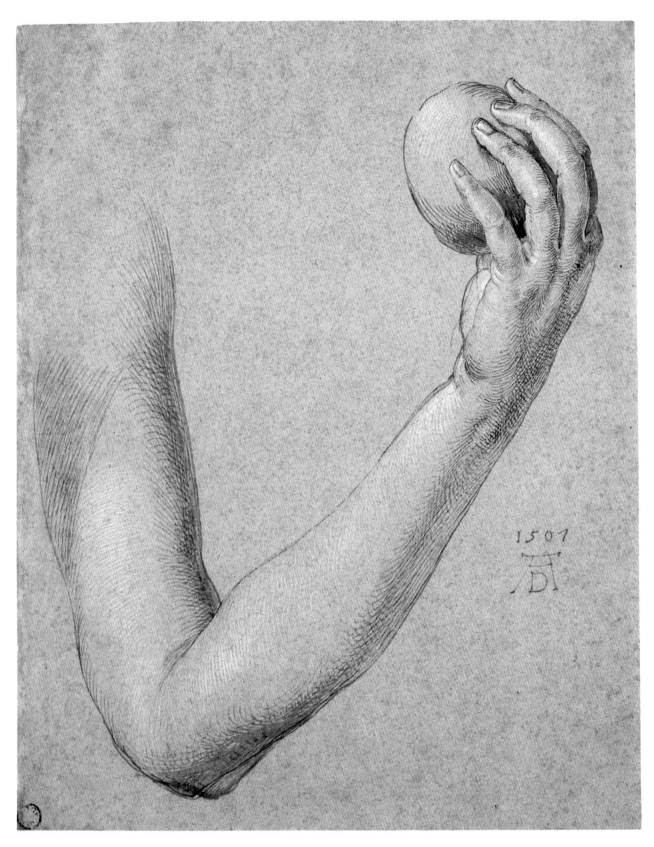

Point of brush and gray and black wash, brush and gray and black wash, heightened with white gouache, on blue laid paper

344 x 267 mm (13⅛ x 10½ in.)

WATERMARK: center: anchor in circle (similar to Briquet 461)

INSCRIPTIONS: signed, center right, in gray ink: *1507* / [artist monogram: AD]; verso, lower left, in graphite: *Nro 24. F 13 z.* [bn?] *10zgL.*

Accessions Reserve Fund 1965.470

Wolfgang Huber

Feldkirche 1490–Passau 1553

View of a Castle shows Wolfgang Huber at the height of his descriptive powers, before his style was affected by the more fantastical elements of the Danube School. Huber's mastery is evident throughout the drawing, from the meandering, apparently casual lines describing the contours of the earth to the careful, hooked strokes capturing the lushness of summer foliage. Despite the disarming appearance of spontaneity and plein-air realism, Huber carefully composed the scene. Indeed, as Erwin Heinzle pointed out, lacking the mountains and forests of more typical landscapes, Huber uses the castle and road to organize the composition.[1] For instance, he placed the closest corner of the main defense tower near the center of the page, where it almost bisects the drawing. Directly below, in the lower center of the composition, he situated one of the most complex elements of the work, a pile of cut timber drying in a makeshift shed. Likewise, he carefully situated the road leading up to the castle at lower center, allowing its subtle contours to lead the eye up to the bridge and gate. He underscored this flowing movement with the lines of the wattle fences to either side of the path.

This work belongs to a small number of pen and ink landscapes that Huber executed early in his career. As Christopher Wood noted, these works are dated and often signed, suggesting that the artist clearly meant them as independent subjects.[2] The earliest of these, *View of Mondsee,* has much in common with the present drawing. Like *View of a Castle*, it focuses entirely on a recognizable, but unremarkable landscape. Thus the Cleveland drawing—seemingly recording nature faithfully and with relatively little embellishment—is among those marking the emergence of landscape as a distinct genre.

The identification of Huber's specific geographic subject remains the most problematic aspect of this drawing. The work's copious detail, as well as the distinctive walls and towers of the fortress, surely were meant to evoke a specific place. Following Adam Horn's argument that the drawing represents the castle Harburg im Ries, a medieval fortress in Bavaria, many scholars have referred to it as such in the literature.[3] However, this identification is not conclusive. Other scholars have identified it as both the Castle of Viechtenstein[4] and the Castle of Schattenburg bei Feldkirch.[5] Too often questions regarding the subject and how it might function as a document regarding Huber's travel and related artistic development have overshadowed appreciation of the drawing itself. Regardless of its subject and documentary value, the work is noteworthy for both its quality and its place in the development of the landscape genre. The verso (fig. 1) bears a drawing of an eight-sided beaker. Huber occasionally incorporated still-life elements in his religious panels, and this sketch may have been intended for such a purpose. ST

1. Heinzle 1953, 15.
2. Christopher Wood, *Albrecht Altdorfer and the Origins of Landscape* (Chicago, 1993), 203.
3. Horn 1950, 35–37.
4. Francis 1952, 54.
5. Weinberger 1930, 68.

Fig. 1. Wolfgang Huber. *Eight-Sided Cup* (verso of no. 60), charcoal with inscription by the artist[?] in black ink. The Cleveland Museum of Art, John L. Severance Fund 1951.277.b.

Eight-Sided Cup (verso)

Pen and brown ink, on cream laid paper (discolored to gray); verso, charcoal

131 x 212 mm (5⅛ x 8⁵⁄₁₆ in.)

WATERMARK: lower center: indistinct, within circle (cropped)

INSCRIPTIONS: upper center, in brown ink: *1513*; lower left, in brown ink: V. H; verso: by artist?, across entire sheet, in black ink: [Ov]*iduss Beschribet gar schon / Von einem Cunig Akteon / Wie er aing malß wolt jagen thain / jagt hin und da jm Holtze / fand er ein Göttin Rein vnd stoltze /*

Diana / die padet mit jeren junkfrauen / die pegünnt er an zu schowen / Daß es sie ser verdross / sy in mit Wasser pegoss / Zw [illegible] Hirschen un wissent / daß jm sin eigen Hünt zeryssen / Daß er sich zum Hirschen verkert / von seinen Hunden zerrissen zu d[illegible]

/ Erd [sideways]; upper center, in red chalk: [illegible, crossed out] / *adltof.*

John L. Severance Fund 1951.277.a,b

Albrecht Altdorfer

? c. 1480–Regensburg 1538

This drawing, from the collection of the prince of Liechtenstein, was virtually unknown until it was purchased by the Cleveland Museum of Art in 1948.[1] Franz Winzinger immediately embraced it as an "exceedingly beautiful" drawing by Albrecht Altdorfer.[2] Although many scholars have accepted Winzinger's opinion, doubts concerning authorship have been raised, most significantly by Karl Oettinger, who attributed it to an unidentified pupil known as the Master of the Parisian Lansquenet.[3]

The majority of Altdorfer's surviving drawings are chiaroscuro drawings, made with pen and black or dark-brown ink, highlighted with white gouache applied with a brush, on dark-colored prepared paper.[4] This technique was very common among northern artists of the early sixteenth century, especially artists associated with the so-called Danube School. The primary purpose of chiaroscuro studies was to explore the depiction of volume. Altdorfer went one step further, using white in such a whimsical manner in *Salome with the Head of St. John the Baptist* that the result is as much decorative as it is practical.

The truncated number "17," which appears in the lower left corner of the sheet, may indicate the date of the work. Winzinger accepted this date on stylistic grounds and related the overall character of the highlights, as well as the treatment of the hand and mouth, to those found in *St. Thomas,* a drawing by Altdorfer in Berlin, inscribed with the same date.[5] He also noted the similarities between the figures of Salome in both the Cleveland sheet and in a woodcut by Altdorfer, the *Beheading of St. John the Baptist,* of 1512.[6] Judging by Salome's position on this sheet, Winzinger also observed that the drawing may have originally been twice as wide, with another figure, perhaps Judith or Lucretia, completing the sheet on the left half.[7] The white and brown hatchings along the bottom and right edge do not seem to be connected with this image.[8]

Appearing first in northern Italy shortly after 1500, the unusual half-length format of Salome was introduced into German art by Lucas Cranach the elder around 1510.[9] It reflected a new development in the pictorial tradition of the Salome episode, one that evolved from a straightforward narrative scene, closely following the biblical account, to a devotional image focusing on the head of St. John the Baptist.[10] Part of St. John's importance rested with the notion that he was regarded by Christians of the day as Christ's precursor. His execution foreshadowed Jesus' sacrifice, the feast of Herod presaged the Last Supper, and his head on a salver recalled the Eucharist. In fact, the relic of St. John's head, located in Amiens, was a major pilgrimage site during the Renaissance and it was thought to possess protective and curative powers. The pairing of Salome with the head of the Baptist emphasizes her sinful nature by comparison with his saintly character. Elaborated with a billowing, plumed headdress and a costly chain, Salome wears the fashionable clothing of the day. In this way, Altdorfer may have been inviting the viewer to draw comparisons between Salome and the excesses of the wealthy classes.

SMK

1. Francis 1950a, 117–18.
2. Winzinger 1952, 82–83, no. 64: "hervorragend schönen."
3. Oettinger 1959b, 111.
4. For information on Altdorfer's drawing technique, see Berlin/Regensburg 1988, 17–18.
5. Winzinger 1952, 82, no. 61.
6. Bartsch 18. The dating of this print is in dispute. The unique surviving impression, which is currently in the Albertina in Vienna, bears a date of 1517. However, Winzinger and others have argued that the lower portion of the last digit was damaged and from a stylistic point of view, it must date to 1512, based on its relationship with another woodcut by Altdorfer of the same subject (Bartsch 52). For a discussion of the situation with the relevant literature, see Berlin/Regensburg 1988, 146, no. 69.
7. Winzinger 1952, 83.
8. Joyce Bailey proposed that the white marks along the upper edge of the lower portion of the sheet may indicate a decorative railing. This seems unlikely as there is no indication of a repeating pattern. See New Haven et al. 1969–70, 45.
9. Altdorfer may have also seen the half-length Salome in a woodcut by Hans Baldung Grien (c. 1511–12; see Bartsch 32). For a discussion concerning the iconography of Salome, see Merkel 1990, 189–95. Two important examples are *Salome,* c. 1510–12, oil on panel, Bayerisches Nationalmuseum, Munich, inv. no. 8378, and *Salome,* c. 1509–10, oil on panel, Museu National de Arte Antiga, Lisbon, inv. no. 738; see Friedländer/Rosenberg 1978, 75, nos. 32 and 33, respectively.
10. For a discussion of this subject, see Stuebe 1968–69.

c. 1517

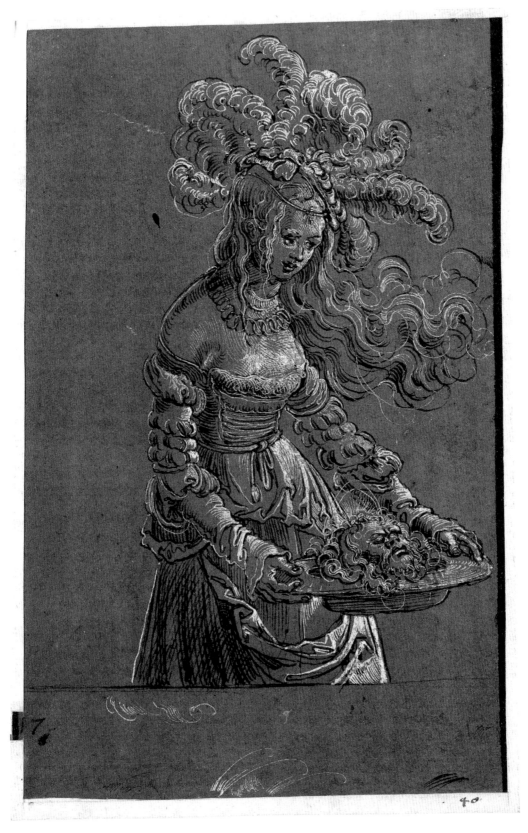

Pen and brown ink and brush
and white gouache, framing
lines in black ink, on laid paper
prepared with brown ground,
laid down on cream laid paper

191 x 126 mm (7½ x 4¹⁵⁄₁₆ in.)

WATERMARK: none visible
through mount

INSCRIPTIONS: lower right, in
brown ink: *17*; on paper mounted
to recto, lower right, in brown
ink: *40*; verso of secondary sup-
port, center, in graphite:
Liechtenstein

John L. Severance Fund
1948.440

Hans Hoffmann

Nuremberg c. 1545/50–Prague 1591/92

Hans Hoffmann is best known for his copies of Albrecht Dürer's nature studies, which he would have seen in his native Nuremberg in the collection of Willibald Imhoff the elder. Hoffmann's exquisite watercolor and gouache of a dead blue roller (*Coracias garrulus L.*) is a faithful copy of Dürer's celebrated work of about 1512 (fig. 1). Three other copies of Dürer's drawing by Hoffmann exist, located today in Berlin, Paris, and London.[1]

Yet the Cleveland *Blue Roller* is not an exact imitation of the Vienna study. The color of the feathers and the definition of shapes within the body vary significantly, not only between the original and the Cleveland sheet, but among the copies as well. Slight differences also exist between the original and the replicas in the outlines of the birds. Fritz Koreny suggested that Hoffmann used a tracing, as all four copies are very similar and differ from Dürer's *Blue Roller* in the same details: the gap between third and fourth claw of right foot is V-shaped in the original and almond-shaped in the copies;[2] and Hoffmann stretched out the roller's neck, smoothing out the contour along the upper right side of the bird.

Cleveland's *Blue Roller* is characterized by a network of very fine brush strokes that not only imitate the individual plumes of the bird's underside but also create the appearance of an overall soft, downy texture. Close inspection of the neck reveals touches of gold watercolor, indicating small feathers, a detail also visible in Dürer's original. A close variant of this composition by the artist is now in London, with slight modifications including the addition of a nail, from which the bird hangs, and the symmetrical placement of the wings.[3] The London variant and the Cleveland sheet are the only two inscribed with Hoffmann's monogram and the date 1583. As Thomas DaCosta Kaufmann argued, the presence of the artist's signature indicates that these watercolors were not meant to pass as original works by Dürer.[4] Hoffmann was connected with the Dürer Renaissance, the artistic movement of the late sixteenth century. Half a century after his death, Dürer's work continued to inspire artists and collectors, resulting in a surge in the production of prints, drawings, and paintings based directly or indirectly on the master's compositions. One of the most important patrons of this stylistic trend, Emperor Rudolph II in Prague, was a significant collector of Düreresque works, as well as those by the master himself. Rudolph II was also a famed connoisseur of natural history illustration, amassing an extensive collection. Considering both of the emperor's interests, it is no surprise that Hoffmann was brought to Prague in 1585 to be court painter, where he remained until his death.

The pictorial motif of the dead bird, known in classical antiquity, was probably passed on to Dürer through Jacopo de'Barbari, a Venetian artist active in Nuremberg and Wittenberg at the beginning of the sixteenth century.[5] Hoffmann took his nature studies one step further than Dürer, creating works that were meant to be framed and hung as paintings, important precursors to the emerging genre of still life.[6] SMK

1. Kupferstichkabinett, Staatliche Museen Preußischer Kulturbesitz, Berlin, inv. no. KdZ 4822; private collection, Paris (see Koreny 1985, 56, fig. 11.2); British Museum, London, inv. no. G.g.2-220.

2. Koreny 1985, 56, no. 11.

3. British Museum, London, inv. no. 1890-5-12-156.

4. Princeton et al. 1982–83, 88, no. 26.

5. Koreny 1985, 40–42.

6. Hendrix 1997, 159.

Fig. 1. Albrecht Dürer. *Dead Blue Roller*, 1512, watercolor. Graphische Sammlung Albertina, Vienna, inv. no. 3133 (D 105).

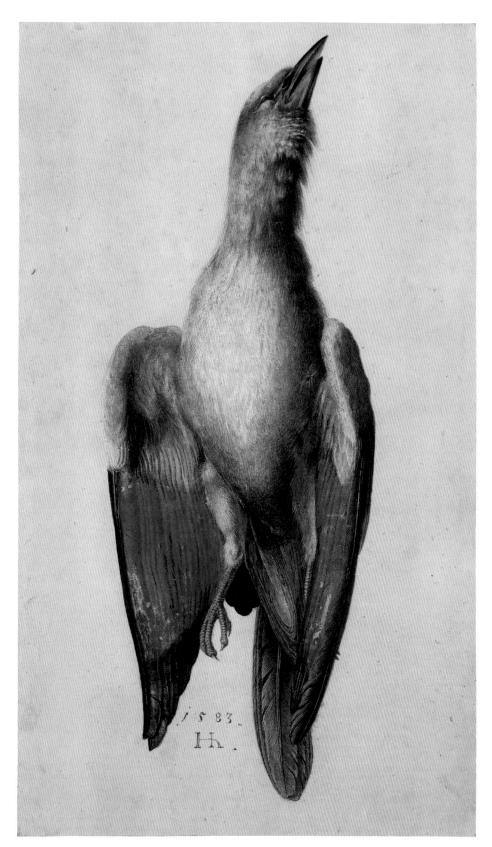

Watercolor and gouache with touches of gold, on cream laid paper, laid down on cream wove paper

292 x 169 mm (11½ x 6⅝ in.)

WATERMARK: none visible through mount

INSCRIPTIONS: signed, lower center, in gray ink: *1583* / [artist's monogram: Hh]; verso, upper left, in ink (?, visible through transmitted light): *182* [sideways]; upper right, in ink (?): *7* [illegible]; center left, in ink (?): *182*; lower left, in ink (?): [*11?*]; lower center, in ink (?): *50*;

verso of secondary support, lower right, in graphite: *3*.

Dudley P. Allen Fund 1946.217

Johann Wolfgang Baumgartner

Ebbs, near Kufstein, Tyrol, 1712–Augsburg 1761

This large drawing on blue paper belongs to a series Baumgartner completed for the German printmaking firm in Augsburg run by the Klauber brothers, Joseph Sebastian and Johann Baptiste. Augsburg was an important center of print publishing, and the rococo style spread throughout Europe in large measure because of the prints produced there. This sheet was part of a series of thirteen scenes of the hunt derived from religious and secular history. We know of the series in its entirety only from archival records,[1] though another drawing for it, of St. Eleutherius, is in the British Museum.[2] Like the British Museum sheet, Cleveland's *St. Deicolus* is extensively scored with a stylus, a technique used to transfer the design as part of the printmaking process.[3] The prints after these drawings are not presently known, but one engraving from the series is in Frankfurt (fig. 1). J. E. von Borries connected the Cleveland sheet to a different series of the four seasons, but that group was made for another publisher, not the Klauber firm, making his supposition seem incorrect.[4]

Baumgartner's innovations in rococo design are magnificently demonstrated in *St. Deicolus* and make an interesting contrast with Boucher's earlier sheet (no. 36), which exemplifies the naissance of the *style rocaille* in France. The general format of the drawing imitates that of a decorative cartouche—a form with an ornamental framework surrounding an open field usually reserved for an inscription, emblem, or the like. The asymmetrical cartouche became an important type of rococo decoration, yet Baumgartner ingeniously adapted it for this narrative scene. He developed the framing elements with inventive forms that seem to grow out of the landscape but which are clearly artificial: they have the appearance of exuberant metalwork intertwined with vegetation and rocks. This elaborate border circumscribes the central scene, where St. Deicolus defends a wild boar from hunters. Deicolus, a sixth-century Irish saint, went to France and founded an abbey in Burgundy toward the end of his life. Baumgartner here depicts the legend of Deicolus saving a boar chased through his land by the hunting party of the Burgundian ruler Clotaire II.[5] Around the perimeter of the image, the artist used the rococo ornamental forms as a playful compositional device through which several subsidiary scenes of the boar hunt play out—most with less happy results for the animal than the main narrative. CEF

Fig. 1. Joseph Sebastian Klauber and Johann Baptiste Klauber, after Johann Wolfgang Baumgartner. *The Conversion of St. Hubertus*, engraving. Städelschen Kunstinstitut and Städtische Galerie, Frankfurt, inv. no. 5051.

1. According to Annette Geissler-Petermann, the series is recorded in the Klaubers' 1770 list of publications titled *Novus Catalogus Imaginum* (letter, CMA files).

2. See Museum der Bildenden Künste Leipzig, *Von Schongauer bis Beckmann: Zeichnungen und Druckgraphik aus Fünfhundert Jahren* (Leipzig, 1990), 151, no. 92, 161 (repr.).

3. A large drawing now in San Francisco is scored as well (see Robert Flynn Johnson and Joseph R. Goldyne, *Master Drawings from the Achenbach Foundation for Graphic Arts* [San Francisco, 1985], 76–77). The verso was covered with red chalk as a way to aid the transfer of the design to another sheet. The Cleveland drawing also has red chalk covering its verso.

4. See von Borries et al. 1988, 102.

5. See John O'Hanlon, *Lives of the Irish Saints* (Dublin/London, c. 1875) 1:311.

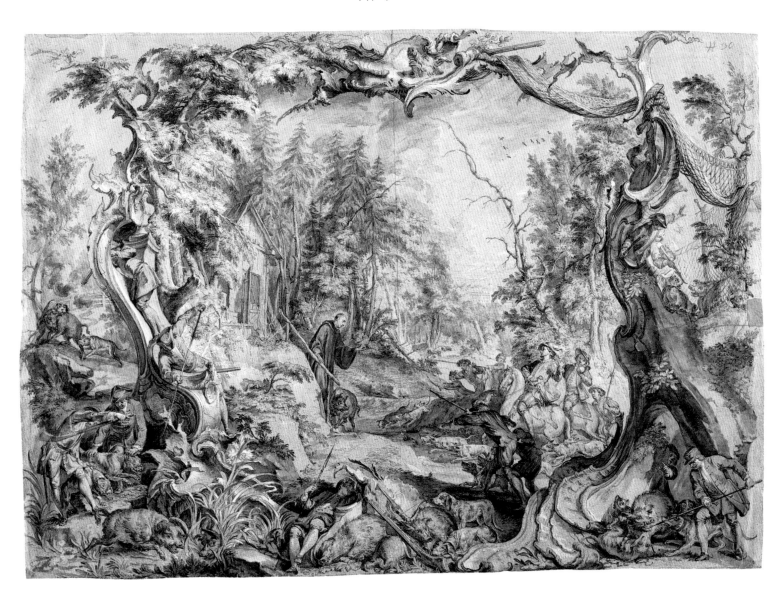

Pen and brown and gray ink and brush and gray wash heightened with white gouache, incised, verso coated with red chalk, on two sheets (joined) of blue laid paper

522 x 735 mm (20⁹⁄₁₆ x 28¹⁵⁄₁₆ in.)

WATERMARK: lower left: shield with crown; lower right: shield with crown and the letters M I

INSCRIPTIONS: upper right, in graphite: *1 30*; verso, upper left, in graphite: *70½–50*

Dudley P. Allen Fund 1967.22

Jakob Philipp Hackert

Prenzlau, Germany, 1737–San Pietro di Careggi, near Florence, 1807

Jakob Philipp Hackert was one of the most successful landscapists working in Italy in the late eighteenth century. Influenced early by landscapes of Claude Lorrain and seventeenth-century Dutch artists, Hackert achieved enough renown during time spent in Paris to allow his move to Italy in 1768. There he transformed the classical landscape tradition through his commitment to close observation of nature.[1] Responding to the desire of upper-class travelers for souvenirs of the Grand Tour, Hackert's precise renderings of beautiful and historic sites attracted an impressive international clientele, including the king of Naples, for whom he became court painter in 1786.

As was true for many of his drawings, the artist translated this view of the *Waterfall of Marmore at Terni* into a painting, dated 1779, and also into a print.[2] However, he considered such a finely crafted drawing to stand on its own as an independent, marketable work. A comparison of the finished sheet with the pen drawing that must have preceded it (fig. 1) illustrates his typical method of beginning with a large line drawing, which he felt made it easier to capture the overall effect before the motif.[3]

Part of Hackert's fame rested upon his traveling the countryside with portfolios of large sheets so that he could execute complete wash drawings like the Cleveland example directly in nature. The artist created this view of the Terni waterfall, located about thirty-five miles north of Rome, either during his travels on foot through Umbria and the Marches in 1776, or when he visited the artist's resting stop Cívita Castellana in 1778. In addition to this work and its closely related images, Hackert pro-duced more views of the Terni waterfall, and several representations of the other two celebrated falls at Tivoli and Isola di Sora, also in central Italy.[4] While Tivoli was significant because of its ancient historical associations and as a signature site of Claude, the Terni waterfall attracted more through purely visual means. As a spectacular natural phenomenon of Italy, only Vesuvius in eruption could begin to compare.[5]

Hilliard Goldfarb has reproduced early photographs of the site that demonstrate the documentary accuracy of Hackert's details in the *Waterfall of Marmore at Terni*.[6] At the same time, the composition possesses idealizing qualities such as the extended rock shelf complete with staffage figures in the lower right, which in actuality would have been cut off by the continued course of the River Nera. Moreover, the artist's meticulous description of every aspect of the falls, from faraway heights to final emptying in the foreground, results in a composite image that the viewer must read in stages. Hackert's studied observation, painstaking construction, and petrified rendition give unique expression to his representation of this sublime natural motif, making it possible to consider him a precursor of German Romanticism. His *Waterfall of Marmore at Terni* recalls words written by his close friend and fellow nature worshiper Johann Wolfgang von Goethe, who declared that an artist should "penetrate into the depths of things, . . . as a rival of Nature, . . . to give his work of art a content and a form through which it appears both natural and beyond Nature."[7] PSC

Fig. 1. Jakob Philipp Hackert. *The Waterfall of Marmore at Terni*, 1776–78, pen and brown ink over graphite. Kunstmuseum, Düsseldorf, inv. no. 12058.

1. For an insightful discussion of how Hackert and other eighteenth-century German landscapists revised the classical landscape models they admired through a new interest in natural science, see Mark A. Cheetham, "The 'Only School' of Landscape Revisited: German Visions of Tivoli in the Eighteenth Century," *Idea: Werke, Theorien, Dokumente* 4 (1985), 133–46.

2. The 1779 painting (98 x 80 cm), signed and dated by the artist, is in a private collection, and is reproduced in Nordhoff/ Reimer 1994, 1:432, color fig. 16. The print is an etching and engraving executed by Carlo Antonini, and is reproduced in Rome 1994, 217.

3. Among the Düsseldorf drawing, the painting, and the print, the CMA object is closest to the print. The figures and central tree in the right foreground of the painting are unique within the group. For both the painting and the print, Hackert added a partial rainbow in the upper center, which certainly relates to his friend Goethe's experiments in color science; for more on this last theme, see Dennis L. Sepper, *Goethe Contra Newton: Polemics and the Project for a New Science of Color* (Cambridge, England/New York, 1988).

4. In London/Leeds 1997–98, 20–21, Timothy Wilcox discusses how Hackert achieved quick notoriety in Italy through his work on his first dated painting of the Tivoli Falls, for which he returned to the site at the same time each day for several weeks in order to complete the canvas in the open air.

5. London/Leeds 1997–98, 136.

6. Goldfarb 1982, 287–78, figs. 6–7.

7. Goethe, writing in the 1798 introduction to his journal *Propyläen*, as translated in Lorenz Eitner, *Neoclassicism and Romanticism, 1750–1850: An Anthology of Sources and Documents* (1970; New York, 1989), 199. Goethe edited Hackert's memoirs and used them to write the first monograph on the artist, published in 1811.

Pen and black ink, brush and brown wash, with white gouache and graphite, on cream laid paper

521 x 399 mm (20½ x 15¹¹⁄₁₆ in.)

WATERMARK: upper center: fleur-de-lys with shield; lower center: J. HONIG / & / ZOON

INSCRIPTIONS: on fragments of old mount, now removed, in brown ink: *No. 177. 13.* [crossed out] / *No: 17.*; in graphite: N^o ["o" underlined] *27.*; in graphite: *116*

Dudley P. Allen Fund 1982.40

(Ernst Christian Johann) Friedrich Preller the elder

Eisenach 1804–Weimar 1878

Friedrich Preller studied in Weimar, Dresden, and Antwerp before winning a stipend from Grand Duke Karl Alexander von Sachsen-Weimar in 1826 to study in Rome. From a letter of recommendation Johann Wolfgang von Goethe wrote for him in 1824, we know that Preller showed an interest in the art of landscape from a young age,[1] and it was Goethe's *Italian Journey* that he took with him as a guide when he left for Italy in 1828.[2] Preller developed into an important landscape painter and enjoyed a long career in Germany, and during his student years in Italy he formed important ideas about the genre. In 1830, the year after he made the Cleveland drawing, he met the painter Joseph Anton Koch, one of the leading German landscape painters of the time and an important theorist as well.

Like Preller and many other German artists in the first decades of the nineteenth century, Koch was drawn to the area near Olevano, a remote mountain village southeast of Rome, and he and many artists in his circle made drawings of its picturesque scenery.[3] Preller, in fact, met Koch just after Preller had spent time there. From an inscription in one of his sketchbooks, we know he spent the months of June through September of 1829 in Casa Baldi at Olevano. He made numerous trips into the countryside around the town and was especially struck by an oak forest near Serpentara, as drawings in his Casa Baldi sketchbook attest.[4] He made the drawing now in Cleveland there on 2 June, in the bright sunlight of a summer day. Preller himself described later what he liked about the area around Olevano: "Nowhere was the organic coherence in nature so clear as there, and my observation was mainly directed toward that."[5] Although the present drawing is no doubt an accurate rendering of an actual view, one the artist made outside in a single sitting, it also reflects a classicizing view of landscape. Before Preller left for Italy, Goethe had advised him to study both Claude and Poussin,[6] and his academic training had taught him to compose a scene with certain principles in mind. Here, the unfinished, dead tree at the left acts as a *repoussoir*, and the scene is balanced by the much fuller pair of oaks at the right. Preller generalized their form through his meticulous penwork, leaving the lightest areas in outline only, the white reserve of the paper signifying the bright sunlight on the leaves, set in relief by darker areas of firm, parallel hatching. Here, the Teutonic quality of Preller's drawing style comes out: he relied on his precise pen lines for all of the forms and nowhere used brushwork or wash. CEF

1. Ina Weinrautner, *Friedrich Preller d. Ä. (1804–1878) Leben und Werk* (Münster, 1997), 16.

2. Ibid., 18.

3. See Domenico Riccardi, *Gli artisti romantici tedeschi del primo Ottocento a Olevano Romano / Deutsche romantische Künstler des frühen 19. Jahrhunderts in Olevano Romano* (Milan, 1997).

4. Weinrautner, *Friedrich Preller*, 21 n. 65.

5. Cited in Rudolf Theilmann and Edith Ammann, *Die deutschen Zeichnungen des 19. Jahrhunderts* (Karlsruhe, 1978), 446, under no. 2876.

6. Weinrautner, *Friedrich Preller*, 18.

Pen and brown ink over black
chalk, on cream laid paper

408 x 540 mm (16¹⁄₁₆ x 21¼ in.)

INSCRIPTIONS: by artist, lower
left, in brown ink: *Olevano /
alla Serpentara il 2 di Guinio /
1829.*

Delia E. Holden Fund 1971.12

Adolph (Friedrich Erdmann) von Menzel

Breslau, Silesia [now Wrocław, Poland], 1815–Berlin 1905

"All *drawing* is useful, and so is drawing *all*"[1] was Menzel's conviction, and he left more than 5,000 sheets created during a long and successful career. Since his was "a world caught with the eye and held by the pencil,"[2] he was always properly equipped. "In his overcoat he had eight pockets, which were partially filled with sketchbooks. . . . On the lower left side of his coat, an especially large pocket was installed, just large enough to hold a leather case, which held a pad, a couple of shading stumps and a gum eraser."[3] Besides making numerous preparatory studies related to specific paintings, Menzel scrutinized almost everything intently. A small, detailed pencil drawing of two different views of a comb full of hairs, inscribed "Lena the cook's comb found in the studio, 8. Jan. 86.," illustrates the artist's own words, that such "finds" were "chance things for possible use."[4] Menzel was obsessed by his observations and the ambition to capture precisely the individuality and vitality of each subject.

Self-taught, Menzel worked hard to gain technical facility as a draftsman. His early attempts are precisely delineated with a sharp pencil, but by the mid 1840s his style had become more painterly. Although in the 1850s he worked in pastel and watercolor, his favored medium remained graphite. By the 1870s he was using a carpenter's pencil—a broad, flat-pointed lead pencil made of soft graphite—and by stumping (rubbing with bits of tightly rolled paper or leather) could obtain varied tones and textures. From 1885, when he was seventy, he worked only on a small scale, and after 1892 he used only gouache, more easily managed than oil paint. As Menzel aged, he worked increasingly in pencil, continuing to search for new expressive possibilities. He considered these drawings independent works of art, sufficiently representative of his oeuvre to be exhibited.[5]

In the last two decades of his life, Menzel executed numerous studies of heads of models that, like the Cleveland work, are especially compelling. Exploiting the ability of a carpenter's pencil to produce varied effects, he first used the stump to create broad areas of soft tone. The virtuosity of the stumping creates the effect of tangible surfaces and light falling on them, especially on the face and hat. While he used the width of the carpenter's pencil vigorously to indicate grainy black shadows in the folds of the coat and seat back, he used the sharp point of the pencil for fine lines describing hair and facial features. A master of the technique of combining pencil and stump, Menzel describes the play of light and shadow. Tonal gradations, from velvety blacks to the palest gray, create a rich painterly effect. The immediacy of the image—the illuminated profile with mouth slightly open—suggests how Menzel captured a fleeting moment. His struggle for authenticity is realized in masterful drawings such as this one, that are, as the artist wrote, "true to nature" without "being copied from nature with fearful exactitude."[6] JG

1. Menzel cited in Françoise Forster-Hahn, "Authenticity into Ambivalence: The Evolution of Menzel's Drawings," *Master Drawings* 16 (Autumn 1978), 256.

2. Irmgard Wirth, *Drawings and Watercolours by Adolph Menzel 1815–1905* (London, 1965), [5].

3. Peter Betthausen et al., *Adolph Menzel, 1815–1905: Master Drawings from East Berlin* (Alexandria, Virginia, 1990), 12.

4. The Fitzwilliam Museum, Cambridge, *Prints and Drawings by Adolph Menzel: A Selection from the Collections of the Museums of West Berlin* (West Berlin, 1984), 10.

5. Claude Keisch and Marie Ursula Riemann-Reyher, eds., *Adolph Menzel, 1815–1905: Between Romanticism and Impressionism* (New Haven/London, 1996), 451.

6. Betthausen et al., *Adolph Menzel*, 49.

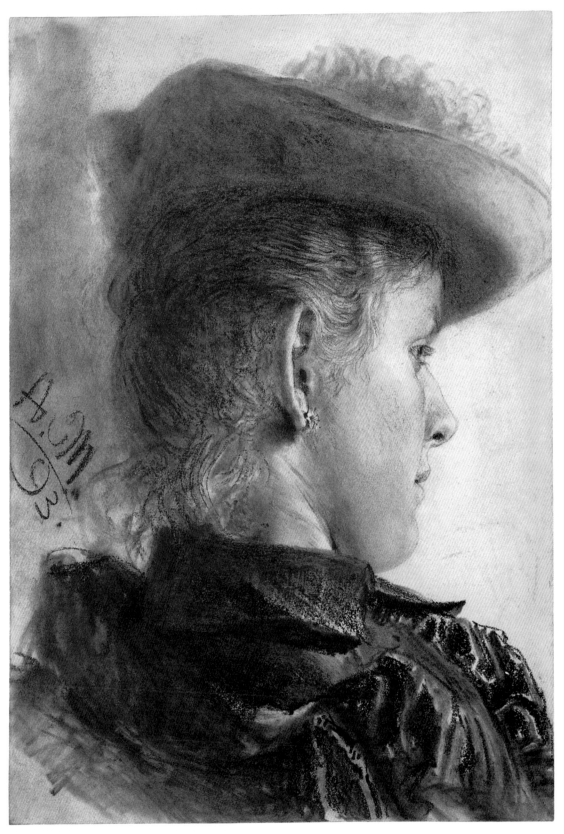

Graphite (carpenter's pencil)
with stumping, on wove paper,
perimeter mounted to a false
margin of cream wove paper

414 x 289 mm (16¼ x 11⅜ in.)

INSCRIPTIONS: signed, center left,
in graphite: *A.M.* [underlined] /
93.

Purchase from the J. H. Wade
Fund, 1994.103

Dutch and Flemish Drawings

Rembrandt van Rijn

Leiden 1606–Amsterdam 1669

Peter Schatborn considers this sheet "one of the finest which Rembrandt made of the story of Tobit."[1] In the apocryphal texts of the Old Testament, the archangel Raphael was sent to answer the prayers of the blind Tobit and the demon-plagued Sarah. Tobit sent his son, Tobias, on a business trip and he was accompanied by the archangel Raphael. Along the way, reaching the River Tigris, Raphael instructed Tobias to kill a gigantic fish and save the heart, liver, and gall; the first two had the power to drive away demons and the last could cure blindness. Following the angel's instructions, Tobias went to Ecbatane, married Sarah, and rid her of her demon. He then returned home and rubbed the fish-gall into the eyes of his father, which restored his sight.

The healing, the climax of the story, is the subject of the Cleveland sheet and one that Rembrandt and artists in his circle repeatedly depicted in the late 1630s and 1640s.[2] Yet the action depicted in the drawing differs from the text on several accounts. First, Sarah, who stands to the far right, did not actually witness the healing. Schatborn noted that her presence expands the story and helps create a link with the viewer.[3] More significant, rather than applying the fish-gall to his father's eyes, Tobias performs a cataract operation with a scalpel.[4] Rembrandt likely witnessed this procedure, which had been performed in Amsterdam by Dr. Job Janszoon van Meekren, a specialist in eye operations. This drawing is a prime example of Rembrandt's innovative approach to biblical narrative, in which he often humanized traditional pictorial formulas through the inclusion of observed details from everyday life. Further, the tightly constructed composition, marked by intersecting diagonals, focuses the viewer's attention on the operation.[5] However, this drawing is especially celebrated for its masterful depiction of human expression and naturalistic details. Tobit's anticipation and trust are evident, as he leans back toward the light, which enters the room from the arched window on the left. Tobias's intense concentration is seen in his directed, fixed gaze, pursed lips, and bent-knee pose. Rembrandt depicted various modes of observation in the remaining figures; Raphael looks with concern, as his protective wings encompass the group, and Hannah peers intently through a pair of spectacles (a unique detail among images of the scene created by Rembrandt and his circle).

Technically, Rembrandt combined fine pen strokes with a few broad pen flourishes and the application of white pigment in four places: to the floor below the left side of the chair; to Tobias's left hand; and to Raphael's right hand (which was drawn twice) and face. What the original appearance and function of the white would have been is difficult to say. Rembrandt typically used white, which today often appears as a semi-opaque wash, to create highlights or cover unwanted passages. Here, however, it lightens the face of Raphael (which does not make pictorial sense if completely obscured), placing a greater emphasis on father and son, and it may even reflect the more ethereal nature of the angel.[6] SMK

1. Berlin et al. 1991, 70.
2. Two drawings by Rembrandt, in the Fodor Museum, Amsterdam (Benesch 1973, no. 548), and the Kupferstichkabinett, Staatliche Museen Preußischer Kulturbesitz, Berlin (Benesch 1973, no. 646), and a painting in the Staatsgalerie, Stuttgart (Corpus III c86), thought to be based on a lost prototype by the master, compare closely to this work in terms of composition and narrative details.
3. Berlin et al. 1991, 70.
4. Greeff 1907 first recognized the operation in the related Stuttgart painting. Roosval has pointed out that it occurred because Luther's translation describes Tobit's condition as "Leukoma," a clouding of the cornea or cataract; see J. Roosval, "En starroperation målad av Rembrandt omkring 1936," *Konsthistorisk Tidskrift* 11 (1942), 39–42, and 12 (1943), 46–50.
5. According to Richards 1970, 74–75, the sheet was probably cut down along the right edge, corresponding more closely to the painting in Stuttgart and the Fodor drawing.
6. As has been suggested by Schatborn and Richards, respectively; see Berlin et al. 1991, 70, and Richards 1970, 73.

Pen and brown ink, touched with white gouache, framing lines in brown ink, on beige laid paper

211 x 177 mm (8⁵⁄₁₆ x 6¹⁵⁄₁₆ in.)

WATERMARK: fleur-de-lys (Heawood 1729)

INSCRIPTIONS: verso, upper center, in graphite: *-13* [crossed out]; upper right, in black chalk: *rembrant*; upper right, in brown ink: *D*; upper center, in brown ink: [15-50?] / *Tobias*; upper left, in brown ink: *9* [sideways]; lower left, in brown ink: [illegible, cropped]; lower left, in brown ink: *No 2910*; lower left, in brown ink: *Rembrandt*; lower right, in brown ink: *-d*[l?]*-13* [upside down]

Purchase from the J. H. Wade Fund 1969.69

Rembrandt van Rijn

Leiden 1606–Amsterdam 1669

One of Rembrandt's twenty-three drawings after Indian miniatures, this sheet portrays the ruler of the Mughal Empire, 1628–58, as he appeared in the mid-1630s.[1] Heinrich Glück was the first to propose a connection between this group of drawings and an album containing seventeenth-century Mughal school miniatures, thought to be of Dutch provenance and dismantled in the eighteenth century.[2] In 1762 the miniatures were trimmed and inserted into the rococo wall decorations of the Millionenzimmer (or Fekentinzimmer) in Schloss Schönbrunn, Vienna.

More recently, scholars have questioned the source of Rembrandt's copies, pointing out that Mughal artists repeated images frequently, complicating the identification of the original.[3] Although we cannot be sure of the exact prototype, the Cleveland sheet closely resembles one of the portraits of the shah in Schönbrunn (fig. 1): the two figures are nearly identical in pose and costume, as well as in minor aspects such as the fly swatter in the left hand and the specific design of the shoes. As if to study that detail intensively, Rembrandt drew the ankles and shoes a second time, adjusting the position of the feet so that they more closely approximate those found in the painting in Vienna.

As has often been noted, however, the drawings are not slavish copies. Rembrandt brought the shah to life by subtly adjusting the posture and proportions, resulting in a more naturalistic appearance. Slightly tilting the figure forward, Rembrandt reduced and softened the flair of the lower half of the tunic and relaxed the position of the right hand. He also added careful shading, increasing the appearance of volume and creating a sense of expression. In sum, he successfully imposed his characteristic realist tendencies on a more detailed, formal, and stylized model, resulting in a copy that has, stylistically, little in common with the original image.

Regarding technique, this sheet is typical of the group. Rembrandt used a Japanese paper toned throughout with a light brown wash. This smooth, less absorbent paper receives ink differently than typical Western laid paper (see no. 67), and here it allowed for the beautifully modulated, evanescent brown washes in the background with which Rembrandt accentuated the figure. He also used especially fine pen strokes in places, particularly in the face and both pairs of shoes. In a few areas, such as the turban and the redrawn slippers at the right, Rembrandt relied on a different technique, reductively scratching off ink (apparently with the tip of his dry pen) in the darkest areas, after first working them over with pen and ink.

These drawings have traditionally been dated from 1656 to 1658 because of the close relationship of one from this group in the British Museum[4] with the etching *Abraham and the Angels* dated 1656.[5] Further, Rembrandt's inventory of the same year lists an album "full of curious miniature drawings . . . of all kinds of costumes" that was sold in 1658.[6] Several scholars have proposed that this album and the one used in the decorative scheme of the Millionenzimmer were one and the same. However, Rembrandt's ownership of the album has yet to be proven. Martin Royalton-Kisch suggested that the style of these drawings is closer to other works from the early 1660s and proposed that they should be dated to about 1656–61.[7] SMK

Fig. 1. Mughal School. *Shah Jahan*, c. 1630s. Millionenzimmer, Schloss Schönbrunn, Vienna.

1. Benesch 1973, 5:nos. 1187–1206 (including no. 1194a), lists 21 drawings. Two other sheets, now in private collections, are mentioned in Royalton-Kisch 1992, 143 n. 10. For the estimation of the age of the Shah Jahan, see Lunsingh Scheurleer 1980, 30–31.

2. Strzychowski/Glück 1933, 18–22. See also Royalton-Kisch 1992, 143 n. 4.

3. Lunsingh Scheurleer 1980. Lisa Kurzner in New York 1988, 129 n. 5, suggested that Rembrandt may have copied outline brush drawings rather than fully colored miniatures.

4. Benesch 1973, 5:no. 1187.

5. Ibid., no. 29.

6. See Strauss/van der Meulen 1979, 369.

7. Royalton-Kisch 1992, 142.

68. Shah Jahan

c. 1656–61

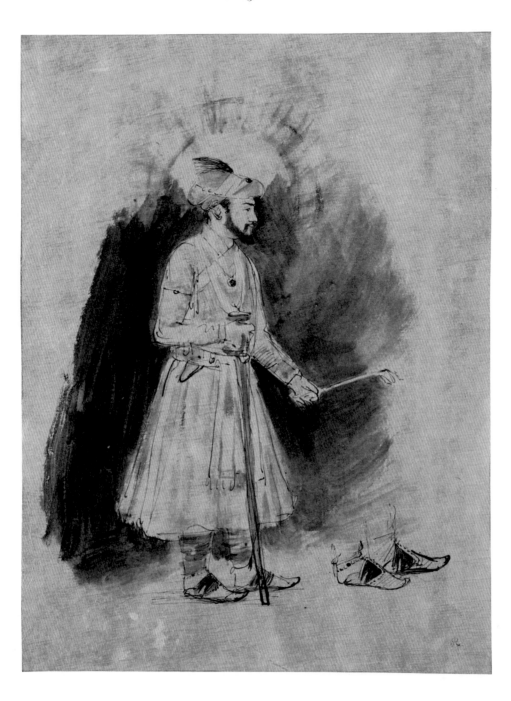

Pen and brown ink and brush and brown wash, on light brown Japanese paper, laid down on beige laid paper

225 x 171 mm (8¹³⁄₁₆ x 6¹¹⁄₁₆ in.)

WATERMARK: none visible through mount

INSCRIPTIONS: verso of secondary support, upper center, in graphite: *Portrait of*; upper center, in brown ink: *Portrait of Sháh Jahán Emperor of Hindustan* / [inscription in Arabic]; upper right, in graphite: [Ouseley?] / *written by Sir Gore Ou*[cropped] *1809*; lower left, in graphite: *334*; fragment of old mount (now removed), in blue pencil: *3*[crossed out with black ink]; fragment of old mount (now removed), in gray ink: *Portrait of Sháh Jehán / Emperor of Hindûstan*; in black ink: *5*[written over 5 in graphite] *Indian Prince* [underlined]

Leonard C. Hanna Jr. Fund 1978.38

Hendrick Goltzius

Mülbracht 1558–Haarlem 1617

This sheet is the only known preparatory drawing for an important group of engravings depicting military figures executed and/or designed by Hendrick Goltzius. Working in Haarlem, Goltzius was particularly active in all aspects of print production from 1582 to around 1600, and he employed several talented pupils and assistants who engraved plates after his drawings. His exceptional talent as a draftsman and printmaker earned him an international clientele of art collectors and connoisseurs.

Standing Officer Holding a Boar's Spear was designed for a print in the series "Three Military Figures," which also included a scribe and a soldier; all were engraved by another hand (fig. 1).[1] Although the prints are unsigned, Jan Piet Filedt Kok convincingly attributed them to Jacques de Gheyn II, who entered the Goltzius workshop around 1585.[2] Filedt Kok dated the set to about 1586, one year before the execution of the related, and more famous, series "Twelve Officers and Soldiers," which bears the signatures of Goltzius as designer and de Gheyn as printmaker.[3]

In the Cleveland drawing, the officer's confident stance and direct gaze emphasize his military prowess and leadership abilities, as he staunchly holds a pole arm in his right hand and carries his sword on his hip. Details such as the fluttering scarf and the feather-trimmed hat enliven the image and typify Goltzius's mannerist style of this period, influenced by Bartholomeus Spranger. Goltzius often used the background of his compositions to illustrate the deeds of the protagonist, and in this work he embellished the scene with troops on the right, and two other officers on the left.

Although the sitter of this work is unidentified, the same figure appears in two other engravings from the Goltzius workshop in very similar compositions.[4] During the 1580s, Goltzius and his assistants produced a number of prints with military subjects that fall into the genre of military propaganda.[5] The assassination of William of Orange in 1584, along with political conflicts in the northern Netherlands and continued warfare with Spain in the southern provinces, created a pessimistic political atmosphere that prints of this type by Goltzius were meant to counter. These prints bear laudatory inscriptions, promoting militaristic values. For example, the inscription under the figure in *Standing Officer* reads: "Laudata ducibus praestat succumbere morte, Quam vitae turpi consuluisse metu." (It is better to suffer a death praised for its harshness than to have had lived a life racked with fear.)[6]

The print, reversing the image in the printing process, corresponds closely to the drawing, which is incised for transfer. Goltzius made two major, visible changes in the drawing, in the shape of the pole arm's blade and in the pose of the figure in the middle ground, to the left of the officer's sword. Drawn on top of one another, the sketchier and less articulated figure, which appears to be underneath the other, is nonetheless the one that was incised and became the model for the print.

As was typical of the artist's preparatory drawings for his engravings, this sheet was executed with fine pen strokes and delicate, brown washes. However, there are red chalk additions on his face and hands, which, while adding a degree of naturalism to the figure and a sense of finish to the drawing, seem superfluous to its preparatory function; Goltzius likely added it as a way of making the drawing more appealing for sale. Like his roughly contemporary drawings *Four Heroes of the Old Testament: Jael, Samson, David,* and *Judith,* this drawing seems to be both a study and a finished work.[7] SMK

1. Anonymous, after Goltzius (Bartsch 95–97); after Goltzius (Hollstein 572–74).
2. Filedt Kok 1991, 368
3. Jacques de Gheyn II (Hollstein 353–64).
4. Jacques de Gheyn II (Hollstein 353) and Hendrick Goltzius (Bartsch 126, Hollstein 245).
5. Amsterdam 1993–94, 352.
6. My thanks to Kenneth Bohač for this translation.
7. Reznicek 1961, K. 16–19.

Fig. 1. Attributed to Jacques de Gheyn II. *An Officer from "Three Military Figures,"* c. 1586, engraving. Rijksmuseum, Amsterdam, inv. no. RP-P-OB-10.246.

Pen and brown ink and brush and brush and brown wash with red chalk (in the face and hands), heightened with traces of white, over black chalk, incised throughout, framing lines in brown ink and graphite, on beige laid paper, perimeter mounted to cream laid paper

206 x 156 mm (8⅛ x 6³⁄₁₆ in.)

WATERMARK: none visible through mount

INSCRIPTIONS: signed, lower center, in brown ink: [artist's monogram, retouched: *HG*]; verso of secondary support, upper right in graphite(?): *£65*; upper left, in graphite: *207420*; upper left, in graphite: *35*[circled]; center, in graphite: *Exh. / Boymans Mus. Rotterdam / Hendrick Goltzius als Tekenaar cat 81*; lower right, in graphite: [illegible] / *10*; lower left, in graphite: *3*

Leonard C. Hanna Jr. Fund 1994.195

Jan Wierix

Antwerp c. 1549–Brussels after 1615

This exquisite work shows Jan Wierix's fine sense of design and extraordinary technical abilities at their height. With almost microscopic strokes, the artist describes Eden as a virtual microcosm, teeming with life, that extends from a verdant hillock, across a deep valley, to peaks in the distance. Wierix's careful attention to balance, tone, and movement keep the composition from being cluttered or overwrought. The jewel-like preciousness and minute detail reinforce the assumption that initially Wierix trained with a goldsmith. His use of tiny dots and minuscule crosshatching to define and shade forms speaks of his skill as an engraver.

Originally the *Expulsion from Paradise* belonged to a series of twenty-one drawings illustrating scenes from the creation and early history of man as recounted in Genesis.[1] Wierix made two other small-scale versions of this series, both of which are also on vellum (fig. 1).[2] As Carl van de Velde pointed out, ultimately the figures and placement of Adam, Eve, and the angel in all three versions of Wierix's *Expulsion* probably rely upon Lucas van Leyden's print of the same subject.[3] However, while there is a debt to the earlier master, it is a small one. A comparison of the two works clearly shows Wierix's individuality and powers of invention. For instance, instead of the stark, rocky landscape of the print, Wierix placed the figures among a bewildering array of plants and animals. Also, he reduced Adam and Eve's relative size, seemingly emphasizing their relationship to all of creation, and allowed light to play across the entire composition, using it to more completely reveal the work's details.

The variety of immediately identifiable flora and fauna in the drawing tempts the viewer to look for iconographical meanings. For instance, the angel, lion, ox, and eagle suggest a prefiguring of the Four Evangelists; while the thistle might be an indication of humankind's coming hardships in the world. The peacock could be read as both a symbol of pride—specifically Adam and Eve's willful disregard of God's command—or eternity, which mankind could only enjoy within the bounds of Paradise. While drawings such as this one doubtlessly appealed to collectors because of the underlying meanings of different elements, they mainly were prized for their beauty and virtuosity. ST

1. For a history of the present work and the other surviving drawings from that series, see London/New York 1993–94, 3–4.

2. One is owned by the British Museum; the second is in the possession of Richard Feigen, see New York 1990a.

3. New York 1990a, 39, no. 10, under 10b.

Fig. 1. Jan Wierix. *The Expulsion from Paradise*, pen and brown ink. British Museum, London, inv. no. 1848.2.12.96.

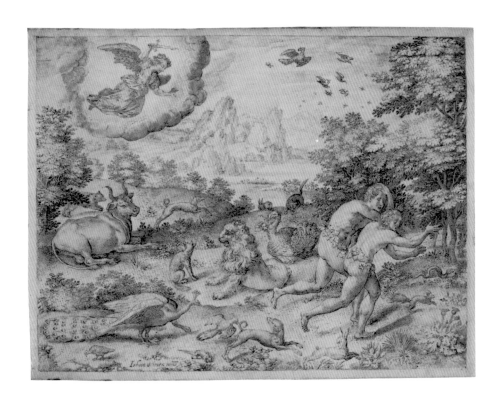

Pen and brown ink, framing
lines in brown ink, on vellum

95 x 124 mm (3¹¹⁄₁₆ x 4⅞ in.)

INSCRIPTIONS: signed, lower left,
in brown ink: *Iohan wiricx inue*
[abbreviation line over "u" and
"e"]; verso, lower left, in graph-
ite: *N°* ["o" with double under-
lines]

Dudley P. Allen Fund 1994.16

Peter Paul Rubens

Siegen 1577–Antwerp 1640

The subjects of the compositional sketches on the recto and verso of this sheet are oddly related—both feature a severed head, the result of revenge at the hands of a powerful woman. The recto shows the artist's initial thoughts for the *Feast of Herod*, a painting in Edinburgh dated to the 1630s (fig. 1). Although the final work differs from this sketch in many respects, the positions of Salome, Herodias, Herod, and the head of St. John the Baptist are essentially the same. Rubens enlarged the composition of the painting, expanding the space to the left and along the bottom, and he added six figures and a classically inspired architectural background.

Drawn in broad pen and ink strokes, Salome stands just left of center, lifting the cover of the salver to reveal the head of St. John the Baptist.[1] Smiling, Herodias grabs the platter with her left hand and points to the saint's mouth with a fork, which she holds in her right hand. Ludwig Burchard convincingly argued that her mocking gesture, which is directed at St. John's tongue, was a response to the harsh words he had spoken to her during his lifetime.[2] Herodias looks over to Herod, who shrinks back in horror, clutching the tablecloth and holding his chin. In the center of the sheet one can see variants of these two figures, lightly sketched in black chalk. The profile in red chalk of a young female, located above the two figures on the far left, closely resembles Salome in the Edinburgh canvas.

Burchard and Roger-Adolf d'Hulst dated this drawing to 1633, while Julius Held placed it a bit later in Rubens's career, to about 1637–38, a date also accepted by Anne-Marie Logan.[3] As few compositional drawings from late in his career survive, this work is especially important for what it reveals about his working method. Not only did Rubens visually record variations in his ideas, but there are a few written notations as well. The arrow and the inscription, just above Salome's head, are usually interpreted as "Herodias somewhat higher." Although Rubens apparently was mistaken as to the identity of the figure, it corresponds to the elevated position of Salome's head found in the final composition. A similar remark in the lower right corner, referring to Herod's chair, is only partially legible.

On the verso, Rubens returned to a theme he had painted at least twice in his career before the 1630s: *Tomyris with the Head of Cyrus*, the subject of paintings in Paris and Boston.[4] A rare theme in northern art, the oldest and most detailed literary account of the story is in Herodotus (1:204–15).[5] Queen Tomyris was the ruler of the Massagetae, a Central Asian tribe attacked by an invading army commanded by Cyrus, the king of Persia. Tomyris's son, Spargapises, was captured and either committed suicide or was slain after Cyrus denied the queen's requests that he be returned. Years later, the Massagetae soundly defeated the Persians and Cyrus was killed in battle. Tomyris searched for and found his body among the dead, severed his head, and placed it in a bag of human blood, thus avenging her son.

In the Cleveland drawing, Tomyris is shown seated under a canopy, to the right of center, and holding a scepter. Below her in the foreground, a servant holds the head of Cyrus in a basin filled with blood. Two kneeling female attendants look on, with three more standing in the background; a group of three or four men stand to the left. The words "plus spatij" (more space) are found in the center of the sheet. Although this sketch is not directly related to any known painting, a few loose connections to other works can be made. Held noted the courtier with a turban was ultimately derived from a figure from Pintoricchio's *Disputation of St. Catherine* in the Vatican.[6] Also, the kneeling servant about to immerse Cyrus's head in blood, a motif thought to be of Rubens's own invention, is found in all three of his treatments of this subject.[7] SMK

Fig. 1. Peter Paul Rubens. *Feast of Herod*, 1630s, oil. National Gallery of Scotland, Edinburgh, inv. no. 2193.

1. Rubens used iron-gall ink, which has bled over time, giving the appearance of especially broad lines. The drawing in the recto has bled through to the verso, which seemingly was originally sketched with finer lines.

2. Burchard 1953, 384 n. 2.

3. Burchard/d'Hulst 1963, 315; Held 1956, 124; and Wellesley/Cleveland 1993–94, 203–5.

4. *The Head of Cyrus Brought to Queen Tomyris*, c. 1620–23, oil on canvas, 263 x 199 cm, Musée du Louvre, Paris (inv. no. 1768); *The Head of Cyrus Brought to Queen Tomyris*, c. 1622–23, oil on canvas, 205 x 361 cm, Museum of Fine Arts Boston (41.40).

5. For a discussion of this subject in northern art, see Berger 1979.

6. Held 1956, 124.

7. Berger 1979, 8.

Tomyris with the Head of Cyrus
(verso)

Pen and brown ink, with black and red chalk, touched with white gouache (in Herod's turban), on beige laid paper; verso, pen and brown ink, with black and red chalk

272 x 472 mm (10¹¹/₁₆ x 18⁹/₁₆ in.)

WATERMARK: center: elephant

INSCRIPTIONS: by artist, upper center, in brown ink: *de Herodias* [wat hooger? (or:

"meden hoofte," "wat hoegte," or "wat hogher")]; by artist, lower right, in brown ink: *den* [or: deze] *stoel te* [cort?]; verso, by artist, center, in brown ink: *plus spatij*

Delia E. Holden and L. E. Holden Funds 1954.2.a,b

Jacob Jordaens

Antwerp 1593–1678

After the death of Rubens in 1640, Jacob Jordaens emerged as the most prominent artist in the southern Netherlands. Trained by the painter Adam van Noort, Jordaens entered the Antwerp guild of St. Luke in 1615 as a *waterschilder*, a watercolorist who made substitute tapestries on paper or canvas. Although he relied on the more profitable technique of oil on canvas for the majority of his finished works, he continued to use watercolor and gouache for tapestry designs and other drawings. A prolific draftsman, at least 450 drawings are attributed to Jordaens.

The two drawings in Cleveland, along with a third in a private collection in Augsburg (fig. 1),[1] are probably studies for Jordaens's painting the *Conversion of Saul*, executed for the altar dedicated to St. Paul (the name of Saul after his conversion) in the Premonstratensian abbey church at Tongerlo, in the province of Antwerp. The altar at Tongerlo is known only through documents recording that Jordaens received 400 Rhenish guilders for the painting in October 1647.[2] Considering the finished quality of the three drawings, it has been suggested that they may have been different *modelli* submitted to the patron for approval so he could choose one.[3] However, as no descriptions of the painting survive, it is impossible to know the exact relationship of the modelli to the finished work. Two other works of the same subject by Jordaens are known: a painting appears in the inventory of his estate sale in The Hague, on 22 March 1734, and an unrelated drawing, dated to about 1665, is in the Hermitage.[4]

According to the Bible (Acts 9:1–9), in the year following the death of Jesus Christ, Saul of Tarsus (who became St. Paul) was on the road to Damascus. He was suddenly surrounded by a brilliant light from above, fell to the ground, and heard the voice of Jesus saying "Saul, Saul, why do you persecute me?" Blinded by the experience for three days, he was then told to go to the city and wait for further instructions.

Jordaens illustrated the climactic moment as Jesus speaks and Paul lies prostrate on the ground. As was standard by the mid-seventeenth century, these images elaborated on the text with the inclusion of horses, a host of companions, and the figure of Christ, all within a nocturnal setting. These pictorial elements are also evident in a painting by Peter Paul Rubens formerly in the Kaiser Friedrich-Museum in Berlin.[5] For Jordaens, Rubens certainly set the most important precedent in terms of this subject, one the older master treated repeatedly throughout his career.[6]

The similarities in size, character, and technique of the two Cleveland sheets have often been emphasized, while their differences have been largely ignored. The *Conversion of Saul with Horseman and Banner* is the more clearly articulated drawing, with sharper outlines and greater resolve in the figures. For example, the man to the left of the rearing horse in the *Conversion of Saul with Christ and the Cross* is sketched loosely, with multiple outlines, so that it is difficult to determine how many figures are actually represented. In addition, the contrast of light and dark is more fully developed in the *Conversion with Horseman*. Another important distinction between them is the size of the figures. In *Conversion with Horseman*, there are fewer men, yet less space is given to the background since they are larger. Saul is accompanied by seven men and four horses as compared to at least nine men and three horses in the *Conversion with*

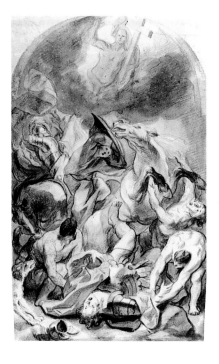

Fig. 1. Jacob Jordaens. *The Conversion of Saul*, c. 1645–47, pen and brown ink, watercolor and gouache over red and black chalk. Private collection, Augsburg.

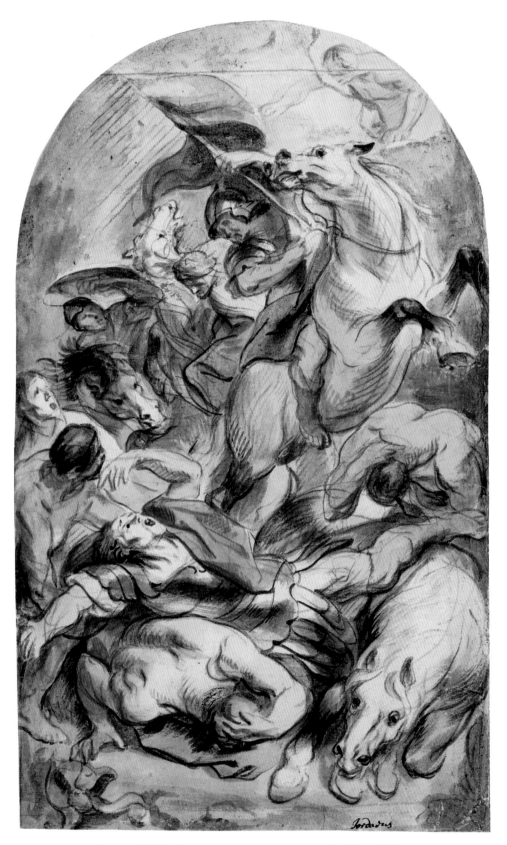

Black and red chalk, pen and black and gray ink, brush and brown wash, watercolor, and gouache, heightened with white gouache, framing lines in red chalk and graphite (right edge), on two sheets (joined) of beige laid paper, laid down on cream laid paper

329 x 199 mm (12¹⁵⁄₁₆ x 7¹³⁄₁₆ in.)

WATERMARK: none visible through mount

INSCRIPTIONS: lower right, in brown ink: *Jordaens*

Delia E. Holden and L. E. Holden Funds 1954.366

Christ. It is also interesting to note that Jordaens repeated only two poses in these two works: the nude cowering in the lower left and the large rearing horse, which is nearly the same in each except for its reversal.

Although Roger Adolf d'Hulst related the drawing in Augsburg to these two sheets with regard to style, subject, and shape, that work is larger than the two Cleveland sheets (37–38 mm higher, 16 mm wider). It was also drawn on a single sheet of paper, unlike these two works, to which the artist added an additional strip on top,

either before or during the execution of the work. Jordaens frequently enlarged or reconstructed his paper supports. The Augsburg *Conversion* compares most closely to the *Conversion with Christ*, especially in terms of composition. In both, although reversed, Paul is seen foreshortened and upside-down, generally mirroring the position of the rearing horse from which he has just fallen. In addition, the figures of Christ, both holding a cross, are more closely related, as is the arrangement of the majority of Paul's companions. SMK

1. 367 x 215 mm; see d'Hulst 1974, no. A240.

2. Waltman van Spilbeeck, *De voormalige abdijkerk van Tongerloo en hare kunstschatten*, *De Vlaamsche School* 29 (Antwerp, 1883), 30, 83–85.

3. Wellesley/Cleveland 1993–94, 171.

4. D'Hulst 1974, 316. For the drawing, see d'Hulst 1974, A406 (inv. no. 4202).

5. *The Conversion of St. Paul* [destroyed in 1945], c. 1621, oil on canvas, 261 x 371 cm, see Freedberg 1984, 123–29, no. 31. This painting existed in several copies and was reproduced in a print by Schelte A. Bolswert (see Voorhelm Schneevoogt 1873, 63, no. 468).

6. For Rubens's treatment of this subject see Freedberg 1984, 110–33, nos. 29–32.

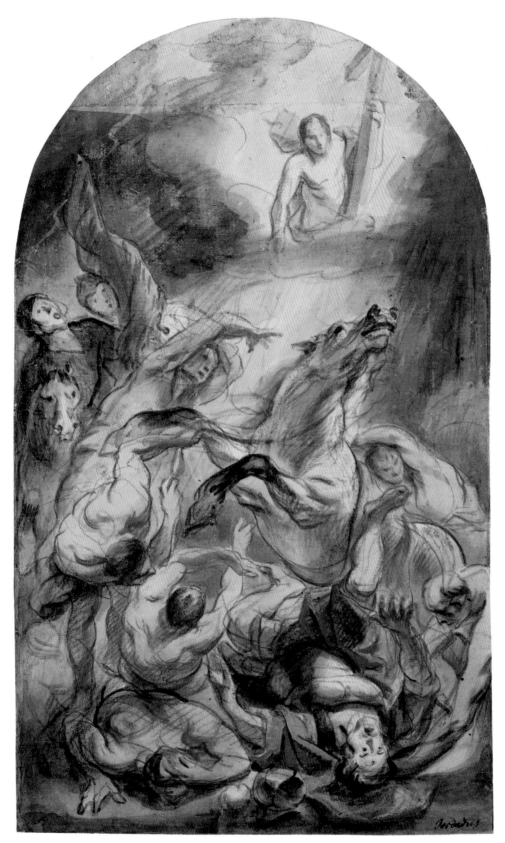

Black and red chalk, brush and
brown wash, watercolor, and
gouache, with black and gray
ink, heightened with white
gouache; framing lines in
graphite, on two sheets (joined)
of beige laid paper, laid down on
cream laid paper

330 x 199 mm (13 x 7¹³⁄₁₆ in.)

WATERMARK: none visible
through mount

INSCRIPTIONS: lower right, in
brown ink: *Jordaens*

Delia E. Holden and L. E.
Holden Funds 1954.367

British Drawings

Henry Fuseli (Johann Heinrich Füssli)

Zurich 1741–Putney Hill, England, 1825

In book four of *Paradise Lost*, John Milton describes Satan's first entry into the Garden of Eden and his discovery of Adam and Eve. Fuseli's drawing illustrates the moment when the angels Ithuriel and Zephon discover Satan in the bower where the couple lies sleeping. They find him "close at the ear of Eve"[1] in the form of a toad. Ithuriel then touches Satan with his spear and forces him to reveal his true form. Fuseli dramatizes the scene with emphatic light on Satan's body, which has no natural source (the moon is behind him), and in doing so creates a visual counterpart to the metaphoric imagery of light and fire with which Milton describes Satan's appearance to the two angels.[2] The lion in the background alludes to an earlier passage in the poem, when Satan takes on the shape of the beast in order to spy on Adam and Eve.[3]

The work of Milton was a major influence on Fuseli; he first became familiar with it through his mentor in his native Switzerland, Johann Jakob Bodner, whose translation of *Paradise Lost* appeared in 1732. The most important project of Fuseli's career was his *Milton Gallery*, a cycle of large-scale paintings illustrating the poet's work and begun in 1790.[4] It included Fuseli's painting of the same subject as the present work (now lost),[5] with which it shares some similarities of composition. Fuseli executed the Cleveland drawing much earlier, however, in 1776, when he was a leading figure among foreign artists living and working in Rome. It shows the influence of several works there that he studied firsthand: the figure of Eve was inspired by a figure on the *Orestes Sarcophagus* in the papal collections; he modeled Ithuriel and Zephon on figures in Raphael's *Expulsion of Heliodorus* fresco, also in the Vatican;[6] his heroically nude Satan recalls figures in Michelangelo's Sistine Chapel, especially Jonah, which Fuseli copied.[7] The artist's choice of this particular passage from Milton may have been influenced by Alexander Runcimen, whom Fuseli met in Rome, and who executed a similar drawing that he may have known.[8]

Fuseli made at least three closely related drawings of *Satan Starts from the Touch of Ithuriel's Spear*, including the Cleveland work. The best known of them was a gift from Fuseli to his friend, the Swedish sculptor Johan Tobias Sergel (fig. 1).[9] Fuseli dated both it and the Cleveland sheet "Roma Oct. 76." The latter is slightly larger than the version in Stockholm; otherwise it differs only in minor details and the addition of hatching in the background. An undated sheet in the British Museum seems to follow the Cleveland drawing.[10] In 1779, Sir Robert Smyth commissioned a large-scale painting of the subject, which is similar in overall conception to the earlier Roman drawings.[11] Fuseli showed it at the Royal Academy in 1780. A drawing related to this painting—probably a copy by another artist after a lost drawing by Fuseli—is also known.[12] CEF

Fig. 1. Henry Fuseli. *Satan Starts from the Touch of Ithuriel's Spear*, 1776, pen and brown ink, brown and reddish-brown wash. Nationalmuseum, Stockholm, inv. no. NM 1685/1875.

1. *Paradise Lost*, book four, line 800.

2. Ibid., 814–19.

3. Ibid., 401–2: "About them round / A lion now he stalks with fiery glare." The lion is also a symbol of Satan in the ninety-first Psalm.

4. See Gert Schiff, *Johann Heinrich Füsslis Milton-Galerie* (Stuttgart, 1963); Stuttgart 1997–98.

5. Schiff 1973, no. 38.

6. Noted in Schiff, *Johann Heinrich Füsslis Milton-Galerie*, 64; New Haven 1979, 40.

7. See Schiff 1973, no. 673.

8. Schiff, *Johann Heinrich Füsslis Milton-Galerie*, 64; New Haven 1979, 14–15, no. 12.

9. Schiff 1973, no. 482; see also New Haven 1979, 40–41, no. 41; Nationalmuseum Stockholm, *Füssli* (Stockholm, 1990), 66, no. 64 (repr.); Stuttgart 1997–98, 19–20, no. 17.

10. Schiff 1973, no. 483; New Haven 1979, 40.

11. Schiff 1973, under "Lost Works," no. 18; the painting recently appeared at auction and is now in the Staatsgalerie, Stuttgart; see *Important Old Master Pictures*, Christie's, New York, 11 January 1995, 296–97, no. N146; Stuttgart 1997–98, 19–22, no. 16.

12. See *Zeichnungen Alter Meister aux Deutschem Privatbesitz* (Hamburg, 1965), 26, no. 108, pl. 53; Stuttgart 1997–98, 20, no. 19. There is also a line engraving related to this drawing by Johann Heinrich Lips; see D. H. Weinglass, *Prints and Engraved Illustrations By and After Henry Fuseli: A Catalogue Raisonné* (Hants, England/Brookfield, Vermont, 1994) 325–26. no. 283. My thanks to David Weinglass for his help in the preparation of this entry.

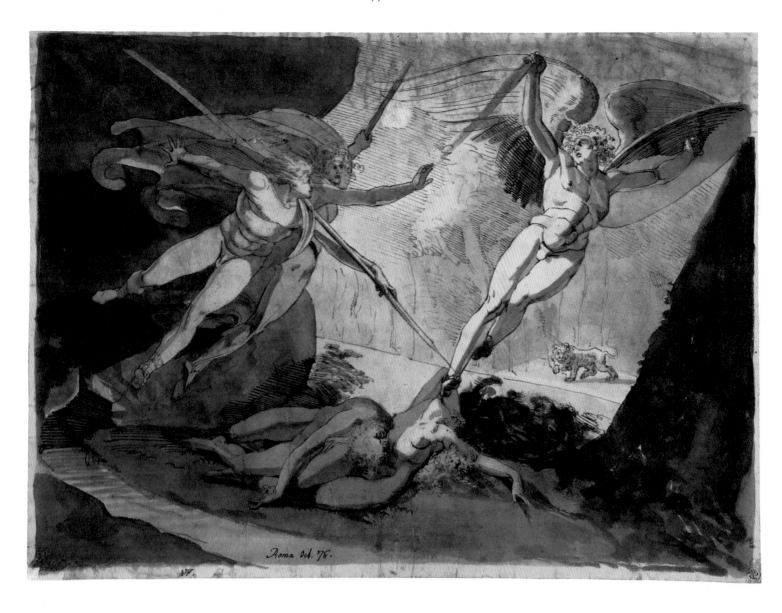

Pen and brown ink and brush and brush and gray wash, on cream laid paper, laid down on cream modern(?) laid paper

309 x 425 mm (12⅛ x 16¹¹⁄₁₆ in.)

WATERMARK: center left: illegible

INSCRIPTIONS: by artist, lower center, in brown ink: *Roma Oct. 76*; lower left, in brown ink: *17.*; verso of secondary support, lower left, in graphite: *Lg*[vo?][last letter underlined twice]; lower center, in graphite: *3*

Dudley P. Allen Fund 1954.365

John Hamilton Mortimer

Eastbourne 1740–London 1779

John Hamilton Mortimer had a relatively short career and a turbulent life,[1] but his paintings, drawings, and prints explored a range of subject matter previously undeveloped in England. He was one of the most gifted draftsmen of his generation, and his talent in drawing was recognized early on and helped him win prizes as a young man. His first major painting, *St. Paul Preaching to the Ancient Britons*,[2] foreshadowed his later exploration of subjects from Anglo-Saxon history, especially the peoples of ancient Britain. Mortimer became known for his drawings and etchings of bandits as well and was strongly influenced by the seventeenth-century Italian artist Salvator Rosa. His exploration of picturesque subject matter often has a violent twist, as in this drawing.

The Druidical subject of this work is an important aspect of Mortimer's mature style of the 1770s. He deliberately sought out unusual scenes from British history that had rarely been depicted in British art.[3] Here he presents an interrupted decapitation, with a Druid priest about to sacrifice a young man at the base of a statue. Mourners at the left react with sorrow, while the priests at the right show surprise as an old man halts the executioner. Sam Smiles has suggested *Cymbeline* by Henry Brooks as the textual source (specifically the scene in which Leonatus offers himself for sacrifice in place of a Roman captive),[4] but there are a number of elements in the drawing that do not match this subject.[5]

The Cleveland sheet perfectly exemplifies the artist's fluid but tightly executed linear drawing style. His use of brown ink pen lines, with close parallel and crosshatching, as well as stippling, is typical of this period in his work. It shows the influence of both Rosa, especially his etching style, and another seventeenth-century painter, Guercino. Although his drawings are much looser in execution than Mortimer's, Guercino was also a master of fluid hatching and stippling with the pen, and his drawings were popular in England. Mortimer likely knew them, for the most part, however, from Francesco Bartolozzi's many reproductive prints after them, and Mortimer's drawing style almost seems a conscious imitation of etching technique. Mortimer did make drawings as preparatory studies for other works—a head study (fig. 1) seems related to the decapitating priest in the work here. But this finished sheet was no doubt intended for exhibition. Mortimer showed another drawing with a subject taken from ancient British history at the Society of Artists in 1777, and the Cleveland sheet may have been shown there as well.[6] CEF

Fig. 1. John Hamilton Mortimer. *Head of a Bearded Old Man*, pen and ink. Victoria and Albert Museum, London, inv. no. E.1074–1948.

1. Sunderland 1988 is the only monographic study of the artist.
2. Guildhall, High Wycombe, England; see Sunderland 1988, 123–24, no. 13, pl. 26.
3. Ibid., 74.
4. Smiles 1995, 45.
5. See ibid. for a description of the scene; as William Pressly has pointed out (letter of 28 June 1999, CMA files), none of the figures other than the youth at center appear to be captives; the group at left are witnesses to the drama rather than captives, and the group at the right are Druid priests, not captives; the old man stopping the sacrifice is too old to be Leonatus; one could add that the scene takes place out of doors, not inside a temple. We have adapted Pressly's suggestion of the general title, *A Druidical Sacrifice Interrupted*, and thank him for his ideas about the sheet.

6. See Algernon Graves, F.S.A, *The Society of Artists of Great Britain 1760–1791. The Free Society of Artists 1761–1783. A Complete Dictionary of Contributors and Their Work from the Foundation of The Societies to 1791* (Bath, 1969), 179, under 1777, no. 348 is titled *St. Paul Converting the Ancient Britons*; 178, no. 180, is simply called *Two Large Historical Drawings*.

75. *A Druidical Sacrifice Interrupted*

1770s

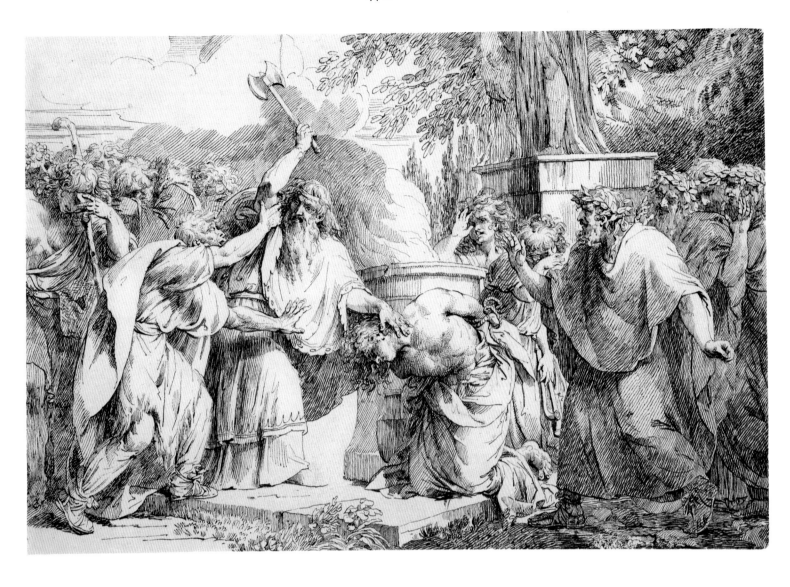

Pen and brown ink, on cream
laid paper

245 x 36 mm (9⅝ x 14⅛ in.)

Cornelia Blakemore Warner
Fund and Delia E. Holden Fund
1978.20

John Robert Cozens

London 1752–1797

This expansive Italian landscape was made toward the end of John Robert Cozens's short career, during a period when his watercolors became larger in format.[1] Cozens was the son of the landscapist and theorist Alexander Cozens, whose radical theories of the emotional impact of landscape his son developed into an individual and highly influential body of work.[2] John Robert was of a solitary nature and grave manner, and eventually went mad in 1794, but before he sank into insanity, he produced beautiful and subtle watercolors that were the basis of the Romantic school of English landscape drawing. Because Cozens made few oil paintings, his fame rests solely on his watercolors. As the artist who raised the appreciation of landscape watercolors to that of oil painting, Cozens's renown rests on the grand simplicity and subtlety of his compositions, which are based in reality rather than on the imagination or classical examples. For him, landscapes represented the universal in nature on which he could impose an emotional meaning; they were at the same time highly personal and broadly familiar.

In the eighteenth century, views of Italy and the continent were in great demand among the travelers of the Grand Tour. Numerous artists interpreted Italian and continental sites as reminders of these visits. Cozens traveled to Italy and Switzerland twice in his career in the company of English writers, whose theories of the sublime he shared. In 1776 he went to Italy with Richard Payne Knight, the scholar and antiquarian who stated that various types of landscape could arouse diverse passions in the viewer. Cozens remained in Italy for three years and returned again in 1782–83 in the company of the eccentric collector William Beckford. Watercolors of Italian views for his patrons were derived from the pencil and wash sketches he made on his two Italian trips.[3] Some of those compositions were so popular that Cozens repeated them eight or nine times for different clients.

The view in *Italian Landscape* was probably worked up from one of the sketches Cozens made during his second trip to Italy. It exists in only one version and, unlike many of the artist's watercolors, has escaped overexposure to light. The subtlety of his washes of grays, greens, and blues—his preferred limited palette—emphasizes the broad expanse of land and sky. The subject is Nature itself and man's small part in the breadth of its domain. It is no wonder that John Constable stated that Cozens was "all poetry, the greatest genius that ever touched landscape."[4] *Italian Landscape,* one of his most lyrical and well-preserved drawings, is of a site not yet identified, but possibly in the campagna south of Rome. C. F. Bell and Thomas Girtin believed that the left-hand portion, with the towers and ridges, was based on the artist's *View near Velletri* (Brighton Museum and Art Gallery) and that the rest of the scene is imaginary and possibly English in origin.[5] The figures in the copse at left may suggest a classical arcadian subject, also indicated by the tranquility of the scene overall. The site and subject are unimportant, however, as Cozens was interested in representing the universal rather than the specific in nature.

DDG

1. Other drawings of the period are large in format (Sotheby's, London, 14 November 1996, lot 59).

2. For a general introduction to the Cozens's art, see Andrew Wilton, *The Art of Alexander and John Robert Cozens* (New Haven, 1980), and Kim Sloan, *Alexander and John Robert Cozens. The Poetry of Landscape* (New Haven/London, 1986).

3. On Cozens's sketchbooks, see Francis W. Hawcroft, "Grand Tour Sketchbooks of John Robert Cozens, 1782–83," *Gazette des Beaux-Arts* 91 (March 1978), 99–106.

4. Sloan, *Alexander and John Robert Cozens,* 88.

5. Bell/Girtin 1935, no. 439ii. For *View near Velletri,* see *26th Exhibition of English Watercolours,* exh. cat., Walker's Galleries (London, 1930), no. 40.

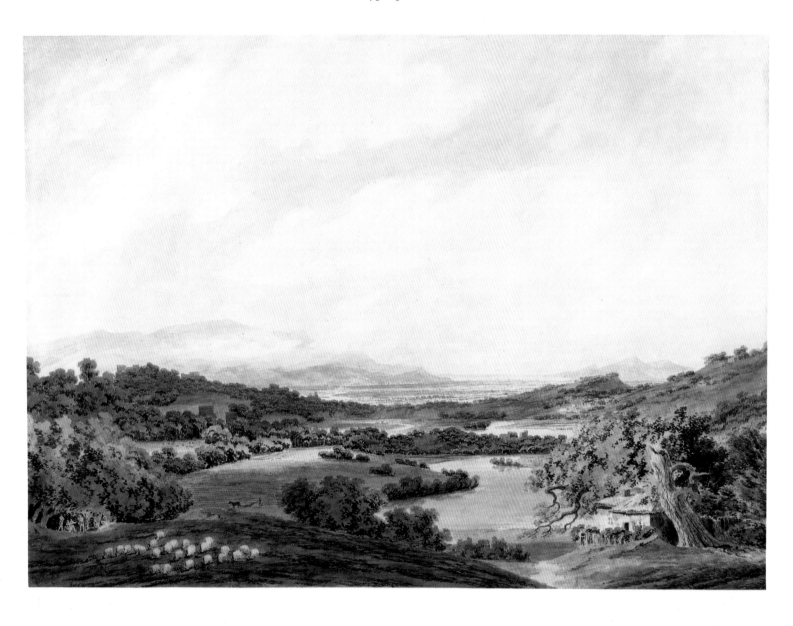

Watercolor over graphite, on
white wove paper, lined with
white wove paper

487 x 669 mm (19³⁄₁₆ x 26⁵⁄₁₆ in.)

Leonard C. Hanna Jr. Fund
1997.137

William Blake

London 1757–1827

As a poet and artist, William Blake melded text and image in unprecedented ways. Trained as a printmaker, Blake's experiments in the medium of etching led to his first masterpieces: illustrations for his poems in which he presented word and image as one. Many of his prints are unique and hand-colored, and his work in the medium of watercolor was a natural extension of that process. Much of his imagery reflects his visionary interpretations of biblical themes, whether inspired by the Bible itself or by literature based on it, such as John Milton's *Paradise Lost*. Although Blake's innovative interpretation of subject matter set him apart from his contemporaries, he was connected to several important neoclassical artists, including Henry Fuseli (see no. 74) and John Flaxman. Flaxman's drawing style was marked by an emphatic use of contour lines articulating flat, shallow, relief-like spaces, and Blake's work reflects the influence of that style and made him an important interpreter of neoclassicism in Britain.

Blake's most important patron was Thomas Butts, a government clerk who began to commission works from him around 1799. The artist's work for Butts began with a number of tempera paintings based on biblical themes.[1] In 1800, he continued his work for Butts in watercolor, eventually completing more than eighty works for his patron in that medium, for which he was paid one guinea each.[2] Although scholars generally refer to Blake's works for Butts as illustrations to the Bible, the Cleveland drawing is one of the few in the series that does not seem to illustrate a specific passage.[3] Blake, however, approached his subjects in a rich and complex way,[4] and it may be that the Cleveland work is an interpretation of a biblical passage yet to be identified. In presenting an image of the Holy Family, he drew from an important iconographic tradition in Western painting, but he developed it here in an unusual way. The Virgin Mary in the center holds the Christ child, whose pose, standing with arms outstretched, prefigures his crucifixion. Below, St. John the Baptist, who foretold Christ's death and resurrection, plays with a lamb. The Virgin is flanked by St. Joseph on the left and St. Anne, her mother, on the right. Blake's symmetrical, iconic depiction of Joseph, Mary, and Anne seated in a row together is unusual, as are the monumental attendant angels.

Stylistically, this watercolor seems to relate most closely to a subgroup of works within the Butts biblical illustrations that depict the Crucifixion and Resurrection.[5] Although the present work does not fit into the narrative sequence of this group, its size, symmetrical composition, and vertical orientation suggest it was likely done around the same time. Blake also executed a version of the work in tempera for Butts several years later, around 1810, which follows the Cleveland composition fairly closely.[6] In 1862, this painting was exhibited as *Christ in the Lap of Truth*,[7] and some subsequent publications began to apply this title to the present work, though no sources identify what the subject could possibly mean. CEF

1. Butlin 1981, 317–35, nos. 379–432.

2. Ibid., 335–72, nos. 433–526; for discussions of the group, see Martin Butlin, *William Blake* (London, 1978), 87–97; David Bindman, *William Blake: His Art and Times* (New Haven/Toronto, 1982), 132–43.

3. Generally, the Butts biblical illustrations were inscribed with the biblical passage to which they corresponded, though in many cases this inscription has been lost due to trimming (discussed in Butlin 1981, 335). The only other works in the series not identifiable with a specific biblical text are *Christ in the Carpenter's Shop* (Butlin 1981, 352–53, no. 474) and *Christ Trampling down Satan* (ibid., 372, no. 526); but some of the other watercolors, such as *The Death of Joseph* (ibid., 365–66, no. 511), represent a text only in the loosest sense (discussed in ibid., 366, under no. 512).

4. See Heppner 1995; Blake's interpretations of the Bible, often based on multiple passages, are discussed in chapter 7.

5. Butlin, *William Blake*, 93, discussed under no. 178.

6. Butlin 1981, 484, no. 671.

7. *International Exhibition 1862. Official Catalogue* [held at the Crystal Palace] (London, 1862), 18, no. 221: "CHRIST IN THE LAP OF TRUTH, AND BETWEEN HIS EARTHLY PARENTS."

8. For a discussion of Blake's monogram and the dating of his works, see Martin Butlin, "Cataloguing William Blake," in Robert N. Essick and Donald Pearce, eds., *Blake in His Time* (Bloomington/London, 1978), 82–83.

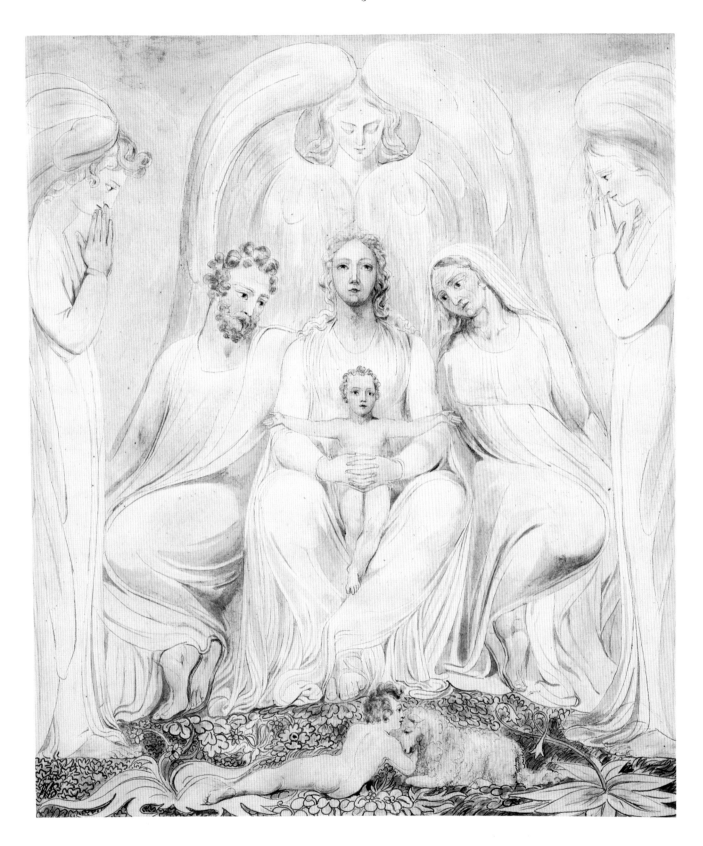

Pen and black and gray ink and brush and black, gray, yellow, and pink wash, with dry pen incisions, on beige wove paper

379 x 325 mm (14⅞ x 12¾ in.)

INSCRIPTIONS: signed, lower right, in black ink: [artist's monogram:[8] inv / WB]; verso, upper center, in graphite: *G*

[collector's mark? (not in Lugt)]; across bottom, in graphite: *no. 9* [S?]*ingle*; across bottom, in graphite: *The Holy Family / Jesus–Mary–Joseph–Elizabeth + St. John*; lower center, in graphite: *50/* [7?]

John L. Severance Fund 1950.239

John Martin

Northumberland 1789–London 1854

One of the most imaginative painters of the nineteenth century, John Martin is famous today for his fantastic mezzotints after his paintings and for his beautifully colored, virtuoso watercolors.[1] He was born into an unusual family of eccentrics and visionaries who professed their ideas freely. He moved to London in 1805 to follow his chosen vocation as a painter and achieved fame and popular recognition with his visionary painting of Belshazzar's Feast. In this and other historical and biblical paintings Martin eschewed the natural proportions of man for the overwhelming power of the Divine and of Nature. In the 1820s he was considered the most popular painter in England and saw himself as a rival to Turner, whose own visions of a powerful Nature influenced him. In his many excursions around London in relation to some of his proposals to improve the city's docks, sewers, and water supply, he took his easel and produced beautiful watercolors of London's environs. Thus, watercolors began to take dominance in his work.

The landscape of his youth influenced Martin throughout his life. In the *Valley of the Tyne*, signed and dated during his maturity, he evoked the beauty and desolation of his native land. Although there is a strong element of topographical truth to this landscape, the panoramic effect of the view is inventive and hints at something beyond man's normal experience. The sweeping stripe of the yellow-green road, with its running couple and little dog, and the dark mist at the left suggest an oncoming storm, with wind and rain on the moors. The small cross and tiny sheep in the distance add to the feeling of the vastness and force of nature. The viewer is made to wonder who the running figures may be: their story is left to the imagination. Although frightening, the landscape is not pessimistic; the flowers and greenery give color and imply the regenerative powers of nature. In this and other drawings, Martin broke the rules of classical landscape in which the view is enclosed at either side and the eye must crisscross the scene and make expected stops from foreground to background. Instead, the eye takes on the whole at once and we thus understand that the untamed landscape exceeds beyond what is drawn—at right, left, and past the distant mountains. The horizontal format of most of Martin's drawings add to the impression of the expansiveness and enormity of the landscape. Martin suggested the sweep of movement from right to left by placing figures in the lower left and giving the right side more dominance in either topographical height or deeper color.[2] Unlike the regularized, man-dominated, and domesticated views of Claude Lorrain (see nos. 33, 34), Martin's landscape expresses the view that the forces of God (as implied by the cross) dictate the actions of man.

In 1841 Martin exhibited a watercolor at the Royal Academy entitled *Valley of the Tyne, My Native Country from near Henshaw*. The Cleveland sheet must be the same drawing, which he signed the following year. The quotation from Sir Walter Scott's *Lay of the Last Minstrel*, which he placed with the picture, indicates a longing for the past and the melancholy spirit the scene evoked in him.[3] The graphite underdrawing suggests that the artist first drew the scene in the open, either on this sheet or another from which he took the basic outlines of the composition. Here, as elsewhere, Martin employed a glazing of gum arabic to enhance the color and atmosphere and give a highly finished, painterly feeling to the sheet. DDG

1. On Martin's life, see Feaver 1975 and Christopher Johnstone, *John Martin* (London/New York, 1974).

2. See Feaver 1975, figs. 129–34 and p. VI.

3. "Still as I view each well-known scene, / Think what is now, and what hath been, Seems as, to me of all bereft, / Sole friends the woods and streams were left; / And thus I love them better still / Even in extremity of ill."

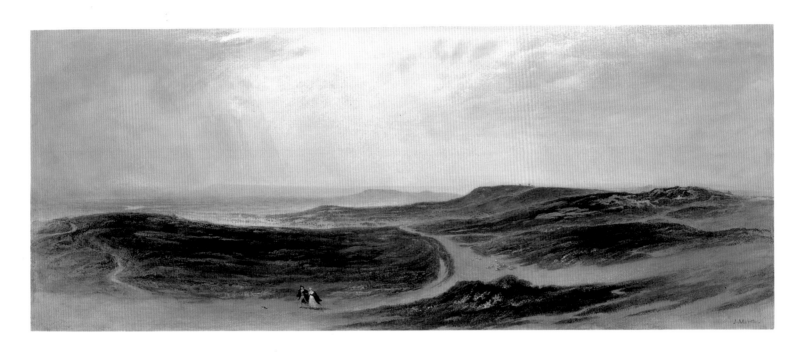

Watercolor and gouache with gum arabic, over graphite, on cream wove paper, lined with beige wove paper

266 x 675 mm (10⁷⁄₁₆ x 26⁹⁄₁₆ in.)

INSCRIPTIONS: signed, lower right, in watercolor: *J. Martin / 1842*

Leonard C. Hanna Jr. Fund 1997.138

Joseph Mallord William Turner

London 1775–Chelsea (now London) 1851

An admirer and longtime imitator of the landscapes of Claude Lorrain, Turner was profoundly influenced by the classical pictorial tradition. A member of the Royal Academy by age twenty-four,[1] and then professor of perspective there, he also theorized visually, in his *Liber studiorum*,[2] on the academic hierarchy of genres that placed the history painter at the summit of artistic creation. Early on he was influenced by such major English landscapists and watercolorists as Alexander Cozens[3] and Thomas Girtin, and through his training at the Royal Academy he became a topographical landscapist.

Landscape was for Turner a constant source of inspiration, which made him an avid traveler. In 1802, the Treaty of Amiens fostered a short peace between England and post-Revolutionary France under Bonaparte, and thus opened the continent to English visitors after many years of interdiction. Disembarking at Calais, Turner went to Paris and visited the Louvre, which was filled with masterpieces confiscated by the French armies in the recent military campaign in Italy. Most important, however, he stayed in the Alps for three months, where he executed more than five hundred sketches that would nourish his production for close to fifteen years. The sketchbooks conserved at the Tate Gallery reveal the artist's method, which consisted of succinctly rendering the essential character of the landscape in pencil. Back in his London studio, he used these studies to create watercolors and paintings filled with color,

monuments, and human activity, as in a historical landscape (see Valenciennes, no. 46). These elements charged the site with poetry and could modify it to the point of making it difficult to recognize.[4]

At age sixty-six Turner returned to this mountain region discovered in his youth. He spent every summer there between 1841 and 1845 for the last voyages of his life, bringing back a series of sketches each year. In the Cleveland view of the village of Fluelen, made after one of the late Swiss sketches, the agitation of the skies and the fantastic opening of light coexist with the fragile, immobile, peaceful landscape and the simply outlined human embarkation on the lake. The watercolor from the Tate Gallery (fig. 1) is the sketch for the Cleveland watercolor.

In a way that baffled his critical champion, John Ruskin, and which Ian Warrell has compared to his early practices, Turner directed his dealer, Thomas Griffith, to sell his compositions ahead of time by showing the sometimes highly developed sketches to his most loyal patrons. Turner's objective was certainly both commercial and aesthetic. The procedure allowed him to realize a series of about thirty completed watercolors and keep all the original sketches. Yet his plan failed to achieve the commercial success anticipated because it attracted only the most eager buyers—for instance, Ruskin, the Scottish landowner Hugh Munro of Novar, and retired coach maker Benjamin Godfrey Windus.[5] SB

Fig. 1. Joseph Mallord William Turner. *Fluelen, from the Lake of Lucerne: Sample Study*, 1844–45, watercolor. Turner Collection, Tate Gallery, London, Turner Bequest CCCLXIV 381.

1. Twenty-four was the youngest age permitted for entry into the illustrious society.

2. Turner published *Liber studiorum* (his personally coined Latin for "Book of Studies") between 1807 and 1819, in fourteen installments, working closely with his engravers and executing some of the mezzotints himself.

3. Alexander Cozens was the father of John Robert Cozens (see no. 76). In 1785–86, Alexander Cozens published *A New Method of Assisting the Invention in Drawing Original Compositions of Landscape*, in which he discussed chance and figuration in watercolor; see Jean-Claude Lebensztejn, *L'Art de la tache: Introduction à la "Nouvelle méthode" d'Alexander Cozens* (Paris, 1990). While it is certainly inaccurate to make analogies between these investigations in eighteenth-century English watercolor and aspects of twentieth-century art, nevertheless they establish the contemporary public's familiarity with the complex art of English watercolor.

4. Ian Warrell's site research on French rivers depicted by Turner has revealed the precise mixture of geographical precision and poetic interpretation in the artist's practice; see Warrell's *Turner on the Loire*, exh. cat., Tate Gallery (London, 1997), and his *Turner on the Seine*, exh. cat., Tate Gallery (London, 1999).

5. For information on Windus, see Selby Whittingham, "Windus, Turner, and Ruskin: New Documents," *J. M. W. Turner, R. A.*, no. 1 (December 1993), 69–116. For details on Turner's Swiss watercolors, see London 1995. The Cleveland drawing is discussed on p. 154, no. 9, under "Finished Watercolours of 1845." See also Peter Bower et al., *Exploring Late Turner* (New York, 1999), and Andrew Wilton, "Personal View: Turner at Brunnen," *Turner Studies: His Art and Epoch* 1, no. 2 (1981), 63–64.

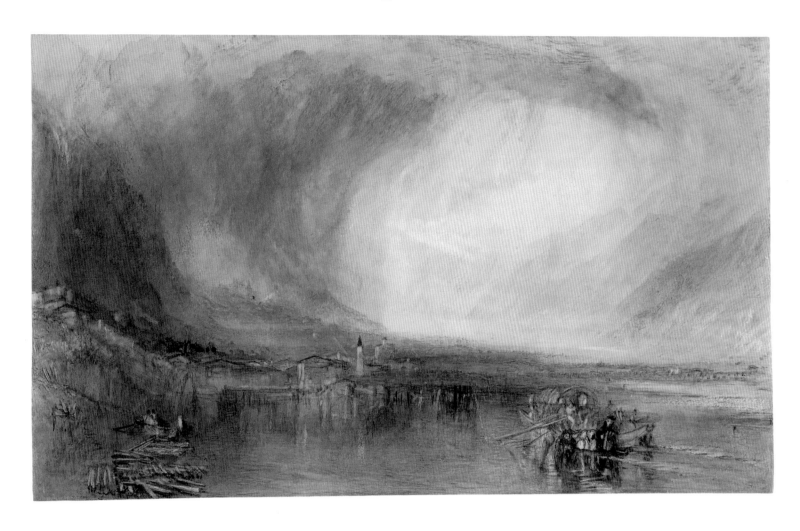

Watercolor with gouache,
scratched away in places, on
cream wove paper

292 x 480 mm (11½ x 18¾ in.)

WATERMARK: center left: J
WHATMAN / 1816

Mr. and Mrs. William H.
Marlatt Fund 1954.129

(Anthony) Frederick (Augustus) Sandys

Norwich 1829–London 1904

Although not formally a member of the Pre-Raphaelite Brotherhood, Frederick Sandys became closely associated with them after he met the group's leader, Dante Gabriel Rossetti, in 1857. This idealized portrait of Mary, Sandys' common-law wife, shows the influence of Rossetti's idealized portraits of women from the 1860s. Rossetti established the Pre-Raphaelite canon of feminine beauty in a series of bust-length paintings of women set against patterned backgrounds.[1] Dense with luxuriant materials and botanical attributes, these pictures reflect his study of Venetian Renaissance portraiture, especially the use of a confined, shallow space. Sandys lived with Rossetti for a time in the 1860s at the latter's house on Cheyne Walk, where they shared studio space and props. Indeed, the eponymous coral necklace of this drawing is likely the same one that appears in Rossetti's *Monna Vanna* and several other works by Sandys.[2] The two artists suffered a falling-out when Sandys became offended at Rossetti's suggestion that Sandys had copied one of his designs.[3] The drawing in Cleveland certainly shows his debt to the older artist, though Sandys' treatment is far more minimal than Rossetti's richly decorated paintings. Like Rossetti, Sandys seems to have been influenced by the Venetian portrait. His use of laurel in the background is symbolic of praise, here, specifically, praise of his wife's beauty.[4]

Whatever he owed to Rossetti's portrait types, Sandys' superior gifts as a draftsman set him apart. He virtually stopped painting in oil after 1866 and made a specialty of portrait drawings. *The Coral Necklace* is not typical of his technique in that he exploited the texture of the paper to give the work a soft sfumato through the stippling effect of the chalk. The sitter seems to dematerialize around the perimeter of the sheet, though Sandys brought her face to a high degree of finish. She appears to emerge, floating, out of a hazy atmosphere. Mary Jones modeled for Sandys many times, and several images of her relate to this one. Closest is the portrait now in the Birmingham Museums and Art Gallery (fig. 1).[5] In that more highly finished work, she turns to the left in a nearly identical pose and appears to be wearing the same dress, this time with a necklace of turquoise. CEF

Fig. 1. Frederick Sandys. *Portrait of Mary Sandys*, c. 1871–73, colored chalks on toned paper. Birmingham Museums and Art Gallery, England, Presented by Charles Fairfax Murray, 1904, 499'04.

1. For example, *Venus Verticordia*, 1864–68; *The Blue Bower*, 1865; *Regina Cordium*, 1866; see Virginia Surtees, *The Paintings and Drawings of Dante Gabriel Rossetti* (Oxford, 1971), nos. 173, 178, and 190, respectively; and *passim* for others of this type. See also Tate Gallery/Allen Lane, *The Pre-Raphaelites* (London, 1984), 208–15.

2. They include Sandys' paintings *La Belle Iseult*, 1862; *Judith*, early 1860s; *Medea*, 1866; and the drawings *Judith and Holofernes*, 1863, and *Head of a Gypsy*, early 1860s. This information comes from Betty Elzea's forthcoming catalogue raisonné entry on the Cleveland sheet, and I am grateful to her for sharing it with me.

3. *The Letters of Dante Gabriel Rossetti* (Oxford, 1967), 2:697, no. 828.

4. My thanks to Sally Smith for her help with the botanical symbolism.

5. See Stephen Wildman, *Visions of Love and Life: Pre-Raphaelite Art from the Birmingham Collection, England*, exh. cat. (Alexandria, Virginia, 1995), 283–84, no. 98.

80. *The Coral Necklace*

1871

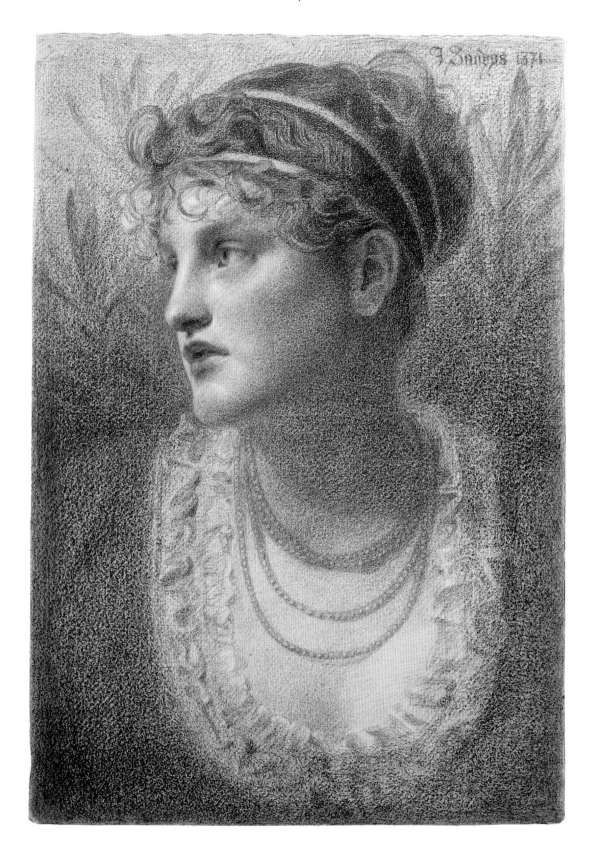

Black, brown, and red chalk, on
cream wove paper, laid down on
beige wove paper

559 x 392 mm (22 x 15⁷⁄₁₆ in.)

WATERMARK: lower left:
[WHATM?]AN 1869 [cropped]

INSCRIPTIONS: signed, upper
right, in black chalk: *F. Sandys
1871*

Leonard C. Hanna Jr. Fund
1997.7

Sir Edward Coley Burne-Jones

Birmingham 1833–Fulham 1898

Edward Burne-Jones first took up the subject "The Briar Rose" (also known as "Sleeping Beauty") in a set of tile designs for the painter Myles Birket Foster in 1864. He turned to the story numerous times over the next thirty years, completing three related sets of paintings over this long span of time.[1] The first group (known as the "small" series and done for his patron William Graham) is now at the Museo de Arte, Ponce, Puerto Rico; it treats the narrative in three separate paintings but does not include *The Garden Court*. The most famous group—and one of the artist's greatest achievements—consists of four larger canvases (including fig. 1) that still decorate the Saloon at Buscot Park in Oxfordshire. Burne-Jones dated them 1870–90, reflecting their long gestation, and when finished, they were exhibited in London to great acclaim and popularity. The London firm Agnew's had paid the artist for the series while he was still working on it, and it was they who sold the paintings to Alexander Henderson, who installed them at Buscot Park. The subject continued to interest Burne-Jones after he completed the second series: he had abandoned three canvases while working on the Buscot Park group but returned to them and finished them in the early 1890s.[2]

Where the Cleveland watercolor fits into the complicated history of these three sets of paintings is not absolutely clear. John Christian has suggested the artist most likely made it in preparation for a never-completed painting conceived along with the early "small" series now in Puerto Rico.[3] Stylistically, the drawing fits this period of the artist's work,[4] and Burne-Jones's work record from 1872 does mention four pictures in the "small" series, suggesting there was a lost or unfinished painting to which the Cleveland sheet is related. Many preparatory drawings for the three Briar Rose projects exist.[5] If the Cleveland drawing falls in this category, then it is unusual among them for its high degree of finish.[6] There are also several independent works inspired by the subject.[7]

The story of the Briar Rose originated with the seventeenth-century French writer Charles Perrault and was retold and popularized by the brothers Grimm, but the more immediate source for Burne-Jones would have been Tennyson's 1842 poem "The Day Dream." In all three series, Burne-Jones's treatment of the narrative is unusual, since he chose not to depict the climactic moment when the prince releases, with a kiss, the princess and her kingdom from the spell of sleep. Burne-Jones himself commented that he wanted to leave the end of the story for the viewer's imagination.[8] His interpretation thus emphasizes a sense of dreamy reverie (as does Tennyson's poem) in that all the figures save the prince repose in sleep. By itself, then, *The Garden Court* is a particularly unusual subject (a fact that supports the argument that Burne-Jones conceived it for the "small" series). Scholars have interpreted the artist's suspension of the narrative in one expanded moment without a climax as an escapist fantasy with both psychological and political motivations.[9] Whatever the case, the innovative interpretation of the story he first began in the 1870s maintained a hold on him for most of his career. CEF

Fig. 1. Sir Edward Coley Burne-Jones. *The Garden Court*, 1870–90, oil. Buscot Park (The National Trust).

1. For the clearest and most detailed recounting of their history, see "The Legend of the Briar Rose" in John Christian et al., *The Reproductive Engravings after Sir Edward Coley Burne-Jones* (London, 1988), 42–44; see also Christopher Wood, *Burne-Jones* (London, 1998), 108–13; New York et al. 1998–99, 156–62.

2. This group is now dispersed among three museums: *The Council Chamber* (Delaware Art Museum, Wilmington, 35-3); *The Rose Bower* (Municipal Gallery of Modern Art, Dublin); *The Garden Court* (Bristol Museums and Art Gallery, K928).

3. See *Fine Victorian Pictures, Drawings, and Watercolours*, Christie's, London, 11 June 1993, 72–73, no. 93 (John Christian wrote this unsigned entry); see also New York et al. 1998–99, 157–58.

4. *Fine Victorian Pictures, Drawings, and Watercolours*, 72.

5. See Edward Morris, *Victorian and Edwardian Paintings in the Walker Art Gallery and at Sudley House* (London, 1996), 58; New York et al. 1998–99, 161, no. 57; Seattle et al. 1995, 325–27, no. 115; Arts Council of Great Britain, *Burne-Jones* (London, 1975), 63, nos. 178–83; Maria Teresa Benedetti and Gianna Piantoni, *Burne-Jones dal preraffaellismo al simbolismo* (Milan, 1986), 116 (repr.), 162, nos. 28–29; Hilary Morgan, *Burne-Jones, the Pre-Raphaelites, and Their Century* (London, 1989), 1:92, no. 86.

6. The painting in Liverpool (see Morris, *Victorian and Edwardian Paintings*, 58) may have been made in preparation for the "small" series, but if so, it represents an earlier stage in the design that the artist then substantially changed.

7. Such as two versions of *The Sleeping Princess*, one in Manchester City Art Gallery (inv. no. 1915.15), the other in a private collection (repr. Art Council of Great Britain, *Burne-Jones*, 63) and *The Prince Entering the Briar Wood*, sold, Christie's, London, 27 November 1987, no. 143.

8. Lady Georgiana Burne-Jones, *Memorials of Edward Burne-Jones* (New York, 1904), 2:195.

9. Kirsten Powell, "Burne-Jones and the Legend of the Briar Rose," *Journal of Pre-Raphaelite Studies* 6 (May 1986), 15–23; Larry D. Lutchmansingh, "Fantasy and Arrested Desire in Edward Burne-Jones's Briar-Rose Series," in Marcia Pointon, ed., *Pre-Raphaelites Re-viewed* (Manchester/New York, 1989), 123–39.

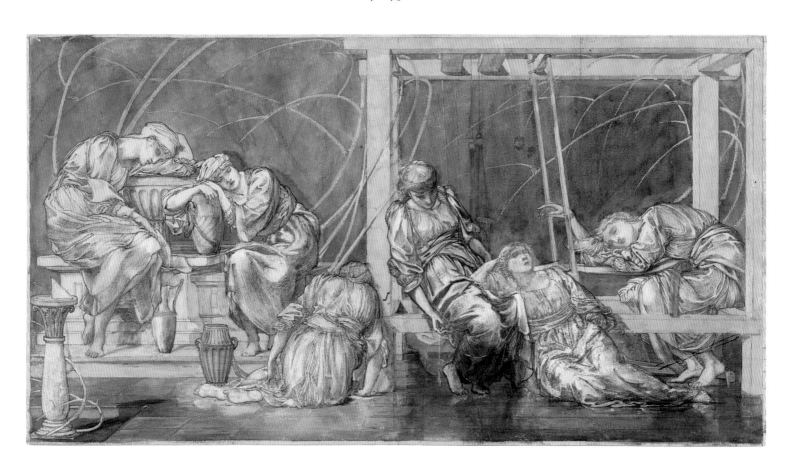

Graphite and watercolor, height-
ened with white gouache, on
white wove paper

323 x 602 mm (12¹¹⁄₁₆ x 23¹¹⁄₁₆ in.)

Andrew R. and Martha Holden
Jennings Fund 1994.197

American Drawings

Benjamin West

Springfield [Swarthmore], Pennsylvania, 1738–London 1820

Benjamin West's study of the head of a man screaming in terror can be connected to an oil sketch now at the Worcester Art Museum, *Pharaoh and His Host Lost in the Red Sea* (fig. 1),[1] that he produced in preparation for a huge canvas executed as part of a large commission for the Royal Chapel at Windsor Castle.[2] The now-lost final painting[3] was shown in the Royal Academy exhibition of 1792, but the project was eventually abandoned and the entire series of paintings returned to West's heirs. A drawing now in Boston seems to record the final composition, which is significantly different from the oil sketch.[4] That sheet clearly shows the pharaoh as the focal point of the lower half of the composition: he twists around in his chariot, his head turning back over his right shoulder, seeing the Red Sea waters crash in around him, his chariot, troops, and horses. As in the Cleveland sheet, his mouth is open wide, his head is tilted toward the left, and there is the same emphatic delineation of the naso-labial fold and the jaw line. In the drawing, West also indicated the same extreme torsion between head and body that one sees in the oil sketch, albeit with just a few broad strokes of chalk in the neck and the shoulders, suggesting that the artist already had the Worcester composition worked out when he executed the Cleveland study. The Boston sheet, however, shows major changes to the composition, so whether he ended up using the Cleveland head study in the final work is hard to gage. There is a similar screaming head near the center of the Boston sheet, but it is not that of the pharaoh and the sketchiness of the drawing makes the connection of this sheet to the final painting difficult to judge.

Aside from its relationship to the painting, though, the Cleveland sheet shows West practicing the "tête d'expression" (expressive head), a French academic genre of drawing. This exercise became an established part of French pedagogy in 1759, when a competition was established for students at the Académie Royale in Paris to study facial expression from a posed model. West's head was probably not done from life, however. Rather, it was directly inspired by the ideas of Charles Le Brun, who established a theory of expression in a lecture (known as the "Conférence sur l'expression") given at the Paris Academy in 1668. Le Brun's ideas were widely disseminated throughout Europe in numerous publications illustrated with prints derived from his drawings. West could have known a variety of these editions, including two in English published in London in 1701 and 1734.[5] Le Brun's system of rendering the passions stressed the legibility of the face, emphasizing a linear rendering of the facial muscles and especially of the eyebrows. In his system, specific external configurations of muscles correspond to specific internal passions.[6] West's Cleveland sheet clearly references Le Brun's idea of terror: the curves of the brow, the facial muscles, the wild hair, and the open mouth all derive from the illustrations of terror and from the text describing it.[7] Terror was, of course, just what West needed to show in the face of the doomed pharaoh for his painting, and as a thoroughly academic painter, it was natural for him to look to Le Brun's theory for inspiration. CEF

Fig. 1. Benjamin West. *Pharaoh and His Host Lost in the Red Sea,* 1792, oil. Worcester Art Museum, Massachusetts, Museum purchase, 1960.18.

1. Erffa/Staley 1986, 99 (repr.), 298, no. 255; see also Erffa 1961.
2. For the history of this commission, see Erffa/Staley 1986, 577–81.
3. Ibid., 298, no. 254.
4. Kraemer 1975, 32–33, under no. 51.
5. Jennifer Montagu, *The Expression of the Passions* (New Haven/London, 1994), 175–87, discusses the various editions of Le Brun's *Conférence.*
6. Le Brun's theory is explained in ibid., 9–30.
7. Especially those editions illustrated by Bernard Picart and those derived from it; see ibid., 178–81.

Woman and Man Playing Cards
(verso)

Black crayon (recto and verso)
on light brown laid paper

323 x 407 mm (12¹¹⁄₁₆ x 16 in.)

Dudley P. Allen Fund
1967.130.a,b

John Singleton Copley

Boston 1738–London 1815

John Singleton Copley was America's first notable artist: his closely observed early portraits of both Tories and patriots provide a unique record of Boston society around the time of the American Revolution. Unfortunately, the outbreak of hostilities dried up his patronage, and consequently he left America for England, never to return. In England, he initially achieved notable successes both as a portrait and history painter. But he proved temperamentally unsuited to the task of flattering and amusing his sitters while they posed for him, or of maintaining his emotional composure when forced to compete with other artists. The quality of Copley's work significantly declined toward the end of his life, and he became bitter and resentful.

In his English drawings, following a method often employed in France, Copley generally used blue paper to serve as a middle tone. He would then quickly work up the image using black chalk to indicate outlines and shadows and white chalk for highlights. He employed that technique in this striking sketch of an equestrian figure. The work is an early study for the figure of the prince of Orange in the *Battle of the Pyrenees* (Museum of Fine Arts, Boston),[1] Copley's last major project, which he worked on from 1812 to 1815, the year of his death. In significant respects, however, this sketch differs from the final painting.[2] Copley produced two oil studies of the prince of Orange (later King William VII of Holland) in a similar pose to that shown in this sketch and with a similar curved sword. One of them is in the queen's collection and the other in the Wellington Museum at Apsleigh House in London.[3] They make it clear that the Cleveland drawing was intended to represent the prince.

In his final painting of the *Battle of the Pyrenees*, however, Copley used the pose shown here for the duke of Wellington, and moved the prince of Orange over to the left, showing him from a different vantage point. Along with placing Wellington's head on the figure shown here, Copley also made other adjustments to the pose—for example, removing the sword and somewhat awkwardly showing Wellington's right arm outstretched in a gesture of command. The end result of all these changes is a curiously clumsy and ungainly painting, far less effective than this impressive figure study. HA

1. See Prown 1966, 2:436, no. 673.

2. Copley's principal biographer, Jules Prown, presents a somewhat muddled and inconsistent account of the purpose of this drawing, tentatively connecting it with the *Battle of the Pyrenees* but also implausibly suggesting that it was made as a study for Copley's *George IV as Prince of Wales* (1804–10; Museum of Fine Arts, Boston); see ibid., 420, no. 661, 381, and pl. 674.

3. Queen's collection, see ibid., 428, no. 671; Wellington Museum, see ibid., 428, no. 672.

4. A Copley drawing in the Museum of Fine Arts, Boston, has the same watermark and includes the date "1810." We thank Roy Perkinson and Sue Reed for their help with this point.

Black and white chalk, on blue
wove paper

276 x 221 mm (10¹³⁄₁₆ x 8¹¹⁄₁₆ in.)

WATERMARK: lower right: COBBS /
Patent⁴

INSCRIPTIONS: verso, lower left,
in black chalk: *Prince of Wales*

Norman O. Stone and Ella A.
Stone Memorial Fund 1950.216

William Rickarby Miller

Staindrop, County Durham, England 1818–Bronx,
New York, 1893

During the later decades of the nineteenth century, such artists as Winslow Homer, Thomas Moran, Henry Roderick Newman, and William Trost Richards firmly established watercolor as a significant medium in American art. The widespread exhibition and selling of watercolors as finished works—meant to be framed and displayed in a way similar to oil paintings—was a fairly new phenomenon in America at the time. In England, however, the tradition was especially rich and stretched back into the eighteenth century, where it was the primary form of expression for many important landscapists. The first flowering of American landscape painting developed from the 1830s onward among the group of artists that became known as the Hudson River School. They used their drawings, primarily in chalk and graphite, not watercolor, to study the particularities of nature on site—the rocks, trees, and riverbanks, for example—that they would later use as aids in making oil paintings in the studio (see, for example, Church, no. 85).

The work of William Rickarby Miller is a link between the ideas embodied by the Hudson River School and later American landscape watercolorists.[1] Miller emigrated from England in 1845, settling in New York City. His father was also an artist, and Miller likely learned the watercolor technique from him at an early age. He drew tirelessly once he began his career in America; many of his sheets were made for reproduction as wood-engraved illustrations in books and magazines. In 1853 he began to show finished "exhibition" watercolors at the National Academy of Design in New York, and he continued to do so through 1876.[2] Given its scale and degree of finish, this carefully composed work likely falls in that category,[3] and he presumably made it as a work to sell. Although his technique would have been perceived then as typically British, Miller shared the interests of Hudson River School artists. The specificity of the inscriptions indicate that he worked on the sheet directly from nature. In that sense, it combines the "study" quality of Hudson River drawings with the more finished painting style typical of studio-made compositions. Miller's combination of graphite pencil and watercolor—that is, of drawn line and painted color in equal measure—was the ideal technique for such an exercise.[4]

In *On the Harlem River* Miller's interest was in recording the specifics of this New York landscape on a crisp fall day. First using graphite, he carefully delineated the outlines of leaves, rocks, and bark, then added watercolor, masterfully rendering the autumn colors and the strong sunlight falling on the clouds, trees, and road. Although realistic, the work is carefully composed, anchored in the center by the large tree around which the road and river wind on either side. His fusion of precisely observed details, such as the cloud formations, with a strong sense of compositional balance follows very much the ideals of his American contemporaries; but Miller's development of the Hudson River School aesthetic in the medium of watercolor was his own innovation. CEF

1. Little has been published on Miller. For an overview of his career, see Grace Miller Carlock, "William Rickarby Miller (1818–1893)," *New-York Historical Society Quarterly* 31 (October 1947): 199–209; for further bibliography on Miller, see Peter Hastings Falk, ed., *Who Was Who in American Art 1564–1975* (Madison, Conn., 1999), 2:2285. The New York Historical Society has large holdings of his drawings; see Richard J. Koke, *American Landscape and Genre Paintings in the New-York Historical Society* (Boston, 1982), 342–77, nos. 1837–2028.

2. Carlock, "William Rickarby Miller," 205, lists the exhibitions in which his work was included.

3. Although Miller did not show at the Academy the year he executed it; he did show there consecutively between 1858 and 1861 (ibid.).

4. A group of watercolors by Miller in the Metropolitan Museum of Art, New York, are close in date and size to the present work and show a similar technique. Two are reproduced in John K. Howat et al., *American Watercolors from the Metropolitan Museum of Art* (New York, 1991), 77.

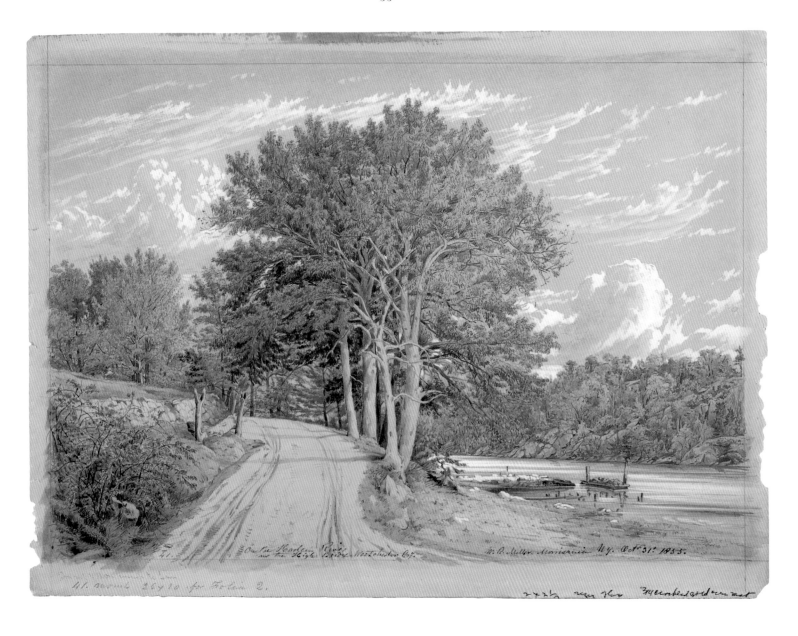

Watercolor with gouache, over graphite, framing lines in graphite, on beige wove paper

378 x 514 mm (14⅞ x 20¼ in.)

INSCRIPTIONS: signed, lower right, in brown ink: *W. R. Miller. Morrisania N Y. Octr 31t. 1855.*; by artist, lower center, in brown ink: *On the Harlem River / nr the High Bridge. Westchester CoY.*; by artist?, lower left, in graphite, above framing line: *41*; by artist?, lower left, in graphite: *41. mount 26 x 20 for Folio 2.*; in graphite, upper center, *View on the Harlem River. 19 x 13.*; lower left, in graphite: *Tree not Yellow enough to* [Sun?]; lower right, in black ballpoint pen: *2 x 2½ [regu?] glass '¼ cracked Gold* [cream?] *mat*

Leonard C. Hanna Jr. Fund 1997.6

Fredreric Edwin Church

Hartford 1826–New York 1900

Frederic Church established his reputation with the massive oil painting *The Great Fall, Niagara*, completed in 1857.[1] By that time, Niagara Falls had long been an icon of the American landscape,[2] attracting artists and visitors since before the founding of the United States. Church's painting, however, was an unprecedented popular and critical success. The first exhibition of *Niagara* in New York drew large crowds. Its subsequent tour in England inspired the admiration of John Ruskin and numerous other British critics, and garnered a new respect for American painting.[3] The picture's success was a result of both the artist's supreme technical mastery of oil paint—his ability to impart the movement of water and the interplay of light—and the unusual composition he developed. Church eliminated a traditional foreground and framing devices and put the spectator right out over the water.

The artist's understanding of the falls and of the geography around it developed during four sketching trips he made in 1856. Niagara Falls consists of two separate cataracts. The larger of the two, on the Canadian side—the Horseshoe Falls—is separated from the much smaller American Falls by Goat Island, which straddles the precipice that creates the falls. Dozens of Church's studies survive, and they illustrate how he explored Niagara from many points of view, from both the Canadian and American sides, from underneath and below the falls, and from Goat Island. The point of view depicted in the Cleveland drawing is likely one visible from on or slightly down river from Table Rock, an area adjacent to the Horseshoe Falls and almost opposite Goat Island.[4] A drawing in New York (fig. 1) shows a similar vantage point, though the full lateral expanse of the Horseshoe Falls is cut off from view.[5] To draw the Cleveland sheet, Church seems to have gone just a bit farther down river from this scene. In both, one can see Terrapin tower, a nineteenth-century viewing structure (torn down in 1873), toward the left.

As a night scene, the Cleveland sheet is unusual among Church's drawings of the falls, and indeed among his drawings in general.[6] He must have specifically selected this brown paper as appropriate for the subject. It allowed him to explore the atmospheric effects of the moon shining through the rising cloud of mist produced by the water's impact. The awe-inspiring quality of Niagara Falls as a natural wonder made it an ideal symbol of the Romantic concept of the sublime in nature. Church's nocturnal, moonlit depiction heightens this quality. Because the artist made several trips to the area, the work is difficult to date precisely. Some of his drawings of the falls bear specific dates as well as color notations or other descriptive notes. His latest dated studies of the falls were made during a trip there in 1858.[7] CEF

Fig. 1. Frederic Edwin Church. *Niagara*, 1856, graphite and white gouache. Cooper-Hewitt National Museum of Design, Smithsonian Institution, New York, 1917-4-33C.

1. Now in the Corcoran Gallery of Art, Washington.

2. Elizabeth Murray, *Niagara Falls: Icon of the American Sublime* (Cambridge, 1985); Jeremy Elwell Adamson, *Niagara: Two Centuries of Changing Attitudes, 1697–1901* (Washington, 1985).

. 3. Jeremy Elwell Adamson, *Frederic Edwin Church's "Niagara": The Sublime as Transcendence* (Ann Arbor, 1981), 32–45.

4. My thanks to Evelyn Lafave for her help with this entry, specifically in locating Church's viewpoint.

5. The sheet was published in Elaine Evans Dee, *To Embrace the Universe: Drawings by Frederic Edwin Church* (Yonkers, New York, 1984), 52, no. 36, fig. 25 as *Niagara: The Canadian Falls from Goat Island*, but this is a misidentification of the location, since Goat Island itself is visible at the far left.

6. Although Church was a prolific draftsman, his drawings and oil sketches are rare outside the collections of Olana, his former house on the Hudson River, and the Cooper-Hewitt in New York; on his drawings, see Dee, *To Embrace the Universe;*

Theodore E. Stebbins Jr., *Close Observation: Selected Oil Sketches by Frederic E. Church* (Washington, 1978); Elaine Evans Dee, *Frederic E. Church: Under Changing Skies: Oil Sketches and Drawings from the Collection of the Cooper-Hewitt, National Museum of Design, Smithsonian Institution* (Philadelphia, 1992).

7. Although we know he visited the falls again at least once, in 1875; see Dee, *To Embrace the Universe,* 55.

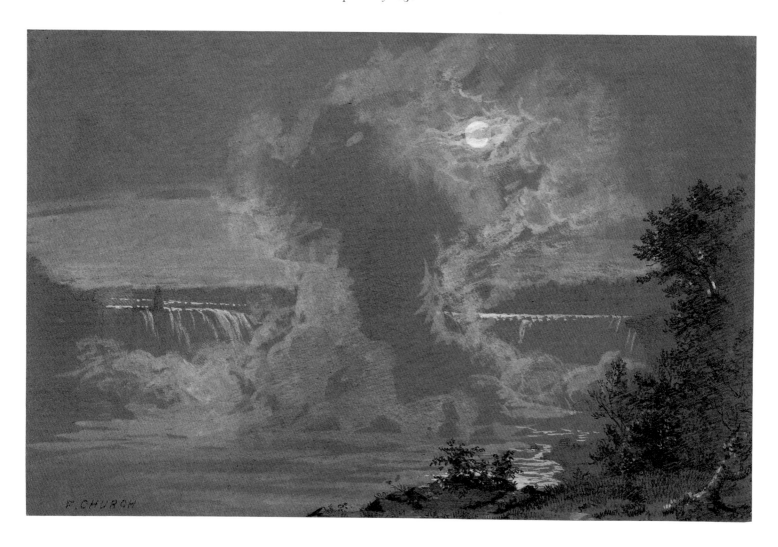

Graphite and white gouache, on
brown wove paper

116 x 164 mm (4⁹⁄₁₆ x 6⁷⁄₁₆ in.)

INSCRIPTIONS: signed?, lower left,
in graphite: *F. CHURCH*

Gift of Robert Arthur Mann
1976.30

Winslow Homer

Boston 1836–Prout's Neck, Maine, 1910

Along with Thomas Eakins, Winslow Homer is generally regarded as the greatest American realist of the late nineteenth century. Over the course of several decades, he progressed gradually from draftsman and illustrator to oil painter, and this watercolor represents a fascinating stage in that development. As a young man, Homer worked as a commercial illustrator, producing designs that were reproduced in magazines such as *Appleton's* and *Harper's Weekly*. In the early 1870s, however, he began to supplement this income by producing watercolors, which apparently he could produce more quickly and sell more easily than oils.[1] His early watercolors are notable for their dramatic clarity of design and concise, forceful application of pigment. Remarkably economical in technique, they were generally drawn first in pencil and then executed with just a few colors. Very often Homer would later combine two or three of his watercolors into a composite image to produce an illustration for a magazine.

A series of watercolors Homer made in Gloucester in 1873 foreshadow his later achievements as a painter of somber marine subjects. During this period, fishing grew considerably more dangerous than it had been a few decades earlier. Because of the railroad, fishermen ventured much farther offshore in order to pull in large hauls that could be iced and shipped by rail to urban centers. Venturing so far from land, however, made the work more perilous because the fishermen could easily drown in storms or be separated from their home vessel by an unforeseen bank of fog. Homer's Gloucester watercolors of 1873 do not portray any of those hazards. Indeed, they almost invariably focus not on grown men but on children and are most often set not at sea but on the shore. Nonetheless, the uncertainties of a fisherman's life generally cast a shadow over those works and contribute to their emotional impact. Nearly always they somehow contrast the play activities of children with the more precarious activities of adults, thus hinting at the dangers the children will face when they reach maturity.

Boy with Anchor explores this theme in an unusual, subtle fashion. The anchor on which he sits is a symbol of safety and stability, of connection with dry land; it is also configured as a pointer, like an arrow directing the viewer's eye out to sea, where someday the boy will be forced to earn a dangerous livelihood. Thus, the Cleveland watercolor implicitly alludes to the burdens of maturity and nostalgically looks back to the innocence and safety of childhood.

This particular watercolor has a notable provenance. It originally belonged to the distinguished Ohioan John Hay, who served as President Abraham Lincoln's private secretary and posthumous biographer and later also held the position of secretary of state under President William McKinley. Hay gave the watercolor to a member of his household, Mrs. C. E. Meder, in gratitude for her service, and the Cleveland Museum of Art purchased it from her. HA

1. For Homer's watercolors of the 1870s, see Lloyd Goodrich, *Winslow Homer* (New York, 1945), 45–46; Helen Cooper, *Winslow Homer Watercolors*, exh. cat., National Gallery of Art (Washington/New Haven, 1986), 20–24; D. Scott Atkinson and Jochen Wierich, *Winslow Homer in Gloucester*, exh. cat., Terra Museum of American Art (Chicago, 1990).

86. Boy with Anchor

1873

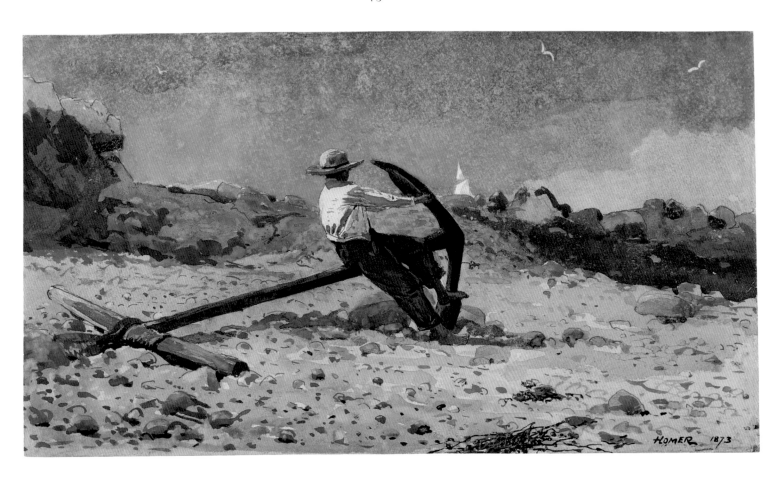

Watercolor and gouache with
graphite, on beige wove paper

194 x 349 mm (7⅝ x 13¾ in.)

INSCRIPTIONS: signed, lower right,
in black watercolor: *HOMER 1873*;
signed, lower right, in black
watercolor: *HOMER 18*[illegible,
partially painted out]

Norman O. Stone and Ella A.
Stone Memorial Fund 1954.128

Winslow Homer

Boston 1836–Prout's Neck, Maine, 1910

In the medium of watercolor, American artists combined the English tradition of watercolor with the sort of free brushwork, rich, bold colors, and striking compositions associated with French Impressionism. The result was one of the most original expressions of American art, unlike anything found in either England or France. Winslow Homer was perhaps the greatest virtuoso of this development, and his skill and originality are wonderfully expressed in this Adirondack watercolor.

Homer first visited the Adirondacks in the 1870s. In 1886, he and his brother Charles were among the twenty charter members of the North Woods Club, a private hunting and fishing preserve established at Baker's farm near Minerva, New York, along the shore of Mink Pond. Around that time, Homer began to produce oils and watercolors of Adirondack subjects, generally focusing on deer hunting or fishing.[1] These paintings strike a tense balance between the beautiful and the horrific. While the colors and compositions are often strikingly decorative, in a manner reminiscent of the Aesthetic movement, we never forget that the subject is a life struggle. Indeed, when viewed as a series, the paintings generally form a sequence progressing from ordinary, peaceful life to the abrupt, savage moment of death, when the life of an innocent helpless creature is snuffed out. While set in a wilderness context, these paintings clearly had a powerful resonance in a period when American society and industry were being ruthlessly reconfigured, and when the philosophy of Social Darwinism—the survival of the fittest—had developed as a viable alternative to the Christian principles of charity and compassion.[2]

Homer's *Leaping Trout* is one of a series of watercolors of jumping fish that he created in the 1880s and early 1890s. Scenes of trout fishing were common in English and American art of the period, but Homer dramatically reconfigured the conventions of this type by viewing the scene from the viewpoint of a fish, not that of a fisherman, thus dramatizing the subject in both visual and emotional terms. He was surely influenced by Japanese paintings and prints of fish, which often treat the subject in dramatic close-up. In addition, while Homer executed only one watercolor of fresh-caught fish, the popular paintings of a fisherman's catch (as exemplified in America by the work of Arthur F. Tait) were surely an influence.

In essence, Homer added animation to this still-life subject, as well as a Japanese sense of asymmetry. In that regard, it is striking that one of the first paintings in the United States to reflect Japanese influence was a panel of a hanging fish that Homer's friend John La Farge executed in 1865 to decorate a dining room in Boston. In a remarkable essay on Japanese art written in 1869, La Farge pinpointed the compositional principles of Japanese art, which stood distinct from the evenly balanced approach favored by Western still-life painters. Homer need not have read La Farge's essay to learn about this approach because he and La Farge were intimate friends and for a decade or so had studios near each other in the Tenth Street Studio Building in New York.[3] HA

1. See "Adirondacks, 1899–1900," in Washington et al. 1986, 162–95; David Tatham, "Winslow Homer at the North Woods Club," *Studies in the History of Art* 26 (Washington, 1990), 115–30.

2. See Henry Adams, "Mortal Themes: Winslow Homer," *Art in America* 71 (February 1983), 112–26.

3. See Gustav Kobbe, "John La Farge and Winslow Homer," *New York Herald*, 4 December 1910, magazine section, p. 11.

87. Leaping Trout

1889

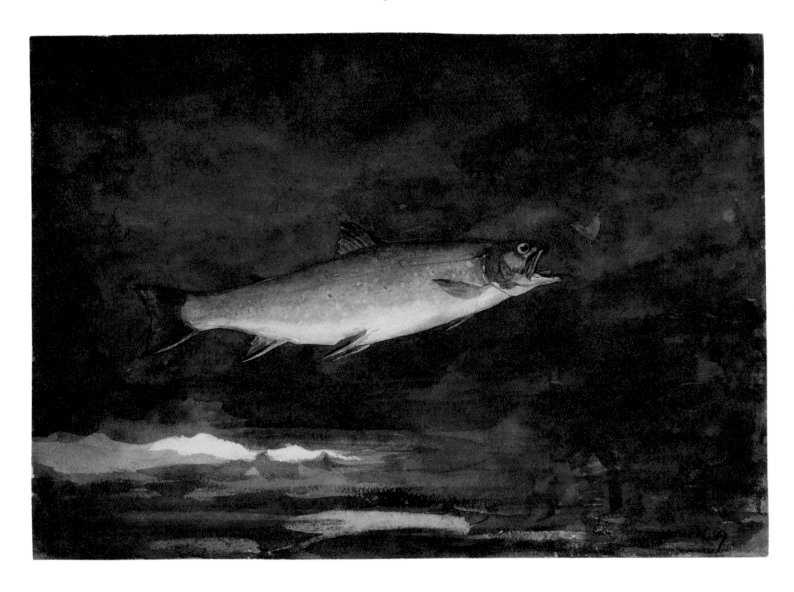

Watercolor over graphite, on
cream wove paper

350 x 506 mm (13¾ x 19⅞ in.)

INSCRIPTIONS: signed, lower
right, in black watercolor:
HOMER '*89*

Anonymous gift 1973.142

Thomas Wilmer Dewing

Boston 1851–New York 1938

One of the leaders of the Aesthetic movement in America, Thomas Dewing was part of the group of younger, more adventurous artists that broke from the National Academy of Design to establish the Society of American Artists.[1] His central subject throughout his career was withdrawn, sensitive women in flowing gowns. Although his style often recalls that of the English Pre-Raphaelites, it was strongly modified by the influence of Whistler, and there are often hints of other sources ranging from Botticelli to Vermeer. The profound significance attached to Dewing's figures in their time is difficult to understand completely today, but clearly they symbolized a world of delicacy, purity, and devotion to high ideals at a time when much of American society seemed to hold values that were vulgar and crass. To some extent, these figures may also have reflected an ideal of Anglo-Saxon racial purity at a time when the United States was flooded with immigrants from Italy and Central Europe. Around the turn of the century, Dewing's paintings were passionately sought after by a group of wealthy collectors such as John Gellatly and Charles Freer, who collected multiple examples of his work.

Gloria was painted early in the artist's career in an uncharacteristic effort to reach a popular audience. In 1880 the Boston firm L. Prang & Company began its annual Christmas card competition, which was judged by Christmas card dealers and carried four prizes, the first worth the substantial sum of one thousand dollars.[2] In the first years of the competition, the flood of applications, many from amateur artists, put off professionals. Consequently, in 1884 the company limited the contest to just twenty-four artists of recognized ability. One of them was Thomas Wilmer Dewing, who submitted a watercolor (a medium he rarely employed, as he generally liked to work in pastel). His design, titled *Gloria*, showed four angels playing harps in a densely packed composition reminiscent of a sculptural relief, which contains just a hint of blue sky. The faces of the angels are so similar that it is clear that Dewing used the same model for all four figures. The concept may have been inspired by a relief of praying angels executed in 1877–78 (sketched by John La Farge and then modeled by Augustus Saint-Gaudens), for the chancel of St. Thomas's Church in New York. Dewing, however, disposed his figures not one above the other but along a diagonal that bisects the picture surface; he also broke away from the strict symmetry of the La Farge/Saint-Gaudens design.[3]

Dewing did not win any of the coveted prizes because the judges felt his design appealed to the "cultivated few" rather than the "universal public."[4] But he did receive many favorable reviews when Prang exhibited the entries in Boston and New York. When the piece was shown at Boston's Noyes and Blakeslee Gallery in early December, a reviewer praised the opalescent colors and "highly artistic conception," noting that it was greatly admired by other artists.[5] Another reviewer praised it as "the most lovely thing in the entire collection."[6] The design was also praised in the *Art Amateur* when the exhibition moved to the Reichart Gallery in New York.[7]

Gloria seems to have been one of the first works by Dewing purchased by John and Edith Gellatly, who later established the National Gallery of Art in Washington (later renamed the National Museum of American Art). With Gellatly's approval, the piece was later illustrated in the magazine *Art World* along with a short essay describing it that Gellatly commissioned from Ezra Tharp.[8] When the piece left the Gellatlys' possession and entered that of Fanny Tewksbury King is not clear. HA

1. The principal study of Dewing is Brooklyn et al. 1996–97, which discusses *Gloria* on pp. 97–98.

2. "The Prang Competition," *Art Amateur* 3 (July 1880), 24.

3. This possible source does not seem to have previously been noted. For the piece by La Farge and Saint-Gaudens, see H. Barbara Weinberg, *The Decorative Work of John La Farge* (New York/London, 1977), 145–67, figs. 115–16. This reredos could easily have served as a model for Dewing since not only was it in New York but also reproduced in a wood engraving by Timothy Cole in *Scribner's Monthly* 15 (February 1878), 576.

4. Unidentified writer, cited in Brooklyn et al. 1996–97, 8, 45 n. 46.

5. Unidentified clipping, *Charles Dewing Scrapbook*, 73, cited by Hobbs in ibid.

6. "The Prang Designs," *Boston Daily Evening Transcript*, 12 December 1884.

7. Montezuma 1885, 29.

8. Ezra Tharp, "'Gloria' and 'The Musician' by Thomas W. Dewing," *Art World* 3 (December 1917), 188.

88. *Gloria*

1884

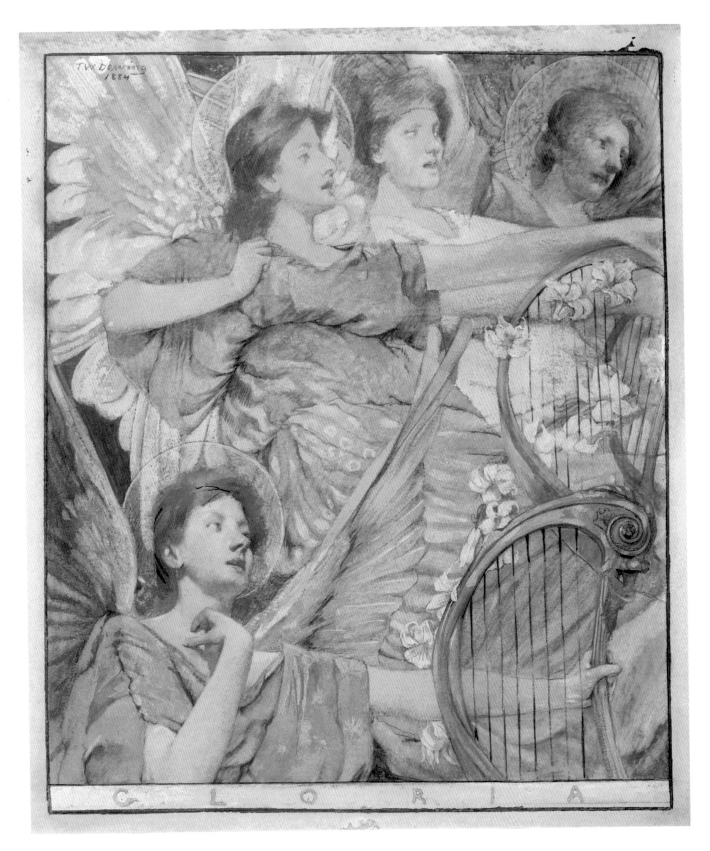

Gouache over graphite, on beige wove paper

308 x 278 mm (12⅛ x 10¹⁵⁄₁₆ in.)

INSCRIPTIONS: signed, upper left, in graphite: *T W Dewing / 1884*; by artist, across bottom, in watercolor: *GLORIA*; verso, center, in graphite: [sTC?] [underlined];

15 x 16² [underlined] / *165*; center left, in graphite: *125* [underlined]

The Fanny Tewksbury King Collection 1956.722

Mary Cassatt

Pittsburgh 1844–Le Mesnil-Théribus, Beaufresne, France, 1926

The Letter is one of the working drawings Mary Cassatt made for her renowned set of ten color prints created during 1890–91.[1] These images show the influence of Japanese color woodcuts in their cropped compositions, slightly skewed perspective, and decorative use of pattern and flat areas of color. Cassatt and her Impressionist colleagues were deeply affected by an exhibition of more than 700 Japanese *ukiyo-e* prints, scrolls, and other works held at the École des Beaux-Arts in Paris in 1890. Cassatt borrowed compositional devices and color schemes from Japanese woodcuts for her print set, but she transformed the images of Japanese courtesans into depictions of elegant French women engaged in everyday rituals set in contemporary Parisian environments.[2]

Cleveland's drawing apparently served as Cassatt's initial idea for the composition of the print (see fig. 1), focusing on the position of the desk, the sitter, and the contour of her voluminous dress. Cassatt placed the sheet on a copper plate covered with softground and traced over the drawing to transfer the image to the plate.[3] The pressure she exerted as she drew over the lines caused the softground to adhere to the back of the sheet, leaving a matrix of lines where the ground was lifted from the plate.[4] She then used those lines as a guide in making the print, strengthening lines in drypoint and filling in the outlines with finely grained aquatint that provided sections of color and pattern, often involving one or more additional plates.[5] She thus developed the image, making modifications and adding details directly on the plates. In

the drawing, there is no evidence of the wallpaper or dress patterns that appear in the final print; the chair has a straight rather than curved back, and the figure's eyes appear nearly closed instead of slightly open. Her position, including her fingers and hair, the shape of the dress and collar, and the placement of the letter, are maintained in the print. The facial features of Cassatt's figures (minimized in order to emphasize the universality of her subjects) nonetheless include tiny details of curled hair and eyelashes in her working drawings, while background forms and interior spaces are rendered in a schematic fashion. Since fine detail would not transfer easily to the softground—appearing only as rough marks (as seen in the verso of the Cleveland drawing)—extremely delicate lines would have been executed directly in drypoint, essentially drawn freehand on the plate. Thus the working drawings, such as this sheet, appear to have served both as a means of putting initial ideas down on paper and as practical tools in the production of the prints.

The Cleveland sheet is the only known drawing related to *The Letter* print. Barbara Shapiro and Nancy Matthews have proposed that the print may have been made near the end of the production of the set, since the known states jump from a single-plate preliminary drypoint to a fairly complete three-plate color image, suggesting the supreme confidence with which Cassatt created the composition, having mastered the medium.[6]

SRL

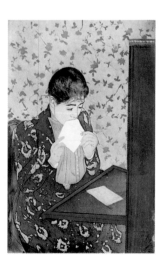

Fig. 1. Mary Cassatt. *The Letter*, 1890–91, drypoint and color aquatint. The Art Institute of Chicago, From the Mr. and Mrs. M. A. Ryerson Collection, 1932.1282.

1. Breeskin 1979, nos. 143–52 (repr.) (no. 148 repr. as frontispiece opposite title page); Washington et al. 1989–90, nos. 5–14 (repr.). For other drawings made for these prints see ibid., nos. 5-2, 6-1, 7-1, 9-2, 12-2, 13-1, 14-4.

2. The Japanese exhibition inspired Cassatt to produce her own exquisitely crafted color prints, using intaglio (a medium she knew and approached with great creativity and experimentation) rather than woodcut techniques. For a discussion of Cassatt's creative approach to printmaking, see Barbara Stern Shapiro, "Mary Cassatt's Color Prints and Contemporary French Printmaking," in Washington et al. 1989–90, 57–85. A formal prototype for *The Letter* may be seen in the courtesan blotting her lips with a cloth in the woodcut *Faces of Beauty: Hinzaru of the Keizetsuro* by Kitagawa Utamaro (1753–1806). Both images present an everyday activity in a private moment

as the basis of universal experience. See Judith Barter, Erica Hirshler, George T. Shackelford, et al., *Mary Cassatt: Modern Woman*, exh. cat., Art Institute of Chicago (1998–99), 84. Cassatt was attracted to Utamaro's prints of Japanese courtesans engaged in domestic activities (washing, bathing, combing their hair, caring for children, drinking tea), and she collected them. Further evidence of Cassatt's interest in Japanese prints is in the slightly Asian physiognomy of the dark-haired woman portrayed in her color prints (as in *The Letter*). For a discussion of her choice of subjects and sources, see Washington et al. 1989–90, 42–44 and 65–68.

3. Old fold marks near the perimeters of the sheet indicate where it was folded over the edges of the plate. Cassatt appears to have reinforced certain lines more than once, using a sharp pencil so they would

transfer more clearly—for example, the contours of the sleeves, parts of the collar and head, fingers, face (eyes, brow, and nose)—while the lines of the desk transferred only faintly on the back of the sheet.

4. The plate was probably lightly etched, setting the image into the metal so that the ground could be removed from the plate and the artist could work directly on metal in drypoint or apply aquatint ground. My thanks to Roy Perkinson and Barbara Shapiro for discussing their understanding of Cassatt's technique.

5. Washington et al. 1989–90, 44, 68.

6. Ibid., 121.

Black crayon and graphite, on cream wove paper; verso, brown offset lines transferred from ground on printing plate

346 x 230 mm (13⅝ x 9¹⁄₁₆ in.)

INSCRIPTIONS: signed lower right, in graphite: *Mary Cassatt*; lower left in graphite: *4423-oss*; verso, lower right, in graphite: *136*

Bequest of Charles T. Brooks 1941.86

Thomas Moran

Bolton, England, 1837–? 1926

Born in the bleak Lancashire milltown of Bolton, Thomas Moran immigrated to the United States with his family when he was seven and settled in Philadelphia the following year. There he received informal art training from his brother Edward, a talented landscape and marine painter, as well as from James Hamilton, a prominent Philadelphia artist who was sometimes known as "the American Turner" because of the degree to which his work resembled that of the Romantic English landscape painter. Moran, too, took Turner as a model, thoroughly assimilating his techniques and even making a special trip to England in 1861 so that he could more closely study Turner's original works.

Moran became famous for applying Turner's dramatic style to the spectacular scenery of the American West. First commissioned to go west by Richard Watson Gilder, the editor of *Scribner's Monthly*, Moran not only produced the drawings he was assigned but executed an enormous panorama in oil of the Grand Canyon.[1] The painting created a sensation and was eventually purchased by the U. S. Congress. For the rest of his career Moran specialized in western scenes, particularly views of the Grand Canyon and of the Yellowstone and Green river regions of Wyoming.

In 1892, while returning from a visit to the Grand Canyon, Moran stopped off in Denver, where he learned that he had received a commission to produce a large painting of Wyoming for the World's Columbian Exposition in Chicago in 1893. Consequently, he rearranged his itinerary in order to travel out to the Yellowstone region to gather research material and make sketches. While in Denver waiting for his travel arrangements to be resolved, Moran made this watercolor sketch of the smelters on the outskirts of the city. Evidently quickly executed, the piece nonetheless reveals masterly observation. For example, he used atmospheric perspective and relative size to show the distance among the various buildings, and he captured the range of colors in the factory smoke, which runs the gamut from rich black to pure white. The mood is at once brooding and uplifting.

Factories play an ambiguous role in nineteenth-century paintings. While some viewed them as "dark satanic mills" (to quote from William Blake's poem "Jerusalem"), others considered them a mark of progress and civilization and even added factories to wilderness landscapes, where no such entities yet existed.[2] It seems likely that Moran viewed these factories with enthusiasm rather than loathing, for in his letters he wrote positively about the growth of Denver as a city. "Denver has grown wonderfully since I was here last," he wrote to his wife, Mollie. "It is about 5 x 10 miles square and full of fine buildings."[3] In 1925, a critic who viewed this watercolor at a show in Santa Barbara considered the subject cheerful and uplifting. Describing the piece as "a little classic," the anonymous writer noted: "Not a thrilling theme, you'll admit. But behold what the artist-soul of him has done with it. Black masses against a yellow and orange sky make it a thing to carry away for a low hour, if you have such."[4] HA

1. *The Grand Canyon of Yellowstone*, 1872, oil. National Museum of American Art, Smithsonian Institution, Washington, L.1968.84.1.

2. For example, Frederic Church added a factory to the foreground of his landscape *Mount Ktaadn* (Yale University Art Gallery, 1969.71), although no such factories existed in Maine at the time.

3. Thurman Wilkins and Caroline Lawson Hinkley, *Thomas Moran, Artist of the Mountains* (Norman, Oklahoma, 1998), 267.

4. *Santa Barbara Morning News* (16 June 1925), cited in Washington et al. 1997–98, 143.

Watercolor and gouache, on
light brown wove paper

240 x 318 mm (9⁷⁄₁₆ x 12½ in.)

INSCRIPTIONS: signed, lower left,
in graphite: [artist's monogram:
TM] *Moran*; signed, lower right,
in graphite: *smelting works at
Denver / T. Moran: June 12ᵗʰ
1892*

Bequest of Mrs. Henry A.
Everett for the Dorothy
Burnham Everett Memorial
Collection 1938.56

John La Farge

New York 1835–Newport, Rhode Island, 1910

Early in his career, in the 1850s and early 1860s, John La Farge played a pioneering role in the appreciation of Japanese art. He collected Japanese prints, made use of Japanese effects in his own work, and wrote an appreciation of Japanese art, published in 1869.[1] Yet he did not have the opportunity to visit Japan until 1886. The previous year the wife of the historian Henry Adams had committed suicide, and as a form of escape Adams chose to make a trip to Japan, taking La Farge with him as a companion.[2]

The two were in an ideal position to learn in depth about Japan because a group of learned Bostonians had settled in Japan and devoted themselves to studies of Japanese art and culture. Acting as an assistant and interpreter to the two friends was Okakura Kakuzō, a leading Japanese writer and connoisseur with whom La Farge seems to have become particularly close. In the course of their visit, La Farge produced a number of remarkable watercolors of the sites they visited and wrote a travelogue, *An Artist's Letters from Japan*.

Perhaps the most delightful outcome of the trip, however, was a group of watercolors of Japanese folklore that La Farge produced shortly after his return. They seem to have been largely inspired by his conversations with Kakuzō about Japanese spiritual ideas, although their eerie weirdness also brings to mind Lafcadio Hearn's wonderful ghost stories of Japan, as well as a group of macabre Japanese-inspired illustrations that La Farge had produced early in his career for *The Riverside Magazine*.[3] Several of the watercolors treat the theme of a mysterious being in touch with the wild forces of nature, such as a rishi in tune with a raging storm; an uncanny badger bellowing beside a mountain waterfall to mislead wayfarers; Kwannon, the guardian of sailors, crossing a tempestuous sea; or a dragon half-visible in an explosion of surf and mist.

Cleveland's watercolor is one of three representations by La Farge of this theme, although it is the only one that can now be located.[4] It shows a bearded figure in flowing oriental robes standing at the edge of a storm-tossed ocean. The setting of waves and rocks resembles the seascapes of La Farge's friend Winslow Homer, although La Farge made the setting exotic, and the interplay between the figure's flowing draperies and the foaming surf gives the image a distinctive La Fargian twist. In Japanese legend, "rishi" or "sennin" is the generic name for individuals who have reached immortality through meditation, asceticism, and the following of Taoist teachings.[5] La Farge also produced a watercolor, *The Spirit of the Storm*,[6] that seems to be an answer to this watercolor. It shows the semi-animate spirit with dragon-like claws conjured up by the rishi.

Interestingly, *A Rishi Stirring Up a Storm* bears a striking resemblance to a Japanese painting of this period, *Kutsugen Wandering in the Barren Hills* by Taikan Yokoyama. This *kakemono* (hanging scroll) shows the exiled prince Kutsugen, who wandered in the wilderness writing poems and finding companionship only in nature until he committed suicide by drowning. Like La Farge, Taikan presented an elegantly attired figure against a backdrop of a stormy landscape. Since La Farge's painting was probably painted in 1897, it seems unlikely that he knew Taikan's painting, which was executed in 1898. The similarity between the two, however, may not be entirely accidental. Taikan was a member of Okakura Kakuzō's painting school, and both his work and that of La Farge probably owed many features of their conception and composition to the stimulus of Okakura.[7]

HA

1. John La Farge, "An Essay on Japanese Art," in Raphael Pumpelly, *Across America and Asia* (New York, 1869), 195–202. See also Henry Adams, "John La Farge's Discovery of Japanese Art: A New Perspective on the Origins of Japonisme," *Art Bulletin* 67 (1985), 449–85.

2. For general background on this trip, see Patricia O'Toole, *The Five of Hearts: An Intimate Portrait of Henry Adams and His Friends, 1880–1918* (New York, 1990); Henry Adams, "John La Farge and Japan," *Apollo* 99 (February 1984), 120–29; James L. Yarnall, "John La Farge and Henry Adams in Japan," *American Art Journal* 21, no. 1 (1989), 40–77.

3. Frank Weitenkampf, "John La Farge, Illustrator," *Print Collector's Quarterly* 5 (1915), 472–94.

4. See James L. Yarnall, *John La Farge, Watercolors and Drawings*, exh. cat., Hudson River Museum of Westchester (Yonkers, New York, 1991), 64.

5. According to the artist: "Rishis in Chinese and Japanese myth are human beings who have attained practical immortality, and who retired in wild places, enjoy control over nature." See Doll and Richards Gallery, Boston, *Exhibition and Private Sale of Paintings in Water Color Chiefly from South Sea Islands and Japan by Mr. John La Farge*, 18–30 March 1898, no. 17. La Farge also wrote of Rishi in *An Artist's Letters from Japan*, noting, "Rishi or Sennin are beings who enjoy rest,—that is to say, are exempt from transmigration,—often in the solitude of mountains for thousands of years, after which delay they again enter the circle of change. If they are merely human, as many of them are, they have obtained this charm of immortality, which forms an important point in the superstitious beliefs and practices of modern Taoism. These appear to have no hold in Japan, as they have in China, but these personages, evolutions of Taoist thought, live here at least in legends and in art." (John La Farge, *An Artist's Letters from Japan* [New York, 1897], 117). According to an essay written by Sumio Huwabara, University of Tsukuba, "Rishi" is a corruption of "Resshi," which is the Japanese form of pronunciation for the Chinese character that means Lao-tzu.

6. Now in the Toledo Museum of Art (Gift of Edward Drummond Libbey 1912.527).

7. Okakura praised Taikan's painting in *The Ideals of the East* (New York/London, 1903), 217–18, and it is reproduced in Horioka Yasuko, *The Life of Kakuzō: Author of The Book of Tea* (Tokyo, 1963).

Watercolor and gouache over
graphite, on cream wove paper,
laid down on beige cardboard

273 x 389 mm (10¾ x 15⁵⁄₁₆ in.)

WATERMARK: none visible
through mount

Purchase from the J. H. Wade
Fund 1939.267

Maxfield (Frederick) Parrish

Philadelphia 1870–Plainfield, New Hampshire, 1966

Maxfield Parrish's popularity, measured by the sheer number of reproductions created after his works, makes him one of the best-known artists of the twentieth century. The permeation of his imagery into popular culture rests in the widespread commercial appeal of his illustrations, posters, and paintings, which have been used in magazines, advertising, and consumer products such as calendars and chocolate boxes. Cleveland's drawing of a young knight battling an enormous serpent falls early in his career and belongs to one of the projects that helped to establish the artist's reputation, a series of illustrations for the children's book by Kenneth Grahame, *The Golden Age*, published in 1899.[1] This series of stories recounts the adventures of four children in an English family living in the country. In "Alarums and Excursions," one of the boys convinces his reluctant friend to join in a make-believe of Arthurian legends. Parrish chose to illustrate the narrator's somewhat flippant description of their often-played games, "once more in this country's story the mail-clad knights paced through the greenwood shaw, questing adventure, redressing wrong.... Once more were damsels rescued, dragons disembowelled, and giants, in every corner of the orchard, deprived of their already superfluous number of heads."[2]

Parrish inscribed the line he chose to illustrate on the work itself, and it was also printed on the protective overleaf covering the reproduction in the book. But his illustration is not a literal adaptation of the story: he decided not to show the children playing, as he did elsewhere in the book. Instead, he projected his own idea of how one of the boys might imagine himself as an older, adolescent hero. The nonchalant confidence of Parrish's knight, though, retains a sense of whimsical innocence: this is a child's fantasy and we know who the victor will be. Parrish's drawings for *The Golden Age* were first reproduced photomechanically as halftone black-and-white illustrations.[3] He thus worked essentially in grisaille, with mostly gray ink washes, creating strong white highlights with white gouache. Parrish was a superb academic draftsman, and, as in his best work, he here combines finely detailed drawing with an overall decorative patterning. The scaly snake's body circumscribes the scene, partially disappearing out of the frame but winding back in and curling up in an inverted "S." Parrish took much care with the scales, the chain mail, and the stylized tree branches, all areas of pattern that add to the strong sense of two-dimensional design typical of his book illustrations. The influence of British Pre-Raphaelite painters, especially Burne-Jones (see no. 81), is especially evident here. Parrish's idealized youth has much in common with the type developed by Burne-Jones, whose work the artist could have known through reproduction and from the works in the Bancroft collection, of Wilmington, Delaware, which was shown in Philadelphia in 1892.[4] CEF

1. For a discussion of these works, see Ludwig 1973, 26–29; Philadelphia et al. 1999–2000, 54–57. For a contemporary critical appreciation of the works, see J. H. Irvine, "Professor Von Herkomer on Maxfield Parrish's Book Illustrations," *International Studio* 29 (July 1906), 35–43.

2. Grahame 1899, 41.

3. In a later, 1904 reissue of *The Golden Age*, the higher quality photogravure process was used. Parrish produced a series of watercolors designed as illustrations for a companion volume by Grahame to *The Golden Age*, titled *Dream Days*.

In 1904, both works were published with identical bindings designed by Parrish; see Ludwig 1973, 29.

4. Philadelphia et al. 1999–2000, 24.

Brush and black and gray wash, with white gouache, over graphite, framing lines in pen and black ink, on beige wove paper

375 x 248 mm (14¾ x 9¾ in.)

INSCRIPTIONS: signed in image, lower right, in black watercolor: *M. P*; lower left, by artist, across bottom margin, in graphite:

"*Alarums and Excursions.*"... *Once again were damsels rescued, dragons / disembowelled, and giants ... etc.*; verso, by artist, in top half: NO. 225 [inside a box] / *Maxfield Parrish.* / "*The Oaks*" / *Windsor: Vermont.* / *June of 1899.*; on fragment of old mount, now removed, in brown ink: *Original pen + ink drawing by Maxfield Parrish. / Being one of the illustrations of "The Golden Age" / by Kenneth Grahame (John Lane Co. 1899)*; on fragment of old mount, now removed: *B*[ought?] *of Frd'k Keppel Co. / 1899–$50-*

Bequest of James Parmelee 1940.723

Modern Drawings

Maurice Brazil Prendergast

St. John's, Newfoundland, 1858–New York 1924

Although Maurice Prendergast made oil paintings, he worked primarily in watercolor and has long been admired, along with Winslow Homer and John Singer Sargent, as one of America's greatest practitioners of the medium. *May Day* is one of numerous watercolors of Central Park Prendergast made during his regular visits to New York City in the early 1900s, when he was living in Boston.[1] The Central Park pictures continue themes of festival and procession that occupied the artist in his watercolors of Venice, executed during his stay in Italy in 1898–99. The park pictures have often been ranked with the Venetian works as among his finest watercolors. These lively images focus on fashionably dressed crowds of women and children engaged in social activities: promenades, carriage rides, holiday celebrations. Like the French impressionists and post-impressionists, and the American artists working in the circle of Robert Henri in New York in the early 1900s, Prendergast was drawn to subjects of modern life and the mixing of classes in urban and coastal environments.[2]

Prendergast's style was influenced by his exposure to the French- and English-speaking avant-garde artists working in Paris during his studies there in the early 1890s, as well as by the art theories of his Boston colleague and friend Arthur Wesley Dow, who emphasized compositional design over drawing (based on principles of Japanese art).[3] Prendergast's work reflects an interest in pattern and the rhythmic treatment of forms and color, which became progressively broader and abstract after 1907. In certain aspects, Cleveland's 1901 *May Day* follows the richly detailed, more representational approach found in the nineteenth-century phase of Prendergast's art. One sees this in the reduced scale of figures near the horizon indicating recession in space and in the modeling of the folds and bulk of the female figures' skirts. These elements are underscored by extensive drawing in graphite, which, though rapid and loose, provides an underlying structure. However, the high horizon line flattens the picture plane, a perception enhanced by the featureless faces and the scattering of bright reds, blues, and areas of white (unpainted areas of paper left in reserve) across a field of green, like a decorative mosaic. Prendergast's practice in works such as *May Day*, as in his earlier watercolors, was to set down the composition in pencil and then work in watercolor quickly, but on one section at a time. The fluid application of watercolor enhances the sense of movement (particularly in the fluttering ribbons of the maypole). Prendergast seems to have been especially drawn to the lively May Day festivities in Central Park, which he represented many times.[4]

SRL

1. Clark et al. 1990, nos. 773–77, 782–87, 789–93, 795 (CMA)–806, 810–11, (also probably 807–9, 813). Note: no. 789, owned by the Whitney Museum of American Art, has the same title as Cleveland's sheet and shows a similar park gathering but set in a forested area rather than an open field.

2. Prendergast was a member of Henri's circle of progressive artists, known as "The Eight," who exhibited together only once, in 1908, in opposition to the conservative American art establishment. Although Prendergast continued to depict images of modern life through-out his career, in his last two decades there was an increasing emphasis on the exploration of color, decorative form, and technique. He was the first painter in the United States to work consistently in a post-impressionist mode. See New York et al. 1990–91, 20.

3. Whistler, Bonnard, Toulouse-Lautrec, and Seurat were just some of the artists in whose work Prendergast found affinities with his own sensibilities while studying abroad. Dow's theories were codified in his art manual *Composition* (1899). For further discussion of these influences, see New York et al. 1990–91, 12–16.

4. A number of the park scenes show May Day activities, see Clark et al. 1990, nos. 789, 790, 795 (CMA)–797, 804, 806, 807, 810–11, many of which include maypoles. There is also a monotype entitled *Central Park* that shows a similar, but more close-up view than the CMA watercolor (fewer figures surround a centrally placed maypole), executed around the same time, see Langdale 1979, 12, 138 (repr.).

93. *May Day, Central Park*
(also known as *Maypole, Central Park*)

1901

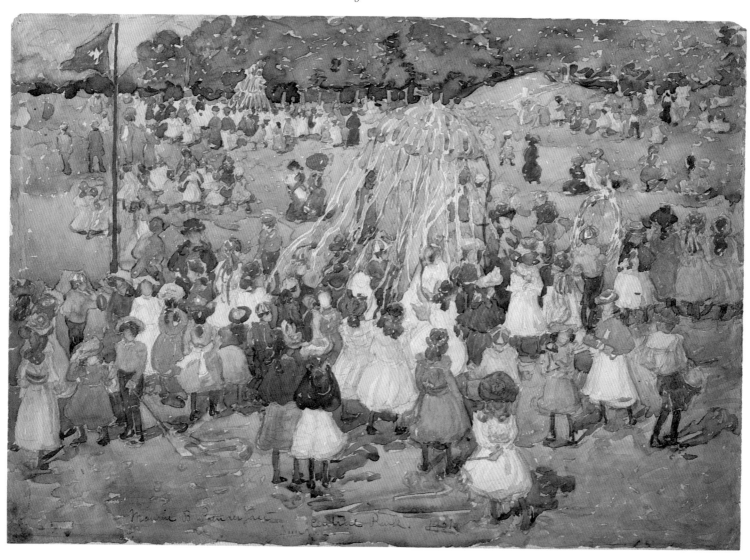

Watercolor over graphite, on
beige wove paper

354 x 506 mm (13⅞ x 19⅞ in.)

INSCRIPTIONS: signed, across
bottom, in brown ink: *Maurice
B. Prendergast Central Park.
1901. / New York.*; verso, upper

left, in graphite: *N⁰ 22*; center,
in graphite: *May Day Central
Park*

Gift from J. H. Wade 1926.17

Paula Modersohn-Becker

Dresden 1876–Worpswede 1907

During her short career, Paula Modersohn-Becker was exposed to a wide variety of artistic influences that she synthesized in her own modernist approach to form. Her symbolic use of color and pattern, her highly subjective vision, and the underlying primitive force of her unidealized figures are often viewed as precursors to German Expressionism. Modersohn-Becker studied art in Bremen, London, and Berlin before joining the artists' colony in Worpswede, near Bremen, in 1898. She was initially attracted to the simple life of the unsophisticated farming village, as well as to the poetic sensibility for nature and the plein-air approach to landscape painting of the artists working there. As her interest in the emotive possibilities of formal principles grew, she felt restricted by the sentimentalized idealization of the Worpswede manner. She traveled to Paris in 1900 and returned again in 1903, 1905, and 1906, engaging in formal study and visiting museums and galleries in search of new sources of inspiration.[1] Her goal was to convey a fundamental essence through the utmost simplicity and economy of form.[2] Modersohn-Becker focused primarily on landscapes and themes of peasant life until around 1902, after which she increasingly concentrated on figural images and still-lifes.

Comparison of the oval face, staring dark eyes, pronounced eyebrows, long nose, and asymmetrical lips of the Cleveland nude with self-portraits made in a variety of media from the end of the 1890s strongly suggests that the artist was the model for this drawing.[3] Modersohn-Becker is well known for her paintings of monumental nude mothers and children, and nude and semi-nude self-portraits made after 1905. However, this drawing clearly relates to her earlier studies of male and female nudes from 1897–1900, which depict figures set against shaded or completely dark backgrounds.[4] The Cleveland sheet exemplifies both her mastery as a draftsman and her modernist impulse. At first glance, the drawing appears to be a traditional academic exercise. However, rather than flaunting her knowledge of anatomical structure, the artist distills the human body into subtle planar elements and abstracted forms. Abbreviated contour lines in the vaguely defined feet, hands, cheek, and brow appear detached, as if hovering above rather than merging with the illuminated areas to suggest rounded flesh. Similarly, the wide-open dark eyes float on the face rather than recede into their sockets. She used a stumping tool to smooth away charcoal, creating highlights on the legs, arms, and the bridge of her nose in long flat strokes, a technique well suited to her schematic rendering of form. The striking whiteness of the illuminated figure against the ambiguous dark ground heightens the overall effect of abstraction. Modersohn-Becker suggests the seat with just a few strokes of the stump, avoiding any sense of three-dimensional solidity. She tweaks the delicate balance between her formal concerns and realistic detail in the subtle articulation of the figure's collarbone and kneecap, and in the faint shading beneath the breasts and along the thighs. This early drawing signals the artist's fascination with the structural solidity of forms while simultaneously illustrating her consistent pursuit of simplification. Here, Modersohn-Becker suppresses the personal element of the self-portrait in favor of the evocation of a fundamental human essence, which she developed into the expression of the vital life-giving force of women in her later work. SRL

1. She attended the Académie Colarossi in 1900 and 1903, and the Académie Julian in 1905. In 1906 she enrolled in an anatomy course and subscribed to a lecture course in art history at the École des Beaux-Arts. She made sketches after paintings and sculpture in the Louvre, viewed contemporary work at leading art dealers (such as Cézanne's paintings at Ambroise Vollard's gallery), and was exposed to a variety of international art by attending the vast World Exposition held in Paris in 1900; see Günter Busch, "Introduction," in *Paula Modersohn-Becker: The Letters and Journals* (New York, 1983), 3–8.

2. Modersohn-Becker embraced a range of avant-garde trends including the strong contours and stylized forms of Symbolism and Art Nouveau, the high-keyed palette of Fauvism, the structured delineation of nature by Cézanne, and Gauguin's expressive use of color and rhythmic pattern. However, she suppressed overtly decorative elements of composition in favor of weighty, earthy portrayals of her subjects, disregarding conventional ideas of beauty in an attempt to give substance to the underlying truths of human and natural forms. See ibid.

3. *Selbstbildnis (frontal)*, c. 1897, watercolor, private collection, reproduced in Christine Hopfengart, *Paula Modersohn-Becker: Zeichnungen, Aquarelle, Gouachen, Pastelle*, exh. cat., Kunsthalle Bremen in collaboration with Paula Modersohn-Becker-Stiftung (Bremen, 1996),17, no. 5; *Selbstbildnis*, 1897, pastel, Paula Modersohn-Becker Foundation, Bremen, reproduced in Wolfgang Werner, *Paula Modersohn-Becker 1876-1907: Gemälde, Aquarelle, Zeichnungen, Druckgraphik*, exh. cat., Graphisches Kabinett Kunsthandel Wolfgang Werner KG (Bremen, 1980), no. 5; *Selbstbildnis vor Fensterausblick (Self-Portrait in front of a Window)*, c. 1900, oil, Niedersächsisches Landesmuseum, Hannover, Landesgalerie, and *Selbstbildnis*, 1897, oil-tempera, private collection, both reproduced in Christa Murken-Altrogge, *Paula Modersohn-Becker: Leben und Werk* (Köln, 1980), 7, no. 1, and 53, no. 39, respectively. The resemblance of the CMA figure to the artist is also evident in the photographs of Modersohn-Becker illustrated in ibid., 21–30.

4. For example, *Sitzendes Mädchen (Young Girl, Seated)*, c. 1899–1900, charcoal, Ludwig-Roselius-Sammlung, Bremen, reproduced in Altrogge, *Paula Modersohn-Becker*, 94, no. 83. See also Werner, *Paula Modersohn-Becker*, nos. 1–2, 12, 36, and Hopfengart, *Paula Modersohn-Becker*, 37, nos. 40–41.

94. Seated Female Nude (Self-Portrait?)

c. 1899

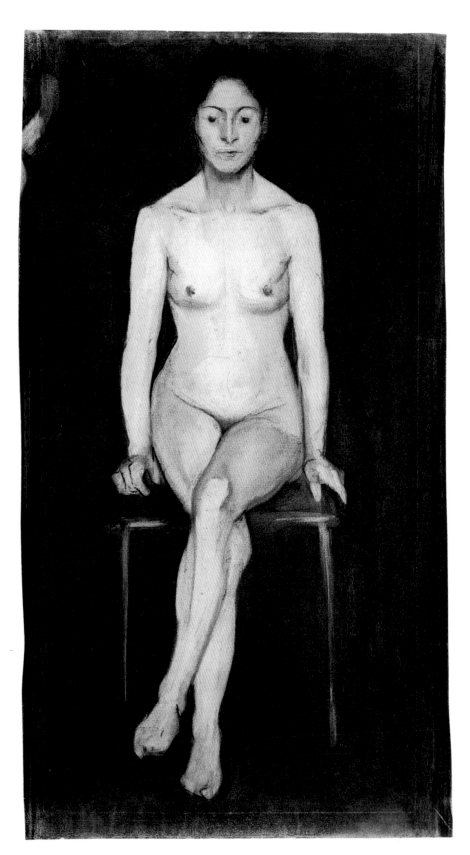

Charcoal with stumping, on off-white laid paper

622 x 339 mm (24½ x 13⅜ in.)

WATERMARK: lower center: PL BAS [sideways]; upper center: V D & C [four brackets with curled ends, lay end to end forming a circle around the letters]

INSCRIPTIONS: signed, lower left, in black crayon: *P.M.B.*; verso, sale stamp, lower right, in purple-gray ink: *Samml. E. Rump /* [pag.?] *102* [underlined] [Nr.?] *2* [underlined] [numerals are written in black ink]; upper center, in graphite: *76* [circled]; lower left, in graphite: *75*

[circled, partially erased]; lower right, in black ink: *Paula Modersohn Becker*

Purchase from the J. H. Wade Fund 1973.35

Pablo Picasso

Málaga, Spain, 1881–Mougins, France, 1973

The warm palette and thin delicate lines of *Head of a Boy* indicate that Picasso painted this gouache during his Rose Period of 1904–6. The boy's facial features, from the pensive lips to the almond-shaped eyes with large dark pupils, are characteristic of the dreamy adolescents who appear repeatedly in Picasso's harlequin and circus paintings of 1905. The boy bears an especially strong resemblance to figures in *Deux saltimbanques avec un chien*, *Deux arlequins*, and *Famille de Saltimbanques*.[1] In 1906, these melancholy circus themes were gradually replaced by more objective renderings of adolescent boys, often depicted nude and engaged in physical activities, amid landscapes suggestive of a classical arcadia. The facial types, however, as seen in *Boy Leading a Horse* (spring 1906),[2] remain similar to those of the previous year.

Head of a Boy has been traditionally dated 1905, based partly on style and iconography, but mostly on the date associated with the signature in the lower left. Christian Zervos and John Richardson have adhered to this convention.[3] However, the signature and date (the latter is curiously incomplete, as there is no "1" before "905") may be later additions by the artist.[4] Pierre Daix argues that Picasso probably painted *Head of a Boy* dur-ing the summer of 1906, which the artist spent at Gósol, a Catalan village in the Spanish Pyrenees.[5] Daix reasons that this gouache is a study for *Les Deux Frères* (fig. 1), a major painting securely dated to 1906 from drawings in Picasso's *Carnet Catalan*, a sketchbook he produced that summer in Gósol. Daix does admit to some uncertainty, however, and notes that Picasso may have painted *Head of a Boy* in late 1905 or early 1906, and subsequently used it as a source for *Les Deux Frères*. Josep Palau i Fabre also dates the gouache to 1905 or 1906, and notes: "I believe that the dating in 1905 which appears under the signature was an involuntary mistake made by Picasso himself, but it is one of the factors that help to create doubts as to whether the work was done in Paris or Gósol. And it is possible that it was this mistake that led Zervos to date many of the Gósol works to 1905, for this is the first one we find in his extensive catalogue."[6]

A photograph taken around 1907[7] shows *Head of a Boy* hanging in a simple white frame in Gertrude Stein's Paris apartment. This photograph, which is difficult to read, suggests that the painting was altered in the lower left. Unfortunately, the photograph is not sufficiently sharp to determine with certainty whether the current signature and date were present at that time. WHR

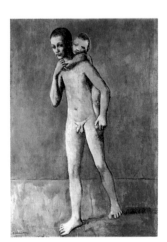

Fig. 1. Pablo Picasso. *Les Deux Frères*, 1906, oil. Kunstmuseum Basel.

1. Pierre Daix and Georges Boudaille, *Picasso: 1900–1906: Catalogue raisonné de l'oeuvre peint* (Neuchâtel, 1988), XII.17, XII.25, and XII.35, respectively.
2. Ibid., XIV.7.
3. Christian Zervos dated the painting 1905 in his catalogue raisonné *Pablo Picasso* (Paris, 1932), 1:303. Richardson 1991, 1:324, repeats the 1905 date.
4. Conservation analysis is unable to determine whether the signature and date are contemporary with the design layer.
5. Daix/Boudaille, *Picasso*, 294.
6. Josep Palau i Fabre, *Picasso: The Early Years: 1881–1907* (New York, 1981), 550, no. 1231. Denys Sutton and Paolo Lecaldano also date the painting 1906 in *The Complete Paintings of Picasso: Blue and Rose Periods* (New York, 1970), 108, no. 256.
7. Reproduced in Richardson 1991, 1:419.

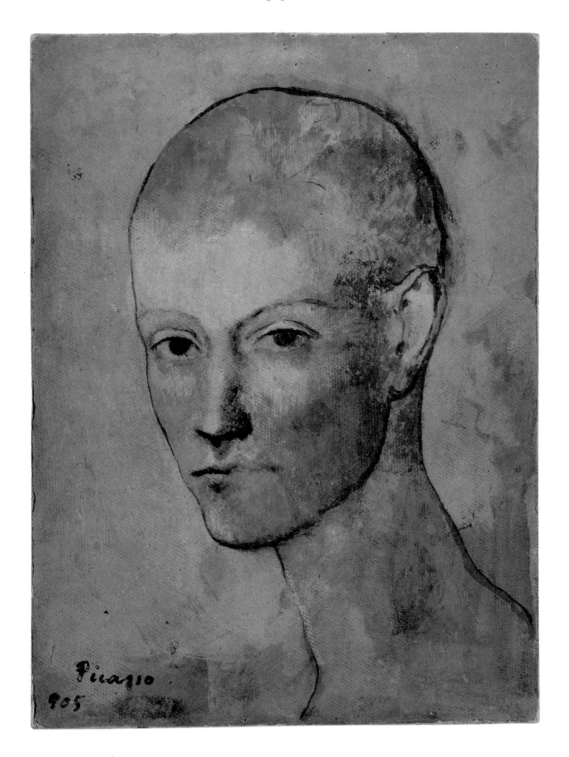

Opaque matte paint, possibly
tempera, on board, laid down on
wood and cradled

246 x 186 mm (9¹¹⁄₁₆ x 7⁵⁄₁₆ in.)

INSCRIPTIONS: signed, lower left,
in paint: *Picasso / 905*

Bequest of Leonard C. Hanna Jr.
1958.43

Pablo Picasso

Málaga, Spain, 1881–Mougins, France, 1973

Picasso painted *Reclining Nude (Fernande)* at Gósol, a remote village in the Spanish Pyrenees where he spent the summer of 1906 with his lover Fernande Olivier. His works from this period are distinguished by radical experimentation with technique and archaizing formal distortions. In this work he applied thin, transparent washes of color with free, gestural strokes over areas of graphite underdrawing. It appears the artist deliberately mixed his paints with some unidentified medium to produce the spotted effect most noticeable in the figure's lower torso and in the blue blanket. Similar effects appear in *Three Nudes* (Alex Hillman Family Foundation) and *The Harem* (Cleveland Museum of Art), a major oil painting executed in Gósol that summer.[1]

Reclining Nude depicts Fernande lying on a blanket with her head draped in a kerchief, an adornment associated both with her personal wardrobe and with the traditional headscarves worn by the peasant women of Gósol.[2] Fernande raises her arms in a gesture of sexual availability, while the contrast between her "clothed" face and fully naked body eroticizes her nudity.[3] The kerchief also draws attention to the disproportionate size of her head, whose stylized features—especially the large almond-shaped eyes and archaic smile—suggest the influence of ancient Iberian sculpture.[4]

Picasso may have derived Fernande's pose from multiple sources, including the supine women in Goya's *Nude Maja* (Museo del Prado, Madrid), Matisse's *Bonheur de Vivre* (Barnes Foundation, Merion, Pennsylvania) and Ingres's *Turkish Bath* (fig. 1). Robert Rosenblum regards the reference to Goya as an attempt by Picasso to reassert his Spanish identity.[5] Yet, Picasso's sojourn in Gósol was also associated with a search for alternative artistic sources in primitive cultures. In this remote village he discovered the *Madonna of Gósol*, a twelfth-century sculpture of painted wood, whose rigid, stylized features are strikingly similar to those of Fernande in this watercolor.[6] Picasso's formal experiments in Gósol must have also been motivated by a desire to respond to the challenge of Matisse's *Bonheur de Vivre*, one of the century's first masterpieces and a painting Picasso had seen at the Salon des Indépendants in the spring of 1906, just before leaving Paris for Gósol. Picasso certainly knew that Matisse had lifted the pose of one of his nudes from the Ariadne figure in the lower right of Ingres's *Turkish Bath*, a painting that had been exhibited at the Salon d'Automne of 1905. Picasso's *Reclining Nude (Fernande)* reinterprets the same pose, but with archaic stylizations and anti-classical figural proportions, reflecting his search for a new aesthetic of primitivist energy and power.[7] After returning to Paris that fall, Picasso would incorporate these stylistic innovations into his unfinished *Portrait of Gertrude Stein*.[8] Fernande's erotic gesture of upraised arms and her stylized facial features, especially the enlarged eyes set off by geometrically arched brows, would serve as a prototype for the woman standing in the center of *Les Demoiselles d'Avignon* of 1906–7 (fig. 2). WHR

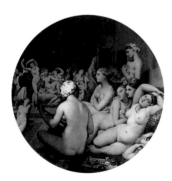

Fig. 1. Jean-Auguste-Dominique Ingres. *The Turkish Bath*, 1862, oil. Musée du Louvre, Paris, inv. no. R.F. 1934.

Fig. 2. Pablo Picasso. *Les Demoiselles d'Avignon*, 1906–7, oil. The Museum of Modern Art, New York, acquired through the Lillie P. Bliss Bequest.

1. Pierre Daix and Georges Boudaille, *Picasso: 1900–1906: Catalogue raisonné de l'oeuvre peint* (Neuchâtel, 1988), XV.18 and XV.40 respectively.

2. Picasso's sketchbook from Gósol depicts local peasant women wearing head scarves. He also portrayed Fernande dressed as a Catalan peasant in *Woman with Loaves* of 1906 (Philadelphia Museum of Art; Daix/Boudaille *Picasso*, XV.46).

3. Study of the underdrawing indicates that the woman's arms were originally crossed over her abdomen, her hips lower, and her right leg higher. There is also evidence of forms drawn in graphite in the upper right, perhaps indicating the presence of a second figure with raised arms and facing the viewer.

4. By the spring of 1906, a group of Iberian sculptures recently excavated in Spain had been placed on display in the Louvre; see Richardson 1991, 1:428.

5. Robert Rosenblum, "Picasso in Gósol: The Calm before the Storm," in *Picasso: The Early Years 1892–1906*, exh. cat., National Gallery of Art (Washington, 1997), 267.

6. The sculpture is reproduced in Richardson 1991, 1:452.

7. Josep Palau i Fabre also associates the nudes and the light, ocher palette of Picasso's Gósol period with the aesthetic of Mediterraneanism championed by the Catalan writer Eugene d'Ors; see "The Gold of Gósol," in *Picasso 1905–1906: From the Rose Period to the Ochres of Gósol* (Barcelona, 1992), 78.

8. Daix/Boudaille *Picasso*, XVI.10.

Watercolor and gouache, with graphite and possibly charcoal, on beige modern laid paper

473 x 613 mm (18⅝ x 24⅛ in.)

WATERMARK: upper left: INGRES; upper right: INGRES

INSCRIPTIONS: signed, lower right, in pink crayon: *Picasso* [underlined]; verso, upper left, in black crayon: *2548* [in a box; upside down]; upper right, in black crayon: *2548* [in a box; sideways]; lower left, in blue crayon: *PH / 94* [sideways]; lower right, in black crayon: *2548* [in a box; sideways]

Gift of Mr. and Mrs. Michael Straight 1954.865

Georges Braque

Argenteuil 1882–Paris 1963

In September 1912, while vacationing at Sorgues near Avignon, Braque invented the technique of *papier collé* (pasted paper) using wallpaper purchased at a local decorator's shop. He was apparently unaware that Picasso, his collaborator in the invention of cubism, had independently invented the new medium of collage (an assemblage of disparate objects) in May. The twin inventions of papier collé and collage were seminal developments in the history of twentieth-century art.

The Violin is among the most elegant and sophisticated of the papiers collés Braque produced between September 1912 and August 1914, when mobilization by the French army brought an end to his collaborative relationship with Picasso.[1] As Braque indicated to the collector Jean Paulhan, objects in a cubist composition create their own space and advance forward, rather than backward, from the picture surface.[2] Here, a violin and a glass (lower right) rest on a table supported by a single wooden leg. Braque defined the violin with charcoal drawing, a slice of cut newspaper, a small piece of rectangular paper with faux wood grain, and a larger piece of block-printed paper decorated with horizontal and vertical lines of ocher and white. The pasted papers situate the violin in a complex space of transparent, intersecting planes, distinguished by paradoxical reversals of space and positive-negative shapes. The violin should logically rest on the table, but it floats upright, parallel to the picture surface, while a strip of wallpaper border suggesting wainscoting from the distant wall actually overlaps part of the violin. Rosalind Krauss observes that newsprint in cubist papiers collés creates subtle optical effects equivalent to traditional atmospheric perspective.[3] The newsprint in this papier collé defines the shadowed side of the violin, although Braque deliberately repudiated the convention of a single light source by adding charcoal shadows to the instrument's opposite side. The ocher and white lines of the block-printed paper (perhaps a playful reference to Mondrian's austere abstractions) optically vibrate to create yet another "chord" of atmosphere that floats above the violin. The arch created by the dark paper at the top derives from Braque's experiments with curved spaces and oval formats, and here unifies the composition.

Pierre Daix dates *The Violin* to 1912, but it was most likely created in Paris in early 1914.[4] Evidence for the later date derives from comparison with Braque's *Violin et pipe (Le Quotidien)*, a papier collé containing the same wallpaper border, as well as a newspaper clipping published on 28 December 1913.[5] Moreover, an entire page from *Le Journal*, dated 19 February 1914 (fig. 1), was glued to the back of *The Violin*. Unfortunately, the exact date of the newspaper column on the front has not been identified, but the article is signed (bottom left) by Jean d'Orsay, who wrote for *Le Matin* during the winter of 1913–14.[6] WHR

Fig. 1. Reverse side of George Braque's *Violin* showing glued-down page from the newspaper *Le Journal*.

1. Bernard Zurcher estimates that Braque produced sixty to seventy papiers collés during this period. See *Georges Braque: Life and Work* (New York, 1988), 102.

2. Ibid., 102.

3. Rosalind E. Krauss, *The Originality of the Avant-Garde and Other Modernist Myths* (Cambridge, 1980), 33.

4. The 1912 date apparently derives from a statement by Jean Paulhan, one of the painting's first owners. See *Jean Paulhan à travers ses peintres* (Paris, 1974), 207, and Pierre Daix, *Cubists and Cubism* (New York, 1982), 102. *The Violin* was dated to 1913 by Tristan Tzara in "Le papier collé ou le proverbe en peinture," *Cahiers d'Art* 6 (1931), 73, and to late 1913 by Christian Zervos in "Georges Braque," *Cahiers d'Art* 8 (1933), 27. Nicole Worms de Romilly and Jean Laude date *The Violin* to 1913–14 in *Braque: Le Cubisme, fin 1907–1914* (Paris, 1982), no. 216.

5. Bernard Dorival, "Les préemptions de l'état à la seconde vente André Lefèvre," *La Revue du Louvre*, no. 2 (1966), 112–14.

6. This page from *Le Journal* features advertisements for a photograph and a subscription for records of music ranging from opera to the newest popular dances. The ad apparently reflects Braque's fascination with modern technology and music, and provides ironic commentary to the violin—a traditional instrument used to perform both classical and popular music—on the front. Alternatively, this newspaper, which is attached upside down, may have been applied for the more practical purpose of serving as a counter mount. Information about Jean d'Orsay was provided by Lewis Kachur in a letter to Edward Henning, 28 August 1979 (CMA files).

Cut and pasted papers (news-
print, block-printed or stenciled
decorative paper, and *faux bois*),
with charcoal and graphite, on
cardboard

718 x 518 mm (28 x 20½ in.)

Leonard C. Hanna Jr. Fund
1968.196

John Marin

Rutherford, New Jersey, 1870–Cape Split, Maine, 1953

A prolific artist, John Marin produced approximately twenty-five hundred watercolors and five hundred oil paintings during his long career.[1] He was one of several twentieth-century American painters who advanced the watercolor medium by creating major stylistic developments that carried over to his work in oil. Marin owed much of his success to his champion, the trailblazing New York art dealer and photographer Alfred Stieglitz, a major advocate of both the American and European avant-garde who played a key role in the development of American modernism.[2] Marin is well known for fragmented and distorted images that captured the dynamic energies and architecture of the modern city. However, as an avid outdoorsman since his youth, Marin held a lifelong fascination with landscape and water. He preferred to live and work outside of New York City, spending winters at his home in New Jersey and summers in the Adirondacks, Pennsylvania, New Mexico, or New England. Aside from his city pictures, Marin is most often associated with his images of Maine. He discovered Maine in the summer of 1914 and spent extended periods there (often from early summer through late fall) for the rest of his life. The range of landscape—mountains, woods, rocky shores, islands, and seascapes—provided endless sources of inspiration for Marin's expressive images, which, like his city pictures, evoke an experience of place rather than providing a detailed record of a specific locale.

Sand Dunes, Wallace Head, Maine is one of dozens of watercolors Marin made in 1915 during his stay in Small Point, in the Casco Bay area. His work of this period shows an increased openness and economy of form verging on flat abstraction. In the Cleveland sheet, this approach is evident in the unpainted areas of paper in both land and sky, the veils of wash describing the sunstruck dunes in the foreground, and the schematic fir trees along the horizon. Marin clearly reveled in his medium: spontaneous fluid brush strokes and calligraphic lines create a sense of movement and flux that heightens the experiential impact of the image. Here, one sees Marin's development of an abstract shorthand, a stylized equivalent of reality that he used to represent the ephemeral qualities of light, wind, and motion. The broad, flat washes filling the windswept sky and thinly drawn "drier" lines defining the varied terrain in *Sand Dunes* exemplify the diversity of Marin's line and the vigor of his execution. He suggests rough textures of shrub and trees with agitated brush strokes or scribbled marks he apparently made by drawing with the handle-end of the paintbrush into the wet watercolor. The pale, salmon-colored dunes contrast with the multiple shades of intense blue sky (perhaps suggesting a coming change in weather). The hallmark of Marin's style is his ability to create a remarkable dialogue between the flatness of the picture plane and a recognizable configuration of his observed subject, striking a balance between his modernist approach and his love of the visible world.[3] Marin articulated this dynamic in his work in a letter to Stieglitz: "I demand of [my paintings] that they are related to experiences—I demand of them that they have the story—embracing these with the all over demand that they have the music of themselves—so that they do stand of themselves as beautiful—forms—lines—and paint on beautiful paper or canvas."[4] SRL

1. Ruth Fine, *John Marin* (Washington, 1990), 10.

2. Stieglitz frequently opened the gallery season with an exhibition of Marin's work: first at his Little Galleries of the Photo-Secession (best known as 291), 1909–17. Then Stieglitz arranged for Marin exhibitions at the Daniel, Montross, and Ardsley galleries until he began regularly showing Marin's work again himself, 1925–28, at the Intimate Gallery and then at An American Place from 1929 until his death in 1946. See the chronology in ibid., 290–95. Stieglitz encouraged Marin's abandonment of his early Whistler-influenced style for a more modern one that reflected the impact of cubism and futurism in shifting, fragmented forms and radiating lines of energy. Marin was also undoubtedly influenced by his exposure to other modernist artists in Stieglitz's circle such as Arthur Dove and Marsden Hartley as well as works by European artists such as Kandinsky and Cézanne that Stieglitz owned or exhibited.

3. The balance shifted toward a broader, more flamboyant abstraction in Marin's later work, in which he deliberately confounded his landscape forms, allowing the viewer the choice to perceive an image as mountain, sea, or cloud (as revealed in titles such as *Movement—Sea or Mountain as You Will*, 1947); see Sue Welsh Reed and Carol Troyen, *Awash in Color: Homer, Sargent, and the Great American Watercolor* (Boston, 1993), 194, under no. 92, and Fine, *John Marin*, 165–66. However, Marin emphasized the importance of basing a picture on observed reality, believing that an artist could not create shapes he or she had not seen in nature, even if the artist then proceeded to distill and abstract those forms. See Nannette V. Maciejunes, *Paintings by John Marin*, exh. cat., Kennedy Galleries, Inc. (New York, 1992), [3–4].

4. Marin to Alfred Stieglitz, 31 August 1940, as cited by Fine, *John Marin*, 271.

Watercolor over graphite, on cream wove paper

418 x 492 mm (16⁷⁄₁₆ x 19⅜ in.)

WATERMARK: upper left: J WHATMAN

INSCRIPTIONS: signed, lower left in graphite: *Marin 15*; verso, probably by the artist, center, in graphite: *Sand Dunes / Wallace Head / maine*; upper right, in graphite: *305* [circled]; lower left, in graphite: *48*; lower left, in graphite *S.B.C. / 2* [circled]; lower right, in graphite: *$850*

Mr. and Mrs. William H. Marlatt Fund 1946.256

Egon Schiele

Tulln, Austria, 1890–Vienna 1918

Although he died at the age of twenty-eight, Schiele created a vast body of work, one primarily devoted to the expressive capacity of the human form. He often depicted those close to him and was a great self-portraitist as well, but the individuality of his sitter was often secondary. Many of his drawings and watercolors have no other subject than the representation of psychic state through bodily form, which he developed through a seemingly exhaustive range of contorted, mannered poses.

Like nearly all his drawings, the Cleveland work is completely devoid of setting. It shows a small child wrapped in a brightly colored, multipatterned fabric set against the bareness of the paper itself. The child's placement in space is ambiguous, and he seems to teeter at an angle, standing unsupported on an unidentifiable object (perhaps a pillow), presented from the back as if turning from one position into another. The child can be identified as Anton Peschka Jr.[1] based on the similarity to a boy in other drawings as well as the figures of two children in the painting *Mother with Two Children III*, for which we know Peschka was the model.[2] Schiele began the painting in 1915 but did not date it as finished until 1917. Similarly, the date on this drawing (he apparently changed the last digit from a "5" to a "6") suggests that he worked on it over a span of time. If it was in fact a study for the painting, Schiele substantially changed the final pose to a more static, frontal position. The greatest similarity between drawing and painting is the garment, which has a comparable color scheme and variegated striped patterning in both works.[3]

Anton Peschka Jr., known as "Toni," was born on 27 December 1914. Schiele did numerous drawings of him, as both an infant and a toddler, and in 1918 he completed an oil painting of the child.[4] Schiele made his earliest drawings of the boy in 1915, the same year he likely began the Cleveland sheet.[5] One of those works (fig. 1) makes a interesting contrast: the boy is naked, but the position of his body, especially his head in profile, is very similar, and one wonders if the work in Cleveland originated at the same drawing session. In the earlier dated work, we can better understand the pose and how he stands in space. Since Schiele focused on the costume in the Cleveland sheet, perhaps he used the earlier pose as a starting point and then drew and painted in the colors of the costume later. The artist seems to have worked from a doll for some of the studies related to *Mother and Two Children III*, as drawings in his sketchbook suggest,[6] and perhaps he drew the costume in the Cleveland drawing using that method. CEF

Fig. 1. Egon Schiele. *Putto (Anton Peschka Jr.)*, 1915, gouache, watercolor, and graphite. Leopold Museum, Vienna, inv. no. 1423.

1. Kallir 1990, 560, seems to be the first to have done so.

2. Schiele wrote to Anton Peschka that he used his son Toni twice in the painting; see Alessandra Comini, *Egon Schiele's Portraits* (Berkeley/Los Angeles/London, 1974), 186.

3. It is not unlike fabric produced by Wiener Werkstätte artists around the same time, for example, the "Algier" design by Franz von Zülow, reproduced in Angela Völker, *Textiles of the Wiener Werkstätte 1910–1932* (New York, 1994), 124–25, fig. 214; this fabric dates to 1925, but its similarities to what Schiele depicted are striking.

4. Kallir 1990, nos. 318, 1702–6, 1813–15, 1872, 1881–84, 2166.

5. Ibid., nos. 1703–6.

6. Comini, *Egon Schiele's Portraits*, 169.

Gouache, watercolor, and
graphite, on beige wove paper,
discolored to yellow-beige

499 x 322 mm (19⅝ x 12⅝ in.)

INSCRIPTIONS: signed, lower
right, in graphite: *EGON /
SCHIELE 1916* [enclosed in a box];
verso, lower right, in graphite:
Serena Lederer

Severance and Greta Millikin
Collection 1964.285

Charles Burchfield

Ashtabula Harbor, Ohio, 1893–West Seneca, New York, 1967

Charles Burchfield spent most of his childhood in Salem, Ohio, and attended the Cleveland School of Art. Unable to find a job using his artistic skills after graduating, he took a position as a filing clerk at the Mullins Company, a metal-stamping firm in Salem. Despite the considerable demands of this job, he began to sketch and paint compulsively—on his lunch break, in the evenings, on the weekends. His creativity reached a peak in 1917, when he produced several hundred visionary watercolors. Burchfield later looked back on that period as his "miraculous year."

Although isolated from the centers of modern art, Burchfield daringly explored abstract principles in a fashion strikingly similar to artists such as Arthur Dove. One of his most interesting steps in this direction was the series of what Burchfield termed "Conventions for Abstract Thoughts"—about twenty symbolic shapes representing predominantly bleak moods such as Fear, Morbidness, Dangerous Brooding, Insanity, Menace, and Fascination of Evil. While ingeniously simplified, in most cases these motifs were abstracted from real objects. Insanity and Imbecility are staring eye motifs, and Fear probably is also, although it takes the form of a hooked spiral. Fascination of Evil is a smiling mouth, and Menace is a ravenous one. Morbidness and Dangerous Brooding resemble the fantastically peaked houses of witches in fairy-book illustrations.[1]

These motifs appear in several of Burchfield's paintings of 1917, but most fully in *Church Bells Ringing, Rainy Winter Night*. Painted in December 1917, it is generally considered the masterpiece of Burchfield's early visionary phase. Salem, Ohio, had been largely constructed in the mid nineteenth century, and Burchfield was fascinated by the creepy qualities of the Gothic architecture of that period, which provided the emotional impetus for the painting.

Burchfield developed his visual concept in November 1917. While lying in bed listening to the toll of a church bell, he began to recall his fearful feelings as a child, when he snuggled in bed on blustering winter nights, listening to the same ominous sound. He recalled how as his terror increased, he would calm himself with thoughts of Christmas. To prepare for the painting, he went down to the Baptist church and sketched its strangely configured Gothic spire. In his journal he noted the tower's hawk-like aspect, but passing by it later he decided that it looked more like a grotesque parrot. In December he went down to the church when the bells were ringing to absorb fully the quality of the sound. "I wandered between the Baptist and Presbyterian Church waiting to hear the bells ring," he noted. "I ran back to one too late—the other I arrived at in time to hear the last ponderous beats—the whole tower seemed to vibrate with a dull roar afterwards, dying slowly and with a growl."[2]

After making such sketches, including one (of three) in Cleveland (fig. 1), Burchfield began work on the painting itself, incorporating the abstract conventions that he had devised. Thus, the head of the tower (which very much resembles a parrot) has the eyes of Imbecility; the hooked spiral of Fear is woven into the side of the tower and repeated in the sky; the peaked form of Morbidness appears in the roof of the house at the right, as well as in its doors and windows; high on the wall of this house is the smiling mouth of Fascination of Evil; the windows of the other house take the domed form of Melancholy; and the door panels bear crossed eyes that mean either Meditation or Insanity. Counteracting these symbols of gloom, the left house shows a Christmas tree in one window and a brightly burning candle in the other—symbols of the thoughts of Christmas that are repelling these evil thoughts. HA

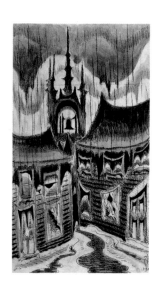

Fig 1. Charles Burchfield. *Study No. 1 for: Church Bells Ringing, Rainy Winter Night*, 1917, pen and black ink, brush and black and gray wash, and black and color crayon. The Cleveland Museum of Art, Norman O. Stone and Ella A. Stone Memorial Fund 1953.429.

1. John I. H. Baur, *Charles Burchfield* (New York, 1956), 27–32; Baur 1982, 73, 79–82.
2. Baur, *Charles Burchfield*, 29; Burchfield/Townsend 1993, 18.

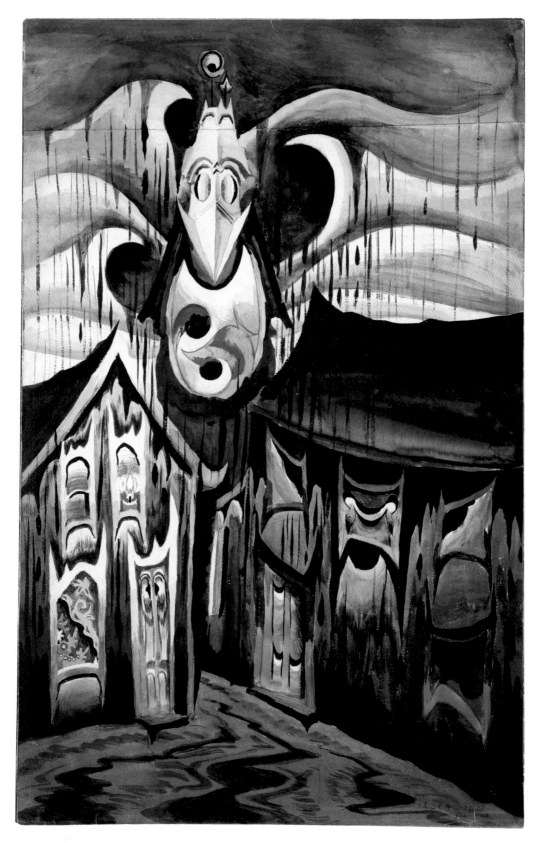

Watercolor and gouache over graphite, on two sheets (joined) of cream wove paper, laid down on cardboard

772 x 500 mm (30⅜ x 19¹¹⁄₁₆ in.)

WATERMARK: none visible through mount

INSCRIPTIONS: signed, lower right, in graphite: *Chas E Burchfield / Dec. 1917*

Gift of Mrs. Louise M. Dunn in memory of Henry G. Keller

1949.544

Charles Demuth

Lancaster, Pennsylvania, 1883–1935

Charles Demuth had his first one-man exhibition of watercolors in 1914 at the Charles Daniel Gallery in New York. As he continued to show there over the next several years, Demuth established himself as a master of this medium. By 1917, he was frequenting New York's avant-garde artistic circles, friendly with Alfred Stieglitz and Walter and Louise Arensberg, among others. Demuth also became a habitué of Greenwich Village nightlife, and *Dancing Sailors* relates thematically to his watercolors of vaudeville performers and lively cabarets.

The artist made two versions of the scene. The Cleveland sheet came first; he used the figures again in another version dated 1918, now in the Museum of Modern Art (fig. 1). Both show nearly identical groups of three couples, with two sailors dancing together in the center and two sailors on either side dancing with women. The main difference is in the background: the Cleveland sheet has a cubist-inspired, quasi-abstract setting, with a turned-up checkered floor and whorls of interlocking planes that enliven the figures' movement and flatten the space; in the second version, a column at left creates a more realistic-looking room. The poses of the figures are identical in both versions; the only changes in the later watercolor are minor details, such as the insignia Demuth added on the sailor's sleeve at the far right.

Both works are impressive examples of Demuth's blotting technique, which he used with great effect to create subtle tonal variation in the watercolor using the white reserve of the paper. This technique is especially prominent in the Cleveland version, where he used it to create horizontal striations that emphasize each sailor's anatomy. Here he also took care to clearly delineate their buttocks, heightening the homoeroticism already inherent in the subject. In that sense, it relates to Demuth's numerous other, more sexually explicit watercolors of men in bathhouses from the same time and it foreshadows his erotic scenes of sailors executed in the 1930s. Jonathan Weinberg and others have noted the significance of Demuth's homoerotic watercolors in light of his own sexuality,[1] and he never showed the works publicly. The Cleveland sheet was, however, included in an exhibition at the Museum of Modern Art during the artist's lifetime. Its eroticism is coy rather than explicit, since one does not immediately notice the male-male couple and the meaningful exchange of glances between one of them and the sailor at the left. As one author has noted, the sight of two sailors dancing with each other may not have been so unusual in post-World War I New York,[2] and the sex roles of working-class men, specifically sailors, could be fairly fluid in that era.[3] *Dancing Sailors* was thus likely inspired by Demuth's frequent forays into New York's nightlife, as other watercolors by him attest. Another work from the same period, *Cabaret Interior with Carl Van Vechten*, done c. 1918,[4] also shows two sailors dancing together, though they are unnoticed by the other revelers in this lively cabaret scene. CEF

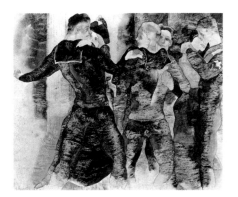

1. Haskell in New York et al. 1988, 55–63; Gerard Kosovitch, "A Gay American Modernist: Homosexuality in the Life and Art of Charles Demuth," *Advocate* (25 June 1985), 50–52; Weinberg 1993, 98–99.

2. Eiseman 1982, 47.

3. See George Chauncey, *Gay New York* (New York, 1994), 76–86.

4. See New York et al. 1988, 84, no. 22.

Fig. 1. Charles Demuth. *Dancing Sailors*, 1918, watercolor and graphite. The Museum of Modern Art, New York, Abby Aldrich Rockefeller Fund, 147.45.

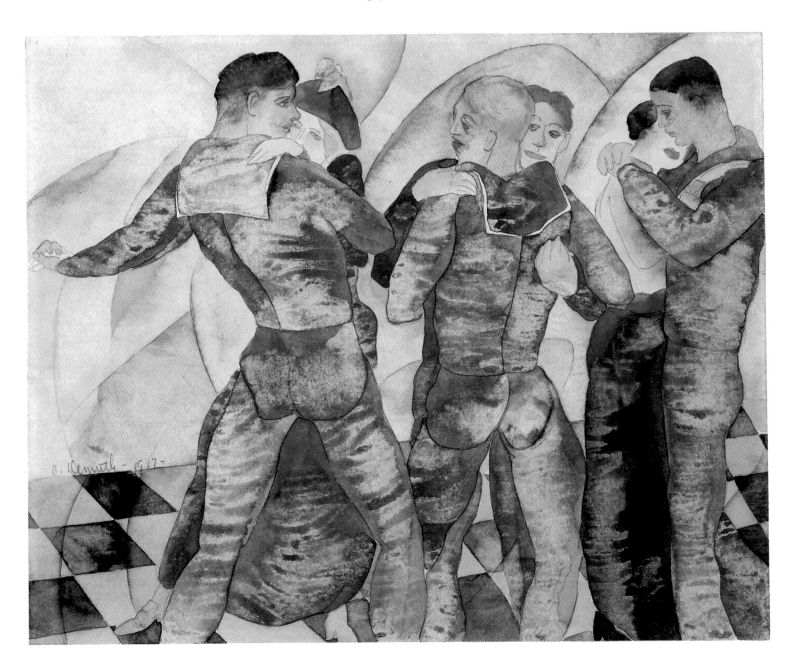

Watercolor over graphite, on cream wove paper, laid down on gray board

204 x 257 mm (8 x 10⅛ in.)

WATERMARK: none visible through mount

INSCRIPTIONS: signed, center left, in graphite: *C. Demuth—1917—*; verso of secondary support, upper right, in graphite: *1214443*

Mr. and Mrs. William H. Marlett Fund 1980.9

Charles Demuth

Lancaster, Pennsylvania, 1883–1935

The same year Demuth executed his *Dancing Sailors* (no. 101), he took a trip to Bermuda and there began to explore a new formal vocabulary influenced by cubism.[1] Demuth became especially interested in architectural motifs, and his study of vernacular and industrial buildings helped him develop a cubist-inspired space structured by faceted, interlocking planes. Such works contrast greatly with his earlier figurative works, the genre scenes inspired by nightlife and works of literature. Yet the spatial abstraction one sees in the background of *Dancing Sailors* is indicative of the direction the artist was taking. His friend the artist Marsden Hartley was certainly an influence, as were the watercolors of Cézanne, which seem to have inspired his new direction to some degree.[2] We know Demuth painted *Amaryllis*[3] in about 1923 because he exhibited the work toward the end of that year. He worked on it during a period of convalescence after a trip to Europe, when he had returned to his hometown to recover from his first bout with diabetes. His physical weakness at the time meant he was limited to working in watercolors, a less demanding medium than the tempera painting he had explored in 1920–21. Demuth temporarily abandoned the architectural subjects, and it must have been natural, given his illness, to turn to the close observation of flowers from which he could work easily and directly.[4] A number of floral and fruit still lifes date to this period of 1922–23,[5] which culminated in an exhibition at the Charles Daniel Gallery that was reviewed with much favor in the New York press.[6]

These watercolors contrast greatly with his first still lifes of 1915–16, where Demuth used a fluid, wet-on-wet technique (fig. 1) influenced by John Marin. In later works, he refined his meticulous control of the medium. In *Amaryllis* he first drew the form in graphite and then brushed on his color with precise applications, using a blotter to develop the pebbly texture that is a hallmark of his technique. Typically, there is a contrast between precise edges and blurred interior modeling of form. The shape of the flower helped determine the composition. It is realistic and recognizable, but there is stylization of the form as well. Demuth has turned the space around the flower into discrete, independently modeled units, curved variations on the angular facets of cubism. These curves and counter-curves play off the forms of the flower and render the space as a kind of matter, set against the neutral background of the paper. Demuth's style would later be termed "precisionist,"[7] and it is ironic that he developed this formal vocabulary in a technique traditionally appreciated for its painterly, wet, and flowing quality.[8]

Demuth's control and precision were noticed in reviews of the 1923 exhibition; one anonymous writer appreciated the "cool restraint . . . found in his radiantly pure sprays of flowers, flowers which are neither attached to the soil nor 'arranged' in the usual manner in the usual vase."[9] *Amaryllis* was purchased by the museum (for its paintings department) right from the Daniel gallery exhibition, and thus became one of the first works by Demuth to enter a public museum collection.[10] It was immediately shown in a larger survey of contemporary American watercolors at the museum, and is now one of four watercolors by him in the collection.[11]
CEF

Fig. 1. Charles Demuth. *Irises,* 1916, watercolor over graphite. The Cleveland Museum of Art, Norman O. Stone and Ella A. Stone Memorial Fund 1953.323.

1. Haskell in New York et al. 1988, 121–41.

2. Ibid., 88, 125.

3. On the original bill of sale from Charles Daniel, the work was called *The Lily* (CMA files). In several subsequent exhibitions (including the 1937–38 memorial retrospective at the Whitney), and in the museum's own records, the title was changed to *Flower Study;* it was changed to *Amaryllis* by curator Henry Francis in 1952, and the flower shown is, in fact, an amaryllis. Perhaps Daniel had given it the title *The Lily,* since one would expect Demuth to have known the kind of flower it was.

4. The Demuth family had a garden kept by his mother, and his interest in flowers was lifelong; see Anderson 1980.

5. Farnham 1959, 577–87, catalogued twenty-four watercolor still lifes datable to 1922–23.

6. See for example, Margaret Breuning, *New York Evening Post* (1 December 1923), 11: "what melting loveliness of color, what brilliancy of surface and exquisite rendering of textures"; also "American Note in Demuth's Art, Water Colors of Rare Distinction Displayed at Daniel's," *World* (2 December 1923), 8: "A selection of his water colors at the Danile [*sic*] Galleries is one of the most delightful exhibitions imaginable. . . . He uses [watercolor] impeccably with delicate perfection of craftsmanship."

7. For a recent discussion of how the term came to be used, see Gail Stavitsky, "Reordering Reality: Precisionist Directions in American Art, 1915–1941," in *Precisionism in America 1915–1941: Reordering Reality* (New York, 1994), 21–35.

8. Noted by Barbara Dayer Gallati in "Language, Water-color, and the American Way," in Linda Ferber and Barbara Dayer Gallati, *Masters of Color and Light: Homer, Sargent, and the American Watercolor Movement* (Washington/London, 1998), 164.

9. *Art News* 22 (1 December 1923), 3; it should be added to the list of reviews for the 1923 exhibition compiled in New York et al. 1988, 222.

10. A. E. Gallatin noted that in 1922, no works by Demuth were in public museums, but when he published his monograph several years later, he noted several major institutions, including the CMA, had acquired his watercolors; see *Charles Demuth* (New York, 1927), vii.

11. Besides no. 101 and the *Irises* illustrated here (fig. 1), there is *Gladioli,* 1920, watercolor over graphite, Bequest of Lucia McCurdy McBride 1972.226.

Watercolor over graphite, on
cream wove paper

458 x 304 mm (18 x 11¹⁵⁄₁₆ in.)

Hinman B. Hurlbut Collection
2490.1923

Joseph Stella

Muro Lucano, Italy, 1877–New York 1946

Joseph Stella, one of America's most gifted draftsmen, loved flowers and drew them continually. The artist's wish "that my every working day, might begin and end . . . as a good omen . . . with the light, gay painting of a flower,"[1] led to a profusion of floral works. Fellow artist Charmion von Wiegand described a visit to Stella's studio: "Flower studies of all kinds litter the floor and turn it into a growing garden."[2]

Throughout his career, Stella executed nature studies simultaneously with the important paintings that won him acclaim as a leading figure in the origins of American modernism: *Battle of Lights, Coney Island, Mardi Gras* (1913–14), *Brooklyn Bridge* (1919–20), and *New York Interpreted: The Voice of the City* (1920–22).[3] Although Stella was enraptured by the superhuman scale and exhilarating dynamism of the city, he also found urban life suffocating. He described skyscrapers as both "brilliant jewel cases of destiny" and "bandages covering the sky, stifling our breath."[4] So in 1919, while painting canvases that glorified the city, he also executed *Tree of My Life*,[5] a complex composition of finely delineated flowers and birds surrounding the central motif of a gnarled tree.

Stella's botanical subjects, although based on careful observation, are never just scientific specimens. From his Catholic childhood in Italy, Stella learned that flowers served "as symbolic reinforcements of the sublimity of God and devotion of the faithful,"[6] and he was undoubtedly aware of the association of the lily with purity and perfection. In general, however, Stella was less interested in exact iconographic references than in associating flowers with the spiritual.[7] He was familiar with Henry

David Thoreau's transcendental philosophy that divinity can be perceived in nature.[8] Such ideas are expressed in a painting from c. 1930, *Flowers, Italy* (fig. 1), where the brightly colored extravaganza of flowers and birds is set within the architectural framework of a Romanesque church, and the exaggerated size of the blossoms hints at a meaning beyond that of a decorative floral piece.[9]

This same combination of real and fanciful exists in numerous drawings similar to *Lilies and Sparrow*, where carefully depicted flora and fauna[10] are juxtaposed in an imaginary arrangement. Stella had an oriental sensibility for simplicity and spareness and achieved a refined delicacy by using metalpoint, a medium associated with the Italian Renaissance rarely seen in the twentieth century. Although metalpoint cannot be erased, its unique qualities—precision, delicacy, and sharpness of image—appealed to Stella,[11] and he often combined it with colored pencils to achieve a brilliance almost equal to oil painting.[12] He used a ground of thinned zinc white gouache, adding another coat around the image to achieve a stronger contrast.[13] This splotchy white background animates the composition and creates the illusion that the image floats on the surface of the sheet.

The careful execution and large size of *Lilies and Sparrow* suggest that Stella considered it a finished work of art.[14] Since he executed many metalpoint and colored pencil sketches of flowers in conjunction with *Tree of My Life*, some of which are dated 1919, it seems reasonable to place *Lilies and Sparrow* at this time, too, although it could have been made several years earlier or later. JG

Fig. 1. Joseph Stella. *Flowers, Italy*, c. 1930, oil. Phoenix Art Museum, Gift of Mr. and Mrs. Jonathan Marshall 64.20.

1. Quoted in Irma B. Jaffe, *Joseph Stella* (Cambridge, Massachusetts, 1970), 85.

2. Charmion von Wiegand, "Joseph Stella—Painter of Brooklyn Bridge," c. 1940, p. 8, Joseph Stella Papers, Archives of American Art, Smithsonian Institution, Washington, roll 346, frame 1389.

3. *Battle of Lights* and *Brooklyn Bridge* are in the collection of Yale University Art Gallery, New Haven, and *New York Interpreted* is at the Newark Museum, New Jersey.

4. Quoted in Jaffe, *Joseph Stella*, 77–78.

5. Mr. and Mrs. Barney A. Ebsworth Foundation and Windsor, Inc., St. Louis.

6. Haskell in New York 1994b, 109.

7. Ibid.

8. He considered Thoreau, Edgar Allen Poe, and Walt Whitman the three giants of American literature; Joseph Stella Papers, Archives of American Art, "For the American Painting," roll 347, frame 108.

9. Glaubinger 1983, 391.

10. All the flowers can be identified: the tallest is a lily; the other large blossom a calla lily; the small flowers on the branch freesia; and the large pointed leaves and berries *Symphoricarpus alba;* however, certain details are inaccurate. The bird is a type of house sparrow.

11. August Mosca (Stella's studio assistant from 1937) letter to author, 21 June 1983, p. 2, CMA files.

12. Mosca explained that Stella "loved this combination which, to my knowledge, was unique to him. . . . When the silver is applied *over* the color, it deepens and enriches the area, thus giving it a depth not achieved by the silver alone. The color *over* the silver obscures the silver strokes and softens the contrast." Stella used A. W. Faber "Castell" polychrome pencils. Ibid.

13. The zinc white gouache is perhaps Weber's. Ibid.

14. The tallest lily reappears in the oil *Flowers, Italy*, while an extremely similar drawing was sold at Christie's, New York, 7 December 1984, no. 324, and then exhibited at Hirschl and Adler Galleries, New York (*American Masterworks on Paper: Drawings, Watercolors, and Prints*, 1985–86).

Colored pencil, silverpoint, and white gouache, on cream wove paper

724 x 571 mm (28½ x 22⁹⁄₁₆ in.)

724 x 571 mm (28½ x 22 9/16 in.)

INSCRIPTIONS: signed, lower right, in graphite: *Joseph Stella*; along right edge, in graphite: 62 x 74 / 48 [circled]

Purchase, Delia E. Holden Fund 1983.81

George Grosz

Berlin 1893–1959

Student is one of a series of drawings that Grosz made in 1922 for Iwan Goll's 1921 play *Methusalem: The Eternal Bourgeois,* a satirical drama pitting the radical Student against the bourgeois capitalist Methusalem. Grosz produced two sets of costume designs for Goll's play in different styles. Some were executed in a humorous illustrative mode[1] while others, like *Student,* reveal mechanistic and assemblage approaches to form inspired by Grosz's interests in Russian constructivism and Dada. The latter drawings represent full-size mask-like shields, made up of various machine parts and other commonplace objects, from behind which the actors would speak.[2] Far from a traditional costume sketch, the schematic figure of the Student, enlivened by color and the play of repeated geometric forms, parodies the character type, transforming him into a machine with iconographic attributes (such as the book under his arm). Like the Dada artists Marcel Duchamp, Max Ernst, and Francis Picabia, Grosz was intrigued by the possibilities of employing mechanical analogies for human forms, functions, and emotions, which he pursued in the *Methusalem* designs. Grosz's mechanistic approach extended to his use of drafting tools (the straight-edge and compass) to execute the drawings.[3] Motion and sound effects are described in his annotations: "Emits steam from time to time while speaking" (near a narrow tube jutting from the head); "Here it can crackle and rattle while speaking" (near an arrow pointing to the partially exposed brain mechanism). Other annotations enhance the visual description, specifying the artist's conception: "Teeth like old piano keys"; "Feet [like] giant matchboxes"; and "Mask, opened up, a large lard candle with an electric light bulb mounted on top, being the light from whom it originates."[4] Richard West has suggested that the candle may be an ironic play on the "light of knowledge" which in this context is used as a reference to the Student's incendiary philosophy.[5] The hinged metal head is repeated in many of Grosz's satirical drawings to reveal the inner workings of corrupt or incompetent minds. Sue Taylor has read the number "13" emblazoned on the Student's ragged coat as a possible reference to the unlucky fate of the revolution he represents.[6]

Sketches for Methusalem's wife, Amalie, and their daughter, Ida, appear on the verso (fig. 1). The rotund Amalie is drawn on the left, in a pre-mechanized form. Although described primarily in terms of flat patterns, one can still discern elements of a traditional Bavarian woman's costume: felt hat with hatpin, decorative bird and feather; a dress with a bodice that accentuates the breasts; a watch pinned with a bow to her chest; and what appears to be a walking stick to her right. In later versions Grosz transformed the X-pattern of the skirt border into train tracks, changed her hat into a teapot, turned her walking stick into a lever, and streamlined her organic forms into parts of a machine.[7] The more cursory sketch on the right, a tall female nude with a long ovoid head, strongly resembles other images of Ida, both in figure type and skewed profile pose (both breasts are visible).[8] Ida is surrounded by triangles superimposed with the words "ICH DU ER" in block letters. These images are studies for the set design for the rendezvous scene between Ida and the Student.[9]

Although Grosz's designs for *Methusalem* were never realized,[10] these drawings were significant as innovative contributions to the avant-garde German productions of the 1920s that continued to influence contemporary theater and performance art for the rest of the century.[11] These theater designs are also an important facet of Grosz's work that while well known to his contemporaries, remains less familiar to the public today. SRL

1922

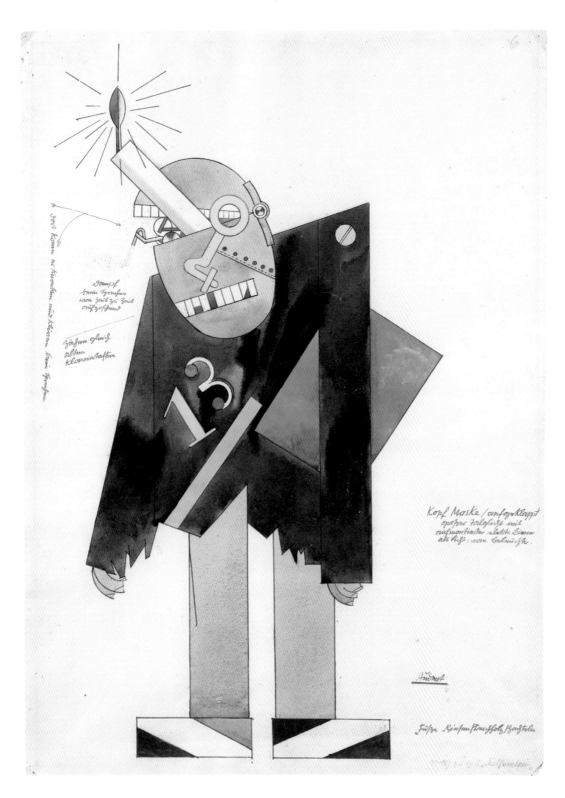

Amalie, Ida, and Set Designs (*Studies for Goll's "Methusalem"*) (verso)

Pen and brown-black ink (applied with the aid of drafting tools) and watercolor, on cream wove paper (now discolored to light brown); verso, graphite

527 x 380 mm (20¾ x 15 in.)

INSCRIPTIONS: upper right, in graphite: *6*; by artist upper left, in brown ink: *Dort kann er knacken und klirren beim sprechen* [sideways along edge]; by artist, upper left, near figure's shoulder, in brown ink: *Dampf / beim sprechen / von Zeit zu Zeit / aufzischen*; by artist, upper left, below previous inscription, in brown ink: *Zähne gleich / alten / Klaviertasten*; by artist, lower right in brown ink: *Kopf Maske/aufgeklappt / großes Talglicht mit / aufmontierte elektr. Birne / als Licht, von beleuchter*; by artist, lower right, in brown ink: *Student* [underlined twice]; by artist, lower right, below previous inscription: *Füße Riesen/ streichholz/schachteln*; lower left, in graphite: *38*; by artist, bottom right, in graphite: *No* ["o" underlined twice] *16) zu Goll "Methusalem"*; verso, lower left, in graphite: *No 22* [sideways]; lower left, in graphite: *1498₁* [upside down, circled]; upper left, in blue crayon: *33* [underlined]; by artist, center right, in graphite: *blau*; by artist, lower right, in graphite: *rot*; by artist, lower right, in graphite: *gr*; lower right, in graphite: *470* [sideways]; lower right, in graphite: *MH4*; by artist, upper right, in graphite: [illegible] / *No* ["o" underlined twice] *7 Student / zu Methusalem / von Iwan Goll* [sideways]; upper right, in graphite: [illegible] / *40.4126* [sideways]

Contemporary Collection of The Cleveland Museum of Art 1966.50.a,b

Fig. 1. *Amalie, Ida, and Set
Designs* (*Studies for Goll's
"Methusalem"*) (verso of no.
104), 1922, graphite. Contempo-
rary Collection of The Cleve-
land Museum of Art 1966.50.b.
[This image has been digitally
enhanced to increase legibility.]

1. See *Ida and the Student*, watercolor; DeShong 1982, pl. 10 (listed as owned by the Estate of George Grosz, Princeton, New Jersey).

2. The concept of disguising the actor's entire face and body would radically transform all conventional acting techniques. The idea probably developed in consultation with Goll, who was interested in masks (as a way to project a state of mind, revealing the inner psyche of a character before any dialogue is spoken) and technical innovations such as the incorporation of film projections in sets for live theater, and was familiar with both Cubist and Dada performance designs. See ibid., 35–36, 39–44, and West 1968, 90, 92–93. Another source of inspiration may have been Alexandra Exter's Constructivist theater designs executed in the Soviet Union around the same time (see DeShong 1982, 40).

3. Many of the drawings (though not the CMA sheet) were stamped "Grosz. Constructor" as one would expect of an engineer's design. See West 1968, 93, and Born/Taylor 1990, 113.

4. My thanks to Hannelore Osborne for her assistance in transcribing and translating the artist's annotations.

5. West 1968, 92.

6. Born/Taylor 1990, 113.

7. See *Amalie*, gouache, ink, and graphite, The Joel Starrels Jr. Memorial Collection, The David and Alfred Smart Museum of Art, The University of Chicago, 1974.140; Born/Taylor 1990, 112, fig. 46.

8. See the pose in *Ida and the Student* (DeShong 1982, pl. 10) and the narrow ovoid head in West 1968, 91, fig. 5. The slightly swelled belly in the Cleveland sketch may refer to Ida's pregnancy.

9. DeShong 1982, 38–39.

10. Unaccountably, the 1922 premiere never took place and in the official premiere of 1924 Grosz's designs were not used; see DeShong 1982, 36. West 1968, 92, suggested that economic uncertainties may have made Grosz's elaborate conceptions impractical. Another possibility is that there was some change in conception about concealing the actors behind the animated shield forms, which would have presented certain pragmatic difficulties, limiting the actor's movement and forcing him/her to shuffle laterally across the stage to prevent revealing him/herself to the audience; see DeShong 1982, 41–44, and *George Grosz: Berlin-New York* (Berlin/Düsseldorf, 1994), 195.

11. Grosz's designs were widely reproduced and admired—their conception inspired more practical adaptations and thus were influential despite their existence only in graphic form. DeShong 1982, 44.

Henri (Émile-Benoît) Matisse

Le Cateau-Cambrésis 1869–Nice 1954

At the end of 1917, Matisse moved alone to Nice where he lived for at least part of each year for the remainder of his life. The attraction of this southern French seaside resort was the beauty of the soft light, which began to infuse his work. From the early 1920s, Matisse often depicted attractive young women idly lounging in exotic rooms bathed in radiant light. Constructing these sets in his studio, the artist created a sensual, artificial world where he surrounded models in appropriate costumes with patterned wallpaper, carpets, and ornate textiles. In the tradition of the nineteenth-century French Orientalist painters, Matisse fabricated "an ideal, imaginary, harmonious fantasy for himself."[1] However, "the splendid display in these pictures," as Matisse commented, "'should not delude us,' for within their torpid atmosphere 'there is a great tension brewing, a tension of a specifically pictorial order, a tension that comes from the interplay and interrelationship of elements.'"[2]

These works, in which Matisse tries to resolve various formal problems, are often inhabited by a languorous odalisque: a female slave or concubine in a harem. When asked in 1929 why he chose this subject, he replied: "I do odalisques in order to do nudes. But how does one do the nude without it being artificial? And then, because I know that they exist. I was in Morocco. I have seen them."[3] Matisse's favorite model between 1920 and 1927 was Henriette Darricarrère, who "adopted the subject roles . . . easily and could express the moods and the atmosphere of Matisse's settings without losing her own presence or her strong appearance."[4] As the artist explained, "My models, human figures, are never just 'ex-tras' in an interior. They are the principal theme in my work. I depend entirely on my model, whom I observe at liberty, and then I decide on the pose which best suits *her nature*."[5]

Henriette appears in Cleveland's drawing, an example of her in culottes, with arms raised behind her head, recumbent on a chaise longue, a pose repeated in several lithographs and paintings from 1921 to 1924.[6] Matisse, who always presents Henriette's sculpturesque body as curvaceous and fleshy, commented on the erotic ambiance as "the sensuality of heavy, drowsy bodies, the blissful torpor in the eyes lying in wait for pleasure."[7] The provocative model, however, looks away, distracted, available, yet distanced.

A brilliant colorist, Matisse nevertheless understood the importance of drawing, writing "I have always seen drawing not as the exercise of a particular skill, but above all as a means of expression of ultimate feelings and states of mind."[8] Sketches like *Reclining Odalisque* allow a more intimate knowledge of the artist since his working method is revealed. Multiple pencil strokes, which define the contours, were changed and then strengthened as Matisse worked quickly and carefully to construct the figure with soft, rounded forms. Influenced by the charcoal and stump drawings executed around 1922, he smeared the graphite in places to achieve a variety of tones to describe the three-dimensional solidity of the model. The figure is so well balanced and drawn with such ease that we naturally accept her horizontal position on a support, even though only a few pale lines and the position of the cascading striped cloth define the furniture. JG

1. John Elderfield, *The Drawings of Henri Matisse*, exh. cat., Hayward Gallery, London, Museum of Modern Art (London, 1984), 83.

2. John Elderfield, *Henri Matisse: A Retrospective*, exh. cat., Museum of Modern Art (New York, 1992), 37.

3. Elderfield, *Drawings*, 83.

4. Jack Cowart and Dominique Fourcade, *Henri Matisse: The Early Years in Nice, 1916–1930*, exh. cat., National Gallery of Art (Washington/New York, 1986), 27.

5. Ibid., 32.

6. Paintings include *Odalisque with Red Culottes* and *Odalisque with Magnolias* (see Elderfield, *Henri Matisse*, pls. 263 and 266) and the lithograph *Odalisque au magnolia* (see Marguerite Duthuit-Matisse and Claude Duthuit, *Henri Matisse: Catalogue raisonné de l'oeuvre gravé* [Paris, 1983], no. 432).

7. Cowart/Fourcade, *Henri Matisse*, 35.

8. Elderfield, *Drawings*, 11.

Graphite on cream wove paper
282 x 385 mm (11 1/16 x 15 1/8 in.)

WATERMARK: upper left: J
PERRIGO

INSCRIPTIONS: signed, lower
right, in graphite: *Henri –
Matisse*; verso, upper right, in
graphite: [S?] [S?]*2 x 40*; from

three labels on the old frame: in
black ink: N° [printed] *24301 /
Matisse / Dessin / a.v.*; in brown
ink: N° [printed] *24301 /
Matisse / Dessin / t.u.*; in black
ink: *21933 / onn*

Gift of The Print Club of Cleve-
land 1927.300

Edward Hopper

Nyack, New York, 1882–New York 1967

Edward Hopper must have identified with lighthouses because he was nearly six feet five inches tall, and stood apart, detached from the rest of the world. He made this watercolor during his last painting excursion to Maine.[1] Thereafter, he summered on Cape Cod, at South Truro, where he eventually constructed a home. "I like Maine very much," Hopper later commented in an interview with Katherine Kuh published in 1962, "but it gets so cold in fall."[2] By the time he made this watercolor, he had already painted the lighthouse at Cape Elizabeth in 1927, but found the motif so interesting that he returned to it. The lighthouse at the top is the same one that figures in his most famous oil of a lighthouse, *Lighthouse at Two Lights* (1929, Metropolitan Museum of Art, New York) and in the almost equally well-known oil, *Lighthouse Hill* (1927, Dallas Museum of Art).

The elements that specifically attracted Hopper to the view portrayed in this watercolor were singled out by his wife, Jo, in a letter of 4 December 1937 to Louise Burchfield (the artist Charles Burchfield's sister, who was then assistant in the Cleveland Museum of Art's paintings department). Jo began by explaining that Hopper was interested in the different purposes of the buildings, the one at the top of the hill being where the lighthouse keepers slept, and the three at the bottom where their families lived. As she noted:

> Your Cape Elizabeth watercolor was done early in the fall of 1929 on the outer edge of the little coast guard settlement called Two Lights. (There were once two (2) light houses, but now only 1). Sitting upon the bluff is this lighthouse, the house of its keeper; other

buildings to do with other light houses or radio station up there too.

> Below are the houses of the families of the coast guard. The men have to sleep at the station (coastguard station) but these men have their families right there within a stone's throw. Life very primitive, water from the village pump.[3]

Jo Hopper went on to observe that the painting was a synthesis of motifs Hopper had already explored in several canvases and some two dozen watercolors. What attracted him to the subject was the timothy grass. "He had previously painted all the other items here more or less. Singly, but he couldn't resist the timothy."[4] "E. Hopper," she noted, "is past master of dead grass."[5]

Despite its seeming simplicity, the piece is a virtuoso example of the use of color. As John O'Connor noted:

> Hopper was a master at capturing the effect of light on surfaces. How effectively he does that may be seen in any number of his paintings, but particularly in the water color "Cape Elizabeth." In this picture there are three separate houses, each of which is painted with a distinct, skillfully graduated tone of color, and on each house there are different tones dependent on the effect of light on a given surface.[6]

The Cleveland Museum of Art acquired this watercolor from the Rehn Gallery in New York the year after it was painted. The museum also acquired a major oil by Hopper, *Hills, South Truro*, 1930, in the next year. HA

1. Hopper titled the Cleveland drawing *Lighthouse Village* in his record book, but he generally signed his watercolors with the location in which he painted them. There are many signed "Cape Elizabeth," and that alternate title to this work is kept here.

2. Carl Little, *Edward Hopper's New England* (San Francisco, 1993), unpaginated.
3. Cited in Levin 1995a, 197.
4. Ibid., 197.
5. Ibid.
6. John O'Connor Jr., "Edward Hopper, American Artist," *Carnegie Magazine* 10, no. 10 (1937), 305.

106. *Lighthouse Village* (also known as *Cape Elizabeth*)

1929

Watercolor with gouache over graphite, on cream wove paper

405 x 633 mm (15⁵⁄₁₆ x 24¹⁵⁄₁₆ in.)

INSCRIPTIONS: signed, lower right, in black gouache: *Edward Hopper / Cape Elizabeth*

Hinman B. Hurlbut Collection 806.1930

Charles (Rettew) Sheeler

Philadelphia 1883–Dobbs Ferry, New York, 1965

Charles Sheeler developed his aesthetic interest in the rise of twentieth-century mechanical culture through numerous paintings and drawings in the 1920s. By the end of that decade, contemporary art critics perceived him as the leader of a group of painters known as the Immaculate School, and later the precisionists. Sheeler was fascinated by the industrial forms driving the modern city, and he presented them with minimalist clarity and clean lines, emphasizing structure through simplification and the elimination of details.

Modern Progress in Transportation represents a significant moment in his career, when many of his ideas from the 1920s came together after an important photography project commissioned by the Ford Motor Company.[1] In 1927, Sheeler spent six weeks photographing the massive new River Rouge plant near Dearborn, Michigan. This vast and totally mechanized landscape exemplified America's worldwide industrial dominance, and Sheeler monumentalized its architecture and machinery with a reverence befitting the buildings of Antiquity. A small group of paintings and drawings closely relates to this photography commission, and it includes some of Sheeler's best-known works, such as *American Landscape* (1930, Museum of Modern Art, New York)[2] and *Classic Landscape* (1931, Mr. and Mrs. Barney A. Ebsworth Foundation).[3] *Modern Progress in Transportation* is also based on a photograph (a unique print, fig. 1)[4] and depicts technicians at a facility near the new plant working on Ford's Trimotor airplane, the first commercially produced aircraft.[5]

Sheeler had been using photographs as the starting point for paintings and drawings since the completion of *The Upper Deck* in 1929 (Fogg Art Museum, Cambridge). He felt the technique allowed him to be more objective and truthful toward the objects he depicted; he could concentrate on the purity of the forms themselves while removing traces of his individual hand. *Modern Progress* perfectly illustrates those ideas. Sheeler used both a compass and a straight-edge to render the corrugated body of the airplane with hard-edged clarity. The palette is restricted to mostly grays and browns, and he was clearly fascinated by the play of light on the shiny industrial surfaces. The human figures—rare in Sheeler's work—are robotic and faceless, dominated by the surrounding mechanical forms of the airplane.

The subject is a perfect symbol of the machine age, and the title of the work, devised by the artist, suggests an optimistic view of industry. The composition, which has a cinematic quality, is cropped so that we see the tail end of another plane at the far right, thus emphasizing the craft's forward movement in an assembly line. Sheeler had been awed by the processes of industrial creation he saw at the Ford plant, and the assembly-line technique developed by Henry Ford was the cornerstone not only of the Ford Company but of modern industry in general. CEF

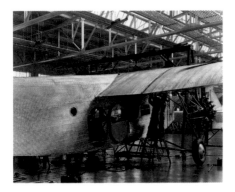

Fig. 1. Charles Sheeler. *Ford Trimotor Airplane*, 1928, gelatin silver print. The Lane Collection, courtesy Museum of Fine Arts, Boston.

1. For the history of this project and Sheeler's work for Ford, see Detroit 1978, 11–43; Boston et al. (Paintings and Drawings) 1987–88, 17–21; Boston et al. (Photographs) 1987–88, 24–34.

2. See Boston et al. (Paintings and Drawings) 1987–88, 118–19, no. 36.

3. See ibid., 120–23, no. 37.

4. Sheeler made several photographs of the Trimotor plane in addition to the one reproduced here, all in the Lane Collection; another is reproduced in Boston et al. (Photographs) 1987–88, 33.

5. Precisionist painter Elsie Driggs also depicted this plane in a work now in a private collection; see Montclair Art Museum, *Precisionism in America 1915–1941: Reordering Reality* (Montclair/New York, 1995), 111, no. 67. Brett Weston's 1944 photograph *Ford Trimotor Plane* bears a striking resemblance to Sheeler's.

Tempera and graphite, on beige
wove paper

316 x 561 mm (12⁷⁄₁₆ x 22¹⁄₁₆ in.)

WATERMARK: lower left: FRANCE;
lower right: B F K

INSCRIPTIONS: fragment of old
label, now removed, in type-
script: MODERN PROGRESS IN
TRA[cropped]; by artist, in
graphite: [b]y *Charles Shee*[ler]
[cropped]

Andrew R. and Martha Holden
Jennings Fund 1996.252

Reginald Marsh

Paris 1898–New York 1954

Reginald Marsh was an avid draftsman who experimented with a variety of media during his career, including oil painting and printmaking. Yet like other American artists working in the first half of the twentieth century, many of his finest works were executed in watercolor. Marsh's early experience as an illustrator and his interest in old master paintings laid the groundwork for his realist style in which he used traditional approaches to modeling and draftsmanship to record observations of contemporary urban life. In addition to his famous depictions of Coney Island, burlesque theater, subways, and the unseemly inhabitants of the Bowery, Marsh also produced images of trains, bridges, and manufacturing structures. His long-standing interest in transportation and industry, revealed in his childhood drawings, was revived in the year or so before the Depression when he began to explore those subjects again in drawings, watercolors, and prints.[1] In many of these works, Marsh shifted his focus from the human figure to the immense bulk and dominating physical presence of a machine or structure.[2] However, unlike the streamlined images of his precisionist colleagues (see Sheeler, no. 107), Marsh imparted a gritty realist quality to his depictions of such themes.

The Cleveland watercolor is an anomaly in the context of Marsh's work, since he is best known for his earthy images of crowds of ordinary people in their urban environment. This image of an empty automobile, however, aligns with his less typical, heroic images of locomotives, bridges, or other forms of modern technology. This 1931 watercolor depicts a luxury car, a custom-bodied Model G close-coupled sports coupe made by the elite auto maker duPont.[3] Fewer than six hundred such cars were made. During the lean years of the Depression, the market for high-end vehicles fell, driving many specialized auto manufacturers out of business.[4] Perhaps Marsh implies the demise of such extravagances in his portrayal of this brand-new car in a dark, muddy palette—greenish and gray browns, dark burgundy, and black.[5] The only bright color is the blue sky. He presents the car as an icon, isolated in an empty, nondescript outdoor setting. This is a major departure from the profusion of background elements found in his city scenes. In the Cleveland sheet, Marsh worked mostly wet in wet (especially evident in the sky and ground), but used a drier brush to paint the tires so that the white of the paper shows through in tiny spots. The exposed paper combined with the small X marks (in the front tire) create a textural contrast with the more smoothly painted metal elements of the car. Apart from the cursory inclusion of a fancy hood ornament, however, the viewer is not left with the feeling that Marsh is presenting an object of desire but rather something for which the moment has passed. SRL

1. *Awash in Color: Homer Sargent and the Great American Watercolor* (Boston, 1993), 242, under no. 115.

2. For example, see *Steel Structures*, 1934, watercolor over graphite, Museum of Fine Arts, Boston in ibid., 243, no. 115 (repr.).

3. The author is indebted to Allan Unrein, collection manager of the Crawford Auto-Aviation Museum at the Western Reserve Historical Society, Cleveland, for his identification of the make and model of the car.

4. According to Unrein, the chassis, fenders, and grille of the coupe in the CMA watercolor appear to be that of the Model G Speedster. DuPont automobiles were produced from 1919–32, and the 1930–31 Speedster derivatives were among the most interesting cars they made. Only 537 duPonts were built and they were noted for style, grace, engineering excellence, and stamina.

5. Marsh's strength was drawing rather than color or brushwork, and his palette was often in the darker red, brown, and ocher range, suitable to his gritty realist style and closer to old master paintings than the high-key vibrant hues of many of his modernist colleagues.

1931

Watercolor over graphite, on white wove paper

354 x 507 mm (13¹⁵⁄₁₆ x 19¹⁵⁄₁₆ in.)

INSCRIPTIONS: signed, lower right in black ink: *Reginald Marsh 1931*; estate stamp in red ink,

lower right: F. Marsh Collection / CAT# *WC 31-17* [inventory number is written in graphite]; verso, lower right, in graphite: *WC 31-17*

Bequest of Felicia Meyer Marsh 1979.66

Thomas Hart Benton

Neosho, Missouri, 1889–Kansas City, Missouri, 1973

The son of a Missouri politician, Benton always enjoyed the sound and spectacle of American politics. His daughter, Jessie, has stated that as a child she learned more about politics than about art at the family dining table.[1] The summer of 1936 was one of the busiest of Benton's life because he was rushing to complete the most ambitious project of his career—a mural for the Missouri State Capitol—which had to be finished before the year was over if he was to collect his payment. Nonetheless, despite the pressure to complete the mural, Benton found time to travel to Cleveland in July 1936 to attend the Republican National Convention and make a series of reportorial drawings.

It was not a good year for Republicans. The party was internally divided and matched against a strong incumbent president, Franklin D. Roosevelt. Indeed, the Leftist magazine Common Sense, in an article ridiculing the Republican platform, gleefully predicted that the party was likely to join company with such long-extinct species as "the Tyrannosaurus, the Pterodactyl, and the Threetoed Horse."[2] This prediction proved premature, but in fact that year's Republican candidate, Alf Landon, was roundly defeated by the largest plurality in U.S. history.

In this drawing of the convention hall, Benton recorded the sound and fury of the Republican gathering, including nicely observed vignettes of shouting, waving, deal making, punch throwing, and police rushing in to intervene. As a lifelong Democrat, Benton must have been inwardly delighted by the chaos and folly of the proceedings.[3] It is unclear whether he produced this drawing on his own initiative or on commission from a magazine. One of the drawings he made in Cleveland, showing politicians and a blonde secretary in a hotel room, was reproduced in Common Sense to accompany the scathing assessment of the Republican Party quoted above.[4] In addition, another source states that Benton was working on commission from Life, although the magazine never published any of his Cleveland work. Most likely Benton's arrangements with prospective publishers were rather loose, for in fact the two most ambitious drawings from the trip, this one and G. O. P. Parade, now in the Benton Trust in Kansas City, were never published despite their unusually finished execution.[5]

This drawing, in fact, must have been based on a number of preparatory sketches and is executed more like a lithograph than like Benton's usual travel drawings. The image is contained within a border, in the manner of a print, and the use of crayon graining to define variations of shading is very similar to the technique of a tonal lithograph. Perhaps the most notable quality of the drawing is Benton's mastery of composition—a skill he had perfected early in his career, while struggling to master purely abstract principles of design. Several devices are used to create visual unity as well as visual appeal. As in many of his compositions, the forms tend to swirl around vertical poles—in this case the state banners held aloft by the convention delegates. In addition, the artist contrived engaging parallel forms in the rushing diagonals of the conventioneers and the spotlights directed down on the floor. Finally, Benton created interesting alternating rhythms of light and dark. The end is a highly personal synthesis of baroque and cubist compositional systems, combined with a vigorous sense of satire that harks back to American political cartoonists such as Thomas Nast. HA

1. Conversation with author, 1989.

2. Thomas R. Amlie, illustrated by Thomas H. Benton, "In Darkest Cleveland," Common Sense 5 (July 1936), 8–11.

3. A less finished version of this composition is in the collection of John W. Uhlmann, Kansas City. See Henry Adams, Thomas Hart Benton: Drawing from Life (New York, 1990), 29.

4. Amlie, "In Darkest Cleveland," 9.

5. Karal Ann Marling, Tom Benton and His Drawings (Columbia, Missouri, 1985), 86, 91; Adams, Thomas Hart Benton, 28–29. Benton later did execute some drawings for Life. See Henry Adams, Thomas Hart Benton: An American Original (New York, 1989), 276, 284.

Pen and brush and black ink
and black crayon, with graphite,
on cream wove paper

374 x 532 mm (14¹¹⁄₁₆ x 20¹⁵⁄₁₆
in.)

INSCRIPTIONS: signed, lower
right, in black ink: *Benton*

Purchase from the Leonard C.
Hanna Jr. Fund 1995.70

Paul Klee

Münchenbuchsee, near Berne, 1879–Muralto, near Locarno, 1940

With its large format, bold coloration, thick painterly lines, and pictographic figuration, *God of War* exhibits a new style that Paul Klee developed in his late career. Debilitated the previous year by the early effects of scleroderma, an incurable skin disease, the artist embarked in 1937 upon a more assertive style and worked prolifically until his death three years later.

Next to fears about his illness, Klee was anxious about the European political situation. Since 1933, he had been exiled from Germany to his native Switzerland; 1936 brought the Spanish civil war; and in 1937, Hitler's Nazi government included seventeen of Klee's works in its Munich exhibition condemning modernism, *Degenerate Art.* As a professor at the Bauhaus in the 1920s, Klee had experimented with the expressive formal potential of the swastika, an interest manifest in the three figures at the bottom of *God of War.* Yet this work stands with others from the 1930s whose titles indicate political meaning.[1] Similarly, while Klee used newspaper as a support in a diverse range of later compositions, often leaving the newsprint to interact with his sign-like marks, the article visible in parts of *God of War* discusses the Spanish civil war and the postwar politics of the Great Powers. Wolfgang Kersten and Osamu Okuda have connected *God of War* with *Sick Girl*, the work immediately preceding it in the artist's oeuvre.[2] Like other pairs Klee produced at this time, together these images speak to his dual sense of personal sickness and the sickness of Europe.[3]

God of War is thus a rare political commentary in Klee's art, yet in it he broadened and essentialized the war theme. As a response to the Spanish civil war, the picture is neither the public declamation of Pablo Picasso's *Guernica,* the famous mural executed for the 1937 World's Fair, nor the raging and anguished heads painted by Joan Miró, such as the 1938 *Head of a Woman.*[4] Instead, true to his temperament, in *God of War* Klee sublimated personal and political concerns through his characteristic lyricism, mythicizing, and formal sign making. With heavy eyelids, long noble nose, and full lips that approach a smile, the large face gazes out with contentment and apparent wisdom, an idea belied only by the figures scurrying below. The principal figure suggests a benevolent Great Sphinx sitting with upraised tail and marked with hieroglyphs. Likely Klee was recalling his only trip to Egypt nine years before.[5] His whimsical treatment of the war theme matches the perspective he expressed four years earlier in a letter to his son Felix, where after discussing imminent exile from Germany, he added, "I'll spike the gall with humor."[6] More generally, the mythic and ideographic qualities in *God of War* reflect the artist's consistently cerebral and poetic approach, summed up in a 1916 diary entry: "In my work I do not belong to the species, but am a cosmic point of reference."[7] It was just this aloof and meditative attitude that had earned Klee the nickname "Bauhaus Buddha" in the 1920s. The sobriquet suggests a final nuance to the meanings of *God of War,* whereby the image may also stand as a figurative self-portrait of the absorptive creator Paul Klee. PSC

1. Vishny 1978, 240–41. Other such works mentioned by the author include the 1937 *Little Mars* and the 1938 *Little Prussian,* reproduced respectively in *Paul Klee: The Last Years* (London, 1974), 31, and G. Di San Lazarro, *Klee* (New York, 1957), 160.

2. Fortunately for historians, early in his career Klee began meticulously cataloguing his own work.

3. Düsseldorf/Stuttgart 1995, 214–15.

4. *Guernica* (Museo del Prado, Madrid, inv. no. 6479); *Head of a Woman,* now in the Minneapolis Institute of Arts, is reproduced in Sam Hunter and John Jacobus, *Modern Art: Painting/Sculpture/Architecture* (New York, 1985), 227.

5. Klee spent a month in Egypt in December 1928 and January 1929. The landscape inspired several variously colored, striated compositions, such as the large oil painting *Highroad and Byroads* (1929, Museum Ludwig, Cologne); see Carolyn Lanchner, ed., *Paul Klee* (New York, 1987), 237 (repr.).

6. From a letter of 22 December 1933, as translated in Vishny 1978, 240.

7. As cited in translation in ibid., 233.

Fig. 1. View of entire sheet showing artist's mount and inscription.

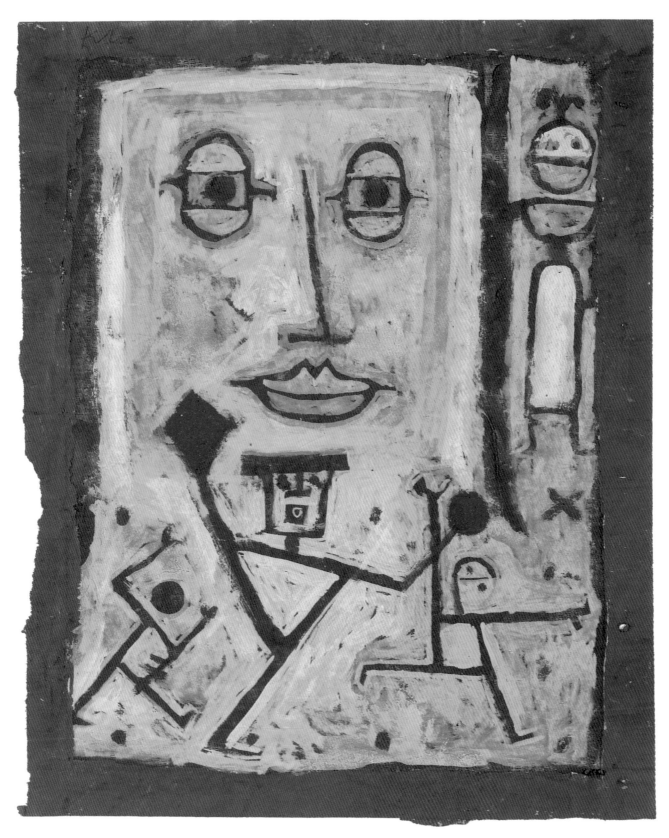

Gouache and tempera on newspaper, tipped onto cream wove paper (artist's mount; see fig. 1)

352 x 290 mm (13¹³⁄₁₆ x 11⅜ in.) (image), 646 x 493 mm (25⁷⁄₁₆ x 19⅝ in.) (secondary support)

INSCRIPTIONS: signed, upper left, in paint: *Klee*; secondary support, by artist, lower center, in brown ink: *1937 K. 5. Kriegs Gott* ["37 K. 5. Kriegs Gott" underlined in graphite]; lower center, in graphite: *III*; verso of secondary support, upper left, in graphite: *Nᵒˢ 39 31 / 35 x 29* [all circled]; upper left, on separately applied label: [upper portion cropped] / *1937* [inscribed in blue ink] *Nᵒ* [printed in black ink] *0843* [stamped in blue ink] / *Paul Klee / Dieu de la Guerre / 35 x 29* [last three lines inscribed in blue ink] / *Photo Nᵒ* [printed in black ink]

Bequest of Lockwood Thompson 1992.278

Yves Tanguy

Paris 1900–Woodbury, Connecticut, 1955

The Cleveland Museum of Art's gouache displays many characteristics typical of Tanguy's work from the mid to late 1930s: a vertical composition, "figures" that are small or modest in scale, and neutral bands of predominantly gray tones that make up a horizonless setting. The highly individualistic imagery of his mature style, formed after 1927, changed little throughout his career, aside from a slight tightening of technique, a heightened use of color, and an increased density in composition during the 1940s and 1950s.

Tanguy did not employ sketches or studies but painted directly and intuitively on canvas or paper in order to describe the unconscious domain of human experience. His approach, however, was not spontaneous. Tanguy, like his surrealist colleagues René Magritte and Giorgio de Chirico, created meticulously rendered dream-like pictures presented in an illusionistic manner, a type of imagery often referred to as *peinture-poésie* (painting-poetry).[1] Using a smooth, fluid application of color, Tanguy painted clearly defined but enigmatic forms. Some possess a biomorphic quality or are otherwise evocative of the natural world; others are entirely fantastic. Dramatic cast shadows emphasize the illusionistic three-dimensionality of the forms, which belie the picture's overriding bizarre and imaginary character. The physical presence that Tanguy gives to these unrecognizable entities and the environments they inhabit lends authenticity to the personal inner visions they represent.

The eerie illumination of the Cleveland image evokes an unknown terrain, a vast expanse in which land and sky merge into a field of graded bands of subdued color. Within this sparse setting, the stark lighting, the scat-tered rock-like objects, and the strange rabbit-eared figure at lower left suggest a quasi-realistic lunar landscape, especially to twenty-first century viewers accustomed to actual photographs and computer-generated images of "outer space." Other forms suggest an ocean setting, evoking aquatic plants, jellyfish, and surfaces worn by the continual passage of water currents.[2] The deliberate ambiguity of Tanguy's setting and its spatial construction is heightened by two pairs of converging lines and their shadows: they appear both to rise vertically and to recede into space as they connect the figures/forms in the "foreground" to objects of slightly smaller scale in the "middleground." Tanguy frequently devised otherworldly environments suggesting aquatic depths, vast deserts, or beaches in which forms hover, stand, or float, deliberately confusing regions of earth, air, and water. The artist's maritime experience in the Merchant Navy in 1918–20, the curious cliff formations and intense clarity of light he observed during a trip to Africa in 1930–31, and the memories of youthful vacations spent among the prehistoric dolmens and menhirs on the plateaus and shores of Brittany, undoubtedly inspired some of the unusual environments he portrayed.

Tanguy inscribed the drawing to the Paris art dealer Jeanne Bucher in 1939. In May of the preceding year, Bucher had held an exhibition of Tanguy's work (the third monographic exhibition of his work in Paris) at the Galerie Jeanne Bucher-Myrbor. Tanguy may have inscribed this work to Bucher in thanks for her support of his work, or perhaps as a parting gift before he left for the United States in November 1939, after the outbreak of war in Europe.[3] SRL

1. Dawn Ades, *Five Surrealists from the Menil Collections*, exh. brochure, National Gallery of Art (Washington, 1983), 2.

2. Tanguy frequently adapts and reuses forms. Seaweed-like clusters and spectral forms can also be found in earlier oil paintings such as *The Storm* (1926, Philadelphia Museum of Art), *The Extinction of Useless Lights* (1927, Museum of Modern Art, New York), *A Large Picture That Is a Landscape* (1927, private collection, Tokyo), and in an untitled gouache (1938, Collection Lefebvre-Foinet, Paris); see *Yves Tanguy: Retrospective 1925–1955*, exh. cat., Centre Georges Pompidou (Paris, 1982), 80, no. 22; 84, no. 27; 87, no. 30; and 122, no. 77, respectively.

3. Margaret Loudon and Alessandra Carnielli, who are currently working on the revised catalogue raisonné of Tanguy's work (forthcoming in 2000), agreed with this author's suggestion that Cleveland's drawing may have been included in the artist's monographic exhibition held at Galerie Jeanne Bucher-Myrbor in 1938 and dated and inscribed later to the owner Jeanne Bucher. Since no checklist from the 1938 exhibition survives, there is no way to confirm the inclusion of the CMA drawing in the show.

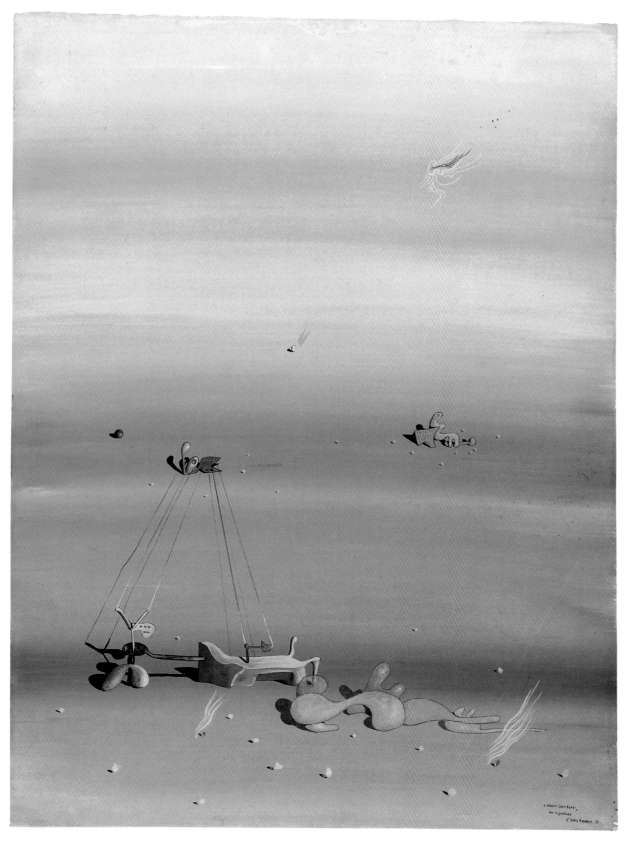

Gouache with some incised lines drawn in metal point, on off-white (probably wove) paper mounted on gray board

319 x 246 mm (12⁹⁄₁₆ x 9¹¹⁄₁₆ in.)

WATERMARK: none visible through mount

INSCRIPTIONS: by artist, lower right, in black gouache: *A Madame Jeanne Bucher, / avec La gratitude / d'YVES TANGUY. 39*

Bequest of Lockwood Thompson 1992.283

Joan Miró

Barcelona 1893–Palma de Majorca 1983

Woman with Blond Armpit Combing Her Hair by the Light of the Stars belongs to Miró's "Constellations," a group of twenty-three works in gouache completed between January 1940 and September 1941.[1] He began the series in Varengeville, in Normandy, where he had retreated from the troubles of the Spanish civil war and the fascist threat. After finishing ten of the "Constellations," including the sheet now in Cleveland, Miró and his family fled France for Spain to escape the advancing German army. They ended up in Majorca, where he did more of the series, finishing the last three in Montroig.

From Miró we know something of both the technique and the inspiration for the series. He had purchased an album of paper to use for cleaning his brushes but became interested in what developed when he brushed the first sheet with a mix of oil and turpentine.[2] The series thus developed partly from chance, and he continued to work that way as it progressed. On these washy, painterly backgrounds he drew meticulously in gouache, developing dense compositions with his own language of symbols, many of which he repeated throughout the series.[3] Miró described how he consciously withdrew into himself because of the looming threat of war, inspired by "the night, music, and the stars."[4] Although he finished the works in succession and each has its place in the series, he wrote about how important it was for him to see them together as he worked.[5]

The Cleveland sheet is the fifth "Constellation." Like all the pieces made in Varengeville, it is less dense compositionally than those done later, the figure more easily readable. Her face dominates the center of the sheet, and its shape seems to have been suggested by the passage of red wash in the background. Her massive hands and arms loom up on either side of her; with one she draws a comb through her hair, with the other she holds up a mirror through which shine the moon and a star. Snails crawl up her armpits. Miró's figures and symbols exist on a single plane that floats in front of an unfocused background of blended colors. Both pure line and flat areas of color indicate form, and a change in color at the intersections where forms meet suggests a kind of transparency. Miró carefully signed, titled, and dated the work on the verso, inside the enormous head of a figure drawn in brown ink (fig. 1).[6]

The "Constellations" have been universally lauded as one of Miró's greatest achievements. They were first shown as a group at Pierre Matisse's New York gallery in 1945, one of the first important exhibitions by a European artist to be seen in postwar America. With their dense, overall compositional structure, they foreshadowed important developments in abstract art that would unfold in New York. In 1959, Matisse issued a set of facsimiles of the "Constellations" with a prose-poem for each by André Breton.[7] CEF

Fig. 1. Joan Miró. *Figure* (verso of no. 112), pen and brown ink. Contemporary Collection of The Cleveland Museum of Art 1965.2.b.

1. All are illustrated in color and catalogued in New York 1993–94, 238–61, 415–22, nos. 156–78; for a useful summary of the series and its importance, see Roland Penrose, *Miró* (London, 1985), 100–107.

2. James Johnson Sweeney, "Joan Miró: Comment and Interview," *Partisan Review* (1948), reprinted in Houston 1982, 117–19; Louis Permanyer, *Miró, Ninety Years* (London, 1986), 55. For an explanation of Miró's technique, see New York 1993–94, 82 n. 295.

3. They were analyzed in Rolnik 1983.

4. Sweeney in Houston 1982, 118.

5. Fundació Joan Miró, *Joan Miró 1892–1983* (Barcelona, 1993), 374–75.

6. Each of the sheets bears similar inscriptions and drawings on the verso; see New York 1993–94, 415–22, nos. 156–78; one of these versos is illustrated on p. 261.

7. *Joan Miró Constellations: Introduction et vingt-deux proses parallèles par André Breton* (New York, 1959). One of the "Constellations," which the artist gave to his wife, was left out of this facsimile edition.

Figure (verso)

Watercolor and gouache over graphite, on white wove paper; verso, pen and brown ink

379 x 458 mm (14⅞ x 18 in.)

INSCRIPTIONS: signed, lower left, in black gouache: *Miró*; verso, signed, center, in brown ink:

*Joan Miró / *Femme à la blonde aisselle coiffant / sa chévelure à la lueur des étoiles* / Varengeville s/mer / 5/III/1940;* center left, in graphite: *5* [circled]

Contemporary Collection of The Cleveland Museum of Art 1965.2.a,b

René Magritte

Lessines, Belgium, 1898–Schaerbeek, Belgium, 1967

René Magritte was one of the leading figures of the surrealist movement. In 1926, he helped found the Belgian group of surrealist poets and painters. These artists disregarded the Parisian surrealists' emphasis on dream narratives and automatism as a path to the unconscious, preferring to explore ways of disrupting expected perceptions of the real world. Magritte's philosophical approach inquired into the very nature of representation. He combined the real and the logical with the utterly ridiculous, changing scale and context to create a startling poetic reality. By manipulating the identification of objects, placing them in radically incongruous juxtapositions or next to words that contradict their visual appearance, Magritte broke down the psychological barriers of awareness, challenging the viewer's assumptions about what he or she sees.

Utopia, however, represents a conservative departure for Magritte.[1] The Cleveland gouache is one of two works on paper by Magritte that Lockwood Thompson purchased from Lou Cosyn's gallery in November 1945 while Thompson was an American soldier stationed in Brussels.[2] Magritte made an oil painting of the same subject and title in June of that year.[3] The Cleveland gouache was probably created around the same time, but certainly by October, when Thompson first saw it at Cosyn's gallery.[4] The composition of the oil and gouache are quite close: in both works a rose is placed slightly off center on a rocky island in a vast sea, set against a blue sky filled with large white clouds. The differences are minor: in the painting there are more clouds, arranged somewhat differently; there are additional leaves near the bottom of the rose stem; and the sea appears calm and distant, while in the gouache there is white foam where waves strike the shore at lower left. Magritte, who generally painted opaquely, seems to have taken advantage of his water-based medium in the Cleveland sheet, applying broad transparent strokes of watercolor to describe the sea and allowing blue watercolor to bleed unevenly near the edges of the clouds, enhancing their atmospheric qualities.

The rose appears as a motif in a number of Magritte's works,[5] but seems to have no fixed meaning for the artist.[6] Two of his rose pictures share similarities with the *Utopia* composition: the 1944 oil painting *L'invitation au voyage* (*Invitation to the Journey*) depicts an enormous rose in full bloom "as immense as a sunset" floating on the horizon out at sea; and the gouache *Le coup au cœur* (*Blow to the Heart*), c. 1958?, portrays a single rose planted in the earth with a dagger sprouting from its stem, against an ocean backdrop.[7] *Utopia* is realistic by comparison, however, using neither exaggerated scale nor unusual juxtapositions of objects to create the image. Nonetheless, the atypical presentation of a single isolated rose, standing like a figure in a seemingly infertile, uninhabited environment, compels the viewer to scrutinize its purpose. Given the dating and the optimistic title, one is inclined to read the image as a possible commentary on the end of World War II in Europe.[8] A number of the surrealists, including their founding father, André Breton, had fled to the United States during the war. This lone rose growing out of the barren earth on a sunny day might suggest the return of the artist refugees and a new beginning.[9] Magritte's acknowledgment of his nostalgic associations with the rose in *L'invitation au voyage* further validates this idea.[10] SRL

1. During 1943–47, responding to the concern he felt under the German occupation to create pictures that would impart some sense of pleasure, Magritte produced a number of works in a brightly colored, quasi-impressionist style (although often retaining subtly disturbing elements). At the same time, he continued to create other paintings in his customary "smooth" manner. See David Sylvester, *Magritte: The Silence of the World* (New York, 1992), 254–65, and Sarah Whitfield, *Magritte* (London, 1992), 309. While Magritte did not execute *Utopia* in his impressionist style, the conservative composition may have grown out of his concern about unpleasant imagery and may have been partially market driven.

2. The other gouache, *The Human Condition* (*La condition humaine*), 1944 or 1945 (Sylvester, 1992–94, no. 1190), was also bequeathed by Thompson to the Cleveland Museum of Art (1992.274). He apparently saw several recent works by Magritte at Cosyn's in October 1945 and decided to purchase two before he left Brussels. See Lockwood Thompson's diary entries for 10 October and 3 November 1945 as cited in ibid., 4:59–60, under nos. 1190 and 1191.

3. *Utopia* (*L'utopie*), 1945, oil on canvas, 60 x 80 cm, private collection, London (Sylvester, 1992–94, no. 586).

4. The oil (referred to by title) is described as nearly completed in a letter from Magritte to Achille Chavée, dated 6 June 1945. See ibid., 2:356, under no. 586. Although many artists work out compositions on a small scale on paper before painting an oil on canvas, Magritte was just as likely to start with oil and later transfer his ideas to gouache, with only minor changes. Yet if *La péri* (*The Fairy*) is indeed an earlier title given to the gouache by Magritte (as suggested by the crossed-out inscription on the verso), the gouache may have been made before the oil was titled. The source of the title, *La péri*, is unclear and does not seem to relate to another work.

5. Examples include *La femme ayant une rose à la place du cœur* (*Woman with a Rose Instead of a Heart*), 1924, oil on canvas, Sylvester 1992–94, no. 62; *Les signes du soir* (*The Signs of Evening*), 1935, oil on canvas, ibid., no. 376; *Reverie de Monsieur James* (*Mr. James's Daydream*), 1943, oil on canvas, ibid., no. 517; *La voie royale* (*The Royal Way*), 1944, oil on canvas, ibid., no. 556; *L'enjôleuse* (*The Seductress*), 1946, gouache on paper, ibid., no. 1201; *Les Tombeau des Lutteurs* (*The Tomb of the Wrestlers*), 1960, oil on canvas, ibid., no. 912; *Untitled* [Woman's face covered by a rose], 1965, gouache on paper, ibid., no. 1575.

6. Magritte explained that the rose depicted next to the figure in the 1956 gouache *La boîte de Pandore* (*Pandora's Box*), 1956, signified the element of beauty that would protect the man, wherever destiny led him (see ibid., no. 1418). However, in 1947, when asked why he often used rose motifs, Magritte replied that he didn't know yet but perhaps he would discover the reason later on. When the question was posed again in 1967 he responded that he still did not know. See quotes from the artist's *Ecrits complets* as cited in *René Magritte*, exh. cat., National Museum of Modern Art (Tokyo, 1988), 150, under no. 124. Magritte resented over-interpretation of his imagery and was perfectly comfortable freely repeating motifs in his

work without attaching a spe-
cific meaning in every case.

7. For *L'invitation au voyage*,
see Sylvester 1992–94, no. 558
(where the quote from
Magritte's *Dix Tableaux* is also
cited). For *Le coup au cœur*, c.
1958?, gouache on paper, and
the 1952 version in oil on canvas
(where the sea backdrop is less
pronounced), see ibid., nos. 1451
and 777, respectively.

8. The Allies declared victory
in Europe on 8 May 1945 (V-E
Day).

9. My thanks to William
Robinson for discussing ideas
relating to the iconography and
dating of this image.

10. Magritte describes his idea
for *L'invitation au voyage* as a
"vivid and effective expression
to a particular feeling made up
of a nostalgia, poetry, etc." See
letter from Magritte to his col-
league Marcel Mariën, cited in
Sylvester 1992–94, under no.
558.

Watercolor and gouache, on
beige wove paper

321 x 418 mm (12⅝ x 16⁷⁄₁₆ in.)

INSCRIPTIONS: signed lower left,
in black ink: *Magritte*; verso,
center right, in graphite:
L'Utopie; center right, in black
ink: *La Peri* [crossed out in

graphite] / *Magritte 1945*; upper
right, stamped in purple ink:
Galerie / Lou Cosyn / 21 rue de
la Madeleine, BRUX. [set inside
an oval border]

Bequest of Lockwood Thompson
1992.275

Jacob Lawrence

Atlantic City, New Jersey, 1917–Seattle 2000

Jacob Lawrence has devoted his distinguished career, now spanning seven decades, to documenting African-American life and history. Early in his career, motivated by the idea that "having no Negro history makes the Negro people feel inferior to the rest of the world,"[1] Lawrence created several series of small paintings on paper, each illustrating the history of a legendary black hero. "The Migration of the Negro" was exhibited by Edith Halpert, one of New York's most prestigious dealers, in the Downtown Gallery in 1941. The set of sixty paintings was divided and sold to the Phillips Collection in Washington, and the Museum of Modern Art in New York, making Lawrence, at twenty-four, the first African-American artist to be represented in the permanent collection of the Museum of Modern Art. He also won unprecedented national recognition when twenty-six of the scenes were reproduced in color in *Fortune* magazine in November 1941.[2]

Although Lawrence's success continued unabated, he began to feel depressed in the late 1940s. In 1946 he taught summer school at Black Mountain College, where Josef Albers expounded his ideas on design and the dynamic effect of color. This experience left Lawrence nervously reappraising his own modernist style of simplified, flat, brightly colored forms fit together in a tight interlocking pattern. In addition, as nonobjective art and especially abstract expressionism began to dominate the New York art scene, Lawrence's socially conscious subject matter and emphasis on narrative became increasingly unfashionable.[3]

Lawrence's intensifying anxieties, some traced to childhood difficulties and self-doubt,[4] led to his voluntary confinement at Hillside Hospital, a psychiatric facility in Queens, where he was a patient from October 1949 to July 1950. Lawrence continued to work and produced eleven paintings, executed with casein on paper (a liquid medium in which the pigment binder is made from acidified skim milk), which were exhibited in the Downtown Gallery in 1950.[5] These included *Depression*, a scene of troubled, lethargic patients wandering in a hallway, *In the Garden*,[6] which portrays three men weeding among brightly colored blossoms and insects, as well as *Creative Therapy*, where patients paint as a release from tension and illness. Dr. Emanuel Klein, Lawrence's physician, who studied the relationship between art and neurosis, explained the works: "These paintings did not come from his temporary illness. As they always have—and as is true for most real artists—the paintings express the healthiest portion of his personality, the part that is in close touch both with the inner depths of his own feeling and with the outer world."[7]

Creative Therapy is one of Lawrence's most sophisticated and complex compositions. Experimenting with cubist-derived ideas, he developed flat, shallow planes of space punctured by the precipitously tipped table in the foreground, which also shifts the point of view. As Lawrence struggled with finding a new direction for his own work, he presented, in the patients' paintings, a variety of modernist styles, and he even transformed their palettes into gaily colored abstract designs. Although Lawrence has included himself in the scene, he hides behind his picture, which we cannot see. He does reveal a favorite pastime, however, by having one of the patients paint chess pieces.[8] JG

1. Quoted in Ellen Harkins Wheat, *Jacob Lawrence: American Painter*, exh. cat., Seattle Art Museum (1986), 40.

2. Ibid., 64.

3. Romare Bearden and Harry Henderson, *A History of African-American Artists from 1792 to the Present* (New York, 1993), 305.

4. Ibid., 305–6.

5. The invitation to the exhibition, which took place 24 October–11 November 1950, lists the works as: 1. *Psychiatric Therapy*; 2. *Occupational Therapy No. 1*; 3. *Recreational Therapy*; 4. *Creative Therapy*; 5. *Drama—Hallowe'en Party*;

6. *Square Dance*; 7. *The Concert*; 8. *Occupational Therapy No. 2*; 9. *Sedation*; 10. *Depression*; and 11. *In the Garden*.

6. Wheat, *Jacob Lawrence*, pls. 47–48.

7. Aline B. Louchheim, "An Artist Reports on the Troubled Mind," *New York Times Magazine* (15 October 1950), 15.

8. Wheat, *Jacob Lawrence*, 103.

Casein over graphite, on cream
Grumbacher (blind stamp lower
left) wove paper

560 x 764 mm (22¹/₁₆ x 30¹/₁₆
in.)

INSCRIPTIONS: signed, lower
right, in black casein: *Jacob
Lawrence / 49*; verso, by artist,
center, in graphite: *"Creative
Therapy" / Hillside Hospital
1949*

Delia E. Holden Fund 1994.2

Louise Bourgeois

Born Paris, 1911

Louise Bourgeois considers herself an American artist, but she spent her childhood and early adulthood in Paris. Her turbulent family life from that time is the acknowledged source of all her work, and she has described her art making as a process of exorcism, in which she analyzes and attempts to resolve the psychological conflicts of her childhood. She works primarily as a sculptor, and her techniques encompass traditional media such as marble, wood, and bronze as well as modern materials such as cast rubber. Her exploration of recurrent themes—dominated by sexuality, fertility, motherhood, fecundity, fear, isolation, and loneliness—characterizes her body of work as a whole. Much of Bourgeois's formal vocabulary comes from the human body or its parts or from other organic forms, but her use of figuration is more expressionistic than realistic. It is often brutal and raw as well as poetic.

The artist's exploration of her own psyche is also an important part of her graphic oeuvre, notably the print series from 1947, "He Disappeared into Complete Silence," where the accompanying texts alluded to incidents in her own life. During the period in which she produced the series, Bourgeois began to develop a vocabulary of expressive lines that appears in many of her drawings and prints: parallel, closely spaced hatching that conveys both compulsion and forceful movement. The Cleveland drawing dates to the early 1950s and belongs to a group known as "skein" drawings because their long thin lines suggest thread and the texture of weaving.[1] This textile metaphor is of great personal significance, since Bourgeois's family sold and restored tapestries, and Bourgeois first exercised her skill as a draftsman while working on parts of tapestries in their workshop.

In the late 1940s and 1950s Bourgeois made numerous drawings using this vocabulary of closely spaced lines rendered in brush and black ink. Some of these sheets show botanical forms or abstracted body parts. Others, like the Cleveland work, suggest landscapes:[2] the vertical downward strokes in the upper part of the sheet evoke a sky and rain,[3] which strikes down forcefully against the undulating, roiling earth below it. In describing a work similar to this one and produced around the same time, Bourgeois suggested that it resembled a geyser gushing out of the earth, and she related the subject to the treatment her mother received at spas for her emphysema.[4] Read as a landscape, the drawing also conveys the power of nature as an uncontrollable force. At the same time, the image works as an overall abstract composition, with short and long strokes of the brush covering the surface entirely. In that sense, it has affinity with the work of the abstract expressionists, many of whom Bourgeois knew. Although she abandoned painting early in her career, she has never stopped making drawings and prints. But Bourgeois kept her drawings in her studio for decades and rarely exhibited them.[5] They became well known to the public only in 1988, when 184 were shown at gallery exhibitions in Paris and New York.[6] CEF

1. For a discussion of these works, see Marie-Laure Bernadac, *Louise Bourgeois* (Paris/New York, 1996), 29–33.

2. An analogy the artist herself has made in relation to some of her drawings; see *Louise Bourgeois, Drawings and Observations*, exh. cat., University Art Museum and Pacific Film Archive/Drawing Center (Berkeley/New York, 1996), 106–9.

3. See the artist's comments in Marie-Laure Barnadac and Hans-Ulrich Obrist, eds., *Louise Bourgeois Destruction of the Father Reconstruction of the Father: Writings and Interviews 1923–1997* (Cambridge, Massachusetts, 1998), 299.

4. Deobrah Wye and Carol Smith, *The Prints of Louise Bourgeois* (New York, 1994), 226; the drawing is reproduced in Jerry Gorovoy and John Cheim, eds., *Louise Bourgeois Drawings* (New York/Paris, 1988), no. 132.

5. A photograph of the artist's studio taken in 1951 shows many drawings of a similar technique to the Cleveland work displayed on her studio wall; see New York 1982–83, 49, pl. 22.

6. Gorovoy/Cheim, *Louis Bourgeois Drawings*.

c. 1950

Brush and black ink and gray
wash, with white paint and
traces of black chalk(?) and blue
crayon, on board faced with
clay-coated white paper, with
collage of cream wove paper

559 x 712 mm (22 x 28 in.)

Purchase from the J. H. Wade
Fund 1998.112

Franz (Rowe) Kline

Wilkes-Barre, Pennsylvania, 1910–New York 1962

"I rather feel that painting is a form of drawing and the painting that I like has a form of drawing to it."[1] Franz Kline's breakthrough exhibition at the Egan Gallery in New York in 1950 was devoted to abstract paintings of bold interlocking forms in black and white paint. It established the style for which he became known, an expressionistic manner of painting that combined the gestural and the architectonic. Drawing was an essential part of Kline's working process, as the above quote suggests. But unlike his contemporary Barnett Newman, for whom drawing and painting were essentially the same act (see no. 117), Kline often worked directly from drawings when making paintings. Kline used drawing as a way to work out his ideas quickly, and he made drawings in large quantities (often on cheap, plentiful paper, such as telephone book pages). He would then find a drawing that interested him and work directly from it to create a painting.[2] After his death, the artist Elaine de Kooning recounted Kline's discovery of how he could use drawing.[3] Her husband, painter Willem de Kooning, was projecting some of his own drawings to a larger scale with a Bell-Opticon projector and suggested that Kline try it as well. This event seems to have been an important catalyst in developing the kind of abstract painting that made Kline an innovator, because it allowed him to see how he could use black and white in large-scale painting.[4] But although Kline often based his paintings on small-scale drawings,[5] they inevitably evolved as he transferred his ideas to canvas and increased the scale.

The Cleveland work does not correspond to any of Kline's paintings, though its form is related in a general way to *Flanders*, 1961.[6] Its date and title come from an old label from the Sidney Janis Gallery,[7] which began representing the artist in 1956. The title was perhaps assigned by the gallery rather than the artist. Kline tended to give his paintings more evocative titles,[8] or they remained "Untitled"; most of his drawings are untitled unless they connect to a specific painting.[9] When Kline titled a work, it usually had personal significance and was not meant to suggest "content." Yet he understood that his works would evoke figurative associations in many viewers. The Cleveland drawing certainly has a strong structural presence, with a long horizontal at the top spanning the width of the paper supported by the broad vertical form underneath it, all made up of numerous fluid black strokes. One of Kline's statements seems especially appropriate: "I think that if you use long lines, they become—what could they be? The only thing they could be is either highways or architecture or bridges."[10] CEF

1. Franz Kline and David Sylvester, "Franz Kline 1910–1962: An Interview with David Sylvester," *Living Arts* 1 (1963), 10.

2. On Kline's working method, see Robert Goodnough, "Kline Paints a Picture," *ArtNews* 51 (December 1952), 36–39, 63–64.

3. Elaine de Kooning, "Franz Kline: Painter of His Own Life," *ArtNews* 61 (November 1962), 67–68.

4. Cincinnati et al. 1985–86, 84.

5. Richard Diebenkorn recounted this from a studio visit in 1953 (noted in Cincinnati et al. 1985–86, 85).

6. See *New Paintings by Franz Kline*, exh. cat., Sidney Janis Gallery (New York, 1961), no. 16, for which there is a preparatory drawing, also generally similar to the Cleveland sheet; see Cincinnati et al. 1985–86, 108–9, where Gaugh associates the form with crucifixion.

7. CMA files.

8. On Kline's titles, see Cincinnati et al. 1985–86, 93–96; Kline/Sylvester, "Franz Kline," 10.

9. Kline's painting *Black and White*, 1951 (repr. in Cincinnati et al. 1985–86, 104) looks nothing like the Cleveland drawing.

10. Kline/Sylvester, "Franz Kline," 7.

Oil on yellow-beige wove paper, laid down on cream wove paper

317 x 252 mm (12⁷⁄₁₆ x 9⁷⁄₈ in.)

INSCRIPTIONS: signed, lower right, in graphite: *KLINE*; verso of secondary support, signed, across top, in black ink: *FRANZ* *KLINE*; by artist, center left, in black ink: [arrow] / Top [underlined]

Contemporary Collection of The Cleveland Museum of Art 1961.134

Barnett Newman

New York 1905–1970

"I hope that I have contributed a new way of seeing through drawing. Instead of using outlines, instead of making shapes or setting off spaces, my drawing declares the space."[1] Barnett Newman was one of the major artists of the New York School, and as a defender of the abstract painting that developed there in the 1940s and 1950s, he was one of the most intellectually focused.[2] The formal language of his style jelled around what he called the "zip," the long vertical element extending from top to bottom of his canvases, with which he defined his compositions. With his spare vocabulary, Newman wished to express universal themes—genesis, unity, and salvation, for example—and to evoke feelings of the sublime in the spectator.

The concept of drawing was important for the artist, and he did not conceive of it as separate from painting: his paintings incorporated the act of drawing. He also made actual drawings on paper, however, which form an important—and in some ways separate—body of work. As Brenda Richardson has noted, Newman made drawings in spurts rather than steadily.[3] He tended to draw when he was not painting, but through drawings he worked out ideas that would become fully realized in painting. A breakthrough in Newman's drawings came in 1945, when the artist moved beyond the biomorphic, surrealist-influenced forms of his previous works on paper and began to use the more minimal vocabulary associated with his painting style, including the zip, which appears first in a 1945 sheet.[4] The Cleveland drawing came at a time of renewed activity for him, and after a decade-long period of not working on paper at all. He had ceased working altogether in 1956–57 (he suffered a heart attack), but in 1958 he began the series of fourteen paintings that would become "The Stations of the Cross" (1958–66), perhaps his greatest achievement. These works are in many ways like large drawings[5]—Newman used unprimed canvas and black and white paint only.

The Cleveland sheet has much in common with the series,[6] though, like all Newman's drawings, it is not a direct preparatory study for any single work. The opposition of a solid black zip[7] at the left with the thin white zip at the right ("drawn" using tape to reserve the white of the paper under painterly brushwork) was established in *First Station* (1958) and further explored in several of the subsequent "Stations." Two of the motifs in the Cleveland sheet are related to his earlier drawings: the "falling form" (the ovoid shape at the left of the white zip), and the "truncated zip" toward the right, both of which are defined by black ink around them. These motifs were common in Newman's drawings from 1945 to 1949,[8] but in his greatest burst of activity in drawing, in the year 1960, the zip became his exclusive concern. In that sense, the Cleveland sheet is a bridge between the early and late periods of his works on paper. CEF

1. Barnett Newman, quoted in Dorothy Gees Seckler, "Frontiers of Space," *Art in America* 50 (Summer 1962), 87.

2. See John P. O'Neill, *Barnett Newman: Selected Writings and Interviews* (New York, 1990).

3. Baltimore et al. 1979–81, 14–17. This is the only study devoted exclusively to Newman's drawing. The Barnett Newman Foundation is preparing the definitive catalogue raisonné of both drawings and paintings, which will include the Cleveland sheet.

4. Ibid., 100–101, no. 34.

5. Richardson in ibid., 19.

6. Richardson notes it is one of the few in Newman's oeuvre to "parallel so closely the basic format of a painting [i.e., *First Station*]" (ibid., 156, under no. 60); she further states that the date of 1959 on the sheet is "curious" in light of the 1958 date of the *First Station* painting and suggests one would have expected this particular drawing to have preceded the painting. However, Cleve Gray clarified the context in which Newman showed him the Cleveland drawing (letter to Brenda Richardson of 13 August 1979; copy in Barnett Newman archives): "To acquaint me with his prior use of black-and-white, Barney then brought out many earlier brush and ink drawings and some recent ones—mine included." Gray felt that the sheet he owned "was one of the few drawings he [Newman] made <u>after</u> the paintings it so closely resembles." Gray's interpretation certainly follows the date Newman inscribed on the work.

7. Note should be made of the condition of the work, which has some visible losses in the black zip at the left. Although in some of his drawings, Newman's zips are broken up intentionally through his exploitation of the texture of the paper, in the Cleveland drawing, solid black seems to have been his intention. The losses are not visible in the reproduction of the sheet that appeared in Plessix 1965, but they are apparent the next time it was published, in Baltimore et al. 1979–81, and so must have occurred in between those dates. The damage appears to have been caused by insect grazing.

8. Richardson defined the development of these motifs in Newman's drawings; see Baltimore et al. 1979–81, passim.

Brush and black ink, on cream
wove paper

533 x 611 mm (21¹⁄₁₆ x 24¹⁄₁₆ in.)

INSCRIPTIONS: signed, lower
right, in black ink: *Barnett
Newman 59*; verso, upper center,
in graphite: *T*; lower left, along
left margin, in graphite: *P-33-
362%*

Purchase from the J. H. Wade
Fund 1986.4

David Smith

Decatur, Indiana, 1906–Bennington, Vermont, 1965

David Smith was the leading sculptor of the American abstract expressionist movement. Also a painter, he disregarded the traditional distinctions between two- and three-dimensional media in pursuit of an aesthetic that combined approaches to both. He conceived his sculptures with a planar organization of metal forms creating a specific point-of-view (front and back, rather than in the round), and he virtually eliminated the division between the sculpture and its base/support. Drawing was integral to Smith's creative process. He made drawings as preparatory studies and as records of sculptures already produced, as well as independently conceived images. He drew in order to analyze forms, to test tones and hues, and to explore subjects and gestural marks, including ideas that he could not develop in three dimensions. He embraced a range of formal languages including figurative expressionism, organic abstraction, and geometric construction.

The Cleveland sheet belongs to a group of drawings known as the "sprays" (c. 1957–early 1960s) which exemplify Smith's additive approach to composition.[1] These drawings developed from his sculpture making process in which he manipulated pieces of steel on large white rectangles painted on his studio floor (which served as a neutral background). Once pleased with a configuration, Smith would tack-weld the pieces together. The flying sparks from the welding process turned the surrounding white areas black, yielding a negative image of the sculpture on the white floor. Similarly, for his spray drawings, Smith placed scraps of metal, paper, and other found objects on a sheet of paper or canvas and sprayed enamel paint from various angles, allowing the support to set the image where the objects blocked the paint.[2] The flatness inherent in the crisp edges of Smith's geometric shapes, such as those in the Cleveland sheet, are offset by the subtle illusion of three dimensions suggested in the controlled leakage of paint along the blurred edges of the masked shapes and in the shadow-like effect of the surrounding paint spray. The sense of atmosphere is also enhanced by the layering of more than one paint color. The absence of objects (which appear in the drawing only as an afterimage) alludes to both the process of making and the passage of time. The ethereal nature of the images emphasizes their origins in Smith's imagination. This method allowed Smith to improvise and articulate more ideas than he could possibly have produced in the more cumbersome process of making sculpture.

Many of the sprays, including the Cleveland drawing, relate to Smith's final sculpture series, the "Cubis" (1961–65). He designed these monumental combinations of cubic forms (ten to twenty feet high) to be placed outdoors where their burnished stainless steel surfaces could reflect color and light and interact with the surrounding landscape. Light dissolves the precise outlines of the sculpture, effectively dematerializing massive form and weight. Smith's fascination with gravity and the appearance of weightlessness is further underlined in his use of precariously balanced shapes. The geometric figures in the related sprays, though smaller in scale, share a similar disembodiment of form, appearing as luminous shapes that simultaneously emerge from and recede into an ambiguous space, while maintaining a precarious equilibrium. Although the images in the Cleveland spray cannot be linked to specific sculptures, a variation on the arrangements of tilted cubes and columnar elements appears in *Cubi XII*, 1963 (fig. 1). SRL

Fig. 1. David Smith. *Cubi XII*, 1963, stainless steel. Hirshhorn Museum and Sculpture Garden, Smithsonian Institution, Washington, Gift of the Joseph H. Hirshhorn Foundation 72.268.

1. Smith's early paintings incorporated collaged elements, and in his sculpture he consistently combined metal shapes with found objects, composing the image around them. The sprays use a similar collage approach, although the objects are then physically removed leaving only visual traces of their existence.

2. See E. A. Carmean Jr., *David Smith*, exh. cat., National Gallery of Art (Washington, 1982), 27–28, as cited in Trinkett Clark, *The Drawings of David Smith*, exh. cat., International Exhibitions Foundation (Washington, 1985), 30–31.

118. *Untitled* (Cubi Study)

1962

Black and blue spray paint, on
cream wove paper

505 x 662 mm (19⅞ x 26⅟₁₆ in.)

Purchase from the J. H. Wade
Fund 1986.19

Ellsworth Kelly

Born Newburgh, New York, 1923

Study for Red Green Blue relates to a painting now at the Walker Art Center in Minneapolis.[1] In the early 1960s, Kelly executed several paintings exploring this color scheme,[2] most of which feature abstract shapes and fall into the category of what Roberta Bernstein has described as "figure/ground" paintings.[3] In *Red Green Blue*, however, the artist developed a composition with inverted, reversed L-shapes around a "kernel"[4] of red. He first explored this idea in a multipanel painting from 1963, *Red Yellow Blue 1*.[5] In it the individual color areas are actually separate panels joined together to form a square, a treatment that emphasizes reading the colors as individual shapes without a figure/ground hierarchy. *Red Green Blue* evolved out of that work: Kelly wanted to substitute green, a secondary color, for the primary yellow used in the earlier work because he was interested in the different statement green would make.[6] He had begun the painting in New York in preparation for an exhibition at the Maeght Gallery in Paris in November 1964. He took it with him to Paris and finished it during his stay there from October to December 1964, when he was working in Joan Miró's studio in Levallois.[7]

Kelly completed the Cleveland sheet, along with three other oil sketches,[8] while he worked on the larger painting.[9] These rapidly executed works allowed him to explore different colors and shapes on a smaller scale. Their overall structure is the same as the large work, but each is a variation on the theme with different proportions and colors. For example, the Cleveland study uses a red that tends more toward orange than the primary red of the painting. As exercises on paper in the study of a related idea, these oil sketches have a distinctly different impact on the viewer than the artist's large-scale works.

Kelly's paintings represent a conscious break with "easel" painting[10]—pictures that present an image contained within the edges of the support. Instead, he creates objects in space that activate the setting in which they exist. In that sense, they do not present a defined space with a foreground and background: the wall on which they are placed acts as the ground. With a work on paper such as *Study for Red Green Blue*, however, the paper becomes the ground, and the placement of the colors on the sheet and their relationship to its edges become elements of the composition. CEF

1. See *Walker Art Center: Painting and Sculpture from the Collection* (New York, 1990), 274–75.

2. Including paintings in San Diego, *Red Blue Green*, 1963, see Diane Waldman, ed., *Ellsworth Kelly: A Retrospective*, exh. cat., Solomon R. Guggenheim Museum (New York, 1996), 146–47, no. 42, repr. in color; Whitney Museum of American Art, *Green, Blue, Red*, 1964, see Lisa Phillips, *The American Century: Art and Culture 1950–2000* (New York, 1999), 146, fig. 229; Metropolitan Museum of Art, New York, *Blue Green Red*, 1962–63, see John Coplans, *Ellsworth Kelly* (New York, 1971) pl. 170; also pl. 176 for a related work; and Stedelijk Museum, Amsterdam, see Coplans, *Ellsworth Kelly*, pl. 164, and Joop M. Joosten,

Twenty Years of Art Collecting: Acquisitions Stedelijk Museum Amsterdam 1963–1984 (Amsterdam, 1984), 226, no. 410 (repr.). According to Roberta Bernstein, Kelly first used a red, blue, and green color scheme in the 1957–58 painting *Mask* and produced at least eight others; see Bernstein, *Ellsworth Kelly at Right Angles, 1964–1966*, exh. cat. (Los Angeles/San Francisco/New York, 1991), 10 n. 4.

3. Roberta Bernstein, "Ellsworth Kelly's Multipanel Paintings," in Waldman, *Ellsworth Kelly*, 44.

4. The term used by Kelly to explain the shape; see *Walker Art Center*, 275.

5. Fondation Maeght, St. Paul de Vence, France; see Bernstein, "Ellsworth Kelly's Multipanel Paintings," 45, fig. 12; the idea of the concentric L-shapes was explored even earlier by the artist, in a 1955 sketchbook from his first stay in Paris; see *Walker Art Center*, 275; another painting that explores this compositional type is *Two Reds, Blue, and Green*, 1963; see William Rubin, "Ellsworth Kelly: The Big Form," *ArtNews* 62 (November 1963), 32 (repr.).

6. Stated by the artist in a telephone conversation with author, 1 November 1999.

7. *Walker Art Center*, 275.

8. According to Kelly, there are only four studies for the Walker painting (conversation with author, 10 December 1999).

9. One of these sketches is reproduced in color in Diane Upright, *Ellsworth Kelly: Works on Paper* (New York, 1987), 123, no. 94 (repr. on cover).

10. See Ellsworth Kelly, "Notes from 1969," in *Ellsworth Kelly Paintings and Sculptures 1963–1979*, exh. cat., Stedelijk Museum (Amsterdam, 1980), 30.

Oil on cream wove paper

759 x 565 mm (29⅞ x 22¼ in.)

WATERMARK: upper right: Arches / FRANCE ; lower right: Arches / FRANCE

INSCRIPTIONS: signed, lower right, in graphite: *Kelly*; verso, signed, lower right, in graphite: *Kelly 1964*; by artist, lower center, in graphite: *Study for Red / Green Blue 1* [1 circled]; by artist, lower left, in graphite: *64.29*; by artist, upper left, in graphite: *1* [circled]

Gift of Mrs. John B. Dempsey 1997.196

Edward (Joseph) Ruscha

Born Omaha, Nebraska, 1937

Edward Ruscha first rose to prominence in the 1960s in Los Angeles as an exponent of Pop art. The *Flag* and *Target* works of Jasper Johns were inspirational to him, influencing much of his early work. Like Johns, Ruscha became interested in how found images with a predetermined structure could be aesthetically transformed by the process of painting them. He was, however, more oriented toward commercial imagery. Unlike Johns, Ruscha used words and advertising logos as found images to structure the visual field of his paintings. In such early works as *Standard Station, Amarillo, Texas* from 1963,[1] he transformed vernacular, commercial architecture into an iconic image, presenting American car culture and commercialism with both precision and irony.

Bronson Tropics, like *Standard Station*, grew out of one of Ruscha's photography projects. He self-published a number of books throughout the 1960s illustrated with offset halftone reproductions of his photographs, works that mundanely recorded particular themes or structures: including *Twentysix Gasoline Stations* (Alhambra, California, 1962); *Various Small Fires and Milk* (Los Angeles, 1964); *Every Building on the Sunset Strip* (Los Angeles, 1966); *Thirtyfour Parking Lots in Los Angeles* (New York, 1967). The commercial architecture and wide, car-oriented spaces of Los Angeles have been important sub-

jects for Ruscha. *Bronson Tropics* derives from one of the illustrations in his 1965 book, *Some Los Angeles Apartments* (fig. 1). Ruscha has described his aim as bookmaker: to create a serial product with "a professional polish, a clear-cut machine finish."[2] Not interested in photography as art, he used it instead to objectify what he saw, to present found images in a serial format that tends to make the subjects equivocal. Ruscha explored these issues further in the series of drawings he made after ten of the photographs in the *Apartments* book project. All the drawings were made on paper of the same shape, size, and color; on each sheet he used the drawing process to simplify and further generalize the images of the photographs. For *Bronson Tropics* he eliminated the cars and window treatments to streamline the façade, changed the cropping of the image to emphasize the perspectival recession, and smoothed out the planes and shadows of the building through his subtle application of powdered graphite in finely gradating tones. Ruscha's considerable technical gifts are an essential part of this work's even-handed precision, giving an intentionally banal subject iconic form. However virtuoso his technique, though, the slickness of presentation is essential to the work's conception and is very much a part of the Pop aesthetic. CEF

Fig. 1. Edward Ruscha. *1323 Bronson*, from *Some Los Angeles Apartments*, 2d ed. (Los Angeles, 1970).

1. Hood Museum of Art, Dartmouth College, Hanover, New Hampshire.
2. John Coplans, "Edward Ruscha Discusses His Perplexing Publications," *Artforum* 3 (February 1965), 25.

Graphite powder and graphite
wash, with point of brush and
graphite wash, on cream wove
paper

355 x 537 mm (13^{15}/$_{16}$ x 22^{9}/$_{16}$
in.)

INSCRIPTIONS: signed, lower left,
in graphite: *Edward Ruscha 1965*

Purchase from the J. H. Wade
Fund 1998.114

1. Parri Spinelli

Navicella, 1410s (recto), *Two Drawings of Ships* (verso). Purchase from the J. H. Wade Fund 1961.38.a,b.

PROVENANCE
Giorgio Vasari (according to Richardson, Ottley, Kurz, Virch, Collobi). Jonathan Richardson Sr., London (Lugt 2183, lower right, in black ink); [his sale, 28 January 1747, no. 68]; Sir Joshua Reynolds, London (Lugt 2364, lower right, in black ink); [probably his sale, 15 March 1798, no. 967]. C. M. Metz, Rome and London. W. Young Ottley, London. [Sale, 11 June 1814, no. 622]; possibly Sir Thomas Lawrence (Lugt 2445, incomplete blind stamp, lower left); Samuel Woodburn, London; [his sale, Christie's, London, 12 June, 1860, no. 1230, as Giotto, *Calling of St. Peter*); Gase, Paris (from annotated sale catalogue). Marquess of Northampton, Castle Ashby; [Thomas Agnew & Sons Ltd., London].

LITERATURE
Richardson/Richardson 1722, 293 (as Giotto); Richardson 1728, 2, 538 (as Giotto); Metz 1790, no. 5 (repr.) (as Giotto); Ottley 1823, no. 9 (repr.) (as Giotto); Lubke 1878, 123; Crowe/Cavalcaselle 1912, 2:45 (as Giotto); Venturi 1922, 49–69, fig. 4 (as circle of Lorenzo Monaco); Popham 1931, no. 1, pl. 1 (as copy from Giotto, in the style of Parri Spinelli); Kurz 1937, 7; Berenson 1938, 2:254, no. 1837K; "Annuaire des Ventes d'Objects d'Art," *Art-Price Annual* 14 (1958–59), 418 (repr.); Bean 1960, under no. 92; *CMA Bulletin* 48 (1961), 251, no. 93, 239 (repr.); Virch 1961, 189–93, fig. 5; Richards 1962a, 168–69, 174; *CMA Bulletin* 50 (1963), 182, 213, fig. 86, no. 86; Bean 1964, under no. 2; CMA Handbook 1966, 1969, 57; Degenhart/Schmitt 1968, 2:281, 637, no. 183; 3:pls. 204a,b (as circle of Lorenzo Monaco); van Regteren Altena 1970, 400; Levenson et al. 1973, 160, figs. 7–11; Zucker 1973, 66–74, 223–39, 330–36, 359–61, 393–94; Collobi 1974, 1:28, 38–39; 2:figs. 46–47 (as Antonio Veneziano); Zucker 1981, 426–41; Bean 1982, 170, under no. 164; CMA Handbook 1991, 61; Köhren-Jansen 1993, 225–29, 268–80, fig. 75; Elen 1995, 182–85, no. 20; Dunbar/Olszewski 1996, no. 20.

EXHIBITIONS
London 1930, no. 1; London 1959a, no. 14; CMA, "Year in Review 1961," 1961; Baltimore 1962, no. 32; CMA 1964; CMA 1965b; CMA 1966–67a; CMA 1968b; Cleveland 1971, no. 50; CMA 1978b; CMA 1986–87b; CMA 1988b; CMA 1991–92b.

2. Fra Filippo Lippi

The Funeral of St. Stephen, c. 1460. John L. Severance Fund 1947.70.

PROVENANCE
Possibly Giorgio Vasari, Arezzo (according to Ragghiante Collobi 1971, who suggested that the sheet may have been part of Vasari's *Libro de'Disegni* based on Vasari's statement in his *Lives* that drawings by Filippo Lippi of the chapel in Prato were in his "book of

* not in Lugt

drawings"). Paul Oswald, Locarno, Switzerland. Carl O. Schniewind, Zurich and Chicago, 1922. Dr. August Maria Klipstein, Berne. Possibly Simon Maller, Budapest, 1935 (letter from Bernard Berenson).

From here forward, the provenance is from a letter (CMA files) to Henry Francis from Dr. F. A. Drey: Ludwig Rosenthal, Berne (Ludwig Rosenthal did not recognize the drawing as one that he had owned when he visited the museum 22 June 1967). Dr. F. A. Drey, Munich, 1936; [Colnaghi, London, 1936]; Colonel Norman Colville, London; [Colnaghi, London]. [Richard H. Zinser, Long Island, New York].

LITERATURE
Francis 1948b, 15–18; Popham/Pouncey 1950, 90, under no. 149; White 1957, 186, pl. 47a; New York 1959a, 53, 351; Werner 1960, 54, no. 1; Berenson 1961, 2:275–76, no. 1387 E–2; Pouncey 1964, 286–87, pl. 35; CMA Handbook 1966, 1969, no. 79; CMA Selected Works [1967], no. 117 (repr.); Degenhart/Schmitt 1968, 2:438, no. 357; 4:pl. 301; Collobi 1971, 18 (repr.); Collobi 1974, 1:60; Borsook 1975, 23–24, fig. 31; Marchini 1975, 219, cat. K, 223, no. 185; CMA 1978b, 90 (repr.); Cadogan 1978, 212–16; Meder 1978, 1:31, 426; 2:fig. 16; Borsook 1980, 104, fig. 15; Cadogan 1980, 25–26, no. 13; Ruda 1982, 152–54, 164–65, fig. 81; Miller 1990a, 158, fig. 15, 173–74; CMA Handbook 1991, no. 63; Ruda 1993, 342–46, pl. 193, 502–3, no. DR2; Pouncy/Di Giampaolo 1994, 269, 283–84, 300, fig. 9; Dunbar/Olszewski 1996, 18–25, no. 4; Roettgen 1996, 305–6, fig. 77.

EXHIBITIONS
CMA 1958–59; New York 1959a, 5–6, no. 3, pl. 4; CMA 1960b; London 1960a, pl. 55; Columbus 1961, 21, no. 73; CMA 1964; Cleveland 1971, no. 51; CMA 1978b; CMA 1986–87b; CMA 1988b (as Domenico Ghirlandaio or his workshop); New York 1997, 18, 90, 94–95, no. 3.

3. Perugino

St. Sebastian, c. 1493. Dudley P. Allen Fund 1958.411.

PROVENANCE
Possibly Comte Josef von Fries (Lugt 2903: "C'est le comte Josef . . . qui doit être considéré comme le fondateur de la collection, par ses nombreuses acquisitions faites en Italie entre 1785–1787"); his brother, Comte Moriz von Fries (Lugt 2903, lower left, in black ink). Possibly A. Ritter von Franck (Lugt 947: mentions the sale of a drawing of St. Sebastian by Perugino for 301M). Prince of Liechtenstein (according to departmental card). [Herbert N. Bier, London].

LITERATURE
van Marle 1923–38, 14:396, 538; *CMA Bulletin* 46 (1959), 212, 231 (repr.); "Accessions of American and Canadian Museums," *Art Quarterly* 22 (1959), 396 (repr.); Moskowitz 1962, 1:no. 241; Richards 1962a, 170–72; CMA Selected Works [1967], no. 123; CMA Handbook 1966, 1969, 83; Camesasca 1969, 124; Aymar 1970, 56; CMA Handbook 1978, 95; Borowitz 1978, 58; Scarpellini 1984, 87; CMA 1991, 67; Dunbar/Olszewski 1996, 84–90, no. 17.

EXHIBITIONS
CMA 1959; CMA 1960b; CMA 1962a; CMA 1964; CMA 1966–67a; Cleveland 1971, no. 53; CMA 1978b; Cleveland 1980, 33–35, fig. 28; 1980–81; CMA 1983f; CMA 1986–87b; CMA 1991–92d; Grand Rapids (Michigan) 1997–98, 149–51, 240–43, no. 4.

4. Fra Bartolommeo

Farmhouse on the Slope of a Hill, c. 1508. Gift of the Hanna Fund, purchase, Dudley P. Allen Fund, Delia E. Holden Fund, and L. E. Holden Fund 1957.498.

PROVENANCE
Probably from a large group of drawings left by Fra Bartolommeo to Fra Paolino da Pistoia (c. 1490–1547), convent of San Marco, Florence; possibly bequeathed by Fra Paolino to Sister Plautilla Nelli (1523–1588), convent of Santa Caterina, Florence (the bird in the lower left, recto, in brown ink is probably the bird Monbeig-Goguel considered to be the collector's mark of Suor Platilla Nelli; see Monbeig-Goguel 1991, 453; for the Platilla Nelli provenance, see also Sotheby's sales catalogue 1957 and Fischer 1989); purchased from the convent of Santa Caterina in 1725 by Cavaliere Francesco Maria Nicolò Gabburri, Florence; William Kent, London. Purchased for private collection in Ireland in 1925; [sold, Sotheby's, London, 20 November 1957, no. 3].

LITERATURE
Jeudwine 1957, 132, fig. 1, 135; Fleming 1958, 227; "International Salesroom," *Connoisseur* 141 (February 1958), 44 (repr.); Frankfurter 1958, 30, fig. 18; Kennedy 1959, 11 n. 30; Berenson 1961, 2:72; Jaffé 1962, 232–33; Richards 1962a, 172–73, fig. 5; Harkonen 1965, 26; CMA Handbook 1966, 1969, no. 86; CMA Selected Works [1967], no. 139 (repr.); von Holst 1971, 18 n. 34; Avery 1972, 97–98; Baer 1973, 15, 50, no. 8, 51 (repr.); Joachim/McCullagh 1979, 24; Denison/Mules 1981, 39; Olszewski 1981, 285, 287; Byam Shaw 1983a, 23, under no. 16; Gordley 1988, 38, 365, under no. 32; Fischer 1989, 301–42, fig. 33; Ellis 1990, 3–7, 13–14, fig. 2; CMA Handbook 1991, 75; Monbeig-Goguel 1991, 453; CMA Masterpieces 1992, 10; Olszewski 1998, 29, 31 fig. 2. Torriti 1998, 204, under no. D1.

EXHIBITIONS
CMA 1958–59; New York 1959a, 16–18, pl. IX, no. 13; CMA 1960b; CMA 1962a; CMA 1964; CMA 1965b; CMA 1966–67a; CMA 1968b; Cleveland 1971, no. 57; Saint Louis 1972, no. 2; CMA 1978b; Cleveland 1979a, 13, 16, 21, 25, 27–28, no. 3; Cleveland 1980, 39–42, no. 42; CMA 1983f; CMA 1986–87b; Rotterdam et al. 1990–92, 107, 375–77, 379, 393–94, no. 111.

5. Raphael

Studies of a Seated Female, Child's Head, and Three Studies of a Baby, c. 1507–8. Purchase from the J. H. Wade Fund 1978.37.

PROVENANCE
Cavalier Benvenuti, Florence (listed in Passavant 1839, no. 145). Grand Duke of Tuscany (probably Leopold II, d. 1870). Emperor Charles I of Austria (d. 1922) (possibly

by descent: Emperor Charles I of Austria was also Grand Duke of Tuscany, and as Charles IV, king of Hungary, was the last ruler of the Austro-Hungarian monarchy [1916–18]). Stefan von Licht, Vienna. Edwin Czeczowiczka; [his sale, Boerner and Graupe, Berlin, 12 May 1930, no. 121, frontispiece]; [Colnaghi (from annotated sales catalogue)]. Robert von Hirsch, Basel; [his sale, Sotheby's, London, 20 June 1978, no. 16].

LITERATURE
Passavant 1839, 489–90, no. 145; Passavant 1860, 428, no. 161; Ruland 1876, 69, no. XXVI, 7, 317 no. XXX; Fischel 1912, 295 (repr.), 299, no. 6; "Rundschau," *Der Cicerone* 22 (1930), 230 (repr.); Fischel 1939, 187, pl. IIIB; Fischel 1941, 366–67, no. 354 (repr.); Fischel 1948, 129–30, 360, no. 138B (repr.); Kurz 1948, 100, fig. 22; Pouncey/Gere 1962, 20, under no. 23; *Art Investment Guide* 6 (1978), 19 (repr.); Sotheby 1978, 11, 46 (repr.); *CMA Bulletin* 66 (1979), 3, 13 (repr.), 45, no. 101; "La Chronique des Arts, Principes Acquisitions des Musées en 1978," *Gazette des Beaux-Arts* 93 (1979), 35, no. 172 (repr.); Olszewski 1981, 285, fig. 7; Gere/Turner 1983, 143, under no. 116; Joannides 1983, 21, 201, 204, 256, no. 273; Knab et al. 1983, 120, 128, 595–96, no. 417 (repr.); Paris 1984, 278–80, under nos. 96–97; Miller 1987, 11–12 (repr.); CMA Handbook 1991, 75; Cordellier/Py 1992, 183–84; Edinburgh 1994, 52, 54, 66, fig. 43.

EXHIBITIONS
CMA 1978b; CMA 1979a; Cleveland 1979a, 8, 16, 54, 86–88, no. 61; Cleveland 1980, 27–29, 34, fig. 20; CMA 1980–81; CMA 1983f; CMA 1986–87b.

6. Michelangelo Buonarroti

Study for the Nude Youth over the Prophet Daniel, 1510–11 (recto), *Figure Studies for the Sistine Ceiling* (verso). Gift in memory of Henry G. Dalton by his nephews George S. Kendrick and Harry D. Kendrick 1940.465.a,b.

PROVENANCE
Pierre Jean Mariette (Lugt 1852, lower left, in black ink); [his sale, Paris, 15 November 1775–30 January 1776, lot 236: "Quarante feuilles de differentes Etudes de compositions, Tombeaux, Figures & Tetes"]. Bürckel family, Vienna; [possibly Prof. Heinrich Bürckel sale, Vienna, 9–10 December 1869]. Dr. Alexander de Frey, Temesvar, Romania; [his sale, Galerie Jean Charpentier, Paris, 12–14 June 1933, no. 7, pl. II (as school of Michelangelo)]. [Wildenstein & Co., Inc., New York]; Henry G. Dalton, Cleveland; by descent to his nephews George S. and Harry D. Kendrick, Cleveland.

LITERATURE
Berenson 1938, 2:213, no. 1599A; 3:figs. 606–16; Frankfurter 1939, 97–119, 180–85; "Cleveland Gets One of Two Michelangelo Drawings in America," *Art News* 42 (March 1943), 8 (repr.); Francis 1943a, 25–26; Francis 1943b, 60, 63; de Tolnay 1945, 2:211, nos. 19A and 20A (as copy, school of Michelangelo); Coe 1955, 2:46, no. 5; CMA Handbook 1958, no. 570; Milliken 1958, 36; Dussler 1959, 208, no. 387 (as Michelangelo follower); Berenson 1961, 2:285, no. 1397B-1, 3:fig. 567; Barocchi 1962, 1:24, 150, 180; Gould 1962, 93; Jaffé 1963, 457–67; CMA Handbook 1966, 1969, 92; Avery 1972, 641; Hartt 1972, 20, 82, no. 79, 86–87, no. 104, 98, 108, 377; Seymour 1972, 60, fig. 120; Gould 1975, 147; de Tolnay 1975, 1:112, no.

147; Goldstein 1976, 158, 161; Olszewski 1976, 12–26; Olszewski 1981, 284–85; Miller 1990a, 147–74; Miller 1990b, 175–78; CMA Handbook 1991, 79; CMA Interpretations 1991, no. 16; CMA Masterpieces 1992, 108; Roos 1998, 121, fig. 12, 122.

EXHIBITIONS
CMA 1945a; CMA 1958–59; CMA 1960b; CMA 1962a; CMA 1964; CMA 1966–67a; Providence 1967, 12; Cleveland 1971, no. 58 (as Alessandro Allori); Tokyo/Kyoto 1976, no. 22; CMA 1978b; Cleveland 1979a, 10, 11, 16, 25, 57, 81–83, no. 55; CMA 1980–81; CMA 1983c; CMA 1983f; CMA 1986–87b; CMA 1988b; CMA 1991f; Cleveland 1997, 111, no. 35.

7. Baccio Bandinelli

Seated Male Nude, c. 1516–20. John L. Severance Fund 1998.6.

PROVENANCE
[Sotheby's, New York, 1 December 1964, lot 170 (as Rosso Fiorentino)]; [W. H. Schab, New York]; [Christie's, London, 8 December 1987, lot 72]; private collection, New York; [Sotheby's, New York, 28 January 1998, lot 69, bought in].

LITERATURE
Ward 1982a, no. 265; Ward 1982b, 32–36, fig. 10; *CMA Annual Report* (1998), 30, 39 (repr.), 50; "Museum Acquisitions: Cleveland Acquires Bandinelli," *Drawing* 20 (Fall 1998), 26 (repr.).

EXHIBITIONS
None known.

8. Domenico Beccafumi

Three Male Nudes, c. 1540–47. Delia E. Holden Fund 1958.313.

PROVENANCE
The Earl of Pembroke and Montgomery; [his sale, Sotheby's, London, 10 July 1917, lot 511 (lot included *Madonna Ascending to Heaven* by Simone Cantarini; sold to Moore according to Cleveland 1979)]; Archibald George Blomefield Russell (Lugt 2770a, lower center, in black ink); [his sale, Sotheby's, London, 9 June 1955, lot 1 (repr.)]; A. Scharf, London (according to Cleveland 1979).

LITERATURE
Sanminiatelli 1956, 59, fig. 32; Richards 1959, 24–29; Vienna 1966b, 134, under no. 206; Sanminiatelli 1967, 133, under no. 4, 138, no. 4; Fern/Jones 1969, 14–15 (repr.); Providence 1973, 72, under no. 75; New York 1984, under no. 19; Gordley 1988, 282, 284–86, 291, 359, no. 20, 363, under no. 26, 405, under no. 103; Hartley 1991, 422–23; Landau/Parshall 1994, 273, 276–77, no. 292; Torriti 1998, 264, under no. D46, 329–30, no. D157, 330, under no. D158.

EXHIBITIONS
Detroit 1959, 26, no. 9B; CMA 1962a; CMA 1964; CMA 1965b; CMA 1968b; Providence 1968, 32–33, no. 1; Cleveland 1979a, 19, 25, 30–32, no. 5, and under no. 7; CMA 1980–81; CMA 1986–87b; Siena 1990, 420, 476, under no. 142, 480, no. 147.

9. Federico Barocci

Cupid Drawing His Bow, c. 1560s. Dudley P. Allen and Delia E. Holden Funds 1969.70.

PROVENANCE
Giuseppe Vallardi, Milan (Lugt 1223, lower left, in blue ink); A. Mouriau, Belgium

(Lugt 1853, lower left, in black ink); [his sale, Paris, 11 March 1858, no. 21]. Unidentified collector's stamp, upper left, black ink. [Nathan Chaikin, until 1969].

LITERATURE
CMA Bulletin 57 (1970), 48, no. 155 (repr.); Miller 1987, 13–14; McCullagh 1991, 62–65.

EXHIBITIONS
CMA 1970a; Saint Louis 1972, no. 8; Cleveland/New Haven 1978, 38–40, no. 11; Cleveland 1979a, 17–18, 55, 60–61, no. 33; CMA 1980–81; CMA 1991f.

10. Federico Barocci

The Flight of Aeneas from Troy, 1587–88. L. E. Holden Fund 1960.26.

PROVENANCE
Possibly Peter Paul Rubens (Jaffé 1963). Pierre Crozat [his sale, 10 April–13 May 1741, lot 248: "Deux grands desseins du Baroche faits à huile en blanc & noir; l'un de l'Incendie de Troyes qui a été gravé par le Carache"]; Agar collection (annotated sales catalogue). Probably Nourri collection [his sale, 24 February–14 March 1785, lot 119: "Enée qui porte son pere Anchise suivi de Creuse & d'Ascagne. Par F. Baroche"]; Langlier(?) collection (annotated sales catalogue). Guichardot collection; [his sale, Paris, 7–10 July 1875, no. 18: "Dessin pour le tableau de l'incendie de Troye. Au lavis d'encre de Chine, de bistre et réhaussé de blanc"]. [E. Aeschlimann, Milan].

LITERATURE
CMA Bulletin 47 (1960), 253, no. 72, 245 (repr.); Richards 1961, 64–65; Olsen 1962, 77–78, 182, under no. 39, fig. 64; Jaffé 1963, 462, fig. 5, 466; CMA Handbook 1966, 1969, 100; CMA Selected Works [1967], 148; Günther 1970, 242; Paris 1974c, 19, under no. 14; Bertelà 1975, 61, under no. 56; Bologna 1975, 152, under no. 166; Günther 1977, 1858 (repr.), 1859; Morford/Lenardon 1977, 326 (repr.); CMA Handbook 1978, 116; Walters 1978, 129–31; De Grazia Bohlin 1979, 328; Emiliani 1985, 236–37, fig. 490; Miller 1987, 3; CMA Handbook 1991, 86; Larsen 1994, 80, fig. 3, 82–84.

EXHIBITIONS
CMA 1960d; CMA 1964; Detroit 1965, 73, no. 63; CMA 1966–67a; CMA 1968b; Los Angeles 1976a, 92, no. 112; Cleveland/New Haven 1978, 9–10, 77–78, no. 54; Cleveland 1979a, 8, 55, 60–63, no. 34; Cleveland 1980, 43–44, fig. 46; CMA 1980–81; CMA 1983f; CMA 1986–87b; CMA 1991f.

11. Giorgio Vasari

The Risen Christ Adored by Saints and Angels, 1566–68. John L. Severance Fund 1991.43.

PROVENANCE
Marchese Ludovico Moscardo, Verona; through Moscardo heirs to Teresa Moscardo, then to last Moscardo heir, Count Mario Miniscalchi-Brizzo; possibly Luigi Grassi, Florence; the Dukes of Savoia-Aosta, Brianza, until 1952 (probably Emanuele Filiberto and by descent to his son Amadeo). Janos Scholz, New York; [anonymous sale, Savoy's, New York, 25 February 1961]; Norbert L. H. Roesler, New York; [Colnaghi]. The Moscardo provenance given here was proposed by Evelyn Karet in "Stefano da Verona, Felice Feliciano, and the First Renaissance Collection of Drawings," *Arte*

Lombarda 124 (1998), 31–52. The traditional provenance of drawings from the Moscardo collection includes the Marquis of Calzolari as one of the former owners (first proposed by Frits Lugt, Lugt supplement 1171b), but according to Coner Fahy (*Printing a Book at Verona: The Account Book of Francesco Calzolari Junior* [Paris, 1993]), that is incorrect.

LITERATURE

del Vita 1929, 98–99; Monbeig-Goguel/ Vitzthum 1968, 92–93, no. 14; Hall 1979, 111–13; van den Akker 1991, 82–85, fig. 128; *CMA Bulletin* 78 (1991), 75 (repr.); "Principales Acquisitions des Musées en 1991," *Gazette des Beaux-Arts* 119 (March 1992), 60, fig. 201.

EXHIBITIONS

Indianapolis 1954, no. 60; South Bend/ Binghamton 1970, 88–89, no. D47; CMA 1991d; CMA 1991f; New York 1991, no. 5.

12. Veronese

Various Sketches of the Madonna and Child, c. 1580 (recto), *Architectural Studies* (verso). Gift of Robert Hays Gries 1939.670.a,b.

PROVENANCE

Dr. Daniel Huebsch, Cleveland; Robert Hays Gries, Cleveland.

LITERATURE

Scholz 1967, 295, no. 34 (as Carlo Saraceni); Rosand 1971, 204, 206–9, fig. 3; Shapely 1973, 3:44 (as attributed to Paolo Veronese); Pignatti 1976, 1:under A5, fig. 722; Cocke 1977, 263 n. 22; Olszewski 1977, fig. 24; Cocke 1984, 21, 28, 71, 95–96, 102, no. 34, 103, 111; Bettagno 1988, 57.

EXHIBITIONS

CMA 1940–41; CMA 1964; CMA 1968b; Birmingham/Montgomery 1972, 7, 44 (repr.); Cleveland, 1979a, 18, 75, 109, 119, 135, no. 109; Cleveland 1980, 27–28, no. 19; CMA 1980–81; CMA 1983f; CMA 1986–87b; Washington 1988–89, 94–95, no. 46; CMA 1991f.

13. Annibale Carracci

Hercules Resting, 1595–97 (recto), *Footed Vessel with Handle* (verso). Leonard C. Hanna Jr. Fund 1997.52.a,b.

PROVENANCE

[Hôtel Drouot, Paris, summer 1997]; [Talabardon, Paris].

LITERATURE

Burlington Magazine 139 (1997), xvii (repr.); *CMA Annual Report* (1997), 26, 32 (repr.), 44; De Grazia 1998, 296–97, fig. 2; "Principales Acquisitions des Musées en 1997," *Gazette des Beaux-Arts* 140 (1998), no. 191; "Powerful and Evocative Master Drawings by Annibale Carracci," *Journal of the Print World* 22 (1999), 49 (repr.); Williams 1999, under no. 11; Bohn 2000, 68, fig. 5; Robertson 2000, 64, fig. 104 (as anonymous follower), 65, no. 34.

EXHIBITIONS

Paris 1997 (Salon du Dessin, Hôtel George V, 23–28 April 1997); Washington 1999–2000, 136–38, no. 34.

14. Guercino

Venus and Cupid, 1615–17. Dudley P. Allen Fund 1925.1188.

PROVENANCE

[Colnaghi].

LITERATURE

Tietze 1947, 114, no. 57, 115 (repr.); Mongan 1949, 72, 73 (repr.); Marangoni 1959, 11, no. 8; Lurie 1963, 217–33; CMA Handbook 1966, 1969, 115; Roli 1968, 77 n. 89; Bologna 1969, 47–48; Roli/Cavina 1972, 4, no. XXI; Bagni 1984, 141–50, 151 (repr.), 165, no. 119; Salerno 1988, under no. 24; Mahon/Turner 1989, under no. 1; Stone 1989, 233–36, fig. 40; Bologna 1991, 28, under no. 3; CMA Handbook 1991, 88; London 1991, 35–36; Stone 1991, 38.

EXHIBITIONS

Buffalo 1935, no. 38; CMA 1938c; CMA 1940– 41; Northampton 1941, no. 42; Worcester 1948, no. 45; Cambridge 1948–49, no. 34; Detroit 1950, no. 21; CMA 1958–59; CMA 1959–60a; CMA 1960b; CMA 1964; Detroit 1965, 101, no. 103; CMA 1966–67a; CMA 1968b; CMA 1980–81; CMA 1983f; Cleveland 1984– 85, 51–52, no. 23; CMA 1986–87b; Cambridge et al. 1991, 4–5, no. 2.

15. Pietro da Cortona

The Idolatry of Solomon, 1622–23. John L. Severance Fund 1987.142.

PROVENANCE

Captain C. Prayer (Lugt 2044, lower right, in red ink). Bernasconi collection; [sale, Christie's, London, 1 April 1987, no. 66].

LITERATURE

CMA Bulletin 75 (1988), 54–55, 68, no. 120; "Museum Acquisitions," *Drawing* 10 (1988), 17 (repr.); CMA Handbook 1991, 88; Merz 1991, 25, 45, 69–71, 145, fig. 99.

EXHIBITIONS

CMA 1988a; CMA 1991f.

16. Pietro da Cortona

Study for the Head of St. Michael, 1633. Leonard C. Hanna Jr. Fund 1996.257.

PROVENANCE

[Anonymous sale, Christie's, London, 28 March 1979, no. 173A (as Francesco Romanelli in catalogue, attribution changed to Pietro da Cortona by date of sale)]; Duke Roberto Ferretti, Montreal; [his sale, Christie's, London, 2 July 1996, no. 47].

LITERATURE

Russell 1979b, 405, fig. 98; Merz 1991, 234 n. 215, fig. 366; Merz 1994, 38–39, fig. 2; Christie's 1996, 31 (repr.); *CMA Annual Report* (1996), 28, 38 (repr.), 47; "International Auction Review," *Drawing* 18 (1996), 60–61 (repr.); "International Auction Review," *On Paper* 1 (1996), 45 (repr.); "Adjugé," *L'Object D'Art* 307 (1996), 22 (repr.); Russell 1996, 22–23 (repr.); "Principales Acquisitions des Musées en 1996," *Gazette des Beaux-Arts* 139 (1997), 60, no. 230.

EXHIBITIONS

Toronto/New York 1985–86, 76–77, no. 32.

17. Domenichino

Temperance, 1628–30. Dudley P. Allen Fund 1964.445.

PROVENANCE

Lord Barrymore. Prof. J. Isaacs; [his sale, Sotheby's, London, 27 February 1964, 10, no. 24 (as seventeenth-century Italian School)]; Gemma Donati (as Porbu in sales catalogue; see letter from Jacob Bean, CMA files).

LITERATURE

CMA Bulletin 52 (1965), 155, no. 119; Francis 1965, 175–77; Spear 1967, 158, no. 27;

Robertson 1967, 37; Vitzthum 1971, 82, fig. VII; Olszewski 1977, 172, fig. 59; Macandrew 1980, 106, under no. 842C; Paris 1981, 169, under no. 102; Spear 1982, 275–78, no. 102.iv, fig. 340.

EXHIBITIONS

CMA 1965b; CMA 1965f; CMA 1968b; Providence 1968, 23–24, no. 5; Saint Louis 1972, no. 26; Cleveland 1979a, 18, 49, 56, 71, no. 42; Cleveland 1980, 56, fig. 65; CMA 1980–81; Ottawa 1982, 79–81, no. 40; CMA 1983f; Cleveland 1984–85, 9, 29, 36–38, 51, 54, no. 14; CMA 1986–87b; CMA 1991f.

18. Bernardo Strozzi

Allegorical Figure, c. 1635. John L. Severance Fund 1953.626.

PROVENANCE

E. Stroiffi; Z. Sagredo; by descent to his nephew Gherardo Sagredo (d. 1738). Unidentified collector's inscription (verso, lower center, in brown ink). [H. M. Calmann].

In addition to the similarity of inscriptions noted in Genoa 1995, further evidence that the Cleveland sheet belonged to the Sagredo collection, the so-called Borghese albums, exists in the remnants of heavy L-shaped tabs on the back of the sheet that are identical to those appearing on other sheets from the Sagredo collection. See W. R. Rearick, "More Veronese Drawings from the Sagredo Collection," *Master Drawings* 33 (1995), 132–44.

LITERATURE

"Accessions of American and Canadian Museums," *Art Quarterly* 19 (1956), 304, 306 (repr.); Comstock 1956, 211–12 (repr.); Francis 1956b, 123–26; CMA Handbook 1958, no. 573; Mahon 1965, 384, 386, fig. 8; Mortari 1966, 61, 99, 219, fig. 474; Matteucci 1966, 7, under no. VI; CMA Handbook 1966, 1969, 115; Meder 1978, 302, fig. 153; Pignatti 1980, 1:24; Lurie 1982, 421, under no. 184; CMA Handbook 1991, 93; Chong 1993, 229; Newcome 1993, 21; Mortari 1995, 201, under no. 532, 223, no. 2; Kravietz in Turner 1996, 29:784.

EXHIBITIONS

Cleveland 1956–57, 41, no. 76; CMA 1959– 60a; CMA 1964; Detroit 1965, 177–78, no. 204; Binghamton 1967, 12, 72, under no. 30, 86– 87, no. 37; CMA 1968b; Los Angeles 1976a, 220, no. 130; Cleveland 1980, 45–46, fig. 51; CMA 1980–81; CMA 1986–87b; CMA 1991f; Genoa 1995, 222, 280, 281 n. 25, 304–5, no. 103, 324.

19. Giovanna Garzoni

Still Life with Birds and Fruit, c. 1650. Bequest of Mrs. Elma M. Schniewind in memory of her parents, Mr. and Mrs. Frank Geib 1955.140.

PROVENANCE

Elma M. Schniewind.

LITERATURE

Bacci 1963, 53, 77, under n. 20, fig. 5 (as Jacopo Ligozzi); Naples et al. 1964–65, 28, under no. 17; Bachmann/Piland 1978, 77 (repr.); Ciardi/Tomasi 1984, 64; Florence 1986–87, 459, under no. 1.259; Casale 1991, 30, 45 (repr.), 47, 90, no. A35 (as after Giovanna Garzoni); de'Medici 1992, 6 (repr.); Trinity Fine Art Ltd. 1998, 36, under no. 16.

EXHIBITIONS

New York 1969, 41–42, no. 36, fig. 18; Los Angeles 1976b, 17, 134 (repr.), 135–36, 342, no. 21; CMA 1986–87a; CMA 1991f.

20. Giambattista Piazzetta

A Flying Angel, 1723–27 (recto), *Studies of Hands Playing Instruments* (verso). Purchase from the J. H. Wade Fund 1938.388.a,b.

PROVENANCE

[Italico Brass, Venice].

LITERATURE

"Cleveland: A Museum's New Acquisitions," *Art News* 38 (September 1940), 13–14; Francis 1940, 108–9; Milliken 1940, 87–93; Jones 1981, 158, 160, fig. 35; Pallucchini/Mariuz 1982, 84–85, fig. 37a; Puglisi 1987, 210, 215 under n. 5; Knox 1992, 110, fig. 86; Venice 1995, 199, fig. 72; Cambridge/New York 1996, 88, under no. 31, 91, fig. 3.

EXHIBITIONS

CMA 1941b; Cambridge 1948; Oberlin 1951, 54, no. 12; CMA 1958–59; CMA 1959–60a; CMA 1965b; Cleveland 1980, 54, fig. 63, 56; CMA 1981c; CMA 1985f; Washington 1983–84, 9, 24, 68, no. 15; CMA 1986–87b; London/Washington 1994–95, 166, 480, no. 87.

21. Giambattista Piazzetta

A Young Woman Buying a Pink from a Young Man, c. 1740. Purchase from the J. H. Wade Fund 1938.387.

PROVENANCE

[Italico Brass, Venice].

LITERATURE

Ravà 1921, 71; Fiocco 1929, 565 (repr.); Ojetti 1932, fig. 244; Pallucchini 1934, 58, 100, fig. 74; "Cleveland: A Museum's New Acquisitions" *Art News* 38 (1940), 13–14; Francis 1940, 108–9; Goering 1941, 261(repr.), 262–63; Mongan 1942, 93; Pallucchini 1943, 22, fig. 53; Benesch 1947, 29, no. 11; Tietze 1947, 172–73, no. 86; Milliken 1950, 908 (repr.); Morassi 1953, 52; Pallucchini 1956, 53, fig. 143; CMA Handbook 1958, no. 572; Milliken 1958, 46; Morassi 1958, 13, under no. 1; Alsop 1966, 23, 28 (repr.); CMA Handbook 1966, 1969, 143; Milan 1971, 15, 23, under nos. 1 and 2, 28, under no. 5; New York 1971, 34, under no. 40; Pallucchini/Mariuz 1982, 131 (repr.), 133, no. D12; Byam Shaw 1983b, 786 n. 6; Pallucchini et al. 1983, 134, under no. 50; Venice 1983, 25, under no. 16, 30, under no. 37; Hale 1985, 100–101; Goldstein 1986, 173–74, fig. 5.75; Westfehling 1986, 110; CMA Handbook 1991, 106; CMA Masterpieces 1992, 126; Alpers 1995, 66 (repr.).

EXHIBITIONS

CMA 1941b; Northampton 1941, no. 51; Cambridge 1948; Detroit/Indianapolis 1952, 44–45, no. 53; Kansas City 1956, no. 157; CMA 1958–59; CMA 1959–60a; CMA 1961a; CMA 1965b; CMA 1968b; CMA 1981c; Washington 1983–84, 10, 30, 37, under fig. 14, 126, under no. 45, 134, no. 51; CMA 1986–87b; London/Washington 1994–95, 145, 147 (repr.), 474, no. 65.

22. Giambattista Tiepolo

The Adoration of the Magi, c. 1740. Dudley P. Allen Fund 1944.474.

PROVENANCE

G. Déloye, Paris (inscribed with initials, lower right, in brown ink, similar to Lugt 756); [*Adoration of the Magi* in Déloye collection, sold 1898; see H. Mireur,

Dictionnaire des Ventes d'Art (Paris, 1911), 7:183]. [Richard H. Zinser, New York].

LITERATURE

Francis 1946, 8–9 (repr. on cover); Millier 1956, 24 (repr., and on cover); Bean 1964, under no. 41; Udine 1965, 63, under no. 17; Cambridge 1970, under no. 21; Russell 1972, 28; Dreyer 1979, under no. 74; Gorizia 1985, 40; Miller 1987, 13–14, 17; Bean/Griswold 1990, 200, under no. 190; CMA Handbook 1991, 109; Eitner et al. 1993, 138–40; London/Washington 1994–95, 498, under no. 109.

EXHIBITIONS

CMA 1948a; CMA 1949a; CMA 1949c; CMA 1954–55; CMA 1958–59; CMA 1959–60a; CMA 1965b; CMA 1968b; CMA 1981d; CMA 1985b.

23. Canaletto

Capriccio: A Palace with a Courtyard by a Lagoon, c. 1750–55. Purchase from the J. H. Wade Fund 1930.23.

PROVENANCE

Purchased from Obach's by Dr. Guy Bellingham Smith, London (letter from Dr. Smith, CMA files); [Frederik Muller, Amsterdam, 6 July 1927, no. 9 (repr.)]; [Thomas Agnew and Sons].

LITERATURE

von Hadeln 1929, 14; Francis 1933a, 23–26; Ames 1938, 53–54, pl. 56; Benesch 1947, 36–37, no. 49; CMA Handbook 1958, no. 576; Constable 1962, 426, under nos. 502 and 504, 557, no. 819, pl. 154; CMA Handbook 1966, 1969, 147; Puppi 1968, 118, under no. 310; Washington et al. 1974–75, 48, under no. 100; Burr 1979, 28, fig. 11, 29; Pignatti 1980, 35; Corboz 1985, 119–20, fig. 126, 283, 286, 288, 291, 306, 311, 350, 356, 359–60, 364, 438, 461, 466, 737, D133; Baetjer/Links 1989, 267, under no. 80; Constable/Links 1989, 463, under no. 502, 464, under no. 504, 606–7, no. 819, pl. 154; CMA Handbook 1991, 111; CMA Masterpieces 1992, 124.

EXHIBITIONS

CMA 1932–33; CMA 1934; New London 1936; New York 1938, no. 57; New Haven 1940, no. 11; CMA 1940–41; CMA 1941b; Northampton 1941, no. 10; CMA 1945b; Northampton 1950; CMA 1953b; CMA 1958–59; CMA 1959–60a; Pittsfield 1960, no. 15; Toronto et al. 1964–65, 133, no. 110; CMA 1968b; CMA 1985b; CMA 1991e.

24. Francesco Guardi

Piazza San Marco, Venice, 1780s. John L. Severance Fund 1951.83.

PROVENANCE

Private collector, Budapest. [Sale, Hôtel Drouot , Paris, 11 June 1911, no. 107]; [Knoedler]. [Cesar M. De Hauke, Paris].

LITERATURE

Byam Shaw 1954, 160, under no. 7; CMA Handbook 1958, no. 577; Francis 1958, 8–13; Venice 1962, 57, under no. 69; Pignatti 1967, no. LIV; Morassi 1975, 135, no. 320; Venice 1993, 90, under no. 24.

EXHIBITIONS

Akron 1952; CMA 1953b; CMA 1958–59; CMA 1959–60a; CMA 1965b; CMA 1985b; Venice 1965, 314, no. 41.

25. Francesco Guardi

A Procession of Triumphal Cars in the Piazza San Marco, Venice, Celebrating the Visit of the Conti del Nord, 1782 (recto), *Three Sketches of Arches* (verso). John L. Severance Fund 1955.164.a,b.

PROVENANCE

Henry Oppenheimer, London; [his sale, Christie's, London, 10 July 1936, no. 93]; Brinsley Ford, London; [his sale, Sotheby's, London, 10 November 1954, no. 39]; [Richard Zinser, New York].

LITERATURE

Byam Shaw 1934, 50 under n. 4; Arnolds 1941, 20; Byam Shaw 1951, 28, 69, no. 43; "Accessions of American and Canadian Museums," *Art Quarterly* 18 (Autumn, 1955), 307; Francis 1958, 8–13; CMA Handbook 1966, 1969, 148; Bortolatto 1974, 130, under no. 687; Morassi 1975, 124, no. 266; Byam Shaw 1977, 5, under no. 1; Biadene 1992, 102, 250 (repr.); Pask 1992, 49, 52 under n. 24; Venice 1993, 192, under no. 69.

EXHIBITIONS

Birmingham, 1951, 19–20, no. 42; CMA 1958–59; CMA 1959–60a; CMA 1965b; CMA 1968b; CMA 1981–82a; CMA 1985b.

26. Giandomenico Tiepolo

The Disrobing of Christ, c. 1785–90. Purchase from the J. H. Wade Fund 1999.5.

PROVENANCE

Luzarches, Tours; Camille Rogier; [sale, Christie's, New York, 13 January 1993, no. 62]; [Stephen Mazoh & Co., Inc., New York]; Martin Kline, Rhinebeck, New York.

LITERATURE

Guerlain 1921, 81–82, pl. 81.

EXHIBITIONS

Udine/Bloomington 1996–97, 82, 175, no. 104.

27. Giandomenico Tiepolo

A Spring Shower, c. 1790s–1804. Purchase from the J. H. Wade Fund 1937.573.

PROVENANCE

[Anonymous sale, Sotheby, Wilkinson, and Hodge, London, 6 July 1920, lot 41: "one hundred and two Carnival Scenes, with many figures"]; [Colnaghi]; [Richard Owen, Paris]. [Italico Brass, Venice].

LITERATURE

"Art Throughout America," *Art News* 37 (1939), 15 (repr.); Francis 1939, 46–49; Tietze 1947, 198, no. 99; Morassi 1953, 53–54, fig. 43; Muraro/Grabar 1963, 211 (repr.); CMA Handbook 1966, 1969, 148; Moore 1968, 91 (repr.); Mariuz 1971, fig. 36; Fehl 1979, 791, fig. 23; Gealt 1979, 136–37 (repr.); Vetrocq 1979, 12, 66 under n. 28, 143, no. 55, 230 (repr.); "Museum and Dealer's Catalogues: Frick Collection" *Print Collectors Newsletter* 11 (1980), 19 (repr.); Washington 1980–81, 20, fig. 2, 85, no. 4; Knox 1983, 145, no. 74; Borowitz 1984, 122, 123, fig. 11; Gealt 1986, 21, 160, no. 68 (repr. frontispiece); Levey 1986, 134, fig. 124; Mariuz 1986, 273, fig. 11; Succi 1988, 303, under no. 10, 322; Wood 1988, 80, fig. 5–4; Pedrocco 1990, 90, no. 39, pl. 39; Fehl 1992, 348, fig. 224; Alpers 1995, 69 (repr.); Paulin/Hutchinson 1996, 77, fig. 4; Wolk-Simon 1996–97, 26, under no. 39, 68, no. 107.

EXHIBITIONS
Paris 1921; CMA 1939b; San Francisco 1940a, 24, no. 99, 43 (repr.); San Francisco 1940b, 99, no. 498; Detroit 1950, no. 50 (repr.); Detroit/Indianapolis 1952, 63–64, no. 82; CMA 1968b; Bloomington/Palo Alto 1979, 17, 82, no. 23, 83 (repr.); CMA 1981d; CMA 1985b; London/Washington 1994–95, 329–30, 505, no. 223; Venice 1995, no. 204; Udine/Bloomington 1996–97, 246, no. 74.

28. Giuseppe Cades

Portrait of a Lady with an Elaborate Cartouche, 1785. John L. Severance Fund 1999.172.

PROVENANCE
Archibald George Blomefield Russell (Lugt 2770a, lower center, in black ink); [Colnaghi]. [Christies, London, 11–13 December 1985, no. 183]; private collection; [Sotheby's, New York, 28 January 1998, no. 60]; [Thomas Williams Fine Art, Ltd, London].

LITERATURE
Caracciolo 1990, 259 no. 69, pl. 9.

EXHIBITIONS
London 1952, no. 43 (as Augustin de St. Aubin).

29. Jusepe de Ribera

St. Sebastian, 1626–30. Delia E. Holden Fund 1997.53.

PROVENANCE
John A. Gere, London; [C. G. Boerner, New York].

LITERATURE
Florence 1967, 26–27, under no. 32; Paris 1967, 12–13, under no. 20; Vitzhum 1970, 81, pl. III; Brown 1972, 6, fig. 7; Naples 1992, 339, under no. 2.20; CMA Annual Report (1997), 26, 45.

EXHIBITIONS
Edinburgh 1972, 37, no. 94, 118 (repr.); Princeton/Cambridge 1973–74, 124, 165, no. 17, pl. 44; New York 1992c, 208–9, no. 96; CMA 1999.

30. Bartolomé Esteban Murillo

Madonna Nursing the Christ Child, c. 1670. Mr. and Mrs. Charles G. Prasse Collection 1968.66.

PROVENANCE
J. de Mons; [Frederick Mont, New York]; Mr. and Mrs. Charles G. Prasse.

LITERATURE
"Accessions of American and Canadian Museums," *Art Quarterly* 31 (Winter 1968), 446, 449 (repr.); Richards 1968, 235–39; CMA Bulletin 56 (1969), 47, no. 91; Iñiguez 1974, 105, fig. 18; Nuño 1978, 105, under no. 217 (repr.); Iñiguez 1981, 160, under no. 164; Richards 1985, 8–9 (repr.); Mena in Turner 1996, 22:347; Brown 1998, 231, fig. 301.

EXHIBITIONS
CMA 1969; Lawrence 1974, 49–50, no. 26, 51, under no. 27, 56, under no. 31 (repr. on cover); Los Angeles 1976a, 207, 212 no. 226; Princeton 1976–77, 31, 162, under no. 77, 164, under no. 78, 165–66, no. 79, 168, under no. 81; Cleveland 1980, 45–48, fig. 53; Madrid/London 1982–83, 61, 216, no. D19.

31. Francisco de Goya

Prostitute Soliciting a Fat, Ugly Man, 1796–97 (recto), *Young Woman Wringing Her Hands over Naked Man Lying in a Thicket* (verso). John L. Severance Fund 1995.15.a,b.

PROVENANCE
Javier Goya; Mariano Goya; Valentín Carderera(?); Federico de Madrazo; Clementi-Vannutelli Collection, Rome. Dorothy Edinburg, Boston; Jo-Ann Edinburg Pinkowitz, John Edinburg, and Hope Edinburg; [sold by them at Sotheby's, New York, 12 November 1987, no. 108]. [Pace Gallery, New York]. [David Carritt Limited/The Artemis Group, London].

On the early provenance of the work, see Gassier 1973, 14–16, and Juliet Wilson-Bareau, "Goya in the Metropolitan Museum," *Burlington Magazine* 138 (February 1996), 102.

LITERATURE
Mariani 1928, 104–7, figs. 7–8; Wehle 1938, 13 ("Girl Mourning Her Dead Lover," "Young Woman Unconvinced"); López-Rey 1953, 1:38–39, 2:vi, figs. 39–40; Sayre 1964, 28, nos. 49–50; Gassier/Wilson 1971, 174, nos. 413–14 (repr.); Gassier 1973, 85–86, 129–30, nos. 58–59 (repr.); Camón Aznar [1980], 15, nos. 49–50; CMA Annual Report (1995), 25, 32 (repr.), 45; "Cleveland Museum of Art Acquires Goya and Benton Drawings," *Drawing* 17 (November 1995–March 1996), 105.

EXHIBITIONS
None known.

32. Anonymous French

A Lady with Three Suitors, c. 1500. John L. Severance Fund 1956.40.

PROVENANCE
Antonio Badile II, Verona (according to Byam Shaw 1983a, 214 n. 1). Ludovico Moscardo, Verona; through Moscardo heirs to Teresa Moscardo, then to last Moscardo heir, Count Mario Miniscalchi-Brizzo; Luigi Grassi, Florence. [Francis Matthiesen, London].

The Moscardo provenance given here was proposed by Evelyn Karet in "Stefano da Verona, Felice Feliciano, and the First Renaissance Collection of Drawings," *Arte Lombarda* 124 (1998), 31–52. The traditional provenance of drawings from the Moscardo collection includes the Marquis of Calzolari as one of the former owners (first proposed by Frits Lugt, Lugt supplement 1171b), but according to Coner Fahy (*Printing a Book at Verona: The Account Book of Francesco Calzolari Junior* [Paris, 1993]), that is incorrect.

LITERATURE
"Accessions of American and Canadian Museums, April–June, 1958," *Art Quarterly* 21 (Autumn 1958), no. 336 (repr.); CMA Bulletin 45 (1958), no. 63 (repr.); CMA Handbook 1958, no. 578 (repr.); CMA Handbook 1966, 1969, 75 (repr.); Wixom 1967, 314–15, no. VII 11 (repr.); Byam Shaw 1983a, 1:214 n. 1; Muylle 1983, 131; Tortora/Eubank 1989, 129, fig. 9.2; Backhouse/Giraud 1994, 138–39 (repr.); "Drawings on Exhibition," *Drawing* 16 (March–April 1995), 131.

EXHIBITIONS
CMA 1958–59; CMA 1966–67b; Lawrence 1969, 43–44, no. 38, pl. LXVIII; Ann Arbor 1975, 97, no. 58, pl. IX; CMA 1988b; CMA 1994–95.

33. Claude Lorrain

Pastoral Scene with Classical Figures, 1640–45. Leonard C. Hanna Jr. Fund 1982.13.

PROVENANCE
Estate of the artist; Queen Christina of Sweden, Rome (traditional provenance); Cardinal Decio Azzolini, Rome; Don Livio Odescalchi, Duke of Bracciano, Rome; Odescalchi family until 1845; Polish collection until 1939; Swiss collection until 1960; [George Wildenstein, Paris]; Norton Simon, Pasadena; [Eugene Victor Thaw, New York].

LITERATURE
Roethlisberger [1961], 5, 21–22, no. 27; Roethlisberger 1962a, 138, 147, no. 5; Roethlisberger 1968, 197–98, no. 461; Roethlisberger 1970, 50–51, fig. 19; CMA Bulletin 70 (1983), 51, no. 41, 50 (repr.); Goldfarb 1983, 165–71; "La Chronique des Arts," *Gazette des Beaux-Arts* 101 (1983), 33, no. 181; "La Chronique des Arts," *Gazette des Beaux-Arts* 115 (1990), 11, fig. 13; CMA Handbook 1991, 96.

EXHIBITIONS
Zurich 1971; Los Angeles 1971, 19, no. 18, 21, under no. 24; Princeton et al. 1973–74, 24, no. 18, 27, under no. 24, 41, under no. 52; CMA 1983a; Cleveland et al. 1989–90, 71–72, no. 30.

34. Claude Lorrain

View of the Acqua Acetosa, c. 1645 (recto), *David and Goliath* (verso). Gift of Mr. and Mrs. Edward B. Greene 1928.15.a,b.

PROVENANCE
Sir Joshua Reynolds(?); Sir Abraham Hume; by descent to Lord Alford; by descent to the Earls of Brownlow; [sale, Sotheby's, London, 14 July 1926, lot 43]; Mr. and Mrs. Edward Belden Greene, Cleveland.

LITERATURE
Francis 1928a, 127–29; Francis 1932, 166; *Pantheon* 16 (December 1935), 421 (repr.); Mongan 1949, 82–82; Shoolman/Slatkin 1950, 28, no. 17; Lee 1954, 36 (repr.); CMA Handbook 1958, no. 589; Milliken 1958, 39; Roethlisberger [1961], 1979 (reprint), 438, under LV185; Roethlisberger 1962c, 157; Mongan 1963, 595, 618, fig. 25; CMA Handbook 1966, 1969, 118; Roethlisberger 1968, 235, no. 591; Spencer 1975, 185, fig. 130; Langdon 1989, 17, fig. 10; "Drawings on Exhibition," *Drawing* 16 (March–April 1995), 132.

EXHIBITIONS
CMA 1932–33; CMA 1934; Buffalo 1935, no. 47; CMA 1941b; Boston 1945, 4; Cambridge 1948–49, no. 42; CMA 1949a; Philadelphia 1950–51, 5, 65, no. 57; Northampton 1952, 6, no. 6; Rotterdam et al. 1958–60, 39, no. 22; CMA 1959–60a; CMA 1965b; CMA 1966–67a; Düsseldorf 1973, 112, under no. 45; CMA 1979b; CMA 1981a; CMA 1982a; Washington 1982–83, 238–39, no. 36; Cleveland 1984–85, 69, under no. 38; Cleveland et al. 1989–90, 72–73, no. 31, 75, under no. 32, 78, under no. 35, 80, under no. 36; CMA 1991e; CMA 1994–95.

35. Charles de La Fosse

St. John the Evangelist, c. 1700–02. Gift of Alida di Nardo in memory of her husband, Antonio di Nardo 1956.602.

PROVENANCE
Unknown eighteenth-century? collector (inventory number with flourish on verso corresponds to similar numbers on other

sheets by artist, see Vercier 2000, 150). Rémi Valdemar Chardey (1813–?), Le Havre; [sale, Hôtel Drouot, Paris, 14–16 May 1877, no. 353: "vingt-six beaux Dessins au crayon noir et à la sanguine: Composition, Têtes d'expression, Études de nus et de draperies" (inscription on verso notes sheet was part of this lot)]. (On Chardey, see Vercier 2000, 136; Hedley 2001 notes that drawings by La Fosse with the Charday provenance are often in poor condition and show water damage. A pronounced water stain on the Cleveland sheet, visible in all previous photographs, was removed for this exhibition.) Mr. and Mrs. Antonio di Nardo, Cleveland.

LITERATURE
Rosenberg 1972, 12, fig. 5; "Drawings on Exhibition," *Drawing* 16 (March–April 1995), 131; Vercier 2000, 136–38, figs. 6, 8; Hedley 2001.

EXHIBITIONS
Appleton 1968, no. 23; Toronto et al. 1972–73, 169, pl. v; Providence 1975, 86–87, no. 23 (repr.); CMA 1982a; CMA 1982–83b; CMA 1988b; CMA 1994–95.

36. François Boucher
Fountain with Two Tritons Blowing Conch Shells, c. 1736. John L. Severance Fund 1952.529.

PROVENANCE
Possibly Gabriel Huquier; [his sale, 1771, no. 89: "Quatorze desseins de fontaines, cartouches &c. par *Boucher*"]. Probably Marmontel; [his sale, Drouot, Paris, 25–26 January 1883, no. 44: "Projet de fontaine. Crayon. Haut., 35 cent., larg.; 22 cent."]. Possibly "M[onsieur] S."; [his sale, Paris, 1 June 1896, no. 2: "Projet de Fontaine. Pierre noire rehaussée de blanc"]. Franz Lederer (according to Washington/Chicago 1973–74, 38); [Erich Lederer, Geneva].

Mention should be made of the group of drawings sold in the sale of M. Rochaz (Paris, 11 February 1856), where four drawings described as fountain designs by Boucher in "encre de Chine, exécutés à la plume et teintés de couleur" are listed under lot 3. The composition of the Cleveland drawing is clearly described ("Dans le second, ce sont des dauphins qui soutiennent dans une vasque des tritons qui lancent de l'eau par leurs conques"). However, the disparity of media suggests the Rochaz work was possibly a copy after the Huquier print. The description of it as "tinted with color" does not suggest a drawing by Boucher.

LITERATURE
Michel [1906], 141, no. 2554? (refers to the drawing listed in the Marmontel sale, 1883); "Accessions of American and Canadian Museums," *Art Quarterly* 16 (Winter 1953), 353; Ananoff 1966, 249, no. 968? ("Projet de Fontaine"); CMA Handbook 1966, 1969, 135 (repr.); Ananoff/Wildenstein 1976, 11, fig. 22; CMA Handbook 1978, 177 (repr.); Jean-Richard 1978, 274, under no. 1096.

EXHIBITIONS
CMA 1959–60a; Minneapolis 1961, 18, no. 6, pl. I; Toronto et al. 1972–73, 136, no. 12, pl. 85; Washington/Chicago 1973–74, 38, no. 29; CMA 1981c; Tokyo/Kumamoto 1982, 189, 245, no. 84, 113 (repr.); CMA 1986–87c; CMA 1988b; CMA 1989c; CMA 1994–95.

37. François Boucher
The Departure of Jacob, c. 1755. Delia E. Holden and L. E. Holden Funds 1981.58.

PROVENANCE
[possibly sold, Drouot, Paris, 3–5 May 1858, 48, no. 630: "Le Pâtre, sa Famille et son Troupeau au repos, beau dessin à l'encre de Chine lavé au bistre"]. Marius Paulme, 1905 (according to Agnew's; label from an old backing in CMA files confirms Paulme provenance); Mme D., Paris (according to Ananoff/Wildenstein 1976).

LITERATURE
Ananoff/Wildenstein 1976, 1:171–72, under no. 34, fig. 222; *CMA Bulletin* 68 (1982), 41, 49, 80, no. 64 (repr.); Goldfarb 1984, 81–89 (repr.); Laing 1986, 61, under n. 3; Amiens 1997–98, 50, under no. 1 (as belonging to Collection de Mme D., Paris).

EXHIBITIONS
London 1977, no. 32 (repr.); CMA 1982a; CMA 1988b; CMA 1989c; CMA 1994–95.

38. François Boucher
The Presentation in the Temple, c. 1770. Gift of Leonard C. Hanna Jr. 1925.1005.

PROVENANCE
Probably Blondel d'Azincourt [his sale, Paris, 18 April 1770, no. 61: "Une Présentation au Temple: dessin très spirituel, à la plume, par *M. Boucher*: hauteur 11 pouces 3 lignes, largeur 7 pouces 3 lignes"]; to Chariot for 58.19 livres (annotated catalogue in Rijksbureau voor kunsthistorische en ikonografische Documentatie, The Hague); [possibly Chariot sale, Paris, 28 January 1788, no. 128: "La Présentation au Temple, très-beau dessin à la plume, lavé de bistre & de sanguine, dans le stile de Rembrandt. Hauteur 14 pouces, largeur 10 pou. De la vente de M. Baudoin, Peintre"]; [Chariot drawing sold to Basan for 34 livres (annotated copy of catalogue in library of the Institute de France, Paris)]. Jan Baptist de Graaf, Amsterdam (Lugt 1120, lower left, blindstamp). Possibly Tripier-LeFranc [his sale, Paris, 5–7 June 1883, 12, no. 45: "La Presentation au Temple. Plume et sepia"]. John Postle Heseltine, London (Lugt 1507, verso, lower right, in black ink). [Richard Owen, Paris]; Leonard C. Hanna Jr., Cleveland.

LITERATURE
Heseltine 1900, 25, no. 16; Michel [1906], 45, no. 819; Heseltine/Guiraud 1913, no. 4 (repr.); Sizer 1926, 5–7; Houghton/Bouchot Saupique 1958, under Boucher (repr.); Ananoff 1966, 175, no. 651; Sérullaz 1968, under no. 50; Paris 1971, 104, under no. 113; Toronto et al. 1972–73, 138, under no. 14; Ananoff/Wildenstein 1976, 311, under no. 686, fig. 1788; Ananoff/Wildenstein 1980, 143, under no. 724; *The American Federation of Arts Exhibitions Program 1999* (New York, 1999) 60 (repr. in color).

EXHIBITIONS
New York 1914, no. 4; CMA 1932–33; Palm Beach 1952–53, no. 16; Rotterdam et al. 1958–60, 48, no. 37, pl. 46 [no. 37, pl. 52, French ed.]; 46, no. 37, pl. 46, English ed.]; CMA 1934; CMA 1959–60a; Washington/Chicago 1973–74, 129, no. 99; CMA 1965b; CMA 1979b; CMA 1981c; CMA 1982a; CMA 1982–83b; CMA 1994–95.

39. Maurice Quentin de La Tour
Jacques Dumont, called Le Romain, c. 1742. John L. Severance Fund 1983.89.

PROVENANCE
Camille Marcille; [his sale, Drouot, Paris, 6–7 March 1876, no. 152: "Portrait de Dumont le Romain. Il est vu de trois quarts, regardant à droite, et coiffé d'un fichu noué au haut du front. Dessin sur papier bleu au crayon noire rehaussé de blanc. H., om, 30. L., om, 20."; purchased by "Groult" for 300 F (annotated copy in Frick Library, New York)]. Edmond and Jules de Goncourt (Lugt 1089, stamped twice, lower right); [Goncourt sale, Paris, 15–17 February 1897, no. 157: "Il est vu de trois quarts, tourné à droite, un mazulipatan noué sur la tête. Préparation sur papier bleu, aux trois crayons"]; bought by Paulme for 2,100 F (annotated catalogue); Marquis de Biron; [his sale, Galerie Georges Petit, Paris, 9–11 June 1914, no. 38 (repr.), for 11,500 F]. Gaston Le Breton; [his sale, 2 July 1922, Galerie Georges Petit, Paris, no. 91, pl. IX]; purchased by Ducrey for 14,000 F (according to Launay 1991); private collection, 1935 ("A Mme X," in Copenhagen 1935, 86, no. 276); [Sotheby's, London, 18 November 1982, no. 50, 43 (repr.)]; [David Carritt, Ltd., London.].

LITERATURE
Goncourt/Goncourt 1867, 359; Burty 1876, 3, under no. 11; Goncourt/Goncourt 1880, 1:285; Goncourt 1881, 103; Goncourt/Goncourt 1902, 1:408–9 (for other editions of this publication, see Launey 1991, 350, 527); Bautier 1921, 661–62 (repr.); Besnard/Wildenstein 1928, 140, no. 119, fig. 210; Bouchot-Saupique 1930, 30, under no. 44; Paris 1949, 18, under no. 32; Bury 1971, (opp. pl. 49); Monnier 1972, under no. 64; *CMA Bulletin* 71 (1984), 73–74, no. 164 (repr.); Richards 1984; Launay 1991, 66, 86, 350–51, no. 173, fig. 15; New York 1996, 95.

EXHIBITIONS
Copenhagen 1935, 86–87, no. 276; CMA 1983–84b; CMA 1984b; CMA 1988b; CMA 1994–95.

40. Charles-Nicolas Cochin the younger
Funeral for Marie-Thérèse of Spain, Dauphine of France, in the Church of Notre Dame, Paris, on 24 November 1746, c. 1746. John L. Severance Fund 2000.2.

PROVENANCE
Private collection, France (according to Didier Aaron, Inc.); [Didier Aaron, Inc.].

LITERATURE
None known.

EXHIBITIONS
None known.

41. Jean-Baptiste Oudry
Wild Sow and Her Young Attacked by Dogs, 1748. Andrew R. and Martha Holden Jennings Fund 1997.191.

PROVENANCE
Nijman (Neyman), Amsterdam [his sale ("M. Neyman"), Paris, 8–11 July 1776, no. 613: "Une laye entourée de six marcassins, & attaquée par six gros dogues; à la plume & au bistre. 19 pouces sur 14 de haut."]; purchased by Fouquet for 80 livres (annotated copy of sale catalogue in Doucet Library, Paris).

Fäsch family (not stamped; according to subsequent owner). [Private collection, Switzerland].

LITERATURE
Locquin 1912, 125, no. 675; Opperman 1977, 738, no. D612; Paris 1982–83, 204, under no. 110; *CMA Annual Report* (1997), 32 (repr.), 44; "Cleveland Acquires Oudry and Long," *Drawing* 19 (Winter–Spring 1998), 101 (repr.); "Principales Acquisitions des Musées en 1997," *Gazette des Beaux-Arts* 131 (March 1998), 51, no. 204.

EXHIBITIONS
None known.

42. Gabriel de Saint-Aubin

Costumed Dancers Performing in a Garden Tavern, c. 1760. Purchase from the J. H. Wade Fund 1966.124.

PROVENANCE
John S. Thacher, Cambridge, Massachusetts, and Washington (listed as owner in Tietze 1947, 216; letter in CMA curatorial files confirms he still owned the work in 1951). (Most of Thacher's collection is now in the Morgan Library, New York; see Stephanie Wiles, "The John S. Thacher Bequest," in Charles Ryskamp, ed. *Twenty-First Report to the Fellows of the Pierpont Morgan Library 1984–1986* [New York, 1989], 311–13.) "Member of the Rothschild family" (by 1966, letter from Saemy Rosenberg, CMA archives); [Rosenberg & Stiebel, Inc., New York].

LITERATURE
Parker 1938, 58, pl. 60; Tietze 1947, 216–17, no. 108 (repr.); Cailleux 1960, iii–iv; *CMA Bulletin* 53 (1966), 225, 283, no. 102 (repr.); CMA Handbook 1966, 1969, 139 (repr.); "La Chronique des Arts," *Gazette des Beaux-Arts* 68 (Supplement for October 1966), 5, fig. 2; Stechow 1966, 43–44; Richards 1967; CMA Handbook 1978, 183 (repr.); McCullagh 1981, 183–85, fig. 156; CMA Handbook 1991, 114 (repr.).

EXHIBITIONS
New York 1939, 17, no. 7 (repr.); Pittsburgh 1951, no. 144; CMA 1966; Toronto et al. 1972–73, 208, no. 130; Middletown/Baltimore 1975, 76–77, no. 41, 87 (repr.); CMA 1982–83b; CMA 1983f; CMA 1988b; CMA 1989c; CMA 1994–95.

43. Jean-Baptiste Greuze

Head of Caracalla, c. 1768. Purchase from the J. H. Wade Fund 1999.48.

PROVENANCE
M and Mme Jules Porges (according to Spink-Leger Pictures, London); Countess Fitzjames, Paris (ibid.); [Schab Gallery, New York (according to Hartford et al. 1977)]. Julian Raskin, Scarsdale, New York, acquired in 1956 (according to Spink-Leger Pictures, London); and by descent through family; [Spink-Leger Pictures, London].

LITERATURE
Hartford et al. 1977, 148, under no. 70 (as the drawing formerly with the Schab Gallery, New York); "A Selection of 1999 Museum Acquisitions," *Apollo* 150 (December 1999), 33 (repr.).

EXHIBITIONS
None known.

44. Jean-Baptiste Greuze

The Guilty and Repentant Daughter, early 1770s. Leonard C. Hanna Jr. Fund 1989.46.

PROVENANCE
C. Magne, Marseilles; [his sale, Drouot, Paris, 25 January 1902, no. 21: "La Fille coupable et repentie. Important dessin à l'encre de Chine. Haut., 48 cent.; larg., 64 cent."]. ["The Property of a Lady," Christie's, London, 4 July 1984, no. 121]; [Kate de Rothschild—Didier Aaron, London].

LITERATURE
Duncan Bull, "Exhibition Reviews: London Old Master Drawings," *Burlington Magazine* 131 (January 1989), 49 (repr.); Paris 1989, 240, under no. 99, fig. 1; *CMA Bulletin* 77 (1990), 47–48, 75, 151 (repr.); "Recent Acquisitions at the Cleveland Museum of Art 1: Departments of Western Art," *Burlington Magazine* 133 (January 1991), 63, fig. XI; CMA Handbook 1991, 116 (repr.); CMA Masterpieces 1992, 132 (repr.).

EXHIBITIONS
New York/London 1988, no. 41; CMA 1990a; CMA 1994–95.

45. Hubert Robert

Vaulted Staircase, c. 1770–79. Gift of Leonard C. Hanna Jr. 1926.504.

PROVENANCE
Possibly Count Alexandre Stroganov (artist's inscription on sheet). Baron Dominique Vivant-Denon, Paris (Lugt 779, lower right, in black ink); [his sale, Paris, Pérignon, 1–19 May 1826, 178, no. 736, as Fragonard: "Un dessin à la plume et au lavis, au bistre, représentant un escalier sous des voûtes."]. [Richard Owen, Paris].

LITERATURE
Portalis 1889, 300, as Fragonard; Sizer 1927; CMA Handbook 1928, 55 (repr.); Duvivier 1928, 77 (repr.); Francis 1932, 167; Shoolman/Slatkin 1950, 96–97, pl. 53; Boucher/Jaccottet 1952, 177, pl. 102; Francis 1956a, 9; CMA Handbook 1958, no. 592 (repr.); Milliken 1958, no. 129; Ananoff 1961–70, 3:109, no. 1527, fig. 408, as Fragonard; Berckenhagen 1970, 333, under no. 6590; Deriabina 1999, 95; Paris 1999–2000, 515 (as Fragonard).

EXHIBITIONS
CMA 1932–33; CMA 1934; Buffalo 1935, no. 87 (repr.); Baltimore 1939–40, no. 62 (no catalogue); Detroit 1950, no. 45; Palm Beach 1952–53, no. 29; CMA 1958–59; CMA 1959–60a; Washington 1978–79, 112–13, no. 43 (repr.); CMA 1979b; CMA 1981a; CMA 1981c; CMA 1982a; CMA 1983c; CMA 1989c; CMA 1994–95.

46. Pierre-Henri de Valenciennes

Classical Landscape, 1779. Purchase from the J. H. Wade Fund 1980.91.

PROVENANCE
[Heim Gallery, London]. [Shepherd Gallery, New York]; [Jean-Pierre Selz, New York].

LITERATURE
CMA Bulletin 68 (1981), 164, 192, 217, no. 245 (repr.).

EXHIBITIONS
London 1975a, no. 121 (repr.); New York 1979b, no. 134 (repr.); CMA 1981b; CMA 1982a; CMA 1988b; CMA 1994–95.

47. Jean-Honoré Fragonard

Invocation to Love, c. 1781. Grace Rainey Rogers Fund 1943.657.

PROVENANCE
The mountmaker François Renaud (Lugt 1042; dry mark, on mount, lower right). Possibly M. Sireul; [his sale, 3 December 1781, no. 241: "une jeune fille invoquant l'Amour, au pied de sa Statue; le fond présente une intention de Paysage"]. Possibly François-Martial Marcille; [his sale, 4–7 March 1857, under no. 416: "prière à l'amour et scène de famille 2 dessins lavés au bistre"]. Pierre Désiré Eugène Franc Lamy (according to letter from Félix Wildenstein, CMA files); [acquired from the Lamy collection about 1922 by Wildenstein & Co., Inc., New York (ibid.)]; Grace Rainey Rogers, New York (purchased from Wildenstein in 1922 according to ibid.); [her sale, Parke-Bernet Galleries, New York, 18–20 November 1943, no. 46].

The provenance of this work has been confused in the literature because of a similar sheet in the Art Museum, Princeton University. Two eighteenth-century sale catalogues could refer to either work: that of M de Sireul (Lugt 3329) and an anonymous catalogue for 24 March 1783 (experts: Le Brun and Boileaux), under no. 39 (according to O'Neill 1981). The Princeton drawing, which measures 35.4 x 46.3 cm, has been connected to the Sireul sheet (recorded as measuring 35.1 x 45.9 cm) as their dimensions correspond fairly closely, but whether the two are the same is difficult to know with absolute certainty. The drawing in the Marcille sale could also have been either sheet. The Princeton drawing is traceable directly back to the Walferdin sale (Ross 1983). Most of the literature on the Cleveland sheet lists the French painter Pierre-Désiré-Eugène Franc Lamy (Lugt 949b) as a previous owner and either states or implies that his mark is present on the sheet's mount (see Grace Rainey Rogers sale, Parke Bernet Galleries, New York, 18–20 November 1943, no. 46; Rotterdam et al. 1958–60; Los Angeles 1961; Ananoff 1961–70; Toronto et al. 1972–73; Providence 1975; Washington et al. 1978–79; Tokyo/Kyoto 1980; Los Angeles et al. 1993–94). His mark is not present, however, and there are no entries in any of Lamy's sale catalogues that correspond with the Cleveland sheet. He is known to be the owner through letters from Félix Wildenstein in the CMA files.

LITERATURE
Portalis 1889, 305 (may refer to Princeton drawing); Francis 1945, 88, 91 (repr.); CMA Handbook 1958, no. 590 (repr.); Ananoff 1961–70, 4:154, no. 2422; Vermeule 1964, 129, fig. 108; CMA Handbook 1966, 1969, 141 (repr.); CMA Selected Works [1967], 189 (repr.); Watrous 1967, 80–82 (repr.); Princeton 1968, 19, under no. 7; Praeger Encyclopedia of Art 1971, 703 (repr.); CMA Handbook 1978, 186 (repr.); Russell 1979a, 29 (repr.); Leach 1979, 215–26, 379, fig. 77; Williams 1979, 75 (repr.); O'Neill 1981, 1:63–64, under no. 55; Ross 1983, 18; Ashton 1988, 217–18; Cuzin 1988, 211, fig. 262; CMA Handbook 1991, 117 (repr.).

EXHIBITIONS
Montreal 1950, 15, no. 73; CMA 1958–59; Rotterdam et al. 1958–60, 54, no. 51, pl. 60 [no. 51, pl. 67, French ed; 53–54, no. 51, pl. 60, English ed.]; CMA 1959–60a; CMA 1961a;

Los Angeles 1961, 60, no. 46; Toronto et al. 1972–73, 159–60, no. 50; Providence 1975, 174–75, no. 56 (repr.); Washington et al. 1978–79, 12, 128–29, no. 50; Tokyo/Kyoto 1980, 77, no. 156; CMA 1981c; CMA 1982a; CMA 1982–83b; Paris/New York 1988, 544–46, no. 282; CMA 1989c; CMA 1991e; Los Angeles et al. 1993–94, 156–57, no. 22 (repr.); CMA 1994–95.

48. Anne-Louis Girodet de Roussy-Trioson

The Meeting of Orestes and Hermione, c. 1800. Leonard C. Hanna Jr. Fund 1989.101.

PROVENANCE
Pierre Didot l'Aîné (1761–1853); his brother, Firmin Didot (1764–1836) [a mention in the 1824 book catalogue by Van Praet suggests that the drawing was still in Firmin Didot's possession that year; see note 3 in entry no. 48 here, p. 124]. Marie de Luynes, Château de Dampierre, until 1988.

LITERATURE
Annales 1809, 71, 162, pl. 45 (reprinted 1815); Coupin 1829, 1:xxxix, lxxviij, 2:343; Mariemont 1979, 11, under no. 2.a; Osborne 1985, 37, 120–21; *CMA Bulletin* 77 (1990), 48, 50, 74, no. 149 (repr.).

EXHIBITIONS
Paris 1800, no. 170.2; CMA 1990a; New York 1990c, no. 17 (repr., color and black-and-white); Los Angeles et al. 1993–94, 37, 216–17, no. 55 (repr.).

49. Théodore Géricault

Fighting Horses, c. 1820. Charles W. Harkness Endowment Fund 1929.13.

PROVENANCE
Possibly Anatole Demidoff; [his sale? Drouot, Paris, 13–16 January 1863, no. 58: "Un Marché aux chevaux. Aquarelle"]. The Marquess of Hertford (inscribed on an old label); by descent to: Sir Richard Wallace; by descent to: Lady Wallace (Hertford House inventory of 1890); by descent to: Sir John Murray Scott; [his sale, 5 Connaught Place, Marble Arch, London (conducted by Phillips, Son & Neale), 9 February 1914, no. 446: "Wild Horses; and Horses in a Stable (a pair)"]; Ernest Leggatt (letter from Guy Bellingham Smith, CMA files); Dr. Guy Bellingham Smith (letter in CMA files); [his sale, Frederik Muller & Cie, Amsterdam, 1927, no. 38: "Combat de chevaux. Au centre, un grand cheval blanc; à gauche et à droite, des chevaux bruns et autres aux fond. Aquarelle.–Haut. 21,5, larg. 29,5 cent"]. [Gustav Nebehay, Berlin].

LITERATURE
Francis 1933b, 111–13 (repr. opp. p. 119); Francis 1937, 24; Berger 1946, 27, no. 24 (repr.); Winterthur 1953, 27, under no. 47; Eitner 1954, 259; Giulia Veronesi, "Saluto alla Francia," *Emporium* 122 (September 1955), 118 (repr.); Claude Roger-Marx, "De David à Toulouse-Lautrec," *Le Jardin des Arts* 7 (May 1955), 396, 400; CMA Handbook 1958, no. 598 (repr.); Zurich 1958, 84, under no. 107; Eitner 1960, 27, under nos. 21, 22; Moskowitz 1962, 3:no. 727 (repr.); CMA Handbook 1966, 1969, 168 (repr.); CMA Selected Works [1967], no. 202 (repr.); Brachert et al. 1973, 58, under no. 10; Grunchec 1978, 101, under no. 98; CMA Handbook 1978, 206 (repr.); Eitner 1980, 206; Grunchec 1982, 94–95 (repr.); Ingamells 1986, 301, no. 139;

CMA Handbook 1991, 125 (repr.); Noël 1991, 66 (repr.); Bazin 1992, 69, 214, no. 1657 (repr.); CMA Masterpieces 1992, 141; "Drawings on Exhibition," *Drawing* 16 (March–April 1995), 131; Paris/Cambridge 1997–98, 221, under no. E.9.

EXHIBITIONS
Bethnal Green 1872–75, 48, no. 735; London 1922, 18, no. 52; CMA 1932–33; CMA 1935; CMA 1937a; CMA 1942a; CMA 1943b; San Francisco 1947, 22, no. 22; Minneapolis 1952, no. 35; Paris 1955, [78], no. 75, pl. 12; CMA 1956b; CMA 1958–59; CMA 1959–60a; Minneapolis/New York 1962, [31], no. 48, pl. 18; CMA 1965b; CMA 1965–66; New York 1968, 56, no. 72; Los Angeles et al. 1971–72, 107, no. 65; CMA 1979b; CMA 1981a; CMA 1983b; New York et al. 1985–86, 122–23, 199, no. 59; CMA 1988b; San Francisco 1989, 64, no. 48; Paris 1991–92, 393, no. 248, pl. 353, 224, also mentioned 400 under no. 277; CMA 1994–95.

50. Jean-Auguste-Dominique Ingres

Madame Désiré Raoul-Rochette, 1830. Purchase from the J. H. Wade Fund 1927.437.

PROVENANCE
Désiré Raoul-Rochette (husband of sitter, to whom drawing is inscribed); by descent through Raoul-Rochette family: the sitter, Mme Désiré Raoul-Rochette (d. 1878); her grandson, Raoul Perrin (d. 1910); his widow, Mme Raoul Perrin (d. 1912); her son, Edmond Perrin; sold by Edmond Perrin during World War I. [Wildenstein & Co., Inc., New York].

All this information is from Naef 1979, 5:162. For an explanation of the descent of Ingres portrait drawings within the Raoul-Rochette family, see Naef 1963b, 20, whose source was the great grandson of Désiré Raoul-Rochette, André Perrin.

LITERATURE
Blanc 1870, 239; Delaborde 1870, 310, no. 398; Montesquiou 1897, 45; Lapauze 1911, 281 (repr.), 286; CMA Handbook 1928, 56 (repr.); Francis 1928b, 27–29 (repr. on cover); Hourticq 1928, 72 (repr.); Gibson 1929, 4–5 (repr.); Zabel 1929, 115; Zabel 1930, 381–82, 374 (repr.); Francis 1932, 168–69; Francis 1948a, 37; Alazard 1950, 84, pl. LXI [Italian edition: 72, pl. LXI]; CMA Handbook 1958, no. 595 (repr.); Milliken 1958, 49 (repr.); Naef 1963a, 9; Naef 1963b, 17; CMA Handbook 1966, 1969, 165 (repr.); CMA Selected Works [1967], 201 (repr.); Schlenoff 1967, 379; Moore 1968, 90–91, fig. 1; Mongan 1969, 148, fig. 28; Delpierre 1975, 150–51, fig. 5; Pansu 1977, 170–71, pl. 62; CMA Handbook 1978, 204 (repr.); Naef 1979, 3:98–99, fig. 2, 5:162, no. 334 (repr.); Miller 1987, 9–10 (repr.); Tortora/Eubank 1989, 224–25, fig. 13.7; CMA Handbook 1991, 127 (repr.); Innsbruck/Vienna 1991, 30, under no. 1.2; CMA Masterpieces 1992, 140 (repr.); Lurie 1994, 3, fig. 1; Ribeiro 1999, 72–3, 179, fig. 50.

EXHIBITIONS
Paris 1867, 97, no. 573; Paris 1911, no. 138; CMA 1929a, 159; CMA 1932–33; CMA 1941b; CMA 1942a; CMA 1943b; San Francisco 1947, 18, no. 12 (repr.); CMA 1948a; CMA 1956b; CMA 1958–59; CMA 1961a; New York 1961, 41, pl. 39; CMA 1965b; CMA 1965–66; Cambridge 1967, 140–41, no. 66 (repr.); Paris 1967–68, 220–21, no. 155 (repr.); CMA 1979b; CMA 1983f; Louisville/Fort Worth 1984, 146, 224, no. 73 (repr.); CMA 1988b; CMA 1994–95.

51. Edgar Degas

Angel Blowing a Trumpet, 1857–59. Gift of The Print Club of Cleveland 1976.130.

PROVENANCE
Monsieur Romanelli (according to Philippe Brame, letter in CMA files); [sale "Le tout appartenant à Monsieur R . . .," Drouot, Paris, 21 November 1936, no. 8 (repr.) (according to Brame letter, this was Monsieur Romanelli sale)]. Prof. François, Lyon (according to Philippe Brame, letter in CMA files); [Hector Brame-Jean Lorenceau, Paris].

LITERATURE
CMA Bulletin 64 (1977), 41, 52, 75, no. 53 (repr.); CMA Handbook 1978, 213 (repr.); Nathanson/Olszewski 1980; Thomson 1988, 36–39, 234, fig. 34; CMA Handbook 1991, 131 (repr.); Turner 1991, 31 (repr.); Print Club of Cleveland 1994, 82 (repr.).

EXHIBITIONS
CMA 1977; CMA 1979–80; CMA 1994–95.

52. Edgar Degas

Sheet of Studies and Sketches, 1858. John L. Severance Fund 1951.430.

PROVENANCE
Estate of the artist (Lugt 658, lower left, in red ink; Lugt 657, verso, upper center, in red ink); [fourth Degas sale, Galerie Georges Petit, Paris, 2–4 July 1919, no. 74b (repr.): "Tête de femme.—Tête d'homme.—Lutteurs.—Cavalier"]; purchased by Nunès for 2,000 F (annotated catalogue). "Private Collection" (according to George 1931). [Victor D. Spark].

LITERATURE
George 1931, 76 (repr. opp. p. 76); Graber 1942, 246 (repr. opp. p. 20); Francis 1957a, 213, 210 (repr.); CMA Handbook 1958, no. 601 (repr.); Russoli/Minervino 1970, 86–87, no. 17 (repr., detail).

EXHIBITIONS
CMA 1961a; CMA 1965c; CMA 1965–66; New York 1975, 317–18 (repr.), no. 134 (repr. in color on cover); CMA 1982–83b; CMA 1983c; Manchester/Cambridge 1987, 15–17, 51, 138, no. 10, pl. 65; CMA 1994–95.

53. Jean-François Millet

First Steps, c. 1858–66. Gift of Mrs. Thomas H. Jones Sr. 1962.407.

PROVENANCE
Emile Gavet, Paris; [his sale, Drouot, 11–12 June 1875, no. 80]; purchased by "Del" (annotated copy of Gavet sale cat., National Gallery of Art Library, Washington); [Rosenberg & Stiebel, Inc., New York]; Mrs. Thomas H. Jones Sr., Cleveland.

Herbert in Paris/London 1975–76 includes in the provenance a work that sold at Drouot, Paris, 30 April 1888, as no. 5, which is incorrect, since this lot is a painting; no other works in the sale correspond to the Cleveland drawing.

LITERATURE
Hitchcock 1887, 168; Roger-Milès 1895 [unpaginated] (repr.); Soullié 1900, 121 (as "Les Premiers pas de l'enfant"); Cartwright 1902, 377; Gensel 1902, 57 (repr.); Rolland 1902, x, 75 (repr.); Holme 1903, pl. M17; Bénédite 1906, 24; Diez 1912, 29 (repr.); Veth 1912, 55, 57–60, fig. 2; Cox 1914, 65–66, pl. 8; Moreau-Nélaton 1921, 2:38, 59, 192, fig. 124; 3:127; Gsell 1928, 55; Cardiff/London 1956,

35, under no. 50(a) [London venue, 27–28, under no. 31(a)]; London 1960a, 13, under no. 27; Paris 1960, 22, under no. 36; Chase 1962, 11, fig. 2; *CMA Bulletin* 50 (1963), 294, no. 135; Talbot 1973, 264–65, fig. 10; Bacou 1975, 206, under no. 43; Fermigier 1977, 54, 62–63, 143 (repr.) [1991 ed. titled *Millet*, 58, 63, 137 (repr.)]; *Important Nineteenth Century European Drawings and Watercolours*, Sotheby's, London, 27 November 1980, under no. 75A; Esteban 1982, 380–81, 826 (repr.); Memphis et al. 1982–83, 85, fig. 27; Boston 1984, 114–15, under no. 77; Meixner 1985, 59–60, fig. 13; Amsterdam 1988–89, 111, under no. 39; Lepoittevin 1990, 41; *Nineteenth Century Continental Pictures, Watercolours, and Drawings*, Christie's, London, 27 November 1992, 25, under no. 17; Kimura 1993, 64, 146, pl. 3–24; *Nineteenth Century European Paintings, Drawings, Watercolors, and Sculpture*, Christie's, New York, 13 October 1994, 70, under no. 91; Paris 1998–99, 158 nn. 33–34; Williamstown et al. 1999, 89, under no. 54.

EXHIBITIONS

CMA 1963–64; CMA 1965b; CMA 1965–66; Paris/London 1975–76, 139–40, no. 97 (repr.) [English ed., 127–29, no. 77 (repr.)]; CMA 1979b; Cleveland 1980, 62–64, fig. 80; CMA 1987b; CMA 1994–95.

54. Honoré Daumier

Art Lovers, 1863–69. Dudley P. Allen Fund 1927.208.

PROVENANCE

Paul Bureau; [his sale, Galerie Georges Petit, Paris, 20 May 1927, 51, no. 66 (repr.)]; [purchased by CMA at the Bureau sale through Marcel Guiot].

LITERATURE

Alexandre 1888, 376 ("*Les amateurs de peinture . . . à Mme Bureau*"); Klossowski 1923, 119, no. 365; Francis 1927; *Le Bulletin de l'art ancien et moderne* 51 (May 1927), 170–71 (repr.); "A Daumier Gem," *Art Digest* (1 January 1928), 32 (repr.); CMA Handbook 1928, 57 (repr.); Escholier 1930, pl. 75; Fuchs 1930, 39, 57, no. 249a, pl. 249; Wilenski 1931, 232, pl. 92 [1949 ed., 212, pl. 86]; Fleischmann 1938, XXXIX, pl. 53; Roger-Marx 1938, 36 (repr.); Huyghe/Jaccottet 1948, 54 (repr.); Adhémar 1954, 17 (repr.); Houghton/Bouchot Saupique 1958, under Daumier (repr.); CMA Handbook 1958, no. 600 (repr.); Milliken 1958, 52 (repr.); Moskowitz 1962, 3:no. 758 (repr.); Moskowitz/Sérullaz 1962, 46; CMA Handbook 1966, 1969, 170 (repr.); Rey 1966, 63, pl. 77; CMA Selected Works [1967], 204; Feldman 1967, 332 [and subsequent editions]; Maison 1968, 2:135, no. 391, pl. 130 (misprinted as "Plate 129" in entry); Moore 1968, 89, 136; Vincent 1968, 78, pl. 60; Praeger Encyclopedia of Art 1971, 512; Roy 1971, 50 (repr.); Nishimura et al. 1972, 113, pl. IV; CMA Handbook 1978, 210 (repr.); Chapman 1978, 66, fig. 4–2; Richard 1979, G1 (repr.); "Drawings on Exhibition," *Drawing* 1 (September–October 1979), 64; Koschatzky 1982, 28, 432, pl. 9; Rotzler 1982, 70, pl. 70; CMA Handbook 1991, 133 (repr.); Goldstein 1992, 201–2, fig. 8.1; Ottawa et al. 1999–2000, 410, under no. 258 (repr.).

EXHIBITIONS

Paris 1878, 62, no. 113; Paris 1901, 29, no. 131; CMA 1932–33; Paris 1934, 101, no. 88; Boston 1935, 39, no. 72; Philadelphia 1937, 28, no. 19 (repr.); San Francisco 1947, 39, no. 54; Detroit 1950, no. 8; Seattle 1951 (no cata-

logue); Rotterdam et al. 1958–60, no. 103, pl. 129; CMA 1959–60a; CMA 1961a; CMA 1965b; CMA 1965–66; CMA 1979b; Washington 1979, 75, no. 81; CMA 1982–83b; CMA 1988b; Frankfurt/New York 1992–93, 44–46, fig. 59, 164–65, no. 70; CMA 1994–95.

55. Georges Seurat

Café-concert, 1887–88. Leonard C. Hanna Jr. Fund 1958.344.

PROVENANCE

The artist (posthumous inv. no. 299 inscribed on verso); [Galerie Hessel, Paris (according to Hauke 1961; in Hessel collection by 1926 according to Paris/New York 1991–92)]. [Van Diemen-Lilienfeld Galleries, New York, by 1937 (according to CMA files)]. [Buchholz Gallery, New York]. Alexander Bing, New York (by 1947). [Césare de Hauke, Inc., Paris].

LITERATURE

Seligman 1947, 84, no. 57, pl. 45; *CMA Bulletin* 46 (1959), 125–26 (repr.); Hauke 1961, 2:272–73, no. 687 (repr.); Herbert 1962, 141–42, 185, fig. 124; CMA Handbook 1966, 1969, 180 (repr.); Rubin 1970, 246 n. 2; Chastel/Minervino 1972, 114–15, no. D175 (repr.); CMA Handbook 1978, 223 (repr.); O'Toole 1982, 237, fig. 2; Clark 1984, 215, fig. 101; Thomson 1985, 197; Miller 1987, under "Crayon" (repr.); Cleveland 1987–88, 7 (repr.); Lebensztejn 1989, 140 (repr.); Madeleine-Perdrillat 1990, 123 (repr.); CMA Handbook 1991, 136 (repr.); Zimmerman 1991, 366, 368, 372, fig. 512; Huntington/Austin 1993–94, 85–86, fig. 52; Hammacher 1994, 58 (repr.).

EXHIBITIONS

Probably Paris 1888 (likely one of the drawings described by Félix Fénéon in *La Revue Indépendante* [February 1888]: "En deux fusains de style calme et simplificateur M. Georges Seurat montre des chanteuses de café-concert en scène et quelques chapeaux des spectateurs du premier rang"; see Félix Fénéon, edited by Joan U. Halperin, *Oeuvres plus que complètes* [Paris, 1970], 1:94); possibly Paris 1892, *Exposition posthume Seurat*, at offices of La Revue Blanche (suggested by inscription on old backing [now lost] recorded in Seligman 1947, 84); Paris 1926, no. 3223 (according to CMA files and to Seligman 1947; however, the catalogue of the exhibition itself describes the work as simply: "Dessin—Appartient à M. Hessel."); possibly London 1926, *Pictures and Drawings by Georges Seurat*, Lefèvre Galleries (suggested by inscription on old backing [now lost] recorded in Seligman 1947, 84); possibly Paris 1926, *Les dessins de Georges Seurat*, Bernheim-Jeune (suggested by inscription on old backing [now lost] recorded in Seligman 1947, 84); New York 1937, Van Diemen-Lilienfeld Galleries (title of exhibition not known), no. 5803 (according to CMA files); New York 1944, no. 74 (according to Seligmann 1947); New York 1947b, no. 26; CMA 1961a; CMA 1965c; CMA 1965–66; CMA 1979b; Cleveland 1981, 57, 70, no. 34 (repr.); Cleveland 1982, 22 (repr.), 66, no. 8; CMA 1983f; Bielefeld/Baden-Baden 1983–84, 194, no. 82 (repr.); CMA 1988b; Paris/New York 1991–92, 302, no. 197 (repr.); CMA 1994–95.

56. Henri de Toulouse-Lautrec

The Laundress, 1888. Gift of the Hanna Fund 1952.113.

PROVENANCE

Roger Marx (his stamp [not in Lugt] on old backing board, recorded in CMA files, board now lost); [his sale, Galerie Manzi, Joyant, Paris, 11–12 May 1914, 104–5, no. 222 (repr.)], sold to Henry Oppenheimer, London for 7,000 F (annotated copy of Marx sale catalogue, Ingalls Library, CMA). Otto Gerstenberg, Berlin (according to Dortu 1971). [M. Knoedler & Co., Inc. New York].

LITERATURE

Michelet 1888, 425 (repr.); Astre 1926, 96; Joyant 1927, 12, 17 (repr.), 191; Mack 1938, 293; Francis 1953; CMA Handbook 1958, no. 108 (repr.); Perruchot 1958, 139 [English ed., 1960, 124]; Focillon/Julien 1959, 68, under no. 17; Paris 1959a, under no. 257; Fabbri 1964, fig. 4; Huisman/Dortu 1964, 253; Neugass 1964; CMA Handbook 1966, 1969, 179 (repr.); Cooper 1966, 27 (repr.); Novotny 1969, 184, no. 15, pl. 15; Sugana 1969, 101, no. 223 (as unverified, location unknown); Dortu 1971, 5:492–93, no. D.3.029; Schimmel 1991, 126, under nos. 163 (possibly the work described by the artist as "the black and white painting") and 164; Thomson 1977, 46; CMA Handbook 1978, 222 (repr.); Cooper 1982, 27 (repr.); Adriani 1987, 76, under no. 27; Sonn 1989, 156–57 (repr.), 322–23 n. 22; CMA Handbook 1991, 136 (repr.); Julien 1991, 84 (repr.); London/Paris 1991–92, 198, under no. 48 (repr.); Murray 1991, xvii, 167–70, 249, fig. 103; Murray 1992, 102–3 (repr.); Mendelowitz/Wakeham 1993, 37, fig. 3-2; Frey 1994, 245–46.

EXHIBITIONS

Philadelphia/Chicago 1955–56, no. 85 (repr.); New York 1956, 46, no. 51; CMA 1958–59; Ann Arbor 1962, no. 156, pl. 12c; New York 1964, no. 64 (repr.); CMA 1965c; CMA 1965–66; Vienna 1966a, 23, 66, no. 39; CMA 1979b; Toronto/Amsterdam 1981, 336–37, no. 120 (repr.); CMA 1982–83b.

57. Paul Gauguin

Head of a Tahitian Woman, 1891. Mr. and Mrs. Lewis B. Williams Collection 1949.439.

PROVENANCE

[César M. de Hauke (1900–1965) (according to CMA files)]; Mr. and Mrs. Lewis B. Williams, Cleveland (by whom purchased in 1929).

LITERATURE

Morice 1919, 149 (repr.); Rewald 1938, 155 (repr.); Francis 1950b, 178–79; CMA Handbook 1958, no. 606 (repr.); Gauguin 1958, 23 (repr.); Milliken 1958, 58 (repr.); Rewald 1958, 36, no. 93; Martini 1964, 3, fig. 4; CMA Handbook 1966, 1969, 181 (repr.); CMA Selected Works [1967], no. 219; Pickvance 1970, 34, pl. 70; CMA Handbook 1978, 223 (repr.); Wadley 1978, no. 56; McFee/Degge 1980, 274, fig. 5.2; Prather/Stuckey 1987, 174 (repr.); Cachin 1988, 146, fig. 153; Huyghe 1988, 61 (repr.); Kantor-Gukovskaya et al. 1988, 67 (repr.); Cachin 1989, 73, 191 (repr.), 73b; CMA Handbook 1991, 140 (repr.); Thomson 1993, 68, 307, no. 129; Ferrara 1995, 68 (repr. under no. 3).

EXHIBITIONS

New York 1946, no. 53; Minneapolis 1950b (no catalogue; see Minneapolis 1950a, possi-

bly mentioned on p. 74 as *Head of a Tahitian Girl*); CMA 1951c; CMA 1958–59; Chicago/New York 1959, 65, no. 82; Newark 1961, no. 52; CMA 1965c; CMA 1965–66; Kyoto/Tokyo 1969, no. 52; CMA 1979b; Toronto 1981–82, 59, no. 18; CMA 1983f; Tokyo/Aichi-ken 1987, 92, fig. 42; Washington et al. 1988–89, 212, 224, no. 118; CMA 1994–95.

58. Charles Angrand

End of the Harvest, 1890s. Purchase from the J. H. Wade Fund 1999.49.

PROVENANCE
[Galerie Berès, Paris].

LITERATURE
None known.

EXHIBITIONS
None known. Angrand showed a work titled *Fin de moisson* at the twenty-first exhibition of the *Société des Artistes Indépendants* in 1905, but since several works by him bear that title, which one was shown is not known. See *Charles Angrand: Correspondances 1883–1926* (Rouen, 1988), 167 n. 1.

59. Albrecht Dürer

Arm of Eve, 1507. Accessions Reserve Fund 1965.470.

PROVENANCE
Joseph Grünling, Vienna (Lugt 1107, lower left, in black ink). Alfred Ritter von Franck, Vienna/Graz (Lugt 947, verso, center, in graphite: *franck / 828*). [Amsler & Ruthhardt, Berlin (see Lugt p. 167)]. Ferdinand Meder and C. Klackner, New York (according to letter from Wolfgang Stechow, CMA files). Edward Habich, Kassel; [his sale, Gutekunst-Auction, Stuttgart, 27 April 1899, 26, lot 236]; Graphische Sammlung Albertina, Vienna (property of Archduke Frederick of Austria) (Lugt 174, blind stamp, lower right). Eugene Meyer, Washington (verbally from Walter Schatzki to Henry Francis, according to CMA files); [Arthur H. Harlow & Co., New York]; sold to Walter Schatzki, New York; sold to Frits Lugt, Paris, and The Hague (according to letter from Frits Lugt). [Richard H. Zinser, New York].

LITERATURE
Heller 1831, 124, no. 24; Ephrussi 1882, 144; Lippmann 1888, 2:19–20, no. 164; Schönbrunner/Meder 1900, no. 793; Meder 1923, 154; Pfister 1928, 100, no. 135; Flechsig 1931, 570, no. 519; Winkler 1936–39, 2:112–113, no. 434, 4:147, no. 434; Tietze/Tietze-Conrat 1937, 38–39, 190, no. 348, under no. 350 (repr.); Panofsky 1943 (and subsequent editions), 120, no. 1208; Tietze 1951, 24; Winkler 1957, 199 n. 2; Hasselt 1964, 368–69; Burton 1966, 129–30, fig. 8; *CMA Bulletin* 53 (1966), 202–3, 282, no. 89 (repr.); CMA Handbook 1966, 1969, 106 (repr.); "La Chronique des Arts," *Gazette des Beaux-Arts* 68 (October 1966), 7, fig. 9; Stechow 1966, 30–42 (repr.); Young 1966, 239, 241, fig. 11; Yamazawa 1966, 93 (repr.); "Accessions of American and Canadian Museums," *Art Quarterly* 30, no. 1 (1967), 71, 76 (repr.); Benesch 1967, 23; CMA Selected Works [1967], 133 (repr.); Werner 1971, 29 (repr.); Young 1971, 42–43, fig. 5; Cooper/Matheson 1973, 78; Strauss 1974, 996, no. 1507/1; Lee [1975], 42–43, no. 18 (repr.); CMA Handbook 1978, 124 (repr.); CMA Handbook 1991, 72 (repr.).

EXHIBITIONS
Boston 1888, 75, no. 278; CMA 1966; Washington 1971, 17–18, 58–59, no. XV; Cleveland 1980, 35–36, fig. 32; CMA 1982–83b; New York/Nuremberg 1986, 296, no. 122; Amsterdam/Cleveland 1992–93 (not in catalogue; Cleveland venue only).

60. Wolfgang Huber

View of a Castle, 1515 (recto), *Eight-Sided Cup* (verso). John L. Severance Fund 1951.277.a,b.

PROVENANCE
Arnold Otto Meyer, Hamburg; [his sale, C. G. Boerner, Leipzig, 19–20 March 1914, no. 300]; collection prince of Liechtenstein (according to CMA files). Art market, 1930 (according to Halm 1930, 4); [Walter Feilchenfeldt, Zurich].

LITERATURE
Halm 1930, 4, 8 (repr.); Weinberger 1930, 56–57, 68, no. 18 (repr.); Horn 1950, 35–37; Francis 1952, 51 (repr.), 53–55; Heinzle 1953, 11, 15, 46, no. 14; Oettinger 1957, 12, 25–26, 69; CMA Handbook 1958, no. 582 (repr.); Stange 1964, 96; CMA Handbook 1966, 1969, 112 (repr.); Praeger Encyclopedia of Art 1971, 3:938 (repr.); Rose 1977, 5; CMA Handbook 1978, 131 (repr.); Winzinger 1979, 1:7, 31, 82–83, no. 22; 193, no. 7 (verso); 2:VII, no. 22, pl. 22; 334, fig. A7 (verso); CMA Handbook 1991, 70 (repr.).

EXHIBITIONS
CMA 1955c; CMA 1958–59; CMA 1960b; CMA 1966–67a; New Haven et al. 1969–70, 11, 16, 76–77, no. 78, pl. 41; CMA 1982–83b; CMA 1988b; CMA 1993b.

61. Albrecht Altdorfer

Salome with the Head of St. John the Baptist, c. 1517. John L. Severance Fund 1948.440.

PROVENANCE
Prince of Liechtenstein, Feldsburg and Vienna (according to inscription, verso of secondary support). [F. A. Drey, London].

LITERATURE
Francis 1950a, 115–18; Winzinger 1952, 82–83, no. 64; CMA Handbook 1958, no. 581 (repr.); Oettinger 1959a, 210–12, fig. 8; Oettinger 1959b, 111; Moskowitz 1962, no. 423; Stange 1964, 91, fig. 84; CMA Handbook 1966, 1969, 112 (repr.); Pfeiffer 1966, 384; CMA Selected Works [1967], pl. 134; Meder 1978, 1:128, 435; 2:74, no. 83; CMA Handbook 1978, 131 (repr.); Miller 1987, 9–10; Merkel 1990, 194, 307, 451, no. 7, fig. 223; CMA Handbook 1991, 72 (repr.); Weingrod 1993a, 12–13 (repr.); Grieder 1996, 91, fig. 3.18.

EXHIBITIONS
CMA 1949a ; CMA 1955c; CMA 1958–59; CMA 1960b; CMA 1966–67a; New Haven et al. 1969–70, 37, under no. 22, 44–45, no. 40, pl. 23; CMA 1982–83b; CMA 1983f; CMA 1991a; CMA 1993b.

62. Hans Hoffmann

Dead Blue Roller, 1583. Dudley P. Allen Fund 1946.217.

PROVENANCE
Paulus II Praun, Nuremberg (according to Achilles 1986–87, 245, under no. 11); Johann Friedrich Frauenholz, Nuremberg (Lugt 1758, not stamped; according to Lugt, Frauenholz acquired the entire Praun collection). Johann Andreas Börner, Nuremberg (according to Achilles 1986–87); [his sale:

Rudolph Weigel's Kunst-Auction, Leipzig, 28 November 1864, no. 113]. Johann August Gottlob Weigel, Leipzig (according to Achilles 1986–87); Theodor Oswald Weigel, Leipzig; [his sale, Gutekunst, Stuttgart, 8 May 1883, no. 444]. A. Freiherr von Lanna, Prague (Lugt 2773, stamped, verso, center); [his sale, Gutekunst, Stuttgart, 6–11 May 1910, no. 296 (sold to Obach for 260 M, annotated sale catalogue, location unknown)]. Henry Oppenheimer, London; [his sale, Christie's, London, 10 and 13–14 July 1936, no. 380 (sold for 178.10 guineas to Eisemann, annotated sale catalogue, CMA)]. Heinrich Eisemann, London. [Schaeffer Galleries, Inc., New York].

For the provenance of the work between the collectors Praun and Weigel, see Achilles 1986–87.

LITERATURE
Weigel 1869, 10, no. 50; Winkler 1936–39, 60, under no. 615; Francis 1947, 12–14; Kurz 1948, 97; Davis 1952, 98; Pilz 1962, 261–62, no. 25; Koschatzky/Strobl 1972, 108, under no. 34; Koreny 1985, 42, 56, 58, fig. 11.1 (English reprint [1988], 42, 56, 58, fig. 11.1); Achilles 1986–87, 245, under no. 11; Achilles-Syndram 1990, 341; Nuremburg 1994, 204, under no. 69; Achilles-Syndram 1994, 244–45, no. 355.

EXHIBITIONS
CMA 1949a; Minneapolis 1952, no. 6; Cleveland 1980, 15–16, fig. 8; Princeton et al. 1982–83, 88–89, no. 26; CMA 1986–87a; CMA 1988b; CMA 1993b.

63. Johann Wolfgang Baumgartner

St. Deicolus and the Boar, 1747–48. Dudley P. Allen Fund 1967.22.

PROVENANCE
[C. G. Boerner, Inc.].

LITERATURE
Boerner 1966a, no. 49 (repr. on frontispiece); Boerner 1966b, no. 5, pl. 4; Boerner "Notable Works of Art Now on the Market," *Burlington Magazine* 109 (December 1967), under pl. XLIII (incorrectly described as pendant to the Baumgartner drawing now in San Francisco, see note 3 in entry no. 63 here, p. 156); *CMA Bulletin* 54 (1967), 344, no. 72, 318 (repr.); Rowlands 1970, 294; Kunstveilingen Sotheby Mak van Waay B.V., Amsterdam, *Sale Catlaogue 320 Fine Dutch, Flemish, and German Drawings* (18 November 1980), 67, under no. 187; Boerner 1981, under no. 28; von Borries et al. 1988, under no. 35; Leipzig 1990–91, 151, no. 93, 161 (repr.); CMA Handbook 1991, 111 (repr.).

EXHIBITIONS
CMA 1967; CMA 1988b; Princeton/Santa Barbara 1989–90, 9, 21, 119–20, no. 39, under no. 40; CMA 1993b.

64. Jakob Philipp Hackert

The Waterfall of Marmore at Terni, 1776–78. Dudley P. Allen Fund 1982.40.

PROVENANCE
Gerda Bassenge (Auktionskatalog Nr. 11), Berlin, 23–27 April 1968, Nr. 581; [Sven H.A. Bruntjen].

Krönig 1971 remarks that a Hackert drawing that sold at Gerda Bassenge (he does not give the date of the sale) was signed and dated 1793, which seems to refer to the Cleveland work. The signature may have

been on the old mount, the original appearance of which was unfortunately not documented when it was removed.

LITERATURE
Krönig 1971, 192; Goldfarb 1982, 281, 286–88, 296 n. 30, figs. 4–5; *CMA Bulletin* 70 (1983), 52, no. 44; Cologne 1984, 98–99, under no. 28; Nordhoff/Reimer 1994, 2:54, under no. 131, 434–35, no. 1140, 438, under no. 1150; Rome 1994, 216, under no. 59; London/Leeds 1997–98, 136–38, under no. 65, fig. 44; Lausanne/Québec 1998–99, 44, fig. 48; Weidner 1998, 87, 221 nn. 54, 60.

EXHIBITIONS
CMA 1983a.

65. Friedrich Preller the elder

La Serpentara near Olevano, 1829. Delia E. Holden Fund 1971.12.

PROVENANCE
[C. G. Boerner, Inc.].

LITERATURE
CMA Bulletin 59 (1972), 43, no. 97.

EXHIBITIONS
Stuttgart/Düsseldorf 1971, 128, no. 132, pl. 132; CMA 1971–72; CMA 1980a.

66. Adolph von Menzel

Bust of a Woman, Seen from Behind, 1893. Purchase from the J. H. Wade Fund 1994.103.

PROVENANCE
[Hazlitt, Gooden & Fox, New York].

LITERATURE
CMA Annual Report (1994), 29 (repr.), 39 (as *Profile of a Young Woman*).

EXHIBITIONS
New York et al. 1994, no. 39 (repr.) (New York venue only); CMA 1994 (as *Profile of a Young Woman*).

67. Rembrandt van Rijn

Tobias Healing His Father's Blindness, c. 1640–45. Purchase from the J. H. Wade Fund 1969.69.

PROVENANCE
Ignace-Joseph de Claussin, Paris and London (Lugt 485, not stamped); [his sale, Schroth, Batignolles, Paris, 2 December 1844, 21, lot 53: "Tobie recouvrant la vue. Le vieillard est assis dans un fauteuil, à gauche de la composition; son fils, accompagné de l'ange, lui applique sur les yeux le fiel du poisson. Ce dessin, de cinq figures, traité avec un profond sentiment, est à la plume. H. 21 c., L. 17 c. 6 m." sold for 90 F to van Os (annotated copy of catalogue, Frick Art Reference Library, New York)]; George Jacob Johan van Os, Paris and Amsterdam; [his sale, Roussel et Defer, Paris, 20–22 January 1851, 24, lot 179, "Tobie recouvrant la vue. Composition de cinq figures. Dessin au bistre"]. Pierre Defer & Henri Dumesnil, Paris (Lugt 739, verso, lower center, in black ink; and on fragment of old mount, now removed); [sold, Drouot, Paris, 10–12 May 1900, 40, lot 87 (repr.), for 4100 F, to Joseph Reinach (annotated copy of catalogue, Philadelphia Museum of Art Library)]; Joseph Reinach (also Reinack), Paris. Mme. Pierre Goujon?, Paris, (according to Benesch 1954–57, Slive 1965; to Wildenstein from Goujon, according to Mme. Hugette Berès [manuscript note in CMA files]); [Wildenstein & Co., Inc, New York].

An exhibition catalogue from 1879 listed this drawing as once belonging to the Narcisse Revil collection (Paris 1879, no. 367), a mistake that has been repeated in the subsequent literature . As late as 1991 (Berlin et al. 1991, 70), it was thought to be possibly owned by Revil, sold on 24 February 1845, in lot 48. However, the description of lot 48 is too vague to be conclusive. Additionally, it was sold to G. J. J. van Os in the 2 December 1844 sale. While it could have passed privately from van Os to Revil and sold, all in less than three months, that is unlikely. In 1970, Louise Richards noted that this sheet matched the description of lot 53 (from the Ignace-Joseph de Claussin collection) in a 1844 sales catalogue, yet the name Claussin had been omitted from listings of previous owners. Richards 1970, 75 n. 2, surmised that sometime between 1844 and 1879, the name Claussin was substituted for Revil, perhaps resulting from the fact that this sale contained drawings owned by both collectors.

LITERATURE
Dutuit 1885, 104 (under le Chevalier de Claussin); de Groot 1906, 182, no. 815; Greeff 1907, 54–56, no. 3, pl. VI; de Groot 1910, fourth series, part 2, pl. 55; Lippmann 1910, fourth series, part 2, no. 55; Bredt 1918, 76, 89; Kruse/Neumann 1920, 60, fig. 69; Bredt 1921, 1:159 (2d ed., 1927, 1:178); Valentiner 1925, 1:252, 271 (repr.), 479, no. 252; Van Dyke 1927, no. 149 (as unknown pupil F.), pl. XXXVIII; Benesch 1935, 35–36; Benesch 1954–57, 3:156, no. 547, fig. 677; Held 1964, 16, pl. 24 (reprinted in Held 1996, 129, pl. 26); Slive 1965, 2:no. 501; *Art Quarterly* 33 (1970), 324 (repr.); *CMA Bulletin* 57 (1970), 14, 49, no. 183 (repr.); *Gazette des Beaux-Arts* 75 (1970), 62, no. 287 (repr.); Richards 1970, 68–75, fig. 1; Tümpel/Tümpel 1970, no. 33; Benesch 1973, 3:150, no. 547, fig. 715; Fabri 1974, 12 (repr.); *Journal of Aesthetic Education* 8 (1974) (repr. on cover); Borowitz 1978, 62; CMA Handbook 1978, 158 (repr.); Schatborn 1982, 254, fig. 2; Bruyn et al. 1986, 555; Schatborn/Tümpel 1987, 43, 65–66 (repr. on cover); Amsterdam/Jerusalem 1991, 121 n. 81; CMA Handbook 1991, 97 (repr.); New York 1995, 166, fig. 87; Garff 1996, 34; Schama 1999, 425–28 (repr.).

EXHIBITIONS
Paris 1879, 99–100, no. 367; Paris 1908, 101, no. 322; CMA 1970a; CMA 1974–75; Washington et al. 1977 (frontispiece), 34 (repr.), 38–39, no. 34; CMA 1982d; CMA 1983f; Berlin et al. 1991, 70–72, no. 18.

68. Rembrandt van Rijn

Shah Jahan, c. 1656–61. Leonard C. Hanna Jr. Fund 1978.38.

PROVENANCE
Jonathan Richardson Sr., London (Lugt 2184, stamped, lower right in black ink; Jonathan Richardson Sr.'s mount); [his sale, Cock, London, 22 January–8 February (actually, Wednesday, 11 February), 1747 (1746 old style), 40, part of lot 70, from "a book of Indian Drawings, 25 in number"]. Lord Brownlow, Belton House; [his sale, Sotheby's, London, 29 June 1926, 10, lot 25]; bought by Duveen for £680 (photocopy of annotated sale catalogue, CMA files). W. R. Valentiner, Detroit; [his sale, Mensing, Amsterdam, 25 October 1932, lot 12 (repr.)]. Robert von Hirsch, Frankfurt and Basel; [his sale, Sotheby's, London, 20 June 1978, 84, lot 38].

LITERATURE
Valentiner 1925, 34, no. 643; Benesch 1935, 56; Benesch 1946, 1:44, no. 229, 2:pl. 229; Benesch 1954–57, 5:338, no. 1193, fig. 1417 (enlarged ed., with Eva Benesch, 1973, 5:321, no. 1193, fig. 1491); Clark 1966, 166–67 (repr.); *CMA Bulletin* 66 (1979), 3, 14, 45, no. 102 (repr.); "Report from America," *Oriental Art* 25 (Spring 1979), 129, fig. 5; Broos 1980, 210–11, fig. 1; Lunsingh Scheurleer 1980, 30–32, fig. 18; Royalton-Kitsch 1992, 143; Melbourne/Canberra 1997–98, 370, under no. 38, fig. 93a.

EXHIBITIONS
Basel 1948, no. 29; CMA 1978b; CMA 1979a; Cleveland 1980, 14–15, 39, fig. 6; New York 1988, 127–29, no. 34; Los Angeles et al. 1989–91, 195–97, fig. 208.

69. Hendrick Goltzius

Standing Officer Holding a Boar's Spear, c. 1586. Leonard C. Hanna Jr. Fund 1994.195.

PROVENANCE
G. Braamkamp, Amsterdam; [his sale, Amsterdam, 29 February 1768, no. 265, "Een staan Officier met een Helbaard in zyn hand, gewassen en weinig gekleurd, door H. *Goltzius*" (according to Reznicek 1961: purchased by Van der Myn)]. Van Der Hoog, Amsterdam; [his sale, Amsterdam, 10 April 1780, no. 128 (according to Reznicek 1961: purchased by Yver)]. [Sold, 30 October 1780, no. 31, "Een Officier, staande met een Sponton in zyn hand, meesteragtig met de pen en geele Oostind. Inkt gewassen en weinig gekleurd, door *Hendrick Goltzius*"]. Juda van Benjamin Sr., Amsterdam; [his sale, Amsterdam, 4 November 1782, no. 27, "een Soldaatje met een lange Spies in zyn hand, zeer fraay geteekend, door *Goltzius*"]. Lord Northwick, London; [his sale, London, 5 July 1921, no. 79, "A Captain with sword and pike/Pen and sepia, with sepia and watercolour wash/ 8-1/8 in. by 6-1/8 in., 207 mm. by 156 mm. / Signed with the artist's monogram"]. Sir Robert Witt, London (Lugt 2228b, on mount, lower left, in black ink). D. F. Springell, Portinscale (Lugt 1049a, on mount, lower left, in red ink). [Sale, Sotheby Mak van Waay B.V., Amsterdam, 3 May 1976, lot 93 (for 56,000 Dutch guilders to Derek Johns, London, according to notation in catalog)]. [Hazlitt, Gooden & Fox Ltd., London].

LITERATURE
Reznicek 1961, 392, no. 337 (Stehender Offizier), pl. 68; Strauss 1977, 434, under no. 252; Filedt Kok 1991, 368; Reznicek 1993, 276, no. A68; Amsterdam 1993–94, under no. 15, fig. 16b; *CMA Annual Report* (1994), 28 (repr.), 37.

EXHIBITIONS
Rotterdam/Haarlem 1958, 38 (repr.), no. 81; London 1959b, no. 35; Manchester, 1965, 93–94, no. 310; Edinburgh 1965, 12, no. 22; CMA 1997.

70. Jan Wierix

The Expulsion from Paradise, c. 1606. Dudley P. Allen Fund 1994.16.

PROVENANCE
Adalbert Freiherr van Lanna, Prague (Lugt 2773, verso, lower right, in black ink); [his sale, H. G. Gutekunst, Stuttgart, 6–11 May 1910, lot 596]; Toni Straus-Negbaur (Lugt 2459a, verso, lower right, in brown ink); [her

sale, Paul Cassirer, Berlin, 25–26 November 1930, nos. 106–18]. [Kunsthandel Bellinger, Munich].

LITERATURE
New York 1990a, 39, no. 10, under no. 10a; *CMA Annual Report* (1994), 40.

EXHIBITIONS
London/New York 1993–94, no. 7.

71. Peter Paul Rubens
The Feast of Herod, 1637–38 (recto), *Tomyris with the Head of Cyrus* (verso). Delia E. Holden and L. E. Holden Funds 1954.2.a,b.

PROVENANCE
unidentified collector, possibly Viennese (Lugt 622, verso, lower right, in black ink). [Herbert N. Bier].

LITERATURE
Burchard 1953, 387; Francis 1954a, 114, 124–26; Held 1954, 122; Held 1956, 124, fig. 34 (verso); CMA Handbook 1958, no. 588 (recto, repr.), no. 587 (verso, repr.); Held 1959, 1:124, no. 67, pl. 77; Burchard/d'Hulst 1963, 1:313–16, no. 196, 2:pl. 196r (recto), 196v (verso); Jaffé 1963, 466; CMA Handbook 1966, 1969, 119 (recto, repr.); Hofstede 1966, 435, 454; CMA Handbook 1978, 154 (repr.); Berger 1979, 24–25, fig. 12 (verso); Jaffé 1989, 346, under no. 1187; CMA Handbook 1991, 90 (recto, repr.).

EXHIBITIONS
Cambridge/New York 1956, 25–26, no. 26, pl. 26; Antwerp 1956, 107–8, no. 131, pl. 59; Cleveland 1980, 29–32; Wellesley/Cleveland 1993–94, 203–5, no. 58.

72. Jacob Jordaens
The Conversion of Saul with Horseman and Banner, c. 1645–47. Delia E. Holden and L. E. Holden Funds 1954.366.

PROVENANCE
Duke Albert of Sachsen-Teschen (according to CMA files). Graphische Sammlung Albertina, Vienna (Lugt 1259–60, not stamped, according to CMA files). Otto Burchard (according to CMA files). [Heinrich Eisemann, London].

LITERATURE
"Accessions of American and Canadian Museums," *Art Quarterly* 17 (Winter 1954), 412; d'Hulst 1956, 249, 373–74, no. 128, 251, fig. 166 (mistakenly says fig. 165 in catalogue entry on p. 373); Francis 1957b, 17–22 (repr.); Jaffé 1963, 465; Brussels 1965, under no. 332; CMA Handbook 1966, 1969, 120 (repr.); CMA Selected Works [1967], pl. 164; Ottawa 1968–69, under no. 228; d'Hulst 1974, 1:315–16, no. A238, 4:fig. 253; CMA Handbook 1978, 155 (repr.).

EXHIBITIONS
Antwerp/Rotterdam 1966–67, 104–5, no. 92, pl. 92; Los Angeles 1976a, 193, 200, 201, no. 217; CMA 1982d; CMA 1982–83b; CMA 1983f; CMA 1988b; Wellesley/Cleveland 1993–94, 170–71, no. 31.

73. Jacob Jordaens
The Conversion of Saul with Christ and the Cross, c. 1645–47. Delia E. Holden and L. E. Holden Funds 1954.367.

PROVENANCE
Duke Albert of Sachsen-Teschen (according to CMA files). Graphische Sammlung Albertina, Vienna (Lugt 1259–60, not stamped, according to CMA files). Otto Burchard (according to CMA files). [Heinrich Eisemann, London].

LITERATURE
"Accessions of American and Canadian Museums," *Art Quarterly* 17 (Winter 1954), 412; d'Hulst 1956, 249, 374, no. 129, 251, fig. 165 (mistakenly says fig. 166 in catalogue entry on p. 374); Francis 1957b, 17–22 (repr. on p. 18); CMA Handbook 1958, no. 586 (repr.); Jaffé 1963, 465; Antwerp/Rotterdam 1966–67, 104–5, under no. 92; d'Hulst 1974, 1:316, no. A239, 4:fig. 254; CMA Selected Works [1967], pl. 164.

EXHIBITIONS
Brussels 1965, 306, no. 332; Ottawa 1968–69, 204, 368, no. 228 (repr.); CMA 1982d; CMA 1982–83b; CMA 1983f; CMA 1988b; Wellesley/Cleveland 1993–94, 171, no. 32.

74. Henry Fuseli
Satan Starts from the Touch of Ithuriel's Spear, 1776. Dudley P. Allen Fund 1954.365.

PROVENANCE
Dr. John Percy, London (Lugt 1504, lower right, in black ink); Sir James Knowles, London (according to tradition; not listed in the Knowles sale of 1908). Eva Trüeb-Baumann, Chateau d'Hauterive, Switzerland; [Dr. G. A. Gericke, Zurich].

LITERATURE
"Accessions of American and Canadian Museums," *Art Quarterly* 17 (Winter 1954), 412; Schiff 1973, 76, 110, 456, no. 483a; New Haven 1979, 40, under no. 41; Washington et al. 1985–86, 84, no. 103; *Important Old Master Pictures*, Christie's, New York, 11 January 1995, 296–97, under no. N146 (as part of Nureyev sale); to be included in the forthcoming updated catalogue raisonné by David Weinglass.

EXHIBITIONS
Zurich 1941, 76, no. 240; New York et al. 1954, no. 70 (not in catalogue; Cleveland venue only?); Allentown 1962, 76, no. 55; CMA 1989c; CMA 1991–92a.

75. John Hamilton Mortimer
A Druidical Sacrifice Interrupted, 1770s. Cornelia Blakemore Warner Fund and Delia E. Holden Fund 1978.20.

PROVENANCE
[Ramiel M. Howitt, London].

LITERATURE
CMA Bulletin 66 (1979), 44, no. 95; Sunderland 1988, 198–99, no. 163, pl. 283; CMA Handbook 1991, 116 (repr.); Smiles 1994, 100–101, pl. 52; Smiles 1995, 45–46, fig. 3.

EXHIBITIONS
CMA 1979a; CMA 1990b.

76. John Robert Cozens
Italian Landscape, c. 1790–92. Leonard C. Hanna Jr. Fund 1997.137.

PROVENANCE
Mr. Eden; Mr. Deverell; Mrs. Deverell; William Eden (from old label attached to the backboard written in William Eden's hand). Norman D. Newell; [his sale Christie's, London, 13 December 1979, lot 25]; private collection; [sale Sotheby's, London, 14 November 1996, lot 59 (as *The Property of a Lady*)]; [Spink-Leger Pictures, London].

LITERATURE
Bell/Girtin 1935, 80, no. 439II; *CMA Annual Report* (1997), 26, 32 (repr.), 44; *Drawing* 19 (Fall 1997), 68–69; *Gazette des Beaux-Arts* 131 (1998), 55, no. 220.

EXHIBITIONS
Manchester 1937, no. 76; Newcastle-upon-Tyne 1953, no. 31.

77. William Blake
The Holy Family, c. 1805. John L. Severance Fund 1950.239.

PROVENANCE
Thomas Butts; Thomas Butts Jr.; [sale, "The Property of Thomas Butts, Esq.," Messrs. Foster and Son, London, 29 June 1853, no. 127, as *Holy Family*]; purchased by H. G. Bohn (according to Gilchrist/Rossetti 1863: Mr. Bohn from Mr. Butts). Alexander Anderdon Weston (according to Butlin 1981); by descent to his widow (according to Preston 1952); [sold by her (according to Preston 1952) anonymously at Christie's, London, 28 June 1904, no. 5]; purchased by E. Parsons (according to Butlin 1981); sold in 1904 to W. Graham Robertson (according to Butlin 1981); [his sale, Christie, Manson & Woods, Ltd., London, 22 July 1949, no. 24]; [Thomas Agnew and Sons, London].

LITERATURE
Gilchrist/Rossetti 1863, 2:230, no. 182; Gilchrist/Rossetti 1880, 2:243, no. 207 or 209; Richter 1906, 173, pl. V; de Selincourt 1909, 200–202 (repr.) (as *Christ in the Lap of Truth*); Russell 1920, 34; Preston 1952, 144–45; Keynes 1957, 30–31, no. 104, pl. 104; CMA Handbook 1958, no. 608 (repr.) (as *Christ in the Lap of Truth*); Hoover 1973, 8–9, fig. 3; Mellor [1974], 332–35, pl. 87; Butlin 1981, 351, no. 471, pl. 556, 484, under no. 671; Heppner 1995, 194.

EXHIBITIONS
London 1876, no. 144 (as *Holy Family: St. John and the Lamb*); London 1906, 19, no. 69 (as *Christ in the Lap of Truth*); London 1911, 35, no. 125 (as *Christ in the Lap of Truth*); London 1947, 37, no. 76; London 1950, no. 74; Washington 1957, 19, no. 26; CMA 1961a; Cleveland 1964, 117, no. 122 (repr.); CMA 1989c.

78. John Martin
The Valley of the Tyne, My Native Country near Henshaw, 1842. Leonard C. Hanna Jr. Fund 1997.138.

PROVENANCE
Henry and Margaret Hobhouse; C. D. Hobhouse. [Spink-Leger Pictures, London].

LITERATURE
Feaver 1975, 178–79, fig. 137, 232 n. 50, 233 n. 91; *CMA Annual Report* (1997), 26, 44; "Cleveland Acquires Cozens and Martin Works," *Drawing* 19 (Fall 1997), 68.

EXHIBITIONS
London 1975c, no. 43; London 1997, no. 15.

79. Joseph Mallord William Turner
Fluelen, from the Lake of Lucerne, 1845. Mr. and Mrs. William H. Marlatt Fund 1954.129.

PROVENANCE
Hugh A. J. Munro of Novar? ["Windus" is inscribed on the verso of the sample study, and while B. G. Windus may have commissioned the work, Munro of Novar was appar-

ently the first owner; for the most recent and exact commentary, see London 1995, 152–54]; by c. 1850, Rev. C. Upham Barry, Ryde, Isle of Wight; his daughter, wife of Colonel P. G. Hewitt, Ryde, Isle of Wight; [her sale Christie's, London, 25 March 1884, no. 139]; Ralph Brocklebank Sr., Haughton Hall, Tarporley; Ralph Brocklebank Jr.; [his sale Christie's, London, 7 July 1922, no. 34]; [Thomas Agnew and Sons, London]; Grace Rainey Rogers, New York; [her sale Parke-Bernet Galleries, New York, 18 November 1943, no. 41]; Walter F. Wedgwood, New York; [Durlacher Brothers, New York].

LITERATURE
Wedmore 1900, 2:xi (repr. opp. p. 294); Armstrong 1902, 264; Carter 1904, xi, xv, 87, no. 77 (repr.); "Accessions of American and Canadian Museums October–December, 1953," *Art Quarterly* 7 (Summer 1954), 183; Francis 1954b, 426–27, 429 (repr.); Francis 1954c, 201–3; CMA Handbook 1958, no. 477 (repr.); Hawes 1966, 312; CMA Handbook 1966, 1969, 183 (repr.); London 1975b, 157, under no. 287; Cambridge 1975, 70, under no. 44; Wilton 1976, 139, no. 93; CMA Handbook 1978, 208 (repr.); Wilton 1979, 244, 478, under no. 1483, 486, no. 1549 (repr.); *Asia* 4 (January–February 1982), 28 (repr.); Ditner 1983, 159–60, 163 n. 48, fig. 9; Wilton 1987, 213; CMA Handbook 1991, 126 (repr.); Charleroi 1994, 242, under no. 83; *Decor* (August 1995) (repr.); London 1995, 79, under no. 38, 150, 154, fig. 50.

EXHIBITIONS
London 1899b, 19–20, 112, no. 150; Boston 1946, 21, no. 44; Toronto/Ottawa 1951–52, 11, no. 58; Indianapolis/Dayton 1955–56, no. 47 (repr.); New York 1959a, 91–92, no. 84, pl. LIX; New York 1960, no. 43 (repr.); London 1964, 31, no. 104; Detroit/Philadelphia 1968, 15, 26, 196–98, no.121 (repr.); CMA, *Turner Watercolors from the British Museum*, 1977 (not in catalogue); CMA 1982b; New Haven et al. 1992–93, 72–73, no. 8 (repr.).

80. Frederick Sandys

The Coral Necklace, 1871. Leonard C. Hanna Jr. Fund 1997.7.

PROVENANCE
J. Beecroft, Esq., Bradford, England; [his sale, Christie's, London, 21 February 1927, no. 68]; Dr. J. N. Nicoll; [his sale, Sotheby's, London, 29 October 1964, no. 225]; C. Powney, Esq. [Sotheby's, London, 21 December 1966, no. 305]. Anthony C. W. Crane; [his sale, Sotheby's, London, 12 November 1992, no. 157]; Hartnoll; [Kate Ganz Ltd.].

LITERATURE
Seattle et al. 1995, 284, under no. 98; *CMA Annual Report* (1997), 45; "Principales Acquisitions des Musées en 1997," *Gazette des Beaux-Arts* 131 (March 1998), 61, no. 243; to be included in the forthcoming catalogue raisonné on Sandys by Betty Elzea.

EXHIBITIONS
Brighton/Sheffield 1974, 36, no. 146, pl. 106; New York 1993, no. 21.

81. Edward Coley Burne-Jones

The Garden Court, 1870–75. Andrew R. and Martha Holden Jennings Fund 1994.197.

PROVENANCE
Charles Edward Hallé (1846–1919). [Sold, Sotheby's, London, 26 November 1926, no. 22]. [Sold, Christie's, London, 11 June 1993, no. 93]; [J. S. Maas and Son, London].

LITERATURE
Cartwright 1894, 24; Bell 1903 (repr. opp. p. 66); de Lisle 1907, 183 n. 1 (repr. opp. p. 139); *CMA Annual Report* (1994), 28 (repr.), 37; Seattle et al. 1995, 325–26, under no. 115 (as the drawing sold at Christie's, London 11 June 1993); New York et al. 1998–99, 157–58 n. 1 (as the drawing sold at Christie's, London 11 June 1993).

EXHIBITIONS
London 1899a, 18, no. 88; New York 1994a, no. 29; Seattle et al. 1995 (Cleveland venue only; mentioned under no. 115).

82. Benjamin West

Head of a Screaming Man, c. 1792 (recto), *Woman and Man Playing Cards* (verso). Dudley P. Allen Fund 1967.150.a,b.

PROVENANCE
[Sven Gahlin, Ltd.].

LITERATURE
CMA Bulletin 44 (1967), 345, no. 127 (repr.), 321; "Drawings on Exhibition," *Drawing* 19 (Summer 1998), 137 (repr.)

EXHIBITIONS
CMA 1967; CMA 1990b; CMA 1998.

83. John Singleton Copley

A Hussar Officer on Horseback, c. 1812. Norman O. Stone and Ella A. Stone Memorial Fund 1950.216.

PROVENANCE
The artist; through artist's family to Martha Babcock Amory (granddaughter of the artist), Boston; Linzee Amory, Boston; Mr. Wallace, Foxboro, Massachusetts (the valet of Linzee Amory); [Charles D. Childs Gallery, Boston].

This provenance follows information given in a letter to the CMA from the Boston dealer Charles D. Childs; according to him this drawing and three others by Copley sold to the CMA at the same time came directly through the Copley family; Childs did not include Baron Lyndhurst as a former owner, though Prown 1966, 410, suggests he may have been.

LITERATURE
Amory 1882, 270–71; Prown 1966, xxi, 281–83, 436, no. 674; CMA Handbook 1978, 198 (repr.); CMA Handbook 1991, 122 (repr.).

EXHIBITIONS
New York 1947c, 108, no. 9; Detroit/Philadelphia 1968, 96, no. 48; CMA 1983f; CMA 1984–85b; CMA 1998.

84. William Rickarby Miller

On the Harlem River, 1855. Leonard C. Hanna Jr. Fund 1997.6.

PROVENANCE
[Mary Lublin Fine Arts, New York].

LITERATURE
CMA Annual Report (1997), 44.

EXHIBITIONS
CMA 1998.

85. Frederic Edwin Church

Niagara Falls by Moonlight, probably 1856. Gift of Robert Arthur Mann 1976.30.

PROVENANCE
Robert Arthur Mann, Cleveland.

LITERATURE
CMA Bulletin 64 (1977), 75, no. 50.

EXHIBITIONS
CMA 1977; CMA 1984–85b; CMA 1998.

86. Winslow Homer

Boy with Anchor, 1873. Norman O. Stone and Ella A. Stone Memorial Fund 1954.128.

PROVENANCE
John Hay (according to CMA files); Mrs. C. E. Meder (according to CMA files).

LITERATURE
"Accessions of American and Canadian Museums," *Art Quarterly* 17 (Summer 1954), 180; Francis 1955c, 52; CMA Handbook 1958, no. 561; CMA Handbook 1966, 1969, 186; Adams et al. 1972, 10–11; *CMA Bulletin* 60 (1973), 28, no. 87; CMA Handbook 1978, 231; Hendricks 1979, 318, pl. CL-554; Placidi 1990, 370–71, fig. 6; Wierich 1990, 41, fig. 31.

EXHIBITIONS
Los Angeles et al. 1968, 8, 82, no. 1; Boston et al. 1995–96, 137, no. 68 (Washington and Boston venues only).

87. Winslow Homer

Leaping Trout, 1889. Anonymous gift 1973.142.

PROVENANCE
Ralph T. King Sr., Cleveland.

LITERATURE
CMA Bulletin 61 (1974), 52, no. 36, 186; Hendricks 1979, 318, pl. CL-561; Cikovsky 1991, 65, 119, pl. 51; CMA Handbook 1991, 134; Tatham 1996, 140.

EXHIBITIONS
CMA 1927; Cleveland 1937, 26, no. 92; CMA 1974a; Washington et al. 1986, 166, 171–72, 252, no. 154 (Fort Worth and New Haven venues only); Boston et al. 1995–96, 266–67, no. 165 (Washington and New York venues only).

88. Thomas Wilmer Dewing

Gloria, 1884. The Fanny Tewksbury King Collection 1956.722.

PROVENANCE
John and Edith Gellatly; [William MacBeth Galleries, New York].

LITERATURE
"The Prang Prize Designs," *Boston Daily Evening Transcript* (12 December 1884), 6; Montezuma 1885, 29; Tharp 1917, 188, frontispiece; *CMA Bulletin* 60 (1973), 25, no. 48.

EXHIBITIONS
Boston/New York 1884; Cleveland 1925, 5, no. 49; CMA 1984–85b; Brooklyn et al. 1996–97, 8, 13, 97–98, 106, no. 7.

89. Mary Cassatt

The Letter, 1890–91. Bequest of Charles T. Brooks 1941.86.

PROVENANCE
Galerie Durand-Ruel, Paris (according to Breeskin 1970, under no. 805); Charles T. Brooks.

LITERATURE
Breeskin 1970, no. 805 (repr.); Breeskin 1979, 63, under no. 146.

EXHIBITIONS
Washington et al. 1989–90, 121, fig. 8–1; CMA 1993–94.

90. Thomas Moran

Smelting Works at Denver, 1892. Bequest of Mrs. Henry A. Everett for the Dorothy Burnham Everett Memorial Collection 1938.56.

PROVENANCE

Biltmore Salon, Los Angeles (according to Fort Worth et al. 1980–81); Henry A. Everett, Cleveland.

LITERATURE

Francis 1938, 129; Wilson 1955, no. 56; *CMA Bulletin* 60 (1973), 31, no. 138; Trenton/Hassrick 1983, 204–5, no. 73; Truettner 1991, 48, no. 42; Morand 1996, 78–79, 254, no. 814; Wilkins 1998, 267.

EXHIBITIONS

Denver 1892, no. 82 (as *The Smelters, Denver*); Santa Barbara 1925, no. 49, (as *The Smelters, Denver, Colorado*); New York 1926, no. 53; Los Angeles 1926, no. 6 (as *The Smelters, Denver, Colorado*); Fort Worth et al. 1980–81, 114, 143, 171, no. 156; CMA 1984–85b; Washington et al. 1997–98, 125–26, 143, 254, 400, no. 72.

91. John La Farge

A Rishi Stirring Up a Storm, c. 1897. Purchase from the J. H. Wade Fund 1939.267

PROVENANCE

[Doll & Richards, Boston] (according to CMA files); Wheelright family, Boston; Mary C. Wheelright, Boston.

LITERATURE

Burchfield 1939, 159–60; CMA Handbook 1958, no. 562 (repr.); CMA Handbook 1966, 1969, 188 (repr.); *CMA Bulletin* 60 (1973), 30, no. 123; CMA Handbook 1978, 233 (repr.); Lefor 1978, 156–57, 159, 165, 267 n. 6, 370, no. 70; Kuwabara 1980, 7–10, no. 1; Adams 1987, 50; Westgeest 1996, 42–43, no. 22.

EXHIBITIONS

Boston 1936; New York 1936, no. 47; Cleveland 1937, 31, no. 119; Washington et al. 1987–88, 53–54, 265, no. 69, fig. 35; Yonkers et al. 1990, 14, 64, 117, 132, no. 152, pl. 1.

92. Maxfield Parrish

Alarums and Excursions, 1899. Bequest of James Parmelee 1940.723.

PROVENANCE

[Frederick Keppel Co., New York (who purchased it in 1899, according to old label, CMA files)]. James Parmelee, Cleveland.

LITERATURE

Grahame 1899 (repr. opp. p. 42 and in 1904 ed.); Ludwig 1965–66, 143–44, fig. 2; Ludwig 1973, 29, 32, 206, fig. 20; Gomes 1982, 85 (repr.); CMA Handbook 1991, 138 (repr.).

EXHIBITIONS

New York 1899; Chadds Ford 1974, 40–41, no. 105 (repr.); CMA 1998; Philadelphia et al. 1999–2000, 54, 56 (repr.).

93. Maurice Brazil Prendergast

May Day, Central Park, 1901. Gift from J. H. Wade 1926.17.

PROVENANCE

Kraushaar Galleries; CMA [files indicate the work was purchased out of the 1926 Prendergast Memorial exhibition with J. H. Wade Fund, though credit line is given as Gift from J. H. Wade].

LITERATURE

Milliken 1926a, 38 (repr.); Milliken 1926b, 187 (repr.); National Cyclopedia of American Biography 1943, 398–99; Metcalfe 1950, 50; Rhys 1952, 81–82, 176, no. 22 (repr.); McKinney 1954 (repr.); CMA Handbook 1958, no. 563 (repr.); Dodd 1960, 7; *Life* Magazine (1 September 1961), 71; Simon 1961, X:19; CMA Handbook 1966, 1969, 189 (repr.); *CMA Bulletin* 60 (1973), 32; Boyle 1974, 255 (repr. as frontispiece); Glubok 1974, (repr. inside front and back cover); CMA Handbook 1978, 235 (repr.); Perlman 1979, 153 (repr.); New York 1979a, 12, 138 (repr.); Koschatzky 1982, 337 (repr.); Wattenmaker 1982, 36; Langdale 1987, 1089; Clark et al., 1990, 412, no. 795 repr.; CMA Handbook 1991, 140 (repr.); Anderson 1996, 114–15 (repr.).

EXHIBITIONS

CMA 1926, (no. 45, unpublished checklist); New York 1934b, no. 95; Santa Barbara 1941, no. 97 (as *Maypole, Central Park*); Minneapolis et al. 1946–47, no. 6; New Delhi 1954, no. 1; Toledo 1954, no. 27; Boston 1960, 41, 90, no. 88 (repr.); Los Angeles et al. 1968, no. 36 (repr.); CMA 1974b; Evanston 1981, 18 (repr.); Tokyo 1982, 23, no. 62 (repr.); New York et al. 1990–91, 20, 87, 184, no. 42 (repr.).

94. Paula Modersohn-Becker

Seated Female Nude, c. 1899. Purchase from the J. H. Wade Fund 1973.35.

PROVENANCE

Ernst Rump Collection, Hamburg (sale stamp on verso); [probably sold, Dr. Ernst Hauswedell (auction house), Hamburg, June 1967, no. 1006]; [Allan Frumkin Gallery, New York].

LITERATURE

CMA Bulletin 61 (1974), 50 (repr.), 75, no. 100; CMA Handbook 1978, 240.

EXHIBITIONS

CMA 1974a; CMA 1993b.

95. Pablo Picasso

Head of a Boy, 1905–6. Bequest of Leonard C. Hanna Jr. 1958.43.

PROVENANCE

Gertrude Stein, Paris; Horst Bohrmann, Berlin; Jacques Doucet, Paris; [Jacques Seligmann & Co., Inc., New York]; Leonard C. Hanna Jr.

LITERATURE

Zervos 1932–78, 1:no. 303, pl. 135; CMA Handbook 1958, no. 28 ; Ponge/Chessex 1960, 74, no. 25; Seligman 1961, pl. 92; CMA Handbook 1966, 1969, 195; Daix/Boudaille 1967, 29, no. XV.7; Sutton/Lecaldano 1968, 108–9, no. 256; Palau i Fabre 1980, 444–45, no. 1231, 550, no. 1231; CMA Handbook 1991, 142; Richardson 1991, 324 (repr.); Turner 1991, 153; Barcelona/Bern 1992, 264, under no. 107; Geelhaar 1993, 26.

EXHIBITIONS

New York 1937, no. 4; CMA 1939a; New York 1947a, no. 27; New York 1970, 91, 166, pl. 39; CMA 1973b; Cincinnati 1981, 13; CMA 1991e.

96. Pablo Picasso

Reclining Nude, 1906. Gift of Mr. and Mrs. Michael Straight 1954.865.

PROVENANCE

Paul Guillaume, Paris. Mr. and Mrs. Michael Straight, Washington.

LITERATURE

Zervos 1932–78, 1:pl. 143, XLVIII, no. 317; CMA Handbook 1958, no. 519; CMA Handbook 1966, 1969, 195 (repr.); Daix/Boudaille 1967, 100, 305, no. XV:47; Sutton/Lecaldano 1968, 113 no. 295; Gaya Nuño 1975, 65 (repr.); Hilton 1975, 67, 71, fig. 51; Palau i Fabre 1980, 461, 552, no. 1308; Rubin 1980, 59, 72 (repr.); Rubin 1988, 398–90, fig. 14; Catoni 1990, 122–23, fig. 11; Daix/Lévy 1990, 151, no. 1; Chevalier 1991, 81 (repr. on back jacket); Richardson 1991, 448 (repr.); Suenaga et al. 1991, 94 (repr.); Høvikodden 1992, 60–61 (repr.); New York 1992b, 168, fig. 65; Harrison et al. 1993, 119–20, pl. 104; Rubin et al. 1994, 36, fig. 17; New York/Paris 1996–97, 266.

EXHIBITIONS

Hartford 1934, no. 91; Milwaukee 1957, 57, 65, no. 88 (repr.); Toronto/Montreal 1964, no. 36; CMA 1973b; Tokyo/Kyoto 1983, 53, 192, no. 29; Tübingen/Düsseldorf 1986, 22, 275, no. 42; Barcelona/Bern 1992, 342–43, no. 175; Washington/Boston 1997–98, 267, 296, 328, 364, no. 160, fig. 6.

97. Georges Braque

The Violin, early 1914. Leonard C. Hanna Jr. Fund 1968.196.

PROVENANCE

[Galerie Kahnweiler, Paris (no. 1183)]. Jean Paulhan. Albert Loeb Krugier.

LITERATURE

Tzara 1931, 65 (repr.); Isarlov 1932, 19, no. 184; Zervos 1933, 27 (repr.); Einstein 1934, pl. XXII; Fumet 1945, fig. 19; Ponge 1946, 1 (repr.); CMA Handbook 1966, 1969, 197 (repr.); Dorival 1966, 112–13, fig. 3; *CMA Bulletin* 56 (1969), no. 108 (repr.); Henning 1969a, 55–60; Henning 1969b, 223 (repr.); Henning 1970, 338–39, fig. 94; Henning 1972, 197–98, fig. 9; Daval 1973, 259 (repr.); Henning 1976, 2, figs. 2, 3; Gross 1977, 144, fig. 3; Henning 1977, 56, fig. 5; Henning 1981, 39–40, fig. 3; Daix 1982, 102 (repr.); Pouillon/Monod-Fontaine 1982, 54, fig. 2, under no. 13; Worms de Romilly/Laude 1982, 286, no. 216; Zurcher 1988, 108–9, fig. 73, 124; Perruchot 1992, 57 (repr.).

EXHIBITIONS

Paris 1961, no. 17; New York 1967, no. 4; CMA 1969; Paris 1974a, 30, pl. 6, 207–8, no. 456; Washington/Paris 1982–83, 126–27 no. 39.

98. John Marin

Sand Dunes, Wallace Head, Maine, 1915. Mr. and Mrs. William H. Marlatt Fund 1946.256.

PROVENANCE

[An American Place (gallery of Alfred Stieglitz)], New York; Mr. Zirinsky (according to CMA files, an old label from the American Place gallery, now lost, was inscribed in Stieglitz's hand: "Acquired by Mr. Zirinsky 12/10/45"); [James N. Rosenberg].

LITERATURE

Kelly 1948, 22-D; Reich 1970, 2:409, no. 15.35.

EXHIBITIONS

Possibly included in the one-man exhibition of Marin's work held at the Little Galleries of the Photo-Secession (known as 291), New York, 18 January–12 February 1916 (it cannot be confirmed since no checklist or catalogue exists); Colorado Springs 1948, no. 14; AFA 1949–50; CMA 1991b.

There was an exhibition (*John Marin, Paintings—1945*) held at An American Place, 30 November 1945–17 January 1946, and although the work was not included (the show featured Marin's recent work), the previous owner, Mr. Zirinsky, seems to have purchased it from Stieglitz's inventory at the time of the show (see Provenance).

99. Egon Schiele

Portrait of a Child, 1916. Severance and Greta Millikin Collection 1964.285.

PROVENANCE
Lederer family, Vienna (inscription on verso; Lanyi 1917); purchased from Lederer family by Walter Feilchenfeldt, Zurich (Kallir 1990; letter from Jane Kallir, CMA files). Severance and Greta Millikin, Cleveland.

LITERATURE
Schiele 1917, pl. 10; published as a postcard by Verlag der Buchhandlung Richard Lanyi, Vienna, c. 1917–20; CMA Handbook 1991, 145 (repr.); Kallir 1990, 560, no. 1814 (repr.).

EXHIBITIONS
Possibly Munich 1917 (according to Kallir 1990); CMA 1991b.

100. Charles Burchfield

Church Bells Ringing, Rainy Winter Night, 1917. Gift of Mrs. Louise M. Dunn in memory of Henry G. Keller 1949.544.

PROVENANCE
Louise M. Dunn, Cleveland.

LITERATURE
Francis 1950c, 23–24, cover illustration; Baur 1956a, 30–40, fig. 6; Baur 1956b, 26–27, 65–66; CMA Handbook 1958, no. 561; *CMA Bulletin* 50 (1963), 108; CMA Handbook 1966, 1969, 191; Trarato et al. 1970, 57, no. 401; Adams et al. 1972, 18–19; CMA Handbook 1978, 237; Baur 1982, 73, 80, no. 55, 215–16; Buffalo 1986–87, 6–7; CMA Handbook 1991, 146; Burchfield/Townsend 1993, 18, 19, nos. 4, 28, 112, 136, 311, 332, 410, 437, 577, 666 n. 26, 667 n. 18, 671 n. 15, 627 n. 38, 682 n. 20, 688 n. 13; Steine 1993, 176–77.

EXHIBITIONS
New York 1930, 5–7, 11, no. 17, pl. 17; Cleveland 1953, 20, no. 30, pl. I; CMA 1957, no. 9; New York et al. 1963–64, 25, 71, no. 9; Los Angeles et al. 1968, 15, 67, 84, no. 84; Utica 1970, no. 77; CMA 1984–85b; CMA 1985a; Boston et al. 1986–87, no. 48; Buffalo et al. 1993–94, 41, fig. 15, 42–43, 112 nn. 47–49, 115; Cleveland 1996, 88–89, 104 n. 56, 245, no. 44; Columbus et al. 1997–98, 113, 160, 264, no. 34.

101. Charles Demuth

Dancing Sailors, 1917. Mr. and Mrs. William H. Marlett Fund 1980.9.

PROVENANCE
Albert Rothbart, Ridgefield, Connecticut (purchased from the artist, according to Farnham 1959). "Property of the Topstone Fund (A Charitable Foundation) New York" [sold, Parke-Bernet Galleries, Inc., New York, 14 October, 1970, no. 29]. [Kennedy Galleries, Inc., New York].

LITERATURE
Farnham 1959, 507, no. 253; *CMA Bulletin* 68 (1981), 164, 199, 213, no. 90 (repr.); "La Chronique des Arts," *Gazette des Beaux Arts* 97 (Supplement, March 1981), 43, no. 236; Eiseman 1982, 46–47, pl. 13; Shone 1988, 58, fig. 63; Weinberg 1993, 99–100, pl. 41.

EXHIBITIONS
New York 1929–30, 17, no. 8; New York 1934a, 28, no. 64 (repr.); CMA 1981b; Norfolk 1983, 41 (repr.), 109; New York et al. 1988, 87, pl. 26; CMA 1991b; CMA 1998.

102. Charles Demuth

Amaryllis, c. 1923. Hinman B. Hurlbut Collection, 2490.1923.

PROVENANCE
[Daniel Gallery, New York]. Farnham 1959 (583, no. 435) incorrectly listed Hinman B. Hurlbut as an owner, her confusion arising because it was purchased with a fund bearing his name. Hurlbut died in 1888.

LITERATURE
Farnham 1959, 583, 862, no. 435, pl. 109; Farnham 1971, 149; Adams et al. 1972, 18–19 (repr.); Anderson 1980, 64–65, pl. 24.

EXHIBITIONS
Daniel Gallery, New York, *Watercolors by Charles Demuth,* 1923 (as *The Lily;* there was apparently no catalogue; that the work was in this show is indicated by CMA records, which state the piece was "Bought from Exhibition in November–December 1923 at Daniel Gallery, New York." Daniel's bill of sale to the CMA is dated 28 November 1923); CMA 1923–24, no. 29 (as *Flower Study*); Cleveland 1937, 19, no. 45 (as *Flower Study*); New York 1937–38, no. 63 (as *Flower Study*); Washington 1942, no. 21; New York et al. 1950–51, 78, 92, no. 123 (repr.) (as *Flower Study*); Harrisburg 1966, 27, no. 94 (as *Amaryllis*); AFA 1967–68, no. 6 (as *Amaryllis*); Santa Barbara et al. 1971–72, 83, no. 85 (as *Amaryllis*); New York et al. 1988 (Los Angeles venue only), 79, pl. 16 (as *Amaryllis*).

103. Joseph Stella

Lilies and Sparrow, c. 1920. Delia E. Holden Fund 1983.81.

PROVENANCE
Sergio Stella, Glen Head, New York; [Harriet Griffin Fine Arts, Inc., New York].

LITERATURE
Glaubinger 1983; *CMA Bulletin* 71 (1984), 75, no. 201 (as *Sparrow and Lilies*), 171 (as *Sparrow and Lilies*).

EXHIBITIONS
CMA 1984b; CMA 1984–85b; New York 1994b, no. 136 (repr.) (as *Sparrow and Lilies*).

104. George Grosz

Student, 1922 (recto), *Amalie, Ida, and Set Designs* (verso). Contemporary Collection of The Cleveland Museum of Art 1966.50.a,b.

PROVENANCE
[Galerien Flechtheim, Berlin/Düsseldorf (according to old label)]; [Eugene Victor Thaw, New York].

LITERATURE
Baur 1954, 16–17, 19 (repr.); *CMA Bulletin* 53 (1966), 241, 283, no. 116 (repr.); West 1968, 90–94, fig. 1 (repr. on cover); Rubin 1968, 88, pl. 76; Ashton 1969, 40–41 (repr.); London 1978, 94, fig. 4.34; DeShong 1982, 43, pl. 14; Born/Taylor 1990, 113, fig. 6.

EXHIBITIONS
CMA 1966; Berlin/Frankfurt 1977–78, 3/51, 3/261, fig. 3/663; London 1978, 94, fig. 4.34; Akron 1978; Boston/Fort Worth 1980–81 [12, 26]; Cleveland 1981, 29, no. 14 (repr.); Madison 1985–86, [3] (repr.), insert; CMA 1989–90.

105. Henri Matisse

Reclining Odalisque, c. 1923. Gift of The Print Club of Cleveland 1927.300.

PROVENANCE
[Bernheim Jeune & Co., Paris (their inventory no. 24301) who purchased drawing from Matisse in 1925]; [C. W. Kraushaar Art Galleries, New York, who purchased drawing from Bernheim Jeune & Co. in 1927]. For documentation concerning the provenance, see Dauberville/Dauberville 1995, 2:744, 1247.

LITERATURE
Dauberville/Dauberville 1995, 2:1247, no. 652 (repr.); *CMA Bulletin* 15 (1928), 16.

EXHIBITIONS
CMA 1938d; CMA 1942a; CMA 1943b; CMA 1949b; CMA 1952; CMA 1994–95.

106. Edward Hopper

Lighthouse Village, 1929. Hinman B. Hurlbut Collection 806.1930.

PROVENANCE
[Frank K. M. Rehn, New York (who received the work from Hopper in October 1929)].

LITERATURE
Hopper/Hopper 1913–63, 71; O'Conner 1937, 305; Coates 1945, 67; Goodrich 1971, 1989, 72; Levin 1995a, 197, pl. W-228; Levin 1995b, 224; Lyons 1997, 34; Washington/Montgomery 1999–2000, 90–3, fig. 99.

EXHIBITIONS
CMA 1930; Pittsburgh 1937, 20, no. 93; Minneapolis et al. 1945, 20, 52, no. 14; Minneapolis et al. 1946–47, 20, no. 12; Vienna 1949, no. 29; New York et al. 1950, 58, no. 103; New York et al. 1964–65, 67, no. 103.

107. Charles Sheeler

Modern Progress in Transportation, c. 1930. Andrew R. and Martha Holden Jennings Fund 1996.252.

PROVENANCE
"Property of a Philadelphia Collection"; [sold, Sotheby's, New York, 14 March 1996, no. 157]; [Martha Parrish & James Reinish, Inc., New York].

LITERATURE
CMA Annual Report (1996), 28, 38 (repr.), 47.

EXHIBITIONS
CMA 1998.

108. Reginald Marsh

1931 Coupe, 1931. Bequest of Felicia Meyer Marsh 1979.66.

PROVENANCE
Estate of the artist (estate stamp, lower right, in red ink); Felicia Meyer Marsh (artist's wife, through Norman Sasowsky).

LITERATURE
CMA Bulletin 67 (1980), 97, no. 74.

EXHIBITIONS
CMA 1980c.

109. Thomas Hart Benton

G. O. P. Convention, Cleveland, 1936. Purchase from the Leonard C. Hanna Jr. Fund 1995.70.

PROVENANCE
Private collection, New York, by early 1950s; [Jordan-Volpe Gallery, Inc., New York].

LITERATURE
CMA Annual Report (1995), 24–25, 33 (repr.), 45; "Museum Acquisitions: The Cleveland Museum of Art Acquires Goya and Benton Drawings," Drawing 17 (November 1995– March 1996), 105 (repr.); De Grazia 1996, 7.

EXHIBITIONS
CMA 1998.

110. Paul Klee
God of War, 1937. Bequest of Lockwood Thompson 1992.278.

PROVENANCE
[Galerie Jeanne Bucher-Myrbor, Paris]; purchased by Lockwood Thompson, 14 September 1938.

LITERATURE
Vishny 1978, 241, 243 n. 30; Kersten 1990, 60–61, 63, fig. 41; CMA Bulletin 80 (1993), 62, 72, no. 230 (repr.); Düsseldorf/Stuttgart 1995, 214–15.

EXHIBITIONS
Paris 1938, no. 34; CMA 1939a; New York 1940, no. 86 (repr.); Northampton et al. 1941, no. 65; CMA 1993a.

111. Yves Tanguy
Untitled, c. 1939. Bequest of Lockwood Thompson 1992.283.

PROVENANCE
Jeanne Bucher (inscribed to her by Tanguy); [possibly Galerie Jeanne Bucher, Paris]; Lockwood Thompson, Cleveland.

Thompson may have purchased the work directly from the gallery since he frequently bought from Paris and London galleries— Galerie Jeanne Bucher owned other works by Tanguy as late as 1963 (according to Kay Sage's catalogue raisonné of that year); since the Cleveland drawing does not appear in the 1963 catalogue, Thompson may have owned it by that time, unbeknown to Tanguy's wife, Kay Sage.

LITERATURE
CMA Bulletin 80 (1993), 75, no. 317; Matisse Foundation/De Pury & Luxembourg Art (Tanguy catalogue raisonné, forthcoming).

EXHIBITIONS
[Possibly Exposition Yves Tanguy, Galerie Jeanne Bucher-Myrbor, Paris, 17–30 May 1938]; CMA 1975b; Cleveland 1979c, 34 (detail repr. on cover); CMA 1993a.

112. Joan Miró
Woman with Blond Armpit Combing Her Hair by the Light of the Stars, 1940 (recto), Figure (verso). Contemporary Collection of The Cleveland Museum of Art 1965.2.a,b.

PROVENANCE
[E. V. Thaw & Co., Inc., New York].

LITERATURE
New York 1959b, no. 5 (repr., recto and verso); Dupin 1962, 541, no. 542 (repr.); CMA Bulletin 52 (1965), 142–43, 157, no. 172 (repr.); Alsop 1966, 30 (repr.); CMA Handbook 1966, 1969, 199 (repr.); CMA Selected Works [1967], 244 (repr. in color); Henning 1968; Sweeney 1970, no. 99 (repr.); Tapié 1970, 20, no. 52 (repr.); Cooper/Matheson 1973, 78; CMA Handbook 1978, 248; Henning 1979, 239–40, fig. 8; Rolnik 1983, 3, fig. 5; Malet 1984, 127, no. 57, pl. 57; Serra 1984, 57, 288, fig. 57; Penrose 1985, 185; Matthews 1986, 90–91 (repr.); Rowell 1987, 170; CMA Hand-

book 1991, 150 (repr.); Bozal Fernandez 1992, 36:384–85 (repr.); Dupin 1993, 271, fig. 275.

EXHIBITIONS
Possibly New York 1945, no. 5 (all the "Constellation" series drawings, except Nocturne, the one Miró gave to his wife, are listed in the brochure printed for the 1945 exhibition at the Pierre Matisse Gallery; according to Lilian Tone, however, who compiled exhibition histories for the 1993 Miró retrospective [New York 1993–94], not all the "Constellation" drawings were shown there; she listed only the few mentioned in contemporary reviews of the show as ones we know for certain were in the exhibition); possibly New York 1959b (according to New York 1993–94, 417, under no. 160); Paris 1959b (according to New York 1993–94, 417, under no. 160); CMA 1965f; Cleveland 1966, 204, no. 77 (repr.); Saint-Paul-de-Vence 1968, no. 38; Barcelona 1968–69, 61, no. 42; Cleveland 1979b, 80–81, no. 34, 175, color pl. XXI; Houston 1982, 4; Cleveland 1987, 79–82, no. 38, color pl. VII; Madrid 1993, 153, no. 65 (repr.) 114; New York 1993–94, 417, no. 160, 242 (color repr.).

113. René Magritte
Utopia, 1945. Bequest of Lockwood Thompson 1992.275.

PROVENANCE
Galerie Lou Cosyn; Lockwood Thompson, Cleveland.

LITERATURE
CMA Bulletin 80 (1993), 73, no. 243 (as Rose); Sylvester 1992–94, 4:60, no. 1191 (repr.).

EXHIBITIONS
Cleveland 1979c, 33; CMA 1993a (as Rose).

114. Jacob Lawrence
Creative Therapy, 1949. Delia E. Holden Fund 1994.2.

PROVENANCE
[Downtown Gallery, New York]; private collection, New York; [Terry Dintenfass, Inc., New York].

LITERATURE
CMA Annual Report (1994), 22, 29 (repr.), 38.

EXHIBITIONS
New York 1950, no. 4; CMA 1998.

115. Louise Bourgeois
Untitled, c. 1950. Purchase from the J. H. Wade Fund 1998.112.

PROVENANCE
Private collection, New York (according to New York 1982–83, 50, pl. 25). BP America, Inc., Cleveland.

LITERATURE
CMA Annual Report (1998), 31, 50.

EXHIBITIONS
New York 1980 (repr.); New York 1982–83, 50, pl. 25.

116. Franz Kline
Black and White, 1954. Contemporary Collection of The Cleveland Museum of Art 1961.134.

PROVENANCE
[Sidney Janis Gallery, New York (label in CMA files) by 1957]; lent to Rental Gallery of the Contemporary Arts Center, Cincinnati Art Museum, in 1957 (label in CMA files). [Leo Castelli Gallery, New York].

LITERATURE
CMA Bulletin 48 (1961), 233, 251, no. 87 (repr.); Richards 1962b, 56, 58–59, fig. 3; Henning 1967, 223, 226–67, fig. 7; Henning 1969a, 62–63, fig. 3; Meder 1978, 302, pl. 309.

EXHIBITIONS
CMA 1961b; New York 1976, 73, no. 113; Cincinnati et al. 1985–86 (Cincinnati and Philadelphia venues only), 160, pl. 160; Coral Gables et al. 1989–90 (Chicago and New Brunswick venues only), 45, no. 53, fig. 23; CMA 1991b; CMA 1998.

117. Barnett Newman
Untitled, 1959. Purchase from the J. H. Wade Fund 1986.4.

PROVENANCE
Sold by the artist to Cleve and Francine du Plessix Gray, Warren, Connecticut, in 1961 (for Cleve Gray's recounting of the story of its purchase, see Baltimore 1979–81, 156); [Xavier Fourcade, Inc., New York].

LITERATURE
Plessix 1965, 33; CMA Bulletin 74 (1987), 47, 72, no. 171 (repr.).

EXHIBITIONS
New York 1966–67, 33, no. 228; Baltimore et al. 1979–81 (American venues only), 156–57, no. 60; CMA 1987a.

118. David Smith
Untitled, 1962. Purchase from the J. H. Wade Fund 1986.19.

PROVENANCE
Estate of the artist (the artist's daughters Candida and Rebecca Smith); [Anthony d'Offay Gallery, London].

LITERATURE
CMA Bulletin 74 (1987), 71, 73, no. 184 (repr.).

EXHIBITIONS
London 1985, no. 47 (repr.); Stuttgart et al. 1976, 6–7, 25 (repr.); CMA 1987a.

119. Ellsworth Kelly
Study for Red Green Blue, 1964. Gift of Mrs. John B. Dempsey 1997.196.

PROVENANCE
The artist until 1997; [Matthew Marks Gallery, New York].

LITERATURE
CMA Annual Report (1997), 26, 32 (repr.), 44. "Drawings on Exhibition," Drawing 19 (Summer 1998), 137.

EXHIBITIONS
CMA 1998.

120. Edward Ruscha
Bronson Tropics, 1965. Purchase from the J. H. Wade Fund 1998.114.

PROVENANCE
The artist, until 1998; [Anthony d'Offay Gallery, London].

LITERATURE
Ruscha/Schjeldahl 1980, 20, no. 12; CMA Annual Report (1998), 31, 39 (repr.), 50.

EXHIBITIONS
Minneapolis 1972, no. 14; San Francisco et al. 1982–83, 66, 176, no. 66, pl. 28; Lake Worth, Florida 1988, 61, no. 24 (repr.), 38; New York 1990b, 19; London 1998, 27 (repr.).

Achilles 1986–87
Katrin Achilles. "Naturstudien von Hans Hoffmann in der Kunstsammlung des Nürnberger Kaufmanns Paulus II. Praun." *Jahrbuch der Kunsthistorischen Sammlungen in Wien* 82–83 (1986–87), 243–59.

Achilles-Syndram 1990
Katrin Achilles-Syndram. "Die Zeichnungssammlung des Nürnberger Kaufmanns Paulus II. Praun (1548–1616). Versuch einer Rekonstruktion." Ph.D. diss., Technische Universität, Berlin, 1990.

Achilles-Syndram 1994
Katrin Achilles-Syndram. *Die Kunstsammlung des Paulus Praun.* Nuremberg, 1994.

Adams 1987
Henry Adams. "First 'A Marvel,' Then Out of Fashion, A Fine Artist Returns." *Smithsonian* 68 (July 1987), 46–59.

Adams et al. 1972
Celeste Adams, Rita Myers, Adele Z. Silver. *An Introduction to American Art at the Cleveland Museum of Art.* Cleveland, 1972.

Adhémar 1954
Jean Adhémar. *Honoré Daumier: Drawings and Watercolours.* New York/Basel, 1954.

Adriani 1985
Götz Adriani. *Degas: Pastels, Oil Sketches, Drawings.* Translated by Alexander Lieven. New York/London, 1985.

Adriani 1987
Götz Adriani. *Toulouse-Lautrec.* London [German ed., Cologne], 1987.

AFA 1949–50
"Water Color Paintings." American Federation of Arts Museum Series Program of Exhibitions (ten venues). Washington, 1949–50.

AFA 1967–68
"American Still-Life Painting: 1913–1967." American Federation of Arts (eleven venues). New York, 1967–68.

Akron 1952
"Artists on Architecture." Akron Art Institute (now Akron Art Museum), Ohio, 1952.

Akron 1978
"Dada Revisited." Akron Art Institute (now Akron Art Museum), Ohio, 1978.

Alazard 1950
Jean Alazard. *Ingres et l'ingrisme.* Paris, 1950.

Alexandre 1888
Arsène Alexandre. *Honoré Daumier l'homme et l'oeuvre.* Paris, 1888.

Allentown 1962
Richard Hirsch. *The World of Benjamin West.* Allentown Art Museum, Pennsylvania, 1962.

Alpers 1995
Svetlana Alpers. "Post-Genius Venice." *Art in America* 83 (March 1995), 62–70.

Alsop 1966
Joseph Alsop. "Treasures of the Cleveland Museum of Art." *Art in America* 54 (May–June 1966), 21–45.

Ames 1958
Winslow Ames. "Antonio Canaletto." *Old Master Drawings* 48 (March 1938), 53–59.

Amiens 1997–98
Dessins français des XVIIIe et XIXe siècles du Musée de Picardie. Musée de Picardie, Amiens, 1997–98.

Amory 1882
Martha Babcock Amory. *The Domestic and Artistic Life of John Singleton Copley, RA.* Boston, 1882.

Amsterdam 1988–89
Louis Tilborgh et al. *Van Gogh and Millet.* Rijksmuseum Vincent Van Gogh, Amsterdam, 1988–89.

Amsterdam 1993–94
G. Luijten et al. *Dawn of the Golden Age: Northern Netherlandish Art, 1580–1620.* Rijksmuseum, Amsterdam, 1993–94.

Amsterdam/Cleveland 1992–93
Nancy Bialler. *Chiaroscuro Woodcuts: Hendrick Goltzius (1558–1617).* Rijksmuseum, Amsterdam; Cleveland Museum of Art, 1992–93.

Amsterdam/Jerusalem 1991
Christian Tümpel et al. *Het Oude Testament in de Schilderkunst van de Gouden Eeuw.* Joods Historisch Museum, Amsterdam; Israel Museum, Jerusalem, 1991.

Ananoff 1961–70
Alexandre Ananoff. *L'Oeuvre dessiné de Jean-Honoré Fragonard (1732–1806).* 4 vols. Paris, 1961–70.

Ananoff 1966
Alexandre Ananoff. *L'Oeuvre dessiné de François Boucher (1703–1770).* Paris, 1966.

Ananoff/Wildenstein 1976
Alexandre Ananoff and Daniel Wildenstein. *François Boucher.* 2 vols. Lausanne/Paris, 1976.

Ananoff/Wildenstein 1980
Alexandre Ananoff and Daniel Wildenstein. *L'opera completa di Boucher.* Milan, 1980.

Anderson 1980
Dennis R. Anderson. *American Flower Painting.* New York, 1980.

Anderson 1996
Janice Anderson. *Children in Art.* New York, 1996.

Ann Arbor 1962
A Generation of Draughtsmen. University of Michigan Museum of Art, Ann Arbor, 1962.

Ann Arbor 1975
William Levin, Ralph Williams, Clifton Olds. *Images of Love and Death in Late Medieval and Renaissance Art.* University of Michigan Museum of Art, Ann Arbor, 1975.

Annales 1809
Annales du Musée et de l'École Moderne des Beaux-Arts. Première collection. Tome complémentaire. Paris, 1809.

Antwerp 1956
L. Burchard and Roger-A. d'Hulst. *Tekeningen van P. P. Rubens.* Rubenshuis, Antwerp, 1956.

Antwerp/Rotterdam 1966–67
Roger-A. d'Hulst. *Tekeningen van Jacob Jordaens 1593–1678.* Rubenshuis, Antwerp; Museum Boymans-van Beuningen, Rotterdam, 1966–67.

Appleton 1968
Drawing Before 1800. Lawrence University, Appleton, Wisconsin, 1968.

Armstrong 1902
Sir Walter Armstrong. *Turner.* London/New York, 1902.

Arnolds 1941
Günter Arnolds. "Ein Festzug auf dem Marcus-Platz." *Berichte aus den Preussischen Kunstsammlungen* 62 (1941), 17–21.

Art Digest 1928
"A Daumier Gem." *Art Digest* 2 (1 January 1928), 32.

Art News 1930
"Two Tiepolo Drawings Added to Cleveland Museum Collection." *Art News* 28 (1 February 1930), 13.

Art News 1939
"Cleveland: Tiepolo Drawings from a Famous Series." *Art News* 37 (20 May 1939), 15.

Ashton 1969
Dore Ashton. "A Planned Coincidence." *Art in America* 57 (September–October 1969), 36–47.

Ashton 1988
Dore Ashton. *Fragonard in the Universe of Painting.* Washington, 1988.

Asia 1982
"Visions of Landscape East and West: An Arresting Show at *Cleveland Museum* Contrasts the Way Two Philosophical Traditions Color the Painter's World." *ASIA* 4 (January–February 1982), 24–29.

Astre 1926
Achille Astre. *H. de Toulouse-Lautrec.* Paris, 1926.

Avery 1972
Catherine B. Avery, ed. *The New Century Italian Renaissance Encyclopedia.* New York, 1972.

Aymar 1970
Brandt Aymar. *The Young Male Figure.* New York, 1970.

Bacci 1963
Mina Bacci. "Jacopo Ligozzi e la sua posizione nella pittura fiorentina." *Proporzioni* 4 (1963), 46–85.

Bachmann/Piland 1978
Donna G. Bachmann and Sherry Piland. *Women Artists: An Historical, Contemporary, and Feminist Bibliography.* London, 1978.

Backhouse/Giraud 1994
Janet Backhouse and Yves Giraud. *Pierre Sala: Petit livre d'amour.* Lucerne, 1994.

Bacou 1975
Roseline Bacou. *Millet: One Hundred Drawings.* New York, 1975.

Baer 1973
Curtis O. Baer. *Landscape Drawings.* New York, 1973.

Baetjer/Links 1989
Katherine Baetjer and J. G. Links. *Canaletto.* New York, 1989.

Bagni 1984
Prisco Bagni. *Guercino a Cento, le decorazioni de Casa Pannini.* Bologna, 1984.

Bailey 1995a
Martin Bailey. "The Lubomirski Dürers: Where Are They Now?" *Art Newspaper* (5 May 1995), 5.

Bailey 1995b
Martin Bailey. "Hitler, the Prince and the Dürers." *Art Newspaper* (16 April 1995), 1, 6.

Baltimore 1939–40
"Interpretations of Architecture in Drawings and Prints from the Renaissance through Le Corbusier." Typescript list by Adelyn Breeskin. Baltimore Museum of Art, 1939–40.

Baltimore 1944
Hans Tietze. *Three Baroque Masters: Strozzi, Crespi, Piazzetta.* Baltimore Museum of Art, 1944.

Baltimore 1959
Age of Elegance: The Rococo and Its Effect. Baltimore Museum of Art, 1959.

Baltimore 1962
The International Style. Walters Art Gallery, Baltimore, 1962.

Baltimore et al. 1979–81
Brenda Richardson. *Barnett Newman: The Complete Drawings, 1944–1969.* Baltimore Museum of Art; Detroit Institute of Arts; Museum of Contemporary Art, Chicago; Metropolitan Museum of Art, New York; Stedelijk Museum, Amsterdam; Musée National d'Art Moderne/Centre Georges Pompidou, Paris; Museum Ludwig, Cologne; Kunstmuseum, Basel, 1979–81.

Barcelona 1968–69
Miró. Recinto del Antiguo Hospital de la Santa Cruz, Barcelona, 1968–69.

Barcelona/Bern 1992
Nuria Rivero. *Picasso 1905–1906: From the Rose Period to the Ochres of Gósol.* Museu Picasso, Barcelona; Kunstmuseum, Bern, 1992.

Barocchi 1962
Paolo Barocchi. *Michelangelo e la sua scuola.* 2 vols. Florence, 1962.

Barocchi 1964
Paola Barocchi. *Vasari pittore.* Milan, 1964.

Barr 1946
Alfred Barr Jr. *Picasso: Fifty Years of His Art.* New York, 1946.

Basel 1948
Rembrandt-Ausstellung. Katz Galerie, Basel, 1948.

Baur 1954
John Ireland Howe Baur. *George Grosz.* New York, 1954.

Baur 1956a
John Ireland Howe Baur. "Fantasy and Symbolism in Charles Burchfield's Early Watercolors." *Art Quarterly* 19 (Spring 1956), 30–40.

Baur 1956b
John Ireland Howe Baur. "Burchfield's Intimate Diaries." *Art News* 54 (January 1956), 26–27, 65–66.

Baur 1982
John Ireland Howe Baur. *The Inlander: Life and Work of Charles Burchfield, 1893–1967.* East Brunswick, New Jersey, 1982.

Bautier 1921
Pierre Bautier. "Le Carnet d'un curieux. Trois portraits de Jacques-Jean Dumont, dit Le Romain, peintre et graveur, par Maurice Quentin de La Tour." *La Renaissance de l'art français et des industries de luxe* 4 (July 1921), 660–62.

Bazin 1992
Germain Bazin. *Théodore Géricault étude critique, documents et catalogue raisonné, Tome V le retour à Paris: Synthèse d'expériences plastiques.* Paris, 1992.

Bean 1960
Jacob Bean. *Les Dessins italiens de la collection Bonnat.* Paris, 1960.

Bean 1964
Jacob Bean. *100 European Drawings in the Metropolitan Museum of Art.* New York, 1964.

Bean 1982
Jacob Bean. *Fifteenth and Sixteenth Century Italian Drawings in the Metropolitan Museum of Art.* New York, 1982.

Bean/Griswold 1990
Jacob Bean and William Griswold. *Eighteenth Century Italian Drawings in the Metropolitan Museum of Art.* New York, 1990.

Bell 1903
Malcolm Bell. *Sir Edward Burne-Jones: A Record and Review.* London, 1903.

Bell/Girtin 1935
C. F. Bell and T. Girtin. "The Drawings and Sketches of John Robert Cozens." *Walpole Society* 23 (1935), 1–80.

Bénédite 1906
Léonce Bénédite. *Les Dessins de J. F. Millet.* Paris, 1906.

Benesch 1935
Otto Benesch. *Rembrandt, Werk und Forschung.* Vienna, 1935.

Benesch 1946
Otto Benesch. *Rembrandt Selected Drawings.* London, 1946.

Benesch 1947
Otto Benesch. *Venetian Drawings of the Eighteenth Century in America.* New York, 1947.

Benesch 1954–57
Otto Benesch. *The Drawings of Rembrandt.* 6 vols. London, 1954–57.

Benesch 1967
Otto Benesch. *Master Drawings in the Albertina: European Drawings from the 15th to the 18th Century.* New York, 1967.

Benesch 1973
Otto Benesch. *The Drawings of Rembrandt.* 2nd ed., revised and enlarged by E. Benesch. London/New York, 1973.

Berckenhagen 1970
Ekhart Berckenhagen. *Die französischen Zeichnungen der Kunstbibliothek Berlin.* Berlin, 1970.

Berenson 1938
Bernard Berenson. *The Drawings of the Florentine Painters.* 3 vols. Chicago, 1938.

Berenson 1961
Bernard Berenson. *I disegni dei pittori fiorentini.* Milan, 1961.

Berger 1946
Klaus Berger. *Géricault: Drawings and Watercolors.* New York, 1946.

Berger 1979
Robert W. Berger. "Rubens's 'Queen Tomyris with the Head of Cyrus'." *Bulletin of the Museum of Fine Arts, Boston* 77 (1979), 4–35.

Berlin et al. 1991
Holm Bevers, Uwe Wieczorek, Peter Schatborn, Barbara Welzel. *Rembrandt, the Master and His Workshop: Drawings and Etchings.* Kupferstichkabinett, Staatliche Museen Preussischer Kulturbesitz, Berlin; Rijksmuseum, Amsterdam; National Gallery, London, 1991.

Berlin et al. 1994–95
Peter Klaus Schuster, ed. *George Grosz: Berlin—New York.* Neue Nationalgalerie, Berlin; Kunstsammlung Nordrhein-Westfalen, Düsseldorf; Staatsgalerie Stuttgart, 1994–95.

Berlin/Frankfurt 1977–78
Eberhard Roters, Hanne Bergius, Klaus Gallwitz. *Dada in Europa: Werke und Dokumente* (shown at unknown venues in Berlin as *Dritter Teil der 15, Kunstausstellung des Europarates: Tendenzen der Zwanziger Jahre*). Berlin; Städtische Galerie im Städelschen Kunstinstitut, Frankfurt, 1977–78.

Berlin/Regensburg 1988
Hans Mielke. *Albrecht Altdorfer. Zeichnungen, Deckfarbenmalerei, Druckgraphik.* Kupferstichkabinett, Staatliche Museen Preussischer Kulturbesitz, Berlin; Museen der Staadt, Regensburg, 1988.

Bertelà 1975
Giovanna Gaeta Bertelà. *Disegni di Federico Barocci.* Florence, 1975.

Besnard/Wildenstein 1928
Albert Besnard and Georges Wildenstein. *La Tour: La vie et l'oeuvre de l'artiste.* Paris, 1928.

Bethnal Green 1872–75
C. C. Black. *Catalogue of the Collection of Paintings, Porcelain, Bronzes, Decorative Furniture, and Other Works of Art, Lent for the Exhibition in the Bethnal Green Branch of the South Kensington Museum, By Sir Richard Wallace.* Bethnal Green Branch Museum, England, 1872–75.

Bettagno 1988
Alessandro Bettagno. *Paolo Veronese: disegni e dipinti.* Vicenza, 1988.

Biadene 1992
Susanna Biadene. "Le Feste per I Conti del Nord: 'Ironico e Malinconico' Crepuscolo del Rococò." In *Per Giuseppe Mazzariol.* Venice, 1992.

Bielefeld 1988
Ulrich Weisner. *Picassos Klassizismus.* Kunsthalle, Bielefeld, 1988.

Bielefeld/Baden-Baden 1983–84
Erich Franz and Bernd Growe. *Georges Seurat Zeichnungen.* Kunsthalle Bielefeld; Staatliche Kunsthalle, Baden-Baden, 1983–84.

Binghamton 1967
Michael Milkovich. *Bernardo Strozzi: Paintings and Drawings.* University Art Gallery, State University of New York at Binghamton, 1967.

Binion 1971
Alice Binion. "Giovanni Antonio and Francesco Guardi: Their Life and Milieu, with a Catalogue of Their Figure Drawings." Ph.D. diss., Columbia University, 1971.

Birmingham 1951
Eighteenth Century Venice. Whitechapel Art Gallery, Birmingham, England, 1951.

Birmingham/Montgomery 1972
David Rosand. *Veronese and His Studio in North American Collections.* Birmingham Museum of Art, Alabama; Montgomery Museum of Fine Arts, Alabama, 1972.

Birmingham/Springfield 1978
Barry Hannegan and Edward Weeks. *The Tiepolos: Painters to Princes and Prelates.* Birmingham Museum of Art, Alabama; Museum of Fine Arts, Springfield, Ohio, 1978.

Blanc 1870
Charles Blanc. *Ingres: Sa vie et ses ouvrages.* Paris, 1870.

Bloomington/Palo Alto 1979
Adelheid Gealt and Marcia Vetrocq. *Domenico Tiepolo's Punchinello Drawings.* Indiana University Art Museum, Bloomington; Stanford University Museum of Art, Palo Alto, 1979.

Blunt/Croft-Murray 1957
Anthony Blunt and Edward Croft-Murray. *Venetian Drawings of the XVII and XVIII Centuries in the Collection of Her Majesty the Queen at Windsor Castle.* London, 1957.

Bober/Rubinstein 1986
Phyllis Pray Bober and Ruth Rubinstein. *Renaissance Artists and Antique Sculpture.* Oxford, 1986.

Boerner 1966a
C. G. Boerner. *Ausgewählte Druckgraphik und Handzeichnungen aus Vier Jahrhunderten: Neue Lagerliste Nr. 42.* Düsseldorf, 1966.

Boerner 1966b
C. G. Boerner. *Handzeichnungen vor 1900: Neue Lagerliste Nr. 44.* Düsseldorf, 1966.

Boerner 1981
C. G. Boerner. *Aus Unseren Mappen 1981: Zeichnungen des 16. bis 19. Jahrhunderts: Neue Lagerliste 74.* Düsseldorf, 1981.

Bohn 2000
Babette Bohn. "Draftsman Extraordinaire: Annibale Carracci at the National Gallery." *Art on Paper* 4 (January–February 2000), 64–72.

Bologna 1969
Denis Mahon. *Il Guercino (Giovanni Francesco Barbieri, 1591–1666): Catalogo critico dei disegni.* Palazzo dell'Archiginnasio, Bologna, 1969.

Bologna 1975
Andrea Emiliani and Giovanna Gaeta Bertelà. *Mostra di Federico Barocci.* Museo Civico, Bologna, 1975.

Bologna 1991
Denis Mahon. *Il Guercino 1591–1666: Disegni.* Museo Civico Archeologico, Bologna, 1991.

Bonicatti 1971
Maurizio Bonicatti. "Il Problema dei Rapporti Fra Domenico e Giovanni Battista Tiepolo." In *Celebrazioni tiepolesche: Atti del congreso internazionale di studi sul Tiepolo.* Milan, 1971.

Borenius 1927
Tancred Borenius. "G. B. Tiepolo." *Old Master Drawings* 4 (1927), 54.

Borghini 1584
Raffaello Borghini. *Il Riposo.* Florence, 1584.

Born/Taylor 1990
Richard A. Born and Sue Taylor. *The David and Alfred Smart Museum of Art: A Guide to the Collection.* Chicago/New York, 1990.

Borowitz 1978
Helen O. Borowitz. "Making the Rounds at the Cleveland Museum of Art." *Bulletin of the Cleveland Medical Library* 24 (1978).

Borowitz 1984
Helen O. Borowitz. "Three Guitars: Reflections of Italian Comedy in Watteau, Daumier, and Picasso." *CMA Bulletin* 71 (1984), 116–29.

Borsook 1975
Eve Borsook. "Fra Filippo Lippi and the Murals for Prato Cathedral." *Mitteilungen des Kunsthistorischen Institutes in Florenz* 19, no. 1 (1975), 1–148.

Borsook 1980
Eve Borsook. *The Mural Painters of Tuscany from Cimabue to Andrea del Sarto.* Oxford, 1980.

Bortolatto 1974
Luigina Rossi Bortolatto. *L'opera completa di Francesco Guardi.* Milan, 1974.

Boston 1888
Exhibition of Albrecht Dürer's Engravings, Etchings . . . with Eight Original Drawings from the Collection von Franck. Museum of Fine Arts, Boston, 1888.

Boston 1935
Independent Painters of Nineteenth Century Paris. Museum of Fine Arts, Boston, 1935.

Boston 1936
"Homer—La Farge." Museum of Fine Arts, Boston, 1936.

Boston 1945
A Thousand Years of Landscape East and West. Museum of Fine Arts, Boston, 1945.

Boston 1946
An Exhibition of Paintings, Drawings, and Prints by J. M. W. Turner, John Constable, R. P. Bonington. Museum of Fine Arts, Boston, 1946.

Boston 1960
Hedley Howell Rhys and Peter A. Wick. *Maurice Prendergast: 1859–1924.* Museum of Fine Arts, Boston, 1960.

Boston 1984
Alexandra R. Murphy. *Jean-François Millet.* Museum of Fine Arts, Boston, 1984.

Boston et al. (Paintings and Drawings) 1987–88
Carol Troyen and Erica E. Hirshler. *Charles Sheeler: Paintings and Drawings.* Museum of Fine Arts, Boston; Whitney Museum of American Art, New York; Dallas Museum of Art, 1987–88.

Boston et al. (Photographs) 1987–88
Theodore E. Stebbins Jr. and Norman Keyes Jr. *Charles Sheeler: The Photographs.* Museum of Fine Arts, Boston; Whitney Museum of American Art, New York; Dallas Museum of Art, 1987–88.

Boston et al. 1986–87
An American Visionary: Watercolors and Drawings of Charles E. Burchfield. Boston Athenaeum; Berkshire Museum, Pittsfield, Massachusetts; Currier Gallery of Art, Manchester, New Hampshire, 1986–87.

Boston et al. 1995–96
Nicolai Cikovsky and Franklin Kelly. *Winslow Homer.* National Gallery of Art, Washington; Museum of Fine Arts, Boston; Metropolitan Museum of Art, New York, 1995–96.

Boston/Fort Worth 1980–81
Helmut Wohl. *DADA: Berlin, Cologne, Hannover.* Institute of Contemporary Art, Boston; Fort Worth Art Museum, 1980–81.

Boston/New York 1884
"The Prang Competition." Noyes & Blakeslee Gallery, Boston; Reichart Gallery, New York, 1884.

Boucher/Jaccottet 1952
François Boucher and Philippe Jaccottet. *Le Dessin français au XVIIIe siècle.* Lausanne, 1952.

Bouchot-Saupique 1950
Jacqueline Bouchot-Saupique. *Musée National du Louvre: Catalogue des pastels.* Paris, 1950.

Boyle 1974
Richard J. Boyle. *American Impressionism.* Boston, 1974.

Bozal Fernandez 1992
Valeriano Bozal Fernandez. *Pintura y escultura españolas del siglo XX.* Vols. 36–37 of *Summa artis.* Madrid, 1992.

Brachert et al. 1973
Thomas Brachert, Adelheid Brachert, Leopold Reidemeister, et al. *Stiftung Sammlung Emil G. Bührle.* Zurich, 1973.

Bredt 1918
Ernst Wilhelm Bredt. *Rembrandts Erzählungen.* Munich, 1918.

Bredt 1921
Ernst Wilhelm Bredt. *Die Rembrandt-Bibel, Altes und Neues Testament.* Munich, 1921.

Bredt 1927
Ernst Wilhelm Bredt. *Die Rembrandt-Bibel, Altes und Neues Testament.* 2nd ed. Munich, 1927.

Breeskin 1970
Adelyn D. Breeskin. *Mary Cassatt: A Catalogue Raisonné.* Washington, 1970.

Breeskin 1979
Adelyn D. Breeskin. *Mary Cassatt: A Catalogue Raisonné of the Graphic Work.* Washington, 1979.

Briganti 1977
Giuliano Briganti. *I pittori dell'immaginario: Arte e rivoluzione psicologica.* Milan, 1977.

Briganti 1988
Giuliano Briganti. "Risultati de um'esplorazine ravvicinata della volta Farnese." In *Les Carrache et les dècors profanes.* Rome, 1988.

Brighton/Sheffield 1974
Betty O'Looney. *Frederick Sandys 1829–1904.* Brighton Museum and Art Gallery, England; Mappin Art Gallery, Sheffield, England, 1974.

Brooklyn et al. 1996–97
Susan A. Hobbs, ed. *The Art of Thomas Wilmer Dewing: Beauty Reconfigured.* Brooklyn Museum of Art; Detroit Institute of Arts; National Museum of American Art, Smithsonian Institution, Washington, 1996–97.

Broos 1980
B. P. J. Broos. "Rembrandts Indische Miniaturen." *Spiegel Historiael* 15 (April 1980), 210–18.

Brown 1972
Jonathan Brown. "Notes on Princeton Drawings 6: Jusepe de Ribera." *Record of the Art Museum of Princeton University* 31, no. 2 (1972), 2–7.

Brown 1998
Jonathan Brown. *Painting in Spain 1500–1700.* New Haven, 1998.

Brückle 1993
Irene Brückle. "Blue-Colored Paper in Drawings." *Drawing* 15 (November–December 1993), 73–77.

Brussels 1965
L. Van Puyvelde. *Le Siècle de Rubens.* Musée Royaux des Beaux-Arts de Belgique, Brussels, 1965.

Bruyn et al. 1986
J. Bruyn, B. Haak, S. H. Levie, P. J. J. van Thiel, E. van de Wetering. *A Corpus of Rembrandt Paintings.* Translated by D. Cook-Radmore. Vol. 3 of *Stichting Foundation Rembrandt Research Project.* Dordrecht/Boston/London, 1986.

Buffalo 1935
Master Drawings Selected from the Museums and Private Collections of America. Buffalo Fine Arts Academy, Albright Art Gallery, Buffalo, 1935.

Buffalo 1986–87
Nancy Weekly. *Charles Burchfield: Hidden Treasures.* Burchfield Art Center, Buffalo, 1986–87.

Buffalo et al. 1993–94
Nancy Weekly. *Charles E. Burchfield: The Sacred Woods.* Drawing Center, New York; Minnesota Museum of American Art, St. Paul; Burchfield Art Center, Buffalo; Hunter Museum of Art, Chattanooga, 1993–94.

Bull 1989
Duncan Bull. "London: Old Master Drawings." *Burlington Magazine* 81 (January 1989), 49–50.

Bulliet 1936
C. J. Bulliet. *The Significant Moderns and Their Pictures.* New York, 1936.

Burchard 1953
Ludwig Burchard. "Rubens' Feast of Herod at Port Sunlight." *Burlington Magazine* 95 (December 1953), 384–87.

Burchard/d'Hulst 1963
L. Burchard and Roger-A. d'Hulst. *Rubens Drawings.* Brussels, 1963.

Burchfield 1939
Louise Burchfield. "'Rishi Calling up a Storm' by John La Farge." *CMA Bulletin* 19 (1939), 159–60.

Burchfield/Townsend 1993
J. Benjamin Townsend, ed. *Charles Burchfield's Journals: The Poetry of Place.* Albany, 1993.

Burr 1979
Wallen Burr. *The William A. Gumberts Collection of Canaletto Etchings.* Santa Barbara, 1979.

Burton 1966
Richard Burton. "Fifty Years of the Cleveland: Some Golden Anniversary Acquisitions." *Connoisseur* 163 (October 1966), 128–36.

Burty 1876
Philippe Burty. *Eaux-fortes de Jules de Goncourt.* Paris, 1876.

Bury 1971
Adrian Bury. *Maurice-Quentin de La Tour.* London/Edinburgh/Oslo, 1971.

Butlin 1981
Martin Butlin. *The Paintings and Drawings of William Blake.* New Haven, 1981.

Byam Shaw 1934
James Byam Shaw. "Francesco Guardi." *Old Master Drawings* 35 (December 1934), 50–51.

Byam Shaw 1951
James Byam Shaw. *The Drawings of Francesco Guardi.* London, 1951.

Byam Shaw 1954
James Byam Shaw. "Unpublished Guardi Drawings." *Art Quarterly* 17 (Summer 1954), 159–66.

Byam Shaw 1962
James Byam Shaw. *The Drawings of Domenico Tiepolo.* London, 1962.

Byam Shaw 1977
James Byam Shaw. "Some Guardi Drawings Rediscovered." *Master Drawings* 15 (Spring 1977), 3–15.

Byam Shaw 1979
James Byam Shaw. "Some Unpublished Drawings by Giandomenico Tiepolo." *Master Drawings* 17 (Autumn 1979), 239–44.

Byam Shaw 1983a
James Byam Shaw. *The Italian Drawings of the Frits Lugt Collection.* Paris, 1983.

Byam Shaw 1983b
James Byam Shaw. "Exhibition Reviews: 'Venice: Piazzetta at San Giorgio Maggiore.'" *Burlington Magazine* 125 (December 1983), 786–87.

C. D. 1929
C. D. "Review of 'Albrecht Dürer's Zeichnungen im Lubomirski-Museum im Lemberg.'" *Burlington Magazine* 54 (April 1929), 216–17.

Cachin 1988
Françoise Cachin. *Gauguin.* Paris, 1988.

Cachin 1989
Françoise Cachin. *Gauguin "ce malgré moi de sauvage."* Paris, 1989.

Cadogan 1978
Jean Cadogan. "Drawings by Domenico Ghirlandaio." Ph.D. diss., Harvard University, 1978.

Cadogan 1980
Jean Cadogan. *Maestri Toscani del Quattrocento.* Vol. 17 of *Biblioteca di disegni.* Florence, 1980.

Cailleux 1960
Jean Cailleux. "An Unpublished Painting by Saint-Aubin: 'Le Bal Champêtre.'" *Burlington Magazine (Supplement)* 102 (May 1960), i–iv.

Cambridge 1940
Master Drawings Lent by Philip Hofer, Class of 1921. Fogg Art Museum, Harvard University, Cambridge, 1940.

Cambridge 1948
"Life in Eighteenth-Century Venice." Fogg Art Museum, Harvard University, Cambridge, 1948.

Cambridge 1948–49
Seventy Master Drawings: A Loan Exhibition Arranged in Honor of Professor Paul J. Sachs on the Occasion of his Seventieth Birthday. Fogg Art Museum, Harvard University, Cambridge, 1948–49.

Cambridge 1967
Agnes Mongan and Hans Naef. *Ingres: Centennial Exhibition.* Fogg Art Museum, Harvard University, Cambridge, 1967.

Cambridge 1970
George Knox. *Tiepolo: A Bicentenary Exhibition 1770–1970.* Fogg Art Museum, Harvard University, Cambridge, 1970.

Cambridge 1975
Malcolm Cormack. *J. M. W. Turner, R. A. 1775–1851.* Fitzwilliam Museum, Cambridge, England, 1975.

Cambridge et al. 1991
David M. Stone. *Guercino, Master Draftsman. Works from North American Collections.* Arthur M. Sackler Museum, Harvard University, Cambridge; National Gallery of Canada, Ottawa; Cleveland Museum of Art, 1991.

Cambridge et al. 1998–2000
Alvin L. Clark Jr. et al. *Mastery and Elegance: Two Centuries of French Drawings from the Collection of Jeffrey E. Horvitz.* Harvard University Art Museums, Cambridge; Art Gallery of Ontario, Toronto; Musée Jacquemart-André, Paris; National Gallery of Scotland, Edinburgh; National Academy Museum and School of Fine Arts, New York; Los Angeles County Museum of Art, 1998–2000.

Cambridge/New York 1956
Drawings and Oil Sketches by P. P. Rubens from American Collections. Fogg Art Museum, Harvard University, Cambridge; Pierpont Morgan Library, New York, 1956.

Cambridge/New York 1996
Bernard Aikema. *Tiepolo and His Circle: Drawings in American Collections.* Harvard University Art Museums, Cambridge; Pierpont Morgan Library, New York, 1996.

Camesasca 1969
Ettore Camesasca. *L'opera completa del Perugino.* Milan, 1969.

Camón Aznar [1980]
José Camón Aznar. *Fran. de Goya.* Saragossa, [1980].

Canterbury 1985
Guardi, Tiepolo and Canaletto from The Royal Museum, Canterbury and Elsewhere, and a Selection of Venetian 18th Century Decorative Arts. Royal Museum, Canterbury, 1985.

Caracciolo 1990
Maria Teresa Caracciolo. *Giuseppe Cades 1750–1799 et la Rome de son temps.* Paris, 1990.

Cardiff/London 1956
Drawings by Jean-François Millet. Arts Council of Great Britain. National Museum of Wales, Cardiff; Arts Council Gallery, London, 1956.

Carter 1904
R. Radcliffe Carter. *Pictures and Engravings at Haughton Hall Tarporley in the Possession of Ralph Brocklebank.* London, 1904.

Cartwright 1894
Julia Cartwright. *The Life and Work of Sir Edward Burne-Jones Bart.* London, 1894.

Cartwright 1902
Julia Cartwright. *Jean François Millet, His Life and Letters.* New York, 1902.

Casale 1991
Gerardo Casale. *Giovanna Garzoni; Insigne miniatrice 1600–1670.* Milan, 1991.

Cassou 1940
Jean Cassou. *Picasso.* New York, 1940.

Catoni 1990
Maria Luisa Catoni. "Parigi 1904: Picasso 'iberico' e le 'Demoiselles d'Avignon.'" *Bollettino d'Arte* 62–63 (July–October 1990), 117–31.

Chadds Ford 1974
Maxfield Parrish: Master of Make-Believe. Brandywine River Museum, Chadds Ford, Pennsylvania, 1974.

Chapman 1978
Laura H. Chapman. *Approaches to Art in Education.* New York, 1978.

Charleroi 1994
J. M. W. Turner 1775–1851: Watercolours and Drawings from the Turner Bequest. Palais des Beaux-Arts, Charleroi, 1994.

Chase 1962
Alice Elizabeth Chase. *Famous Paintings: An Introduction to Art.* New York, 1962.

Chastel/Minervino 1972
André Chastel and Fiorella Minervino. *L'opera completa di Seurat.* Milan, 1972.

Chevalier 1991
Denys Chevalier. *Picasso: The Blue and Rose Periods.* New York, 1991.

Chicago 1937
The Sixteenth International Exhibition: Water Colors, Pastels, Drawings, and Monotypes. Art Institute of Chicago, 1937.

Chicago 1938
Loan Exhibition of Paintings, Drawings, and Prints by the Two Tiepolos: Giambattista and Giandomenico. Art Institute of Chicago, 1938.

Chicago/New York 1939
Alfred H. Barr Jr. *Picasso: Forty Years of His Art.* Art Institute of Chicago; Museum of Modern Art, New York, 1939.

Chicago/New York 1959
Theodore Rousseau Jr. *Gauguin: Paintings, Drawings, Prints, Sculpture.* Art Institute of Chicago; Metropolitan Museum of Art, New York, 1959.

Chong 1993
Alan Chong. *European and American Painting in the Cleveland Museum of Art: A Summary Catalogue.* Cleveland, 1993.

Christie's 1996
"Old Master Drawings." *Christie's Review of the Year 1996* (1996), 30–36.

Ciardi/Tomasi 1984
Roberto Paolo Ciardi and Lucia Tongiorgi Tomasi. *Immagini anatomiche e naturalistiche nei disegni degli Uffizi; Secc. XVI e XVII.* Florence, 1984.

Cikovsky 1991
Nicolai Cikovsky. *Winslow Homer Watercolors.* New York, 1991.

Cincinnati 1981
Small Paintings from Famous Collections. Taft Museum, Cincinnati, 1981.

Cincinnati et al. 1985–86
Harry F. Gaugh. *The Vital Gesture: Franz Kline in Retrospect.* Cincinnati Art Museum; San Francisco Museum of Modern Art; Pennsylvania Academy of the Fine Arts, Philadelphia, 1985–86.

Clark 1966
Kenneth Clark. *Rembrandt and the Italian Renaissance.* London, 1966.

Clark 1984
T. J. Clark. *The Painting of Modern Life.* New York, 1984.

Clark et al. 1990
Carol Clark, Gwendolyn Owens, Nancy Matthews. *Maurice Brazil Prendergast / Charles Prendergast: A Catalogue Raisonné.* Williamstown, Massachusetts, 1990.

Cleveland 1925
Second Exhibition: Water Color and Pastels. Cleveland Museum of Art, 1925.

Cleveland 1937
An Exhibition of American Painting from 1860 until Today. Cleveland Museum of Art, 1937.

Cleveland 1953
The Drawings of Charles E. Burchfield. Cleveland Museum of Art, 1953.

Cleveland 1956–57
The Venetian Tradition. Cleveland Museum of Art, 1956–57.

Cleveland 1964
Henry Hawley. *Neo-Classicism: Style and Motif.* Cleveland Museum of Art, 1964.

Cleveland 1966
Edward B. Henning. *Fifty Years of Modern Art, 1916–1966.* Cleveland Museum of Art, 1966.

Cleveland 1971
Edmund Pillsbury. *Florence and the Arts, Five Centuries of Patronage.* Cleveland Museum of Art, 1971.

Cleveland 1979a
Edward J. Olszewski. *The Draftsman's Eye, Late Italian Renaissance Schools and Styles.* Cleveland Museum of Art, 1979.

Cleveland 1979b
Edward B. Henning. *The Spirit of Surrealism.* Cleveland Museum of Art, 1979.

Cleveland 1979c
Michael Lawrence. *Surrealism in Perspective.* Cleveland Museum of Art, 1979.

Cleveland 1980
Mark M. Johnson. *Idea to Image: Preparatory Studies from the Renaissance to Impressionism.* Cleveland Museum of Art, 1980.

Cleveland 1981
Ellen Breitman. *Art and the Stage.* Cleveland Museum of Art, 1981.

Cleveland 1982
Sheila Webb. *Paper: The Continuous Thread.* Cleveland Museum of Art, 1982.

Cleveland 1984–85
John E. Schloder. *Baroque Imagery.* Cleveland Museum of Art, 1984–85.

Cleveland 1987
Edward B. Henning. *Creativity in Art and Science, 1860–1960.* Cleveland Museum of Art, 1987.

Cleveland 1987–88
David H. Katzive. *Fringe Patterns.* Cleveland Center for Contemporary Art, 1987–88.

Cleveland 1996
William H. Robinson and David Steinberg. *Transformations in Cleveland Art, 1796–1946.* Cleveland Museum of Art, 1996.

Cleveland 1997
Diane De Grazia, Robert Bergman, Stephen Fleigel. *Vatican Treasures.* Cleveland Museum of Art, 1997.

Cleveland et al. 1989–90
Hilliard Goldfarb. *From Fontainebleau to the Louvre: French Drawing from the Seventeenth Century.* Cleveland Museum of Art; Fogg Art Museum, Harvard University, Cambridge; National Gallery of Canada, Ottawa, 1989–90.

Cleveland/New Haven 1978
Edmund P. Pillsbury and Louise S. Richards. *The Graphic Art of Federico Barocci.* Cleveland Museum of Art; Yale University Art Gallery, New Haven, 1978.

CMA Handbook 1928
Handbook of The Cleveland Museum of Art. Cleveland, 1928.

CMA Handbook 1958
The Cleveland Museum of Art Handbook. Cleveland, 1958.

CMA Handbook 1966, 1969
Handbook of the Cleveland Museum of Art. Cleveland, 1966, 1969.

CMA Handbook 1978
Handbook of the Cleveland Museum of Art. Cleveland, 1978.

CMA Handbook 1991
Handbook of the Cleveland Museum of Art. Cleveland, 1991.

CMA In Memoriam 1958
In Memoriam: Leonard C. Hanna, Jr. Cleveland, 1958.

CMA Interpretations 1991
Interpretations: Sixty-Five Works from the Cleveland Museum of Art. Cleveland, 1991.

CMA Masterpieces 1992
Masterpieces from East and West. New York, 1992.

CMA Selected Works [1967]
Selected Works: The Cleveland Museum of Art. Cleveland, [1967].

Coates 1945
Robert Coates. "The Art Galleries: Water Colors and Oils." *New Yorker* (20 May 1945), 67–68.

Cocke 1977
Richard Cocke. "Veronese's Independent Chiaroscuro Drawings." *Master Drawings* 15 (Autumn 1977), 259–68.

Cocke 1984
Richard Cocke. *Veronese Drawings, A Catalogue Raisonné*. London, 1984.

Coe 1955
Nancy Coe (Wixom). "The History of the Collecting of European Paintings and Drawings in the City of Cleveland." 2 vols. M.A. thesis, Oberlin College, Ohio, 1955.

Collobi 1971
Licia Ragghianti Collobi. "Il 'Libro de' disegni' de Giorgio Vasari." *Critica d'Arte* 18 (March–April 1971), 13–40.

Collobi 1974
Licia Ragghianti Collobi. *Il Libro de' disegni del Vasari*. 2 vols. Florence, 1974.

Cologne 1984
Heroismus und Idylle: Formen der Landschaft um 1800: bei Jacob Philipp Hackert, Joseph Anton Koch und Johann Christian Reinhart. Wallraf-Richartz-Museum, Cologne, 1984.

Colorado Springs 1948
"New Accessions U.S.A." Colorado Springs Fine Arts Center, 1948.

Columbus 1961
The Renaissance Image of Man and the World. Columbus Gallery of Fine Arts, Ohio, 1961.

Columbus et al. 1997–98
Henry Adams et al. *The Paintings of Charles Burchfield: North by Midwest*. Columbus Museum of Art, Ohio; Burchfield-Penny Art Center, Buffalo; National Museum of American Art, Smithsonian Institution, Washington, 1997–98.

Comstock 1956
Helen Comstock. "A Drawing by Bernardo Strozzi." *Connoisseur* 138 (November 1956), 211–12.

Constable 1962
W. G. Constable. *Canaletto*. Oxford, 1962.

Constable/Links 1989
W. G. Constable. *Canaletto*. Edited by J. G. Links. 2nd ed. Oxford, 1989.

Cooper 1966
Douglas Cooper. *Henri de Toulouse-Lautrec*. New York, 1966.

Cooper 1982
Douglas Cooper. *Henri de Toulouse-Lautrec*. Norwalk, Connecticut, 1982.

Cooper/Matheson 1973
Barbara Cooper and Maureen Matheson. *The World Museums Guide*. London, 1973.

Copenhagen 1935
Exposition de l'art français au XVIIIe siècle. Charlottenborg Palace, Copenhagen, 1935.

Coral Gables et al. 1989–90
Jeffrey Wechsler, Sam Hunter, Irving Sandler. *Abstract Expressionism: Other Dimensions*. Lowe Art Museum, University of Miami, Coral Gables, Florida; Terra Museum of American Art, Chicago; Jane Voorhees Zimmerli Art Museum, New Brunswick, New Jersey, 1989–90.

Corboz 1985
André Corboz. *Canaletto: Una Venezia immaginaria*. Milan, 1985.

Cordellier/Py 1992
Dominique Cordellier and Bernadette Py. *Raphaël: Son atelier, ses copistes*. Paris, 1992.

Cormack 1975
Malcolm Cormack. *J. M. W. Turner, R. A. 1775–1851*. Cambridge, England, 1975.

Coupin 1829
P. A. Coupin. *Oeuvres posthumes de Girodet-Trioson*. Paris, 1829.

Cox 1914
Kenyon Cox. *Artist and Public and Other Essays on Art Subjects*. New York, 1914.

Crowe/Cavalcaselle 1912
Joseph Archer Crowe and Giovanni Battista Cavalcaselle. *A History of Painting in Italy*. London, 1912.

Cuzin 1988
Jean-Pierre Cuzin. *Jean-Honoré Fragonard: Life and Work—Complete Catalogue of the Oil Paintings*. New York, 1988.

Dacier 1914
Émile Dacier. *L'Oeuvre gravé de Gabriel de Saint-Aubin*. Paris, 1914.

Dacier 1929–31
Émile Dacier. *Gabriel de Saint-Aubin: Peintre, dessinateur et graveur (1724–1780)*. 2 vols. Paris/Brussels, 1929–31.

Daix 1982
Pierre Daix. *Cubists and Cubism*. New York, 1982.

Daix/Boudaille 1967
Pierre Daix and Georges Boudaille. *Picasso: The Blue and Rose Periods. A Catalogue Raisonné of the Paintings, 1900–1906*. New York, 1967.

Daix/Lévy 1990
Pierre Daix and Lorraine Lévy. *Picasso*. Paris, 1990.

Dauberville/Dauberville 1995
Guy-Patrice Dauberville and Michel Dauberville. *Matisse: Henri Matisse chez Bernheim-Jeune*. Paris, 1995.

Daval 1973
Jean-Luc Daval. *Journal de l'art moderne*. Geneva, 1973.

Davis 1952
R. S. Davis. "Dürer as a Watercolorist." *Bulletin of the Minneapolis Institute of Arts* 41 (May 1952), 97–99.

Degenhart/Schmitt 1968
Bernhard Degenhart and Annegritt Schmitt. *Corpus der italienischen Zeichnungen, 1300–1450*. Berlin, 1968.

De Grazia 1996
Diane De Grazia. "An American Scene." *Cleveland Museum of Art Members Magazine* 36 (December 1996), 7.

De Grazia 1998
Diane De Grazia. "Carracci Drawings in Britain and the State of Carracci Studies." *Master Drawings* 36 (Fall 1998), 292–304.

De Grazia Bohlin 1979
Diane De Grazia Bohlin. *Prints and Related Drawings by the Carracci Family: A Catalogue Raisonné*. Washington, 1979.

de Groot 1906
Cornelis Hofstede de Groot. *Die Handzeichnungen Rembrandts*. Haarlem, 1906.

de Groot 1910
Cornelis Hofstede de Groot. *Original Drawings by Rembrandt Harmensz van Rijn*. The Hague, 1910.

Delaborde 1870
Henri Delaborde. *Ingres: Sa vie, ses travaux, sa doctrine*. Paris, 1870.

de Lisle 1907
Fortunée de Lisle. *Burne-Jones*. London, 1907.

Delpierre 1975
Madeleine Delpierre. "Ingres et la mode de son temps." In *Actes du colloque international Ingres et le néo-classicisme*. Montauban, 1975.

Delteil
Loys Delteil. *Théodore Géricault*. Vol. 18 of *Le Peintre-Graveur Illustré*. Paris, 1924.

del Vita 1929
Alessandro del Vita, ed. *Il Libro delle Ricordanze di Giorgio Vasari*. Arezzo, 1929.

de'Medici 1992
Lorenza de'Medici. *Florentines: A Tuscan Feast*. London, 1992.

Denison/Mules 1981
Cara D. Denison and Helen B. Mules. *European Drawings 1375–1825*. New York, 1981.

Denver 1892
Catalogue: The Works of Thomas Moran. Denver Art League, 1892.

Deriabina 1999
Ekaterina Deriabina. "Hubert Robert et les collectionneurs russes." In *Hubert Robert (1773–1808) et Saint-Pétersbourg: Les commandes de la famille Impériale et des Princes russes entre 1773 et 1802*. Valence, France, 1999.

de Selincourt 1909
Basil de Selincourt. *William Blake*. London, 1909.

DeShong 1982
Alan DeShong. *The Theatrical Designs of George Grosz*. Ann Arbor, 1982.

de Tolnay 1945
Charles de Tolnay. *The Sistine Ceiling*. 2 vols. Princeton, 1945.

de Tolnay 1975
Charles de Tolnay. *Corpus dei disegni di Michelangelo*. 4 vols. Novara, 1975.

Detroit 1950
"Loan Exhibition of Old Master Drawings from Midwestern Museums." Detroit Institute of Arts, 1950.

Detroit 1959
Paul Grigaut. *Decorative Arts of the Italian Renaissance 1400–1600*. Detroit Institute of Arts, 1959.

Detroit 1965
Bertina Suida Manning. *Art in Italy 1600–1700*. Detroit Institute of Arts, 1965.

Detroit 1978
The Rouge: The Image of Industry in the Art of Charles Sheeler and Diego Rivera. Mary Jane Jacob and Linda Downs. Detroit Institute of Arts, 1978.

Detroit/Indianapolis 1952
Venice 1700–1800. Detroit Institute of Arts; John Herron Art Museum, Indianapolis, 1952.

Detroit/Philadelphia 1968
Frederick J. Cummings and Allen Staley. *Romantic Art in Britain: Paintings and Drawings, 1760–1860*. Detroit Institute of Arts; Philadelphia Museum of Art, 1968.

d'Hulst 1956
Roger-A. d'Hulst. *De Tekeningen van Jakob Jordaens*. Brussels, 1956.

d'Hulst 1974
Roger-A. d'Hulst. *Jordaens Drawings*. 4 vols. Brussels, 1974.

Diez 1912
E. Diez. *Jean François [sic] Millet*. Bielefeld/Leipzig, 1912.

Ditner 1983
David Ditner. "Claude and the Ideal Landscape Tradition in Great Britain." *CMA Bulletin* 70 (1983), 147–63.

Dobbs 1999
Michael Dobbs. "Stolen Beauty." *Washington Post Magazine* (March 1999), 12–18, 29.

Dodd 1960
Loring Holmes Dodd. "Two Important Shows at Boston Museum." *Worcester* (Massachusetts) *Evening Gazette* (5 November 1960), 7.

Dorival 1966
Bernard Dorival. "La préemption de l'État à la seconde vente André Lefèvre." *La Revue du Louvre et des Musées de France* 16, no. 2 (1966), 111–20.

Dortu 1971
M. G. Dortu. *Toulouse-Lautrec et son oeuvre*. New York, 1971.

Dreyer 1979
Peter Dreyer. *Kupferstichkabinett Berlin: Italienische Zeichnungen*. Stuttgart, 1979.

Dunbar/Olszewski 1996
Edward J. Olszewski and Burton L. Dunbar, eds. *Early Works*. Vol. 1 of *Drawings in Midwestern Collections*. Columbia, Missouri, 1996.

Dupin 1962
Jacques Dupin. *Miró*. New York, 1962.

Dupin 1993
Jacques Dupin. *Miró*. New York, 1993.

Düsseldorf 1973
Dieter Graf. *Master Drawings of the Roman Baroque from the Kunstmuseum Düsseldorf*. Kunstmuseum, Düsseldorf, 1973.

Düsseldorf/Stuttgart 1995
Wolfgang Kersten and Osamu Okuda. *Paul Klee: Im Zeichen der Teilung*. Kunstsammlung Nordrhein-Westfalen, Düsseldorf; Staatsgalerie, Stuttgart, 1995.

Dussler 1959
Luitpold Dussler. *Die Zeichnungen des Michelangelo*. Berlin, 1959.

Dutuit 1885
Eugène Dutuit. *Tableaux et dessins de Rembrandt, catalogue historique et descriptif*. Paris, 1885.

Duvivier 1928
Brett Duvivier. "Intimate Aspects of Hubert Robert." *International Studio* 89 (February 1928), 74–79.

Ebertshäuser 1976
Heidi Ebertshäuser. *Adolf von Menzel: Das graphische Werk*. Munich, 1976.

Edinburgh 1965
Keith Andrews. *Old Master Drawings from the Collection of Dr. and Mrs. Francis Springell*. National Gallery of Scotland, Edinburgh, 1965.

Edinburgh 1972
Italian 17th Century Drawings from British Private Collections. Scottish Arts Council, Edinburgh Festival, 1972.

Edinburgh 1994
Aidan Weston-Lewis, John Dick, Timothy Clifford. *Raphael: The Pursuit of Perfection*. National Gallery of Scotland, Edinburgh, 1994.

Einstein 1934
Carl Einstein. *Georges Braque*. Paris, 1934.

Eiseman 1982
Alvord L. Eiseman. *Charles Demuth*. New York, 1982.

Eisenstadt 1930
Marie Eisenstadt. *Watteaus Fêtes galantes und ihre Ursprünge*. Berlin, 1930.

Eitner 1954
Lorenz Eitner. "Géricault at Winterthur." *Burlington Magazine* 96 (August 1954), 254–59.

Eitner 1960
Lorenz Eitner. *Géricault: An Album of Drawings in the Art Institute of Chicago*. Chicago, 1960.

Eitner 1980
Lorenz Eitner. "The Literature of Art: Tout l'oeuvre peint de Géricault. Introduction by Jacques Thuillier, catalogue and documentation by Philippe Grunchec." *Burlington Magazine* 122 (March 1980), 206–10.

Eitner et al. 1993
Lorenz Eitner, Betsy Fryberger, Carol Osborne. *Stanford University Museum of Art: The Drawing Collection*. Seattle, 1993.

Elen 1995
Albert Jan Elen. *Italian Late-Medieval and Renaissance Drawing Books from Giovannino de'Grassi to Palma Giovane*. Leiden, 1995.

Elgar 1956
Frank Elgar. *Picasso*. New York, 1956.

Ellis 1990
Charles Ellis. "Two Drawings by Fra Bartolommeo." *Paragone* 41 (January–March 1990), 3–19.

Elzea
Betty Elzea. *Frederick Sandys 1829–1904: A Catalogue Raisonné and Biography* [working title]. Forthcoming.

Emiliani 1985
Andrea Emiliani. *Federico Barocci*. Bologna, 1985.

Ephrussi 1882
Charles Ephrussi. *Albert Dürer et ses dessins*. Paris, 1882.

Erffa 1961
Helmut von Erffa. "A Lost Painting by Benjamin West." *Worcester* (Massachusetts) *Art Museum News Bulletin and Calendar* 26 (1961) [unpaginated].

Erffa/Staley 1986
Helmut von Erffa and Allen Staley. *The Paintings of Benjamin West*. New Haven, 1986.

Escholier 1930
Raymond Escholier. *Daumier 1808–1879*. Paris, 1930.

Esteban 1982
Claude Esteban. *Les Plus belles pages de la poésie française*. Paris, 1982.

Evans 1969
M. W. Evans. *Medieval Drawings*. London, 1969.

Evanston 1981
Ronald McKnight Melvin. *Five American Masters of Watercolor*. Terra Museum of American Art, Evanston, Illinois, 1981.

Fabbri 1964
Dino Fabbri, ed. *Toulouse-Lautrec, I maestri del colore*. Milan, 1964.

Fabri 1974
Ralph Fabri. "What We Can Learn from the Old Masters." *Ohio Art Graphic* 22 (October 1974), 4–17.

Farnham 1959
Emily Farnham. "Charles Demuth: His Life, Psychology, and Works." Ph.D. diss., Ohio State University, 1959.

Farnham 1971
Emily Farnham. *Charles Demuth: Behind a Laughing Mask*. Norman, Oklahoma, 1971.

Feaver 1975
William Feaver. *The Art of John Martin*. Oxford, 1975.

Fehl 1979
Philipp Fehl. "Farewell to Jokes: The Last *Capricci* of Giovanni Domenico Tiepolo and the Tradition of Irony in Venetian Painting." *Critical Inquiry* 5 (Summer 1979), 761–91.

Fehl 1992
Philipp Fehl. *Decorum and Wit: The Poetry of Venetian Painting*. Vienna, 1992.

Feldman 1967
Edmund Burke Feldman. *Varieties of Visual Experience*. New York, 1967.

Fénéon 1888
Félix Fénéon. "Calendrier de Janvier." *La Revue Indépendante* (1888).

Fermigier 1977
André Fermigier. *Jean-François Millet*. Geneva, 1977.

Fern/Jones 1969
Alan Fern and Karen Jones. "The Pembroke Album of Chiaroscuro Woodcuts." *Quarterly Journal of the Library of Congress* 26 (January 1969), 12–20.

Ferrara 1995
Ziva Amishai-Maisels et al. *Paul Gauguin e l'avanguardia russa*. Palazzo dei Diamanti, Ferrara, 1995.

Filedt Kok 1990
Jan Piet Filedt Kok. "Jacques de Gheyn II, Engraver, Designer and Publisher I, II." *Print Quarterly* 7 (September 1990), 248–81, 370–96.

Filedt Kok 1991
Jan Piet Filedt Kok. "Proefdrukken uit Goltzius' atelier omstreeks 1587." *Bulletin van het Rijksmuseum* 39, no. 4 (1991), 363–74.

Filedt Kok 1993
Jan Piet Filedt Kok. "Hendrick Goltzius— Engraver, Designer, and Publisher 1582– 1600." *Nederlands Kunsthistorisch Jaarboek* 42–43 (1993), 159–218.

Fiocco 1929
Giuseppe Fiocco. "La Peinture à l'exposition du XVIII siècle à Venise." *La Renaissance* 12 (December 1929), 559–75.

Fiocco 1952
Giuseppe Fiocco. "Il Problema di Francesco Guardi." *Arte Veneta* (1952), 99–120.

Fischel 1912
Oskar Fischel. "Some Lost Drawings by or near to Raphael." *Burlington Magazine* 20 (February 1912), 294–300.

Fischel 1939
Oskar Fischel. "Raphael's Pink Sketchbook." *Burlington Magazine* 74 (April 1939), 181–87.

Fischel 1941
Oskar Fischel. *Raphaels Zeichnungen*. 9 vols. Berlin, 1941.

Fischel 1948
Oskar Fischel. *Raphael*. Translated by Bernard Rackham. 2 vols. London, 1948.

Fischer 1989
Chris Fischer. "Fra Bartolommeo's Landscape Drawings." *Mitteilungen des Kunsthistorischen Institutes in Florenz* 33 (1989), 301–42.

Flechsig 1931
Eduard Flechsig. *Albrecht Dürer: Sein Leben und Seine Künstlerische Entwickelung*. Berlin, 1931.

Fleischmann 1938
Benno Fleischmann. *Honoré Daumier Gemälde Graphik*. Vienna, 1938.

Fleming 1958
John Fleming. "Mr. Kent, Art Dealer, and the Fra Bartolommeo Drawings." *Connoisseur* 141 (May 1958), 227.

Flint 1961
Masterpieces in the Midwest. Flint Institute of Arts, Michigan, 1961.

Florence 1967
Walter Vitzthum and Anna Maria Petrioli. *Cento disegni napoletani sec. XVI–XVIII*. Uffizi, Florence, 1967.

Florence 1986–87
Elisa Acanfora et al. *Il Seicento Fiorentino: Arte a Firenze da Ferdinando I a Cosimo III*. Palazzo Strozzi, Florence, 1986–87.

FMR 1996
"I Tiepolo a Udine [review]." *FMR* 81 (August 1996), 10–12.

Focillon/Julien 1959
Henri Focillon and Édouard Julien. *Dessins de Toulouse-Lautrec*. Lausanne, 1959.

Fort Worth et al. 1980–81
Carol Clark. *Thomas Moran, Watercolors of the American West*. Amon Carter Museum, Fort Worth; Cleveland Museum of Art; Yale University Art Gallery, New Haven, 1980–81.

Francis 1927
Henry Francis. "A Drawing by Daumier." *CMA Bulletin* 14 (1927), 155–57.

Francis 1928a
Henry Francis. "A Landscape Drawing by Claude Lorrain." *CMA Bulletin* 15 (1928), 127–29.

Francis 1928b
Henry Francis. "A Portrait Drawing by Ingres." *CMA Bulletin* 15 (1928), 27–29.

Francis 1929
Henry Francis. "French Art Since Eighteen Hundred." *CMA Bulletin* 16 (1929), 155–72.

Francis 1930
Henry Francis. "Two Drawings by Tiepolo." *CMA Bulletin* 17 (1930), 4–7.

Francis 1932
Henry Francis. "Drawings in the Classic and Romantic Tradition Before 1830." *CMA Bulletin* 19 (1932), 166–70.

Francis 1933a
Henry Francis. "A Wash Drawing by Canaletto." *CMA Bulletin* 20 (1933), 23–26.

Francis 1933b
Henry Francis. "A Drawing by Théodore Géricault." *CMA Bulletin* 20 (1933), 111–13.

Francis 1935
Henry Francis. "A Picasso Water Color." *CMA Bulletin* 22 (1935), 117–19.

Francis 1937
Henry Francis. "Exhibition of the Work of Géricault." *CMA Bulletin* 24 (1937), 24–26.

Francis 1938
Henry Francis. "The Dorothy Burnham Everett Memorial Collection." *CMA Bulletin* 25 (1938), 124–30.

Francis 1939
Henry Francis. "Six Drawings from the Life of Pulcinella by the Younger Tiepolo." *CMA Bulletin* 26 (1939), 46–49.

Francis 1940
Henry Francis. "Two Drawings by Piazzetta." *CMA Bulletin* 27 (1940), 108–9.

Francis 1943a
Henry Francis. "A Drawing in Red Chalk by Michelangelo." *CMA Bulletin* 30 (1943), 25–26.

Francis 1943b
Henry Francis. "A Drawing in Red Chalk by Michelangelo." *Art Quarterly* 6 (Winter 1943), 63.

Francis 1945
Henry Francis. "A Drawing by Jean-Honoré Fragonard." *CMA Bulletin* 32 (1945), 88.

Francis 1946
Henry Francis. "'The Adoration of the Magi,' A Drawing by Giovanni Battista Tiepolo." *CMA Bulletin* 33 (1946), 8–9.

Francis 1947
Henry Francis. "Drawing of a Dead Blue Jay by Hans Hoffmann." *CMA Bulletin* 34 (1947), 13–14.

Francis 1948a
Henry Francis. "Two Graphic Portraits by Ingres." *CMA Bulletin* 35 (1948), 36–37.

Francis 1948b
Henry Francis. "A Fifteenth Century Drawing." *CMA Bulletin* 35 (1948), 15–18.

Francis 1950a
Henry Francis. "A Painting and a Drawing by Albrecht Altdorfer." *CMA Bulletin* 37 (1950), 115–18.

Francis 1950b
Henry Francis. "A Drawing by Gauguin." *CMA Bulletin* 37 (1950), 178–79.

Francis 1950c
Henry Francis. "'Church Bells Ringing: Rainy Winter Night' by Charles E. Burchfield." *CMA Bulletin* 37 (1950), 23–24.

Francis 1951
Henry Francis. "A Drawing and Two Oils by Tiepolo." *CMA Bulletin* 38 (1951), 130–32.

Francis 1952
Henry Francis. "A Pen Drawing by Wolfgang Huber." *CMA Bulletin* 39 (1952), 53–55.

Francis 1953
Henry Francis. "La Blanchisseuse by Toulouse-Lautrec." *CMA Bulletin* 40 (1953), 51–53.

Francis 1954a
Henry Francis. "The Preliminary Pen and Ink Drawing for the 'Feast of Herod' by Peter Paul Rubens." *CMA Bulletin* 41 (1954), 114, 124–27.

Francis 1954b
Henry Francis. "A Water Color by J. M. W. Turner in the Cleveland Museum of Art." *Art Quarterly* 17 (Winter 1954), 427–29.

Francis 1954c
Henry Francis. "A Water Color by J. M. W. Turner." *CMA Bulletin* 41 (1954), 201–3.

Francis 1955a
Henry Francis. "Two Drawings by Albrecht Dürer." *CMA Bulletin* 42 (1955), 2–5.

Francis 1955b
Henry Francis. "Early German Paintings in the Cleveland Museum of Art." *American-German Review* 21 (1955), 4–10.

Francis 1955c
Henry Francis. "Recent Additions to the Collection of Homer." *CMA Bulletin* 42 (1955), 51–55.

Francis 1956a
Henry Francis. "'Roman Ruins, Villa Pamfili' A Water-Color Drawing by Hubert Robert." *CMA Bulletin* 43 (1956), 9–11.

Francis 1956b
Henry Francis. "A Drawing for Strozzi's 'Minerva.'" *CMA Bulletin* 43 (1956), 123–26.

Francis 1957a
Henry S. Francis. "Drawings by Degas." *CMA Bulletin* 44 (1957), 210–17.

Francis 1957b
Henry S. Francis. "'The Conversion of St. Paul' by Jacob Jordaens: Two Drawings in Washes and Chalks." *CMA Bulletin* 44 (1957), 17–22.

Francis 1958
Henry Francis. "Four Drawings by Francesco Guardi." *CMA Bulletin* 45 (1958), 8–13.

Francis 1965
Henry Francis. "Preparatory Drawing of *Temperance*." *CMA Bulletin* 52 (1965), 175–77.

Frankfurt 1982
Hildegard Bauereisen. *Jean-Antoine Watteau: Einschiffung nach Cythera*. Städelsches Kunstinstitut and Städtische Galerie, Frankfurt, 1982.

Frankfurt/New York 1992–93
Colta Ives, Margret Stuffmann, Martin Sonnabend. *Daumier Drawings*. Städelsches Kunstinstitut and Städtische Galerie, Frankfurt; Metropolitan Museum of Art, New York, 1992–93.

Frankfurter 1939
Alfred M. Frankfurter. "Master Drawings of the Renaissance, Notable and New Items in American Collections." *Art News Annual* 37 (1939), 108.

Frankfurter 1958
Alfred M. Frankfurter. "Cleveland: Model Museum for a Modern Cosmopolis." *Art News* 57 (March 1958), 24–37.

Freedberg 1984
David Freedberg. *Rubens. The Life of Christ after the Passion*. Oxford/New York, 1984.

Frey 1994
Julia Frey. *Toulouse-Lautrec: A Life*. London, 1994.

Frey/Frey 1982
Karl Frey and Herman-Walther Frey. *Giorgio Vasari: Der Literarische Nachlass*. 3 vols. Hildesheim, 1982.

Friedländer/Rosenberg 1978
Max J. Friedländer and Jakob Rosenberg. *The Paintings of Lucas Cranach*. London, 1978.

Friedman 1990
Martin L. Friedman. *Walker Art Center Painting and Sculpture from the Collection*. Minneapolis/New York, 1990.

Fuchs 1930
Eduard Fuchs. *Der Maler Daumier*. Munich, 1930.

Fumet 1945
Stanislas Fumet. *Braque*. Paris, 1945.

Galassi 1991
Peter Galassi. *Corot in Italy: Open-Air Painting and the Classical Landscape Tradition*. New Haven/London, 1991.

Garff 1996
Jan Garff. *Drawings by Rembrandt and Other 17th Century Dutch Artists in the Department of Prints and Drawings*. Copenhagen, 1996.

Gassier 1973
Pierre Gassier. *Francisco Goya Drawings: The Complete Albums*. New York, 1973.

Gassier/Wilson 1971
Pierre Gassier and Juliet Wilson. *The Life and Complete Work of Francisco Goya: with a Catalogue Raisonné of the Paintings, Drawings, and Engravings*. New York, 1971.

Gauguin 1958
Emil Gauguin. *Paul Gauguin's Intimate Journals*. Bloomington, 1958.

Gaya Nuño 1975
Juan Antonio Gaya Nuño. *Picasso*. Madrid, 1975.

Gealt 1979
Adelheid Gealt. "The Courtship, Marriage and Other Exploits of Punchinello." *Art News* 78 (November 1979), 134–37.

Gealt 1986
Adelheid Gealt. *Domenico Tiepolo: The Punchinello Drawings*. New York, 1986.

Gebarowicz/Tietze 1929
M. Gebarowicz and Hans Tietze. *Albrecht Dürers Zeichnungen im Lubomirski Museum in Lemberg*. Vienna, 1929.

Geelhaar 1993
Christian Geelhaar. *Picasso: Wegbereiter und Föederer seines Aufstiegs 1899–1939*. Zurich, 1993.

Genoa 1995
Bernardo Strozzi: Genova 1581/82–Venezia 1644. Ezia Gavazza, Giovanna Nepi Sciré, Giovanna Rotondi Terminiello. Palazzo Ducale, Genoa, 1995.

Gensel 1902
Walther Gensel. *Millet und Rousseau*. Bielefeld/Leipzig, 1902.

George 1931
Waldemar George. "The Youth of Degas." *Formes* 15 (May 1931), 76.

Gere/Turner 1983
J. A. Gere and Nicholas Turner. *Drawings by Raphael: From the Royal Library, the Ashmolean, the British Museum, Chatsworth and Other English Collections*. London, 1983.

Gibson 1929
Katherine Gibson. "Ingres the Artist." *Bystander*. 30 November 1929, 4–5.

Gilchrist/Rossetti 1863
Alexander Gilchrist and William Michael Rossetti. *Life of William Blake, "Pictor Ignotus." with Selections from His Poems and Other Writings*. London, 1863.

Gilchrist/Rossetti 1880
Alexander Gilchrist and William Michael Rossetti. *Life of William Blake with Selections from His Poems and other Writings*. 2 vols. London, 1880.

Glaesemer/McCully 1984
Jürgen Glaesemer and Marilyn McCully. *Der Junge Picasso: Frühwerk und Blaue Periode*. Bern, 1984.

Glaubinger 1983
Jane Glaubinger. "Two Drawings by Joseph Stella." *CMA Bulletin* 70 (1983), 382–95.

Glubok 1974
Shirley Glubok. *The Art of America in the Early Twentieth Century*. New York, 1974.

Goering 1941
Max Goering. "Giovanni Battista Piazzetta als Zeichner." *Pantheon* 28 (November 1941), 259–63.

Goldfarb 1982
Hilliard Goldfarb. "Defining 'Naive and Sentimental' Landscape: Schiller, Hackert, Koch, and the Romantic Experience." *CMA Bulletin* 69 (1982), 282–96.

Goldfarb 1983
Hilliard Goldfarb. "A Pastoral Scene with Classical Figures by Claude Lorrain." *CMA Bulletin* 70 (1983), 165–71.

Goldfarb 1984
Hilliard Goldfarb. "Boucher's Pastoral Scene with Family at Rest and The Image of the Pastoral in Eighteenth-Century France." *CMA Bulletin* 71 (1984), 82–89.

Goldstein 1976
Nathan Goldstein. *Figure Drawing: The Structure, Anatomy, and Expressive Design of Human Form*. Englewood Cliffs, New Jersey, 1976.

Goldstein 1986
Nathan Goldstein. *A Drawing Handbook: Themes, Tools, and Techniques*. Englewood Cliffs, New Jersey, 1986.

Goldstein 1992
Nathan Goldstein. *The Art of Responsive Drawing*. 4th ed. Englewood Cliffs, New Jersey, 1992.

Gomes 1982
Rosalie Gomes. *Black and White: Being the Early Illustrations of Maxfield Parrish*. Brooklyn, 1982.

Goncourt 1881
Edmond de Goncourt. *La Maison d'un artiste*. Paris, 1881.

Goncourt/Goncourt 1867
Edmond de Goncourt and Jules de Goncourt. "La Tour." *Gazette des Beaux-Arts* 22 (April 1867), 350–71.

Goncourt/Goncourt 1880
Edmond de Goncourt and Jules de Goncourt. *L'Art du dix-huitième siècle*. Paris, 1880.

Goncourt/Goncourt 1902
Edmond de Goncourt and Jules de Goncourt. *L'Art du XVIIIe siècle*. Paris, 1902.

Goodrich 1971, 1989
Lloyd Goodrich. *Edward Hopper*. New York, 1971, 1989.

Gordley 1988
Barbara Pike Gordley. "The Drawings of Beccafumi." Ph.D. diss., Princeton University, 1988.

Gorizia 1985
Dario Succi. *Giambattista Tiepolo: il segno e l'enigma*. Castello di Gorizia, 1985.

Gould 1962
Cecil Gould. *National Gallery Catalogue: The Sixteenth-Century Italian Schools*. London, 1962.

Gould 1975
Cecil Gould. *National Gallery Catalogues, The Sixteenth-Century Italian Schools*. London, 1975.

Graber 1942
Hans Graber. *Edgar Degas Nach Eigenen und Fremden Zeugnissen*. Basel, 1942.

Grahame 1899
Kenneth Grahame. *The Golden Age*. New York, 1899.

Grand Rapids 1997–98
Joseph Antenucci Becherer. *Pietro Perugino: Master of the Italian Renaissance*. Grand Rapids Art Museum, Michigan, 1997–98.

Grant et al. 1980
John E. Grant, Edward Rose, Michael Tolley. *William Blake's Designs for Edward Young's "Night Thoughts."* London, 1980.

Greeff 1907
R. Greeff. *Rembrandts Darstellungen der Tobiassheiling*. Stuttgart, 1907.

Grieder 1996
Terence Grieder. *Artist and Audience*. London, 1996.

Gross 1977
Lori Gross. "Guitar and Bottle of Marc on a Table." *CMA Bulletin* 64 (1977), 141–46.

Grunchec 1978
Philippe Grunchec. *L'opera completa di Théodore Gericault* [sic]. Milan, 1978.

Grunchec 1982
Philippe Grunchec. *Géricault: Dessins et aquarelles de chevaux*. Lausanne, 1982.

Gsell 1928
Paul Gsell. *Millet*. Paris, 1928.

Guerlin 1921
Henri Guerlin. *Au Temps du Christ*. Tours, 1921.

Guiffrey/Marcel 1907–28
Jean Guiffrey and Pierre Marcel. *Inventaire général des dessins du Musée du Louvre et du Musée de Versailles, Ecole Française*. 10 vols. Paris, 1907–28.

Günther 1970
Hubertus Günther. "Uffizien 135 A- Eine Studie Baroccis." *Mitteilungen des Kunsthistorischen Institutes in Florenz* 14 (1970), 239–46.

Günther 1977
Hubertus Günther. "Federico Barocci 'Die Flucht des Äneas aus Troja': Zur Geschichte des Bildes." *Weltkunst* 47 (October 1977), 1858–59.

Hale 1985
Robert Beverly Hale. *Master Class in Figure Drawing*. New York, 1985.

Hall 1979
Marcia B. Hall. *Renovation and Counter-Reformation: Vasari and Duke Cosimo in Sta Maria Novella and Sta Croce 1565–1577*. Oxford, 1979.

Halm 1930
Peter Halm. "Die Landschaftszeichnungen des Wolfgang Huber." *Münchner Jahrbuch der Bildenden Kunst* 7, no. 1 (1930), 1–104.

Hammacher 1994
A. M. Hammacher. *Silhouette of Seurat*. Otterlo, 1994.

Harkonen 1965
Helen Harkonen. *Farms and Farmers in Art*. Minneapolis, 1965.

Harrisburg 1966
Charles Demuth of Lancaster. William Penn Memorial Museum, Harrisburg, Pennsylvania, 1966.

Harrison et al. 1993
Charles Harrison, Francis Frascina, Gill Perry. *Modern Art Practices and Debates: Primitivism, Cubism, Abstraction, the Early Twentieth Century*. New Haven, 1993.

Hartford 1934
Pablo Picasso. Wadsworth Atheneum, Hartford, 1934.

Hartford et al. 1977
Edgar Munhall. *Jean-Baptiste Greuze 1725–1805*. Wadsworth Atheneum, Hartford; California Palace of the Legion of Honor, Fine Arts Museum of San Francisco; Musée des Beaux-Arts, Dijon, 1977.

Hartley 1991
Craig Hartley. "Beccafumi 'glum and gloomy.'" *Print Quarterly* 8 (December 1991), 418–25.

Hartt 1972
Frederick Hartt. *Michelangelo's Drawings*. New York, 1972.

Hassell 1974
James Woodrow Hassell. *Amorous Games: A Critical Edition of Les Adevineaux Amoureux*. London, 1974.

Hasselt 1964
Carlos van Hasselt. "Old Master Drawings in the Lugt Collection." *Apollo* 80 (November 1964), 368–79.

Hauke 1961
C. M. de Hauke. *Seurat et son oeuvre*. 2 vols. Paris, 1961.

Hawes 1966
Louis Hawes. "Turner in New York." *Burlington Magazine* 108 (June 1966), 311–16.

Hedley 2001
Jo Hedley. "Towards a New Century: Charles de La Fosse as a Draughtsman." *Master Drawings* (2001). Forthcoming.

Heinzle 1953
Erwin Heinzle. *Wolf Huber um 1485–1553*. Innsbruck, 1953.

Held 1954
Julius S. Held. "Rubens' 'Feast of Herod.'" *Burlington Magazine* 96 (April 1954), 122.

Held 1956
Julius S. Held. "Drawings and Oil Sketches by Rubens from American Collections." *Burlington Magazine* 98 (April 1956), 123–24.

Held 1959
Julius S. Held. *Rubens. Selected Drawings*. London, 1959.

Held 1964
Julius S. Held. *Rembrandt and the Book of Tobit*. Northampton, Massachusetts, 1964.

Held 1969
Julius S. Held. *Rembrandt's Aristotle and Other Rembrandt Studies*. Princeton, 1969.

Heller 1831
Joseph Heller. *Das Leben und die Werke Albrecht Dürer's*. Leipzig, 1831.

Hendricks 1979
Gordon Hendricks. *The Life and Work of Winslow Homer*. New York, 1979.

Hendrix 1997
Lee Hendrix. "Natural History Illustration at the Court of Rudolph II." In *Rudolph II and Prague. The Court and the City*. Edited by E. Fucikova. London, 1997.

Henning 1963
Edward Henning. "In Pursuit of Content." *CMA Bulletin* 50 (1963), 218–39.

Henning 1967
Edward Henning. "Two New Contemporary Sculptures." *CMA Bulletin* 54 (1967), 219–27.

Henning 1968
Edward Henning. "Joan Miró: Woman with Blond Armpit Combing Her Hair by the Light of the Stars." *CMA Bulletin* 55 (1968), 71–77.

Henning 1969a
Edward Henning. "Some Modern Paintings: Georges Braque, *Le Violoncelle*; Franz Kline, *Accent Grave*; Adja Yunkers: *Untitled, No. 2*; Robert Rauschenberg, *Gloria*; Lee Bontecou, *Untitled*; Morris Louis, *Number 99*." *CMA Bulletin* 56 (1969), 55–87.

Henning 1969b
Edward Henning. "Contemporary Art." *CMA Bulletin* 56 (1969), 223–24.

Henning 1970
Edward Henning. "Acquisitions of Modern Art by Museums." *Burlington Magazine* (Supplement) 112 (May 1970), 338.

Henning 1972
Edward Henning. "Pablo Picasso: Bouteille, Verre, et Fourchette." *CMA Bulletin* 59 (1972), 195–203.

Henning 1976
Edward Henning. "Picasso: Harlequin with Violin (Si Tu Veux)." *CMA Bulletin* 63 (1976), 2–11.

Henning 1977
Edward Henning. "The Cubist Collection at the Cleveland Museum of Art." *Apollo* 105 (January 1977), 53–56.

Henning 1979
Edward Henning. "A Painting by Joan Miró." *CMA Bulletin* 66 (1979), 234–40.

Henning 1981
Edward Henning. "Two New Cubist Paintings by Juan Gris and Pablo Picasso." *CMA Bulletin* 68 (1981), 38–50.

Heppner 1995
Christopher Heppner. *Reading Blake's Designs*. New York, 1995.

Herbert 1962
Robert L. Herbert. *Seurat's Drawings*. New York, 1962.

Heseltine 1900
J[ohn] P[ostle] Heseltine. *Drawings by François Boucher, Jean Honoré Fragonard, and Antoine Watteau in the Collection of J[ohn] P[ostle] H[eseltine]*. London, 1900.

Heseltine/Guiraud 1913
J[ohn] P[ostle] Heseltine and Lucien Guiraud. *Dessins de l'école française du dix-huitième siècle provenant de la collection H[eseltine]*. Paris, 1913.

Hilton 1975
Timothy Hilton. *Picasso*. London, 1975.

Hitchcock 1887
Ripley Hitchcock. "Millet and the Children." *St. Nicholas* 14 (1887), 166–78.

Hofstede 1966
Justus Müller Hofstede. "Review of Books. L. Burchard and R.-A. d'Hulst: Rubens Drawings." *Master Drawings* 4, no. 4 (1966), 435–54.

Holme 1903
Charles Holme. *Corot and Millet*. New York, 1903.

Hoover 1973
Suzanne Hoover. "Pictures at the Exhibitions." *Blake Newsletter* 21 (1973), 6–13.

Hopper/Hopper 1913–63
Edward Hopper and Jo Hopper. *Artist's Ledger Book I*. New York, 1913–63.

Horn 1950
Adam Horn. "Eine Wiederentdeckte alte Ansicht der Burg Harburg im Ries." *Zeitschrift des Historischen Vereins für Schwaben* 57 (1950), 35–37.

Houghton/Bouchot Saupique 1958
Amory Houghton and Jacqueline Bouchot Saupique. "Les Dessins Français dans les Collections Américaines de Clouet à Matisse." *Art et Style* 47 (1958).

Hourticq 1928
Louis Hourticq. *Ingres: L'Oeuvre du maitre*. Paris, 1928.

Houston 1982
Barbara Rose. *Miró in America*. Houston, 1982.

Høvikodden 1992
Picasso Besøker Norge. Per Hovdenakk. Henie-Onstad Kunstsenter, Høvikodden, Norway, 1992.

Hugelshofer 1977
Walter Hugelshofer. "Überlegungen zu Hans Baldung." In *Zeitschrift für Schweizerische Archäologie und Kunstgeschichte*. Zurich, 1977.

Huisman/Dortu 1964
P. Huisman and M. G. Dortu. *Lautrec by Lautrec*. New York, 1964.

Huntington/Austin 1993–94
Jeffrey Coven. *Baudelaire's Voyages: The Poet and His Painters*. Heckscher Museum, Huntington, New York; Archer M. Huntington Gallery, University of Texas, Austin, 1993–94.

Huyghe 1988
René Huyghe. *Gauguin*. New York, 1988.

Huyghe/Jaccottet 1948
René Huyghe and Philippe Jaccottet. *Le Dessin français au XIX siècle*. Lausanne, 1948.

Indianapolis 1954
Pontormo to Greco: The Age of Mannerism. John Herron Art Museum, Indianapolis, 1954.

Indianapolis/Dayton 1955–56
Turner in America. John Herron Art Museum, Indianapolis; Dayton Art Institute, Ohio, 1955–56.

Ingamells 1986
John Ingamells. *French Nineteenth Century*. Vol. 2 of *The Wallace Collection Catalogue of Pictures*. London, 1986.

Iñiguez 1974
Diego Angulo Iñiguez. "Algunos Dibujos de Murillo." *Archivo Español de Arte* 47 (April–June 1974), 97–108.

Iñiguez 1981
Diego Angulo Iñiguez. *Murillo: Catalogo critico*. Madrid, 1981.

Innsbruck/Vienna 1991
Gert Amman et al. *J. A. D. Ingres: Zeichnungen und Ölstudien aus dem Musée Ingres, Montauban*. Tiroler Landesmuseum Ferdinandeum, Innsbruck; Graphische Sammlung Albertina, Vienna, 1991.

Isarlo 1941
George Isarlo. *Caravage et le caravagisme européen*. Aix-en-Provence, 1941.

Isarlov 1932
Georges Isarlov. *Braque*. Paris, 1932.

Jaffé 1962
Michael Jaffé. "Italian Drawings from Dutch Collections." *Burlington Magazine* 104 (June 1962), 231–38.

Jaffé 1963
Michael Jaffé. "The Figurative Arts of the West c. 1400–1800." *Apollo* 78 (December 1963), 457–67.

Jaffé 1989
Michael Jaffé. *Rubens. Catalogo Completo*. Milan, 1989.

Jardot 1959
Maurice Jardot. *Pablo Picasso Drawings*. New York, 1959.

Jean-Richard 1978
Pierrette Jean-Richard. *L'Oeuvre gravé de François Boucher dans la collection Edmond de Rothschild*. Paris, 1978.

Jestaz et al. 1981
Bertrand Jestaz, François Fossier, François-Charles Uginet. *Le Palais Farnèse*. 4 vols. Rome, 1981.

Jeudwine 1957
W. R. Jeudwine. "Fine Works on the Market, a Volume of Landscape Drawings by Fra Bartolommeo." *Apollo* 66 (November 1957), 132–35.

Joachim/McCullagh 1979
Harold Joachim and Suzanne Folds McCullagh. *Italian Drawings in the Art Institute of Chicago*. Chicago, 1979.

Joannides 1983
Paul Joannides. *The Drawings of Raphael: With a Complete Catalogue*. Oxford, 1983.

Jones 1981
Leslie Jones. "The Paintings of Giovanni Battista Piazzetta." Ph.D. diss., New York University, 1981.

Joyant 1927
Maurice Joyant. *Henri de Toulouse-Lautrec 1864–1901 dessins-estampes-affiches*. Paris, 1927.

Julien 1991
Édouard Julien. *Lautrec*. New York, 1991.

Kallir 1990
Jane Kallir. *Egon Schiele: The Complete Works*. New York, 1990 [expanded ed. 1998].

Kansas City 1956
Mozart and the Age of Reason. William Rockhill Nelson Gallery of Art, Kansas City, Missouri, 1956.

Kantor-Gukovskaya et al. 1988
Asya Kantor-Gukovskaya, Anna Barskaya, Marina Bessonova. *Paul Gauguin in Soviet Museums*. St. Petersburg, Russia, 1988.

Kelly 1948
Grace V. Kelly. "Superb Marin Water Color Acquired by Museum of Art." *Plain Dealer* (25 July 1948), 22–D.

Kennedy 1959
Ruth Wedgwood Kennedy. "A Landscape Drawing by Fra Bartolommeo." *Bulletin of the Smith College Museum of Art* 39 (1959), 1–12.

Kersten 1990
Wolfgang Kersten. *Paul Klee. Übermut. Allegorie der Künstlerischen Existenz*. Frankfurt, 1990.

Keynes 1957
Sir Geoffrey Keynes. *William Blake's Illustrations to the Bible*. London, 1957.

Keynes 1970
Sir Geoffrey Keynes. *Drawings of William Blake: 92 Pencil Studies*. New York, 1970.

Kimura 1993
Kimura Shigenobu, ed. *Toshi no yutopia* [*Urban Utopia*]. Tokyo, 1993.

Klossowski 1923
Erich Klossowski. *Honore Daumier*. Munich, 1923.

Knab et al. 1983
Eckhart Knab et al. *Raphael: Die Zeichnungen*. Stuttgart, 1983.

Knox 1961
George Knox. "The Orloff Album of Tiepolo Drawings." *Burlington Magazine* 103 (June 1961), 269–75.

Knox 1974
George Knox. *Un quaderno di vedute di Giambattista e Domenico Tiepolo*. Milan, 1974.

Knox 1975
George Knox. *Catalogue of the Tiepolo Drawings in the Victoria and Albert Museum*. London, 1975.

Knox 1980
George Knox. *Giambattista and Domenico Tiepolo: A Study and Catalogue Raisonné of the Chalk Drawings*. Oxford, 1980.

Knox 1983
George Knox. "Domenico Tiepolo's Punchinello Drawings: Satire, or Labor of Love?" In *Satire in the Eighteenth Century*. Edited by J. D. Browning. New York, 1983.

Knox 1992
George Knox. *Giambattista Piazzetta 1682–1754*. Oxford, 1992.

Knox/Dee 1976
George Knox and Elaine Evans Dee. *Etchings by the Tiepolos*. Ottawa, 1976.

Köhren-Jansen 1993
Helmtrud Köhren-Jansen. *Giotto's Navicella: Bildtradition, Deutung, Rezeptionsgeschichte*. Worms am Rhein, 1993.

Koreny 1985
Fritz Koreny. *Albrecht Dürer and the Animal and Plant Studies of the Renaissance*. Boston, 1985.

Koschatzky 1982
Walter Koschatzky. *Die Kunst des Aquarells: Technik, Geschichte, Meisterwerke*. Salzburg/Vienna, 1982.

Koschatzky/Strobl 1972
Walter Koschatzky and Alice Strobl. *Dürer Drawings in the Albertina*. Greenwich, Connecticut, 1972.

Kraemer 1975
Ruth S. Kraemer. *Drawings by Benjamin West and His Son Raphael Lamar West*. New York, 1975.

Krönig 1971
Wolfgang Krönig. "Sepia-Zeichnungen aus der Umgebung Neapels von Philipp Hackert." *Wallraf-Richartz-Jahrbuch* 33 (1971), 175–204.

Kruft 1966
H. W. Kruft. "Altichiero und Avanzo. Untersuchungen zur Oberitalienischen Malerei des ausgehenden Trecento." Ph.D. diss., University of Bonn, 1966.

Kruse/Neumann 1920
John Kruse and Carl Neumann. *Die Zeichnungen Rembrandts und seiner Schule im National-Museum zu Stockholm*. The Hague, 1920.

Kurz 1937
Otto Kurz. "Giorgio Vasari's 'Libro di disegni.'" *Old Master Drawings* 12 (June 1937), 1–14.

Kurz 1948
Otto Kurz. *Fakes: A Handbook for Collectors and Students*. New Haven, 1948.

Kuwabara 1980
Sumio Kuwabara. "John La Farge and Okakura Kakuzo: On Their Ideological Relationship." *Geijutsu kenky-uh-o: Bulletin of the Institute of Art and Design of the University of Tsukuba* 1 (March 1980), 5–30.

Kyoto/Tokyo 1969
Exhibition on Gauguin. National Museum, Kyoto; Seibu Department Store, Tokyo, 1969.

Laing 1979
Alastair Laing. "French Ornamental Engravings and the Diffusion of the Rococo." In *Le Stampe e la diffusione delle immagini e degli stili.* Edited by H. Zerner. Bologna, 1979.

Laing 1986
Alastair Laing. "Boucher et la pastorale peinte." *Revue de l'art* 73 (1986), 55–64.

Lake Worth 1988
Edward Ruscha: Words without Thoughts Never to Heaven Go. Lannan Museum, Lake Worth, Florida, 1988.

Landau/Parshall 1994
David Landau and Peter Parshall. *The Renaissance Print 1470–1550.* New Haven, 1994.

Langdale 1987
Cecily Langdale. "The Late Watercolor/Pastels of Maurice Prendergast." *Antiques* 132 (November 1987), 1084–95.

Langdon 1989
Helen Langdon. *Claude Lorrain.* Oxford, 1989.

Lapauze 1911
Henry Lapauze. *Ingres: Sa vie & son oeuvre.* Paris, 1911.

Larsen 1994
Erik Larsen. "Ein unbekanntes Hauptwerk des Peter Paul Rubens aus seiner italienischen Zeit 'Die Flucht des Äneas aus Troja.'" *Pantheon* 52 (1994), 79–85.

Launay 1991
Élisabeth Launay. *Les Frères Goncourt collectionneurs de dessins.* Paris, 1991.

Lausanne/Québec 1998–99
Jörg Zutter et al. *Abraham-Louis-Rodolphe Ducros: Un Peintre suisse en Italie.* Musée cantonal des Beaux-Arts, Lausanne; Musée du Québec, 1998–99.

Lawrence 1969
J. L. Schrader. *The Waning Middle Ages.* University of Kansas Museum of Art, Lawrence, 1969.

Lawrence 1974
Gridley McKim Smith. *Spanish Baroque Drawings in North American Collections.* University of Kansas Museum of Art, Lawrence, 1974.

Le Blanc 1854–88
Charles Le Blanc. *Manuel de l'amateur d'estampes.* Paris, 1854–88.

Le Bulletin de l'art ancien et moderne 1927
"Un ensemble unique de 50 Daumier: La collection bureau." *Le Bulletin de l'art ancien et moderne, supplément de la Revue de l'art* 51 (1927), 167–73.

Leach 1979
Mark Carter Leach. "The Literary and Emblematic Activity of Herman Hugo, S. J. (1588–1629)." Ph.D. diss., University of Delaware, 1979.

Lebensztejn 1989
Jean-Claude Lebensztejn. *Chahut.* Paris, 1989.

Lee 1954
Sherman Lee. *Chinese Landscape Painting.* Cleveland, 1954.

Lee [1975]
Sherman Lee. *The Cleveland Museum of Art.* Hannover, [1975].

Lefor 1978
Patricia Joan Lefor. "John La Farge and Japan, An Instance of Oriental Influence in American Art." Ph.D. diss., Northwestern University, 1978.

Leipzig 1990–91
Von Schongauer bis Beckmann: Zeichnungen und Druckgraphik aus Fünfhundert Jahren. Museum der Bildenden Künste, Leipzig, 1990–91.

Lemoisne 1946
Paul-Andre Lemoisne. *Degas et son oeuvre.* Paris, 1946.

Lepoittevin 1990
Lucien Lepoittevin. *Jean-François Millet: Images et Symboles.* Cherbourg, 1990.

Levenson et al. 1973
Jay A. Levenson, Konrad Oberhuber, Jacquelyn L. Sheehan. *Early Italian Engravings from the National Gallery of Art.* Washington, 1973.

Levey 1986
Michael Levey. *Giambattista Tiepolo: His Life and Art.* New Haven, 1986.

Levin 1995a
Gail Levin. *Edward Hopper: A Catalogue Raisonne.* New York, 1995.

Levin 1995b
Gail Levin. *Edward Hopper: An Intimate Biography.* New York, 1995.

Lieb 1952
Norbert Lieb. *Die Fugger und Die Kunst: im Zeitalter der Spätgotik und frühen Renaissance.* Munich, 1952.

Life Magazine 1961
"Holiday Idylls of Long Ago." *Life Magazine* 51 (September 1961), 68–73.

Lippmann 1888
Friedrich Lippmann. *Zeichnungen von Albrecht Dürer.* Berlin, 1888.

Lippmann 1910
Friedrich Lippmann. *Original Drawings by Rembrandt.* The Hague, 1910.

Locquin 1912
Jean Locquin. *Catalogue raisonné de l'oeuvre de Jean-Baptiste Oudry peintre du roi (1686–1755).* Paris, 1912.

L'Oeil 1962
"Les Livres sur l'art." *L'Oeil* 93 (September 1962), 50–57.

London 1876
Exhibition of the Works of William Blake. Burlington Fine Arts Club, London, 1876.

London 1899a
Drawings and Studies by Sir Edward Burne-Jones Bart. Burlington Fine Arts Club, London, 1899.

London 1899b
G. Temple. *Pictures and Drawings by J. M. W. Turner, R. A.* London Art Gallery, 1899.

London 1903
Malcolm Bell. *Sir Edward Burne-Jones: A Record and Review.* London, 1903.

London 1905
Catalogue of Books, Engravings, Watercolors and Sketches by William Blake. Grolier Club, London, 1905.

London 1906
Exhibition of Works by William Blake. Carfax and Co. Ltd., London, 1906.

London 1911
The Century of Art Exhibition of the International Society of Sculptors, Painters, and Gravers. Grafton Galleries, London, 1911.

London 1922
Catalogue of Pictures, Drawings, and Sculpture of the French School of the Last 100 Years. Burlington Fine Arts Club, London, 1922.

London 1927
"[No title]." Magnasco Society, London, 1927.

London 1930
"Italian Drawings." Burlington House, London, 1930.

London 1947
Archibald Russell. *William Blake (1757–1827).* Tate Gallery, London, 1947.

London 1950
77th Annual Exhibition of Water-Colour Drawings. Thomas Agnew & Sons, Ltd., London, 1950.

London 1952
Exhibition of Old Master Drawings. Colnaghi, London, 1952.

London 1959a
"Collection of Marquess of Northampton from Castle Ashby, Northampton." Christie's, London, 1959.

London 1959b
Loan Exhibition of Drawings by Old Masters from the Collection of Dr. and Mrs. Francis Springell. Colnaghi, London, 1959.

London 1960a
Colnaghi's 1760–1960. Colnaghi, London, 1960.

London 1960b
Some Paintings of the Barbizon School VI. Hazlitt Gallery, London, 1960.

London 1964
Ruskin and His Circle. Arts Council Gallery, London, 1964.

London 1975a
Exhibition of French Drawings: Neo-Classicism. Heim Gallery, London, 1975.

London 1975b
Andrew Wilton. *Turner in the British Museum: Drawings and Watercolours.* British Museum, London, 1975.

London 1975c
William Feaver. *John Martin Loan Exhibition: Oil Paintings, Watercolours, Prints.* Hazlitt, Gooden & Fox, London, 1975.

London 1977
Master Drawings. Thos. Agnew & Sons Ltd., London, 1977.

London 1978
Dawn Ades. *Dada and Surrealism Reviewed.* Hayward Gallery, London, 1978.

London 1983
Ronald Pickvance. *Edgar Degas 1834–1917*. David Carritt Limited, London, 1983.

London 1985
Will Ameringer. *David Smith: Sprays from Bolton Landing*. Anthony d'Offay Gallery, London, 1985.

London 1987
Master Drawings: The Woodner Collection. Royal Academy of Arts, London, 1987.

London 1991
Nicholas Turner and Carol Plazzotta. *Drawings by Guercino from British Collections*. British Museum, London, 1991.

London 1995
Ian Warrell. *Through Switzerland with Turner*. Tate Gallery, London, 1995.

London 1997
British Paintings and Watercolours of the 17th, 18th, and 19th Centuries. Spink-Leger Pictures, London, 1997.

London 1998
Neville Wakefield and Dave Hickey. *Ed Ruscha New Paintings and a Retrospective of Works on Paper*. Anthony d'Offay Gallery, London, 1998.

London/Leeds 1997–98
Timothy Wilcox. *Francis Towne*. Tate Gallery, London; Leeds City Art Gallery, 1997–98.

London/New York 1993–94
Katrin Bellinger and Harald Weinhold. *Nine Drawings From the Creation and the Early History of Man*. Harari & Johns Ltd., London; Hazlitt, Gooden & Fox, New York, 1993–94.

London/Paris 1991–92
Toulouse-Lautrec. Hayward Gallery, London; Grand Palais, Paris, 1991–92.

London/Washington 1994–95
Jane Martineau and Andrew Robison. *The Glory of Venice: Art in the Eighteenth Century*. Royal Academy of Arts, London; National Gallery of Art, Washington, 1994–95.

López-Rey 1953
José López-Rey. *Goya's Caprichos: Beauty, Reason & Caricature*. 2 vols. Princeton, 1953.

Los Angeles 1926
Water Colors by Thomas Moran, NA, 1837–1926. Biltmore Salon, Los Angeles, 1926.

Los Angeles 1961
French Masters Rococo to Romanticism. UCLA Art Galleries, Los Angeles, 1961.

Los Angeles 1971
Marcel Roethlisberger. *The Claude Lorrain Album in the Norton Simon, Inc. Museum of Art*. Los Angeles County Museum of Art, 1971.

Los Angeles 1976a
Edria Feinblatt. *Old Master Drawings from American Collections*. Los Angeles County Museum of Art, 1976.

Los Angeles 1976b
Ann Sutherland Harris and Linda Nochlin. *Women Artists: 1550–1950*. Los Angeles County Museum of Art, 1976.

Los Angeles et al. 1968
Larry Curry. *Eight American Masters of Watercolor: Winslow Homer, John Singer Sargent, Maurice B. Prendergast, John Marin, Arthur B. Dove, Charles Demuth, Charles E. Burchfield, Andrew Wyeth*. Los Angeles County Museum of Art; De Young Memorial Art Museum, Fine Arts Museums of San Francisco; Seattle Art Museum, 1968.

Los Angeles et al. 1971–72
Lorenz Eitner. *Géricault*. Los Angeles County Museum of Art; Detroit Institute of Arts; Philadelphia Museum of Art, 1971–72.

Los Angeles et al. 1989–91
Pratapaditya Pal et al. *Romance of the Taj Mahal*. Los Angeles County Museum of Art; Toledo Museum of Art, Ohio; Virginia Museum of Fine Arts, Richmond; Asia Society, New York, 1989–91.

Los Angeles et al. 1993–94
Victor Carlson and Richard Campbell. *Visions of Antiquity: Neoclassical Figure Drawings*. Los Angeles County Museum of Art; Philadelphia Museum of Art; Minneapolis Institute of Arts, 1993–94.

Louchheim 1944
Aline B. Louchheim. "Trio con Brio: Baroque Comes to Baltimore." *Art News* 48 (May 1944), 9–11.

Louisville/Fort Worth 1984
Patricia Condon, Marjorie B. Cohen, Agnes Mongan. *In Pursuit of Perfection: The Art of J.-A.-D. Ingres*. J. B. Speed Art Museum, Louisville; Kimbell Art Museum, Fort Worth, 1984.

Lubke 1878
Wilhelm Lubke. *Geschichte der italienische Malerei*. Stuttgart, 1878.

Ludwig 1965–66
Coy Ludwig. "From Parlor Print to Museum: The Art of Maxfield Parrish." *Art Journal* 25 (Winter 1965–66), 143–46.

Ludwig 1973
Coy Ludwig. *Maxfield Parrish*. New York, 1973.

Lunsingh Scheurleer 1980
P. Lunsingh Scheurleer. "Mogol-miniaturen door Rembrandt nagetekend." *De Kroniek van het Rembrandthuis* 32, no. 1 (1980), 10–40.

Lurie 1963
Ann T. Lurie. "A Drawing by Guercino." *Art Quarterly* 26 (Summer 1963), 217–33.

Lurie 1982
Ann T. Lurie, ed. *European Paintings of the 16th, 17th, and 18th Centuries: The Cleveland Museum of Art Catalogue of Paintings*. Cleveland, 1982.

Lurie 1994
Ann T. Lurie. "Ferdinand George Waldmüller in the Cleveland Museum of Art: Portrait of Crescentia, Countess Zichy (later Countess Széchenyi) with a Parrot and a Camellia in a Mountainous Landscape." *CMA Bulletin* 81 (1994), 3–17.

Lyons 1997
Deborah Lyons. *Edward Hopper: A Journal of His Work*. New York, 1997.

Macandrew 1980
Hugh Macandrew. *Ashmolean Museum, Oxford. Catalogue of the Collection of Drawings*. 6 vols. Oxford, 1980.

Mack 1938
Gerstle Mack. *Toulouse-Lautrec*. New York, 1938.

Madeleine-Perdrillat 1990
Alain Madeleine-Perdrillat. *Seurat*. Geneva/New York, 1990.

Madison 1985–86
Trent Myers. *Robots: History, Fantasy and Reality* [brochure]. Madison Art Center, Wisconsin, 1985–86.

Madrid 1993
Joan Miró: Campo de Estrellas. Museo Nacional Centro de Arte Reina Sofia, Madrid, 1993.

Madrid/London 1982–83
Manuela Mena Marqués. *Bartolomé Esteban Murillo 1617–1682*. Museo del Prado, Madrid; Royal Academy of Arts, London, 1982–83.

Mahon 1965
Denis Mahon. "Stock-Taking in Seicento Studies." *Apollo* 82 (November 1965), 378–91.

Mahon/Turner 1989
Denis Mahon and Nicholas Turner. *The Drawings of Guercino in the Collection of Her Majesty the Queen at Windsor Castle*. Cambridge, England, 1989.

Maison 1968
K. E. Maison. *Honoré Daumier: Catalogue Raisonné of the Paintings, Watercolours and Drawings*. 2 vols. London/Greenwich, Connecticut, 1968.

Malet 1984
Rosa Maria Malet. *Joan Miró*. New York, 1984.

Manchester 1937
"Watercolour Drawings by J. R. Cozens and J. S. Cotman." Whitworth Art Gallery, Manchester, 1937.

Manchester 1965
Between Renaissance and Baroque. City Art Gallery, Manchester, 1965.

Manchester/Cambridge 1987
Richard Thomson. *The Private Degas*. Whitworth Art Gallery, University of Manchester; Fitzwilliam Museum, Cambridge, England, 1987.

Marangoni 1959
Matteo Marangoni. *Guercino*. Milan, 1959.

Marchini 1975
Giuseppe Marchini. *Filippo Lippi*. Milan, 1975.

Mariani 1928
Valerio Mariani. "Primo Centenario dalla Morte di Francisco Goya: Disegni Inediti." *L'Arte* 33 (1928), 97–108.

Mariemont 1979
L'Illustration en France et en Belgique de 1800 à 1914. Cent livres de la réserve précieuse du Musée royal de Mariemont. Musée royal de Mariemont, 1979.

Mariette 1854–56
Pierre-Jean Mariette. *Abecedario de P. J. Mariette et autres notes inédites de cet amateur sur les arts et les artistes*. Edited by P. de Chennevières and A. de Montaiglon. Paris, 1854–56.

Mariuz 1971
Adriano Mariuz. *Giandomenico Tiepolo*. Venice, 1971.

Mariuz 1986
Adriano Mariuz. "I Disegni di Pulcinella di Giandomenico Tiepolo." *Arte Veneta* 40 (1986), 265–73.

Martini 1964
Alberto Martini. *Paul Gauguin*. Milan, 1964.

Matisse Foundation
Matisse Foundation/de Pury and Luxembourg Art. *Yves Tanguy Catalogue Raisonné*. Forthcoming.

Matteucci 1966
Anna Maria Matteucci. *Bernardo Strozzi*. Milan, 1966.

Matthews 1986
J. H. Matthews. *Languages of Surrealism*. Columbia, Missouri, 1986.

McCullagh 1981
Suzanne Folds McCullagh. "The Development of Gabriel de Saint-Aubin (1724–1780) as a Draughtsman." Ph.D. diss., Harvard University, 1981.

McCullagh 1991
Suzanne Folds McCullagh. "Serendipity in a Solander Box: A Recently Discovered Pastel and Chalk Drawing by Federico Barocci." *Museum Studies: The Art Institute of Chicago* 17, no. 1 (1991), 52–65.

McFee/Degge 1980
June King McFee and Rogena M. Degge. *Art, Culture, and Environment: A Catalyst for Teaching*. Dubuque, 1980.

McKinney 1954
Roland McKinney. *The Eight*. New York, 1954.

Meder 1923
Joseph Meder. *Die Handzeichnung ihre Technik und Entwicklung*. Vienna, 1923.

Meder 1978
Joseph Meder. *The Mastery of Drawing*. Translated by Winslow Ames. New York, 1978.

Meixner 1985
Laura L. Meixner. "Will Hicok Low (1853–1932): His Early Career and Barbizon Experience." *American Art Journal* 17 (Autumn 1985), 51–70.

Melbourne/Canberra 1997–98
Albert Blankert. *Rembrandt. A Genius and His Impact*. National Gallery of Victoria, Melbourne; National Gallery of Australia, Canberra, 1997–98.

Memphis et al. 1982–83
Laura L. Meixner. *An International Episode: Millet, Monet, and Their North American Counterparts*. Dixon Gallery and Gardens, Memphis; Terra Museum of American Art, Evanston, Illinois; Worcester Art Museum, Massachusetts, 1982–83.

Mellor [1974]
Anne Kostelanetz Mellor. *Blake's Human Form Divine*. Berkeley, [1974].

Mende 1978
Matthias Mende. *Hans Baldung Grien: Das Graphische Werk*. Nuremberg, 1978.

Mendelowitz/Wakeham 1993
Daniel Marcus Mendelowitz and Duane A. Wakeham. *A Guide to Drawing*. Fort Worth, 1993.

Merkel 1990
Kerstin Merkel. "Salome. Ikonographie im Wandel." Ph.D. diss., Johannes Gutenberg-Universität, Mainz, 1990.

Merz 1991
Jörg Martin Merz. *Pietro da Cortona; Der Aufstieg zum führenden Maler im barocken Rom*. Tübingen, 1991.

Merz 1994
Jörg Martin Merz. "I disegni di Pietro da Cortona per gli affreschi nella Chiesa Nuova a Roma." *Bollettino d'Arte* 86–87 (1994), 37–77.

Metcalfe 1950
James J. Metcalfe. "Artists." *Cleveland News* (19 August 1950), 50.

Metz 1790
C. M. Metz. *Imitations of Ancient and Modern Drawings*. London, 1790.

Michel [1906]
André Michel. *François Boucher*. [1906].

Michelet 1888
Émile Michelet. "L'Été à Paris." *Paris illustré* 6 (1888), 425–27.

Middletown/Baltimore 1975
Victor Carlson, Ellen D'Oench, Richard Field. *Prints and Drawings by Gabriel de Saint-Aubin 1724–1780*. Davison Art Center, Wesleyan University, Middletown, Connecticut; Baltimore Museum of Art, 1975.

Milan 1971
Mercedes Precerutti-Garberi. *Giambattista Piazzetta e l'accademia*. Castello Sforzesco, Milan, 1971.

Miller 1987
Michael Miller. *Drawing, a Glossary of Materials*. Cleveland, 1987.

Miller 1990a
Michael Miller. "A Michelangelo Drawing." *CMA Bulletin* 77 (1990), 146–74.

Miller 1990b
Bruce Miller. "Technical Note on the Cleveland Michelangelo Drawing." *CMA Bulletin* 77 (1990), 175–79.

Miller 1991
Michael Miller. "Notable Acquisitions." *CMA Bulletin* 78 (1991), 63–147.

Millier 1956
Arthur Millier. *The Drawings of Tiepolo*. Los Angeles, 1956.

Milliken 1926a
William Milliken. "The Maurice Prendergast Memorial Exhibition." *CMA Bulletin* 13 (1926), 40–41.

Milliken 1926b
William Milliken. "Maurice Prendergast, American Artist." *Arts* 9 (April 1926), 180–92.

Milliken 1940
William Milliken. "Two Drawings by Piazzetta." *Burlington Magazine* 26 (March 1940), 87–93.

Milliken 1950
William Milliken. "L'Arte Italiana nel Museo di Cleveland." *Le Vie del Mondo* 12 (September 1950), 897–908.

Milliken 1958
William Milliken. *The Cleveland Museum of Art*. New York, 1958.

Milwaukee 1957
An Inaugural Exhibition: El Greco, Rembrandt, Goya, Cézanne, Van Gogh, Picasso. Milwaukee Art Institute, 1957.

Minneapolis 1950a
"Rare Drawings in Gauguin Exhibition." *Bulletin—Minneapolis Institute of Arts* 39 (April 1950), 74.

Minneapolis 1950b
"Gauguin Exhibition." Minneapolis Institute of Arts, 1950.

Minneapolis 1952
Watercolors by the Masters: Dürer to Cézanne. Minneapolis Institute of Arts, 1952.

Minneapolis 1961
Hylton Thomas, Lorenz Eitner, Sidney Simon. *The Eighteenth Century: One Hundred Drawings by One Hundred Artists*. University Gallery, University of Minnesota, Minneapolis, 1961.

Minneapolis 1972
Edward Ruscha (Ed-werd Rew-shay) Young Artist. Minneapolis Institute of Arts, 1972.

Minneapolis et al. 1945
Lloyd Goodrich. *American Watercolor and Winslow Homer*. Walker Art Center, Minneapolis; Detroit Institute of Arts; Brooklyn Museum, 1945.

Minneapolis et al. 1946–47
Acquarela-E. E. U. U. Watercolor—USA, A Survey of Watercolor—USA from 1870 to 1946. Walker Art Center, Minneapolis; Pan-American Union, Washington; venues in South America, 1946–47.

Minneapolis/New York 1962
Lorenz Eitner. *The Nineteenth Century: One Hundred Twenty-Five Master Drawings*. University Gallery, University of Minnesota, Minneapolis; Solomon R. Guggenheim Museum, New York, 1962.

Monbeig-Goguel 1991
Catherine Monbeig-Goguel. "Book Reviews." *Burlington Magazine* 133 (July 1991), 453–54.

Monbeig-Goguel/Vitzthum 1968
Catherine Monbeig-Goguel and Walter Vitzthum. "Dessins inédits de Giorgio Vasari." *Revue de l'Art* 1–2 (1968), 89–93.

Mongan 1942
Agnes Mongan. "Italian Drawings 1330–1780: an Exhibition at the Smith College Museum of Art." *Art Bulletin* 24 (March 1942), 92–94.

Mongan 1949
Agnes Mongan, ed. *One Hundred Master Drawings*. Cambridge, 1949.

Mongan 1963
Agnes Mongan. "European Landscape Drawing 1400–1900: A Brief Survey." *Daedalus* 92 (Summer 1963), 581–635.

Mongan 1969
Agnes Mongan. "Ingres as a Great Portrait Draughtsman." In *Colloque Ingres*. Montauban, 1969.

Monnier 1972
Geneviève Monnier. *Musée du Louvre—Cabinet des dessins: Pastels XVIIème et XVIIIème siècles*. Paris, 1972.

Montagu 1994
Jennifer Montagu. *The Expression of the Passions*. New Haven/London, 1994.

Montaiglon 1972
Anatole de Montaiglon. *Procès-verbaux de l'Académie royale de peinture et de sculpture 1648–1793*. 11 vols. Paris, 1972.

Montesquiou 1897
Robert de Montesquiou. *Roseaux pensants*. Paris, 1897.

Montezuma 1885
Montezuma (Mary Gay Humpheys). "My Note Book." *Art Amateur* 12 (January 1885), 29.

Montreal 1950
The Eighteenth Century Art of France and England. Montreal Museum of Fine Arts, 1950.

Montreal 1953
Five Centuries of Drawings. Montreal Museum of Fine Arts, 1953.

Moore 1968
Janet Gaylord Moore. *The Many Ways of Seeing: An Introduction to the Pleasures of Art.* Cleveland, 1968.

Morand 1996
Anne Morand. *Thomas Moran, The Field Sketches.* Norman, Oklahoma, 1996.

Morassi 1953
Antonio Morassi. "Una mostra del settecento veneziano a Detroit." *Arte Veneta* 25 (1953), 49–62.

Morassi 1958
Antonio Morassi. *Dessins vénitiens du dix-huitième siècle de la collection du Duc de Tallyrand.* Milan, 1958.

Morassi 1975
Antonio Morassi. *Guardi: Tutti i disegni di Antonio, Francesco e Giacomo Guardi.* Milan, 1975.

Moreau-Nélaton 1921
Étienne Moreau-Nélaton. *Millet raconté par lui-même.* 3 vols. Paris, 1921.

Morford/Lenardon 1977
Mark Morford and Robert J. Lenardon. *Classical Mythology.* 2nd ed. New York, 1977.

Morice 1919
Charles Morice. *Paul Gauguin.* Paris, 1919.

Mortari 1966
Luisa Mortari. *Bernardo Strozzi.* Rome, 1966.

Mortari 1995
Luisa Mortari. *Bernardo Strozzi.* Rome, 1995.

Mosby 1977
Dewey F. Mosby. "A Rediscovered Salon Painting by Pierre-Henri de Valenciennes: Landscape of Ancient Greece." *Bulletin of the Detroit Institute of Arts* 55, no. 3 (1977), 153–57.

Moskowitz 1962
Ira Moskowitz, ed. *Great Drawings of All Time.* 4 vols. New York, 1962.

Moskowitz/Sérullaz 1962
Ira Moskowitz and Maurice Sérullaz. *Drawings of the Masters: French Impressionists.* London, 1962.

Munhall 1965
Edgar Munhall. "Les dessins de Greuze pour 'Septime Sévère.'" *L'Oeil* 11 (April 1965), 22–29, 59.

Munich 1917
"Secession im Glaspalast." Kunstausstellungsgebäude, Munich, 1917.

Muraro/Grabar 1963
Michelangelo Muraro and André Grabar. *Treasures of Venice.* Geneva, 1963.

Murray 1991
Gale B. Murray. *Toulouse-Lautrec: The Formative Years 1878–1891.* Oxford, 1991.

Murray 1992
Gale B. Murray, ed. *Toulouse-Lautrec: A Retrospective.* New York, 1992.

Muylle 1983
Jan Muylle. "Big Fishes Eat the Little Fishes by Pieter Bruegel after Hieronymous Bosch(?). A Question of Interpretation." In *Le Dessin sous-jacent dans la peinture, Colloque V. Dessin sous-jacent et autres techniques graphiques.* Louvain-la-Neuve, 1983.

Naef 1963a
Hans Naef. "Ingres und die Familie Raoul-Rochette." *Schweizer Monatshefte* (December 1963), 1–34.

Naef 1963b
Hans Naef. "Ingres et la Famille Raoul-Rochette." *Bulletin du Musée Ingres* (December 1963), 13–23.

Naef 1979
Hans Naef. *Die Bildniszeichnungen von J.-A.-D. Ingres.* 5 vols. Bern, 1979.

Naples 1992
Silvia Cassani and Tatiana Travaglini. *Jusepe de Ribera 1591–1652.* Castel Sant' Elmo, Naples, 1992.

Naples et al. 1964–65
Estella Brunetti et al. *La Natura Morta Italiana.* Palazzo Reale, Naples; Kunsthaus, Zurich; Museum Boymans-van Beuningen, Rotterdam, 1964–65.

Nathanson/Olszewksi 1980
Carol A. Nathanson and Edward J. Olszewski. "Degas's Angel of the Apocalypse." *CMA Bulletin* 62 (1980), 243–55.

National Cyclopedia of American Biography 1943
National Cyclopedia of American Biography. Vol. 30. New York, 1943.

Neilson 1971
Nancy Ward Neilson. "Notes on Two of the 'Fasti della repubblica veneziana' Drawings." *Burlington Magazine* 113 (May 1971), 271.

Neugass 1964
Fritz Neugass. "Henri de Toulouse-Lautrec und der Kunstmarkt." *Weltkunst* 34 (March 1964), 139.

New Delhi 1954
American Watercolor Exhibition. All-India Fine Arts and Crafts Society, New Delhi, 1954.

New Haven 1940
Exhibition of Eighteenth-Century Italian Landscape Painting and Its Influence in England. Gallery of Fine Arts, Yale University, New Haven, 1940.

New Haven 1979
Nancy Pressly. *The Fuseli Circle in Rome: Early Romantic Art of the 1770's.* Yale Center for British Art, New Haven, 1979.

New Haven et al. 1969–70
Charles Talbot and Alan Shestack. *Prints and Drawings of the Danube School.* Yale University Art Gallery, New Haven; City Art Museum of St. Louis; Philadelphia Museum of Art, 1969–70.

New Haven et al. 1992–93
Scott Wilcox and Christopher Newall. *Victorian Landscape Watercolors.* Yale Center for British Art, New Haven; Cleveland Museum of Art; Birmingham Museums and Art Gallery, England, 1992–93.

New London 1936
"Six Centuries of Drawings." Lyman Allyn Museum, New London, Connecticut, 1936.

New Orleans 1961
Masks and Masquerades. Isaac Delgado Museum of Art, New Orleans, 1961.

New York 1899
"Exhibition of Drawings by Maxfield Parrish." Keppel Gallery, New York, 1899.

New York 1914
The French Eighteenth Century Drawings Coming from the J. P. Heseltine Collection. E. Gimpel & Wildenstein, New York, 1914.

New York 1926
Memorial Exhibition: Water Color Sketches by Thomas Moran. Milch Galleries, New York, 1926.

New York 1929–30
Paintings by Nineteen Living Americans. Museum of Modern Art, New York, 1929–30.

New York 1930
Charles Burchfield Early Watercolors. Museum of Modern Art, New York, 1930.

New York 1934a
Alfred H. Barr Jr., ed. *Modern Works of Art.* Museum of Modern Art, New York, 1934.

New York 1934b
Walter Pach. *Maurice Prendergast Memorial Exhibition.* Whitney Museum of American Art, New York, 1934.

New York 1936
Royal Cortissoz and Herbert Eustin Winlock. *An Exhibition of the Work of John La Farge.* Metropolitan Museum of Art, New York, 1936.

New York 1937
Twenty Years in the Evolution of Picasso: 1903–1923. Jacques Seligmann & Co., Inc., New York, 1937.

New York 1937–38
Henry McBride. *Charles Demuth Memorial Exhibition.* Whitney Museum of American Art, New York, 1937–38.

New York 1938
Tiepolo and His Contemporaries. Metropolitan Museum of Art, New York, 1938.

New York 1939
The Stage: A Loan Exhibition for the Benefit of the Public Education Association. Jacques Seligmann & Co., Inc., New York, 1939.

New York 1940
Paul Klee. Buchholz Gallery/Willard Gallery, New York, 1940.

New York 1944
Exhibition of Drawings of the Nineteenth and Twentieth Centuries. American-British Art Center, New York, 1944.

New York 1945
Joan Miró: Ceramics 1944 Tempera Paintings 1940 to 1941 Lithographs 1944 [one-page brochure]. Pierre Matisse Gallery, New York, 1945.

New York 1946
A Loan Exhibition of Paul Gauguin for the Benefit of the New York Infirmary. Wildenstein & Co. Inc., New York, 1946.

New York 1947a
Picasso before 1907. Knoedler Galleries, New York, 1947.

New York 1947b
Seurat: His Drawings. Buchholz Gallery, New York, 1947.

New York 1947c
Helen Comstock. *Exhibition of Drawings by John Singleton Copley.* Harry Shaw Newman Gallery, New York, 1947.

New York 1950
Jacob Lawrence: Exhibition of New Paintings in Casein. Downtown Gallery, New York, 1950.

New York 1955
Felice Stampfle. *Drawings and Prints by Albrecht Dürer.* Pierpont Morgan Library, New York, 1955.

New York 1956
Toulouse-Lautrec: Paintings, Drawings, Posters, and Lithographs. Museum of Modern Art, New York, 1956.

New York 1959a
M. T. Glaser. *Great Master Drawings of Seven Centuries.* M. Knoedler and Company, New York, 1959.

New York 1959b
Joan Miró and André Breton. *Joan Miró Constellations: Introduction et vingt-deux proses parallèles par André Breton.* Pierre Matisse Gallery, New York, 1959.

New York 1960
Joseph Mallord William Turner: Watercolours and Drawings. Otto Gerson Gallery, New York, 1960.

New York 1961
Ingres in American Collections. Paul Rosenberg & Co., New York, 1961.

New York 1964
Toulouse-Lautrec. Wildenstein & Co., Inc., New York, 1964.

New York 1966–67
Mario Cooper and Stuart P. Feld. *Two Hundred Years of Watercolor Painting in America: An Exhibition Commemorating the Centennial of the American Watercolor Society.* Metropolitan Museum of Art, New York, 1966–67.

New York 1967
Jean Paulhan et ses environs. Albert Loeb and Krugier Gallery, New York, 1967.

New York 1968
Claus Virch. *The Artist and the Animal.* M. Knoedler & Co., Inc., New York, 1968.

New York 1969
Joan Nissman and Howard Hibbard. *Florentine Baroque Art from American Collections.* Metropolitan Museum of Art, New York, 1969.

New York 1970
Four Americans in Paris. Museum of Modern Art, New York, 1970.

New York 1971
Jacob Bean and Felice Stampfle. *The Eighteenth Century in Italy.* Metropolitan Museum of Art, New York, 1971.

New York 1975
Martin L. H. Reymert et al. *Ingres & Delacroix Through Degas & Puvis de Chavannes: The Figure in French Art 1800–1870.* Shepherd Gallery, New York, 1975.

New York 1976
Twentieth-Century American Drawing: Three Avant-Garde Generations. Solomon R. Guggenheim Museum, New York, 1976.

New York 1979a
Cecily Langdale. *The Monotypes of Maurice Prendergast: A Loan Exhibition.* Davis & Long Company, New York, 1979.

New York 1979b
Peter S. Rohowsky. *Nineteenth Century French and Other Continental Drawings, Watercolors and Oil Sketches.* Shepherd Gallery Associates, New York, 1979.

New York 1980
The Iconography of Louise Bourgeois. Max Hutchinson Gallery, New York, 1980.

New York 1982–83
Deborah Wye. *Louise Bourgeois.* Museum of Modern Art, New York, 1982–83.

New York 1984
Michael Hunt Stolbach. *Inaugural Exhibition: Master Paintings, Drawings and Sculpture.* Spencer A. Samuels, New York, 1984.

New York 1987
Barbara Haskell. *Charles Demuth.* Whitney Museum of American Art, New York, 1987.

New York 1988
Egbert Haverkamp-Begemann. *Creative Copies, Interpreting Drawings from Michelangelo to Picasso.* Drawing Center, New York, 1988.

New York 1990a
Carl Van de Velde. *Jan Wierix: The Creation and the Early History of Man.* Richard L. Feigen & Co., New York, 1990.

New York 1990b
Richard Marshall. *Edward Ruscha Los Angeles Apartments 1965.* Whitney Museum of American Art, New York, 1990.

New York 1990c
Master Drawings 1760–1880. W. M. Brady & Co., New York, 1990.

New York 1991
An Exhibition of Old Master Drawings. Colnaghi, New York, 1991.

New York 1992a
Thomas Le Claire. *Master Drawings 1500–1900.* W. M. Brady & Co. Inc., New York, 1992.

New York 1992b
William Rubin and Matthew Armstrong. *The William S. Paley Collection.* Museum of Modern Art, New York, 1992.

New York 1992c
Alfonso E. Pérez Sánchez and Nicola Spinosa. *Jusepe de Ribera 1591–1652.* Metropolitan Museum of Art, New York, 1992.

New York 1993
Kate Ganz. *Heads and Portraits: Drawings from Piero di Cosimo to Jasper Johns.* Jason McCoy Inc., New York, 1993.

New York 1993–94
Carolyn Lanchner. *Joan Miró.* Museum of Modern Art, New York, 1993–94.

New York 1994a
English Romantic Art 1840–1920 Pre-Raphaelites, Academics, Symbolists: Drawings, Watercolours, Graphics and Paintings. Shepherd Gallery Associates, New York, 1994.

New York 1994b
Barbara Haskell. *Joseph Stella.* Whitney Museum of American Art, New York, 1994.

New York 1995
Walter Liedtke et al. *Rembrandt/Not Rembrandt in the Metropolitan Museum of Art: Aspects of Connoisseurship.* Metropolitan Museum of Art, New York, 1995.

New York 1996
Alan Wintermute and Donald Garstang. *The French Portrait 1550–1850.* Colnaghi, New York, 1996.

New York 1997
George R. Goldner and Carmen C. Bambach. *The Drawings of Filippino Lippi and His Circle.* Metropolitan Museum of Art, New York, 1997.

New York et al. 1950
Lloyd Goodrich. *Edward Hopper Retrospective Exhibition.* Whitney Museum of American Art, New York; Museum of Fine Arts, Boston; Detroit Institute of Arts, 1950.

New York et al. 1950–51
Andrew Carnduff Ritchie. *Charles Demuth.* Museum of Modern Art, New York; Detroit Institute of Arts; University of Miami Art Gallery, Coral Gables, Florida; Winnipeg Art Gallery; Lawrence Art Museum, Williams College, Williamstown, Massachusetts; University of Delaware Art Museum, Newark; Allen Memorial College Art Museum, Oberlin College, Ohio, 1950–51.

New York et al. 1954
Fuseli. Smithsonian Institution Traveling Exhibition Service. Pierpont Morgan Library, New York; Cleveland Museum of Art; Detroit Institute of Arts; City Art Museum, St. Louis; Baltimore Museum of Art, 1954.

New York et al. 1963–64
Lloyd Goodrich. *The Decade of the Armory Show: New Directions in American Art, 1910–1920.* Whitney Museum of American Art, New York; City Art Museum, St. Louis; Cleveland Museum of Art; Pennsylvania Academy of Fine Arts, Philadelphia; Art Institute of Chicago; Albright-Knox Art Gallery, Buffalo, New York, 1963–64.

New York et al. 1964
Sidney Simon and Emily Rauh. *Twentieth Century Master Drawings.* Solomon R. Guggenheim Museum, New York; University Gallery, University of Minnesota, Minneapolis; Fogg Art Museum, Harvard University, Cambridge, 1964.

New York et al. 1964–65
Lloyd Goodrich. *Edward Hopper.* Whitney Museum of American Art, New York; Art Institute of Chicago; Detroit Institute of Arts; City Art Museum, St. Louis, 1964–65.

New York et al. 1985–86
Philippe Grunchec. *Master Drawings by Géricault.* Pierpont Morgan Library, New York; San Diego Museum of Art; Museum of Fine Arts, Houston, 1985–86.

New York et al. 1988
Barbara Haskell. *Charles Demuth*. Whitney Museum of American Art, New York; Los Angeles County Museum of Art; Columbus Museum of Art, Ohio; San Francisco Museum of Modern Art, 1988.

New York et al. 1990–91
Nancy Mowll Matthews. *Maurice Prendergast*. Whitney Museum of American Art, New York; Williams College Museum of Art, Williamstown, Massachusetts; Los Angeles County Museum of Art; Phillips Collection, Washington, 1990–91.

New York et al. 1994
European Master Drawings. Hazlitt, Gooden & Fox, New York; Galerie de Bayser S. A., Paris; Hazlitt, Gooden & Fox, London, 1994.

New York et al. 1998–99
Stephen Wildman and John Christian. *Edward Burne-Jones: Victorian Artist-Dreamer*. Metropolitan Museum of Art, New York; Birmingham Museums and Art Gallery, England; Musée d'Orsay, Paris, 1998–99.

New York/London 1988
Master Drawings 1550–1850. Didier Aaron, Inc., New York; Didier Aaron, Inc., London, 1988.

New York/Nuremberg 1986
Gothic and Renaissance Art in Nuremberg 1300–1550. Metropolitan Museum of Art, New York; Germanisches Nationalmuseum, Nuremberg, 1986.

New York/Paris 1996–97
William Rubin. *Picasso and Portraiture: Presentation and Transformation*. Museum of Modern Art, New York; Grand Palais, Paris, 1996–97.

Newark 1960
William Gerdts and Elaine Evans Gerdts. *Old Master Drawings*. Newark Museum, New Jersey, 1960.

Newark 1961
Elaine Evans Gerdts and William H. Gerdts. *Nineteenth Century Master Drawings*. Newark Museum, New Jersey, 1961.

Newcastle-upon-Tyne 1953
"Coronation Exhibition." Laing Art Gallery, Newcastle-upon-Tyne, 1953.

Newcome 1993
Mary Newcome. "Oil Sketches and Drawings by Strozzi." *Antichità viva* 32, no. 6 (1993), 14–24.

Nishimura et al. 1972
Nishimura Toshio et al. *Courbet et le réalisme*. Tokyo, 1972.

Noël 1991
Bernard Noël. *Géricault*. Paris, 1991.

Nordhoff/Reimer 1994
Claudia Nordhoff and Hans Reimer. *Jakob Philipp Hackert 1737–1807: Verzeichnis seiner Werke*. 2 vols. Berlin, 1994.

Norfolk 1983
Thomas W. Sokolowski. *The Sailor 1930–45: The Image of an American Demigod*. Chrysler Museum, Norfolk, Virginia, 1983.

Northampton 1941
"Exhibition of Italian Drawings, 1330–1780." Smith College Museum of Art, Northampton, Massachusetts, 1941.

Northampton 1950
"Antonio Canaletto." Smith College Museum of Art, Northampton, Massachusetts, 1950.

Northampton 1952
Janet Denithorne. *Claude Lorrain 1600–1682: Paintings, Drawings, Prints*. Smith College Museum of Art, Northampton, Massachusetts, 1952.

Northampton et al. 1941
Paul Klee: Memorial Exhibition. Smith College Museum of Art, Northampton, Massachusetts; Arts Club of Chicago; Portland Art Museum, Oregon; San Francisco Museum of Art; Stendahl Art Galleries, Los Angeles; City Art Museum, St. Louis; Wellesley College, Massachusetts; Museum of Modern Art, New York, 1941.

Novotny 1969
Fritz Novotny. *Toulouse-Lautrec*. London/New York, 1969.

Nuño 1978
Juan Antonio Gaya Nuño. *L'opera completa di Murillo*. Milan, 1978.

Nuremberg 1928
Albrecht Dürer Ausstellung im Germanischen Museum. Germanischen Museum, Nuremberg, 1928.

Nuremberg 1994
Katrin Achilles-Syndram and Rainer Schoch. *Kunst des Sammelns Das Praunsche Kabinett. Meisterwerke von Dürer bis Carracci*. Germanischen Nationalmuseum, Nuremberg, 1994.

Oberlin 1951
Exhibition of Master Drawings of the Eighteenth Century in France and Italy. Allen Memorial Art Museum, Oberlin College, Ohio, 1951.

O'Conner 1937
John O'Conner Jr. "Edward Hopper, American Artist." *Carnegie Magazine* 10 (March 1937), 303–6.

Oettinger 1957
Karl Oettinger. *Datum und Signatur bei Wolf Huber und Albrecht Altdorfer: Zur Beschriftungskritik der Donauschulzeichnungen*. Erlangen, 1957.

Oettinger 1959a
Karl Oettinger. "Ein Altdorfer-Schüler: Der Zeichner der Pariser Landsknechte." In *Festschrift Friedrich Winkler*. Berlin, 1959.

Oettinger 1959b
Karl Oettinger. *Altdorfer-Studien*. Nuremberg, 1959.

Ojetti 1932
Ugo Ojetti. *Il Settecento Italiano*. 2 vols. Milan, 1932.

Olsen 1962
Harald Olsen. *Federico Barocci*. Copenhagen, 1962.

Olszewski 1976
Edward J. Olszewski. "A Design for the Sistine Chapel Ceiling." *CMA Bulletin* 63 (1976), 12–26.

Olszewski 1977
Edward J. Olszewski, ed. *Giovanni Battista Armenini: On the True Precepts of the Art of Painting*. New York, 1977.

Olszewski 1981
Edward J. Olszewski. "Italian Drawings in Cleveland." *Connoisseur* 206 (April 1981), 284–88.

Olszewski 1998
Edward J. Olszewski. "Central and Lateral Landscape in Italian Renaissance Painting." *Source: Notes in the History of Art* 17 (Spring 1998), 29–35.

Omaha 1971
"The Thirties Decade: American Artists and Their European Contemporaries." Joslyn Art Museum, Omaha, 1971.

O'Neill 1981
Mary O'Neill. *Catalogue Critique les peintures de l'école française des XVIIe et XVIIIe siècles*. 2 vols. Orléans, 1981.

Opperman 1977
Hal N. Opperman. *Jean-Baptiste Oudry*. 2 vols. New York/London, 1977.

Osborne 1985
Carol Margot Osborne. *Pierre Didot the Elder and French Book Illustration 1789–1822*. New York, 1985.

O'Toole 1982
Judith Hansen O'Toole. "Henri-Gabriel Ibels and Georges Seurat: An Attribution Confirmed." *CMA Bulletin* 69 (1982), 236–43.

Ottawa 1968–69
Michael Jaffé. *Jacob Jordaens 1593–1678*. National Gallery of Canada, Ottawa, 1968–69.

Ottawa 1982
Mimi Cazort and Catherine Johnston. *Bolognese Drawings in North American Collections 1500–1800*. National Gallery of Canada, Ottawa, 1982.

Ottawa et al. 1999–2000
Didier Blin and Caroline Larroche. *Daumier 1808–1879*. National Gallery of Canada, Ottawa; Grand Palais, Paris; Phillips Collection, Washington, 1999–2000.

Ottley 1823
William Y. Ottley. *The Italian School of Design*. London, 1823.

Palau i Fabre 1980
Josep Palau i Fabre. *Picasso: The Early Years 1881–1907*. New York, 1980.

Pallucchini 1934
Rodolfo Pallucchini. *L'Arte di Giovanni Battista Piazzetta*. Bologna, 1934.

Pallucchini 1943
Rodolfo Pallucchini. *Giovanni Battista Piazzetta*. Rome, 1943.

Pallucchini 1956
Rodolfo Pallucchini. *Piazzetta*. Milan, 1956.

Pallucchini et al. 1983
Rodolfo Pallucchini et al. *Giambattista Piazzetta: Il suo tempo, la sua scuola*. Venice, 1983.

Pallucchini/Mariuz 1982
Rodolfo Pallucchini and Adriano Mariuz. *L'opera completa del Piazzetta*. Milan, 1982.

Palm Beach 1948
Five Hundred Years of Watercolor. Society of the Four Arts, Palm Beach, Florida, 1948.

Palm Beach 1952–53
Eighteenth Century Masterpieces. Society of the Four Arts, Palm Beach, Florida, 1952–53.

Panofsky 1943
Erwin Panofsky. *The Life and Art of Albrecht Dürer*. Princeton, 1943.

Pansu 1977
Evelyne Pansu. *Ingres dessins*. Paris, 1977.

Paris 1800
Salon de 1800. Musée du Louvre, Paris, 1800.

Paris 1867
Des Tableaux, études peintes, dessins et croquis de J.-A.-D. Ingres. École des Beaux-Arts, Paris, 1867.

Paris 1872
Collection des livrets des anciennes expositions depuis 1673 jusqu'en 1800. Exposition de 1800. Paris, 1872.

Paris 1878
Exposition des peintures et dessins de H. Daumier. Galeries Durand-Ruel, Paris, 1878.

Paris 1879
Catalogue descriptif des dessins de maîtres anciens exposé à l'école des beaux-arts. L'École des Beaux-Arts, Paris, 1879.

Paris 1888
"Exposition de La Revue Indépendante." Offices of La Revue Indépendante, Paris, 1888.

Paris 1901
Exposition Daumier. Palais de l'École des Beaux-Arts, Paris, 1901.

Paris 1908
Exposition d'oeuvres de Rembrandt, dessins et gravures. Bibliothèque Nationale, Paris, 1908.

Paris 1911
Exposition Ingres. Galeries Georges Petit, Paris, 1911.

Paris 1921
"[no title]." Musée des Arts Décoratifs, Paris, 1921.

Paris 1926
Trente ans d'art indépendant 1884–1914: Exposition rétrospective. Grand Palais, Paris, 1926.

Paris 1934
Charles Sterling. *Daumier: Peintures, aquarelles, dessins*. Musée de l'Orangerie, Paris; Bibliothèque Nationale, Paris, 1934.

Paris 1938
Paul Klee: Oeuvres récentes. Galerie Simon, Paris, 1938.

Paris 1949
Pastels français des collections nationales et du Musée La Tour de Saint-Quentin. Musée de l'Orangerie, Paris, 1949.

Paris 1955
De David à Toulouse-Lautrec. Musée de l'Orangerie, Paris, 1955.

Paris 1959a
Collection M. L. Ensemble Exceptionnel d'Estampes Originales Livres Illustrés Important Dessin aux Crayons de Couleur de Henri de Toulouse-Lautrec. Galerie Charpentier, Paris, 1959.

Paris 1959b
"Constellations." Galerie Berggruen, Paris, 1959.

Paris 1960
Roseline Bacou. *Dessins de Jean-François Millet*. Musée du Louvre, Paris, 1960.

Paris 1961
Jean Cassou. *L'Atelier de Braque*. Musée du Louvre, Paris, 1961.

Paris 1967
Walter Vitzhum and Catherine Monbeig-Goguel. *Le Dessin à Naples du XVI siècle au XVIII siècle*. Musée du Louvre, Paris, 1967.

Paris 1967–68
Lise Duclaux et al. *Ingres*. Petit Palais, Paris, 1967–68.

Paris 1971
Pierrette Jean-Richard. *François Boucher gravures et dessins provenant du Cabinet des Dessins et de la Collection Edmond de Rothschild au Musée du Louvre*. Musée du Louvre, Paris, 1971.

Paris 1974a
André Berne Joffroy, Jean Leymarie, Michèle Richet. *Jean Paulhan à travers ses peintres*. Grand Palais, Paris, 1974.

Paris 1974b
Jean Cailleux. *Giambattista Tiepolo, Domenico Tiepolo, Lorenzo Tiepolo: Peintures, dessins, pastels*. Galerie Cailleux, Paris, 1974.

Paris 1974c
Roseline Bacou. *Cartons d'artistes du XV au XIX siècle*. Musée du Louvre, Paris, 1974.

Paris 1976–77
Harold Joachim. *Dessins français de l'Art Institute de Chicago de Watteau à Picasso*. Musée du Louvre, Paris, 1976–77.

Paris 1981
Dessins baroques florentins du musée du Louvre. Musée du Louvre, Paris, 1981.

Paris 1982–83
Hal Opperman. *J.-B. Oudry 1686–1755*. Grand Palais, Paris, 1982–83.

Paris 1984
Genevieve Renisio and Jean-Paul Boulanger. *Raphael dans le collections françaises*. Grand Palais, Paris, 1984.

Paris 1985
Pierrette Jean-Richard. *Graveurs français de la seconde moitié du XVIIIe siècle*. Musée du Louvre, Paris, 1985.

Paris 1989
Maîtres Français 1550–1800. École Nationale Supérieure des Beaux-Arts, Paris, 1989.

Paris 1991–92
Sylvain Laveissière and Régis Michel. *Géricault*. Grand Palais, Paris, 1991–92.

Paris 1996
Hans Buijs and Jeroen de Scheemaker. *Dessins vénitiens de la collection Frits Lugt*. Institut Néerlandais, Paris, 1996.

Paris 1998–99
Louis van Tilborgh et al. *Millet/Van Gogh*. Musée d'Orsay, Paris, 1998–99.

Paris 1999–2000
Marie Anne Dupuy et al. *Dominique-Vivant Denon: L'Oeil de Napoléon*. Musée du Louvre, Paris, 1999–2000.

Paris et al. 1988–89
Jean Sutherland Boggs et al. *Degas*. Grand Palais, Paris; National Gallery of Canada, Ottawa; Metropolitan Museum of Art, New York, 1988–89.

Paris/Cambridge 1997–98
Emmanuelle Brugerolles. *Géricault: Dessins & estampes des collections de l'École des Beaux-Arts*. École Nationale Supérieure des Beaux-Arts, Paris; Fitzwilliam Museum, Cambridge, England, 1997–98.

Paris/London 1975–76
Robert L. Herbert. *Jean-François Millet*. Grand Palais, Paris; Hayward Gallery, London, 1975–76.

Paris/New York 1988
Pierre Rosenberg. *Fragonard*. Grand Palais, Paris; Metropolitan Museum of Art, New York, 1988.

Paris/New York 1991–92
Robert L. Herbert et al. *Georges Seurat 1859–1891*. Grand Palais, Paris; Metropolitan Museum of Art, New York, 1991–92.

Parker 1938
K. T. Parker. "Notes on Drawings: Gabriel de Saint-Aubin (1724–1780)." *Old Master Drawings* 48 (March 1938), 58.

Pask 1992
Kelly Pask. "Francesco Guardi and the Conti del Nord: A New Drawing." *J. Paul Getty Museum Journal* 20 (1992), 45–52.

Passavant 1839
Johann David Passavant. *Raphael von Urbino und sein vater Giovanni Santi*. 2 vols. Leipzig, 1839.

Passavant 1860
Johann David Passavant. *Raphael d'Urbin et son père Giovanni Santi*. French ed. Paris, 1860.

Paulin/Hutchinson 1996
Roger Paulin and Peter Hutchinson, eds. *Rilke's Duino Elegies: Cambridge Readings*. London, 1996.

Pedrocco 1990
Filippo Pedrocco. *Disegni di Giandomenico Tiepolo*. Milan, 1990.

Penrose 1985
Roland Penrose. *Miró*. New York, 1985.

Pepper Pike/Lakewood 1985–86
"Drawing: A Line of Departure." Wasmer Gallery, Ursuline College, Pepper Pike, Ohio; Kenneth C. Beck Center, Lakewood, Ohio, 1985–86.

Perlman 1979
Bennard B. Perlman. *The Immortal Eight: American Painting from Eakins to the Armory Show*. Westport, Connecticut, 1979.

Perruchot 1958
Henri Perruchot. *La Vie de Toulouse-Lautrec*. Paris, 1958.

Perruchot 1992
Henri Perruchot. "Cómo Nació el Cubismo?" *Saber Ver* 6 (September–October 1992), 38–54.

Pfeiffer 1966
Wolfgang Pfeiffer. "Die Zeichnungen Michael Ostendorfers am Kirchenmodell der Schönen Maria zu Regensburg." *Pantheon* 24, no. 5 (1966), 378–87.

Pfister 1928
Kurt Pfister. *Albrecht Dürer: Werk und Gestalt*. Zurich, 1928.

Philadelphia 1937
Daumier 1808–1879. Pennsylvania Museum of Art, Philadelphia, 1937.

Philadelphia 1950–51
Carl Zigrosser. *Masterpieces of Drawing: Diamond Jubilee Exhibition*. Philadelphia Museum of Art, 1950–51.

Philadelphia et al. 1999–2000
Sylvia Yount. *Maxfield Parrish 1870–1966*. Pennsylvania Academy of the Fine Arts, Philadelphia; Currier Gallery of Art, Manchester, New Hampshire; Memorial Art Gallery of the University of Rochester, New York; Brooklyn Museum, New York, 1999–2000.

Philadelphia/Chicago 1955–56
Toulouse-Lautrec. Philadelphia Museum of Art; Art Institute of Chicago, 1955–56.

Pickvance 1970
Ronald Pickvance. *The Drawings of Gauguin*. London, 1970.

Pignatti 1957
Terisio Pignatti. "Un disegno di Antonio Guardi donato al Museo Correr." *Bollettino dei Musei Civici Veneziani* 1, no. 1–2 (1957), 21–32.

Pignatti 1965
Terisio Pignatti. *I Disegni veneziani del settecento*. Treviso, 1965.

Pignatti 1967
Terisio Pignatti. *Disegni dei Guardi*. Florence, 1967.

Pignatti 1976
Terisio Pignatti. *Veronese*. Venice, 1976.

Pignatti 1980
Terisio Pignatti. *Disegni antichi del Museo Correr di Venezia*. 5 vols. Venice, 1980.

Pilz 1962
Kurt Pilz. "Ein Nürnberger Dürer-Nachahmer aus der 2. Hälfte des 16. Jahrhunderts." *Mitteilungen des Vereins für Geschichte der Stadt Nürnberg* 51 (1962).

Pittsburgh 1937
An Exhibition of Paintings, Water Colors, and Etchings by Edward Hopper. Carnegie Institute, Pittsburgh, 1937.

Pittsburgh 1951
French Painting 1100–1900. Carnegie Institute, Pittsburgh, 1951.

Pittsfield 1960
Stuart C. Henry. *Canaletto and Bellotto*. Berkshire Museum, Pittsfield, Massachusetts, 1960.

Placidi 1990
Kathleen S. Placidi. "Beyond Bootblacks: *The Boat Builder* and the Art of John George Brown." *CMA Bulletin* 77 (1990), 366–82.

Plessix 1965
Francine du Plessix. "Painters and Poets." *Art in America* 53 (October–November 1965), 24–56.

Ponge 1946
Francis Ponge. *Braque le réconciliateur*. Geneva, 1946.

Ponge/Chessex 1960
Francis Ponge and Jacques Chessex. *Dessins de Pablo Picasso: Epoques bleue et rose*. Lausanne, 1960.

Popham 1931
A. E. Popham. *Italian Drawings Exhibited at the Royal Academy, Burlington House, London, 1930*. London, 1931.

Popham/Pouncey 1950
A. E. Popham and Philip Pouncey. *Italian Drawings in the Department of Prints and Drawings in the British Museum*. London, 1950.

Portalis 1889
Baron Roger Portalis. *Honoré Fragonard sa vie et son oeuvre*. Paris, 1889.

Pouillon/Monod-Fontaine 1982
Nadine Pouillon and Isabelle Monod-Fontaine. *Braques: Oeuvres de Georges Braque (1882–1963)*. Paris, 1982.

Pouncey 1964
Philip Pouncey. "'Reviews': Bernard Berenson: I Disegni dei pittori fiorentini." *Master Drawings* 2, no. 3 (1964), 278–93.

Pouncey/Di Giampaolo 1994
Philip Pouncey and Mario di Giampaolo. *Raccolta di Scritti (1937–1985)*. Florence, 1994.

Pouncey/Gere 1962
Philip Pouncey and J. A. Gere. *Italian Drawings in the Department of Prints and Drawings at the British Museum: Raphael and His Circle*. London, 1962.

Prague 1997
Eliska Fucikova. *Rudolf II and Prague. The Court and the City*. Prague Castle, 1997.

Praeger Encyclopedia of Art 1971
Praeger Encyclopedia of Art. New York/Washington/London, 1971.

Prasse 1931
Leona Prasse. "Five Portrait Drawings by Piazzetta." *CMA Bulletin* 4 (1931), 73–76.

Prasse 1935
Leona Prasse. "A Portrait Drawing by Piazzetta." *CMA Bulletin* 8 (1935), 3–4.

Prather/Stuckey 1987
Marla Prather and Charles F. Stuckey. *Gauguin: A Retrospective*. New York, 1987.

Preston 1952
Kerrison Preston. *The Blake Collection of W. Graham Robertson*. London, 1952.

Princeton 1968
The Elsa Durand Mower Collection of French and Italian Drawings. Art Museum, Princeton University, 1968.

Princeton 1976–77
Jonathan Brown. *Murillo and His Drawings*. Art Museum, Princeton University, 1976–77.

Princeton et al. 1973–74
Marcel Roethlisberger. *The Claude Lorrain Album in the Norton Simon, Inc. Museum of Art*. Art Museum, Princeton University; Fogg Art Museum, Harvard University, Cambridge; Smith College Museum of Art, Northampton, Massachusetts; William Hayes Ackland Memorial Museum of Art, University of North Carolina at Chapel Hill; Allen Memorial Art Museum, Oberlin College, Ohio; Wellesley College Museum, Massachusetts; Art Museum, University of California, Berkeley, 1973–74.

Princeton et al. 1982–85
Thomas DaCosta Kaufmann. *Drawings from the Holy Roman Empire 1540–1680: A Selection from North American Collections*. Art Museum, Princeton University; National Gallery of Art, Washington; Museum of Art, Carnegie Institute, Pittsburgh, 1982–83.

Princeton/Cambridge 1973–74
Jonathan Brown. *Jusepe de Ribera Prints and Drawings*. Art Museum, Princeton University; Fogg Art Museum, Harvard University, Cambridge, 1973–74.

Princeton/Santa Barbara 1989–90
Thomas DaCosta Kaufmann. *Central European Drawings 1680–1800: A Selection from American Collections*. Art Museum, Princeton University; Art Museum, University of California, Santa Barbara, 1989–90.

Print Club of Cleveland 1994
The Print Club of Cleveland 1969–1994. Cleveland, 1994.

Providence 1967
Seven Centuries of Italian Art. Rhode Island School of Design, Providence, 1967.

Providence 1968
Stephen Ostrow. *Visions and Revisions*. Rhode Island School of Design, Providence, 1968.

Providence 1973
Drawings and Prints of the First Maniera. Rhode Island School of Design, Providence, 1973.

Providence 1975
Rubenism. Bell Gallery, Brown University, Providence, 1975.

Prown 1966
Jules David Prown. *John Singleton Copley, in England 1774–1815*. Washington, 1966.

Puglisi 1987
Catherine Puglisi. "Piazzetta's 'Glory of St. Dominic.'" *Arte Veneta* 41 (1987), 210–17.

Puppi 1968
Lionello Puppi. *The Complete Paintings of Canaletto*. New York, 1968.

Ravà 1921
Aldo Ravà. *G. B. Piazzetta*. Florence, 1921.

Reff 1976
Theodore Reff. *The Notebooks of Edgar Degas: A Catalogue of the Thirty-Eight Notebooks in the Bibliothèque Nationale and Other Collections*. 2 vols. Oxford, 1976.

Reich 1970
Sheldon Reich. *John Marin: A Stylistic Analysis and Catalogue Raisonné*. 2 vols. Tucson, 1970.

Reitlinger 1927
H. S. Reitlinger. "An Unknown Collection of Dürer Drawings." *Burlington Magazine* 1 (March 1927), 153–59.

Rewald 1938
John Rewald. *Gauguin*. Paris, 1938.

Rewald 1958
John Rewald. *Gauguin Drawings*. New York, 1958.

Rey 1966
Robert Rey. *Honoré Daumier*. New York, 1966.

Reznicek 1961
E. K. J. Reznicek. *Die Zeichnungen von Hendrick Goltzius*. 2 vols. Utrecht, 1961.

Reznicek 1993
E. K. J. Reznicek. "Drawings by Hendrick Goltzius, Thirty Years Later: Supplement to the 1961 Catalogue Raisonné." *Master Drawings* 31 (Autumn 1993), 215–78.

Rhys 1952
Hedley Howell Rhys. "Maurice Prendergast: The Sources and Development of His Style." Ph.D. diss., Harvard University, 1952.

Ribeiro 1999
Aileen Ribeiro. *Ingres in Fashion: Representations of Dress and Appearance in Ingres's Images of Women*. New Haven, 1999.

Ricci 1935
Seymour de Ricci. *Dessins du dix-huitième siècle: Collection Albert Meyer*. Paris, 1935.

Richard 1979
Paul Richard. "Daumier's Fearless Wit." *Washington Post* (23 September 1979), G1–G7.

Richards 1959
Louise Richards. "'River Gods' by Domenico Beccafumi." *CMA Bulletin* 46 (1959), 24–29.

Richards 1961
Louise Richards. "Federico Barocci: A Study for *Aeneas' Flight from Troy*." *CMA Bulletin* 48 (1961), 63–65.

Richards 1962a
Louise Richards. "Three Early Italian Drawings." *CMA Bulletin* 49 (1962), 168–74.

Richards 1962b
Louise Richards. "Paul Klee, Pavel Tchelitchew, Franz Kline: Three Contemporary Drawings." *CMA Bulletin* 49 (1962), 56–59.

Richards 1967
Louise Richards. "Fête in a Park with Costumed Dancers." *CMA Bulletin* 54 (1967), 215–18.

Richards 1968
Louise Richards. "A Drawing Study for a Virgin and Child." *CMA Bulletin* 55 (1968), 235–39.

Richards 1970
Louise Richards. "A Rembrandt Drawing." *CMA Bulletin* 57 (1970), 68–75.

Richards 1984
Louise Richards. "A Study for a Pastel Portrait of Jacques Dumont Le Romain by Maurice Quentin de La Tour." *CMA Bulletin* 71 (1984), 341–47.

Richards 1985
Louise Richards. "A Tribute to Leona Prasse." *Drawing* 7 (May–June 1985), 8–9.

Richardson 1728
J. Richardson. *Traité de la Peinture*. Paris, 1728.

Richardson 1991
John Richardson. *A Life of Picasso*. New York, 1991.

Richardson/Richardson 1722
J. Richardson Jr. and J. Richardson Sr. *An Account of Some of the Statues, Bas-Reliefs, Drawings and Pictures in Italy*. London, 1722.

Richter 1906
Helene Richter. *William Blake*. Strassburg, 1906.

Robertson 1967
I. G. Robertson. "Report of the Keeper of the Department of Western Art." *Report of the Visitors, Ashmolean Museum* (1967), 19–42.

Robertson 2000
Clare Robertson. "Drawings by Annibale Carracci." *Burlington Magazine* 142 (January 2000), 63–65.

Roethlisberger [1961]
Marcel Roethlisberger. *Claude Lorrain: The Paintings*. 2 vols. New York, [1961].

Roethlisberger 1962a
Marcel Roethlisberger. "Claude Lorrain: Ses plus beaux dessins retrouvés." *Connaissance des Arts* (December 1962), 138–47.

Roethlisberger 1962b
Marcel Roethlisberger. *Claude Lorrain: The Wildenstein Album*. Paris, 1962.

Roethlisberger 1962c
Marcel Roethlisberger. "Les Dessins de Claude Lorrain: à sujets rares." *Gazette des Beaux-Arts* 59 (March 1962), 153–64.

Roethlisberger 1968
Marcel Roethlisberger. *Claude Lorrain: The Drawings*. Los Angeles, 1968.

Roethlisberger 1970
Marcel Roethlisberger. "Claude Lorrain in the National Gallery of Art." *Report and Studies in the History of Art 1969* (1970), 35–56.

Roettgen 1996
Steffi Roettgen. *Italian Frescoes: The Early Renaissance 1400–1470*. New York, 1996.

Roger-Marx 1938
Claude Roger-Marx. *Daumier*. Paris, 1938.

Roger-Milès 1895
L. Roger-Milès. *Le Paysan dans l'oeuvre de J.-F. Millet*. Paris, 1895.

Roland Michel 1984
Marianne Roland Michel. *Lajoüe et l'art rocaille*. Paris, 1984.

Roli 1968
Renato Roli. *I Fregi centesi del Guercino*. Bologna, 1968.

Roli/Cavina 1972
Renato Roli and Anna Ottani Cavina. *Guercino: Disegni*. Florence, 1972.

Rolland 1902
Romain Rolland. *Millet*. London/New York, 1902.

Rolnick 1983
Marc Rolnik. *Miró's Constellations: The Facsimile Edition of 1959*. Purchase, New York, 1983.

Rome 1984–85
Henry Loyrette. *Degas et l'Italia*. Accademia di Francia, Rome, 1984–85.

Rome 1994
Paolo Chiarini. *Il Paesaggio secondo natura: Jacob Philipp Hackert e la sua cerchia*. Palazzo delle Esposizioni, Rome, 1994.

Roos 1998
Michael Roos. "Internet Yields Greater Benefits for Drawing Connoisseurs." *Drawing* 19 (Summer 1998), 121–22.

Rosand 1971
David Rosand. "Three Drawings by Paolo Veronese." *Pantheon* 29 (May–June 1971), 203–9.

Rose 1977
Patricia Rose. "Wolf Huber Studies: Aspects of Renaissance Thought and Practice in Danube School Painting." Ph.D. diss., Columbia University, 1977.

Rosenberg 1972
Pierre Rosenberg. "Dessins français du XVIIe et du XVIIIe siècle dans les collections américaines." *L'Oeil* 213 (August–September 1972), 10–15.

Ross 1983
Barbara T. Ross. "Notes on Selected French Old Master Drawings from the Permanent Collection." *Record of the Art Museum Princeton University* 42, no. 1 (1983), 4–42.

Rotterdam 1996
Bernard Aikema and Marguerite Tuijn. *Tiepolo in Holland: Works by Giambattista Tiepolo and His Circle in Dutch Collections*. Museum Boymans-van Beuningen, Rotterdam, 1996.

Rotterdam et al. 1958–60
Van Clouet Tot Matisse: Tentoonstelling van franse tekeningen uit amerikaanse collecties. Museum Boymans-van Beuningen, Rotterdam; Musée de l'Orangerie, Paris; Metropolitan Museum of Art, New York, 1958–60.

Rotterdam et al. 1990–92
Chris Fischer. *Fra Bartolommeo: Master Draughtsman of the High Renaissance*. Museum Boymans-van Beuningen, Rotterdam; Museum of Fine Arts, Boston; Kimbell Art Museum, Fort Worth; Pierpont Morgan Library, New York, 1990–92.

Rotterdam/Haarlem 1958
Hendrick Goltzius als Tekenaar. Museum Boymans-van Beuningen, Rotterdam; Teylers Museum, Haarlem, 1958.

Rotzler 1982
Willy Rotzler. "A Short History of the Graphic Arts." In *Who's Who in Graphic Art*. Edited by W. Amstutz. Dübendorf, Switzerland, 1982.

Roux 1933
Marcel Roux. *Inventaire du fonds français: Graveurs du dix-huitième siècle*. 8 vols. Paris, 1930–55.

Rowell 1987
Margit Rowell, ed. *Joan Miró Selected Writings and Interviews*. New York, 1987.

Rowlands 1970
John Rowlands. "Review of 'Germanisches Nationalmuseum, Nuremberg. Die Deutschen Handzeichnungen.'" *Master Drawings* 8 (Autumn 1970), 290–95.

Roy 1971
Claude Roy. *Daumier dessins*. Geneva, 1971.

Royalton-Kitsch 1992
Martin Royalton-Kitsch. *Drawings by Rembrandt and His Circle in the British Museum*. London, 1992.

Rubin 1968
William S. Rubin. *Dada and Surrealist Art*. New York, 1968.

Rubin 1970
J. H. Rubin. "Seurat and Theory: The Near-Identical Drawings of the Café-Concert." *Gazette des Beaux-Arts* 76 (October 1970), 237–46.

Rubin 1980
William Rubin. *Pablo Picasso: A Retrospective*. New York, 1980.

Rubin 1988
William Rubin. "La Genèse des Demoiselles d'Avignon." In *Les Demoiselles d'Avignon*. Paris, 1988.

Rubin et al. 1994
William Rubin, Hélène Seckel, Judith Cousins. *Studies in Modern Art 3: Les Demoiselles d'Avignon*. New York, 1994.

Ruda 1982
Jeffrey Ruda. "Filippo Lippi Studies: Naturalism, Style, and Iconography in Early Renaissance Art." Ph.D. diss., Harvard University, 1982.

Ruda 1993
Jeffrey Ruda. *Fra Filippo Lippi: Life and Work with a Complete Catalogue*. New York, 1993.

Ruland 1876
Carl Ruland. *The Works of Raphael Santi: As represented in the Raphael Collection in the Royal Library at Windsor Castle, Formed by H.R.H. The Prince Consort, 1853–1861 and Completed by Her Majesty Queen Victoria.* Weimar, 1876.

Ruscha/Schjeldahl 1980
Edward Ruscha and Peter Schjeldahl. *Guacamole Airlines and Other Drawings.* New York, 1980.

Russell 1920
Archibald Russell. "The Graham Robertson Collection." *Burlington Magazine* 37 (July 1920), 27–39.

Russell 1972
H. Diane Russell. *Rare Etchings by Giovanni Battista and Giovanni Domenico Tiepolo.* Washington, 1972.

Russell 1979a
John Russell. "A Fragonard Festival at the Frick." *New York Times Magazine* (15 April 1979), 29–31.

Russell 1979b
Francis Russell. "Salesroom Discovery; A Study by Pietro da Cortona." *Burlington Magazine* 121 (June 1979), 405–6.

Russell 1996
Francis Russell. "The Ferretti Collection." *Christie's International Magazine* 13 (June 1996), 22–23.

Russell/Wilton 1976
John Russell and Andrew Wilton. *Turner in Switzerland.* Zurich, 1976.

Russoli/Minervino 1970
Franco Russoli and Fiorella Minervino. *L'opera completa di Degas.* Milan, 1970.

Saint Louis 1972
Nancy Ward Neilson. *Italian Drawings Selected from Mid-Western Collections.* City Art Museum, Saint Louis, 1972.

Saint Louis et al. 1967
Jean Sutherland Boggs. *Drawings by Degas.* City Art Museum, Saint Louis; Philadelphia Museum of Art; Minneapolis Society of Fine Arts, 1967.

Saint-Paul-de-Vence 1968
Miró. Fondation Maeght, Saint-Paul-de-Vence, 1968.

Salerno 1988
Luigi Salerno. *I dipinti del Guercino.* Rome, 1988.

San Francisco 1940a
Art: Golden Gate International Exposition Official Catalog. Palace of Fine Arts, Fine Arts Museums of San Francisco, 1940.

San Francisco 1940b
Master Drawings: An Exhibition of Drawings from American Museums and Private Collections. Palace of Fine Arts, Fine Arts Museums of San Francisco, 1940.

San Francisco 1947
19th Century French Drawings. California Palace of the Legion of Honor, Fine Arts Museums of San Francisco, 1947.

San Francisco 1989
Lorenz Eitner and Steven Nash. *Géricault 1791–1824* (exh. title *Géricault: Romantic Paintings and Drawings*). California Palace of the Legion of Honor, Fine Arts Museums of San Francisco, 1989.

San Francisco et al. 1982–85
Anne Livet et al. *The Works of Edward Ruscha.* San Francisco Museum of Modern Art; Whitney Museum of American Art, New York; Vancouver Art Gallery; San Antonio Museum of Art; Los Angeles County Museum of Art, 1982–83.

Sanminiatelli 1956
Donato Sanminiatelli. "L'esposizione di chiaroscuri agli Uffizi." *Paragone* 73 (January 1956), 53–60.

Sanminiatelli 1967
Donato Sanminiatelli. *Domenico Beccafumi.* Milan, 1967.

Santa Barbara 1925
Exhibition of Water Color Sketches by Thomas Moran. Santa Barbara Art Association, 1925.

Santa Barbara 1941
Painting Today and Yesterday in the United States. Santa Barbara Museum of Art, 1941.

Santa Barbara et al. 1971–72
David Gedhard and Phyllis Plous. *Charles Demuth: The Mechanical Encrusted on the Living.* Art Galleries, University of California, Santa Barbara; Art Museum, University of California, Berkeley; Phillips Collection, Washington; Munson-Williams-Proctor Institute, Utica, New York, 1971–72.

Sayre 1964
Eleanor A. Sayre. "Eight Books of Drawings by Goya—I." *Burlington Magazine* 106 (January 1964), 19–30.

Scarpellini 1984
Pietro Scarpellini. *Perugino.* Milan, 1984.

Schama 1999
Simon Schama. *Rembrandt's Eyes.* New York, 1999.

Schatborn 1982
Peter Schatborn. "Ben Broos, Rembrandt en tekenaars uit zijn omgeving, Oude tekeningen in het bezit van de Gemeentemusea van Amsterdam waaronder de collectie Fodor [review]." *Oud Holland* 96 (1982), 251–58.

Schatborn/Tümpel 1987
Peter Schatborn and Christian Tümpel. *Het Boek Tobias, met etsen en tekeningen van Rembrandt en zijn leerlingen.* Zeist, 1987.

Schiele 1917
Egon Schiele. *Zeichnungen Egon Schiele 12 Blatter in Originalgrosse.* Vienna, 1917.

Schiff 1973
Gert Schiff. *Johann Heinrich Füssli 1741–1825: Text und Oeuvrekatalog.* Zurich/Munich, 1973.

Schimmel 1991
Herbert D. Schimmel, ed. *The Letters of Henri de Toulouse-Lautrec.* Oxford, 1991.

Schlenoff 1967
Norman Schlenoff. "Ingres Centennial at the Fogg Museum." *Burlington Magazine* 109 (June 1967), 376–79.

Scholz 1967
Janos Scholz. "Italian Drawings in the Art Museum of Princeton University." *Burlington Magazine* 109 (May 1967), 290–99.

Schönbrunner/Meder 1900
Joseph Schönbrunner and Joseph Meder. *Handzeichnungen Alter Meister aus der Albertina und anderen Sammlungen.* Vienna, 1900.

Seattle 1951
"Nineteenth Century Paintings." Seattle Art Museum, 1951.

Seattle et al. 1995
Stephen Wildman. *Visions of Love and Life: Pre-Raphaelite Art from the Birmingham Collection, England.* Seattle Art Museum; Cleveland Museum of Art; Delaware Art Museum, Wilmington; Museum of Fine Arts, Houston; High Museum of Art, Atlanta; Birmingham Museums and Art Gallery, England, 1995.

Seligman 1947
Germain Seligman. *The Drawings of Georges Seurat.* New York, 1947.

Seligman 1961
Germain Seligman. *Merchants of Art: 1880–1960. Eighty Years of Professional Collecting.* New York, 1961.

Serra 1984
Pere A. Serra. *Miró and Mallorca.* New York, 1984.

Sérullaz 1968
Maurice Sérullaz. *Great Drawings of the Louvre Museum.* New York, 1968.

Seymour 1972
Charles Seymour Jr., ed. *Michelangelo, The Sistine Chapel Ceiling.* New York, 1972.

Seznec 1966
Jean Seznec. "Diderot et l'affaire Greuze." *Gazette des Beaux-Arts* 67 (May–June 1966), 339–56.

Shapely 1973
Fern Rusk Shapely. *Paintings from the Samuel H. Kress Collection.* London, 1973.

Shone 1988
Richard Shone. "New York 20th-Century Exhibitions." *Burlington Magazine* 130 (January 1988), 57–60.

Shoolman/Slatkin 1950
Regina Shoolman and Charles Slatkin. *Six Centuries of French Master Drawings in America.* New York, 1950.

Siena 1990
Giovanni Agosti et al. *Domenico Beccafumi e il suo tempo.* Pinacoteca Nazionale, Siena, 1990.

Simon 1961
John Simon. "Maurice Prendergast." *New York Times* (26 February 1961), x–19.

Sizer 1924
Theodor Sizer. "An Exhibition of Drawings." *CMA Bulletin* 11 (1924), 140–44.

Sizer 1926
Theodore Sizer. "Drawings by Boucher and Fragonard." *CMA Bulletin* 13 (1926), 5–8.

Sizer 1927
Theodore Sizer. "A Drawing by Hubert Robert." *CMA Bulletin* 14 (1927), 143–44.

Slive 1965
Seymour Slive. *Drawings of Rembrandt.* New York, 1965.

Smiles 1994
Sam Smiles. *The Image of Antiquity: Ancient Britain and the Romantic Imagination.* New Haven/London, 1994.

Smiles 1995
Sam Smiles. "J. H. Mortimer and Ancient Britain: An Unrecorded Project and a New Identification." *Apollo* 142 (November 1995), 42–46.

Sonn 1989
Richard D. Sonn. *Anarchism and Cultural Politics in Fin de Siècle France.* Lincoln, Nebraska/London, 1989.

Sotheby 1978
Art at Auction, the Year at Sotheby Parke Bernet 1977–78. London, 1978.

Soullié 1900
Louis Soullié. *Les Grands Peintures aux ventes publiques II: Peintures, aquarelles, pastels, dessins de Jean-François Millet relevés dans les catalogues de ventes de 1849 à 1900.* Paris, 1900.

South Bend/Binghamton 1970
Dean Porter. *The Age of Vasari.* Art Gallery, University of Notre Dame, South Bend, Indiana; University Art Gallery, State University of New York at Binghamton, 1970.

Spear 1967
Richard Spear. "Some Domenichino Cartoons." *Master Drawings* 5, no. 2 (1967), 144–58.

Spear 1982
Richard E. Spear. *Domenichino.* 2 vols. New Haven, 1982.

Spencer 1975
Harold Spencer. *The Image Maker: Man and His Art.* New York, 1975.

Spike 1980
John T. Spike. "Domenico Tiepolo's Punchinello Drawings at the Frick Collection [review]." *Burlington Magazine* 122 (April 1980), 282–86.

Spoleto 1996
Bruno Mantura and Geneviève Lacambre. *Pierre-Henri de Valenciennes 1750–1819.* Palazzo Racani Arroni, Spoleto, 1996.

Stange 1964
Alfred Stange. *Malerei der Donauschule.* Munich, 1964.

Stechow 1966
Wolfgang Stechow. "Cleveland's Golden Anniversary Acquisitions." *Art News* 65 (September 1966), 30–45.

Steine 1993
Deidre Steine. "Kennedy Gallery; The Drawing Center, New York, Exhibits." *Art News* 92 (September 1993), 176–77.

Steward 1996
James Christen Steward, ed. *The Mask of Venice: Masking, Theater, and Identity in the Art of Tiepolo and His Time.* Berkeley, 1996.

Stone 1989
David M. Stone. "Theory and Practice in Seicento Art: The Example of Guercino." Ph.D. diss., Harvard University, 1989.

Stone 1991
David M. Stone. *Guercino: catalogo completo dei dipinti.* Florence, 1991.

Strauss 1974
Walter L. Strauss. *The Complete Drawings of Albrecht Dürer.* New York, 1974.

Strauss 1977
Walter L. Strauss. *Hendrick Goltzius 1559–1617. The Complete Engravings and Woodcuts, The Illustrated Bartsch.* New York, 1977.

Strauss/van der Meulen 1979
Walter L. Strauss and Marjon van der Meulen, eds. *The Rembrandt Documents.* New York, 1979.

Strzychowski/Glück 1933
J. Strzychowski and H. Glück. *Asiatische Minaturenmalerei.* Klagenfurt, 1933.

Stuebe 1968–69
Isabel Combs Stuebe. "The Johannisschüssel: From Narrative to Reliquary to Andachtsbild." *Marsyas* 14 (1968–69), 1–16.

Stuttgart 1997–98
Christoph Becker and Claudia Hattendorff. *Johann Heinrich Füssli: Das Verlorene Paradies.* Staatsgalerie, Stuttgart, 1997–98.

Stuttgart et al. 1976
Stephan V. Wiese and Gudrun Inboden. *David Smith: Zeichnungen.* Staatsgalerie, Stuttgart; Nationalgalerie, Berlin; Wilhelm-Lehmbruck-Museum, Duisburg, 1976.

Stuttgart/Düsseldorf 1971
C. G. Boerner Graphik-Zeichnungen. Gustav-Siegle-Haus am Leonhardsplatz, Stuttgart; C. G. Boerner, Düsseldorf, 1971.

Succi 1988
Dario Succi. *I Tiepolo: Virtuosismo e ironia.* Venice, 1988.

Suenaga et al. 1991
Suenaga Terukazu, Oshima Seiji, Segi Shin'ichi, et al. *Pikaso bijutsukan.* Tokyo, 1991.

Sugana 1969
G. M. Sugana. *The Complete Paintings of Toulouse-Lautrec.* New York, 1969.

Sunderland 1988
John Sunderland. "John Hamilton Mortimer, His Life and Works." *Walpole Society* 52 (1988).

Sutton/Lecaldano 1968
Denys Sutton and Paolo Lecaldano. *The Complete Paintings of Picasso: Blue and Rose Periods.* New York, 1968.

Sweeney 1970
James Johnson Sweeney. *Joan Miró.* Barcelona, 1970.

Sylvester 1992–94
David Sylvester, ed. *René Magritte Catalogue Raisonné.* 5 vols. London, 1992–94.

Talbot 1973
William S. Talbot. "Jean-François Millet: Return from the Fields." *CMA Bulletin* 60 (1973), 259–66.

Tapié 1970
Michel Tapié. *Joan Miró.* Milan, 1970.

Tatham 1996
David Tatham. *Winslow Homer in the Adirondacks.* New York, 1996.

Tharp 1917
Ezra Tharp. "'Gloria' and 'The Musician' by Thomas W. Dewing." *Art World* 3 (December 1917), 188–89.

Thiem 1996
Christel Thiem. *Ein Zeichnungsalbum der Tiepolo in Würzburg: Erkenntnisse zur Praxis und Funktion des Porträtzeichnens im Tiepolo-Studio.* Munich, 1996.

Thomson 1977
Richard Thomson. *Toulouse-Lautrec.* London, 1977.

Thomson 1985
Richard Thomson. *Seurat.* Oxford, 1985.

Thomson 1988
Richard Thomson. *Degas: The Nudes.* London, 1988.

Thomson 1993
Belinda Thomson. *Gauguin by Himself.* Boston, 1993.

Tietze 1947
Hans Tietze. *European Master Drawings in the United States.* New York, 1947.

Tietze 1951
Hans Tietze. *Dürer: Als Zeichner und Aquarellist.* Vienna, 1951.

Tietze/Tietze-Conrat 1937
H. Tietze and E. Tietze-Conrat. *Kritisches Verzeichnis der Werke Albrecht Dürers.* Basel, 1937.

Tokyo 1982
Japanese Artists Who Studied in the USA and the American Scene. National Museum of Modern Art, Tokyo, 1982.

Tokyo/Aichi-ken 1987
Paul Gauguin. National Museum of Modern Art, Tokyo; Aichi Prefectural Art Gallery, Aichi-ken, 1987.

Tokyo/Kumamoto 1982
Denys Sutton. *François Boucher.* Tokyo Metropolitan Art Museum; Kumamoto Prefectural Museum of Art, 1982.

Tokyo/Kyoto 1976
Masterpieces of World Art from American Museums, from Ancient Egyptian to Contemporary Art. National Museum of Western Art, Tokyo; Kyoto National Museum, 1976.

Tokyo/Kyoto 1980
Fragonard. National Museum of Western Art, Tokyo; Kyoto Municipal Museum, 1980.

Tokyo/Kyoto 1983
Picasso: Masterpieces from the Marina Picasso Collection and from Museums in U.S.A. and U.S.S.R. National Museum of Modern Art, Tokyo; Kyoto Municipal Museum, 1983.

Toledo 1938
Contemporary Movements in European Painting. Toledo Museum of Art, Ohio, 1938.

Toledo 1940
Hans Tietze. *Four Centuries of Venetian Painting.* Toledo Museum of Art, Ohio, 1940.

Toledo 1954
The Exhibition of American Painting 1804–1954. Ohio University, Toledo, 1954.

Toronto 1981–82
Alan G. Wilkinson. *Gauguin to Moore: Primitivism in Modern Sculpture.* Art Gallery of Ontario, Toronto, 1981–82.

Toronto et al. 1964–65
W. G. Constable. *Canaletto.* Art Gallery of Ontario, Toronto; National Gallery of Canada, Ottawa; Museum of Fine Arts, Montreal, 1964–65.

Toronto et al. 1972–73
Pierre Rosenberg. *French Master Drawings of the 17th and 18th Centuries in North American Collections.* Art Gallery of Ontario, Toronto; National Gallery of Canada, Ottawa; California Palace of the Legion of Honor, Fine Arts Museums of San Francisco; New York Cultural Center, 1972–73.

Toronto/Amsterdam 1981
Bogomila Welsh-Ovcharov. *Vincent van Gogh and the Birth of Cloisonism*. Art Gallery of Ontario, Toronto; Rijksmuseum Vincent Van Gogh, Amsterdam, 1981.

Toronto/Montreal 1964
Jean Sutherland Boggs. *Picasso and Man*. Art Gallery of Ontario, Toronto; Montreal Museum of Fine Arts, 1964.

Toronto/New York 1985–86
David McTavish. *Italian Drawings from the Collection of Duke Roberto Ferretti*. Art Gallery of Ontario, Toronto; Pierpont Morgan Library, New York, 1985–86.

Toronto/Ottawa 1951–52
An Exhibition of Paintings by J. M. W. Turner (1775–1851) to Commemorate the Centennial of His Death. Art Gallery of Ontario, Toronto; National Gallery of Canada, Ottawa, 1951–52.

Torriti 1998
Piero Torriti. *Beccafumi*. Milan, 1998.

Tortora/Eubank 1989
Phyllis Tortora and Keith Eubank. *A Survey of Historic Costume*. New York, 1989.

Trarato et al. 1970
Joseph Trarato et al. *Charles Burchfield, Catalogue of Paintings in Public and Private Collections*. Utica, New York, 1970.

Trenton/Hassrick 1983
Patricia Trenton and Peter Hassrick. *The Rocky Mountains: A Vision for Artists of the Nineteenth Century*. Norman, Oklahoma, 1983.

Trinity Fine Art Ltd. 1998
"An Exhibition of Old Master Drawings, Prints, and Paintings." Trinity Fine Art Ltd., New York, 1998.

Truettner 1991
William Truettner. "Ideology and Image: Justifying Western Expansion." In *The West as America: Reinterpreting Images of the Frontier*. Edited by W. Truettner. New Haven, Connecticut, 1991.

Tübingen/Düsseldorf 1986
Werner Spies. *Picasso: Pastelle, Zeichnungen, Aquarelle*. Kunsthalle, Tübingen; Kunstsammlung Nordrhein-Westfalen, Düsseldorf, 1986.

Tümpel/Tümpel 1970
Christian Tümpel and Astrid Tümpel. *Rembrandt legt die Bibel aus. Zeichnungen und Radierungen aus dem Kupferstichkabinett der staatlichen Museen preussischer Kulturbesitz Berlin*. Berlin, 1970.

Turner 1991
Evan Turner. *Object Lessons: Cleveland Creates an Art Museum*. Cleveland, 1991.

Turner 1996
Jane Turner, ed. *The Dictionary of Art*. 34 vols. New York, 1996.

Tzara 1931
Tristan Tzara. "Le Papier collé ou le proverbe en peinture." *Cahiers d'Art* 6 (1931), 61–73.

Udine 1965
Aldo Rizzi. *Disegni del Tiepolo*. Loggia del Lionello, Udine, 1965.

Udine 1970
Aldo Rizzi. *Le acqueforti dei Tiepolo*. Loggia dei Lionello, Udine, 1970.

Udine/Bloomington 1996–97
Adelheid Gealt and George Knox. *Domenico Tiepolo: Master Draftsman*. Castello di Udine; Indiana University Art Museum, Bloomington, 1996–97.

Utica 1970
The Nature of Charles Burchfield—A Memorial Exhibition. Munson-Williams-Proctor Institute, Utica, New York, 1970.

Valentiner 1925
Wilhelm R. Valentiner. *Die Handzeichnungen Rembrandts*. Stuttgart, 1925.

van den Akker 1991
Paul van den Akker. *Sporen van Vaardigheid: De Ontwerpmethode voor de Figuurhouding in de Italiaanse Tekenkunst van de Renaissance*. Amsterdam, 1991.

Van Dyke 1927
John C. Van Dyke. *The Rembrandt Drawings and Etchings*. New York, 1927.

van Marle 1923–38
Raimond van Marle. *The Development of the Italian Schools of Painting*. The Hague, 1923–38.

van Regteren Altena 1970
J. Q. van Regteren Altena. "Review of Degenhart and Schmitt *Corpus*." *Master Drawings* 8 (Fall 1970), 396–402.

Vasari/Milanesi 1906
GiorgioVasari, annotated by Gaetano Milanesi. *Le vite d' piu eccellenti pittori, scultori, ed architettori*. Florence, 1906.

Vaughan 1960
Malcolm Vaughan. "The Connoisseur in America." *Connoisseur* 146 (August 1960), 74–78.

Venice 1962
K. T. Parker and James Byam Shaw. *Canaletto e Guardi: Catalogo della mostra dei disegni*. Fondazione Giorgio Cini, Venice, 1962.

Venice 1965
Pietro Zampetti. *Mostra dei Guardi*. Palazzo Grassi, Venice, 1965.

Venice 1983
George Knox et al. *G. B. Piazzetta: Disegni, incisioni, libri, manoscritti*. Fondazione Giorgio Cini, Venice, 1983.

Venice 1993
Alessandro Bettagno. *Francesco Guardi: Vedute capricci feste*. Isola di San Giorgio Maggiore, Venice, 1993.

Venice 1995
Giovanni Nepi Sciré and Giandomenico Romanelli. *Splendori del settecento veneziano*. Ca' Rezzonico, Venice; Palazzo Mocenigo, Venice, 1995.

Venice 1999
Giovanna Nepi Scirè and Annalisa Perissa Torrini. *Da Leonardo a Canaletto: Disegni delle Gallerie dell'Accademia*. Gallerie dell'Accademia, Venice, 1999.

Venturi 1922
L. Venturi. "La Navicella di Giotto." *L'Arte* 25 (1922), 49–69.

Vercier 2000
Paul Vercier. "Trois dessins de Charles de la Fosse pour la Chapelle du château de Versailles." *Versalia* 3 (2000), 140–52.

Vermeule 1964
Cornelius Vermeule. *European Art and the Classical Past*. Cambridge, 1964.

Veth 1912
Jan Veth. "Une même composition chez Joseph Israëls et chez Millet." *L'Art flamande et hollandais* 17 (January–June 1912), 53–60.

Vetrocq 1979
Marcia E. Vetrocq. "The 'Divertimento per li Regazzi' of Domenico Tiepolo." Ph.D. diss., Stanford University, Palo Alto, 1979.

Vienna 1949
Amerikanische Meister des Acquarells. Graphische Sammlung Albertina, Vienna, 1949.

Vienna 1966a
Henri de Toulouse-Lautrec 1864–1901. Österreichisches Museum für Angewandte Kunst, Vienna, 1966.

Vienna 1966b
Konrad Oberhuber. *Renaissance in Italien 16. Jahrhundert*. Graphische Sammlung Albertina, Vienna, 1966.

Vincent 1968
Howard P. Vincent. *Daumier and His World*. Evanston, Illinois, 1968.

Virch 1961
C. Virch. "A Page from Vasari's Book of Drawings." *Metropolitan Museum of Art Bulletin* 19 (March 1961), 185–93.

Vishny 1978
Michèle Vishny. "Paul Klee and War: A Stance of Aloofness." *Gazette des Beaux-Arts* 92 (December 1978), 233–43.

Vitzthum 1970
Walter Vitzthum. *Il Barocco a Napoli e nell' Italia Meridionale*. Milan, 1970.

Vitzthum 1971
Walter Vitzthum. *Il barocco a Roma*. Milan, 1971.

von Borries et al. 1988
J. E. von Borries, Rudolf Theilmann, Gert Reising. *Ausgewählte Werke der Staatlichen Kunsthalle Karlsruhe*. Vol. 2 of *100 Zeichnungen und Druke aus dem Kupferstichkabinett*. Karlsruhe, 1988.

von Hadeln 1927
Detlev von Hadeln. *Handzeichnungen von G. B. Tiepolo*. Florence, 1927.

von Hadeln 1929
Detlev von Hadeln. *The Drawings of Antonio Canal called Canaletto*. London, 1929.

von Holst 1971
Christian von Holst. "Florentiner Gemälde und Zeichnungen 1480–1580." *Mitteilungen des Kunsthistorischen Institutes in Florenz* 15 (May 1971), 1–64.

Voorhelm Schneevoogt 1873
C. G. Voorhelm Schneevoogt. *Catalogue des estampes gravées d'après P.P. Rubens*. Haarlem, 1873.

Wadley 1978
Nicholas Wadley. *Gauguin*. Oxford, 1978.

Walters 1978
Gary R. Walters. "Federico Barocci: Anima Naturaliter." Ph.D. diss., Princeton University, 1978.

Ward 1982a
Roger Ward. "Baccio Bandinelli as a Draughtsman." Ph.D. diss., University of London, 1982.

Ward 1982b
Roger Ward. "Observations on the Red Chalk Figure Studies of Baccio Bandinelli: Two Examples at Melbourne." *Art Bulletin of Victoria* 23 (1982), 32–36.

Washington 1942
Watercolors and Oil Paintings by Charles Demuth. Phillips Memorial Gallery, Washington, 1942.

Washington 1957
The Art of William Blake. National Gallery of Art, Washington, 1957.

Washington 1971
Charles W. Talbot. *Dürer in America: His Graphic Work.* National Gallery of Art, Washington, 1971.

Washington 1974–75
Terisio Pignatti. *Venetian Drawings from American Collections.* National Gallery of Art, Washington, 1974–75.

Washington 1978–79
Victor Carlson. *Hubert Robert: Drawings & Watercolors.* National Gallery of Art, Washington, 1978–79.

Washington 1979
Jan Rie Kist. *Honoré Daumier 1808–1879.* National Gallery of Art, Washington, 1979.

Washington 1980–81
E. A. Carmean Jr. *Picasso: The Saltimbanques.* National Gallery of Art, Washington, 1980–81.

Washington 1982–83
H. Diane Russell. *Claude Lorrain.* National Gallery of Art, Washington, 1982–83.

Washington 1983–84
George Knox. *Piazzetta: A Tercentenary Exhibition of Drawings, Prints, and Books.* National Gallery of Art, Washington, 1983–84.

Washington 1988–89
W. R. Rearick. *The Art of Paolo Veronese 1528–1588.* National Gallery of Art, Washington, 1988–1989.

Washington 1999–2000
Diane De Grazia, Catherine Loisel Legrand, Stacey Sell, et al. *The Drawings of Annibale Carracci.* National Gallery of Art, Washington, 1999–2000.

Washington et al. 1974–75
Terisio Pignatti. *Venetian Drawings from American Collections.* National Gallery of Art, Washington; St. Louis Art Museum; Kimbell Art Museum, Fort Worth, 1974–75.

Washington et al. 1977
Franklin Westcott Robinson. *Seventeenth Century Dutch Drawings from American Collections.* National Gallery of Art, Washington; Kimbell Art Museum, Fort Worth; Denver Art Museum, 1977.

Washington et al. 1978–79
Eunice Williams. *Drawings by Fragonard in North American Collections.* National Gallery of Art, Washington; Fogg Art Museum, Harvard University, Cambridge; Frick Collection, New York, 1978–79.

Washington et al. 1981–82
Pierre Rosenberg and François Bergot. *French Master Drawings from the Rouen Museum: From Caron to Delacroix.* National Gallery of Art, Washington; National Academy of Design, New York; Minneapolis Institute of Arts; J. Paul Getty Museum, Malibu, 1981–82.

Washington et al. 1985–86
Per Bjurström. *Dürer to Delacroix.* National Gallery of Art, Washington; Kimbell Art Museum, Fort Worth; Fine Arts Museums of San Francisco, 1985–86.

Washington et al. 1986
Helen Cooper. *Winslow Homer Watercolors.* National Gallery of Art, Washington; Amon Carter Museum, Fort Worth; Yale University Art Gallery, New Haven, 1986.

Washington et al. 1987–88
Henry Adams. *John La Farge.* National Museum of American Art, Smithsonian Institution, Washington; Carnegie Museum of Art, Pittsburgh; Museum of Fine Arts, Boston, 1987–88.

Washington et al. 1988–89
Richard Brettell et al. *Gauguin.* National Gallery of Art, Washington; Art Institute of Chicago; Grand Palais, Paris, 1988–89.

Washington et al. 1989–90
Nancy Mowll Mathews and Barbara Stern Shapiro. *Mary Cassatt: The Color Prints.* National Gallery of Art, Washington; Museum of Fine Arts, Boston; Williams College Museum of Art, Williamstown, Massachusetts, 1989–90.

Washington et al. 1997–98
Nancy K. Anderson. *Thomas Moran.* National Gallery of Art, Washington; Gilcrease Museum, Tulsa, Oklahoma; Seattle Art Museum, 1997–98.

Washington/Boston 1997–98
Marilyn McCully. *Picasso: The Early Years 1892–1906.* National Gallery of Art, Washington; Museum of Fine Arts, Boston, 1997–98.

Washington/Chicago 1973–74
Regina Shoolman Slatkin. *François Boucher in North American Collections: 100 Drawings.* National Gallery of Art, Washington; Art Institute of Chicago, 1973–74.

Washington/Montgomery 1999–2000
Virginia Mecklenburg and Margaret Lynne Ausfeld. *Edward Hopper: The Watercolors.* National Museum of American Art, Smithsonian Institution, Washington; Montgomery Museum of Fine Arts, Alabama, 1999–2000.

Washington/New Haven 1981
James Marrow and Alan Shestack. *Hans Baldung Grien: Prints and Drawings.* National Gallery of Art, Washington; Yale University Art Gallery, New Haven, 1981.

Washington/Paris 1982–83
Isabelle Monod-Fontaine and E. A. Carmean Jr. *Braque: The Papiers Collés.* National Gallery of Art, Washington; Centre Georges Pompidou, Paris, 1982.

Watrous 1967
James Watrous. *The Craft of Old-Master Drawings.* Madison, Wisconsin/Milwaukee/London, 1967.

Wattenmaker 1982
Richard J. Wattenmaker. "Maurice Prendergast." *Allen Memorial Art Museum Bulletin* 40, no. 1 (1982), 25–37.

Weaver/Hares 1973
Horace R. Weaver and James C. Hares. *Channels of His Spirit: A Study of the Acts of the Apostles.* New York, 1973.

Weber-Caflisch 1994
Antoinette Weber-Caflisch. *Chacun son dépeupleur sur Samuel Beckett.* Paris, 1994.

Wedmore 1900
Frederick Wedmore, ed. *Turner and Ruskin: An Exposition of the Work of Turner from the Writings of Ruskin.* 2 vols. London, 1900.

Wehle 1938
Harry B. Wehle. "Fifty Drawings by Francisco Goya." *Metropolitan Museum of Art Papers* 7 (1938), 5–17.

Weidner 1998
Thomas Weidner. *Jakob Philipp Hackert: Landschaftsmaler im 18. Jahrhundert.* Berlin, 1998.

Weigel 1869
J. A. G. Weigel. *Catalog einer Sammlung von Original Handzeichnungen der deutschen… gegründet und hinterlassen von J. A. G. Weigel in Leipzig.* Leipzig, 1869.

Weinberg 1993
Jonathan Weinberg. *Speaking for Vice: Homosexuality in the Art of Charles Demuth, Marsden Hartley, and the First American Avant-Garde.* New Haven/London, 1993.

Weinberger 1930
Martin Weinberger. *Wolfgang Huber.* Leipzig, 1930.

Weingrod 1993a
Carmi Weingrod. "Using Pen and Ink: Learning from Old Masters, Part II. Ink Washes, Chiaroscuro, and Heightening with White." *American Artist* 57 (February 1993), 10–15.

Weingrod 1993b
Carmi Weingrod. "Methods and Materials: The Essence of Charcoal." *American Artist* 57 (November 1993), 10–16.

Wellesley/Cleveland 1993–94
Anne-Marie Logan. *Flemish Drawings in the Age of Rubens. Selected Works from American Collections.* Davis Museum and Cultural Center, Wellesley, Massachusetts; Cleveland Museum of Art, 1993–94.

Werner 1960
Alfred Werner. "Berichte." *Pantheon* 18 (1960), 44–55.

Werner 1971
Alfred Werner. "Albrecht Dürer: Master Draftsman." *American Artist* 35 (September 1971), 24–29; 61–63.

West 1968
Richard West. "George Grosz—Figure for Yvan Goll's Methusalem." *CMA Bulletin* 55 (1968), 90–94.

Westfehling 1986
Uwe Westfehling. *Meisterzeichnungen von Leonardo bis zu Rodin.* Cologne, 1986.

Westgeest 1996
Helen Francis Westgeest. *Zen in the Fifties: Interaction in Art between East and West.* Leiden, 1996.

White 1957
John White. *The Birth and Rebirth of Pictorial Space.* Cambridge, 1957.

Wierich 1990
Jochen Wierich. "Beyond Innocence: Images of Boyhood from Winslow Homer's First Gloucester Period." In *Winslow Homer in Gloucester*. Edited by S. Taylor. Chicago, 1990.

Wilenski 1931
R. H. Wilenski. *French Painting*. Boston, 1931.

Wilenski 1949
R. H. Wilenski. *French Painting*. 2nd ed. London, 1949.

Wilkins 1998
Thurman Wilkins. *Thomas Moran: Artist of the Mountains*. Norman, Oklahoma, 1998.

Williams 1979
Eunice Williams. "Rescuing Fragonard from 'a Kind of Limbo.'" *ArtNews* 78 (May 1979), 74–78.

Williams 1999
Thomas Williams. *Old Master Drawings*. London, 1999.

Williamstown et al. 1999
Alexandra Murphy et al. *Jean-François Millet: Drawn into the Light*. Sterling and Francine Clark Art Institute, Williamstown, Massachusetts; Frick Art and Historical Center, Pittsburgh; Rijksmuseum Vincent van Gogh, Amsterdam, 1999.

Wilson 1955
James Benjamin Wilson. "The Significance of Thomas Moran as an American Landscape Painter." Ph.D. diss., Ohio State University, 1955.

Wilton 1976
Andrew Wilton. *Turner in Switzerland*. Zurich, 1976.

Wilton 1979
Andrew Wilton. *J. M. W. Turner: His Art and Life*. New York, 1979.

Wilton 1987
Andrew Wilton. *Turner in His Time*. New York, 1987.

Winkler 1927
Friedrich Winkler. "The Collection of Dürer Drawings at Lemberg (Galicia)." *Old Master Drawings* 2 (September 1927), 15–19.

Winkler 1936–39
Friedrich Winkler. *Die Zeichnungen Albrecht Dürers*. 4 vols. Berlin, 1936–39.

Winkler 1957
Friedrich Winkler. *Albrecht Dürer: Leben und Werk*. Berlin, 1957.

Winterthur 1953
Théodore Géricault 1791–1824. Kunstmuseum, Winterthur, Switzerland, 1953.

Winzinger 1952
Franz Winzinger. *Albrecht Altdorfer Zeichnungen*. Munich, 1952.

Winzinger 1979
Franz Winzinger. *Wolf Huber: Das Gesamtwerk*. Munich, 1979.

Wixom 1967
William Wixom. *Treasures from Medieval France*. Cleveland, 1967.

Wolk-Simon 1996–97
Linda Wolk-Simon. "Domenico Tiepolo: Drawings, Prints and Paintings in the Metropolitan Museum of Art." *Metropolitan Museum of Art Bulletin* 54 (Winter 1996–97), 1–68.

Wood 1988
Dan Wood. *The Craft of Drawing*. San Diego, 1988.

Wood 1993
Christopher Wood. *Albrecht Altdorfer and the Origins of Landscape*. Chicago, 1993.

Worcester 1948
"Fiftieth Anniversary Exhibition of the Art of Europe during the XVIth–XVIIth Centuries." Worcester Art Museum, Massachusetts, 1948.

Worms de Romilly/Laude 1982
Nicole Worms de Romilly and Jean Laude. *Braque, le cubisme: Fin 1907–1914*. Maeght, France, 1982.

Yamazawa 1966
Yamazawa Syoichi. "News from Abroad." *Mizue* 742 (November 1966), 92–99.

Yonkers et al. 1990
James Yarnell. *John La Farge: Watercolors and Drawings*. Hudson River Museum, Yonkers, New York; Munson-Williams-Proctor Institute, Utica, New York; Terra Museum of American Art, Chicago, 1990.

Young 1966
Mahonri Sharp Young. "Letter from U.S.A.: Great Guns at Detroit and Cleveland." *Apollo* 84 (September 1966), 237–42.

Young 1971
Mahonri Sharp Young. "The Loving Eye, the Cunning Hand." *Apollo* 94 (July 1971), 40–46.

Zabel 1929
Morton Dauwen Zabel. "The Portrait Methods of Ingres." *Art and Archaeology* 28 (October 1929), 103–16.

Zabel 1930
Morton Dauwen Zabel. "Ingres in America." *Arts* 16 (February 1930), 369–82.

Zervos 1932–78
Christian Zervos. *Pablo Picasso*. 33 vols. Paris, 1932–78.

Zervos 1933
Christian Zervos. "Georges Braque." *Cahiers d'Art* 8, no. 1 (1933), 1–28.

Zimmermann 1991
Michael F. Zimmermann. *Seurat and the Art Theory of His Time*. Antwerp, 1991.

Zucker 1973
Mark Zucker. "Parri Spinelli: Aretine Painter of the Fifteenth Century." Ph.D. diss., Columbia University, 1973.

Zucker 1981
Mark Zucker. "Parri Spinelli Drawings Reconsidered." *Master Drawings* 19 (Winter 1981), 426–41.

Zurcher 1988
Bernard Zurcher. *Georges Braque: Life and Work*. New York, 1988.

Zurich 1941
Johann Heinrich Füssli 1741–1825. Kunsthaus, Zurich, 1941.

Zurich 1958
Sammlung Emil G. Bührle. Kunsthaus, Zurich, 1958.

Zurich 1971
"Claude Lorrain: 60 Zeichnungen." Kunsthaus, Zurich, 1971.

CMA 1923–24
Contemporary American Watercolors, 12 December 1923–27 January 1924

CMA 1924
Special Exhibition of War by Jean Louis Forain, 13 March–24 April 1924

CMA 1925
Exhibition of Lithographs and Paintings by Fantin-Latour, 1–15 December 1925

CMA 1926
The Maurice Prendergast Memorial Exhibition, 16 January–15 February 1926

CMA 1927
Fourth Exhibition of Water Colors and Pastels, 17 February–13 March 1927

CMA 1929a
Sixth Annual Exhibition of Water Colors and Pastels, 22 March–10 April 1929

CMA 1929b
French Art since 1800, 8 November–8 December 1929

CMA 1930
Seventh Annual Exhibition of Water Colors and Pastels, 23 January–23 February 1930

CMA 1932–33
Drawings in the Classic and Romantic Tradition before 1830, 7 December 1932–8 January 1933

CMA 1934
Art of the Seventeenth and Eighteenth Centuries, 8 November–2 December 1934

CMA 1935
Exhibition of Drawings from the Museum Collection Supplemented by Loans from Local Collections, 12 July–15 September 1935

CMA 1937a
Paintings and Drawings by Theodore Géricault, 9 February–7 March 1937

CMA 1937b
Exhibition of Sculptors' Drawings, 9 November–8 December 1937

CMA 1938a
Exhibition of Print Club Publications, Past Fifteen Years, 9 February–20 March 1938

CMA 1938b
Drawings by Old and Modern Masters from the Collection, 21 June–30 September 1938

CMA 1938c
Drawings from the Collection of Sir Robert Witt, London, Supplemented by Drawings from the Collection, 1–30 October 1938

CMA 1938d
Exhibition of Oils by Henri Matisse, 11 November–18 December 1938

CMA 1939a
Exhibition of Expressionism and Related Movements, 25 January–28 February 1939

CMA 1939b
Life of Pulcinella Series, 30 March–30 April 1939

CMA 1940a
Donald Gray Memorial Collection of Fruit and Flower Prints, 29 March–28 April 1940

CMA 1940b
Exhibition with Drawings as a Part of the Museum of Modern Art Travelling Show, Picasso: His Forty Years of Art, 7 November–8 December 1940

CMA 1940–41
Drawings by Old Italian Masters from the Collection, 5 June 1940–25 February 1941

CMA 1941a
Exhibition of the Bequest of James Parmelee, 29 January–16 March 1941

CMA 1941b
Silver Jubilee Exhibition: Prints and Drawings, 23 June–5 October 1941

CMA 1942a
French Drawings and Watercolors from French Public and Private Collections, 15 January–15 February 1942

CMA 1942b
Jean Louis Forain, 10 February–8 March 1942

CMA 1943a
Flower Prints and Drawings from the Collection, 6 April–1 June 1943

CMA 1943b
Exhibition of French Art, 22 June–31 August 1943

CMA 1944–45a
Exhibition of the Month: How to Draw Faces, 25 September 1944–28 January 1945

CMA 1944–45b
Prints and Drawings of Ornamental Designs—Museum Collection, 7 November 1944–26 January 1945

CMA 1945a
Exhibition of the Month: Ways of Drawing Nudes, 1 April–27 May 1945

CMA 1945b
Topographical Viewpoints: Prints and Drawings, 30 October–30 December 1945

CMA 1945–46
Exhibition of the Month: Music in Art, 2 October 1945–3 February 1946

CMA 1946a
Exhibition of Cartoons and Caricatures, 12 March–14 April 1946

CMA 1946b
Flower and Fruit Prints: the Donald Gray Memorial Collection, 8 May–30 June 1946

CMA 1946c
Works by Hilaire Germain Edgar Degas, 15 June–6 October 1946

CMA 1947a
Exhibition of Gifts from Mrs. Ralph King and Family, in Memory of Mr. Ralph King, 15 January–15 February 1947

CMA 1947b
Works by Edgar Degas, 5 February–9 March 1947

CMA 1948a
Geometric and Biomorphic Line, 12 February–13 April 1948

CMA 1948b
The Rise of Line in Landscape, 3 June–26 September 1948

CMA 1949a
Original Prints and Drawings by Masters of the Berlin Paintings, 11 January–27 March 1949

CMA 1949b
Matisse Drawings, 29 March–24 April 1949

CMA 1949c
Classic to Baroque: A Style Change in the Arts, 1 October–6 November 1949

CMA 1951a
Contemporary French Painting, 3 January–12 March 1951

CMA 1951b
Exhibition of Paintings and Drawings by Henri de Toulouse-Lautrec, 9 January–4 February 1951

CMA 1951c
Thirty-fifth Anniversary Exhibition: Exhibition of Representative Gifts and Bequests through Thirty-five Years, 19 June–23 September 1951

CMA 1951–52
Exhibition of Work of Odilon Redon, 29 November 1951–27 January 1952

CMA 1952
Exhibition of Work by Henri Matisse, 6 February–16 March 1952

CMA 1953a
Loan Exhibition: Paintings and Drawings by Ingres, 5–29 March 1953

CMA 1953b
Views of Venice, 10 March–26 April 1953

CMA 1953c
French Drawings from the Collection, 14 January–26 April 1953

CMA 1953–54
French Drawings from the Collection, 22 November 1953–25 April 1954

CMA 1954
French Drawings from the Collection, 30 April–16 June 1954

CMA 1954–55
The Life of the Virgin in Prints, 7 December 1954–2 January 1955

CMA 1955a
Horticultural Motifs in Art, 9 March–24 April 1955

CMA 1955b
French Drawings, 14 March–15 June 1955

CMA 1955c
German Drawings, 11 November–18 December 1955

CMA 1956a
French Prints and Drawings, 29 February–14 June 1956

CMA 1956b
Gros, Painter of Battles: the First Romantic Painter, 8 March–15 April 1956

CMA 1956c
Art: The International Language, 2 October–
4 November 1956

CMA 1957
*Drawings by Charles E. Burchfield Shown
with Loan Exhibition "Retrospective Exhibi-
tion of the Work of Charles E. Burchfield," 4
January–10 February 1957*

CMA 1958a
Prints and Drawings by Aristide Maillol, 1
July–31 August 1958

CMA 1958b
*Contemporary Glass from the Museum Col-
lection*, 2–18 September 1958

CMA 1958–59
*Department of Prints and Drawings: Open-
ing Exhibition*, 3 March 1958–11 October
1959

CMA 1959
The Year in Review for 1959, 2–20 December
1959

CMA 1959–60a
Italian and French Drawings, 13 October
1959–2 February 1960

CMA 1959–60b
*Gifts of the Print Club of Cleveland during
Its First Twenty Years to the Cleveland Mu-
seum of Art: Fortieth Anniversary of the
Print Club of Cleveland, 1919–1959*, 3 De-
cember 1959–20 January 1960

CMA 1960a
The Artist and the Theater, 5 April–12 Sep-
tember 1960

CMA 1960b
*Drawings from the Museum Collection, Fif-
teenth–Seventeenth Centuries*, opened 18 May
1960

CMA 1960c
Flower and Fruit Prints and Drawings, 25
May–11 October 1960

CMA 1960d
The Year in Review for 1960, 30 November–
31 December 1960

CMA 1960–61
*Gifts of the Print Club of Cleveland during
Its Second Twenty Years to the Cleveland
Museum of Art 1939–1959*, 11 October 1960–
3 November 1961

CMA 1961a
Aspects of Drawing, 10 January–3 April 1961

CMA 1961b
Year in Review for 1961, 1–26 November 1961

CMA 1962a
Art and Humanism in the Renaissance, 23
January–25 February 1962

CMA 1962b
The Year in Review for 1962, 23 October–25
November 1962

CMA 1963–64
The Year in Review for 1963, 26 November
1963–5 January 1964

CMA 1964
Old Master Drawings, 10–30 March 1964

CMA 1965a
Year in Review for 1964, 1–31 January 1965

CMA 1965b
Drawings: France, Italy, Netherlands, 14
January–24 March 1965

CMA 1965c
19th and 20th Century Drawings, February
19–24 March 1965

CMA 1965d
*Flower Drawings, Prints, and Books from the
Mr. and Mrs. Warren H. Corning Collection*,
20 April–6 June 1965

CMA 1965e
Ars Medica, 6 August–21 November 1965

CMA 1965f
The Year in Review for 1965, 27 October–14
November 1965

CMA 1965–66
French Drawings, 10 November 1965–16
February 1966; reopened 31 March 1966

CMA 1966
Golden Anniversary Acquisitions, 10 Septem-
ber–16 October 1966

CMA 1966–67a
Old Master Prints and Drawings, 29 July
1966–28 February 1967

CMA 1966–67b
Treasures from Medieval France, 11 Novem-
ber 1966–29 January 1967

CMA 1967
The Year in Review for 1967, 29 November–
31 December 1967

CMA 1968a
Drawings before 1800, January–February
1968

CMA 1968b
Italian Prints and Drawings, 30 January–26
March 1968

CMA 1968c
Mr. and Mrs. Charles G. Prasse Collection, 11
June–21 October 1968

CMA 1969
The Year in Review for 1968, 29 January–9
March 1969

CMA 1970a
The Year in Review for 1969, 27 January–22
February 1970

CMA 1970b
*Gifts from the Print Club to the Cleveland
Museum of Art*, 14 April–2 August 1970

CMA 1971
The Year in Review for 1970, 10 February–7
March 1971

CMA 1971–72
The Year in Review for 1971, 28 December
1971–6 February 1972

CMA 1973a
The Year in Review for 1972, 27 February–18
March 1973

CMA 1973b
In Memoriam—Pablo Picasso, 1881–1973, 10
April–7 May 1973

CMA 1974a
The Year in Review for 1973, 30 January–17
March 1974

CMA 1974b
American Water Colors, July–25 September
1974

CMA 1974c
Art for Collectors, 20 November–18 Decem-
ber 1974

CMA 1974–75
Italian and Netherlandish Drawings, 14
August 1974–3 June 1975

CMA 1975a
The Year in Review for 1974, 11 March–6
April 1975

CMA 1975b
Contemporary Drawings, 13 June–3 August
1975

CMA 1976
The Year in Review for 1975, 3 February–7
March 1976

CMA 1977
Year in Review for 1976, 1 February–6 March
1977

CMA 1977–78
Year in Review for 1977, 28 December 1977–
22 January 1978

CMA 1978a
*Constantin Guys: Crimean War Drawings
1854–1856*, 18 July–3 September 1978

CMA 1978b
*Master Drawings with the Von Hirsch Acqui-
sitions*, September–November 1978

CMA 1979a
Year in Review for 1978, 13 February–18
March 1979

CMA 1979b
*Seventeenth-, Eighteenth-, and Early Nine-
teenth-Century Genre and French Prints and
Drawings*, 31 May–19 August 1979

CMA 1979–80
*Gifts of the Print Club of Cleveland, 1969–
1979*, 11 September 1979–27 January 1980

CMA 1980a
*German Drawings of the Eighteenth, Nine-
teenth, and Twentieth Centuries*, 1 April–13
July 1980

CMA 1980b
*Stefano della Bella, Giovanni Benedetto
Castiglione, Jacques Bellange, Jacques Callot*,
7 May–13 July 1980

CMA 1980c
Year in Review for 1979, 13 February–9
March 1980

CMA 1980–81
*Connoisseurship in Italian Figural Composi-
tions*, 21 October 1980–15 February 1981

CMA 1981a
Brush Drawings, 3 March–10 May 1981

CMA 1981b
Year in Review for 1980, 24 June–19 July 1981

CMA 1981c
*Eighteenth-Century Master Drawings from
the Collection*, 6 October–22 November 1981

CMA 1981d
The Tiepolos and Their World, 6 October–22
November 1981

CMA 1981–82a
*Promenades, Pageants, Processions, and
Pilgrimages*, 25 August 1981–3 January 1982

CMA 1981–82b
*"When Angels Bent Near the Earth to Touch
Their Harps of Gold": The Christmas Story*,
1 December 1981–9 January 1982

CMA 1982a
*French Prints and Drawings in the Age of
the Bourbons, 1589–1792*, 25 January–16 May
1982

CMA 1982b
Visions of Landscape: East and West, 17
February–21 March 1982

CMA 1982c
Year in Review for 1981, 17 February–21 March 1982

CMA 1982d
Seventeenth-Century Netherlandish Graphics, 27 April–1 August 1982

CMA 1982e
Graphic Humor, 1 June–29 August 1982

CMA 1982f
The Impressionist Aesthetic, 10 August–17 October 1982

CMA 1982–83a
Master Goldsmiths of the Renaissance: Their Models and Designs, 2 November 1982–20 March 1983

CMA 1982–83b
Northern European Drawings from the Cleveland Museum of Art, 16 November 1982–9 January 1983

CMA 1983a
Year in Review for 1982, 5 January–6 February 1983

CMA 1983b
Goya, Géricault, and Delacroix, 25 January–24 April 1983

CMA 1983c
The Lessons of the Academy, 8 February–29 May 1983

CMA 1983d
Ca. 1930 [Art Deco], 12 April–31 October 1983

CMA 1983e
The Perennial Garden: Eighteenth- and Nineteenth-Century Botanical Prints, 3 May–31 July 1983

CMA 1983f
National Schools of Style, 14 June–18 September 1983

CMA 1983–84a
Highlights of the Rococo: Norweb Ceramics and Related Arts, 8 November 1983–3 June 1984

CMA 1983–84b
Portraiture: The Image of the Individual, 22 November 1983–22 January 1984

CMA 1984a
I and Thou, 21 February–27 May 1984

CMA 1984b
Year in Review for 1983, 22 February–8 April 1984

CMA 1984c
Lepere, Legros, and Buhot, 1 May–23 September 1984

CMA 1984d
Odilon Redon: Dream Creatures and Anemones, 21 August–14 October 1984

CMA 1984–85a
Mirrors: Art and Symbol, 3 July 1984–27 January 1985

CMA 1984–85b
America Draws, 28 December 1984–17 March 1985

CMA 1985a
Nocturnal Impressions, 20 February–2 May 1985

CMA 1985b
Venice as City and Theater, 27 February–21 April 1985

CMA 1985c
Year in Review for 1984, 3 April–5 May 1985

CMA 1985d
Leona E. Prasse, Connoisseur and Curator, 28 May–10 September 1985

CMA 1985e
Urban Vicissitudes, 2 June–29 September 1985

CMA 1986a
Animals as Romantic Icons in French Art, 8 April–5 October 1986

CMA 1986b
Gallant Ships and Bully Boys, 6 May–17 August 1986

CMA 1986c
From Block Books to Baskin: Artists as Illustrators, 13 May–17 August 1986

CMA 1986–87a
The Magic of Still Life, 4 November 1986–8 March 1987

CMA 1986–87b
Italian Drawings from the Permanent Collection, 15 December 1986–1 March 1987

CMA 1986–87c
Real Prints: Reproduction or Invention, 16 December 1986–18 January 1987 and 31 March–19 May 1987

CMA 1987a
The Year in Review for 1986, 4 February–15 March 1987

CMA 1987b
The Graphic Art of the Barbizon School, 17 March–7 June 1987

CMA 1987c
Images of the Mind, 7 July–30 August 1987

CMA 1987d
Lord Leighton's King David, 21 October–29 November 1987

CMA 1988a
The Year in Review for 1987, 24 February–17 April 1988

CMA 1988b
Treasures on Paper: The Cleveland Museum of Art, 10 May–24 July 1988

CMA 1988–89
Views of Rome from the Permanent Collection, 2 November 1988–8 January 1989

CMA 1989a
Lutes, Lovers and Lyres: Musical Imagery in the Collection, 6 February–11 June 1989

CMA 1989b
The Year in Review for 1988, 1 March–14 May 1989

CMA 1989c
Rococo, Revolution, Restoration, 11 July–24 September 1989

CMA 1989–90
Cross Section: Graphic Art in Germany after the First World War, 10 October 1989–7 January 1990

CMA 1990a
The Year in Review: Selections 1989, 6 February–15 April 1990

CMA 1990b
The Birth and Flowering of British Romantic Art, 1 May–22 July 1990

CMA 1990c
Design and Decoration: Ornament Prints, 7 August–28 October 1990

CMA 1990d
Drawings: Discoveries in the Collection, 7 August–28 October 1990

CMA 1991a
Albrecht Dürer and His Influence, 16 January–10 March 1991

CMA 1991b
Directions in Drawing: 1750–1988, 2 April–4 August 1991

CMA 1991c
Generous Donors: A Tribute to the Print Club of Cleveland, 2 April–4 August 1991

CMA 1991d
Notable Acquisitions, 7 June–15 September 1991

CMA 1991e
Object Lessons: Cleveland Creates an Art Museum, 7 June–8 September 1991

CMA 1991f
Concept, Dogma, and Feeling: Italian Drawings 1550–1650, 27 August–20 October 1991

CMA 1991–92a
Directions in Drawing II: The Human Figure, 5 November 1991–12 January 1992

CMA 1991–92b
Artists' Working Books, 5 November 1991–12 January 1992

CMA 1991–92c
Images of War, 5 November 1991–12 January 1992

CMA 1991–92d
The Recovery of a Renaissance Painting: A Madonna by Pintoricchio, 19 November 1991–12 January 1992

CMA 1992a
Selected 1991 Acquisitions, 28 January–26 April 1992

CMA 1992b
The Flowering of Botanical Prints, 19 May–6 September 1992

CMA 1992–93
Signs of Affection: Gifts Honoring the Museum's Seventy-Fifth Anniversary, 27 October 1992–3 January 1993

CMA 1993a
Selected [1992] Acquisitions, 9 February–11 April 1993

CMA 1993b
The German Tradition, 27 April–27 June 1993

CMA 1993–94
Mary Cassatt and Berthe Morisot, 7 November 1993–2 January 1994

CMA 1994
Recent Acquisitions: Prints, Drawings, Photographs, 13 September–27 November 1994

CMA 1994–95
French Drawings from the Collection, 13 December 1994–12 March 1995

CMA 1997
Mannerism: Italian, French, and Netherlandish Prints, 1520–1620, 3 August–26 October 1997

CMA 1998
American Drawings from the Permanent Collection, 19 April–12 July 1998

CMA 1999
Drawn to the Body: The Human Figure and the Graphic Arts, 1500–1900, 14 March–23 May 1999

Index of Artists